Asian Art

BLACKWELL ANTHOLOGIES IN ART HISTORY

The *Blackwell Anthologies in Art History* series presents an unprecedented set of canonical and critical works in art history. Each volume in the series pairs previously published, classic essays with contemporary historiographical scholarship to offer a fresh perspective on a given period, style, or genre in art history. Modeling itself on the upper-division undergraduate art history curriculum in the English-speaking world and paying careful attention to the most beneficial way to teach art history in today's classroom setting, each volume offers ample pedagogical material created by expert volume editors – from substantive introductory essays and section overviews to illustrations and bibliographies. Taken together, the *Blackwell Anthologies in Art History* will be a complete reference devoted to the best that has been taught and written on a given subject or theme in art history.

1 *Post-Impressionism to World War II*, edited by Debbie Lewer
2 *Asian Art*, edited by Rebecca M. Brown and Deborah S. Hutton
3 *Sixteenth-Century Italian Art*, edited by Michael W. Cole
4 *Architecture and Design in Europe and America, 1750–2000*, edited by Abigail Harrison-Moore and Dorothy C. Rowe

Forthcoming
1 *Fifteenth-Century Italian Art*, edited by Robert Maniura, Gabriele Neher, and Rupert Shepherd
2 *Late Antique, Medieval, and Mediterranean Art*, edited by Eva Hoffman

Asian Art ──────────────

Edited by *Rebecca M. Brown* and
Deborah S. Hutton

Blackwell
Publishing

BLACKWELL PUBLISHING
350 Main Street, Malden, MA 02148-5020, USA
9600 Garsington Road, Oxford OX4 2DQ, UK
550 Swanston Street, Carlton, Victoria 3053, Australia

First published 2006 by Blackwell Publishing Ltd

2 2007

Library of Congress Cataloging-in-Publication Data

Asian art/edited by Rebecca M. Brown and Deborah S. Hutton.
 p. cm.—(Blackwell anthologies in art history; 2)
 Includes index.
 ISBN-13: 978-1-4051-2240-5 (hardback: alk. paper)
 ISBN-10: 1-4051-2240-4 (hardback: alk. paper)
 ISBN-13: 978-1-4051-2241-2 (pbk.: alk. paper)
 ISBN-10: 1-4051-2241-2 (pbk.: alk. paper) 1. Art, Asian. I. Brown, Rebecca M.
 II. Hutton, Deborah S. III. Series.

 N7260.A815 2006
 709.5—dc22

 2006001997

A catalogue record for this title is available from the British Library.

Set in 10.5/13pt Galliard
by SPI Publisher Services, Pondicherry, India

The publisher's policy is to use permanent paper from mills that operate a sustainable
forestry policy, and which has been manufactured from pulp processed using acid-free
and elementary chlorine-free practices. Furthermore, the publisher ensures that the text
paper and cover board used have met acceptable environmental accreditation standards.

For further information on
Blackwell Publishing, visit our website:
www.blackwellpublishing.com

Contents

List of Illustrations ix
Series Editor's Preface xi
Acknowledgments xii
Introduction 1

Part I South and Southeast Asia ——————————— 11
Selected Periods and Dates 11

1 Edicts of the Indian Mauryan Emperor Ashoka 13

2 "The Great Ape Jataka" and "Ruru-Jataka": Selections
 from the *Jataka* 21

3 "The Country of Khotan and the Image Procession" and
 "The Image Procession and the Charitable Hospital":
 Selections from *A Record of the Buddhist Countries* 30
 Fa-Hsien [Faxian]

4 "Varaha, the Boar," "Brahma, Vishnu and the Linga of Shiva,"
 "Mt Govardhana," "The Origin of the Goddess from the Gods,"
 and "The Death of Mahisha, the Buffalo Demon," from
 Classical Hindu Mythology: A Reader in the Sanskrit Puranas 34

5 Playful Ambiguity and Political Authority at the Large Relief
 at Mamallapuram 43
 Padma Kaimal

6 Excerpts from *Borobudur* 57
 Louis Frederic

7 Reading Love Imagery on the Indian Temple 71
 Vidya Dehejia

8 Excerpts from *Angkor Wat: Time, Space, and Kingship* 83
 Eleanor Mannikka

9 "Akbar Riding the Elephant Havai" and "Akbar Supervising the
 Construction of Fatehpur Sikri," from *The Akbarnama of Abul Fazl* 93

10 Excerpts from *The Jahangirnama: Memoirs of Jahangir,*
 Emperor of India 97

11 Orthodoxy, Innovation, and Revival: Considerations of the Past
 in Imperial Mughal Tomb Architecture 101
 Michael Brand

12 Timeless Symbols: Royal Portraits from Rajasthan 17th–19th
 Centuries 116
 Vishakha Desai

13 Indian Images Collected 127
 Richard Davis

14 Image as Presence 140
 Janet Gyatso

15 Excerpts from *Making Merit, Making Art: A Thai Temple in Wimbledon*
 Sandra Cate 147

16 The Artist as Charismatic Individual: Raja Ravi Varma 167
 Partha Mitter

17 The "East–West" Opposition in Chandigarh's Le Corbusier 177
 Vikramaditya Prakash

18 Skyscraper Competition in Asia: New City Images and
 New City Forms 189
 Larry R. Ford

Part II East Asia ———————————————————————————— 199
Selected Periods and Dates 199

19 The Nine Tripods and Traditional Chinese Concepts of
 Monumentality 201
 Wu Hung

20 Shang and Zhou Bronze Inscriptions 214

21 A Magic Army for the Emperor 218
 Lothar Ledderose

22 The Tigress 237
 Arya Shura

23 The Six Laws of Xie He 242

24 The Taming of the Shrew: Wang Xizhi (303–361) and
 Calligraphic Gentrification in the Seventh Century 247
 Eugene Y. Wang

25 Ise Jingu 261
 William H. Coaldrake

26 Proclamation of the Emperor Shomu on the Erection of the
 Great Buddha Image 275

27 Of Nature and Art: Monumental Landscape 278
 Wen C. Fong

28 Guo Xi's Writings on Landscape Painting 289

29 Jocho's Statue of Amida at the Byodoin and Cultural
 Legitimization in Late Heian Japan 295
 Samuel C. Morse

30 "The Oak Tree," from *The Tale of Genji* 311
 Murasaki Shikibu

31 The Unity of the Three Creeds: A Theme in Japanese Ink
 Painting of the Fifteenth Century 325
 John M. Rosenfield

32 Symbolic Virtue and Political Legitimation: Tea and
 Politics in the Momoyama Period 338
 Kendall H. Brown

33 Practices of Vision 352
 Craig Clunas

34 Excerpts from *Chinese Imperial City Planning* 362
 Nancy Shatzman Steinhardt

35 Letters from European Travelers about the Forbidden City:
 "A Jesuit in Beijing: Louis Lecomte" and "An English
 Ambassador in Beijing: Aeneas Anderson" 376

36 The Conventional Success of Chen Shu 380
 Marsha Weidner

37 Artistic Tradition and the Depiction of Reality: True-View
 Landscape Painting of the Choson Dynasty 395
 Yi Song-mi

38 The Meaning of Western Perspective in Edo Popular Culture 408
 Timon Screech

Contents ─────────────────────────

39 The Kizaemon Tea-bowl 424
 Soetsu Yanagi

40 Excerpts from *Quotations from Chairman Mao Zedong* 431
 Mao Zedong

41 Icons of Power: Mao Zedong and the Cultural Revolution 435
 Robert Benewick

42 Morphology of Revenge: The Yomiuri Indépendant Artists and
 Social Protest Tendencies in the 1960s 448
 Alexandra Munroe

43 Pseudo-languages: A Conversation with Wenda Gu, Xu Bing, and
 Jonathan Hay 462
 Simon Leung

44 Believing Is Seeing: Transforming Orientalism and the Occidental
 Gaze 476
 John Kuo Wei Tchen

Index 493

Illustrations

5–1 Great Relief, Mamallapuram, Tamil Nadu, India, seventh to eighth centuries

6–1 Elevation, Borobudur, Java, ninth century

7–1 Vishvanatha Temple, Khajuraho, Sculptural detail, 999 CE

8–1 Plan of Angkor Wat, Cambodia, twelfth century

8–2 Third gallery, east side, south half, Churning of the Sea of Milk, Angkor Wat, Cambodia, twelfth century

10–1 *The Dying Inayat Khan*. India, Mughal period, *c*.1618–19

11–1 Humayun's tomb, 1562–71, Delhi, India

11–2 Akbar's tomb, 1605–13, Sikandra, India

12–1 *Maharana Amar Singh Playing Holi with Courtiers*

13–1 Tipu's Tiger. Painted wood effigy with mechanical organ

17–1 High Court, Chandigarh, 1951–5

18–1 Petronas Twin Towers, Cesar Pelli and Associates, 1997

21–1 Plan of the necropolis of the First Emperor of Qin

21–2 Ground plan and cross-section of pit no. 1, tomb of First Emperor of Qin

24–1 Wang Xizhi (303–361), Letter on the Disturbances (*Sangluan tie*)

24–2 Wang Xizhi (303–361), Old Capital Letter (*Jiujing tie*)

27–1 After Li Cheng (919–967), *Travelers in a Wintry Forest*, early twelfth century

31–1 *The Three Laughers of the Tiger Ravine, c*.1500

34–1 Plan of Beijing from the seventeenth through nineteenth centuries showing imperial and administrative buildings

36–1 Chen Shu (Ch'en Shu), *The White Cockatoo*, 1721

38–1 Katsushika Hokusai, Nihon-bashi in Edo (*c*.1832), from the series *Fugaku sanjurokkei*

42–1 Shusaku Arakawa, *Untitled Endurance I*, 1958

42–2 Akasegawa Genpei, *Morphology of Revenge* (*Fukushu no keitaigaku*), 1968
43–1 Xu Bing, *A Case Study of Transference*, 1993–95
43–2 Wenda Gu, *United Nations-Africa Monument: The World Praying Wall*, 1997

Series Editor's Preface

The *Blackwell Anthologies in Art History* series is intended to bring together writing on a given subject from a broad historical and historiographic perspective. The aim of the volumes is to present key writings in the given subject area while at the same time challenging their canonical status through the inclusion of less well known texts, including contemporary documentation and commentaries, that present alternative interpretations or understandings of the period under review.

Asian Art presents a geographically and chronologically broad coverage of the subject looking at the most ancient periods in art through to the most recent developments from present-day Pakistan on the west to Japan and the Pacific Ocean on the east. The chosen texts discuss a range of media and types of art, so offering a new and innovative mix of the traditional art historical media of painting, sculpture, and architecture, with calligraphy, excavated spaces, gardens, ceramics, posters, and performance art.

This anthology offers an important resource for students and teachers of Asian art. The historical and historiographic themes in the volume challenge canonical representations of the subject and offer a wide-ranging review of how we think about Asian art. In their introduction the authors describe this volume as "comprehensive, accessible, current, and usable," and there is little doubt of the validity of their claims. *Asian Art* is a very welcome addition to the initial volumes to appear in this series.

Dana Arnold

Acknowledgments

Many individuals and institutions have assisted in the preparation and completion of this anthology, most prominently our students in courses as diverse as general introductions to art history and advanced seminars on topics such as gender in Asian and Islamic art. We thank those many students at St Mary's College of Maryland, Skidmore College, and the University of Redlands for their enthusiasm, energy, and helpful feedback. Among them, several have spent endless hours in front of copiers, scanners, and filing cabinets, reading texts dutifully with highlighter and pen in hand, including: Anna Wadsworth, Richard Warr, Jessica Wolfley, Chris Pennington, Jacob Lewis, Elisa Travisiono, Ellie Forseter, Kate Pokorny, and Jeffrey Bussman.

Numerous colleagues have contributed comments, feedback, syllabi, and conversation as we built this reader, including Deepali Dewan, Mary Beth Heston, Padma Kaimal, Elizabeth Ayer, Lisa Safford, Sharon Littlefield, Jennifer Joffee, Marsha Olson, and Reiko Tomii. Pika Ghosh, T. C. (Jack) Kline, and De-nin Lee read over introductions, used pieces of the anthology in their courses, and helped us with transliteration and romanization questions, all invaluable aid as we built the anthology. The anonymous reviewers offered excellent and incisive feedback, pushing us to make the anthology as comprehensive as possible and assisting us in finding several key readings. We hope this volume reflects our colleagues' high standards.

Several institutions have funded the research and student assistance required to build this volume, including St Mary's College of Maryland, Skidmore College, the University of Redlands, and the College of New Jersey. We also would like to thank the excellent interlibrary loan departments at these institutions as well as the unendingly helpful and patient administrative assistants, including Terri Brandt and Terre Hodgson.

During the course of this project, we both realized a debt to the wonderful teachers we have had the privilege of studying with, and whose vision guides this text. Frederick M. Asher, Catherine E. B. Asher, George Gorse, and Bruce Coats

have all directly and indirectly had a hand in shaping this text. We hope we follow in their worthy footsteps.

Our editors at Blackwell, Jayne Fargnoli, Ken Provencher, and Dana Arnold, have been a joy to work with and have guided us through the process with professionalism and grace.

Finally, without the support of those closest to us, we would not have seen this text come to fruition. David Rubin and Sam Chambers know much more about Asian art history now than they ever wanted to know, from the intricacies of South Asian sculptural puns to the pinyin romanization of Mao Zedong's name. Thank you both for being our auspicious partners in this project.

Text Credits

The editors and publisher gratefully acknowledge the permission granted to reproduce the copyright material in this book:

1. "Ashokan Edicts," pp. 141–9 from Ainslie T. Embree (ed.), *Sources of Indian Tradition*, vol. 1. New York: Columbia University Press, 1988. © 1988 by Columbia University Press. Reprinted with permission of the publisher.
2. "The Great Ape Jataka," pp. 149–53 from Caroline A. F. Rhys Davids (ed.), *Stories of the Buddha*. New York: Dover, 1990; and "Ruru-Jataka," pp. 161–6 from E. B. Cowell (ed.), *The Jataka* (trans. W. H. D. Rouse). London: Luzac & Co, 1957.
3. Fa-Hsien [Faxian], "The Country of Khotan and the Image Procession," pp. 18–20, and "The Image Procession," pp. 60–1, from *A Record of the Buddhist Countries*, Li Yung-hsi [Li Yongxi]. Peking [Beijing]: The Chinese Buddhist Association, 1957.
4. "Varāha, the Boar," pp. 75–6, "Brahmā, Viṣṇu [Vishnu] and the Linga of Śiva [Shiva]," pp. 205–6, "Mt Govardhana," pp. 116–17, "The Origin of the Goddess from the Gods," pp. 233–7, "The Death of Mahiṣa [Mahisha], the Buffalo Demon," pp. 237–8, from Cornelia Dimmitt and J. A. B. van Buitenen (eds), *Classical Hindu Mythology: A Reader in the Sanskrit Puranas*. Philadelphia: Temple University Press, 1978.
5. Padma Kaimal, "Playful Ambiguity and Political Authority at the Large Relief at Mamallapuram," pp. 1–9, 13–15, 21–7 from *Ars Orientalis* 24 (1994). Reprinted by permission of Padma Kaimal and *Ars Orientalis*.
6. Louis Frederic, "Borobudur," pp. 18–19, 46, 48–72 from *Borobudur*. New York: Abbeville Press, 1994. Reprinted by permission of Abbeville Press.
7. Vidya Dehejia, "Reading Love Imagery on the Indian Temple," pp. 97–113 from *Love in Asian Art and Culture*. Washington, DC; Seattle and London: Arthur M. Sackler Gallery, Smithsonian Institution; University of Washington

Press, 1998. Reprinted by permission of The Freer Gallery of Art, Arthur M. Sackler Gallery, Smithsonian Institution.

8. Eleanor Mannikka, "Angkor Wat," pp. 9, 17–21, 32–43 from *Angkor Wat: Time, Space, and Kingship*. Honolulu: University of Hawaii Press, 1996. Reprinted by permission of the University of Hawaii Press. ©1996.

9. Abul Fazl, "Akbar Riding the Elephant Havai," pp. 232–5, and "Akbar Supervising the Construction of Fatehpur Sikri," pp. 530–1, from Henry Beveridge (ed.), *The Akbarnama of Abul Fazl*, vol. 2. Delhi: Ess Ess Publications, 1977. Reprinted by permission of Ess Ess Publications.

10. Jahangir, "The Jahangirnama," pp. 133–4, 268, 279–81 from Wheeler M. Thackston (ed.), *The Jahangirnama: Memoirs of Jahangir*. Washington, DC, New York, and Oxford: Freer Gallery of Art, Smithsonian Institution, and Oxford University Press, 1999. Reprinted by permission of The Freer Gallery of Art, Arthur M. Sackler Gallery, Smithsonian Institution.

11. Michael Brand, "Orthodoxy, Innovation, and Revival: Considerations of the Past in Imperial Mughal Tomb Architecture," pp. 323–34 from *Muqarnas* 10 (1993).

12. Vishakha Desai, "Timeless Symbols: Royal Portraits from Rajasthan 17th–19th Centuries," pp. 313–16, 320–6, 337–42 from Karine Schomer et al. (eds), *The Idea of Rajasthan*. Delhi: Manohar, 1994.

13. Richard Davis, "Indian Images Collected," pp. 146–54, 156–7, 167–74 from *Lives of Indian Images*. Princeton: Princeton University Press, 1997. © 1997 by Princeton University Press. Reprinted by permission of Princeton University Press.

14. Janet Gyatso, "Image as Presence," pp. 171–6 from Valrae Reynolds, *From the Sacred Realm: Treasures of Tibetan Art from the Newark Museum*. Munich, London, New York: Prestel, 1999. The Newark Museum, 1999.

15. Sandra Cate, "Making Merit, Making Art," pp. 48–56, 64–8, 174–7, 180–1 from *Making Merit, Making Art: A Thai Temple in Wimbledon*. Honolulu: University of Hawaii Press, 2003. Reprinted by permission of the University of Hawaii Press. © 2003.

16. Partha Mitter, "The Artist as Charismatic Individual: Raja Ravi Varma," pp. 179–80, 199–202, 205–7, 215–18; 406, 411–13, 415 from *Art and Nationalism in Colonial India, 1850–1922*. Cambridge: Cambridge University Press, 1994. Reprinted by permission of Cambridge University Press and Professor Partha Mitter.

17. Vikramaditya Prakash, "The 'East–West' Opposition in Chandigarh's Le Corbusier," pp. 5–9, 11–18, 21, 25–6 from *Chandigarh's Le Corbusier: The Struggle for Modernity in Postcolonial India*. Seattle and London: University of Washington Press, 2002. Reprinted by permission of The University of Washington Press.

18. Larry R. Ford, "Skyscraper Competition in Asia: New City Images and New City Forms," pp. 123–33, 140–2, 144 from Lawrence J. Vale and Samm Bass Warner Jr (eds), *Imaging the City: Continuing Struggles and New Directions*.

New Brunswick, NJ: Center for Urban Policy Research, 2001. Reprinted with permission.

19. Wu Hung, "The Nine Tripods and Traditional Chinese Concepts of Monumentality," pp. 1–10 from *Monumentality in Early Chinese Art and Architecture*. Stanford: Stanford University Press, 1995. Reprinted by permission of Professor Wu Hung.

20. "Shang and Zhou Bronze Inscriptions," p. 59 from Wu Hung, *Monumentality in Early Chinese Art and Architecture*. Stanford: Stanford University Press, 1995. Reprinted by permission of Professor Wu Hung; and "Shang and Zhou Bronze Inscriptions," translated by Constance A. Cook, pp. 15–16 from Deborah Sommer (ed.), *Chinese Religion: An Anthology of Sources*. Oxford: Oxford University Press, 1995. ©1995 by Oxford University Press, Inc. Used by permission of Oxford University Press, Inc.

21. Lothar Ledderose, "A Magic Army for the Emperor," pp. 51–4, 57–63, 68–73, 218–20 from *Ten Thousand Things: Module and Mass Production in Chinese Art*. Princeton: Princeton University Press, 1998. © 2000 by the Trustees of the National Gallery of Art, Washington DC, published by Princeton University Press. Reprinted by permission of Princeton University Press.

22. Ārya Śūra, "The Tigress," pp. 5–9 from Peter Khoroche (ed.), *Once the Buddha Was a Monkey: Ārya Śūra's [Shura's] Jatakamala*. Chicago and London: Chicago University Press, 1989. Reprinted by permission of The University of Chicago Press.

23. Xie He, "The Six Laws of Xie He," pp. 3–15 from William Acker and Reynolds Beal (eds), *Some T'ang [Tang] and Pre-T'ang [Pre-Tang] Texts on Chinese Painting*. Leiden: E.J. Brill, 1954.

24. Eugene Y. Wang, "The Taming of the Shrew: Wang Hsi-chih [Wang Xizhi] (303–361) and Calligraphic Gentrification in the Seventh Century," pp. 133–9, 143–8, 158–63, 166 from Cary Y. Liu, Dora C. Y. Ching, and Judith G. Smith (eds), *Character and Context in Chinese Calligraphy*. Princeton: Princeton University Press, 1999. © by the Trustees of Princeton University.

25. William H. Coaldrake, "Ise Jingu," pp. 20–42 from *Architecture and Authority in Japan*. London and New York: Routledge, 1996.

26. "Proclamation of the Emperor Shomu on the Erection of the Great Buddha Image," pp. 104–5 from Ryusaku Tsunoda, William Theodore de Bary, Donald Keene, *Sources of Japanese Tradition*, Volume 1. New York: Columbia University Press, 1958.

27. Wen C. Fong, "Of Nature and Art: Monumental Landscape," pp. 71–2, 74–83 from *Beyond Representation: Chinese Painting and Calligraphy 8th–14th Century*. New York and New Haven: The Metropolitan Museum of Art, Yale University Press, 1992.

28. Guo Xi, "On Landscape Painting," pp. 150–4, 168–9 from Susan Bush and Hsio-Yen Shih (eds), *Early Chinese Texts on Painting*. Cambridge: Harvard University Press, 1985.

29. Samuel C. Morse, "Jōchō's Statue of Amida at the Byōdo-in and Cultural Legitimization in Late Heian Japan," pp. 96–103, 106–13 from *Res* 23 (Spring 1993).

30. Murasaki Shikibu, "The Oak Tree," pp. 636–50 from Edward G. Seidensticker (ed. and trans.), *The Tale of Genji*. New York: Knopf, 1987.

31. John M. Rosenfield, "The Unity of the Three Creeds: A Theme in Japanese Ink Painting of the Fifteenth Century," pp. 205–17, 224–5 from John Whitney Hall and Toyoda Takeshi (eds), *Japan in the Muromachi Age*. Ithaca, NY: East Asia Program, Cornell University, 2001 [1977]. Reprinted by permission of John M. Rosenfield.

32. Kendall H. Brown, "Symbolic Virtue and Political Legitimation: Tea and Politics in the Momoyama Period," pp. 58–69 from *The Politics of Reclusion: Painting and Power in Momoyama Japan*. Honolulu: University of Hawaii Press, 1997. Reprinted by permission of The University of Hawaii Press. © 1997.

33. Craig Clunas, "Practices of Vision," pp. 111–20 from *Pictures and Visuality in Early Modern China*. Princeton: Princeton University Press, 1997. © 1997 by Craig Clunas. Reprinted by permission of Princeton University Press.

34. Nancy Shatzman Steinhardt, "Introduction," pp. 1–19 from *Chinese Imperial City Planning*. Honolulu: University of Hawaii Press, 1990. Reprinted by permission of The University of Hawaii Press. ©1990.

35. Louis Lecomte, "A Jesuit in Beijing: Louis Lecomte," pp. 99–100, and Aeneas Anderson, "An English Ambassador in Beijing: Aeneas Anderson," p. 103, from Gilles Béguin and Dominique Morel (eds), *The Forbidden City: Center of Imperial China*. New York: Abrams, 1996. Reprinted by permission of Harry N. Abrams Inc.

36. Marsha Weidner, "The Conventional Success of Ch'en Shu [Chen Shu]," pp. 123–4, 129–53 from Marsha Weidner, *Flowering in the Shadows: Women in the History of Chinese and Japanese Painting*. Honolulu: University of Hawaii Press, 1990.

37. Yi Song-mi, "Artistic Tradition and the Depiction of Reality: True-View Landscape Painting of the Chosen Dynasty," pp. 331–4, 340–7, 349–50 from Judith G. Smith (ed.), *Arts of Korea*. New York: Metropolitan Museum of Art and Harry N. Abrams, Inc, 1998. Reprinted by permission by The Metropolitan Museum of Art. © 1998 by The Metropolitan Museum of Art.

38. Timon Screech, "The Meaning of Western Perspective in Edo Popular Culture," pp. 58–68 from *Archives of Asian Art* 47 (1994). Reprinted by permission of The Asia Society.

39. Soetsu Yanagi, "The Kizaemon Tea-bowl," pp. 190–6 from *The Unknown Craftsman*. New York: Kodansha, 1974 [1931]. The Unknown Craftsman: A Japanese Insight into Beauty by Soetsu Yanagi, adapted by Bernard Leach. English language © 1972 and 1989 by Kodansha International Ltd. Reprinted by permission. All rights reserved.

40. Mao Zedong, "Art and Culture," pp. 299–303 from *Quotations from Chairman Mao Tse-tung [Zedong]*. Peking [Beijing]: Foreign Languages Press, 1966.

41. Robert Benewick, "Icons of Power: Mao Zedong and the Cultural Revolution," pp. 123–37 from Harriet Evans and Stephanie Donald (eds), *Picturing Power in the People's Republic of China*. New York: Rowman and Littlefield Publishers, Inc., 1999. Reprinted by permission of Rowman & Littlefield Publishing Group.

42. Alexandra Munroe, "Morphology of Revenge: The Yomiuri Indépendant Artists and Social Protest Tendencies in the 1960s," pp. 150–63 from Munroe, Alexandra, *Japanese Art after 1945: Scream Against the Sky*. New York: H. N. Abrams, 1994. Reprinted by permission of Harry N. Abrams Inc.

43. Simon Leung, "Pseudo-Languages: A Conversation with Wenda Gu, Xu Bing, and Jonathan Hay," pp. 149–63 from *Art Journal* 58:3 (Fall 1999). Reprinted by permission of Simon Leung.

44. John Kuo Wei Tchen, "Believing Is Seeing: Transforming Orientalism and the Occidental Gaze," pp. 13–25 from Margo Machida (ed.), *Asia/America: Identities in Contemporary Asian American Art*. New York: The Asia Society Galleries and the New Press, 1994. Reprinted by permission of The Asia Society.

Introduction

A mountain nearby has one aspect. Several miles away it has another aspect, and some tens of miles away yet another. Each distance has its particularity. This is called "the form of the mountain changing with each step." The front face of a mountain has one appearance. The side face has another appearance, and the rear face yet another. Each angle has its particularity. This is called "the form of a mountain viewed on every face." Thus can one mountain combine in itself the forms of several thousand mountains. Should you not explore this? Mountains look different in the spring and summer, the autumn and winter. This is called "the scenery of the four seasons is not the same." A mountain in the morning has a different appearance from in the evening. Bright and dull days give further mutations. This is called "the changing aspects of different times are not same." Thus can one mountain combine in itself the significant aspects of several thousand mountains. Should you not investigate this?

Guo Xi (after 1000 – c.1090 CE)

Guo Xi's paragraph on mountains might also describe the process of examining texts: looked at from different angles, in differing lights, at different distances, each text evinces multiple readings, raises new questions, produces a different trajectory for investigation. As part of his advice to those painting landscapes, this eleventh-century Chinese artist articulates to us what a single mountain can be, how it can contain within itself the facets, forms, and textures of a thousand mountains. For Guo Xi, this approach allows one mountain to be many, and releases artists from the specificity of painting a particular mountain: one can see a thousand facets of "mountain" in close observation. The painter, then, need not visit every mountain in the world in order to understand mountains; instead, an understanding of how mountains present different aspects leads the viewer further into the landscape, encouraging exploration and intellectual curiosity.

This volume of readings brings together many mountains in a landscape in which certain peaks have been chosen to offer a thousand views into the material. Like Guo Xi's mountains, each of the documents here can be interpreted differently based on the context in which one reads. Rather than distance, season, or time of day (although these undoubtedly affect the practice of reading), these essays, excerpts, and primary documents capture multiple facets of the history of

1

Asian art. Which facets one examines depends on which texts are read in concert with one another, and which artworks are chosen to explore the readings. For example, a reading of Guo Xi's statement on landscape next to Larry Ford's analysis of the late twentieth-century skyscraper surge in the megacities of Southeast Asia, and followed by Japanese art historian Kendall Brown's explanations of the political implications of gardens and tea, produces a thousand or more views of Asian art. Together they might provide statements about the manipulation of the environment, historical examples of hierarchical social relationships, or an understanding of varying Asian aesthetic philosophies. Each article has within it several thousand questions, themes, or issues related to Asian art history. As Guo Xi rhetorically asks, should you not explore this?

The Scope of the Anthology

Guo Xi's text not only explains how a vast, diverse landscape can be grasped through assiduous consideration of select viewpoints, it also describes metaphorically our path through the difficult task of presenting an anthology ostensibly representing "all" of Asian art history. We made several decisions at the outset to limit our task. First, while Asia itself has been defined differently depending on historical context, discipline, and political contingencies,[1] our coverage is bounded on the west by present-day Pakistan and on the east by Japan and the Pacific Ocean. We also include Tibet on the north and insular Southeast Asia to the south. These boundaries roughly reflect the area currently taught and studied under the rubric of Asian art history. Pushing the boundaries of Asia even further, we also include one reading that addresses Asian art of the diaspora, an important facet of Asian culture that remains distinct from, but in dialogue with, art produced in Asia proper.

Second, we are committed to covering as wide a temporal span as possible in the choice of readings. This means moving against the tide of most traditional Asian art survey textbooks, in that we include not only the most ancient periods but also the most recent developments. Asian art continues to be produced; indeed, the contemporary cultures of Asia offer some of the most fascinating and forward-thinking art created today. Several readings thus speak to modern and contemporary art and supplement other general texts that leave off at earlier points.

Third, the readings discuss a range of art media and encompass a range of types of art – from folk and popular art to the highest monumental religious and political structures. Thus, the traditional art historical media of painting, sculpture, and architecture share space in this volume with calligraphy, excavated spaces, gardens, ceramics, posters, and performance art.

Finally, we strive to balance primary source documents with secondary scholarly materials. We choose not to pair primary and secondary sources together, but to

use both types of readings in a more fluid manner, letting the primary documents speak for certain types of art or certain periods while using scholarly analysis to explore other areas. Additionally, the primary documents encompass a range of source types – official histories, royal decrees, artists' writings, travelers' accounts, and inscriptions – providing a broad and deep introduction to the textual material available to scholars and students. With the four parameters just described in mind, each reading offers many different facets of Asian art; it is our hope that together they form a readable, coherent landscape to explore, one that might be worthy of Guo Xi's investigation.

Objectives of the Anthology

In addition to achieving an appropriate scope, this reader seeks to balance a number of other competing goals. We aim to demonstrate the richness of scholarship in the field of Asian art history while simultaneously presenting the breadth and depth of Asian art history in its geographic and temporal range. The process of selecting pieces from what has become a vast store of scholarly work proves both exciting and wrenching. Building from our own pedagogical practices, we combed colleagues' syllabi, bibliographies, and books in order to seek out readings. To our delight, we found many wonderful, accessible, and challenging works. To our dismay, we were forced to choose among them. These choices ultimately respond to the following overarching objectives, some mundane and some more lofty, which guide our process in editing this anthology: comprehensiveness, accessibility, currency, and ease of use.

Comprehensive. As discussed above, we recognize that true comprehensiveness is not possible, so instead we choose to include a reading for each slice of Asian art history traditionally taught. Each major period of Asian art is represented here by a primary or secondary source, with a few exceptions. At times, multiple regions or periods may be touched upon by a single source. For example, Arya Shura's *jataka* tale of the tigress for whom the Bodhisattva sacrifices himself relates to the paintings at Dunhuang in western China (*c.* sixth century), Japan's Asuka/Nara period Tamamushi shrine (*c.*650), and Indonesia's monument at Borobudur on Java (*c.* ninth century). In other areas, our wish to be comprehensive runs up against the very shape of Asian art history. While the major countries of China, Japan, and India are well represented in scholarship, other regions have received less attention and thus many of the scholarly works that treat, for example, Southeast Asia speak more to scholars in the field rather than to the wider audience we hoped to reach. Therefore, unfortunately, the reader contains fewer articles on Southeast Asia and other less-represented regions.

Accessible. Our first audience is our undergraduate students and others new to the study of Asian art. Students in a variety of our courses and at a range of institutions have read these texts, used them in widely varying ways, and responded

to both the readings and our use of them. Their "teachability" – a somewhat intangible but nevertheless potent criterion – has been tested in introductory undergraduate courses as well as upper-level seminars. Introductions to the readings have been shaped by student responses as well as pedagogical working and reworking of various topics. Thus, notations within the readings guide comprehension of some of the more obscure terms; introductions give readers the background needed to engage with the texts; and the readings themselves, while written in different idioms, lend themselves to undergraduate interpretation. This level of accessibility, we hope, will allow interested readers to gain a new appreciation not only of Asian art, but also of the production of knowledge about the field. This text is a glimpse into the workings of the discipline of Asian art history at present, and thus offers an understanding of the controversies and issues facing the field as we continue to refine and extend our knowledge.

Current. Because of our wish to be as up-to-date as possible, several wonderful articles are not included here, some of which were instrumental in pushing the envelope of Asian art history. Wayne Begley's article on the Taj Mahal, for example, was a landmark and controversial work that read the monument through the royal patron, Shah Jahan, and his historical-religious context.[2] Recent excavations at the site,[3] however, have largely debunked his thesis, and thus we did not include it here as we await the next revolution in the interpretation of the monument. Current also means that our task was to reflect the contemporary state of the field rather than reshape it. In practice, this means that the emphases in current scholarship are replicated here. Asian art history remains relatively nascent, and many areas and periods have only a handful of scholars working there, while other areas (Mughal India, Song China) enjoy a relative wealth of scholarship. The volume reflects this asymmetry; our hope is that it spurs future scholars to fill in the gaps.

Usable. These three overarching criteria are joined by our wish to make the volume usable by as many professors, students, and general readers as possible. Malleability, therefore, centers the way we construct the volume and choose texts to include. Instead of singling out one or even several themes for emphasis, the anthology includes readings that touch upon multiple themes. To allow the individual reader to choose approaches to and connections between the readings, the selections are organized geographically and chronologically, rather than thematically, and each is provided with an introduction.

How to Use This Book

This malleability allows for multiple ways of using the anthology. Read in conjunction with any number of textbooks, from one that treats Asia broadly to a more specific regional survey of India or East Asia, the anthology adds depth to the study of the material, while providing insight into how scholars produce the

information provided in a textbook. But that is only the most obvious way this anthology might be used. Museum-goers and travelers to Asia might use it as preparation for their visits or for further exploration of objects and sites upon their return. In the classroom, the anthology serves many thematic topics and provides upper-level undergraduates as well as graduate students with an entrée into Asian art scholarship.

For example, to compare visual expressions of beliefs regarding death and the afterlife, one might read Samuel Morse's discussion of Pureland Buddhist statues in Heian Japan along with Michael Brand's piece on Mughal Indian royal tombs. Alternatively, Morse's article, when matched with Faxian's description of a Khotanese image procession, Louis Frederic's excerpt regarding the Javanese site of Borobudur, and Janet Gyatso's essay on esoteric Tibetan art, gives the reader ample fodder to investigate the employment of art objects in Buddhist ritual. Yet again, Morse's piece, when read in conjunction with the edicts of the Indian emperor Ashoka, Eleanor Mannikka's analysis of the Khmer monument, Angkor Wat, and William Coaldrake's discussion of the Japanese Shinto shrine at Ise, can foster a lively discussion regarding the links between religious monuments and political legitimization.

Religion and spirituality are not the only themes covered in the anthology. Several pieces take up gender and sexuality (Murasaki, Weidner, Dehejia, the *puranas*, and Leung), others deal with narrative (*purana*, *jataka*, and *Akbarnama* selections, Kaimal, Murasaki, and Rosenfield), and yet others explore the relationship between art and nature (Mannikka, Fong, Guo Xi, Brown, and Yi). Additionally, we balance readings that address artistic production, including the roles of artist and patron (*Akbarnama* and *Jahangirnama* selections, Brand, Mitter, Ledderose, Shomu, Guo Xi, Morse, Leung, Weidner, and Munroe), with those that examine post-production life: the reception, uses, and reuses of art (Faxian, Frederic, Gyatso, Davis, Wu, Clunas, Lecomte and Anderson, Brown, Screech, and Benewick).

Perhaps the most reoccurring theme in the volume is that of authority. Almost every selection touches upon authority in one form or another, whether the creation of political authority, the reaffirming of religious authority, the augmentation of the artist's authority, reliance upon the authority of the past, or the subversion of established authority. This coalescence around authority is both a conscious and an unconscious choice on our part. Much of the best current scholarship deals with the relationship between art and authority, and many surviving primary sources, particularly official histories and royal decrees, illuminate the role of art in reinforcing and creating political power. Of course, this stems in part from the internal emphasis of the extant historical and art historical record. Major religious foundations, palaces, and fortifications often send messages of political or religious authority, and thus those structures outlast other types of visual culture, such as clothing, domestic altars, vernacular housing, furniture, and the like. Furthermore, until relatively recently, the grander material has served as the focus for art historical study, and such material belongs to the

culture of the ruling elite, often concerned with legitimacy and authority. Unfortunately, with a few exceptions (Yanagi, Screech), vernacular visual culture does not feature in our volume, a lacuna that we hope the discipline will strive to fill. Authority, then, centers many of these readings, because in our attempt to provide comprehension, currency, and accessibility, we repeatedly found ourselves drawn to readings analyzing the way art interfaces with political rule, class hierarchies, tradition, or religious power. At the same time, because "authority" is such a fluid concept, covering a broad range of societal and cultural relationships, we find it provides a useful tool for discussion, aiding in the "teachability" of the readings. Moreover, it fits with our objective of malleability, a goal also visible in the volume's organization.

The anthology divides the 44 readings into two groups: those addressing the art of South and Southeast Asia, and those covering the art of East Asia. While, in most cases, the geographical placement is clear, in several instances, readings fit into either group. For example, both the *jataka* tales and the travel writings of the Chinese monk Faxian relate to Buddhist art of various Asian locales, and Janet Gyatso's discussion of Tibetan art can fall into both the South Asian and the East Asian categories. Thus, the *jataka* tales are divided between South and East Asian sections, Faxian rests in South Asia because of the discussion of the ancient Indian capital Pataliputra, and Gyatso's discussion is here included in the South and Southeast Asian section. Within each geographical grouping, we then arrange the various essays, book excerpts, and primary documents in chronological order according to the artworks they cover (if a particular reading discusses works from multiple time periods, we have selected the most obvious placement). The introduction prefacing each piece provides the background information necessary for reading comprehension, the time period covered, and the major themes addressed (without merely summarizing the reading beforehand), thereby allowing the reader to discern the content quickly. This straightforward organization affords the simplest way to locate a piece relating to a certain period or culture, while the individual introductions facilitate the use of the anthology in multiple ways, alerting readers to connections and thematic issues in the selections.

Orientalism and the Asian Art Anthology

Alongside malleability, another major motivation for our construction of the anthology was to avoid positioning Asian art as a single, unchanging entity situated in opposition to Western art. We realized from the beginning that the very act of constructing an anthology of all of Asia (as opposed to, for example, focusing on the three-century period of Mughal Indian art that might be parallel to a Western anthology on the Renaissance and Baroque periods) presented a false façade of unity across the temporal and geographic span, equating all of Asian art to smaller temporal and geographic divisions of European and American art. This

fundamental and problematic foundation for the anthology stems from a variety of factors, not least that university and college art history programs themselves tend to be organized in this way. The legacy of nineteenth- and twentieth-century Orientalism continues in the fact of this anthology; our hope is that the act of reading the selections for this volume will quickly undermine Orientalist understandings of Asian art history.

This term, initially theorized by Edward Said in *Orientalism* (1978), describes the construction of "the Orient" as an object of study through the production of maps, scientific research, art, literature, and other imperial discourses.[4] Said focused on the nineteenth-century "Orient," which for the French and British meant northern Africa and the Middle East. However, his theorization of Orientalism provides an understanding of the way Asia, too, has been created as a legitimate, singular object of study in opposition to the space different from it: Europe and "the West." The focus on difference leads to and stems from asymmetrical relations of power, and in the nineteenth and early twentieth centuries this meant justification for colonial rule. Today, this hierarchy of "us" and "them" justifies other kinds of political, economic, and military interventions and reinforces asymmetries of power. Thus, a volume such as this one, which on the surface and in its title attempts to encapsulate "Asia" within its covers, is implicated in such a project of opposing East and West.

We seek to resist this by de-exoticizing and demystifying the texts and art objects presented here. The straightforward (even old-fashioned) chronological and geographic organization of the volume offers up individual texts that are treated in their specific historical and artistic contexts through our introductions. Rather than unify these selections to present a holistic view of what Asia *is*, we suggest connections among them and present diversity within traditionally unified spaces. For example, reading Kendall Brown's essay on tea and politics in the Momoyama period against Soetsu Yanagi's 1930s discussion of the aesthetics of a tea bowl allows for a nuanced analysis of the political implications of rustic pottery and tea in two different time periods in Japan. Rather than coming away from these readings with the notion that Japan is a singular, unified place without historical change, one can better understand the way art both shapes and is shaped by political events – in this case the power of the samurai in the Momoyama period (1568–1600 or 1615) and the colonizing of Korea by Japan in the early twentieth century.

Some of the readings directly address Orientalism and the constructed difference between East and West (Tchen, Leung), while others serve in part as examples of Orientalist attitudes (Yanagi, Lecomte and Anderson). Still other readings question the notion of the East/West divide, or examine art that itself contests that boundary (Cate, Davis, Mitter, Prakash, Ford, Screech, Benewick, Munroe). In their diversity of approach and range of content, these readings thus challenge Orientalist views of Asia both implicitly and explicitly. It would be impossible to ignore or eradicate entirely the Orientalism embedded in our discipline or the legacy of the past few centuries of political relations across the

globe. Our hope is that this volume can be used to challenge Orientalist constructions of "the Other," while acknowledging that those concepts remain powerful in our studies and our everyday lives.

Studying Asian Art History

The responsibility to recognize and grapple with assumptions and biases regarding beauty, creativity, individualism, innovation, and artistic development lies with every art history student; however, this responsibility is especially pointed for those focusing on Asia. By bringing together readings that foster discussion, critical thinking, and (thus) active involvement on the part of the student, we hope to aid in this crucial aspect of the learning process. Ultimately, in approaching the history of Asian art, scholars and students evaluate the art from a variety of points of view: within the culture that produced it rather than solely in comparison to art of the West (as in Wu, Dehejia, Kaimal, Brown, and many others); comparatively across the many and diverse Asian and Western visual cultures (as in Screech, Frederic, Yanagi, Leung, and many others); or through provenance of the image's "post-history" (for example, Davis, Benewick, or Yanagi). The scholarly articles and book excerpts included here do that in a variety of ways, and their methodologies, drawn from art historical practices as well as those of other disciplines, provide useful models for examination. The primary source readings, alternatively, allow the reader to build an analysis of Asian art by using the translated words of various individuals, storytellers, or canonical texts as a small window into the aesthetic and political concerns of artists and patrons.

Viewing art with honesty to its complex historical and cultural context requires familiarity with the politics, vocabulary, and traditions of the periods and societies in question. Because the geographical region of Asia encompasses many distinct cultures, each with its own history, permeable boundaries, body of beliefs and practices, and language(s), the student of Asian art faces a daunting task. For example, there are over 150 separate languages spoken in Southeast Asia and India alone. Yet this diversity, while perhaps overwhelming at times, is one major element that helps to produce the richness of the field. An object might embody Buddhist, Hindu, Islamic, Daoist, Confucian, or Shinto beliefs, or some combination of the above. It might relate to ancient Indo-Brahmanical conceptions of kingship, medieval Japanese codes of the samurai, or contemporary urban life in Singapore. A building might respond to the lush monsoon climate of Cambodia, the granite and sand shores of southeastern India, the deserts of western China, or the pine forests of Japan. A painting might reference literature written in Sanskrit, Pali, Persian, Chinese, Korean, or Japanese, each language carrying its own grammatical structures, visual illusions, metaphors, calligraphic traditions, and oftentimes alphabet, syllabary, or character system.

Indeed, the linguistically varied terminology, including proper names and historical periods, as well as religious and artistic terms, that accompanies the study of Asian art often confounds new students as much as or more than the assorted artistic conceptions and viewing practices they encounter. Recognizing this fact, we took several concerted steps to make the readings and their vocabulary as accessible as possible. When needed, we provide definitions of specialized terms used in the texts in brackets following the words. Because Asian languages employ scripts and characters quite different from the alphabet used in English, we also had to address transliteration and romanization.

Over the years, for each major Asian language, scholars have developed multiple systems for writing particular sounds or characters in their approximate romanized equivalent. Sometimes the differences between two systems are relatively slight. For example, one can transliterate the Sanskrit name for the Hindu god of creation and destruction as Shiva or Śiva. Other times, the differences between alternative systems are more striking. Sources following the Pinyin system for romanizing Chinese characters may write, as we did, the name of the eleventh-century artist quoted at the start of this essay as Guo Xi. Other books and articles employing the Wade-Giles system will spell his name Kuo Hsi. The selections included in this anthology originally featured a variety of transliteration and romanization systems; the differences result in part from the date of a particular piece, the context in which it was published, and the personal preference of the author or translator. Because such spelling variations and the use of diacritical marks in some cases and not in others can prove distracting for non-specialists, we decided to conform the spelling of names and terms throughout the volume to a single system for each language. We chose the transliteration and romanization systems favored by the latest editions of respected textbooks in the field, thereby ensuring currency and accessibility, as well as compatibility with other introductory resources.[5]

Our hope is that careful reading of the texts in this volume will spur further interest in and investigation of the arts of Asia. Although we make every effort to assemble a comprehensive assortment of quality readings, we in no way intend this anthology to be the final word on Asian art. Instead, we hope the selections provide a series of first words, of starting points from which one can forge one's own path – or as Guo Xi might recommend, wander – through the peaks and valleys of Asian art.

Notes

1 The idea of a single geographical region embodied in the term "Asia" is of course problematic and dependent on historical and political negotiations. For more on this construction, see Martin W. Lewis and Karen E. Wigen, *The Myth of Continents: A Critique of Metageography* (Berkeley: University of California Press, 1997).

2 Wayne Begley, "The myth of the Taj Mahal and a new theory of its symbolic meaning," *Art Bulletin*, 61 (March 1979), 7–37.

3 Elizabeth Moynihan (ed.), *The Moonlight Garden: New Discoveries at the Taj Mahal* (Seattle: University of Washington Press, 2001).

4 For an excellent exploration of Orientalism in nineteenth-century French painting, see Linda Nochlin, "The imaginary Orient," in *The Politics of Vision: Essays on Nineteenth-century Art and Society* (New York: Harper & Row, 1989), pp. 33–59.

5 Thus, we have chosen Pinyin romanization for Chinese and followed Vidya Dehejia's *Indian Art* (New York: Phaidon, 1997) for Sanskrit, Pali, Persian, and Arabic. For Korean, we have followed Jane Portal's *Korea: Art and Archaeology* (London and New York: Thames and Hudson, 2000), which uses the McCune – Reischauer system minus diacritical marks. For Japanese, following Penelope Mason's *A History of Japanese Art* (New York: Harry N. Abrams, 1993), we employed the Hepburn system; however, in keeping with our practices for the other languages, we removed diacritical marks. We have moved all appropriate text into these forms, including that quoted within the chosen readings, in order to maintain consistency.

Part I
South and Southeast Asia

Selected Periods and Dates

South Asia

Mauryan Empire	c.323–185 BCE
Kushan Empire	second century BCE to third century CE
Shunga and Andhra Periods	second to first centuries BCE
Gupta Era	c.321 to c.500 CE
Pallava Dynasty	c.550–728
Chola Dynasty	862–1310
Chandella Dynasty	tenth to sixteenth centuries
Tughluk Sultanate	1320–1412
Princely States (Rajasthan and Punjab Hills)	fourteenth to nineteenth centuries
Mughal Empire	1526–1858
Mysore Kingdom	1761–1799
British Colonial Period	mid-eighteenth century to 1947
Independent South Asia	1947 to present

Indonesia

Shailendra Dynasty	eighth to thirteenth centuries

Cambodia

Angkor Dynasty	802–1431

Thailand

Ayutthaya Era	1350–1767
Rattanakosin Era (Chakri Dynasty)	1782 to present

1

Edicts of the Indian Mauryan Emperor Ashoka

Introduction

The edicts of the Indian Mauryan emperor Ashoka (c.268–233 BCE) are inscribed on boulders, rock outcroppings, or tall monolithic pillars found across northern and central India. Ainslie Embree's editorial comments serve to illuminate particular passages and weave together these imperial statements into a cohesive whole. Ashoka's renown stems largely from his conversion to Buddhism and his support of the religion in his empire. These edicts, however, reveal a much broader concern for the royal responsibilities of health care provider, facilitator of trade, and law arbiter. When one examines both the texts and their placement across the empire, Ashoka's abilities as a ruler over diverse ethnicities, religious sects, and linguistic groups come to the fore.

As the third Mauryan emperor, Ashoka inherited a large region of northern India, with a capital city – Pataliputra (present-day Patna) – on the Ganges river. Stretching from present-day Pakistan in the west to what is now Bangladesh to the east, the Mauryan empire under Ashoka was large and multifarious. The inscriptions were written in Prakrit, a vernacular language, using the ancient Brahmi script. On some far-flung edicts, such as those near Afghanistan to the west, Prakrit is joined by a local vernacular translation. Ashoka clearly wished these statements to reach as many of his subjects as possible. Furthermore, the pillars and rock edicts lie along major trade routes, giving them a greater audience, one that traveled across the empire and could spread the edicts' message.

The inscriptions' placements corresponded with more than just trade routes. In many cases they also marked holy or auspicious sites, locations that already carried a spiritual weight. For example, at Sarnath Ashoka erected a large pillar, topped by

"Ashokan Edicts," pp. 141–9 from Ainslie T. Embree (ed.), *Sources of Indian Tradition*, vol. 1. New York: Columbia University Press, 1988. © 1988 by Columbia University Press. Reprinted with permission of the publisher.

an elaborately carved capital of four adorst, hieratic lions supported by a series of symbols, including the wheel and various animals. Sarnath was the site of the Buddha's first sermon, in which he explained the major tenets of Buddhism to his followers. In doing so, he set the wheel (*chakra*) of *dharma* into motion, or, in other words, he presented the Buddhist "law" (*dharma*): the right path or, as Embree translates, the path of righteousness. Lions facing four directions indicate the area over which Ashoka ruled, as well as representing the strength of the leader. At the same time they refer to the Buddha, whose many names and titles include Shakyasimha, or the Lion of the Shakya clan. The iconography of the Ashokan pillar, combined with its placement at important Buddhist sites, reinforces both the dominion of Ashoka and the religious beliefs he hoped to spread.

In addition to the internal political information they provide, these inscriptions indicate the Mauryan relationship to other empires, including the Greeks, communicate what Buddhism meant in the third century BCE, and show some of the personality of Ashoka himself. They can be read at face value to give a sense of why, for example, Ashoka has become vegetarian, or read to understand how history and religion are shaped by those who live them. Ashoka was a powerful and savvy political ruler who understood the value of communication, even with ancient media such as stone pillars and rock outcroppings.

Ashoka: The Buddhist Emperor

The great emperor Ashoka (*c.* 268–233 BCE), third of the line of the Mauryas, became a Buddhist and attempted to govern India according to the precepts of Buddhism as he understood them. His new policy was promulgated in a series of edicts, which are still to be found, engraved on rocks and pillars in many parts of India. Written in a form of Prakrit, or ancient vernacular, with several local variations, they can claim little literary merit, for their style is crabbed and often ambiguous. In one of these edicts he describes his conversion, and its effects:

[From the Thirteenth Rock Edict]

When the king, Beloved of the Gods and of Gracious Mien, had been consecrated eight years Kalinga[1] was conquered, 150,000 people were deported, 100,000 were killed, and many times that number died. But after the conquest of Kalinga, the Beloved of the Gods began to follow righteousness [*dharma*], to love righteousness, and to give instruction in righteousness. Now the Beloved of the Gods regrets the conquest of Kalinga, for when an independent country is conquered people are killed, they die, or are deported, and that the Beloved of the Gods finds very painful and grievous. And this he finds even more grievous – that all the inhabitants – brahmans, ascetics, and other sectarians, and house-holders who are obedient to superiors, parents, and elders, who treat friends,

14

acquaintances, companions, relatives, slaves, and servants with respect, and are firm in their faith – all suffer violence, murder, and separation from their loved ones. Even those who are fortunate enough not to have lost those near and dear to them are afflicted at the misfortunes of friends, acquaintances, companions, and relatives. The participation of all men in common suffering is grievous to the Beloved of the Gods. Moreover there is no land, except that of the Greeks, where groups of brahmans and ascetics are not found, or where men are not members of one sect or another. So now, even if the number of those killed and captured in the conquest of Kalinga had been a hundred or a thousand times less, it would be grievous to the Beloved of the Gods. The Beloved of the Gods will forgive as far as he can, and he even conciliates the forest tribes of his dominions; but he warns them that there is power even in the remorse of the Beloved of the Gods, and he tells them to reform, lest they be killed.[2]

For all beings the Beloved of the Gods desires security, self-control, calm of mind, and gentleness. The Beloved of the Gods considers that the greatest victory is the victory of righteousness; and this he has won here [in India] and even five hundred leagues beyond his frontiers in the realm of the Greek king Antiochus, and beyond Antiochus among the four kings Ptolemy, Antigonus, Magas, and Alexander.[3] Even where the envoys of the Beloved of the Gods have not been sent men hear of the way in which he follows and teaches righteousness, and they too follow it and will follow it. Thus he achieves a universal conquest, and conquest always gives a feeling of pleasure; yet it is but a slight pleasure, for the Beloved of the Gods only looks on that which concerns the next life as of great importance.

I have had this inscription of righteousness engraved that all my sons and grandsons may not seek to gain new victories, that in whatever victories they may gain they may prefer forgiveness and light punishment, that they may consider the only [valid] victory the victory of righteousness, which is of value both in this world and the next, and that all their pleasure may be in righteousness. . . .

> Ashoka's Buddhism, as his title shows, did not lessen his belief in the gods. Here he expresses his faith in Buddhism and declares that the gods have appeared on earth as a result of his reforms:[4]

[From a minor Rock Edict (Maski Version)]

Thus speaks Ashoka, the Beloved of the Gods. For two and a half years I have been an open follower of the Buddha, though at first I did not make much progress. But for more than a year now I have drawn closer to the [Buddhist] Order, and have made much progress. In India the gods who formerly did not mix with men now do so. This is the result of effort, and may be obtained not only by the great, but even by the small, through effort – thus they may even easily win heaven.

Father and mother should be obeyed, teachers should be obeyed; pity . . . should be felt for all creatures. These virtues of righteousness should be practiced. . . . This is an ancient rule, conducive to long life.

giving some social order, compareable to Chinesse Confusisum 15

[From the Ninth Rock Edict]

It is good to give, but there is no gift, no service, like the gift of righteousness. So friends, relatives, and companions should preach it on all occasions. This is duty; this is right; by this heaven may be gained – and what is more important than to gain heaven?

> The emphasis on morality is if anything intensified in the series of the seven Pillar Edicts, issued some thirteen years after the Rock Edicts, when the king had been consecrated twenty-six years:

[From the First Pillar Edict]

This world and the other are hard to gain without great love of righteousness, great self-examination, great obedience, great circumspection, great effort. Through my instruction respect and love righteousness daily increase and will increase.... For this is my rule – to govern by righteousness, to administer by righteousness, to please my subjects by righteousness, and to protect them by righteousness.

> Ashoka's solicitude extended to the animal life of his empire, which in ancient India was generally thought to be subject to the king, just as was human life. He banned animal sacrifices at least in his capital, introduced virtual vegetarianism in the royal household, and limited the slaughter of certain animals; his policy in this respect is made clear in his very first Rock Edict:

[From the First Rock Edict]

Here[5] no animal is to be killed for sacrifice, and no festivals are to be held, for the king finds much evil in festivals,[6] except for certain festivals which he considers good.

Formerly in the Beloved of the God's kitchen several hundred thousand animals were killed daily for food; but now at the time of writing only three are killed – two peacocks and a deer, though the deer not regularly. Even these three animals will not be killed in future.

[From the Second Pillar Edict]

I have in many ways given the gift of clear vision. On men and animals, birds and fish I have conferred many boons, even to saving their lives; and I have done many other good deeds.

> In accordance with the precepts of Buddhism Ashoka, for all his apparent other-worldliness, did not neglect the material welfare of his subjects, and he was especially interested in giving them medical aid:

16

[From the Second Rock Edict]

Everywhere in the empire of the Beloved of the Gods, and even beyond his frontiers in the lands of the Cholas, Pandyas, Satyaputras, Keralaputras,[7] and as far as Ceylon, and in the kingdoms of Antiochus the Greek king and the kings who are his neighbors, the Beloved of the Gods has provided medicines for man and beast. Wherever medicinal plants have not been found they have been sent there and planted. Roots and fruits have also been sent where they did not grow and have been planted. Wells have been dug along the roads for the use of man and beast.

> Ashoka felt a moral responsibility not only for his own subjects, but for all men, and he realized that they could not lead moral lives, and gain merit in order to find a place in heaven, unless they were happy and materially well cared for:

[From the Sixth Rock Edict]

I am not satisfied simply with hard work or carrying out the affairs of state, for I consider my work to be the welfare of the whole world, of which hard work and the carrying out of affairs are merely the basis. There is no better deed than to work for the welfare of the whole world, and all my efforts are made that I may clear my debt to all beings. I make them happy here and now that they may attain heaven in the life to come. . . . But it is difficult without great effort.

> He speaks in peremptory tones to the officers of state who are slow in putting the new policy into effect:

[From the First Separate Kalinga Edict]

By order of the Beloved of the Gods. Addressed to the officers in charge of Tosali.[8] . . . Let us win the affection of all men. All men are my children, and as I wish all welfare and happiness in this world and the next for my own children, so do I wish it for all men. But you do not realize what this entails – here and there an officer may understand in part, but not entirely.

Often a man is imprisoned and tortured unjustly, and then he is liberated for no [apparent] reason. Many other people suffer also [as a result of this injustice]. Therefore it is desirable that you should practice impartiality, but it cannot be attained if you are inclined to habits of jealousy, irritability, harshness, hastiness, obstinacy, laziness, or lassitude. I desire you not to have these habits. The basis of all this is the constant avoidance of irritability and hastiness in your business. . . .

This inscription has been engraved in order that the officials of the city should always see to it that no one is ever imprisoned or tortured without good cause. To ensure this I shall send out every five years on a tour of inspection officers who are not fierce or harsh. . . . The prince at Ujjain shall do the same not more than every three years, and likewise at Taxila.

17

Later, in his Pillar Edicts, Ashoka seems more satisfied that his officers are carrying out the new policy:

[From the Fourth Pillar Edict]

My governors are placed in charge of hundreds of thousands of people. Under my authority they have power to judge and to punish, that they calmly and fearlessly carry out their duties, and that they may bring welfare and happiness to the people of the provinces and be of help to them. They will know what brings joy and what brings sorrow, and, conformably to righteousness, they will instruct the people of the provinces that they may be happy in this world and the next.... And as when one entrusts a child to a skilled nurse one is confident that ... she will care for it well, so have I appointed my governors for the welfare and happiness of the people. That they may fearlessly carry out their duties I have given them power to judge and to inflict punishment on their own initiative. I wish that there should be uniformity of justice and punishment.

In numerous passages Ashoka stresses the hard work that the new policy demands of him. He has given up many of the pleasures of the traditional Indian king, including, of course, hunting, in order to further it:

[From the Eighth Rock Edict]

In the past, kings went out on pleasure trips and indulged in hunting and similar amusements. But the Beloved of the Gods ... ten years after his consecration set out on the journey to Enlightenment.[9] Now when he goes on tour ... he interviews and gives gifts to brahmans and ascetics; he interviews and gives money to the aged; he interviews the people of the provinces and instructs and questions them on righteousness; and the pleasure which the Beloved of the Gods derives therefrom is as good as a second revenue.

As we have seen, Ashoka, though a Buddhist, respects brahmans and the members of all sects, and he calls on his subjects to follow his example:

[From the Twelfth Rock Edict]

The Beloved of the Gods ... honors members of all sects, whether ascetics or householders, by gifts and various honors. But he does not consider gifts and honors as important as the furtherance of the essential message of all sects. This essential message varies from sect to sect, but it has one common basis, that one should so control one's tongue as not to honor one's own sect or disparage another's on the wrong occasions; for on certain occasions one should do so only mildly, and indeed on other occasions one should honor other men's sects. By doing this one strengthens one's own sect and helps the others, whereas by doing otherwise one harms one's

own sect and does a disservice to the others. Whoever honors his own sect and disparages another man's, whether from blind loyalty or with the intention of showing his own sect in a favorable light, does his own sect the greatest possible harm. Concord is best, with each hearing and respecting the other's teachings. It is the wish of the Beloved of the Gods that members of all sects should be learned and should teach virtue.... Many officials are busied in this matter ... and the result is the progress of my own sect and the illumination of righteousness.

> Although he was by no means a rationalist, it appears that Ashoka thought little of the many rituals and ceremonies of Indian domestic life:

[From the Ninth Rock Edict] *reavaluating the purpose & importance of certian ceremonies*

People perform various ceremonies, at the marriage of sons and daughters, at the birth of children, when going on a journey... or on other occasions.... On such occasions women especially perform many ceremonies that are various, futile, and useless. Even when they have to be done [to conform to custom and keep up appearances] such ceremonies are of little use. But the ceremonies of righteousness are of great profit – there are the good treatment of slaves and servants, respect for elders, self-mastery in one's relations with living beings, gifts to brahman and ascetics, and so on. But for their success everyone – fathers, mothers, brothers, masters, friends, acquaintances, and neighbors – must agree – "These are good! These are the ceremonies that we should perform for success in our undertakings ... and when we have succeeded we will perform them again!" Other ceremonies are of doubtful utility – one may achieve one's end through them or one may not. Moreover they are only of value in this world, whereas the value of the ceremonies of righteousness is eternal, for even if one does not achieve one's end in this world one stores up boundless merit in the other; yet if one achieves one's end in this world the gain is double.

> We conclude this selection of the edicts of Ashoka with his last important inscription, in which the emperor, eighteen years after his conversion, reviews his reign:

[From the Seventh Pillar Edict] *trying to employ & promote righteousness throughout the kingdom*

In the past, kings sought to make the people progress in righteousness, but they did not progress.... And I asked myself how I might uplift them through progress in righteousness.... Thus I decided to have them instructed in righteousness, and to issue ordinances of righteousness, so that by hearing them the people might conform, advance in the progress of righteousness, and themselves make great progress.... For that purpose many officials are employed among the people to instruct them in righteousness and to explain it to them....

Moreover I have had banyan trees planted on the roads to give shade to man and beast; I have planted mango groves, and I have had ponds dug and shelters erected along the roads at every eight kos.[10] Everywhere I have had wells dug

for the benefit of man and beast. But his benefit is but small, for in many ways the kings of olden time have worked for the welfare of the world; but what I have done has been done that men may conform to righteousness.

All the good deeds that I have done have been accepted and followed by the people. And so obedience to mother and father, obedience to teachers, respect for the aged, kindliness to brahmans and ascetics, to the poor and weak, and to slaves and servants, have increased and will continue to increase.... And this progress of righteousness among men has taken place in two manners, by enforcing conformity to righteousness, and by exhortation. I have enforced the law against killing certain animals and many others, but the greatest progress of righteousness among men comes from exhortation in favor of noninjury to life and abstention from killing living beings.[11]

I have done this that it may endure ... as long as the moon and sun and that my sons and my great-grandsons may support it; for by supporting it they will gain both this world and the next.

Notes

1 The coastal region [of India] comprising the modern Orissa and the northern part of Andhra State.
2 Note that Ashoka has by no means completely abandoned the use of force. This passage probably refers to the tribesmen of the hills and jungles, who still occasionally cause trouble for the government in Assam and in other parts of India, and who in ancient days were a much greater problem.
3 Antiochus II Theos of Syria, Ptolemy II Philadelphus of Egypt, Antigonus Gonatas of Macedonia, Magas of Cyrene, and Alexander of Epirus. Classical sources tell us nothing about Ashoka's "victories of righteousness" over these kings. Probably he sent envoys to them, urging them to accept his new policy and his moral leadership. Evidently he never gave up his imperial ambitions, but attempted to further them in a benevolent spirit and without recourse to arms.
4 Some authorities have put different interpretations on the relevant phrases, but in our opinion there can be little doubt about their meaning.
5 There is some reason to believe that the adverb implies the royal capital of Pataliputra.
6 *Samaja*, generally interpreted as a fair or festival, but perhaps a society or club. A tone of rather pompous puritanism is sometimes evident in the edicts and suggests a less congenial side of Ashoka's character.
7 Tamil kingdoms, in the southern tip of the peninsula.
8 The chief town of Kalinga, the region conquered by Ashoka in his last war of aggression.
9 This phrase probably implies that Ashoka made a pilgrimage to the Bodhi Tree at Gaya.
10 Sanskrit *krosha*: calling distance, or about two miles; thus here, intervals of about sixteen miles, or a day's journey.
11 For all his humanitarianism Ashoka did not abolish the death penalty, as did some later Indian kings.

2

"The Great Ape Jataka" and "Ruru Jataka": Selections from the *Jataka*

Introduction

Both of these texts relate tales of the historical Buddha's past lives – one in which the Buddha was born as a monkey or ape king and one he was born as a golden deer. These *jataka* tales represent one facet of Buddhist narrative, which includes stories of the Buddha's historical life (c. fifth century BCE), teachings of the Buddha, and later explorations of Buddhist practice by monks, nuns, and lay practitioners. Often depicted in sculptural relief and painting, biographical stories and stories of the Buddha's past lives serve as major sources of subject matter for Buddhist monuments. The Great Ape Jataka, for example, appears in relief on both the railing of the great stupa (burial mound) at Sanchi in central India (c.100 BCE) and the railing of the Bharhut stupa (c.100–80 BCE). Exploring how these ancient stories come alive through sculptural depiction reveals the workings of visual narrative and the relationship between these stories and Buddhist practices of pilgrimage, worship, and storytelling. Furthermore, the stories involve teachings about the proper way of leading or ruling, linking the fabric of Buddhism to politics and governance.

During the night that the Buddha achieved Enlightenment under the branches of the Bodhi tree, all of his past lives were revealed to him. Each *jataka* begins in a framing narrative that occurs in the storyteller's present. The teller is always the "Enlightened One" or Buddha, usually prompted to tell the story because of some controversy or issue his followers debate. The telling of the *jataka* tales serves as a way for the Buddha to explain facets of Buddhist *dharma* (sometimes translated as the "Law") to his relatively new followers. Foremost among his followers is Ananda,

"The Great Ape Jataka," pp. 149–53 from Caroline A. F. Rhys Davids (ed.), *Stories of the Buddha.* New York: Dover, 1990. "Ruru-Jataka," pp. 161–6 from E. B. Cowell (ed.), *The Jataka* (trans. W. H. D. Rouse). London: Luzac & Co., 1957.

21

who figures often in these stories, as he has traveled with the Buddha in his past lives as well. Devadatta also reappears as the Buddha's foil, the example of an ungrateful follower who does not truly understand Buddhist teachings. The historical Buddha is not the only Enlightened One – one of his names, Tathagata, means "he who comes and goes in the same way (as those who preceded him)," indicating that he is one of many Buddhas. He is also called "Bodhisat" (bodhisattva) in these retellings of his previous lives, as that term refers to those who are able to achieve Enlightenment but forgo final extinguishment (*nirvana*) in order to teach others about Buddhist *dharma*.

Like many ancient texts, these *jatakas* were originally oral tales, written down (in the ancient Indian language of Pali, in this case) over a wide span of time leading to a proliferation of different versions of the stories. When these narratives are used to analyze visual representations of *jatakas*, one must take care not to privilege either the image or the text, as it is likely that the text was different from that told to the lay visitor at Sanchi or the sculptor at Bharhut. Furthermore, stories are shaped by their visual representation, and it is also likely that the sculptures helped to refigure the stories as they were told and retold. The comparison of visual and textual narratives enables the mining of these images and stories for their full range of interpretation, probing which message the patron or artist of a particular image wished to highlight as they retold the story of the monkey king or the tale of the golden deer.

The Great Ape Jataka (*Mahakapi-jataka*)

... just now discussion arose in the temple on the way in which the Very Enlightened One acted for the weal of his kin (the Shakyas), and the Teacher, coming and hearing what was the talk, said: "Not now only, monks, but even long ago, the Tathagata acted for the welfare of his kin." And he brought up the past.

In the past, when Brahmadatta was reigning at Benares, the Bodhisat was reborn among the apes, and growing up strong and vigorous, he dwelt with a following of eighty thousand monkeys in the region of Himavant. There, by the bank of the Ganges, stood a mighty full-foliaged mango tree (some say it was a banyan), soaring up like a mountain-peak. Its sweet fruits of divine flavour were as large as waterjars, and from one branch the fruits fell on dry ground, from another they fell into the Ganges, and the fruits of two other branches fell plumb to the roots of the tree. The Bodhisat, eating the fruit with his herd, thought: "A time will come when the fruit which falls into the water will be a source of peril to us." So he made his herd eat or throw away the fruit which was growing over the water, in blossom-time while it was yet no bigger than *kalaya* peas. Though this was so, one ripe fruit, unseen by the monkeys, because hidden by a nest of ants, fell into the river and hung in the upper net where the king of Benares used to sport in the water with a net both above and below him. To the

king, after he had been thus sporting during the day and had gone away in the evening, the fishermen, raising the net, showed the fruit, not knowing what it was. "Who will know what it is?" "The woodmen, sire." The woodmen said it was a mango, and the king, cutting it with a knife and making the woodmen taste it first, ate it himself, sharing it with his women and courtiers. The mango essence pervaded, persisting, the king's whole body. He, craving more, ascertained from which tree the fruit came, made the woodmen take him by a train of boats up the river, and encamping under the tree, he feasted on mangoes and there spent the night, his men guarding him with lighted fire.

When all were asleep, at midnight the Great Being came with his herd, and eighty thousand monkeys, leaping from branch to branch, ate mangoes. The king woke and, seeing them, made his men get up and sent for archers, saying, "So that the monkeys don't run away, surround them and shoot them. Tomorrow we will eat mangoes and monkey-flesh." So they surrounded the tree and stood with arrows fixed. The monkeys, seeing this, came to the Great Being trembling, and asked what they should do. The Bodhisat said, "Fear not; I will save your lives," and, comforting the herd, he climbed a vertical branch and, going along a bough grown towards the river, he leapt from the end of it a hundred bow-lengths and alighted on the (further) bank of Ganges in a bush. Getting down, he calculated the length of his leap, broke a bamboo shoot at the root, stripped it, and reckoning "So much will be joined to the tree, so much will be fixed in air," he bound one end to the bush and the other to his waist, and then, with the speed of a wind-torn cloud, he sprang back home. Failing (owing to the short length) to alight on the great tree, he clutched a branch (as he fell) with both hands and gave the sign to the monkeys: "Swiftly treading on my back go to safety over the bamboo shoot." The eighty thousand monkeys, saluting and asking forgiveness, went so. Devadatta was then one of that herd. Saying "Now is the time to see my enemy's back!" he got up a high branch and, rallying speed, fell on to the chief's back. The Great Being's heart *↗ spine?* cracked and mighty pain arose. The other forthwith got away. The Great Being was alone. The king not falling asleep had seen everything, and thought: "That is but an animal, yet he has got his herd away safely not counting his own life." And when day broke he said: "It is not seemly to destroy the royal ape. I will contrive to get him down and take care of him." So he had the boat-train turned down-stream, and there built a platform and had the Bodhisat gently brought down. He then had him bathed, rubbed with refined oil, clothed in yellow gear and put to rest on an oiled hide. He sat down on a low seat by him and said the first verse:

> "Yourself you made the way to pass, so that they safely crossed.
> Now what are you to them, great ape, and what are they to you?"

The Bodhisat admonished the king in the remaining verses: *talking ape.*

> I, king, am lord of all those apes, conductor of the flock,
> With grief oppressed and terrified at thee, tamer of foes.

I hurled myself a hundred times the length of bow detached,
With a strong shaft of bamboo to the middle of me bound.
Thrust like a cloud wind-torn I leapt across to reach the tree,
Failing t' alight I caught a bough and gripped it with both hands.
On me thus strung and taut between the creeper and the bough
The bough-beasts in unbroken line afoot went safely o'er.
Me can no bondage worry bring, nor will death worry me,
Weal have I brought to those o'er whom the governance was mine.
This parable for you, O king, is made to show you clear.
Of kingdom and of transport-world, of army and of town:
Of all the weal is to be sought by king who understands.

Thus admonishing and instructing the king the Great Being died. The king then bade his courtiers perform the obsequies of the ape-king as for a king, and he ordered his women to go the funeral as the ape-king's retinue with red garments, dishevelled hair and with lamps on staves in hand. At the crematorium the king erected a shrine, where lamps were burnt and flowers and incense offered. And the skull he had inlaid with gold, placed in front of it on the point of a spear and honoured as above; then taking it to Benares, he there honoured it for seven days, the city being decorated; then had it placed in a shrine. And, established in the Bodhisat's exhortation, he reigned righteously, working merit, and became a farer to the Bright World.

The Teacher ... assigned the Jataka: "Then the king was Ananda, the ape-king was just I."

(margin note: the king honored the ape king w/ a grand funeral)

Deer Jataka [*Ruru-jataka*]

"*I bring you tidings,*" *etc.* This story the Master told while dwelling in the Bamboo-grove, about Devadatta. One might say to him, "The Master is most useful to you, friend Devadatta. You received holy orders from the Tathagata, from him you learnt the Three Baskets, you obtained gifts and honour." When such things were said, it is credibly reported he would reply, "No, friend; the Master has done me no good, not so much as a blade of grass is worth. Of myself I received holy orders, myself I learned the Three Baskets, by myself I gained gifts and honour." In the Hall of Truth the Brethren talked of all this: "Ungrateful is Devadatta, my friend, and forgets a kindness done." The Master came in, and would know what they talked of sitting there. They told him. Said he, "It is not now the first time, Brethren, that Devadatta is ungrateful, but ungrateful he was before; and in days long gone by his life was saved by me, yet he knew not the greatness of my merit." So saying, he told a story of the past.

Once upon a time, when Brahmadatta was king of Benares, a great merchant who possessed a fortune of eighty crores, had a son born to him; and he gave him the

24

name of Maha-dhanaka, or Moneyman. But never a thing he taught him; for said he, "My son will find study a weariness of the flesh." Beyond singing and dancing, eating and feasting, the lad knew nothing. When he came of age, his parents provided him with a wife meet for him, and afterwards died. After their death, the youth surrounded by profligates, drunkards, and dicers, spent all his substance with all manner of waste and profusion. Then he borrowed money, and could not repay it, and was dunned by his creditors. At last he thought, "What is my life to me? In this one existence I am as it were already changed into another being; to die is better." Whereupon he said to his creditors, "Bring your bills, and come hither. I have a family treasure laid up and buried on the bank of the Ganges, and you shall have that." They went along with him. He made as though he were pointing out here and there the hiding place of his treasure (but all the while he intended to fall into the river and drown), and finally ran and threw himself into the Ganges. As the torrent bore him away, he cried aloud with a pitiful cry.

Now at that time the Great Being had been born as a Deer, and having abandoned the herd, was dwelling near a bend of the river all by himself, in a clump of sal trees mixt with fair-flowering mangoes: the skin of his body was of the colour of a gold plate well burnished, forefeet and hindfeet seemed as it were covered with lac, his tail like the tail of a wild ox, the horns of him were as spirals of silver, eyes had he like bright polished gems, when he turned his mouth in any direction it seemed like a ball of red cloth. About midnight he heard this sad outcry, and thought, "I hear the voice of a man. While I live let him not die! I will save his life for him." Arising from off his resting place in the bush, he went down to the river bank, and called out in a comfortable voice, "Ho man! have no fear, I will save you alive." Then he cleft the current, and swam to him, and placed him upon his back, and bore him to the bank and to his own dwelling-place; where for two or three days he fed him with wild fruits. After this he said to the man, "O man, I will now convey you out of this wood, and set you in the road to Benares, and you shall go in peace. But I pray you, be not led away by greed of gain to tell the king or some great man, that in such a place is a golden deer to be found." The man promised to observe his words; and the Great Being, having received his promise, took him upon his back and carried him to the road to Benares, and went his way.

On the day when he reached Benares, the Queen Consort, whose name was Khema, saw at morning in a dream how a deer of golden colour preached the Law to her; and she thought, "If there were no such creature as this, I should not have seen him in my dream. Surely there must be such a one; I will announce it to the king."

Then she went to the king, and said, "Great king! I am anxious to hear the discourse of a golden deer. If I may, I shall live, but if not there is no living for me." The king comforted her, saying, "If such a creature exists in the world of men, you shall have it." Then he sent for the brahmans, and put the question – "Are there such things as gold-coloured deer?" "Yes, there are, my lord." The king laid upon the back of an elephant richly caparisoned a purse of a thousand

pieces of money enclosed within a casket of gold: <u>whoso should bring word of a</u> <u>golden deer, the king was willing to give him the purse with a thousand pieces,</u> <u>the casket of gold, and that elephant withal or a better</u>. He caused a stanza to be engraved upon a tablet of gold, and delivered this to one of his court, bidding him cry the stanza in his name among all the townsfolk. Then he recited that stanza which comes first in this Birth:

> Who brings me tidings of that deer, choicest of all the breed?
> Fair women and a village choice who wins him for his meed?

The courtier took the golden plate, and caused it to be proclaimed throughout all the city. Just then this young merchant's son was entering Benares; and on hearing the proclamation, he approached the courtier, and said, "I can bring the king news of such a deer; take me into his presence." The courtier dismounted from his elephant, and led him before the king, saying, "This man, my lord, says he can tell you tidings of the deer." Quoth the king, "Is this true, man?" He answered, "It is true, O great king! you shall give me that honour." And he recited the second stanza:

> I bring you tidings of that deer, choicest of all the breed:
> Fair women and a village choice then give me for my meed.

The king was glad when he heard these words of the treacherous friend. "Come now," said he, "where is this deer to be found?" "In such a place, my lord," he replied, and declared the way they should go. With a great following he made the traitor guide him to the place, and then he said, "Order the army to halt." When the army was brought to a halt, he went on, pointing with his hand, "There is the golden deer, in that place yonder," and he repeated the third stanza:

> Within yon clump of flowering sal and mango, where the ground
> Is all as red as cochineal, this deer is to be found.

When the king heard these words, he said to his courtiers, "Suffer not the deer to escape, but with all speed set a circle about the grove, the men with their weapons in hand." They did so, and made an outcry. The king with a certain number of others was standing apart, and this man also stood not far off. The Great Being heard the sound, and thought he, "It is the sound of a great host, therefore I must beware of them." He rose, and spying at all the company perceived the place where the king stood. "Where the king stands," thought he, "I shall be safe, and thither I must go"; and he ran towards the king. When the king saw him coming, he said, "A creature strong as an elephant would throw

down everything in its path. I will put arrow to string and frighten the beast; if he is for running I will shoot him and make him weak, that I may take him." Then stringing his bow, he stood facing the Bodhisatta.

To explain this matter, the Master repeated a couple of stanzas:

the king was going to shoot the Buddha Deer

> Forward he went: the bow was bent, the arrow on the string;
> When thus from far the deer called out, as he beheld the king:
> "O lord of charioteers, great king, stand still! and do not wound:
> Who brought the news to you, that here this deer was to be found?"

The king was enchanted with his honey-voice; he let fall his bow, and stood still in reverence. And the Great Being came up to the king, and talked pleasantly with him, standing on one side. All the host also dropt their weapons, and came up and surrounded the king. At that moment the Great Being asked his question of the king with a sweet voice (it was like one tinkling a golden bell): "Who brought the news to you, that here this deer was to be found?" Just then the wicked man came closer, and stood within hearing. The king pointed him out, saying, "There is he that informed me," and recited the sixth stanza:

> That sinful man, my worthy friend, that yonder stands his ground,
> He brought the news to me, that here the deer was to be found.

On hearing this, the Great Being rebuked his treacherous friend, and addressing the king recited the seventh stanza:

> Upon the earth are many men, of whom the proverb's true:
> 'Twere better save a drowning log than such a one as you. *omg . HA!*

When he heard this, the king repeated another stanza:

> Who is it you would blame in this, O deer?
> Is it some man, or is it beast or bird?
> I am possessed with an unbounded fear
> At this your human speech which late I heard.

Hereupon the Great Being replied, "O great king, I blame no beast and I blame no bird, but a man," to explain which he repeated the ninth stanza:

> I saved him once, when like to drown
> On the swift swelling tide that bore him down:
> And now I am in danger through it.
> Go with the wicked, and be sure you'll rue it.

The king when he heard this was wroth with the man. "What?" quoth he, "not to recognise his merit after such a good service! I will shoot him and kill him!" He then repeated the tenth stanza:

> This four-winged flyer I'll let fly,
>> And pierce him to the heart! So let him perish,
> The evil-doer in his treachery,
>> Who for such kindness done no thanks did cherish!

Then the Great Being thought, "I would not have him perish on my account," and uttered the eleventh stanza:

> Shame on the fool, O king, indeed!
>> But no good men approve a killing;
> Let the wretch go, and give his meed,
>> All that you promised him fulfilling:
> And I will serve you at your need.

[handwritten note in margin: the king wants to kill the traitor but the Deer will not let him & says he should even get his reward]

The king was very glad to hear this, and lauding him, uttered the next stanza:

> Surely this deer is good indeed,
>> To pay back ill for ill unwilling.
> Let the wretch go! I give his meed,
>> All that I promised him fulfilling.
> And you go where you will – good speed!

At this the Great Being said, "O mighty king, men say one thing with their lips, and do another," to expound which matter he recited two stanzas:

> The cry of jackals and of birds is understood with ease;
> Yea, but the word of men, O king, is harder far than these.
>
> A man may think, "This is my friend, my comrade, of my kin";
> But friendship goes, and often hate and enmity begin.

When the king heard these words, he answered, "O king of the deer! do not suppose that I am one of that kind; for I will not deny the boon I have promised you, not even if I lose my kingdom for it. Trust me." And he gave him choice of a boon. The Great Being accepted this boon at his hands, and chose this: That all creatures, beginning with himself, should be free from danger. This boon the king granted, and then took him back to the city of Benares, and having adorned and decorated the city, and the Great Being also, caused him to discourse to the queen his wife. The Great Being discoursed to the queen, and afterwards to the king and all his court, in a human voice sweet as honey; he admonished the king to hold fast by the Ten Virtues of Kings, and he comforted the great multitude, and then returned to the woodland, where he dwelt among a herd of deer.

The king sent a drum beating about the city, with this proclamation: "I give protection to all creatures!" From that time onwards no one durst so much as raise hand against beast or bird.

Herds of deer devoured the crops of mankind, and no one was able to drive them away. A crowd assembled in the king's courtyard, and complained.

To make this clear, the Master repeated the following stanza:

> The country-folk and townsfolk all straight to the king they went:
> "The deer are eating up our crops: this let the king prevent!"

Hearing this, the king recited a couple of stanzas:

> Be it the people's wish or no, e'en if my kingdom cease,
> I cannot wrong the deer, to whom I promised life and peace.
> The people may desert me all, my royal power may die,
> The boon I gave that royal deer I never will deny.

The people listened to the king's words, and finding themselves unable to say anything, departed. This saying was spread abroad. The Great Being heard of it, and assembling all the deer, laid his bidding on them: "From this time forward you must not devour the crops of men." He then sent a message to men, that each should set up a placard on his own lands. The men did so; and at that sign even to this day the deer do not devour the crops.

When the Master had ended this discourse, he said, "This is not the first time, Brethren, that Devadatta has been ungrateful," and then he identified the Birth: "At that time, Devadatta was the merchant's son, Ananda was the king, and I myself was the deer." ⁴he has many royal past lives ···

29

3

"The Country of Khotan and the Image Procession" and "The Image Procession and the Charitable Hospital": Selections from *A Record of the Buddhist Countries*

Fa-Hsien [Faxian]

Introduction

The following reading contains two excerpts from *Foguoji*, or *A Record of the Buddhist Countries*, written in the early fifth century CE by the Chinese Buddhist monk Sehi, who had adopted the spiritual name Faxian, "Splendor of Dharma." Buddhism, founded in northeast India, reached China in the first century CE and slowly gained a following there. In subsequent centuries, particularly between 300 and 600 CE, Chinese monks undertook pilgrimages to locations marking important moments in the Buddha's life. Along the way, the monks collected images, relics, and *sutras* (books). Once back home, they translated these texts into Chinese, aiding in the development of Buddhism. Many also recorded their travels in diaries and

Fa-Hsien [Faxian], "The Country of Khotan and the Image Procession," pp. 18–20 from *A Record of the Buddhist Countries*, Li Yung-hsi [Li Yongxi]. Peking [Beijing]: The Chinese Buddhist Association, 1957. Fa-Hsien [Faxian], "The Image Procession and the Charitable Hospital," pp. 60–1 from *A Record of the Buddhist Countries*, Li Yung-hsi [Li Yongxi]. Peking [Beijing]: The Chinese Buddhist Association, 1957.

books, thereby leaving important accounts of early Buddhist sites and practices in South Asia.

Faxian was the first – and remains the best known – of such monks to make a pilgrimage to South Asia, to collect and translate *sutras*, and, most importantly, to record his experiences in writing. He left China in 399, traveling from the city of Chang'an (present-day Xi'an) along the Silk Road, across the Gobi desert, to Gandhara in present-day Afghanistan, and on to the plains of north India, where he studied with Indian Buddhist scholars. During his fifteen years of travel, he visited much of the Indian subcontinent before sailing on to Sri Lanka and Sumatra and finally returning to China in 414. He wrote *A Record of the Buddhist Countries* in 416, leaving a detailed account of his journey.

Both excerpts included here from *A Record of the Buddhist Countries* deal with image processions, and, as was Faxian's practice, he writes about his experiences in the third person. The first passage records the procession Faxian witnessed during his time in Khotan (or Hotan), today in southwestern China. The second describes Faxian's time in the northeastern Indian city of Pataliputra (present-day Patna). The city served as an important political and Buddhist center during the Mauryan dynasty, which gained power under Emperor Ashoka in the third century BCE (see the Ashokan inscriptions in this volume). Indeed, as Faxian's account makes clear, that early history was well remembered by the fifth-century CE inhabitants and visitors to the city.

Accounts such as Faxian's are crucial because they provide rare vehicles through which to understand the role of art objects in early Buddhist practices in a manner that goes beyond the ideals presented in Buddhist religious texts. The descriptions provided by the Chinese monk-travelers' accounts, although filtered through the monks' individual experiences and recollections, give contextualization and a sense of dynamism to the surviving statues and stone monuments. For this reason, scholars of early Buddhist art in India often turn to these writings and judiciously mine them for information.

The Country of Khotan and the Image Procession

This country is rich and happy, with a prosperous people. All its inhabitants are Buddhists, who delight in their religion. The number of monks amounts to several tens of thousands, most of whom study Mahayana Buddhism, and all of whom have food provided for them. The houses here are scattered, and a small stupa is built in front of each, from twenty feet upwards in height. There are dwelling places for monks, and provision is made to entertain monks from elsewhere. The king of this country lodged Faxian and his party in a monastery called Gomati, of the Mahayana School. Here 3,000 monks live together, and assemble for meals at the sound of a bell. When they enter the refectory, they behave with sober propriety and take their seats in due order. All is quiet and there

31

is no rattle of bowls. Instead of calling out when they want their bowls refilled, they simply sign with their fingers to the attendants.

Huijing, Daozhen and Huida went on ahead to Khalcha, while Faxian and the others remained behind for another three months to see the image procession. Khotan has fourteen large monasteries, to say nothing of smaller ones. Beginning from the first day of the fourth month, the streets and lanes of the city are swept clean and decorated, while a great canopy, lavishly adorned, is erected above the city gate. Here the king and queen stay with their maids of honour. The monks of Gomati Monastery, being Mahayana monks whom the king respects, are the first to bear images in this procession. Three or four *li* [unit of measurement, approximately one-third of a mile] from the city they make a four-wheeled image car in the shape of a movable palace, more than thirty feet high, which is adorned with the seven precious substances[1] and hung with silk pennants and canopies. Buddha's image stands in the centre of the car attended by two Bodhisattvas, while devas[2] of gold and silver or carved jade are suspended in the air. When the image has approached to within about a hundred paces of the gate, the king takes off his crown and changes into new clothes. Carrying flowers and incense, and followed by his attendants, he goes out of the city barefoot to receive the images, then pays homage at their feet, scattering the flowers and burning the incense before them. As the images enter the city, the queen and her maids on the gate-tower cast down all kinds of blossoms. There are different kinds of car for each ceremonial; and each monastery has one day to parade its images, the procession beginning on the first of the fourth month and ending on the fourteenth. After the procession is completed, the king and queen return to their palace.

Seven or eight *li* to the west of this city is a monastery by the name of New Royal Monastery. Its construction took eighty years and three reigns to complete. Some two hundred feet high, it is ornamented with carvings and inlaid work, and studded with gold, silver and all kinds of jewels. Behind the stupa stands a magnificent and beautiful shrine-hall to Buddha, the beams, pillars, doors and windows of which are plated with gold. There are also monks' dwellings which are so splendid and richly adorned that no words can describe them. The kings of the six countries east of the Pamirs have presented many of their most costly jewels, seldom used by the common people, as offerings to this monastery.

The Image Procession and the Charitable Hospital

Pataliputra is the largest city in the whole Middle Kingdom. The people are rich and prosperous, and vie with each other in performing good deeds. Every year in celebration of the eighth day of the second month they hold an image procession. They use a four-wheeled cart on which five tiers are constructed in bamboo, with a halberd-shaped central post about twenty feet high, the whole structure

resembling a pagoda. This is covered with white woollen cloth, painted with various devas in colour, adorned with gold, silver and glass, and hung with silk pennants and canopies. There are four shrines on the four sides, each containing a seated Buddha, attended by standing Bodhisattvas. About twenty such cars are prepared, each decked out in a different way. On the day of the procession the monks and laymen of the country assemble to dance, play music and offer flowers and incense. The Brahmans come out to receive the images of Buddha, which are brought into the city one after the other, and remain there till the next day. Lamps burn throughout the night, and there is dancing and music to honour the gods. This ceremony is the same in all the Buddhist countries.

The elders and laymen of this country have established charitable hospitals in the city, to which all the poor, homeless, deformed and ill can go. Here all their wants are supplied, and the physicians who attend them prescribe the food and medicine they require. When cured, they are free to leave.

King Ashoka, after he had destroyed seven stupas, built 84,000 new ones, the first being the great stupa three *li* or more to the south of this city. In front of this is one of Buddha's footprints, over which a temple has been erected, its door opening north towards the stupa. South of the stupa there is a stone pillar fourteen or fifteen feet around and more than thirty feet high. The inscription upon this reads:

"King Ashoka offered Jambudvipa to monks from all parts of the world, then redeemed it again with silver. And this he did three times."

Three or four hundred paces north of the stupa is the site of the city of Niraya which King Ashoka built, and here stands a stone pillar more than thirty feet high, with the figure of a lion above it. An inscription on the pillar relates the reason for building it and the year, the month and the day.

[margin note:] righteousness, once again promoted by King Ashoka

Notes

1. Gold, silver, lapis-lazuli, crystal, beryl, emerald, and agate.
2. Divinites of Indian mythology.

4

"Varaha, the Boar," "Brahma, Vishnu and the Linga of Shiva," "Mt Govardhana," "The Origin of the Goddess from the Gods," and "The Death of Mahisha, the Buffalo Demon," from *Classical Hindu Mythology: A Reader in the Sanskrit Puranas*

Introduction

The "stories of the old days" or *puranas* are often illustrated in South Asian sculpture and painting. Telling the tales of the gods and goddesses of Hinduism, these texts distill oral narratives passed down from generation to generation in ancient India, recorded and revised from c.1000 BCE to c.600 CE. Thus, they serve as examples of the stories, rather than definitive retellings of them, and the images on temples and manuscript pages offer yet another version of these narratives.

The three primary gods of Hinduism, Vishnu, Shiva, and Brahma, play major roles in each of these stories. In the Hindu cosmology, these three encompass all and can see all; indeed, Brahma's multiple heads face the four directions. For their followers

"Varāha, the Boar," pp. 75–6, "Brahmā, Viṣṇu [Vishnu] and the Linga of Śiva [Shiva]," pp. 205–6, "Mt Govardhana," pp. 116–17, "The Origin of the Goddess from the Gods," pp. 233–7, "The Death of Mahiṣa [Mahisha], the Buffalo Demon," pp. 237–8, from Cornelia Dimmitt and J. A. B. van Buitenen (eds), *Classical Hindu Mythology: A Reader in the Sanskrit Puranas*. Philadelphia: Temple University Press, 1978.

these three gods do not represent the "god of fire and destruction" or the "god of creation"; instead, each of them encompasses all godly aspects. Other gods may have particular designations (Surya, the sun god, for example) but these three transcend that type of categorization.

Vishnu's ten avatars (incarnations) center a wealth of narratives, from Varaha, the boar, to Krishna and Rama, a cowherder and warrior respectively. The story of Brahma creating Varaha in order to reconstitute the Earth (imaged at the fifth-century relief at Udayagiri and elsewhere as a female goddess called Bhumi) shows the versatility of Vishnu's many forms and his role as preserver of the universe. Likewise, when Krishna holds up Mount Govardhana to save his village from the reprisals of the god Indra, he shows his responsibility and duty to his followers. Both tales invoke a logic of good leadership and protection, which means they often arise in sculpture and painting commissioned by royal patrons. Vishnu appears less omnipotent in the story of the unending mark or *linga* of Shiva, a tale designed to demonstrate the supremacy of Shiva among the three major gods. Found in southern Indian temple sculpture, this story emphasizes the unending nature of the deity and demonstrates to worshippers the power of devotion.

The final selection here tells the story of Durga, the goddess created by the gods in a desperate time when the demon, or *asura*, Mahisha had defeated them and ruled the heavens and earth. Each of the gods gives this new warrior goddess a weapon, thus putting their combined force into her. When she goes on to slay the buffalo demon Mahisha, whom no man or god could kill, she alone wins victory for the entire group of gods. While Vishnu, Shiva, and Brahma represent the three major gods in Hinduism, in the goddesses resides the power, or *shakti*; indeed, each god has a feminine aspect without which he would be powerless. Thus, the story of Durga slaying the buffalo demon gives form to the workings of the masculine and feminine within Hindu narratives: Durga wields all the weapons of the gods; she is truly supreme.

Devotees, laypeople, and rulers might interpret each of these stories differently, and their retelling in stone or paint provides yet another space for reinterpretation to serve the needs of the patron. Examining the historical and physical context of the images shows us whether patrons wish to communicate messages of legitimacy, benevolent rule, success in battle, or simply the propitiation of powerful deities. Visual representations of these stories rarely, if ever, precisely match the Sanskrit texts translated here, and thus the selective way in which these stories are visually retold reveals their historical, religious, and political messages.

Varaha, the Boar

At the end of the last Eon when the tempest of time began, the forest trees were uprooted, the fire god burned the three worlds as if they were straw, the earth was flooded with rain and the oceans overflowed. While all the regions were sunk in vast sheets of water and the waters of destruction had begun their ferocious

dances, leaping with fish and undulating with circular, arm-like waves, Brahma as Narayana slept peacefully in the sea. . . .

The Siddhas who lived in Janaloka, folding their hands in prayer and singing hymns, awoke the lord of the thirty gods who lay in Yogic sleep as he concentrated on Shiva, just as the Shrutis awoke the lord at the beginning of creation, long ago. Waking up and rising from his bed in the middle of the water, his eyes cloudy with Yogic sleep, the lord looked in all directions. He saw nothing whatsoever but himself! Sitting up like one bewildered, he grew deeply concerned, thinking, "Where is that lovely lady, the broad earth, with her many lofty mountains, her streams, towns and forests?" Worrying this way, Brahma could nowhere spy the earth.

Then he called to mind his father, the lord with three eyes. Because he remembered Bhava, the god of gods with infinite splendor, the lord of the world realized that the earth was immersed in the sea. Wanting to rescue earth, Prajapati thought of the heavenly form of the boar with a body like a mighty mountain, who delighted in water-play. This boar was terrifying, making a hissing noise like a big black cloud, booming forth with a dreadful sound. His trunk was round, fat and firm, his hips high and full, his shank-ends short and rounded, his snout sharply pointed. Red as a ruby were his horrible round eyes; his body was long and tubular with shining stiff little ears, curvaceous in trunk and cheek; he was covered with a fine, waving mane of hair.

The ocean of Doomsday was roiled up by the heavy panting of this boar, who was adorned with gems, ornaments and glittering jewelry, shining like lofty piles of clouds filled with lightning. Having assumed this vast, infinite, boar-like shape, the lord entered the netherworld in order to raise up the earth. There this mountainous boar blazed forth as radiantly as if he had gone to the foot of Mahesha's mountain, which is shaped like the *linga*.

Then the earth-upholder dug up the earth which was sunk in the sea and emerged from the netherworld holding it on his tusks. When they saw him, the inhabitants of Janaloka, the seers and Siddhas, rejoiced and danced, showering his head with flowers. The mighty boar's body covered with flowers was as beautiful as a mountain of antimony alive with fireflies on the wing.

When the boar had brought the great earth to its proper place, he returned to his own form and stabilized it. Aligning the earth, the lord piled up the mountains and fashioned the four worlds and all the rest, just as it had been before. Thus having rescued the great earth from the middle of the vast ocean of dissolution, Vishvakarman once more poured forth creation with its moving and unmoving beings.

Brahma, Vishnu and the Linga of Shiva

Lord Vishnu spoke:

Long ago, when everything animate and inanimate was lost in that one awful ocean, Shiva himself appeared in order to awaken Brahma and myself. There was

only this dreadful undifferentiated ocean made up of darkness in the midst of which I myself, with one thousand heads, one thousand eyes, one thousand feet and one thousand arms, lay sleeping, self-controlled, bearing conch, discus and mace. Meanwhile I saw at a distance a god of boundless light, shining like ten million suns, circled by luster, the four-faced god whose Yoga is great, the person of golden color, wearing a black antelope skin, the god who is hymned with Rig Yajur and Sama Vedas.

In the twinkling of an eye, glorious Brahma himself, choicest of those who know Yoga, came to me and smiled as he spoke. "Who are you? Why are you here? For what reason are you staying here? Tell me, O lord! For I am the creator of the worlds, the self-existent, the great-grandfather." Thus addressed by Brahma I replied, "It is I who am creator and destroyer of these worlds time and time again!"

While the argument was going on like this there appeared by the illusion of the supreme god a matchless *linga* whose self was Shiva displayed for awakening. It was bright as the fire of Doomsday, wreathed with garlands of flame, free from growth and decay, without beginning, middle or end. Then the unborn one, the lord, said to me, "Go quickly downwards; I will go upwards. Let us discover the limits of this."

Having made this agreement, the two of us – myself and the Grandfather – went quickly upwards and downwards, but for a hundred years could find no end to it. Amazed and frightened, confused by the illusion of the god who carries a trident, we called to mind the perfect lord. Pronouncing the great sound *OM*, the transcendent syllable, bowing with our hands folded we praised the matchless Shambhu. Being so praised the supreme lord became manifest; the great Yogin shone forth brilliant as ten million suns. Appearing to devour the sky with his hundred million mouths, he displayed a thousand hands and feet; sun, moon and fire were his eyes. He stood there with bow in hand, carrying a trident, wearing a tiger-skin garment, his sacred thread a snake, making a sound like a kettledrum of clouds.

Thus spoke the great god, "I am pleased with you both, O best of the gods. Now see that I am the greatest god and fear no more! Ages ago the two of you eternal ones were produced from my limbs. Brahma, Grandfather of the worlds, lies in my right side. Vishnu, the protector, dwells in my left. And Hara is born in my heart. I am entirely satisfied. I will give to you both whatever you desire."

Having said this, the god Shiva, Mahadeva himself, inclined towards benevolence, embraced Brahma and me. Then Narayana and the Grandfather were very pleased of heart. They prostrated themselves before the great lord when they saw his face. "If you are pleased with us, and if a boon is to be granted, then let us be constantly devoted to you, O god, the greatest lord!"

Mt Govardhana

When the cowherds had been persuaded by Krishna to make their offerings to the mountain instead of to Indra, Shakra became filled with fury, O Maitreya. He

summoned a troop of rainclouds named Samvartaka and addressed them, "*Bhoh!*
Bhoh, you clouds, hear what I have to say, and act immediately on my orders! The
evil-minded cowherd Nanda, together with the other cowherds, proud of the
power of Krishna's protection, had disrupted my sacrifice! Harry with rain and
wind, according to my command, those cows which are their ultimate livelihood
and the cause of their support. Riding on my mountainous elephant I shall assist
you in the storm."

At his command, the thunderclouds loosed a horrendous storm in order to
destroy the cows, O brahman. Then in a flash the earth, horizons and sky
became one under the mighty downpour of water. A huge flood poured from
the clouds as they shook from the blows of whip-like lightning, and the circle
of the horizon was filled with thunder. The world was darkened by the
incessant raining of the clouds, as if it were nothing but water, above, below
and across.

The trembling cows, buffeted by the fierce wind and rain, with shrunken
withers, necks and thighs, began to die. Some stood there sheltering their calves
under their chests, great seer, while others lost their calves to the flood waters.
And the sad-faced calves, their necks shaken by the wind, cried out in feeble
voices, "Help! Help!" as if they were sick.

When Hari saw all Gokula, cows, men and women together, so miserable, O
Maitreya, he began to ponder, "This has been done by Indra, who is angry
because of the loss of his offerings. I must now rescue the entire cowpen! I
shall root up this mountain with its broad expanse of rock, and firmly hold it
aloft over Gokula like a wide umbrella."

Having made up his mind, Krishna lifted Mt Govardhana with one hand and
playfully held it aloft! Then Shauri, holding the uprooted mountain, said to
the cowherds with a smile, "Now quickly hide under here where I have stopped
the rain. You may stay here contentedly, as in a windless spot, without fear of the
mountain falling down."

At Krishna's words the cowherds, who were being pelted by the rain, entered
under the mountain with their herds, and so did the cowherd women with their
belongings piled on carts. And so Krishna held that mountain steadily aloft to the
delight of the inhabitants of Vraja, their eyes thrilled with wonder. As Krishna
supported that mountain, his deed was celebrated by the delighted cowherd men
and women with eyes wide with joy.

For seven nights huge clouds sent by Indra poured rain on Nanda's Gokula,
O brahman, in order to annihilate the cowherds. But since they were protected
by the mighty mountain held on high, that slayer of Bala, his promise
proven false, dispersed the clouds. After the sky was free of clouds and Indra's
promise had been shown to be empty, the happy people of Gokula came out
and returned to their own homes. And Krishna then returned Mt Govardhana
to its own place as the inhabitants of Vraja looked on with wonder in their
faces.

The Origin of the Goddess from the Gods

Once long ago there was a battle between the gods and demons that lasted a hundred years, in which Mahisha was the leader of the Asuras, and Indra, sacker of cities, was the chief of the gods. In this contest the army of the gods was defeated by the more powerful demons. When Mahisha had conquered all the gods, he became their leader. So the gods, utterly defeated, put the lotus-born Prajapati before them and went to Isha and Vishnu, the god whose banner bears Garuda. In the dwelling place of these two deities, the thirty gods related at length the exploits of Mahisha and their own defeat.

"Mahisha himself has taken charge of the offices of Surya, Indra, Agni, Vayu, Yama, Varuna and the other gods. All the hosts of gods have been expelled from heaven by this evil-souled demon and have spread all over the earth like mortals. You have been told all about this struggle against the enemy of the gods. Now we have come to you for protection. Let us plot his destruction!"

When they heard this speech of the gods, Madhusudana and Shambhu grew angry, their brows knitted in frowns. Pure energy blazed forth from the discus-bearer's mouth as he filled with rage, and from Brahma and Shankara as well. From the bodies of Indra and the other gods too emerged great *tejas* and all their energies united into one. As the gods witnessed this fiery crest of energy pervading all the directions and blazing forth like a mountain peak aflame with the sun, this matchless energy that sprang from the bodies of all the gods, its light illuminating the three worlds, became concentrated in one spot and took form as the goddess. Her mouth was born from the energy that arose from Shambhu; from Yama's energy came the hairs of her head, and from Vishnu's her arms. From the energy of the moon were born her two breasts; from Indra's her waist. From Varuna's energy came her calves and thighs, and from energy itself, her genitals. From the energy of Brahma arose her feet, her toes from the Sun's; from the Vasus' came her fingers and hands, and her nostrils from Kubera's. Her teeth sprang from the energy of Prajapati and her three eyes from that of Fire. From the energy of the two twilights came her eyebrows, and her ears from the wind's. In this manner was the goddess Shiva born from the *tejas* of the other gods.

When the immortals, who were tormented by Mahisha, saw this goddess emerging from the energy of all the gods combined, they all rejoiced and all gave her their own weapons, crying aloud, "Victory! Victory! Our leaders will be victorious by *tejas!*"

The Pinaka-bearer gave her a trident which was drawn out of his own weapon, while Krishna gave her a discus severed from his own. Varuna gave the conch to her; the oblation-eating Fire, his spear. The Wind gave her a bow and two quivers full of arrows. Producing a thunderbolt from his own thunderbolt, Indra, lord of the gods, gave it to her; this thousand-eyed god also gave her the bell from his elephant Airavata. Yama gave her a staff from his staff of time; Varuna, lord of the waters, gave her a noose; Prajapati a necklace of beads; and Brahma a water-jar.

39

Sun put his own rays into the pores of her skin and Time gave her his sword and shining shield. The milk ocean bestowed on her a shining necklace, two never-fading garments, a celestial crown jewel with a pair of earrings and upper-arm bracelets, a lustrous half-moon, bangles for all her arms, a pair of bright anklets, and jeweled rings for all her fingers and toes. Vishvakarman gave her an immaculate axe, impenetrable armor and all manner of weapons. The ocean placed on her head and breast an incomparable wreath of undecaying lotuses and put in her hand a beautiful lotus flower. Himavat gave her the lion for her mount and an abundance of jewels. Kubera, lord of wealth, gave her a goblet full of wine. And Shesha, lord of the Snakes, who supports this earth, gave her a necklace of Snakes studded with large gems.

The goddess, thus honored by the other gods with ornaments and weapons, roared aloud ebulliently, cackling again and again with demoniac laughter. The whole sky was filled with her hideous cries; as her monstrous bellow reverberated forth, all the worlds shook, the oceans trembled and the mountains quaked, while the joyful gods cried out, "Victory!" to the goddess who rides a lion; and the seers praised her too, their heads bowed low in devotion.

When they saw the three worlds shaking, the foes of the gods who had readied their armies sprang up, their weapons raised aloft. "*Aho*, what is this?" cried the demon Mahisha, accompanied by all the Asuras as he rushed in fury toward the sound. Then he saw the goddess pervading the three worlds with her splendor, while the earth sank under her feet and her crown towered above the sky, shaking the whole netherworld with the hiss of her bow-string, filling the universe in all directions with her thousand arms.

Between this goddess and the enemies of the gods a battle was joined spanning the blazing directions, with all manner of striking and throwing weapons. The great demon called Chikshus, leader of Mahisha's army did battle with the gods, as did Chamara, accompanied by a four-fold army. The mighty demon Udagra (Ferocious) fought with 60,000 chariots and Mahahanu (Big-Jaw) battled with a million; Asiloma (Sword-Hair) fought with fifty million and Bashkala entered the fray with six million. With vast multitudes of elephants and horses, Ugradarshana (Terrible Sight) fought in that conflict accompanied by a million chariots. And the mighty Daitya called Bidala (The Cat) battled in that war surrounded by a half a million chariots, while the demon Kala (Time) was accompanied by as many as five million. Then myriads of other great Asuras with their chariots, elephants and horses fought in that battle with the goddess. And Mahishasura was encircled in the conflict by thousands of millions of chariots, elephants and horses. They fought against the goddess with lances, slings, mighty clubs, swords, axes and three-bladed pikes. Some flung spears, other nooses; with blows of the sword the demons went forth to kill the goddess.

But this goddess Chandika, raining down her own striking and throwing weapons, cut down those of her enemy as if in play. Her face serene and praised by the seers, the goddess thrust her striking and throwing weapons into the bodies of the demons. The lion mount of the goddess, her mane shaking with

fury, moved through the Asura army like fire through a wood. And Ambika's snorts as she struggled on the battlefield became troops in the battle by the hundreds of thousands. They fought with axes, with slings, with three-bladed pikes; sustained by the power of the goddess, they annihilated the demons. Some of her troops sounded war drums and others blew conches, while still others beat the small drums in that grand celebration of war.

Then the goddess with her trident, club and showers of spears, with swords and other weapons, destroyed the demons by the hundreds. Some, confused by the ringing of her bell, were felled by the goddess with her trident, club and showers of arrows. Others she lassoed with her noose and dragged along the ground. Some were split in two by blows of her sharp swords, while others were pulverized by her attack, and still others lay felled by her club on the earth. Some of that enemy horde vomited blood after being hammered by her club. Others fell to the ground pierced in the chest by her trident. The mountain-like tormentors of the thirty gods, huddled together on the battlefield, overcome by a shower of arrows, gave up their lives. Some of those mighty demons – some whose arms were cut off, others whose necks were severed, some who were decapitated, others cut in two at the waist, and still others with legs dismembered – fell to the ground. But some who had been cloven in two by the goddess, each half bearing one arm, one eye and one foot, and others who had lost their heads rose up again. These headless trunks, still grasping their fine weapons, battled against the goddess. Other dead bodies were also dancing on the battlefield, keeping time to the rhythm of the musical instruments. Headless corpses holding swords, spears and lances in their hands shouted out, "Stand still! Stand still!" to the goddess. Other demons with limbs torn off made a shudder go through the host.

The earth became unfit to walk on where the ferocious battle raged because of the vast rivers of blood from the felled elephants, horses and demons that flowed through the middle of the Asura forces. Ambika sent that mighty demon army to perdition in a flash, just as fire consumes a heap of grass and wood. And the lion, roaring aloud, shaking his mane, plucked the life-breath from the bodies of those enemies of the gods. After that battle between the great demons and the goddess with her troops, the gods in heaven praised her, raining down showers of flowers.

The Death of Mahisha, the Buffalo Demon

When his army was being destroyed in this manner, the demon Mahisha himself, in the form of a buffalo, terrorized the troops of the goddess. Some of them he beat with his snout, others he trampled with his hooves, still others he lashed with his tail, while some were ripped to shreds by his horns. Some were thrown to the ground by his bellowing and the speed of his charge while others were felled by the gusts of his panting breath. After felling her troops, the demon rushed to attack the lion that was with the great goddess. At this Ambika became enraged.

41

The mighty, virile buffalo, whose hooves pounded the earth, also grew furious, smashing the lofty mountains with his horns and bellowing aloud. Trampled by his violent sallies, the earth was shattered, and the ocean, lashed by his hairy tail, overflowed on all sides. Shaken by his slashing horns, the troops were utterly dispersed. Mountains tumbled by the hundreds from the sky, struck down by the wind of his snorting breath.

When she saw this great demon attacking, swelling with rage, Chandika then became furious enough to destroy him. She threw her noose and lassoed the great Asura. Thus trapped in that mighty battle, he abandoned his buffalo shape and became a lion. At the moment Ambika cut off its head, a man appeared, sword in hand. As soon as Ambika cut down that man along with his sword and shield, the demon became a huge elephant. With a roar he dragged the goddess's lion along with his trunk, but while he was pulling the lion, she cut off his trunk with her sword. Then the great demon resumed his wondrous buffalo shape, causing all three worlds with their moving and unmoving creatures to tremble.

Provoked by this, Chandika, mother of the world, guzzled her supreme liquor, laughing and red-eyed. And the Asura, puffed up with pride in his own strength and bravery, bellowed aloud and tossed mountains at Chandika with his horns. Pulverizing those mountains that were hurled at her with arrows sent aloft, the goddess, excited by anger, her mouth red with liquor, cried out to him and his invincible troop, "Roar and bellow, but only as long as I drink the mead, you fool! In a moment the gods will be howling at you when you die by my hand!" So speaking, the goddess flew up and trod on his throat with her foot, piercing him with her spear. Crushed by her foot, overcome by the power of that goddess, the demon came half-way out of his own mouth. Still battling in this way, he was felled by the goddess who cut off his head with her mighty sword. So that demon Mahisha, his army and his allies, who had so distressed the three worlds, were all annihilated by the goddess.

At Mahisha's death, all the gods and demons, mankind and all creatures living in the three worlds cried "Victory!" And when the entire army of the lamenting Daityas was annihilated, the whole host of the gods went into exultant rapture. The gods and the great celestial seers praised that goddess, while Gandharva lords sang aloud and hosts of Apsarases danced.

5

Playful Ambiguity and Political Authority at the Large Relief at Mamallapuram

Padma Kaimal

Introduction

In this article, Padma Kaimal, a leading scholar of Indian art, analyzes the monumental seventh-century narrative relief at Mamallapuram, the primary trade and port city of the southern Indian Pallava dynasty (550–728). In 630, the king Narasimha, whose epithet was "Mamalla" or "Great Warrior," founded a new port city, which he named Mamallapuram after himself. Over the next hundred years, generations of Pallava craftsmen created scores of monuments from the granite outcroppings dotting the region. The best known of these is a large narrative relief facing the ocean. Scholars have long debated the subject matter of this work, as it has elements from at least two major stories found in the Indian textual tradition. Kaimal develops her own reading that incorporates both stories into a holistic reading of the relief.

 To accomplish this, she looks to other examples of similar subject matters and compares their iconography to that of the relief. She also draws on what we know of the politics of the time: the way in which the royal image of the Pallavas is communicated and its implications for this prominent relief. She examines the position of this relief in relation to other carvings at Mamallapuram, asking how viewers might encounter the relief, and what else was nearby to support its program. And she looks to contemporary linguistic patterns in Sanskrit, the ancient courtly

[handwritten margin note: this relief has elements from two stories, making it difficult to ascertain its meaning]

Padma Kaimal, "Playful Ambiguity and Political Authority at the Large Relief at Mamallapuram," pp. 1–9, 13–15, 21–7 from *Ars Orientalis* 24 (1994). Reprinted by permission of Padma Kaimal and *Ars Orientalis*.

and religious language of India, to see if similar patterns can be discerned in the relief's visual language.

This article takes readers through the major gods and goddesses of Hinduism, including Shiva, Vishnu, Krishna, and the river goddess Ganga (the Ganges). The *Mahabharata* and the *Ramayana*, texts mentioned by Kaimal, are ancient Sanskrit epics that center much of Hindu thought and social practice. The *Ramayana* details the life of Rama, an Indian god-king who is an incarnation of Vishnu, while the *Mahabharata* includes Krishna, another incarnation of Vishnu, among its gods. Figures such as Arjuna and Bhagiratha are not gods but humans who feature in these narratives. Other texts, such as the *Panchatantra*, and various *puranas* or books Kaimal draws upon form well known fables, stories, and hymns often connected with deities, such as the *Bhagavata Purana*, or the book of the lord, which centers on Krishna. Both the stories and the retelling of those stories in stone give a sense of the dynamism of Hindu thought and culture, and Kaimal points out the ways in which religion and the constant negotiations of politics intertwine.

Art historians have debated for decades the meaning of scenes carved during the Pallava period into a cliff at Mamallapuram in southern India (Fig. 5–1). Depicted on a sheer granite face are more than a hundred figures, each well over life-size and chiseled in a high relief that catches the bright coastal sunshine. Do these figures, carved during the seventh century, allude to penance the warrior Arjuna undertakes in order to gain a supreme weapon[1] or to the mythical king

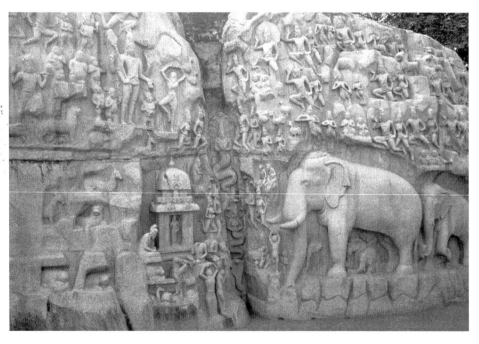

Fig. 5-1 Great Relief, Mamallapuram, Tamil Nadu, India, seventh to eighth centuries. Photograph by Deborah Hutton.

Bhagiratha's successful efforts to bring the celestial river Ganga (Ganges) to earth?[2] Posed as exclusive alternatives, neither argument has won universal acceptance. Both stories correlate with many of the figures on this rock, and yet elements of the composition resist each narrative with equal stubbornness.

My purpose in this article is to pursue the suggestion advanced briefly by Michael Lockwood and Susan Huntington: that the relief means to tell both of these stories.[3] I believe that, along with these two narratives, audiences were meant to perceive in this frieze a collection of metaphors, comic allusions, and political promises and that these multiple elements do more than coexist peacefully. They interact, as voices in a dialogue, working in cooperation rather than competition. Establishing these separate voices and facilitating their interaction is a series of purposefully constructed ambiguities, deliberate exploitations of the multiple connotations embedded within a single, fixed arrangement of carved figures. There is, furthermore, a playful quality to these ambiguities. The witty interplay among these voices sets up a deciphering game for viewers. Some narrative elements are openly comic.

It is in the deliberate nature of these ambiguities that I find my colleagues' political readings of the Mamallapuram relief to make the most sense.[4] Many of the themes articulated in this relief converge upon a set of ideas about kingship. This political meaning emerges with particular clarity where separate visual narratives overlap, as they do around the theme of royal protection. In tones that are alternately heroic and humorous, threatening and comforting, they articulate the Pallava king's promise to protect his people and the land they inhabit from all dangers – human, climatic, and divine. The dialogue communicating this message involves the voices of a second relief adjacent to the large relief, as well as the voices within the Descent/Penance relief itself.

These voices convey their message all the more powerfully for having been temporarily perceived as separate. Each narrative can read as the description of yet another aspect of the king's protective capabilities. The initial confusion produced by the apparently competing meanings is, I maintain, a constructive and intended phase of reading this relief. Competition between alternative narratives eludes a quick reading. Uncertainty can make viewers pause, look beyond initial impressions, and appreciate the cleverness of this visual game. Lengthy contemplation can alert viewers to the complexity of messages conveyed; it can divert them with amusing subplots; it can also reveal convergence among these apparently contradictory meanings.

The relief overlooks the Bay of Bengal. While none of the area's many other rock outcroppings obstructs its view of the ocean, time has necessarily transformed the experience of viewing this work: more recent buildings and vegetation now interfere with the view from the east. Currently, most visitors arrive here by tour bus along the highway that extends north to Madras, and Mamallapuram (also called "Mahabalipuram") is now a small, remote fishing village. Originally, however, the huge carving must have been one of the first sights to greet the crowds that arrived by sea at what was once a teeming port.

[margin note: 'both' relief deal w/king hinting at its political importance]

45

Since the Pallava dynasty was heavily engaged in maritime warfare and trade, and since Mamallapuram was its primary port, these crowds were probably sizeable. During the Pallava period great quantities of Mamallapuram's copious granite were carved into cave temples, free-standing monoliths, structural temples, and reliefs, and many of these monuments were inscribed by the Pallava kings themselves. The intense concentration of sculpture in this town suggests that the Pallavas recognized the opportunity offered here for addressing a substantial audience. I suspect that the prominent relief at the town's center made a particularly eloquent statement in this visual introduction to the Pallava kingdom.

Viewers drawn to this relief by its address to the sea and its monumental scale are then urged to study the composition at some length, moving to the left and right repeatedly and perhaps interacting with other members of the large crowds that probably assembled before this broad frieze. A deep pit in front of the relief establishes a distance of some ten meters between audience and carved surface, delaying a bit longer the viewer's recognition of figures presented. The great quantity of figures represented and the complexity of their interactions further encourage deliberate observation. Figures that wrap around the edges of the cliff and nestle in its central crevice also invite viewers to traverse this cliff's wide face. The figures accommodate both the moving viewer and the large crowds of spectators by projecting prominently and at a consistent angle from the rock surface. Figural proportions are not distorted, that is, in order to privilege a single viewing angle. This establishes a shifting perspective that resolves coherently from any point across this facade, in contrast to a one- or two-point perspective, which would restrict observers to a single ideal vantage point.

The methods of narration employed here further detain the viewer. Rather than reading from left to right as Indian written languages do, or in a clockwise direction as the sculptural programs on Hindu temples often do, each narrative in this work demands to be traced by a gaze that hops about, linking distant figures, zigzagging up, down, left, right, and back again. With the recognition of additional readings, the mind revisits each figure, perhaps in a slightly different sequence, rethinking its significance and relationship to surrounding figures. Each time these paths are retraced, they become more familiar, more intimately within the viewer's possession. Like a verbal epic, this relief offers rewards of increasing intensity with each of the many rereadings it demands.

Arjuna's Penance/Descent of the Ganges

To assist modern readers in reconstructing this process of reading, I will summarize the two narratives most often perceived in this relief by modern scholars and the arguments for and against each interpretation. One of the most prominent of the narratives embedded here, Arjuna's Penance, is related in the *Maha-*

bharata and in a poem (*mahakavya*) reputedly popular at the Pallava court, the *Kiratarjuniyam* by Bharavi.

> The *Mahabharata* describes Arjuna and his brothers, deprived of their kingdom by their cousins, retreating to the forest and preparing to win back what they had lost. Armed with a magic spell (*mantra*) that would compel the gods to grant his wishes, Arjuna headed north, settled in the wilderness where he practiced severe austerities, and succeeded in capturing Shiva's attention. Shiva appeared to him but in the guise of a hunter claiming to have shot the same boar Arjuna's arrow had just brought down. The hunters fought. When Arjuna recognized his opponent's identity, he stopped fighting and offered obeisance to the god. Shiva then granted Arjuna the weapon he had been seeking, the *pashupatastra*, which was strong enough to destroy the world.[6]

Scholars who would see this narrative in the Mamallapuram relief read the penitent Arjuna in the emaciated, bearded man just to the left of the vertical cleft that bisects the rock. His protruding ribs and untrimmed hair reveal that, in true ascetic fashion, he has abandoned care of his physical body. In the posture of the Penance of Five Fires, he stands on one leg, his hands joined together over his head, his face raised toward his hands and staring at the sun. (Four other fires are to be understood burning on the ground around him.) To his left stands a four-armed and colossal figure that may be read as Shiva granting Arjuna the *pashu-patastra*.[7] Wielding his famous trident in his lower right hand, Shiva extends his lower left hand toward the emaciated man, palm open and fingers extended downward in a gesture of bestowal (*varada mudra*). Directly beneath that hand stands a dwarf, his round belly ruptured into a leering demonic face. Is this a personification of the *pashupatastra* that iconography texts describe as a terrifying aspect of Shiva?[8] Five other fat dwarves of the sort that frequently accompany Shiva cluster behind the god.

The wilderness, appropriately, surrounds this scene of penitence. Lions, elephants, a lizard, and birds cluster amid trees and caves in the relief's lower registers (Fig. 5–1). One of these animals is a boar. Near the animals on the left half of the cliff are male figures that represent hunters, distinguished by their mustaches, short kilts, and the bows they carry. Serpentine creatures (*nagas*) undulate in the central crevice of the composition, their multiple cobra heads fanning out behind human heads and upper bodies. Frequently described as water spirits in Hindu mythology, these *nagas* suggest here the presence of water in the vertical cleft beside Arjuna, perhaps a river beside Arjuna's camp.

Several disjunctions exist, however, between this relief and verbal narratives of Arjuna's Penance. For one thing, the boar who would lie pierced by two fatal arrows as Shiva grants Arjuna's boon spryly twists its neck and lifts a delicate foreleg. Though this boar matters to Arjuna's story more than the other wild creatures surrounding it, it receives no particular sculptural emphasis. Moreover, the hunters arranged across the left half of the cliff are difficult to peg as Arjuna

boar is still living & it is hard to identify Arjuna or Siva

or Shiva. There are four of them rather than two, and all four ignore the boar. They do not fight or, for that matter, interact with one another at all. Figures in the relief that might be components of Arjuna's story – hunters, the boar, Shiva, and the ascetic – are dispersed among other animals and a host of flying beings who have no obvious connection to that narrative. The ascetic's pose also seems not to fit this story. Why is he still performing penance when Shiva grants the boon? Once Shiva appears in his divine form, wouldn't Arjuna be bowing in adoration?[9]

Yet those who designed this relief may not have held the rigid and linear sense of time embedded in such objections. The designers may have intentionally collapsed a diachronic sequence (first Arjuna's asceticism, then Shiva after the fight) into a single scene, framing that within yet another moment (the boar and hunters before any arrows are shot). Nevertheless, this process of chronological manipulation does not account for the curious and, I think, deliberate omission of features that could articulate this narrative more precisely. At the Kailasanath temple in Kanchipuram, for example, Arjuna's Penance is clearly identified through the depiction of the fight itself. The bodies of Shiva, clearly identified by his tall crown, and Arjuna, wearing the crossed chest straps of the archer, cross over each other in a bold "X" of energetic conflict. Bracing to deliver and receive blows, reaching for arrows, bows, and staves, the two figures take up mirroring poses as they act out their excruciatingly protracted and well-balanced duel. Just behind Shiva's bent leg, a single boar may help identify this scene (although it seems, curiously, to be alive here too).

By contrast, the large relief at Mamallapuram avoids the finality that would exclude other interpretations of the same figures. The large relief merely contains Arjuna's Penance as a possible subject. Scenes that indicate Arjuna's Penance without ambiguity seem conspicuously absent from the large Mamallapuram relief. The emphasis this composition places on the idea of water presents a further obstacle to reading the relief simply as Arjuna's Penance. Since the interaction between Arjuna and Shiva is the climactic event of that narrative, that scene should compel the attention of figures as they look, gesture, and move toward the center of this relief. However, two celestial couples, two geese, and a monkey pointedly ignore Shiva and Arjuna to gaze at the watery cleft, an element that has little significance beyond scene-setting for that story.[10] Thus, a river that is only incidental to Arjuna's story eclipses the warrior as the focus of this composition.

Clearly, Arjuna's Penance cannot account for the entire design of this relief, and yet the work communicates this resistance so quietly. The figures ignoring Arjuna are tucked well into the cleft, where they might initially escape notice, and the juxtaposition of penance group and cleft leaves viewers uncertain, at least for a moment, of the frieze's true focus. This is a moment of very productive uncertainty, a moment during which images tug in several directions at once and viewers have the opportunity to glimpse the rich complexity such ambiguities can offer.

Something else has been encoded here as well, but that too has been done with a very light, almost slippery, touch. The emphasis on water, the strongest indication of the presence of another narrative, suits nicely the story of the Descent of the Ganges. That story, a subplot in both the *Ramayana* and the *Mahabharata*, describes the terrible drought caused after the sage Agastya swallowed all the water of the earth.

> For centuries the land had been barren and the ashes of the deceased, including those of King Bhagiratha's ancestors, lay unsanctified. Finally Bhagiratha performed penances in order to win the gods' assistance. Impressed by the king's austerities, the celestial river Ganga agreed to descend to earth, but she warned that if she fell from such a height she would reach the earth in a murderous torrent. Shiva again intervened, catching the falling river in a lock of his matted hair where she wandered for years until the energy of her fall was spent. She trickled out gently, purifying and fructifying the earth. The multitudes of creation witnessed and celebrated her descent.[11]

Here is a story about divine water falling from the sky, an idea dramatically expressed by the precipitous angle of the cleft, by the devout gestures (*anjali mudra* [palms pressed together]) of the *nagas* in that cleft, and perhaps on festival days by a cascade of actual water over that cleft.[12] This water could then have pooled in the wide pit in front of the relief, lapping at the feet of the humans and elephants carved in the lowest register. Ascetics beside the base of the cleft take up the postures of prayer one still observes among bathers entering the Ganges River at Varanasi, and the smiling elephants and their cavorting babies appear to rejoice in the glorious wetness at their feet.

Penance in Ganga's story is only a prelude to the fall of waters, which could explain why the cleft rather than the ascetic draws the attention of almost every figure in the composition. This rich variety of beings united by their focus upon the cleft could represent the entirety of creation witnessing and celebrating the momentous event. Assembled together are minor divinities, human beings, and animals. In the upper registers of the composition are celestial couples (male *gandharvas* and female *apsarases*) who look human but for the way they lift their feet behind them, a device suggesting that they float through the air. Interspersed among these couples are pairs of *kinnaras*, minor divinities who possess the lower bodies of birds and the upper bodies of humans. Hunters and the holy men (*rishis*) beneath the ascetic allude to the human sphere of creation. Sharing the earthly realm with them are all manner of animals, among them lions, elephants, monkeys, lizards, turtles, deer, antelope, geese, mice, and a cat.[13]

The ascetic can easily be read as Bhagiratha performing his penance and gaining his boon from Shiva. His juxtaposition with the cleft articulates the causal link between virtuous penance and the purifying cascade. Placed between Shiva and the cleft, his image links the visual representations of the boon won (falling water) and the boon realized (Shiva in *varada mudra*), just as

[handwritten margin note: possible connection b/t the two stories; Shiva]

Bhagiratha's action linked Ganga to Shiva physically by causing her to fall through the god's hair.

Directly beneath this ascetic stands a small Vishnu temple surrounded by *rishis* in prayer. The figure seated to the left of that shrine could also represent Bhagiratha, here thanking Vishnu, who in his form as the sage Kapila helped to convince Shiva to break Ganga's fall.[14] That several of the other men turn their backs upon the cleft as they pray to Vishnu suggests that this ashram scene is chronologically separate from the moment of Ganga's Descent.

Beyond the imagery of the relief itself, external circumstances suggest that the Pallavas found the Descent of the Ganges a theme directly relevant to themselves. Ganga's Descent appears on at least eleven other Pallava monuments, sometimes with the same arrangement of Shiva and the ascetic.[15] Pallava inscriptions liken Pallava kings to Ganga, claiming that these kings similarly purified the earth by their presence.[16]

Other elements of this frieze, however, resist the Ganga narrative. The prominent hunters and Shiva's gesture differ from that in other Pallava representations of Ganga's Descent. At Mamallapuram he does not hold out the lock of hair that will interrupt Ganga's torrential descent, nor does he bend one leg to brace himself against the force of her fall; he does both in shrine no. 24 of the Kailasanath temple in Kanchipuram and at Trichy. In these and other Pallava representations of Ganga's Descent there is also a tiny female personification of the river suspended just above Shiva's outstretched lock of hair, but the large Mamallapuram relief contains no such figure.

A Purposeful Multivalence

I would maintain that it is at this point – once the familiar and the puzzling narrative cues are recognized and sorted – that the viewer can discern the dialogue in which the multiple voices of this work engage. The complexity and the purpose of that interaction, which initially may sound quite discordant, begin to emerge as the viewer recognizes the deliberate quality of this narrative's ambiguity. By omitting the outstretched lock of hair, the personification of Ganga, and fighting hunters, the designers of the Mamallapuram work have omitted iconography familiar to seventh-century viewers, iconography that could have identified either narrative exclusively and thus restricted the reading of the relief. The absence of such unequivocal signs creates space for the coexistence and interaction of multiple voices and therefore meanings. Selecting instead the ascetic's penance and Shiva's acquiescence, features common to both stories, keeps that space open.[17] So do supporting figures that fit both narratives: the river could flow beside Arjuna's camp or down from the heavens; the animals and trees could describe Arjuna's wilderness or Bhagiratha's universe; the celestials could be celebrating

[handwritten margin note: keeping the sceane ambguos alows for both stories to have a presence & interact]

50

the world's purification or sharing with all creation a vulnerability to Arjuna's weapon of universal destruction.

These ambiguities may even create room for further narrative voices. One scholar has viewed this relief as a depiction of *naga* worship; others have read in it the story of Shiva as the beautiful mendicant (Shiva Bhikshatana), or a declaration of the supremacy of Lord Vishnu or a Jain legend; yet others have understood it to identify this site as a sacred bathing place (*tirtham*).[18] While none of these readings has as yet been supported by sufficiently compelling evidence, and none accounts for nearly as many elements of the relief as Arjuna's Penance or the Descent of the Ganges do, the capacity of this relief to invite a wide variety of interpretations seems significant in itself. The representations seem to possess a degree of neutrality that deliberately leaves them open to multiple readings. They are not infinitely open; boundaries do govern the limits of this piece's intelligibility. Penance, Shiva, and water are so visually assertive that any persuasive reading must involve them. But within such limits a flexibility is apparent, and that flexibility signals the strong possibility that this relief speaks in yet other narrative voices.

Projecting Political Authority

↳ essentually showing protection

Puns can be eloquent indices of the surprising commonalities between their seemingly disparate layers of meaning, and in this case those layers intersect with some intensity at issues central to Pallava kingship. The narratives about Ganga and Arjuna converge on the subject of penance, and in both cases penance leads to protection. In both stories, heroic leaders protect their families, their kingdoms, and the earth from threats of war, natural disaster, and divine wrath. Arjuna's act of penance makes him the supreme warrior, enabling him to defend his brothers and their shared kingdom against rival kings. Bhagiratha's act of penance establishes the ritual purity and fertility of his kingdom and of the entire earth as well. Self-sacrifice gives both men special access to the gods, access that they use to elicit from the gods items (such as weapons and water) that enable kings to guarantee the safety of their kingdom. Shiva too embodies the protective when he grants Arjuna the weapon that guarantees victory in the great war and when he averts natural disaster by catching Ganga in his locks. Meanwhile, the adult elephants that dominate the right half of the composition shelter their playful babies under their powerful bodies.

These themes had considerable political resonance for kings of early south India. The paramount duty of kings was to protect their subjects from all manner of threats. Like Arjuna the king needed to be the best warrior in the land, and he enacted that role by waging almost constant battles against neighboring kings.[19] The king's protective responsibilities extended beyond the human sphere. He was

thought to link his kingdom to the rest of the cosmos and to maintain through the performance of special rituals the proper balance in the climate, the fertility of the fields, and the good will of the gods. Heroic in stature, the king was the conduit through which good things flowed from the rest of the cosmos to the people of his kingdom.[20]

The coincidence between the narratives in this relief and the rhetoric of early south Indian kingship seems purposive and calculated. Indeed, the desire to expatiate upon the power of the king may have motivated designers to interpolate multiple narratives into the larger relief. The coexistence of Arjuna's and Ganga's stories within the large relief articulates these ideas about kingship with special force. Points at which these narratives interact most energetically are the issues central to ideals of royal behavior. The possible identities of the ascetic characterize the Pallava leader as both king (Bhagiratha) and military hero (Arjuna). Divergences between the two narratives also enrich the royal promise: Bhagiratha offers his kingdom climatic and ritual protection; Arjuna's story adds the dimension of military safeguard. Both stories demonstrate that beings in all levels of creation rely upon the heroic behavior of the king.

It is appropriate to listen for kings' voices in these works because, for one thing, the Pallava kings are the most likely patrons of Mamallapuram's carvings. Furthermore, the nature of early Indian kingship permitted art to play a significant role in promulgating royal authority, which depended heavily upon popular perceptions of a king's heroism, potency, and strength, upon his ability to project charismatic images of himself that elicited the devotion of his subjects.[22] The visual arts provided an opportunity for presenting appealing, compelling reflections of himself to large audiences of potential subjects whose loyalty he wooed. Indeed, the Pallavas and other kings in early India patronized numerous art works depicting the feats of mythic heroes, and these may incorporate allegories demonstrating precisely the qualities the patrons claimed to possess.

Another hint of the political in the Descent/Penance relief is the presence of half a dozen heraldic male lions carved at the left and right edges of this composition.[23] The manner in which they are rendered suggests that they are royal emblems of the Pallavas, and their flanking placement suggests that issues raised by Ganga's Descent and Arjuna's Penance lay within the sphere of the Pallava kingship. Whereas the other animals in this relief are softly carved in poses of gentle alertness, these lions snap to attention with the stylized rigidity of a military guard. They take on postures almost identical to one another. Each lion strains his mouth open in the same wide snarl and arches his tail in an elegant loop. The exaggerated sinews of their legs stand out dramatically, a schematization of ferocity and power. Each mane is composed of a precise grid of tight curls. This energetic stylization lends the lions an emblematic quality that separates them from the narrative flow of the rest of the relief. Their resemblance to heraldic lions atop columns bearing inscriptions of the Emperor Ashoka's decrees may have lent these lions royal associations. Such lions also had specifically Pallava connotations. They are rendered sedant on column bases or rampant along

52

exterior walls in almost every structure excavated or constructed by the Pallavas after the early seventh century. At least two Pallava kings, Simhavishnu and Rajasimha, used the term for lion, *simha*, in their coronation names. Rajasimha (Nandivarman II Pallava) drew heavily on leonine symbolism to present himself. His inscriptions characterize him as "the lion in battle ... the lion among princes ... he who resembles the lion in valor." He also appears to have been responsible for excavating the fantastic cave in Shaluvankuppam that is rendered as a colossal lion's open mouth.[24]

Conclusion

The strenuous tone of my call for tolerating ambiguity may strike the reader as somewhat ironic, but my purpose in writing this article has not been to close debate about the Descent/Penance relief. Far from finding the persisting debate "disheartening,"[25] I hope others will continue to discover in this relief new voices interacting with those I have described above. It seems quite likely that a single intellect – even one trained to look for *dhvani* [puns] – cannot exhaust the panoply of references already located in this relief. The relief's unfinished state invites us to consider that yet other voices may have been encoded. At the same time, I wish to stress that I do not see indecision as having permeated the process of *creating* this relief. I do not believe that the creators of this relief, the senders of these signs, were uncertain about what the relief could mean, nor do I suspect that these designers sought to bewilder viewers. I see the ambiguities as opportunities for communication among the work's many voices. In this case, that communication reveals an intramural coherence among the work's supposedly competing voices and links between this relief and representations in adjacent sculptures. These conclusions emerge only if the process of reading remains as open as possible and the separate voices of the work are permitted to reverberate and even conflict.

Notes

1 Among the proponents of this argument are T. N. Ramachandran, "The Kīratārju-nīyam in Indian Art," *Journal of the Indian Society of Oriental Art* 28 (1951): 58–89; M. Hirsh, "Mahendravarman I Pallava: Artist and Patron of Māmallapuram," *Artibus Asiae* 48, 1/2 (1987): 109–30; S. Kramrisch, *The Art of India* (London: Phaidon Press, 1965), 205; and C. Sivaramamurti, *Gaṅgā* (New Delhi: Orient Longman, 1976), 79.

2 Among the strongest cases advanced for the Descent of the Ganges reading are: V. Goloubew, "La Falaise d'Arjuna de Mavalipuram et la Descent de la Gaṅgā sur la Terre, selon le Rāmāyaṇa et le Mahābhārata," *Journal Asiatique*, 2ᵉ sér., 4 (Paris, 1914): 210–12; A. H. Longhurst, *Pallava Architecture*, pts. 1 and 2, Memoirs of the Archaeological Survey of India 17 (1924) and 33 (1928) (rpt. New Delhi: Cosmo

24 For inscriptions describing Rajasimha in leonine terms, see *South Indian Inscriptions*, vol. 1, no. 24, v. 11; no. 25, v. 7, 13, 20, 52, 54; no. 27, v. 3. On the attribution of the Shaluvankuppam *yali-mandapam*, see Srinivasan, *Cave-Temples*, 182.

25 "It is disheartening that scholars should continue to argue about [the subject of this relief]": *The Indian Express*, Madras, 28 December 1974, as cited by Lockwood, *Māmallapuram*, 8, n. 4.

6

Excerpts from *Borobudur*

Louis Frederic

Introduction

The following excerpts from Louis Frederic's book on Borobudur present a series of interpretations of this enigmatic Buddhist monument, from both a historically grounded understanding of the religious and political context of ninth-century Indonesia, and a more ahistorical spiritual and formal perspective. As Frederic guides the reader through the monument, he explores the experiences of the patron, the pilgrim, and the contemporary scholar. Thus, rather than proposing a single interpretation of Borobudur, he offers the reader a spectrum of options for reading the structure, as a temple, stupa (burial mound), mandala or *yantra* (both types of cosmic diagrams), labyrinth, or numerological diagram.

The Shailendra Dynasty (eighth to thirteenth centuries) ruled over much of what is now Indonesia, centering their empire on the island of Java, but extending to Kalimantan to the north, Sulawesi to the northeast, and Sumatra to the northwest. Scholars debate the precise dates of Borobudur, but for the most part agree that a series of Shailendra kings of the eighth century patronized the structure and brought it to completion in the late eighth or early ninth century. Because no inscriptions on the monument detail its patronage, this too remains unclear. Several of the kings recorded in inscriptions on other monuments from the period carry Hindu names, further raising questions of religious identity and patronage for present-day viewers.

As Frederic points out, however, this period of Javanese history saw a great deal of syncretic activity, bringing Brahmanical (Hindu) religious practices together with Buddhism. On the island of Java at this time, Shailendra kings patronized other *chandis*, or temples, to Hindu gods, and as Frederic argues, aligned the Buddhist monument of Borobudur in relation to both a major Hindu temple nearby and

Louis Frederic, "Borobudur," pp. 18–19, 46, 48–72 from *Borobudur*. New York: Abbeville Press, 1994. Reprinted by permission of Abbeville Press.

another important site for the local, indigenous religion. Thus, these monuments fulfill the royal duty to support the spiritual life of the kingdom in all its forms.

Despite our lack of certainty about what Borobudur *is*, Frederic presents us with a wealth of reasons for looking closely at this monument. The structure purposively guides its visitors through a series of escalating galleries, focusing the pilgrim's attention on the many relief sculptures along the passageways. Its sculptural and architectural program suggests a complex planning process, from the precise number of Buddhas seen on the pilgrim's path to the relationship with the larger geography of the site. Like Angkor Wat and other major sites, Borobudur guides the visitor through a series of spiritual realms while clearly embodying a symbiosis of political and religious power.

Building Borobudur

Borobudur is shaped like a somewhat flattened, stepped pyramid, with straight sides that incorporate uneven projections. The whole complex serves as a plinth for an immense stupa with a three-tiered base. Its design was inspired in part by certain Indian stupas, and also by Indonesian traditions, but whatever its origin, in its definitive state Borobudur was probably conceived as the roof of an invisible shrine, represented by the hill itself, a symbol for the Mount Meru of Hindu and Buddhist tradition. The structure resembles, on an infinitely grander scale, the roofs of certain nearby temples, namely Chandi Pawon and Chandi Mendut, whose characteristics are present in Borobudur: the rising stories of diminishing size, the terminal stupa surrounded by subsidiary ones, and the whole covering the true shrine – the hill itself – a symbol of both Mount Meru and the Shailendra dynasty, whose rulers were known as the "Lords of the Mountain." This title, which identifies royalty with mountains, was also used in India and Funan (ancient Cambodia), where it was later revived by the Khmer rulers. It is likely that Borobudur was built on a site where people had worshiped since the earliest times, to be a Buddhist counterpart to Mount Tidar, the Nail of Java.

It is possible that Borobudur was built on a hill facing Tidar (from whose heights it is readily visible) to proclaim the newly adopted Buddhist faith of the Shailendra rulers. When the ancient Hindu complex at Dieng was abandoned in favor of the one at Prambanan, where Chandi Kalasan was built in 778, the hill at Borobudur might have been chosen for the monument because it was thought to exist in a magical relationship with these other sacred sites.

[handwritten margin note: the mountain might have = importance to the building possibly even more symbolic]

The Initiate's Journey

On entering the east gate and starting his ascent, the pilgrim undergoes a number of symbolic transformations, depending on his spiritual state and his beliefs. The

ascent itself represents a being's rise through the many stages of existence, with the experience extending over one and a half miles (2,500 m) of narrative reliefs. The tales of the Buddha's earlier lives (*jatakas*) line the way, reminding the pilgrim that every being is fated to repeat the cycle of death and rebirth many times before his final release.

The Double Structure of Borobudur

A pilgrim traveling between Chandi Mendut and Borobudur would have found himself crossing wooded terrain, and he must have been astonished when he arrived at the foot of the monument. Even today it is practically impossible to photograph the monument from far enough away to capture its profile undistorted. Either one is too close and cannot see the whole, or one moves back to find oneself suddenly at the bottom of the hill with the profile hidden. Trees also obscure it from view. To get an idea of the monument as it appears viewed from a distance, as one would with any European monument, is impossible. We can therefore reasonably infer that the total effect, an aesthetic consideration we are quite accustomed to having from our own monuments, played little or no part in the design of Borobudur. On the contrary, it would seem that every effort had been made to keep the pilgrim from seeing the round terraces and the terminal stupa. Consequently, the internal structure of Borobudur remains invisible from the outside.

As Paul Mus has pointed out, the better part of what forms the religious aspects of Borobudur remains invisible from the outside. Hidden behind its facade, the sacred aspects of the monument are obscured from view. Thus there exist two Borobudurs, one that is exoteric or external, and another that is esoteric or hidden and initiatory, to which the visitor can only gain access from within the galleries.

From the outside, the infinitude of buddhas in their countless niches evoke the idea, in the end, of one and the same Buddha. Why, when the original base was encased, were the reliefs on it not reproduced elsewhere? Paul Mus suggests they remained hidden "because they were part of the microcosm that initiates reserved for themselves as a *yantra*, sheltered from all eyes.... The apparent Borobudur conceals a secret world under its covering of stone, and that secret world was now complete."[1]

When the pilgrim enters the first gateway and starts to walk through the galleries, illustrated with scenes from the life of the Buddha and other didactic tales, high balustrades separate him from the external world. He is cut off from both the surrounding countryside and the summit of the monument. His attention is entirely drawn toward the narrative reliefs. "Each story," writes Paul Mus, "must have been assigned to a separate level of initiation."[2] The disposal of the

four galleries, each separate from the others, would have reinforced the hierarchy of knowledge. "In Ceylon as in Java, the floors or *bhumis* (grounds) of the sacred sites correspond one to one with the 'grounds' or levels of transcendence."[3] Mus further writes: "It was undoubtedly the general rule that the initiate would rise from terrace to terrace as he progressed in religious instruction.... Borobudur does not offer its center freely to the worshiper, it is surrounded with a succession of obstacles. Each of these marks a particular world and a particular degree of ecstasy."[4]

It is at this stage that the "magical" function of the monument becomes apparent, the monument being a place where meditation is reinforced by an array of symbolic teachings and hence becomes initiation. Today's visitor, even if prepared and genuinely affected by the sacred aspect of the monument, can have no conception of what a Buddhist pilgrim or monk would have seen on approaching or ascending Borobudur in the year 800. "The monument only assumes its full meaning if we restore to the sacred hill its population of monks, the minute preparation and ordering of whose movements by the sole arrangement of the site undoubtedly played an integral part in the architect's plans."[5]

As soon as the visitor reaches the three upper terraces, his view opens out onto the entire surrounding countryside. After the confinement of the galleries, the cosmic universe is revealed to him along with the imposing mass of the final stupa. All around him, seventy-two small stupas partially conceal from sight as many buddhas, visible only by peering through the square or diamond-shaped openings. This makes it easier to understand the term *budur* and those related to it, which, according to Mus, do not mean "to stand, to rise up" but rather "to be partially visible."[6] Once arrived at the third level (the round terraces), the pilgrim is in some sense freed of the attachments that are inherent to the world of forms. Doubtless he still understands the world conceptually, the all being more accessible to him for his having found inner freedom. And, according to a saying in the *Dharmapada*, "He who considers the world a bubble, a mirage, becomes invisible to the King of Death." The rounded surfaces in fact represent the celestial vault, extension, just as the circle is an extension of the point. It indicates at one and the same time the center and the immaterial nature of all things, insofar as the visible is only the apparent structure and form of the invisible.

The Three Levels of Reality

The pilgrim who makes the spiritual ascent of Borobudur is invited to explore symbolically the different levels of being and to attain by his ascent the ultimate vision, which, like the topmost point of the stupa crowning the edifice, is beyond both words and concepts.

The symbolism, generally accepted by the experts, provides for three levels to the monument, namely, the realm of desire (*kamadhatu*), the realm of form (*rupadhatu*), and the realm of formlessness (*arupadhatu*), in conformity with Buddhist tradition but also with the models used in contemporary physics to understand the universe.

The first level, *kamadhatu*, represents the world of the senses – the desires and the passions. It is therefore the plane of the ego. Its world is linear, which is to say dualistic, ruled by cause and effect. Man is consequently the victim of his own desires as long as he fails to see the essence of reality and judges it on the sole evidence of his senses.

This world of desire, which is the world of ordinary men, is represented on the original base of the monument and hidden by the added plinth; it is therefore

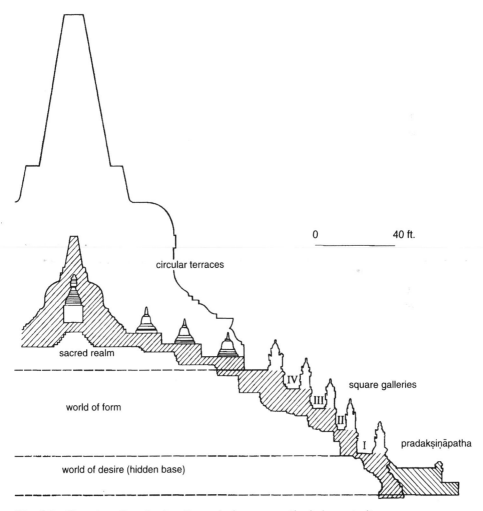

Fig. 6-1 Elevation, Borobudur, Java, ninth century. Shaded area indicates extant monument; outline marks conjectural planned monument.

invisible to those making the pilgrimage to Borobudur, who may well be expected to have gone beyond notions of good and evil. The scenes depicted in the reliefs of the hidden base do in fact illustrate karmic law, or the law of cause and effect, showing how bad actions and good necessarily have their respective consequences. As a whole, the reliefs show the endless and repetitive cycle of birth and death, of expiatory punishment for actions considered bad and fortunate rebirth for those considered just.

The law of karma continues to hold as long as a man remains bound to his desires (causes), which inevitably produce effects (either pleasures or torments). This is the Buddhist concept of *samsara*, the wheel of existence where illusory beings are reborn and die, and from which one must free oneself. The initial action is generally presented on the right side of the panel, and its consequence (good or bad) on the left, as the reliefs were to be read in the direction of the *pradakshina* or ritual circumambulation. Men who are shown tossing fish and turtles into a cauldron to boil will in turn find themselves roasting on the fires of hell – this is the law of correspondence at work. A matricidal man is plunged headfirst into the flames of perdition. A person who refuses to give alms sinks into poverty. These different examples also illustrate the law of compensation, whereby each thing calls into being its opposite effect. An early death is the result of a life in which the person was a criminal, a hunter, or in some way accessory to a crime, and might be represented in the narrative reliefs by a child's illness or death, an abortion, or a view of a cemetery. Other reliefs show an aristocrat being reborn into the low caste of a fisherman.

Although the sculptors modeled the scenes on daily life in Java, the examples they chose to illustrate are inspired by the *Karmavibhanga*, a popular Buddhist text describing the stages of deliverance from the bonds of karma. They are therefore illustrations of the law of cause and effect (karma). According to Hindu-Buddhist thought, each is responsible for his or her own salvation. No god, either wrathful or compassionate, exists to punish or reward the acts of men; the faithful are simply warned against actions that Buddhist philosophy considers bad. Good and evil assume a binary structure when put in opposition, but the dualistic world perceived by men is in itself an absurd, illusory, and unreal conception of what is. Those unable to grasp this truth are doomed to the realm of oppositions and to run counter to the laws of nature and wisdom. They will be subject to the law of retribution, which will condition their future lives.

The text of the *Karmavibhanga* exists in different versions: in Pali, Sanskrit, Tibetan, Chinese, and even Kuchean. Of different lengths, the texts consist of concrete examples, augmented by moral and philosophical reflections that are ill-suited to pictorial representation. Only the scenes that illustrate the working of the law of cause and effect, or individual karma, are represented at Borobudur. The sculptors seem to have used the *Karmavibhanga* to describe humorously and with great accuracy a multitude of actions from daily life that Buddhist morality judges to be either good or bad. Domestic life is represented, as are street scenes, festivals, and merry-making.

Many actions are illustrated that, though not necessarily catastrophic in effect, result in rebirth at a lower level, usually in one of the lower castes. It is certain that the sculptors went beyond the strict description of cause and effect that appears in the *Karmavibhanga* and gave free rein to their imaginations, thus sparing the reliefs from monotonous repetition. But a panel-by-panel description of the narratives would be tedious and of little interest to any except specialists. These pictures of people and animals primarily interest us as an ensemble.

The hidden base was discovered in 1885 by the Dutch architect J. W. IJzerman. Wanting to shore up the first balustrade, he moved some of the stones of the processional plinth and found, to his surprise, that the original base was decorated with a series of rectangular reliefs. This so-called hidden base is provided with 160 narrative panels, some of them unfinished, others still bearing inscriptions in Kawi script that allows the whole to be dated approximately to the year 800. IJzerman cleared away the encasing stones from the reliefs, had them photographed, then carefully replaced the entire 12,500 cubic meters of material that form the massive plinth.

During the restoration of Borobudur from 1975 to 1982, the question arose whether the added terrace might not be entirely removed, or, failing that, whether a space might not be provided between it and the original base to allow the reliefs to be viewed. The decision was made, however, to leave the monument as it was in order to preserve it in its finished state; an added consideration was the financial burden such a project would have created. Finally, it seemed the stability of the whole structure would be better served – despite what some architects advised – by retaining the buttress in place. Today, that base is visible at only one corner, where the stones have been cleared to expose five of the long-hidden panels.

The second level, or *rupadhatu*, represents the world of form, the multiple self. It is a striking fact that the initiatory path of the pilgrim at Borobudur centers on this level in particular, comprising as it does four stories of galleries with thousands of reliefs illustrating the essential tenets of Buddhist philosophy. While this long pilgrimage is carried out under the open sky, one is isolated from the exterior world by high balustrades, which cut off one's view of the surrounding countryside, as well as the galleries above and below, and encourage the mind to concentrate on the deep significance of the scenes pictured. The slow, somewhat spiraling progress of the pilgrim represents the ascent through the world of form, that is, through the multiple stages of his consciousness. While the first level, or *kamadhatu*, represents the directly perceptible world, the second associates the multiplicity of representations and the continuous aspect of the voyage with the discontinuity of forms. No longer is the experience localized on a single plane, but on a succession of planes where the relation of the one to the many is constantly internalized. Today one might associate the second level, or *rupadhatu*, with the quantum aspect of reality, whereby it is impossible to locate absolutely both the position and momentum of an object in space. Localization is never more than a mental construct. In other words, the self is not linked to

63

continuous time, but to the discontinuous or oscillating time of consciousness and its modes of representation. At Borobudur, as in all religious traditions, the voyage is a symbol for consciousness discovering itself amid the multiplicity of images relating to the various states of being.

The gods of meditation, spiritual projections of the immanent Buddha, reside in the realm of appearance and form, *rupadhatu,* and in the realm of formlessness; being universal, they are assigned to the points of the compass and are represented by the *jinas* on the balustrades of the galleries.

The gods who have freed themselves of all desire but who may still appear before men in various forms live in the upper realm of form. They are divided among four levels according to their degree of meditation and psychic state, with each level comprising several stations. It is these four stages that allow one to identify the four galleries of Borobudur with the realm of form.

3rd level The third level, *arupadhatu,* consists of the three concentric circles around which sit the seventy-two buddhas under their perforated stupas. The buddhas here are practically invisible from the outside. They can only be seen through the diamond-shaped or square openings into the stupa. Unlike the buddhas that preside over the five preceding levels and face toward the outside, the seventy-two buddhas of the circular terraces are symbols of the secret inner world, that is, a world stripped of form, at once present and hidden. These buddhas suggest formlessness. The third level therefore represents the state where being and nonbeing become one. It is the highest vision a being in this world can attain. Above is the great mass of the enormous central stupa, rising to the final point, symbolic of being, of the conjunction of the visible and the invisible: the absolute. At this high point there exists no concept or word to express reality. It is the Buddhist image of a being that has been perfectly liberated into a realm of namelessness and formlessness, to become that which *is.*

In the downward direction, by contrast, the whole of Borobudur reveals the world of manifestations, for the stupa is also the germ of all creation. The stupa's vanishing point is both its being (our present infinity) and the beingness of all creation, which constantly engenders the infinity of all creation in every dimension of space and time.

This identification of Borobudur with the three Buddhist worlds would be more justifiable if those who built the monument had not changed doctrine during its construction. Since the original base, corresponding to the sphere of desire (*kamadhatu*), was obliterated, it can no longer be thought of as part of the symbolic nature of the monument; it was intended by its builders to be seen by pilgrims and the faithful. Thus one should not include the "hidden" base in discussions of the general symbolism of Borobudur.

It would be more plausible to disregard that base and consider the four square galleries as representing the realm of desire; the three round terraces as the realm of form; and the terminal stupa as the realm of formlessness. One can only account for the presence of the *jinas* in the realm of desire if one considers them as existing above it, serving as guides to those who find themselves in that realm.

64

One could alternatively consider that the "levels" of Borobudur symbolize the four states of meditation that lead progressively toward *nirvana*, the state of perfect bliss without desires or conscious thought, bringing to an end the cycle of rebirth and, as a result, all suffering. The first level would be the discrimination (*viveka*) between the good and the evil, and the exclusion of all that is considered evil. In the second level of meditation, there is the stilling of spiritual activities, or pure joy. The third consists of the suppression of the notion of happiness, and the achievement of full consciousness and bliss without active thought. The fourth and ultimate level is the achievement of total purity, imperturbability, and aware-ness of mind.

Mandala, Yantra, and Labyrinth

Even the theoretical form of Borobudur, its ground plan, immediately brings to mind a *mandala*, a diagram representing the cosmic organization of the deities, and their forces, in the Buddhist pantheon. It has the *mandala*'s square exterior and inner circular organization. The center of the Hindu diagram is reserved for Mount Meru, as the axis of the world, and is therefore identified with the immaterial body of the divinity. On the slopes of Mount Meru are the stages representing the levels of the various gods; beyond it are the continents and the seas. From the center of this diagram of the universe, the world expands outward like the petals of a lotus flower opening. In some Buddhist *mandalas*, it is of course Vairochana Buddha (representing *dharma*, or Buddhist law) that stands at the center. All around him on the petals of the central open lotus are arrayed the *jinas* with their corresponding bodhisattvas among them. But Borobudur's re-semblance to a *mandala* ends there. For if one can identify the terminal stupa with the highest expression of the idea of Buddhism, the central point without real existence from where all things come, one cannot explain the cosmic function of the buddhas in the perforated stupas on the three round terraces, nor the presence of the *jinas* in the square galleries. Even less can one explain the set of reliefs that ornament the galleries. It would be more tempting instead to see Borobudur as a gigantic *yantra*, or instrument of meditation and self-perfection for those seeking awakening. The pilgrim on his initiatory journey to Borobudur, having paid homage to the Buddha and his law by performing the ritual circum-ambulation (*pradakshina*), penetrates "into" the monument as into a shrine (here, the square terraces may be compared to the stories of a *prasada*). After crossing the first entry – the east one, on the side where the sun is born – the pilgrim proceeds through the galleries in an ascending spiral, passing from one story to the next through a gateway that symbolizes his death and subsequent rebirth on a higher plane; he sees on his right the relief carvings that unfold for him the life of the historical Buddha, his earlier lives and those of his close followers, and the odyssey of young Prince Sudhana in search of enlightenment,

until, moved by example, the pilgrim too receives the spirit of *bodhi* and perfect knowledge, by the grace of the bodhisattva Samantabhadra. Having become bodhisattva himself, the pilgrim arrives at the round terraces where the material world and the world of ideation disappear little by little to be replaced by principle, represented by the great stupa. Afterward he descends in a downward spiral, still keeping the center of the monument on his right, this time observing the reliefs on the balustrade and passing a second time through the gateways, gradually to return to the world below. He will complete his pilgrimage with a further ritual circumambulation.

In so doing, he will have pronounced his mantra (the word or syllable given to him by his guru or spiritual teacher to invoke the deity) 1,008 times, once before each statue of a Buddha. Having traveled the entire labyrinth, in the process perhaps becoming an enlightened being himself, he will have directly experienced a spiritual ascent comprising a "progressive concentration of the many into one: the self reintegrated into the all, and the all reintegrated into the self, thus passing in his spiritual journey from the diversity of creation and ideas to the One, and subsequently returning to earth from the One to diversity."[7] Borobudur therefore can be identified with the labyrinth and its related symbolism – the pilgrim must after all pass through its galleries to reach the end of his journey of initiation and find the hidden meaning at its center. The monument is from top to bottom a symbol, at times not easy to understand, of the way to follow, which leads at last to the infinite, summed up in a nonexistent central point, the image of emptiness in Mahayana Buddhism, *shunyata*. As in a labyrinth, such as that of the cathedrals of Chartres or Amiens, the pilgrim who passes to every level of the monument and crosses every threshold, symbolizing the passage to a higher state, must follow a complicated itinerary, passing through each gallery twice, but each time in a different direction. This is why reliefs cover both walls of the galleries. The very center of the labyrinth (in this case the three round terraces) is reserved for the initiate who has completed the passage through all the galleries and undergone all the trials of initiation before at last receiving knowledge, through which the formless is revealed to him. The round trip into the labyrinth and back symbolizes the pilgrim's spiritual death and rebirth, beyond which he must venture to reach the interior sanctuary hidden in the depths of the unconscious. A person then rediscovers the unity of the self, dispersed by the multiplicity of perceptions and desires. The pilgrim's voyage thus marks, according to Marcel Brion, "the victory of the spiritual over the material and, at the same time, of the eternal over the perishable, of intelligence over instinct, and knowledge over blind violence."[8]

Thus Borobudur is at the same time a *mandala*, a *yantra*, and a labyrinth. It gives the highest aspirations of the human soul a concrete form in stone, providing simultaneously their illustration, their experience, and their demonstration. It is the heavenly Jerusalem, saying, "I am Alpha and Omega, the beginning and the end."[9]

The symbol is the same, the heavenly Jerusalem being square in outline while paradise is circular: the union of the two makes up the universe, heaven on earth and earth in heaven.

The Number Symbolism

The harmony and coherence of Borobudur become evident through its proportions. But one of its most fascinating aspects only becomes apparent when one studies its numerical correspondences, which reveal an underlying coherence and harmony, calculated and symbolic in all its parts. This supports the belief in a strong initial plan, rigorously carried out.

In its present form, Borobudur has five square platforms (those of the four galleries and another supporting the round terraces). The processional plinth cannot be counted in this number, as it serves only as part of the ritual *pradakshina*. If we add the three round terraces to the five square platforms, we arrive at a total of eight, the most sacred of all numbers, symbolic of infinity.

On the three circular terraces we find three series of 32, 24, and 16 perforated stupas – all multiples of 8. This gives us a simple arithmetic progression: 4 ($4 \times 8 = 32$), 3 ($3 \times 8 = 24$), 2 ($2 \times 8 = 16$), and finally 1, for the central stupa. As to the 1,472 ornamental *stupikas* (368 on each side of the monument), they also represent multiples of 8. The number 8 is a symbol of infinity and limitlessness. While infinity is comparable to eternity, the latter in some sense resolves into itself and exists in space-time, a present infinity.

The *jinas* are arrayed in five zones corresponding to the total number of balustrades surmounting the four square galleries and bordering the final platform. They number 108 on each side of the monument: 92 *jinas* associated with the cardinal points (26 on each of the first two balustrades, 22 on the third, 18 on the fourth), and 16 Samantabhadras.

The number 108 is sacred throughout Indian civilization, as it symbolizes victory (*jaya*) according to Indian numerology: the syllable *ja* has a value of 1, and the syllable *ya* a value of 8. The number 0 is not counted. The 108 buddhas on each side of Borobudur are a reminder that *dharma* or Buddhist law is everywhere victorious, and the *jinas* are also "conquerors" (of their passions and desires). The total number of buddhas on the five balustrades, counting all four sides of the monument, is therefore $4 \times 108 = 432$. But the pilgrim who has completed his initiatory journey and reached the highest point must add the 72 buddhas from the perforated stupas on the round terraces to this number. The total number of statues of the Buddha, therefore, stands at 504. This number would mean nothing in itself, but the pilgrim cannot be expected to stay at the top of Borobudur. He must continue his journey by returning down through the round terraces and the square galleries, always keeping the center of the

monument on his right hand. He completes his spiral course in this way and passes before each of the 504 buddhas a second time. He will therefore have paid homage to them 1,008 times. This number is also symbolic of his own victory over his desires and passions. Before each statue of the Buddha, he will likely have recited a sacred invocation, the mantra, which he will have repeated 1,008 times – just as in India the name of each deity is to be repeated 1,008 times, and there are said to be 1,008 (*ashtottasabasranamastotra*) of them, or by going twice through one's rosary, which consists of 54 beads.

Let us also note that the number 108 constantly recurs in Hindu numerology. For instance, the *Brahmanas* tell us that the *Rig Veda* consists of 10,800 *panktis* (a metric form consisting of five octosyllabic elements or lines).[10] The 432 *jinas* of the balustrades also correspond to the 432,000 *panktis* of the *Rig Veda*. Analogies could be multiplied endlessly, and they are far from coincidental, as Brahmanic tradition makes great use of numbers.

These calculations have been criticized for not accounting for a central buddha, supposed by some authors to have been hidden in the terminal stupa. But it can be argued here that there is no need to count this hypothetical and invisible buddha. Even if we agree that the terminal stupa at Borobudur in fact contained a statue of a buddha (but which one?), the pilgrim could not take it into account, as it was completely invisible. Further, in the 54 beads of Hindu and Buddhist rosaries, the central bead (*shikhamani, mukha,* or *bindu*, meaning "point") is never counted. One may not go beyond it, and must retrace one's tracks, just as when visiting the monument; in so doing one counts 108 "pearls" on the rosary.

Further, an ancient Hindu ritual notes that the central bead is also known as Meru, "evoking as it does the cosmic mountain, or *axis mundi*, and marking the end of each counting of the rosary, of which it is both the end point and the center. The recital of the rosary reaches the central bead and halts there temporarily, unable to 'cross over' it, Meru being the place of dwelling of the lord himself, the unsullied omniscient one."[11]

The number 8 crops up everywhere at Borobudur. Representing as it does multiplicity, it is also the symbol of cosmic equilibrium. This explains why the *harmikas* atop the perforated stupas of the highest round terrace are octagonal, while those of all the other stupas are square. It is also for this reason that the central masts rising from the *harmikas*, and which represent transcendental unity, are also octagonal in section. Similarly, the primordial lotus has eight petals, and the lotus flowers at the foot of the stupas have a number of petals that is a multiple of eight. The number 8, symbolic of equilibrium and justice, appears in the theories of Pythagoras and the Gnostics, and in most other world religions as well. Eight is also the symbol of a new era, and a new person, who has managed to transcend his own nature and so regained his fundamental unity with all existence. For 8 reduces to 1: here also one finds the concept of diversity (8) in unity (1). When paired with the latter, it becomes the celestial number: $8 + 1 = 9$, a number that subsumes all numbers and which, in mathematics, is equivalent to zero. This is *shunyata* or emptiness itself. The 72 (9×8) perforated stupas of the round terraces represent

the union of man, symbolized by 7, which joins the earth (4), the sky (3), and diversity (8). The one reality (1) is in the center; it is the terminal stupa. The whole therefore represents $8 + 1 = 9$, which is to say the all, emptiness.

Tantric Buddhism, like most esoteric traditions, gives great weight to number symbolism. One can therefore imagine the builders of Borobudur conceiving of their work as a sort of colossal rosary; the pilgrim gained merit by journeying through, thus improving his individual karma, or the "rosary" at least might serve as the subject of his meditations.[12]

Exploring the Hindu-Balinese religion, one finds that tantric cults related to the techniques of *kundalini* yoga play a large part in it: Shiva becomes the synthesis of the three major elements represented by the sacred syllable "OM." As R. Goris explains it, "The ten-syllable mantra (expressing the all, $3 \times 3 = 9 = 1$, or zero) disappears in the five-syllable mantra invoking Shiva, then into the three-syllable one (A-U-M) to finally dissolve into nonbeing."[13] Which brings us back ineluctably to the Buddhist concept of *shunyata*, unity in emptiness. This is what the Balinese and Javanese call even to this day *sang hyang widi*, a term expressing the very essence of divinity that goes beyond (or contains) all diversity, and in consequence "plays the role of guardian of the cosmic and moral order."[14]

Borobudur without question offers a model of knowledge that calls for severing the ties of this world. Man is a lion: an old Chinese saying holds that every hair of the lion is also a lion. Put differently, the part reflects the whole. For those who possess knowledge, then, there can be no difference between the part and the whole. This image of the lion, which one finds at Borobudur on the stairway walls, acts as a protector but also functions as a symbol. Representative of power and the penetrating force of light, the lion is also the embodiment of the verb, that is, of the original sound that engendered all creation. Just as the lion is the emblem of Shakyamuni Buddha – is he not called the "Lion of the Shakyas?" – it is at the same time the supporter of Vairochana, the ineffable Buddha of spiritual light. The roar of the lion is likened to the word of the law, *dharma*. In the *Mahavairochana sutra*, the ultimate sound is represented by the letter *A*. The terminal stupa at Borobudur – like the heart of the central lotus in a *mandala* – can be identified with the pure heart of *bodhi*, created by the short vowel sound "a." From the spiritual point of view, a person who has disposed over his own body all the syllables or sounds that follow from the sound "a" transforms his body into a sphere of light, and all his latent virtues blossom and become reality. The sound-symbol *AM*, defined as the "mantra of the universal shining forth of the hundred splendors," produces the hundred syllables that are all developments of the primordial sound "a," for if *A* is the cause, *M* is the effect. And these hundred syllables of esoteric Buddhism consequently symbolize the effect, which is the realization of buddhahood. Might not these "hundred syllables" correspond at Borobudur to the hundred waterspouts that pour forth rainwater through the *makara* jaws, just as the mouth of man sends forth engendering sounds?

Are we to see in the *makaras* a simple play of forms? Or is it not rather a way of defining living beings, various as the sounds that created them, as they appear in all the traditional architectures of Asia, as well as medieval Europe and Byzantium? Monsters, whether *makaras* (crocodilian creatures) or *kalas* (monsters with human heads and no lower jaw) are above all mythical beasts that symbolize the instinct toward creation and, therefore, of diversity and plurality.

Notes

1 Paul Mus, *Barabudur* (1935; reprint, Paris: Arma Artis, 1990), p. 367.
2 Ibid., p. 357.
3 Ibid., p. 362.
4 Ibid., p. 363.
5 Ibid.
6 Ibid., p. 367.
7 J. Filliozat, *L'Inde classique: Manuel des études indiennes* (Paris: Payot, 1954), vol. 2, section 2302.
8 Marcel Brion, *Léonard de Vinci* (Paris, 1952), p. 202.
9 Revelations 12:1–16.
10 Mario Piantelli, Preface to *Borobudur: Mandala de pierre*, by L. Saccà (Milan: Archè, 1983), p. 11.
11 André Padoux, "Un rituel hindou du rosaire, Jayākasaṃhita," *Journal Asiatique* 275, nos 1–2 (1987): 118, 126.
12 Mus, *Barabudur*, p. 684.
13 R. Goris, *Bijdrage tot de Kennis der Oud-Javanische en Balineesche Theologie* (Leiden, 1926), p. 123.
14 J. L. Swellengrebel, *Bali: Studies in Life, Thought and Ritual* (The Hague, 1960), p. 52.

7

Reading Love Imagery on the Indian Temple

Vidya Dehejia

Introduction

In this essay, Vidya Dehejia examines the variety of scholarly interpretations of Hindu temples and sculptural decoration at Khajuraho, a site in north-central India. Focusing on three temples in particular – the Lakshmana (954), Vishvanatha (999), and Kandariya Mahadeo (early eleventh century) – Dehejia offers several readings of the sexually explicit sculptural programs that adorn the exteriors of these structures. In the end she leaves open the possibility that multiple readings of these temples coexisted, depending on the sophistication and background of the viewer or worshipper who saw these impressive structures.

Dehejia summarizes a longstanding art historical problem for specialists in South Asian art: how to interpret the erotic sculpture found on these North Indian sacred spaces. She outlines the various explanations for the sexual imagery, suggesting the longstanding auspicious nature of couples, or *mithunas*, on Buddhist and Hindu monuments, noting possible connections to tantric sexual practices, and pointing to the architectural punning of couples joining at the connection between porch and sanctum. She raises counterarguments for each of these, and no interpretation appears free of flaws.

Along the way, Dehejia's text offers an excellent example of the various types of readings of a temple program one can pursue, and the related proof one can bring to bear on those readings. The debates she traces draw on various sorts of texts,

Vidya Dehejia, "Reading Love Imagery on the Indian Temple," pp. 97–113 from *Love in Asian Art and Culture*. Washington, DC; Seattle and London: Arthur M. Sackler Gallery, Smithsonian Institution; University of Washington Press, 1998. Reprinted by permission of The Freer Gallery of Art, Arthur M. Sackler Gallery, Smithsonian Institution.

including inscriptions from the Chandella Dynasty (tenth to sixteenth centuries) patrons of the monuments, philosophical treatises on the nature of divinity, and statements about kingship from both southern India and the central Indian Deccan plateau. She uses visual evidence from the temples themselves, playing the program of one temple against that of its neighbor, and she draws on her knowledge of both historical context and the language used by the patrons in order to support some of these arguments. Behind each of the approaches to Khajuraho lies intensive scholarly work; Dehejia's text offers a starting point from which to pursue these interpretations in further depth. One can also clearly see that no single reading of these complex structures can encapsulate their richness, and thus scholars may continue to debate these issues for many years to come.

Flushed with love, the moon puts forth his hand upon the closed breasts of the night whose dark robe he has opened

Standing in the midst of scrub forests, with the fragrant blossoms of the *mahua* tree adding crimson splashes of color to the otherwise tan and brown scene, are a group of some twenty-five temples at the site of Khajuraho, ancient capital of the Chandella rulers (*c*.831–1308). Today the sandstone temples are deserted and in partial ruins, but originally they stood in their grandeur along the borders of an ornamental lake of irregular outline. The congregation of so large a number of temples at a single site (the ruins of several more exist), most of them erected within a century and a half, from 950 to 1100, is suggestive of a special goal. The fact that they are dedicated to a range of Hindu deities – Shiva, Vishnu, solar god Surya, and the Goddess – as well as to the saviors of the Jain faith, suggest the possibility that the Chandella monarchs intended their capital to be a major sacred center.

In the last twenty-five years, since tourism has become a priority in India, Khajuraho has acquired fame, one might almost say infamy, as the erotic temple capital of India, and coffee table books highlighting the sensational aspect of this art have proliferated. Khajuraho's entwined figures are carved with remarkable mastery over the flexibility of the human figure, both male and female; they seem to offer a plea to viewers to join the sculptors in their appreciation of the joy of love and sex. But there is much else to admire at Khajuraho, not the least being the exquisite architectural conception of the temples; a series of halls with pyramidal roofs, each taller than the preceding, finally sweep up in a crescendo of curves to the tall tower that crowns the sanctum. Equally exquisite are the sinuously elegant forms of the world of humans and immortals who people the walls of these temples. While the deities are presented frontally and in a somewhat formal mode, the human male and female figures twist and turn with abandon. Figures of both men and women are long-limbed, slender, and sensuous; eyes are elongated, limbs are smooth and pliant; long hair is styled in a great variety of

ways; and jewelry is elaborate and abundant. The sculptor's art had clearly reached a stage of great fluency and perfection. Yet we know next to nothing about the sculptors who worked on the temples. All we may assume is that, like elsewhere in ancient and medieval India, a workshop system was in effect and an entire guild worked jointly on each temple to produce its finest work; in such a scenario, individual names were considered somewhat irrelevant.

The joyful experience of love is revealed in distinctive forms of expression found in every culture. Unique to India is the celebration of love in the form of graphic three-dimensional imagery carved in stone on the walls of Hindu temples. Such images were not reserved for the viewing pleasure of a select audience of temple patrons and their immediate coterie; rather, being displayed on the outer walls of temples in a public arena, these erotic images met a much wider gaze. The viewing audience may also have been extremely diverse since temples generally served as a unifying center for different sectarian groups. Irrespective of whether viewer reactions were similar or consistent, the temples continued to function as cohesive institutions that could, and did, encompass a rich variety of attitudes.

Although love imagery was created across the length and breadth of India from the first century BCE to the nineteenth century, this essay concentrates on the tenth- and eleventh-century temples at Khajuraho in central India, not only because these are renowned for erotic images but also because their sacred iconographic programs have recently been studied. Clearly any assessment of erotic temple imagery must take into account the sacred programs and religious functions of the shrines as well as the cultural milieu.

"Medieval" (*c*.600–1300) India was a culture with attitudes toward sexuality very different from those we encounter today. A consideration of the titles given to a Hindu monarch indicate, for instance, that after heroism, physical distinction was the trait most admired. While the eighth-century Pallava ruler Rajasimha was praised as a great warrior and fearless conqueror, inscriptions on his personal chapel at his capital of Kanchipuram mention also that he was handsome (*abhirama*), possessed of the grace of the god of love (*kamavilasa*), and sported the attraction of musk (*gandhahasti*). When the ruler Vijayalaya established the Chola dynasty (*c*.862–1310) by capturing the southern town of Tanjavur in the year 862, the terminology used in the official declaration alludes to this event as love-sport:

> He, the light of the Solar race, took possession of Tanchapuri – which was pictur-
> esque to the sight, was as beautiful as Alaka [mountain], had reached the sky by its
> high turrets, and the whitewash on whose mansions appeared like the scented
> cosmetic applied to the body – just as he would seize by the hand his own wife
> who has beautiful eyes, graceful curls, a cloth covering her body, and the sandal paste
> as white as lime, in order to sport with her.[1]

When Krishna III of the Rashtrakuta dynasty (*c*.753–973) was crowned king in 939 and prepared to collect revenue from the tax-paying provinces of his Deccan

kingdom, the official account described the relationship between the monarch and the provinces, called quarters, in terms of love-sport. It speaks of "the quarters, which began to tremble and be submissive on account of this preparation to exact tribute – as girls would have manifested tremor and affection at his preparation to take their hand – became pleasing to him in consequence of their observing the proper time for paying it of their own accord – as the others [girls] would have been dear to him in consequence of their keeping to the auspicious juncture for giving themselves away."[2]

Sexuality and love were not treated as private and personal matters; rather, sexuality was a valued attribute of a leader or monarch, to be celebrated in official charters and inscriptions. It is intriguing to note that in ancient Mesopotamia sexuality was similarly linked to potency, male vigor, authority, and hence dominance.[3] In India, it was the hallmark of a ruler that he strike a balance between sexual vitality, which implied regal power, and control of the senses, which spoke of yogic power. It is in this context that the Khajuraho temples and their erotic imagery must be examined.

From the eighth century onward, northern India was divided into series of regional kingdoms of varying size in which local loyalties, rather than a central authority, played a major role. These regional dynastic houses operated on the Indian feudal system in which kings granted land to vassals in return for a portion of the revenue from that land. For the privilege of ruling their mini-kingdoms, feudatories had to provide military support whenever their overlord went to war, to proclaim his name in any inscriptions they issued, and to attend his court on a variety of ceremonial and formal occasions.

In the early tenth century, local Chandella chieftains with somewhat dubious tribal backgrounds had, for a period of a hundred years, ruled a small area of northern India as feudatories of the powerful Pratihara dynasty whose kingdom lay to their north and east. In a bold move, Yashovarman Chandella (reigned 925–50) appropriated from his Pratihara overlord an important statue of Vishnu and built a sandstone temple to enshrine it at his capital of Khajuraho. This temple, known today as the Lakshmana, and completed by his son Dhanga in 954, was Yashovarman's defiant gesture to establish the sovereignity of his new dynasty. The early part of Dhanga's reign was devoted to extensive military activity to consolidate the new kingdom. His own temple known as the Vishvanatha, completed in 999, was dedicated to Shiva and enshrined both a stone and an emerald linga. Since the use of emerald in images of worship traditionally signifies the fulfillment of desires, the consecration of the emerald linga may have been Dhanga's act of thanksgiving both for his military successes and for his lifespan of close to a century. One of the most important of Chandella rulers was Vidyadhara (reigned 1004–35), during whose reign the Chandellas were recognized as the dominant power in northern India. It is probable that he was the builder of the Kandariya Mahadeo temple that marks the climax of building activity at Khajuraho.

Hindu temples, simple in plan, consist of a square sanctum fronted by a square hall; larger temples may have a second hall as well as a porch. Among the twenty

or so still standing at Khajuraho are three large *sandhara* temples in which an inner circumambulatory passage encircles the shrine; these three temples are the focus of this essay. The earliest of these *sandhara* temples is the Lakshmana, the creation of the first Chandella ruler Yashovarman, completed in 954 and dedicated to Vishnu. It was followed by two Shiva temples, the Vishvanatha temple of King Dhanga, completed in 999, and the Kandariya Mahadeo temple created almost certainly by King Vidyadhara. All three temples display a graceful grouping of the superstructures of their four units, with the lowest pyramidal roof over the entrance porch and the successively taller pyramids above the two halls, sweeping up to the elegant tower above the shrine. All three exhibit prominently placed erotic imagery and are royal commissions of the Chandella monarchs.

Ancient *shilpa*, or art, texts written for practicing architects and sculptors, speak of the sanctum as the bridegroom and the main hall as the bride and refer to the juncture wall between them as the *milana-sthala*, or meeting-place. The texts further specify, "That place in front where the bridegroom meets the bride becomes the *sandhikshetra* or place of juncture" (also trysting place).[4] It is on the exterior of these juncture walls of the Lakshmana, Vishvanatha, and Kandariya Mahadeo temples that we find the erotic imagery for which Khajuraho is renowned. The ground plan of the *sandhara* temples (and only of these) reveals that the square of the sanctum and the square of the hall actually overlap to create this juncture wall. The occasional small erotic figure appears on various parts of the temple; however, it is at the very center of this joining wall, this meeting-place, that the temple builders carved a panel of entwined or "joining" couples, positioned on two or three levels according to the scale of the temple.

The idea of thus creating a visual and architectural pun need not seem strange or farfetched since it was a commonplace in the literary vocabulary. For instance, the lengthy dedicatory inscription on the Vishvanatha temple contains a passage that plays with the dual meanings of the word *digambara*, meaning "sky-clad," a word largely used to designate the Jain sect of naked monks. One verse of the inscription is in the form of a joking dialogue between god Shiva and his consort Parvati; she inquires who is at the door and intentionally pretends to misunderstand Shiva when he answers "Digambara" (Shiva often went around clad only in a loincloth with snakes and other ornaments to cover him). Parvati counters that she will not open the door to a Jain monk.[5] With puns a common form of literary expression, it should be no great surprise to come across puns in the visual arts and to find images of *sandhi* (union) at points of *sandhi* (juncture or combination).

Imagery as Auspicious and Celebratory

In exploring the erotic imagery, the obvious is often overlooked: one reason for the profusion of such imagery on temple walls is surely to celebrate the joy and pleasure of life, of love and of sex. This important fact is often relegated to

oblivion in the desire to seek explanations for what has today become an embarrassment to many Indians, whose earlier heritage has been superseded by centuries of Islamic thought, British Victorian values, and nationalistic ideals. The loving couple, or *mithuna*, is a stock theme of Indian art, being seen as early as the first century BCE in the decoration of Buddhist stupas. The significance of the theme is demonstrated by the prominence given to *mithunas* in the veranda of the rock-cut Buddhist monastic chapel at Karle, created in the first century CE along the west coast of India, where we find eight life-sized loving couples with sensuously modeled bodies. Each male fondly places his arm around the shoulder of his partner, and inscriptions, speaking of them as *mithunas*, inform us that some were gifted by monks. For voluptuous couples to be thus displayed in a sacred Buddhist monastic setting at Karle, the *mithuna* theme must have won early widespread acceptance. The couple, like the individual woman, was an obvious and indisputable emblem of fertility, and thereby of growth, abundance, and prosperity. From this, it was a short step to considering the couple an auspicious emblem, equally appropriate for adorning the walls of a palace, a temple, or a Buddhist chapel. When sculptors of the third century CE created friezes portraying the main events from the Buddha's life as decoration for monuments at the Buddhist monasteries of Nagarjunakonda, they considered it wholly appropriate to separate each life scene with loving couples flanked by pilasters.

To state that love was a prominent theme in art, whether sacred or secular, might seem curious to those less familiar with the tenor of life in ancient India. Ancient Indian sages propounded that the goals of life were fourfold, and each individual was exhorted to pursue all four and not neglect any in favor of the other three. *Dharma* implied ethical living; *artha* was the acquisition of wealth through the rightful pursuit of one's profession; *kama* was love (familial and sexual); and *moksha* was spiritual liberation. While a Hindu temple was constructed to aid the pursuit of spiritual liberation through meditation, symbolized by the worship of the deity enshrined within its sanctum, it was appropriate that the temple reveal the wholeness and totality of life by carrying on its walls imagery relating to the other three goals. In addition to portraying stories from the myths relating to the deities, the temple walls frequently show preaching sages, scenes of hunting, festival processions, as well as images of women, couples, and lovemaking. It is in this context that one may seek to understand much of the love imagery on temple walls.

Equally significant is the auspicious-cum-apotropaic role played by images of couples in protecting a temple. Cultures across the world – for instance Pompeii during the second and first centuries BCE – have believed in the power of images, particularly of those that depict inappropriate attitudes, sexual or otherwise.[6] Warding off the evil eye by the use of apotropaism is not a rare phenomenon. Places of juncture, in particular, are considered to be especially vulnerable points, liminal areas that require additional protection. And it is precisely where the

sanctum of the Khajuraho temples meets the hall that such apotropaic images are seen in greatest profusion. In fact, as one examines the temples more closely, one may discern erotic figures placed along the juncture of the roofs as well.

Metaphor

Images of loving couples may also be understood on a metaphorical level. Several decades ago the eloquent writer Mulk Raj Anand coined the phrase "union of cosmic principles" to suggest that entwined couples represent the union of the individual human soul with the divine. Ancient philosophical texts known as Upanishads, composed beginning in the fourth century BCE, put forward a philosophy termed "monism" that opposed any kind of dualism and proposed that the individual soul and the universal soul were not two distinct entities. Rather, the individual soul emerged from the universal principle, lived its life on earth, and when it reached an advanced spiritual state, it merged back into the universal soul, realizing the bliss of salvation. To explain this profound philosophy of the essential unity of an apparent duality, the sages of the Upanishads used sexual terminology. They compared the bliss of salvation that arises when the individual soul merges with the universal soul to the blissful state that arises when lovers merge and lose themselves in each other. If sexual terminology could be used freely and explicitly in sacred literature to explain the concept of monism and the bliss of salvation, then surely it could be used in the visual arts, as three-dimensional sculpture, to explain the same concept.

Can the metaphorical explanation be extended to the scenes on the juncture walls of the three *sandhara* temples at Khajuraho? These joining scenes invariably portray an erotic couple flanked by two other figures, one male and one female, though occasionally both female, who actively assist the couple in achieving their union. For instance, both the Kandariya Mahadeo and Vishvanatha temples feature a couple united in a yogic-coital posture with one partner in the headstand pose and the other supported by helpers. Is it too radical to suggest that spiritual union needs the intervention of gurus and guides to lead to that state of liberation? When the Vishvanatha wall depicts unconventional postures, is it going too far to say that they, too, may be interpreted on a metaphorical level? It may be difficult for us to conceive of such a concept since, as twentieth-century viewers, we are accustomed to regarding sex as an intimate private matter.

What about the viewers and their responses to the erotic imagery on the temple walls? In India's ancient theory of aesthetics, a viewer response theory called *rasa-shringara*, or love, is the first of the nine aesthetic emotions, or *rasas*, in fact, love is described as the king of *rasas (rasaraja)*. To what extent can we suggest that a response of arousal may have been intended to resonate with the importance

given to fertility? A point that needs consideration here is the bashful attitude of the "helpers" in two of the scenes on the Vishvanatha temple's joining walls; in one, both women flanking a coital couple cover their faces with one hand in apparent embarrassment, while in another, a woman uses both hands to cover her eyes (Fig. 7–1). On the Lakshmana temple, the woman next to an entwined couple turns away from them with a degree of hesitance and uncertainty. On the Kandariya Mahadeo walls, by contrast, none of the figures display any misgivings but appear quite matter-of-fact regarding the activities of the central couple. It would seem that the temples embody the two apparently contradictory attitudes of acceptance and embarrassment toward sexuality. Such images do not seem to be metaphors for spiritual bliss; if they were thus intended, surely flanking figures would not display misgivings but would rather reinforce the underlying metaphor.

Fig. 7-1 Vishvanatha Temple, Khajuraho, Sculptural detail, 999 CE. Photograph by Rebecca M. Brown.

Esoteric Tantric Sects

One explanation of the activities portrayed on these juncture walls is that they represent the practices of esoteric tantric sects. The Kaula sect of Shaivism, for instance, which was prominent during the tenth and eleventh centuries when the Khajuraho temples were built, believed that the path to salvation lay through the five Ms, so-called because each of the five items start with the Sanskrit letter *M*. These five ingredients are *matsya*, or fish; *mamsa*, or meat; *mudra*, or grain; *mada*, or wine; and *maithuna*, or sex. Kaulas defined the ultimate state, to which they gave the name Kula, as one in which sight and mind are united, the sense organs lose their individuality, and sight merges into the object to be visualized.[7] They advocated the path of *bhoga*, or enjoyment, rather than yoga, or discipline. Contemporaneous literature speaks disparagingly of their lavish banquets that culminated in orgiastic rituals. While the sculptures have indeed been read as portraying the rites of such tantric sects, the explanation presents problems that need to be resolved. Since all three temples are royal dedications, the implication would be that the monarchs themselves were followers of tantric practices; inscriptions, however, suggest that the monarchs followed the Vedic path. The Lakshmana temple inscription, for instance, concludes with the wish "May the law of the three Vedas prosper!" The Vishvanatha temple record speaks of religious services administered according to the *Shastras*, or orthodox sacred texts, by chief priest Yashodhara, and performed by Brahmans of pure lineage. A second problem pertains to the secret hidden nature of tantric practices that, according to their texts, must never be divulged or revealed to a non-initiate. Why then would their practices be displayed so prominently on temple walls? The only way to counter this objection would be to postulate that portrayals of Kaula tantric practices were permitted by their Vedic opponents in order to hold them up to public ridicule. This explanation is, however, exceedingly unlikely, for ridicule hardly thrives via emphatic portrayal of the ridiculed on the walls of such magnificent temples. Similarly suspect is the suggestion that the naked figures of "monks" seen in certain panels represent monks of the *digambara* sect of heterodox Jains who are thus held up to public contempt.[8] This issue is unresolved.

It should be noted that tantra visualizes a set of seven *chakras*, or centers of spiritual energy, that exist at various points within the body. The lowest is visualized at the base of the spine, the next in the genitalia, and the topmost at the apex of the skull. Tantric practitioners strive to arouse awareness within the *chakras*, directing sexual energy upward toward the top of the skull. When such energy reaches the topmost *chakra*, known as *sahasrara*, or thousand-petaled lotus, a state of meditative bliss is achieved. Throughout such tantric practice, arousal is to be maintained to achieve a state of meditative perception; seed is never to be spilled. It is this aspect of ascetic and yogic arousal that is behind the concept of the linga of Shiva; the phallic emblem represents Shiva's yogic and meditative control and not his sexuality, as might mistakenly be thought.

Sacred Program

It would be appropriate now to turn to the sacred programs of the temples, of which the Lakshmana is dedicated to Vishnu, and the Vishvanatha and Kandariya Mahadeo to Shiva. Recent scholarly research on the iconographical programs of these temples indicates that their imagery is based on the concept of a hierarchical and pyramidal emanation of deities or cosmic elements.[9] Starting from the inner sanctum and moving outward, such emanation results in the evolution of the universe; in reverse, commencing from the exterior and moving inward, the emanation culminates in its involution or dissolution.

The philosophic system known as Pancharatra is seen as the basis for the Lakshmana Vishnu temple. Pancharatra visualizes the unmanifest supreme without form, who then enters the stage of being-becoming and finally manifests in a variety of forms that include the incarnations of Vishnu. In meditative practice, the devotee starts with the manifest and moves gradually toward the supreme being. The existence of such a complex metaphysical ideology makes it problematic to sustain the theory that an allegorical play was portrayed on the temple's walls. The ideology underlying the Shiva temple of Kandariya Mahadeo is the Shaiva Siddhanta system; its emanation principle commences with formless Shiva in the sanctum's aniconic linga and moves through the manifest-unmanifest Sadashiva, to the various manifest forms of Shiva.

Both the Vaishnava Pancharatra system and the Shaiva Siddhanta philosophy assert that the supreme being, who is unmanifest and formless, takes on form to help the devotee in worship and meditation. Both are esoteric paths that belong to the right-handed *(dakshina)* tantra as opposed to the left-handed *(vama)*. The distinction between right- and left-handed tantra lies in the concepts of literality and symbolic substitution; thus if a tantric text demands an offering of blood, left-handed tantrics follow it literally while the right-handed system would substitute a blood-red hibiscus flower. So, although the inscriptions of the monarchs responsible for these temples speak of them as upholding the Vedic path, they appear, in fact, to be followers of right-handed tantric philosophies that were apparently not considered to be heterodox paths but accepted as belonging within the scope of the Vedic fold.

Returning to a reading of the love imagery on these temple walls, we find ourselves faced with a curious situation. Since all three temples belong to philosophical systems of right-handed tantra, and since such systems, whether Shaiva or Vaishnava, believe in substitution, one might ask why the temple walls portray actual sexual rites in place of using a substitute for the element of *maithuna*, or sex. Perhaps the answer is implicit in the very question. Perhaps the stone imagery on the temple walls stood as a substitute for the physical performance of sexual rites. Possibly this last hypothesis is one that most adequately takes into account the various apparently conflicting facts and provides a

manner of coming to terms with the erotic imagery and a means to partially reconcile apparent contradictions.

Love Imagery

One thing is certain: no single explanation accounts for the many categories of love images on the temple walls, which may be read on a number of levels, depending perhaps on the level of cultural and spiritual sophistication of the viewer. *Mithunas*, or loving couples, stood for growth, abundance, and prosperity and were an auspicious and accepted decoration on temple walls; they made reference also to *kama*, one of the four goals of life in ancient India. Erotically entwined "joining" images were placed on the walls that connect the sanctum likened to the bridegroom, with the hall likened to the bride, to create a visual and architectural pun. Love imagery also served an auspicious-cum-apotropaic function, placed specially at those vulnerable points where a juncture occurred in order to protect a temple from danger. Love images may also be read on a metaphorical level, with the bliss of sexual union understood to suggest the bliss of salvation that arises upon the union of individual soul with the infinite. Finally, we must take into account the fact that the sacred programs of the temples belong to right-handed tantric paths that reject the extreme and literal practices of left-handed tantrics and use symbolic substitution for various rites including the five *M*s. The sculpted love imagery on the joining walls of the temples may be interpreted as the substitute for the physical performance of sexual rituals by the right-handed tantrics, whether followers of the Pancharatra or Shaiva Siddhanta systems.

Notes

The epigraph is from "The Moon," *Sanskrit Poetry from Vidyakara's Treasury*, trans. H. H. Ingalls (Cambridge, MA, and London: Belknap Press of Harvard University Press, 1979), no. 944, p. 205.

1 Inscription no. 205, verse 45, in *South Indian Inscriptions* (Madras: Archaeological Survey of India, 1920), 3: 148.
2 Quoted in R. G. Bhandarkar, "Karhad Plates of Krishna III: Saka-Samvat 793," *Epigraphia Indica* 4 (1896–7): 278–90.
3 Irene J. Winter, "Sex, Rhetoric, and the Public Monument: The Alluring Body of Naram-Sin of Agade," in *Sexuality in Ancient Art*, ed. Natalie Boymel Kampen (Cambridge: Cambridge University Press, 1996), pp. 11–26.
4 Ramacandra Kaulacara, *Silpa Prakasa*, trans. Alice Boner and Adasiva Rath Sarma (Leiden: Brill, 1966), part 2, p. 111.

5 Devangana Desai, *The Religious Imagery of Khajuraho* (Mumbai: Franco-Indian Research, 1996), pp. 177–8.
6 John Clarke, "Hypersexual Black Men in Augustan Baths: Ideal Somotypes and Apotropaic Magic," in *Sexuality in Ancient Art*, ed. Kampen, pp. 184–98.
7 Pramod Chandra, "The Kaula-Kapalika Cults at Khajuraho," *Lalit Kala* 1, no. 2 (1955–6): 98–107.
8 Desai, *The Religious Imagery of Khajuraho*, p. 181.
9 Ibid., pp. 181–9.

8

Excerpts from *Angkor Wat: Time, Space, and Kingship*

Eleanor Mannikka

Introduction

These selections from Eleanor Mannikka's monograph on Angkor Wat (early to mid-twelfth century) highlight the relationships at the site among architecture, political and spiritual authority, and the cosmos. Angkor Wat is both a Hindu temple (*wat*) to the god Vishnu and a royal foundation whose patron, Suryavarman II (r. 1113–50), promoted the intersection of god (*deva*) and king (*raja*) central to the authority of his Cambodian Angkor dynasty (802–1431). Mannikka analyzes both the architectural plan of the structure in its relation to the cosmos and the sculptural program of the temple, reading the site as representative of both temporal and spiritual power.

Cambodian (or Khmer) culture has appropriated a variety of "foreign" cultural practices and beliefs over the course of its history, and the building projects of the Angkor rulers exemplify this multifaceted heritage. The presence of Indian culture in Cambodia arrived via trade and migration at the beginning of the first millennium. In the eighth century, the southeast Asian island kingdom of Java invaded and took over much of the Cambodian region; in the ninth century the newly established Angkor dynasty pushed back the Javanese and reclaimed Cambodia. The Khmer, or Cambodians, credited their success to the special relationship the kings were said to have with *nagas*, or snake deities, who are especially associated with water and rivers and from whom the dynasty traced its Somavamsha, or moon lineage. Therefore, water – and the *nagas* who represent the power of water – was central to the

Eleanor Mannikka, "Angkor Wat," pp. 9, 17–21, 32–43 from *Angkor Wat: Time, Space, and Kingship*. Honolulu: University of Hawaii Press, 1996. Reprinted by permission of the University of Hawaii Press. ©1996.

culture of the Angkor dynasty. A good ruler provided water to the kingdom and protected the kingdom from flooding. Reservoirs, or *barays*, as well as moats and ponds, thus played a crucial role in Angkor's architecture.

Angkor Wat exemplifies deft manipulation of space: the architecture dictates how one approaches the structure and what decorative theme one sees first, while integrating its shape with the wider cosmos to become larger than a mere temple rooted in the earth. Mannikka's text takes seriously the numerological relationships found at the temple complex and uses proportions, units of measurement, and visual programmatic connections to understand this multifaceted site. She explores the symmetry and precision of the structure, from its relationship to the cycles of the moon to its use of the arm of the king as a unit of measurement. She finds the same numerology, symmetry, and relation to the cosmos in the relief sculpture of the churning of the sea of milk, a Hindu narrative of the cosmic tug-of-war between gods and demons. At Angkor Wat, all of these facets come together into a unified whole meant as a message of authority (both temporal and spiritual) of the Angkor *devarajas*.

Angkor Wat

The temple of Angkor Wat was built at the height of Cambodian political power, during the reign of King Suryavarman II (r. 1113–*c*.1150). Like the kings before him, Suryavarman decided to build his own royal sanctuary at a place distinct from those of his predecessors.[1] He chose a site in the southern sector of Angkor and faced the temple toward the west because it was dedicated to Vishnu the great Brahmanical god who rules over the western quarter of the compass. With its 1300-m north–south axis and 1500-m west–east axis – since the entrance is on the west, that axis runs west–east – no other temple at Angkor is as spacious and open as Angkor Wat. Today tourists still request to be taken to watch the sun rise over the temple, for it is a view that cannot be obtained anywhere else at Angkor.

The design of Angkor Wat is focused on three rising, concentric galleries at the heart of the temple and a vast amount of space circling the galleries. Around it all is a rectangular moat, a water-filled border that isolates the grounds of the monument (Fig. 8–1).

In the early 1960s, Angkor Wat was completely surveyed for the first time by Guy Nafilyan, a French architect, one of several who has worked for years at Angkor, and his team of Khmer and French assistants. Their results, incorporating 113 plans and drawings, were published in France in 1969 as *Angkor Vat: description graphique du temple*. On close inspection, I noticed that the temple's measurements were extraordinarily precise along certain sectors.[2] As an example of this precision, both the northern and southern corridors of the third gallery are

N&S ~ 202.14 m
E&W ~ 114.22m

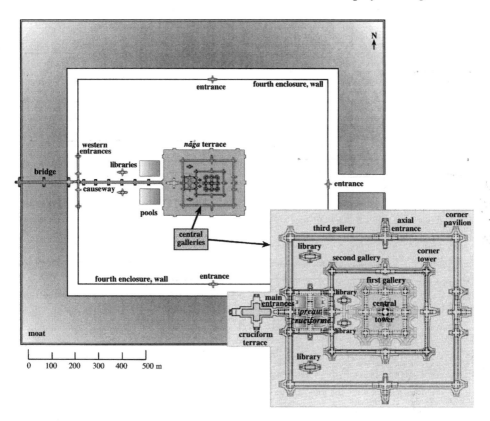

Figure. 8-1 Plan of Angkor Wat, Cambodia, twelfth century.

202.14 m long.[3] The eastern and western corridors are 114.22 and 114.24 m, respectively. Why – and how – would anyone construct the circumference in such a remarkably accurate manner?

To find out why Angkor Wat was constructed so precisely, I started to search for the unit of measure used to build the temple. That unit had to be a cubit length – the distance between the elbow and outstretched fingertips – since no viable alternative existed in Khmer inscriptions. Cubits and related units of measure were inherited from India. Although there was no standard cubit at Angkor, or anywhere else in Asia for that matter, we can be fairly certain that King Suryavarman's cubit was used to build his temple. In the end, the cubit length would have to be deduced from the temple itself. Aside from the cubit length, another common measurement was equal to 4 cubits, called a *phyeam* in Khmer. As it turned out, the builders of Angkor Wat used various cubit "blocks" as modules: 10 cubits, 27/28 cubits, 32 cubits, 108 cubits, and similar groupings.

A standard cubit in Cambodia would range roughly between 0.40 and 0.50 m. I used this range to divide axes and circumferences at Angkor Wat until finally, after 4 months of trial and error, a very precise unit of 0.43545 m yielded the

most consistent results. Originally this figure was derived from the north–south axis of the central sanctuary. I estimated that, between steps, the axis should be 12 cubits long.[4] In other words, 11 cubits would make the cubit length too long and 13 would make it too short. Whether or not this turned out to be a valid procedure – since the distance between steps was later discarded as not always relevant – it gave a fortunate result. Since then, experimentation with other central sanctuaries at Angkor has indicated that the number 12 might be present in their axial measurements too.

[handwritten margin note: 12 is a very important number w/ regard to the temple]

The number 12 is highly significant at Angkor Wat. There are 12 staircases leading up to the central sanctuary at this level. They face the four cardinal directions, three staircases in each direction. The Khmer astronomers described the sun as traveling in a counterclockwise direction, from south to east to north to west, with 3 months between the equinox and solstice days. The 12 stairways are thus excellent symbols for the yearly solar calendar. Vishnu is a supreme solar deity, one of the 12 *adityas* or gods of the solar months. His solar aspect and the solar interpretation of the 12 staircases leading up to the main central sanctuary are in agreement.

When I measured the same north–south axis in the sanctuary, door to door, it came to 13.41 cubits. Angkor is at 13.43 degrees north latitude, expressed by the fact that the north celestial pole is 13.43 degrees above the northern horizon at Angkor. As it turned out, 13.41 cubits is a basic module in the second gallery, devoted to Brahma who is "situated" at the north celestial pole. When all of this information began to be assimilated, I started to wonder where it would lead me. I did not suspect that it would take 20 years of research to answer that question fully.

Working within a system of priorities, the architects were still able to provide all of the chambers, axes, and galleries of Angkor Wat with measurements that were cosmologically or calendrically significant.

The Churning of the Sea of Milk

The churning myth begins with the *devas* losing battles against the *asuras* and continues in several variations. To defeat their classic *asura* enemies, the *devas* (or Vishnu, depending on the text) devised an ingenious scheme.[5] They asked Bali, the king of the *asuras*, to call a truce and command the *asuras* to help them churn up (and share in) the elixir of immortality from the Sea of Milk. If the gods could gain immortality, the *asuras*, finally, could be defeated for good. If the *asuras* drank the elixir, too, the plan would fail, of course, but that possibility was ruled out from the start.

The *devas* persuaded the *asuras* to cooperate and then asked the great Lord Vishnu to help them. First the king of mountains, Mount Mandara, was uprooted from its place to the east of Mount Meru, the home of the gods, to be used as the

churning pivot. Next the king of snakes, Vasuki, was roused from the bottom of the Sea of Milk to serve as the churning rope. Vishnu supported the churning pivot in his incarnation as the tortoise Kurma ("half a globe"). With Vasuki wrapped around the pivot, the gods stationed at the multiheaded side of the snake, and the antigods aligned along the tail, the great churning began.

Eventually the elixir emerged, but neither the gods nor antigods had a chance to drink it. The *asuras*, piqued that they were never intended to share in the benefits of immortality, attacked the *devas*, which led to another great battle. Vishnu intervened, helped the *devas* to win, and left with the elixir to keep it out of harm's way. Once the battle had ended, Indra was crowned king of the gods: "Indra, after slaying the *asuras*, became king of the *devas* and with the help of the sages began to rule with joy."[6] This last detail, which seems at first irrelevant to the main thrust of the story, is in fact a key to the significance of the Churning of the Sea of Milk at Angkor.

[handwritten margin note: Vishnu took the elixar to keep it out of harms way, meaning no one got it]

A bas-relief of the churning event is sculpted across 49 m of the eastern wall in the third gallery of Angkor Wat (Fig. 8–2). This relief measures 54 cubits on the side of the *devas* and 54 on the side of the *asuras*, repeating the numerology found on the western entrance bridge and on the bridges to Angkor Thom.[7]

The Khmers were the only people in South and Southeast Asia to depict precisely 54 *asuras* and 54 *devas* in the illustration of the churning scene. This might be because 108 is the most auspicious number in all of Asia. It occurs in

[handwritten note: b/c in Buddist & Hindu texts]

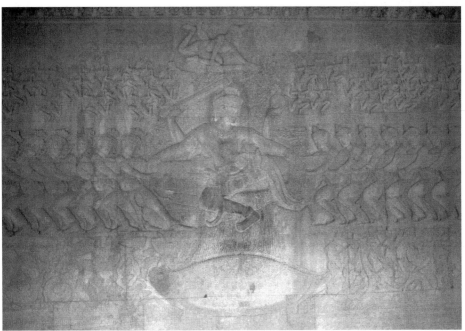

Fig. 8-2 Third gallery, east side, south half, Churning of the Sea of Milk, Angkor Wat, Cambodia, twelfth century. Photograph by Deborah Hutton.

Buddhist and Hindu texts in many guises and forms. Vishnu, for example, has 108 names; Buddhist and Hindu "prayer beads" number 108. Therefore mantras are often chanted with these beads 108 times (or multiples thereof). The recurrences of 108 seem endless. The number 108 is important in astrology and astronomy, as well. In this specific instance, the deliberate pairing of units of 54 may have a connection to the relationship of Mount Mandara (the churning pivot), Mount Meru (the home of the gods), and the earth's axis.

A bas-relief of the churning scene in the southwest corner pavilion at Angkor Wat, like many Asian depictions of the Churning of the Sea of Milk, has the sun and moon on each side of the central mountain. Surya and Chandra, the solar and lunar gods, are usually shown inside large disks (their "orbs") on each side of the central pivot. As it happens, Surya and Chandra, the sun and moon, move approximately 54 degrees north and south during the year.

On the day of the winter solstice, around December 22, the sun is at its southernmost position in the sky. The sun starts to move northward with each successive sunrise until, on June 21, the summer solstice day, it is at its northernmost point in the sky. After that, it starts to rise farther south each day. This north–south and south–north solar oscillation ranges between 49°12′ and 43°58′, depending on the year in question.[8] Could the venerated numbers 49 and 44 derive from the limits of the sun's yearly oscillation? The moon oscillates between north–south extremes across the celestial equator in an arc that can reach a maximum of 59°28′.[9] Could the 54/54 pairing at Angkor also trace its origins to solar and lunar movement? Although there is no precise and unvarying figure for the amount of north–south arc crossed by the sun and moon, the average degree of *maximum* oscillation is 54°20′ for both the sun and moon combined, or 108 degrees for the annual north–south, back and forth, movement. At present the sun oscillates at 46°54′ and the arc is decreasing. The 54° maximum average arc may have inspired the 54/54 pairing of gods and antigods in Cambodia.

The bas-relief of the Churning of the Sea of Milk has several other aspects that refer to a north–south oscillation. Brahmanical astronomy, for example, locates the *devas* on Mount Meru, the axis of the earth:

> The round ball of the earth, composed of the five elements, abides in the midst of the starry sphere, like a piece of iron suspended between magnets. ... In its middle there is Sumeru, the abode of the gods. Below [at the pole opposite Meru] there are placed the Asuras. ... Straight above Meru in space one pole is seen; the other pole is seen below, placed in space. ... For those who dwell on the back of Meru the sun once risen remains visible for six months, while he moves in the six signs beginning with Aries; for the Asuras he is visible as long as he is in the latter [half of the ecliptic].[10]

One of the more unusual revelations in this paragraph is that the Indians knew the earth was round in the sixth century CE. In addition, these stanzas and others like them describe Mount Meru as the north–south axis of the earth, with the *devas*

at the north celestial pole and the *asuras* at the south. This is why the bas-reliefs of the Churning of the Sea of Milk at Angkor Wat and at the Bayon (*c.*1200) put the *asuras* on the south side of the scene and the *devas* on the north. And this may be why 54/54 is associated with the gods and antigods. Their "pulling" on the snake Vasuki causes the sun and moon to move back and forth, north and south, each year, covering a 54-degree maximum arc every 6 months.[11]

In the bas-relief at Angkor Wat, the position of the churning pivot would correspond to the position of the spring equinox. The 91 *asuras* in the south represent the 91 days from equinox to winter solstice, and the 88 northern *devas* represent the 88 days from equinox to summer solstice. In fact, there are either 88 or 89 *devas* in the scene, 89 if the *deva* atop Mount Mandara is counted with the others. There are 88 or 89 days from the spring equinox, counted from the first day of the new year, to the summer solstice.

In Cambodia, the spring equinox (beginning of the sun's yearly journey) lasted for 3 or 4 days: Thngai Chaul, "day of entry," Vone Bat, "day(s) of the middle," and the last day, the Langsak.[12] The Langsak, the first day of the new year, occurred 3 or 4 days after the spring equinox, depending on the year. (In some years, there were two Vone Bat, or middle days.) Mount Mandara as the churning pivot would symbolize the 3 or 4 days of the equinox period, the northernmost *deva* would represent the summer solstice day, and the southernmost *asura* would correspond to the winter solstice day. In other words, this scene is a calendar. It positions the two solstice days at the extreme north and south, counts the days between them, and measures 54 units for the north- and south-bound arcs of the sun and moon in its own 54/54-*phyeam* halves. In all of these aspects, it emulates the symbolism on the bridge or in the western entrances, which repeat the 54/54-unit pairs several times.

Three oversize figures depicted on each side of Mount Mandara divide the churning scene into six segments representing the 6 months between December 22 and June 21. One large figure holds the snake Vasuki at his head, another holds the tail. These are the figures representing the solstice days. There are two large, equidistant *devas* on the north and two large, equidistant *asuras* on the south that further divide the space between the end solstice figures and the central pivot into three segments on each side.

The period between the solstices is also expressed in terms of days: the total of 180 *devas* and *asuras* in the relief, plus the 3 days symbolized by the churning pivot at the spring equinox center of the relief, add up to the 183 days between solstices (182 if the flying *deva* on top of Mandara is excluded). Both numbers, 183 and 182, are correct, depending on the year ($183 + 183 = 366$, one leap year; $183 + 182 = 365$, a normal year).

Every aspect of this relief – the number of figures it contains; the distances the figures cover (54 *phyeam* on each side); the way the figures are divided; the composition's use of a central axis, equally symbolic of the vernal equinox and Mount Mandara; the cardinal directions occupied by the figures on each side of the axis – all work together to define the lunisolar calendar.

89

There is another connection between the solstice and 54/54, and that is on the bridge to Angkor Wat. If one stands at the center point between all three end staircases on the west side of the bridge on December 21, the sun rises exactly over the center of the southern gateway of the western entrances. On June 21, the summer solstice, the sun rises over the center of the northern gateway. It is convenient, but probably coincidental, that the point of observation on the bridge is marked by a sunken, rectangular space. The north and south end gateways in the western entrances thus correspond to the north and south end figures in the churning scene: both are defined by the movement of the sun and the calendar dates of June 21 and December 22, respectively. The central tower of the western entrances is equivalent, in this regard, to the churning pivot. Both are positioned at the spring equinox center, both are central to the north and south arms that extend outward from them, and both have 54/54 divisions in measurements on each side of them. The bas-relief of the Churning of the Sea of Milk and the main entrance to Angkor Wat therefore convey exactly the same calendrical information in the same type of solstice-equinox pattern.

The two solstice alignments at the very beginning of the bridge are an extraordinary component of the architecture of Angkor Wat. They bracket the western entrances just as the solstices themselves bracket the north–south journey of the sun each year. They are the first alignments to occur on entering the temple and are highly significant in defining the function and meaning of the western entrances. The pattern, or conceptual set, that created this solstice bracketing could be expressed as the principle of using the solstice sun to flank an equinox center, based on the fact that the equinox point is at the center in time and in space between the two solstices. The bas-relief and the western entrances mirror this formation. At the same time, the king is like the equinox: he is at the center of his realm. The central sanctuary of Angkor Wat is at the conceptual center of the capital and the nation. As it turns out, the king himself is, in fact, directly tied to the symbolism of the solstice–equinox movement and to the Churning of the Sea of Milk. There is no need to postulate. The relationship is spelled out.

Notes

1 We do not know if there was a previous temple at the site of Angkor Wat. Although there are no signs that this was the case, it would not be unusual to build over an already sacred site. There are layers of laterite paving underneath the Bayon that in certain respects may indicate the presence of an earlier temple. There are also the remains of an older trench around the inner perimeter of Angkor Thom, and there were indications of a wall beneath two of the eastern structures at the Bakheng. The Phimeanakas has a 910 CE inscription which indicates that a Vishnu temple may previously have occupied that site. Temples built over the remains of previous temples are common outside of Cambodia as well, in Indonesia and Thailand especially.

2 Angkor Wat's precise measurements were revealed for the first time in Guy Nafilyan, *Angkor Vat: description graphique du temple*, Mémoire archéologique IV (Paris: École française d'Extrême-Orient, 1969).

3 Ibid., pl. 11.

4 After basing the 0.43545 unit on the measurements of Guy Nafilyan, I later found that Georges Trouvé's measurements were slightly different. Nevertheless, since the unit worked so well with the rest of the temple, I did not alter it in any way. In fact, I tried experimentally reducing it to 0.435, 0.434, and 0.436, as well as a range between 0.4354 and 0.4356, but none of these variations worked as well with all the measurements of the temple (although some yielded results that were more accurate in some instances). Since the 0.43545 unit seemed to work the best over the longest distances (4 km or more), I retained it.

5 For a comparison of the basic elements in the churning story see V. M. Bedekar, "The Legend of the Churning of the Ocean in the Epics and the Purāṇas: A Comparative Study," *Purāna* 9/1 (Jan. 1967): 7–61; Asoke Kumar Bhattacharyya, "The Themes of Churning of the Ocean in Indian and Khmer Art," *Arts Asiatiques* 6/2 (1959): 121–34; Madeleine Giteau, "Le barattage de l'Océan au Cambodge," *Bulletin de la Societé des Études Indochinoises* n.s. 26/2 (1951): 141–59; and Horace Hayman Wilson, trans., *Vishnu Purāna*, 5 vols (London: Trubner, 1864–70), vol. 1, book 7, chap. 9, pp. 146–7, n. 1. The story of the churning event itself is told in the *Vishnu Purāna*, pp. 139–47.

6 Hari Prasad Shastri, trans., *Rāmāyana of Vālmīki*, 3 vols (London: Shanti Sadan, 1952–7), vol. 1, p. 92. See also Wilson, *Vishnu Purāna*, vol. 1. After the Churning of the Sea of Milk and the defeat of the *asura*s in battle, "Indra, the chief of the gods, was restored to power."

7 The distance between the south end of the panel and the central Vishnu is 23.496 m, or 53.96 cubits; the same distance for the northern half is 23.69 m, or 54.40 cubits. This information was taken from the photographs in Louis Finot, *Angkor Vat*, part 3, no. 2, pls 351–69, and an unnumbered plan at the back of the volume [this book is not listed in the author's bibliography].

8 Lucien Rudaux and G. de Vaucouleurs, *Larousse Encyclopedia of Astronomy*, 2nd edn (New York: Prometheus Press, 1962), p. 39.

9 Ibid., p. 122.

10 Varāha Mihira, *The Panchasiddhāntikā*, trans. G. Thibauth and Mahāmahopādhyaya Sudhākara Dvivedī (Benares: Medical Hall Press, 1889), p. 69, st. 1, 2, 5, and p. 7, st. 27. This text dates to the sixth century.

11 All accounts of the churning story describe Mount Mandara as the mountain that is uprooted and brought to the shores of the Sea of Milk to serve as the churning pivot. Despite a Khmer tendency to identify Mount Mandara with Mount Meru and the axis of the earth, this is not at all the case according to cosmology. Mount Meru *is* the north–south axis of the earth, and Mount Mandara is not. This point is taken up in Madeleine Giteau, "Le barattage," pp. 145–7, and Kamaleswar Bhattacharya, "Notes d'iconographie khmère," *Arts Asiatiques* 4/3 (1957): 211–13. Mount Meru would remain stable as the axis of the earth while Mount Mandara gyrates, just as the world's axis remains stable while the sun and moon appear to oscillate. See also Johannes Adrianus Bernardus van Buitenen, trans. and ed., *The Mahābhārata, Book 1, The Book of Beginning*, 1 (Chicago and London: University of Chicago Press,

1973), pp. 1–5, Astika, 72 and 73, 15.5–16.5; and the *Vishṇu Purāṇa*, vol. 2 (1865), book 1, pp. 110–11, no. 1, and pp. 112–38.

12 F. Gaspard Faraut, *Astronomie Cambodgienne* (Saigon: F. H. Schneider, 1910), pp. 17, 26–7, and 97.

9

"Akbar Riding the Elephant Havai" and "Akbar Supervising the Construction of Fatehpur Sikri," from *The Akbarnama of Abul Fazl*

Introduction

The Indo-Islamic Mughal emperors (1526–1858) inherited from their Central Asian predecessors a predilection for recording historical events. In 1589 Akbar (r. 1556–1605), the third Mughal ruler, appointed one of his courtiers and a close friend, Abul Fazl, to write a history of his reign. Abul Fazl, assisted by the court records detailing the emperor's daily activities since 1574, eventually produced three volumes, the first two generally grouped together and called the *Akbarnama* (History, or Tales, of Akbar) and the third, which lists the institutions of the court, referred to as the *Ain-i Akbari* (Laws of Akbar). These histories not only describe specific events and administration systems, but also express Akbar's religious ideology and Mughal conceptions of kingship, information vital to the study of Mughal art. Moreover, during the 1590s court artists produced lavish illustrations for at least two manuscript copies of the *Akbarnama*, making it an important artwork in and of itself.

The first excerpt deals with an infamous episode during which Akbar mounted a frenzied elephant named Havai in pursuit of another elephant. Abul Fazl specifically shapes his discussion of the controversial event in order to present Akbar as an infallible ruler. The second passage describes the construction of the palace-city

Abul Fazl, "Akbar Riding the Elephant Havai," pp. 232–5, and "Akbar Supervising the Construction of Fatehpur Sikri," pp. 530–1, from Henry Beveridge (ed.), *The Akbarnama of Abul Fazl*, vol 2. Delhi: Ess Ess Publications, 1977. Reprinted by permission of Ess Ess Publications.

Fatehpur Sikri, which served as the empire's capital between 1569 and 1585. Again, the author describes the event in terms of Akbar's greatness.

Abul Fazl wrote the *Akbarnama* in formal courtly Persian that, even in translation, can sometimes be difficult for readers today to comprehend immediately. For example, the historian refers to Akbar by various epithets such as *Shahinshah* (King of Kings), "the *Khedive* (Sovereign) of the Age," or, in one instance, the "tiger-hunter of audacity's forest." The obscurity of the prose is heightened by the "old-fashioned" style of the translation, completed in the early part of the twentieth century by Henry Beveridge, a British civil servant stationed in India, then part of the British Empire (Beveridge's translation of the *Akbarnama*, originally published between 1902 and 1939, remains the most recently published English translation of the text). Yet, in many respects, the deferential wording precisely fits the overall purpose of the history, and in that manner, rather than taking away from the meaning of a passage, the formal language adds to it.

The *Akbarnama* is a crucial source, one that embodies the close relationship between political authority and royal art in Mughal India. Many segments of the text record the construction of important architectural projects like Fatehpur Sikri, with the emperor firmly at the center of every event taking place. The illustrations, specifically designed by the artists to further the political message of the text, speak to the strong relationship between text and image in Mughal arts of the book.

Akbar Riding the Elephant Havai

Among the occurrences of this time was His Majesty the Shahinshah's mounting the elephant Havai and engaging it in a fight. The life-giving and world-adorning Creator was daily exalting his degrees of greatness by new methods and new lights and was making the spiritual and physical perfections of this sole one of unity's Court perceptible to the superficial and short-sighted. The Age's Khedive was contented with rendering thanks inwardly and continued to wear a veil over his actions. Whenever owing to a Divine decree a veil might be removed from his world-adorning beauty, His Majesty by the might of his own far-seeing meditation fashioned some other yet more beautiful and wonderful veils. He was at once a spectator of the system of Divine decrees, and an administrator of the world according to the best laws. Secretly he was testing the sincerity, the large-mindedness, and business-capabilities of men; ostensibly, he was prosecuting hunting and elephant-fights which the ignorant regard as a kind of neglect of the duties of sovereignty, but which the wise regard as the cream of practical skill. In those very amusements which led the superficial into this error there appeared certain actions which involuntarily brought such superficialists into the highway of devotion and made them travellers on the path of true knowledge. Among them is the following extraordinary occurrence. The story of this instructive affair, and of this opener of reason's ear is as follows. The elephant Havai was a mighty

animal and reckoned among the special elephants. In choler, passionateness, fierceness and wickedness he was a match for the world. Strong and experienced drivers who had spent a long life in riding similar elephants mounted him with difficulty, so what could they do in the way of making him fight? That royal cavalier of bravery's plain and tiger-hunter of audacity's forest one day without hesitation mounted this elephant, in the very height of its ferocity, on the polo-ground which he had made for his pleasure outside of the fort of Agra, and executed wonderful manœuvres. After that he pitted him against the elephant Ran Bagha which nearly approached him in his qualities. The loyal and the experienced who were present were in a state such as had never happened to them before.

As the courtiers who were witnesses of this dangerous scene were disturbed by its continuance and were unable to remonstrate, it all at once occurred to them that a remedy might be found if the Ataga Khan who was the prime minister were brought, and if he by prayers and entreaties could withdraw His Majesty from this dreadful occupation, the contemplation of which turned the gall-bladder of the lion-hearted to water. When the distracted Ataga Khan arrived and saw the state of affairs he dropped from his hand the thread of endurance and bared his head. He cried and lamented like oppressed suppliants for justice. Great and small raised hands of entreaty and implored from God the safety of that sacred person which is the principle of peace and tranquillity for mankind. When His Majesty perceived the Ataga Khan's perturbation he said to him, "You must not make all this lamentation, and if you don't stop I'll at once throw myself down from the elephant." When the Ataga Khan saw that His Majesty was bent upon the business he at once obeyed and from deference outwardly composed his agitated mind. The lion-hearted Shahinshah calmly went on with his terrifying pursuit until the elephant Havai by the strength of a hidden arm, and the Divine fortune, got the victory over his opponent. Ran Bagha let fall the strong cable of steadfastness and turned to flee. Havai looked neither behind nor before and disregarded heights and hollows and went like the wind in pursuit of the fugitive. His Majesty, a rock of firmness, continued to sit steadily and to watch the ways of destiny. After running a long way the elephant came to the edge of the river Jamuna and to the head of the great bridge of boats. Dal Bagha in his confusion went on to the bridge and Havai with the tiger of fortune's jungle on his back came upon the bridge behind him. Owing to the great weight of those two mountain forms the pontoons were sometimes submerged and sometimes lifted up. The royal servants flung themselves into the water on both sides of the bridge and went on swimming until the elephants had traversed the whole of the bridge and got to the other side. At this time when the spectators were looking on at the wonderful affair, the Khedive of the age in a moment restrained Havai, who was like fire in disposition and like wind in swiftness. Ran Bagha ran off, carrying his life. Now life, too, same to the world and distraught hearts were composed. Some ill-thoughted, short sighted ones imagined that perhaps there was some drunken-ness in the brain of Ruler of time and terrestrials, and that this performance was the result thereof. They immediately recoiled from this baseless idea and

perceived that His Majesty was a wondrous portrayer of the arts of reason who was bringing into evidence a specimen from the wondrous inner gallery and was summoning the astray in the wilderness of ignorance to the king's highway of knowledge. He was giving eyes to the blind, and was anointing the eyes of the seeing with impearled collyrium. Several times when this fortunate writer has had the privilege of private conversation with His Majesty the Shahinshah he has heard from his holy lips that "our knowingly and intentionally mounting on vast, murderous elephants when they have a moment previous brought their drivers under their feet and killed them, and when they have slain many a man, has this for its cause and motive that if I have knowingly taken a step which is displeasing to God or have knowingly made an aspiration which was not according to His pleasure, may that elephant finish us, for we cannot support the burden of life under God's displeasure." Good God, what an insight is this! and what a calculation with oneself? In fine, at all times, whether that of holy privacy, or that of engrossment in business in time of battle, and in time of banquet, he is ever regardful of the real, guiding thread, and while he is outwardly with the creature, and inwardly with the Creator, he is at one and the same moment the arranger of the sections of the outward and inward and acts as the leader of both those great parties, and while deriving pleasure from both of these pleasant products adorns the throne both of the spiritual and the temporal universe.

Akbar Supervising the Construction of Fatehpur and Sikri —

Among the dominion-increasing events was the making of Sikri, which was a dependency of Bjana, into a great city. As the Khedive of the world is an architect of the spiritual and physical world, and is continually engaged in elevating the grades of mankind, and making strong the foundations of justice, and causes the longing ones of the age to be successful, so also does he strive for increasing the glory of the earth, and cherishes every place in accordance with its condition. Inasmuch as his exalted sons had taken their birth in Sikri and the God-knowing spirit of Shaykh Salim had taken possession thereof, his holy heart desired to give outward splendour to this spot which possessed spiritual grandeur. Now that his standards had arrived at this place, his former design was pressed forward, and an order was issued that the superintendents of affairs should erect lofty buildings for the special use of the Shahinshah. All the grades of officers, and the public generally made dwellings for themselves, and a high wall of stone and lime was placed round the place. In a short time there was a great city, and there were charming palaces. Benevolent institutions, such as khankahs, schools and baths, were also constructed, and a large stone bazaar was built. Beautiful gardens were made in the vicinity. A great place of concourse was brought together such as might move the envy of the world. H.M. gave it the name of Fatehabad and this by common use was made into Fatehpur.

10

Excerpts from *The Jahangirnama: Memoirs of Jahangir, Emperor of India*

Introduction

In 1605 Jahangir ("World Seizer") succeeded his father Akbar to become the fourth ruler of the Mughal dynasty (1536–1858). Jahangir (r. 1605–27) was not the active military man and political strategist that his father was. Instead, he preferred to spend his time in a more leisurely manner, partaking in the pleasures of courtly life. This inclination led the emperor to overindulge in wine and opium, but it also made him an important patron of the arts, as well as a consummate connoisseur and astute observer of the world and objects around him. Jahangir's memoirs, referred to variously as the *Jahangirnama* and the *Tuzuk-i Jahangiri*, capture these aspects of his reign and personality. In the journal, which operated as both a personal and a public document covering the first nineteen years of his reign, Jahangir notes the promotions of courtiers, the multitude of gifts given and received, his own eating and drinking habits, as well as exotic and/or interesting objects and animals that he encountered.

Three excerpts from the journal are included here. The first describes a wondrous, strange animal – the North American turkey – given to the emperor by a courtier, the second is an oft-quoted passage in which the emperor comments on his discerning

Jahangir, "The Jahangirnama," pp. 133–4, 268, 279–81 from Wheeler M. Thackston (ed.), *The Jahangirnama: Memoirs of Jahangir*. Washington, DC, New York, and Oxford: Freer Gallery of Art, Smithsonian Institution, and Oxford University Press, 1999. Reprinted by permission of The Freer Gallery of Art, Arthur M. Sackler Gallery, Smithsonian Institution.

eye for painting, and the third records Jahangir's shock at the physical state of a Mughal courtier, Inayat Khan, dying from alcohol and opium abuse.

Like the *Akbarnama*, the late sixteenth-century history composed for Jahangir's father (featured in the previous reading), artists made images corresponding with the text. Unlike the *Akbarnama*, however, no intact illustrated manuscripts of the *Jahangirnama* survive. Single-page pictures, such as the painting of the North American turkey and the preparatory sketch of Inayat Khan dying, do exist that relate to specific textual passages, but it is unclear whether they were intended for inclusion in a manuscript copy of the memoirs. Their non-narrative context suggests that they may have been intended for an album (*muraqqa*) compiling individual paintings and calligraphy specimens. That the images were produced at Jahangir's request is certain, since he mentions the production of many of them in the journal.

By composing an autobiographical account of his reign, Jahangir was following the Mughal tradition of dynastic history writing, just as his father was when he commissioned the *Akbarnama*. Indeed, the two documents share many qualities. Both convey the power of the emperors, as well as the role of the arts in augmenting and communicating that power, both demonstrate the relationship between text and image in Mughal arts of the book, and, finally, both provide crucial information for students of Mughal art. At the same time, the imperial accounts are distinct from one another. Their particularities stem from differences in authorship, the emperors' personalities, the evolution of Mughal kingship, and developments within the early modern world of which the Mughal Empire was a part. Jahangir's interest in close observation and his love of the "exotic," particularly as manifest in material objects, speak to some of the cultural changes taking place in the sixteenth and seventeenth centuries.

Muqarrab Khan Brings Rarities from Goa

On the sixteenth of Farvardin [March 25], Muqarrab Khan, one of the most important and long-serving Jahangirid servants, who had been promoted to the rank of 3000/2000, arrived from the port of Cambay to pay homage. I had ordered him to go to the port of Goa on several items of business and see the vice-rei, the governor of Goa, and to purchase any rarities he could get hold of there for the royal treasury. As ordered, he went to Goa with all preparedness and stayed there a while. Without consideration for cost, he paid any price the Franks [Europeans] asked for whatever rarities he could locate. When he returned from there to court, he presented the rarities he had brought for my inspection several times. He had every sort of thing and object. He had brought several very strange and unusual animals I had not seen before. No one even knew what their names were. Although His Majesty Firdaws-Makani [Babur; founder of the Mughal dynasty] wrote in his memoirs of the shapes and forms of some animals,

apparently he did not order the artists to depict them. Since these animals looked so extremely strange to me, I both wrote of them and ordered the artists to draw their likenesses in the *Jahangirnama* so that the astonishment one has at hearing of them would increase by seeing them.

One of the animals was larger in body than a peahen and significantly smaller than a peacock. Sometimes when it displays itself during mating it spreads its tail and its other feathers like a peacock and dances. Its beak and legs are like a rooster's. Its head, neck, and wattle constantly change color. When it is mating they are as red as can be – you'd think it had all been set with coral. After a while these same places become white and look like cotton. Sometimes they look turquoise. It keeps changing color like a chameleon. The piece of flesh it has on its head resembles a cock's comb. The strange part about it is that when it is mating, the piece of flesh hangs down a span from its head like an elephant's trunk, but then when it pulls it up it stands erect a distance of two fingers like a rhinoceros' horn. The area around its eyes is always turquoise-colored and never changes. Its feathers appear to be of different colors, unlike a peacock's feathers.

My Enjoyment of Painting and My Expertise at Discrimination

I derive such enjoyment from painting and have such expertise in judging it that, even without the artist's name being mentioned, no work of past or present masters can be shown to me that I do not instantly recognize who did it. Even if it is a scene of several figures and each face is by a different master, I can tell who did which face. If in a single painting different persons have done the eyes and eyebrows, I can determine who drew the face and who made the eyes and eyebrows.

The Death of Inayat Khan

On this date news came of the death of Inayat Khan. He was one of my closest servants and subjects. In addition to eating opium he also drank wine when he had the chance. Little by little he became obsessed with wine, and since he had a weak frame, he drank more than his body could tolerate and was afflicted with diarrhea. While so weakened he was overcome two or three times by something like epileptic fits. By my order Hakim Rukna treated him, but no matter what he did it was to no avail. In addition, Inayat Khan developed a ravenous appetite, and although the doctor insisted that he not eat more than once a day, he couldn't restrain himself and raged like a madman. Finally he developed cachexia [extreme weight loss] and dropsy [edema] and grew terribly thin and weak.

Several days prior to this he requested that he be taken ahead to Agra. I ordered him brought to me to be given leave to depart. He was put in a palanquin and

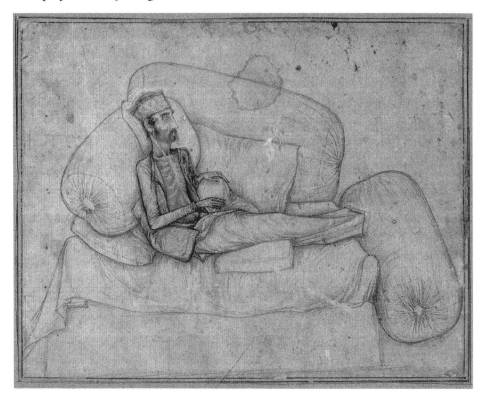

Fig. 10–1 The Dying Inayat Khan. India, Mughal period, *c.*1618–19. Ink and light color on paper. 9.5 × 13.3 cm. 14.679. Reproduced courtesy of the Museum of Fine Arts, Boston, Francis Bartlett Donation of 1912 and Picture Fund.

brought. He looked incredibly weak and thin. "Skin stretched over bone." Even his bones had begun to disintegrate. Whereas painters employ great exaggeration when they depict skinny people, nothing remotely resembling him had ever been seen. Good God! how can a human being remain alive in this shape? The following two lines of poetry are appropriate to the situation: "If my shadow doesn't hold my leg, I won't be able to stand until Doomsday. / My sigh sees my heart so weak that it rests a while on my lip."

It was so strange I ordered the artists to draw his likeness. At any rate, I found him so changed that I said, "At this time you mustn't draw a single breath without remembrance of God, and don't despair of His graciousness. If death grants you quarter, it should be regarded as a reprieve and means for atonement. If your term of life is up, every breath taken with remembrance of Him is a golden opportunity. Do not occupy your mind or worry about those you leave behind, for with us the slightest claim through service is much." Since his distress had been reported to me, I gave him a thousand rupees for traveling expenses and gave him leave to depart. He died the second day.

[handwritten margin note:] He was Intregued by the dying mans form.

100

11

Orthodoxy, Innovation, and Revival: Considerations of the Past in Imperial Mughal Tomb Architecture

Michael Brand

Introduction

In today's advertising, the Taj Mahal serves as an architectural metaphor for the quintessential: the Taj Mahal of bourbons, the Taj Mahal of baseball stadiums, the Taj Mahal of shopping malls. Michael Brand's essay questions the assumed quintessential nature of the Taj Mahal embedded in these advertising slogans, and proposes a more historically grounded reading of the tombs of the Indian Mughal Empire (1526–1858). His essay examines the political, religious, and cultural factors at stake for each Mughal emperor who commissioned an imperial tomb – either for his predecessor or for himself.

The Mughals traced their ancestry to Persian rulers of present-day Iran, specifically the renowned Persian emperor Timur (or Tamerlane, r. 1370–1405), and to the Mongols, who in the thirteenth century under Genghis Khan had invaded Central Asia and Persia. Timur's reign in Persia was the beginning of a cultural renaissance for the Iranian region, one that extended to the Mughals' home region in present-day Afghanistan. Thus Persian tomb architecture was of central importance for the Indian Mughal rulers as they attempted to claim legitimacy over their Indian empire. As Islamic rulers over a diverse populace that worshipped various Hindu deities or

Michael Brand, "Orthodoxy, Innovation, and Revival: Considerations of the Past in Imperial Mughal Tomb Architecture," pp. 323–34 from *Muqarnas* 10 (1993).

followed the teachings of the Jain religion, the Mughals needed to prove their legitimacy to rule on a cultural level as well. Earlier Islamic rulers of South Asia, including the Tughluk Sultanate (1320–1412), had already established a vocabulary of Indian Islamic architecture, melding Persian and Afghani elements with local building materials and aesthetics. Mughal tomb architecture used this already established Indian Islamic aesthetic as a tool to describe their relationship with prior Islamic Indian dynasties and Indian culture more broadly.

Islam, like most religions, changes over time and from region to region, and thus Indian Islam has different emphases from other types of Islamic practice. For example, under the third Mughal emperor, Akbar (1556–1605), the worship of Islamic saints became more popular and paralleled similar Hindu worship practices. Active cross-religious pollination took place, a syncretism that can be seen in the architecture of the time. Thus, where one emperor emphasized orthodoxy, another would emphasize worship of saints or a particular interpretation of Islamic paradise.

By weaving politics, religion, and culture together, Brand produces a reading of both Mughal tombs and Mughal history that remains honest to the sometimes messy struggle of ruling a diverse and far-flung empire. Brand debunks the earlier art historical narrative that placed the Taj Mahal at the pinnacle of all Mughal architecture and replaces it with a more nuanced understanding of the dialogue between architecture and history over the course of six reigns and 181 years.

Between 1606 and 1608 Mughal architects committed a blunder of monumental proportions. Working in the absence of their imperial patron, they constructed a royal tomb considered so inappropriate that when the emperor first saw it he immediately ordered its destruction. In the words of the emperor Jahangir, it "did not come up to my idea of what it ought to be."[1] The structure that had risen at Sikandra, one stage out of the Mughal capital Agra on the road to Delhi, was intended to serve as the tomb of Jahangir's father, the radical but long-serving emperor Akbar who had died in October 1605. The problems began almost as soon as work commenced.

In April 1606, Jahangir's son Khusraw rebelled and headed off towards Lahore, leaving the new emperor with no option but to follow in hot pursuit. Perhaps because Jahangir had once rebelled against his own father, Khusraw escaped fatal punishment when captured the following month near Lahore. Jahangir spent most of the next year based in Lahore consolidating his position and monitoring the situation on the northwest frontier. Khusraw was subsequently blinded in the aftermath of an abortive coup during an expedition to Kabul in mid-1607. The royal cavalcade finally returned to Agra in 1608, with Jahangir later conceding that it was his absence from Agra for the two years that it took him to crush Khusraw's rebellion that allowed his architects to run rampant at Sikandra.

Beyond the immediate question as to whether the original tomb constructed in Jahangir's absence was deemed too radical or too conservative, this strange episode raises two other issues that will serve as theme and sub-theme throughout this essay. The first is that almost a century after the establishment of the Mughal

dynasty in northern India there was apparently still no consensus as to what constituted an appropriate imperial tomb. The second is that the patronage, design, and construction of these crucial markers of political intent were often heavily informed by the storms of dynastic rebellion that clouded the issue of Mughal succession. As a first foray into these areas, this essay can only deal with the death, burial, and entombment of the first six Mughal emperors: Babur (1483–1530), Humayun (1505–56), Akbar (1542–1605), Jahangir (1569–1627), Shah Jahan (1592–1666) and, finally, Awrangzeb (1618–1707). The generalizations are intentional, and no attempt will be made to discuss either finer architectural details or broader themes of landscape context. Burials without major tomb structures, however, will be given equal treatment here for the first time.

Descendants of the great Central Asian amir Timur (1338–1405), the Mughals described their dynasty as "Timurid" rather than the now more commonly used "Mughal" but ruled India as permanent residents.[2] The first Mughal emperor Babur had won and lost the great Timurid capital of Samarqand twice before he gave up on his attempts to revitalize the fading Timurid empire in its home territories and turned his sights towards India, where he established himself on the throne of Delhi in 1526. Because Timur had captured Delhi in 1397, however, he saw this challenge as one of reconquest, not invasion.

Despite an increasingly secure power base in northern India, Mughal power, like that of their late-Timurid forebears, seldom perpetuated itself smoothly. The Mughal imperial system was particularly susceptible to rebellion when it came to deciding matters of succession. The eldest prince was not automatically entitled to follow his father on the throne, and the picture was often further complicated by different wives of the emperor pushing their own progeny towards power. More often than not, violent rebellions relating to succession broke out before the emperor's death. As Jahangir said in 1606, "Kingship regards neither son nor son-in-law. No one is a relation to a king."[3]

Because of the complexity of this Mughal polity it is hardly surprising that the artistic and architectural forms it gave birth to raise so many interesting questions. And no Mughal architectural type is more paradoxical than the imperial tomb.

Three Social and historical factors came into play when the Mughal emperors and their architects thought of burial and entombment: their religion (Islam), their ancestry (Timurid), and their empire (India). To begin with, it is in the Koran that Muslims are instructed in the rudiments of how to bury their dead: after Cain had killed Abel, God sent down a raven which "dug the earth to show him how to bury the naked corpse of his brother."[4] An uncovered grave exposed to the purifying moisture of rain and dew is considered a symbol of humility. Nothing more is required. On the other hand, saints' tombs, which were often covered and occasionally monumental, became an alternative model for royal burial. A variety of responses were thus possible on the occasion of the death of a significant Muslim personage. In imperial circles, however, few opportunities were lost to create a funerary monument of the most impressive and lasting kind.

103

The dichotomy between orthodox prescriptions and imperial practice is a constant issue in the history of the Islamic tomb.

Apart from the strictures of religion, the Mughals were also guided in their entombment practices by their knowledge of two traditions of funerary architecture: one gained through ancestry, the Timurid, and one through conquest, that of pre-Mughal Islamic India (the so-called Sultanate period). When Amir Timur died in 1405 he was buried in a mausoleum in Samarqand known as the Gur-i Amir.[5] As more of Timur's sons and grandsons were buried there over the next half-century, it became a true dynastic mausoleum. For such a historically important building, the form of the Gur-i Amir is quite simple: a modified octagon with a projecting portal.[6] The monument's most obviously Timurid features are its double dome, which rises to a height of thirty-seven meters from an exceptionally tall drum, and its magnificent glazed tile revetment. Although no contemporary painted images of the Gur-i Amir are known, the basic form of this building must have been famous throughout the Timurid world. That few, if any, Timurid buildings carried more prestige is attested by the fact that both Jahangir and Shah Jahan later sent funds to Samarqand for the upkeep of the Gur-i Amir.[7]

On the Indian side of the equation, the Mughals inherited a veritable museum of architecture, as well as teams of architects and masons skilled in the erection of both Islamic and Hindu monuments. Their most direct encounter was with the architectural remains of the fourteenth-century Tughluk dynasty in Delhi. One of the most impressive structures was the tomb of Sultan Ghiyas al-Din Tughluk (r. 1320–5), whose mausoleum lies in a miniature fortress on an artificial island connected by a causeway to the Tughluk citadel. It is a square structure, sixteen meters to a side, faced with red sandstone highlighted with white marble. The dramatically battered walls and squat white marble dome with no drum create a stern aesthetic far removed from what the Mughals would have recalled from their Timurid homeland. These themes – the correct manner of Islamic burial and the relative merits of Timurid and Indian architecture – are barely mentioned in the Mughal histories, but physical evidence suggests that they were the subject of significant intellectual debate.

Babur, the author of a deservedly famous autobiography in which he shows himself to be a keen observer of everything from the architecture of Herat and Samarqand to the flora and fauna of India,[8] had ruled northern India for barely four years when he died in 1530. Even so, the struggle for succession had already begun. The previous year Humayun, his son and heir-apparent, had ridden back to Agra from Badakhshan in contradiction of orders when he heard word of a rumor that his uncle Mahdi Khwaja was being prepared to succeed Babur. Once back in India, however, Humayun fell seriously ill and after the leading imperial physicians had failed to cure him, Babur is said to have decided to offer his own life in return for Humayun's recovery.[9] The exact chronology is sketchy, yet the twenty-two-year-old prince recovered while Babur died on 26 December 1530. Humayun ascended the throne four days later with, as the above story had aimed to show, his late father's blessings.

Babur's death presents our first paradox. Despite being the first Timurid ruler of India and having died at a point when their power was in desperate need of legitimacy, no major dynastic monument was conceived to commemorate his passing. It was marked, instead, by the orthodox burial Babur is said to have requested before his death. He is commonly thought to have been buried first in the so-called Aram Bagh on the opposite side of the Jamuna river in Agra, but there is no contemporary textual evidence to this effect.[10] Babur's daughter Gulbadan Begam mentions a first assembly at his "tomb" (*mazar*), to which sixty Koran reciters had been assigned, but gives a description neither of the grave nor of its location.[11]

At some point between 1539 and 1544, allegedly in compliance with Babur's wishes but perhaps more because of Humayun's flight from India after his defeat by Sher Shah Sur, Babur's body was moved from Agra and re-interred in Kabul.[12] Over the next century his grave was frequently visited by his descendants. As described by the Shah Jahani historian Qazvini, embellishments contributed by Jahangir and Shah Jahan were always in line with Babur's original wishes:

> The burial-garden was 500 yards (*gaz*) long; its ground was in 15 terraces, 30 yards apart [?]. On the 15th terrace is the tomb of Ruqayya Sultan Begam; as a small marble platform (*chabutra*) had been made near it by Jahangir's command, Shah Jahan ordered both to be enclosed by a marble screen three yards high. – Babur's tomb is on the 14th terrace. In accordance with his will, no building was erected over it, but Shah Jahan built a small marble mosque on the terrace below. It was begun in the 17th year [of Shah Jahan's reign (1643–4)] and was finished in the 19th [1645–6].[13]

Although a garden is not a necessary adjunct to Islamic burial, it is clear that Babur's stipulation that he be buried in an uncovered grave reflects a wish to be seen to adhere to orthodox practice. That the minimal nature of such an important memorial could survive almost a century and a quarter of later Mughal attention is clear evidence of the great respect orthodox burial enjoyed at the Mughal court. Since then, however, this original Mughal context of Babur's grave has been totally destroyed.

Humayun does not appear to have had a chance to plan his own burial. Exiled from India by the Afghan Suris in 1540, this mystical and eccentric ruler eventually recaptured Delhi in 1555 only to die in a freak accident the following year. Until the thirteen-year-old Prince Akbar could be brought back from Kalanaur in the Punjab, a local mullah [Muslim cleric] was disguised as Humayun and presented at the times of regular audiences in order to reassure the public about the stability of Timurid rule in India. Humayun's body was at first interred in one of his palaces in Delhi, but afterwards was moved to Sirhind in the Punjab, where Akbar paid homage to the curtain-shrouded coffin in 1558.[14]

Akbar's grip on power was far too insecure at this stage to embark upon any major building projects. With the help of his regent Bayram Khan, three of the

main obstacles to Mughal power – Hemu, Sikandar Shah Sur and Adil Shah Sur – were vanquished by 1557, and an internal rival – Adham Khan – was dispatched (literally, over a parapet at Agra fort) in late November 1561.[15] Thus it was not until 1562 that he ordered work to commence on a tomb for his father in Delhi.[16] Six years after Humayun's original burial, and thirty-six years after the establishment of Mughal rule in India, the symbolic potential of mausoleum architecture had finally proved irresistible.

The site chosen for Humayun's tomb was between the new city of Din-Panah that he had founded in 1533 and the *dargah* of the great Chishti saint Nizam al-Din Awliya. By late 1568 or early 1569, when Akbar sought blessings in Delhi on his way to attempt the capture of a major Rajput fortress, Humayun's remains had already returned to Delhi, but his tomb was not fully completed until 1571.[17] The eight or nine years of construction resulted in a remarkable building the likes of which had never been seen in India (Fig. 11–1). Designed by the emigré Iranian architect Mirak Mirza Ghiyas, who had previously worked in Timurid Herat and Bukhara as well as India, it first impresses by its sheer scale. The mausoleum proper, square in shape with chamfered corners and faced with red sandstone inlaid with white marble, measures almost fifty meters to a side. Its double dome, sheathed in white marble and flanked at each corner by a very Indian chatri (a small pillared pavilion surmounted by a cupola), rises to a height

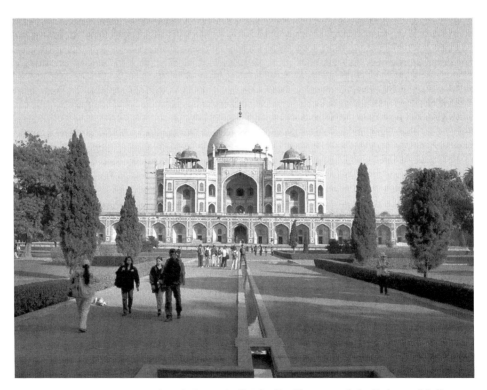

Fig. 11-1 Humayun's tomb, 1562–71, Delhi, India. Photograph by Rebecca M. Brown.

106

of over forty-two meters from a tall drum. The radially symmetrical floor plan consists of an octagonal central tomb chamber surrounded by four corner chambers, with the addition of an ambulatory on the upper level. Also provided by Mirak Mirza Ghiyas was an enclosed garden, almost 350 meters square, replete with paradisiacal allusions.

The form of the building, especially its dome, elegant iwans [vaulted spaces open at one end], and radially symmetrical floor plan point conclusively to Timurid models even though more decorative features, such as the striking juxtaposition of red sandstone and white marble, show a desire to invoke Tughluk or Indian models.[18] The spaciousness of the mausoleum and its many cells suggest that Akbar might originally have intended Humayun's tomb to serve as a dynastic mausoleum, the Mughal equivalent to the Gur-i Amir in Samarqand.

Political instability during the first six years of Akbar's reign had delayed the commissioning of a tomb for Humayun. After three decades of remarkable territorial conquest and political reform, the last five years of Akbar's reign proved to be equally tense as Prince Salim (the future emperor Jahangir) tested his father's strength and resolve. By 1604 Salim was in danger of being pushed aside in the battle to succeed the ageing Akbar by his own seventeen-year-old son Khusraw, but when Akbar presented Salim with his most potent imperial regalia (including Humayun's sword) shortly before he died in 1605 Salim had reason to believe that most of his problems were over. He ascended the throne and adopted the title *jahangir* ("seizer of the world") on 24 October 1605, one week after his father's death.

There is no concrete evidence that Akbar had either planned or started construction of his own tomb in the Agra suburb of Sikandra before he died.[19] As mentioned earlier, Jahangir was in power for six months before he set off in pursuit of the rebellious Khusraw in April 1606. From his comments when he visited the tomb on Akbar's *urs* (death anniversary) in October 1608 that the rebellion had started "at the time of erecting" the tomb and that work had proceeded for three or four years, it may be surmised that work had commenced on the basis of a presumably hurried commission in those first six months after Jahangir ascended the throne. From an inscription on the south façade of the tomb's southern gateway it is known that the tomb was completed in the seventh year of Jahangir's reign, corresponding to 1612–13, after seven years of work.[20]

Akbar's tomb is a highly unusual building that has consistently defied description and analysis. Fergusson [a nineteenth-century art historian] was so baffled that he ventured to suggest its design had been based on a Hindu or Buddhist model and that a "domical chamber" crowning the whole structure would have been part of the original design.[21] It is certainly a far cry from Humayun's tomb in Delhi, with almost the only features in common being its scale and setting in the center of a large walled garden. The tomb, which is also primarily constructed of red sandstone, can perhaps best be described as a series of progressively smaller single-story pavilions set directly on top of each other (Fig 11–2). The lower level, surrounded by small cells opening onto an arcade, is over 100 meters to a side. A

107

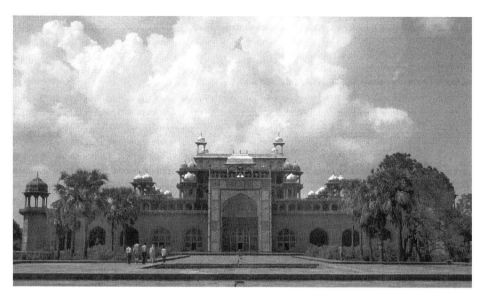

Fig. 11-2 Akbar's tomb, 1605–13, Sikandra, India. Photograph by Deborah Hutton.

womb-like hall, reached by a single dark passageway sloping down from the main entrance, holds Akbar's sarcophagus. The three additional upper floors with their numerous chatris are crowned by a beautiful but incongruous white marble pavilion with a central courtyard open to the sky. In the center of this twenty-five-meter-square terrace, directly above the tomb chamber, lies a cenotaph carved out of a single block of white marble and decorated with floral designs and the ninety-nine names of God. At its head is a marble pedestal that perhaps functioned as a *mibkhara* (censer), but is also said to have once held the Koh-i Nur diamond.

Jahangir had gone through the usual difficult times with his son and heir-apparent Khurram, who was awarded the title Shah Jahan while still a prince in 1617. At first his claims as heir-apparent were supported by his mother, Nur Jahan, but she eventually transferred her support to his brother Shahriyar. By 1622 Shah Jahan was in open revolt against his father, and remained that way for most of the last four years of Jahangir's reign. When Jahangir died on his way back to Lahore from Kashmir on 29 October 1627, Shah Jahan was in the Deccan, and it was only through the tactical brilliance of Asaf Khan (Nur Jahan's brother and the late emperor's governor in the Punjab) that Shah Jahan was able to ascend the Mughal throne in Agra on 24 January 1628.

Almost immediately upon his death, Jahangir's body was dispatched to Lahore for burial in an unnamed garden constructed by Nur Jahan in Shahdara, a recreational zone across the Ravi river.[22] Nur Jahan also returned to Lahore where her family held large tracts of land. It is possible that Nur Jahan, languishing in Lahore in what amounted to internal exile, was partly responsible for the construction of her late husband's tomb, but there is no contemporary evidence to support this frequently made claim. Jahangir's memoirs do not mention how

and where he wished to be buried, so the earliest details are provided in a telling passage by another Shah Jahani historian, Abd al-Hamid Lahori:

> A paradise resembling edifice, in one of the gardens on the other side of the river [Ravi] was constructed as the sacred tomb. As His Majesty [Jahangir], following the tenets of the sunni faith, and the example laid by the late king Babar had willed that his tomb should be erected without the ornamentation of a building, and be entrusted to Divine propitiation in an open space, so that it may always benefit from the countless clouds of Divine forgiveness without any obstruction, his successor [Shah Jahan], in pursuance of His Majesty's will, built an elevated platform of red sand-stone measuring hundred by hundred *ziras* round the tomb, surmounted by a white marble *Chabutra* (podium), twenty by twenty, inlaid in a fashion better than mosaic work, in the exact middle of which was placed a replica of the sarcophagus of the king living in paradise [Jahangir]. Notwithstanding the minimum formalities it cost ten lakhs of rupees and took ten years to build.[23]

Although his sarcophagus is dated 1037 (1627), Jahangir's tomb would thus have been completed in about 1637 and, it would appear, cost thirty percent less than Akbar's at Sikandra, even though the latter was begun over twenty years earlier.

Jahangir's wish that there should be no structure over his grave elicited a unique response from the tomb's unknown architect, which combined open-air orthodoxy with the fundamentals of Mughal monumentality. It is set in the center of a garden enclosure, like Humayun's and Akbar's tombs, almost five hundred meters square and entered through a gate in the eastern wall of a large serai [place of lodging]. The arcaded single-story structure lined with cells, in effect a glorified plinth 110 meters to a side, is faced with red sandstone inlaid with white marble (which would all have to have been brought to the Punjab from a great distance). The white marble tomb chamber, where Jahangir's remains lie in a white marble sarcophagus decorated with magnificent pietra dura designs and the ninety-nine names of God inlaid with black marble, is set within its solid center. A minaret inlaid with chevron patterns and topped by a white marble chatri rises thirty meters from each corner of the terrace above.

But, in what must rank as the boldest gesture in the history of Mughal architecture, the center of the upper terrace has been left completely empty (except for the small platform or pavilion directly above the tomb chamber, mentioned in Lahori's description, that has since disappeared). So powerful is the vast scale of emptiness created by the terrace and the minarets that the viewer is almost compelled to imagine the large domed mausoleum in their midst that Jahangir so expressly forbade. In fact there has been much speculation ever since about whether or not the architect had still actually intended such a chamber to have been built.[24] No one else was buried in Jahangir's tomb, but Asaf Khan's tomb enclosure was attached to the west of the serai in 1641, and Nur Jahan's still further to the west (but separated from the rest of the complex by a narrow roadway) in 1645.[25]

Three of the six Mughal tombs that form the subject of this essay were built, or modified, during the reign of Shah Jahan: the marble enclosure and mosque for Babur's grave in Kabul, Jahangir's tomb in Lahore, and his own, the famous Taj Mahal in Agra. Shah Jahan, Akbar's favorite grandson and a self-styled "second Timur," is thus the only Mughal emperor to have been buried in a tomb designed and built during his own lifetime. Behind this deviation from established Mughal practice lay his wife's premature death in June 1631.

When Mumtaz Mahal died from complications after childbirth in Burhanpur she was given a temporary burial (*amanat*) in a garden there before her body was moved back to Agra, where it arrived in January 1632.[26] Work on the Taj Mahal began almost immediately and Mumtaz Mahal's first *urs* was celebrated at its foundations in June 1632. The tomb was sited on land resumed from one of Shah Jahan's courtiers, Raja Jai Singh of Amber, on the banks of the Jamuna river to the east of the city. Shah Jahan is known to have played a leading role in architecture during his reign,[27] and there is no reason to believe he did not continue this practice with the Taj Mahal during the eleven years of his construction. The architect with overall responsibility for the project was probably Ustad Ahmad Lahori who, as his name suggests, was a local rather than an emigré from Iran or Central Asia.

It was at Mumtaz Mahal's twelfth *urs* on 6 February 1643 that the completion of the "Illumined Tomb" (as it was known in Mughal histories) was celebrated. The entire complex had cost the imperial treasury 5 million rupees, five times the cost of Jahangir's tomb.[28] While Shah Jahan ruled confidently and largely without internal challenge during the construction of the Taj Mahal, he was eventually deposed in 1658 by his son Alamgir, who ruled under the title Awrangzeb after imprisoning his father in Agra fort. Shah Jahan died there on 22 January 1666 and was buried next to his wife in the Taj Mahal the following day, after a modest funeral. Awrangzeb was in Delhi when his father died but came to offer prayers at his tomb the following month.

Serais and bazaars, which also contributed revenue to the maintenance of the Taj Mahal, sit directly to the south of the main gateway balancing the mausoleum itself, which sits on a raised marble plinth occupying a similar area on the other end of a formal garden 300 meters square. The whole complex stretches approximately 545 meters from the north to south. The square white marble mausoleum with chamfered corners is almost 60 meters to a side and 35 meters tall. Its central double dome sitting on a tall drum, rising to a total height of about 60 meters, is balanced by 44-meter-tall minarets at each corner of the plinth. The floor plan is radially symmetrical, focusing on an octagonal domed hall above an octagonal crypt. A matching pair of cenotaphs for Shah Jahan and Mumtaz Mahal, surrounded by a pierced marble screen, lie in the upper chamber and another pair of sarcophagi in the lower; all are of white marble and decorated with magnificent pietra dura inlay as well as the ninety-nine names of God. A distinguishing feature of the Taj Mahal is the first use on a Mughal imperial tomb of a significant inscriptional program, consisting mainly of verses from the Koran.[29] The white

marble mausoleum is flanked to the west and east respectively by a red sandstone mosque and resthouse (*mihman-khana*).

Awrangzeb has a reputation for being a far more orthodox Muslim than his predecessors. While this reading of his character is not unwarranted, his policies were not always far removed from prior Mughal practice. When his main consort Dilras Banu, known as Rabia al-Daurani, died in Aurangabad in 1657 he had her buried in a tomb designed by Ata Allah, the son of Ustad Ahmad who is presumed to have designed the Taj Mahal. Bearing a striking resemblance to the latter building and now known as the Bibi ka Maqbara (the Wife's Tomb), it was completed in 1660–1. It was towards the end of his life, when grand political failures wrecked his ambitious plans in the Deccan, that Awrangzeb became even more devout and orthodox in his beliefs. By 1667–8 he had memorized the entire Koran (an endeavor that took him seven years) and written it out a number of times in his own hand. He also issued a decree stating that visiting graves is contrary to the sharia.[30]

Awrangzeb died in Ahmadnagar on 20 February 1707 at the age of 91. According to his ardent wishes, his burial was, not surprisingly, a very simple affair:

> The Qazi, scholars, and pious men engaged in furnishing and shrouding his corpse for burial, in the terms of his last will, performed the funeral prayer, and kept his body in the khabgah, till at last … Prince Muhammad Azam … arrived on Saturday, the 22nd February.…According to His Majesty's last will, he was buried in the courtyard of the tomb of Shaykh Zaynuddin [at Rauza, near Daulatabad] in a sepulchre built by the emperor in his own lifetime.…The red stone platform (*chabutra*) over his grave, not exceeding three yards in length, two and half yards in breadth, and a few fingers in height, has a cavity in the middle. It has been filled with earth, in which fragrant herbs have been planted.[31]

This is the scene that still greets the many pious visitors to his grave in Khuldabad, just outside Aurangabad in the Deccan. A Taj Mahal it is not, but what it lacks in monumentality it certainly makes up for with its powerfully conceptual aesthetic.

The preceding survey of these six imperial Mughal graves and tombs – Babur's in Kabul, Humayun's in Delhi, Akbar's at Sikandra, Jahangir's at Lahore, Shah Jahan's in Agra, and Awrangzeb's near Aurangabad – highlights a number of important facts. The first, and most obvious, is that the Mughals did not construct a single dynastic mausoleum. If, as is quite possible, Humayun's tomb was intended by Akbar to serve such a function, then Jahangir's construction of a tomb for Akbar at Sikandra was an implicit rejection of the notion. None of these Mughal emperors were even buried in the same city (although, admittedly, Sikandra was only one stage out of Agra). Nor was one form or style adopted for all the tombs we have looked at, although Humayun's tomb and the Taj Mahal do share similar forms, and certain themes, such as the use of white marble and garden settings, do recur. Furthermore, this diversity of form does not even develop in

111

a single direction. There are clearly too many missing links and throwbacks to support a theory of evolution marching resolutely towards the Taj Mahal.

Rebellions, wars of succession, and, in one case, the premature death of a wife further cloud the history of Mughal tombs in terms of both chronology and patronage. Final embellishment of Babur's grave in Kabul, for example, was only completed in 1645–6, two years after the Taj Mahal was finished in Agra. Between 1632 and 1637 the last five years of construction work at Jahangir's tomb in Lahore overlapped with the first five years of work at the Taj Mahal. Although Fergusson wrote that the "princes of the Tartar races, in carrying out their love of tombs, made it the practice to build their own in their lifetime, as all people must who are really desirous of sepulchral magnificence,"[32] the Mughals were seldom able to plan ahead. In fact, while Babur and Awrangzeb willed their own simple burials, only Shah Jahan designed and built the tomb in which he was buried. Humayun, Akbar, and Jahangir were all entombed in structures built by their sons and successors (perhaps with the assistance of his wife in the latter case). In this context it might be asked whether Mughal tombs were really erected to commemorate dead emperors or as victory monuments for the survivors of internecine warfare.

Patterns do emerge, however, in the development of Mughal tomb architecture. Babur and Awrangzeb were buried in accordance with orthodox Muslim practice. Their simple graves are open to the sky and free from any other superstructure. Only stone screens and formal gardens define any kind of commemorative space. Both Humayun and Shah Jahan, on the other hand, were buried in tombs that, rejecting the precedents set by their own fathers' tombs, can only be described as Timurid revivals. Huge double-domes set on elevated drums, lofty arched iwans, and radially symmetrical floor plans all point towards the Timurid past, even if other key Timurid elements such as multicolored glazed revetments are nowhere to be found. Of course, neither building is a complete appropriation of a Timurid design, but the effect on the Indian viewer would hardly have been diminished.[33] After all, less goes further on the frontier. The tombs of Akbar and Jahangir, however, fit into neither category. Tentative steps towards the dramatic design of Jahangir's tomb were admittedly taken a few years earlier at Itimad al-Dawla's tomb in Agra (1622–8; perhaps commissioned by Nur Jahan, his daughter), but nothing would have prepared the viewer for Akbar's tomb at Sikandra. Neither tomb follows a known imperial model, Indian or Timurid. The highly adventurous nature of these buildings is reflected in the way they attempt to memorialize an individual in a monumental way while still adhering to the orthodox notion of open-air burial. They are among the most radically innovative structures in the history of Indian and Islamic architecture.

During the almost two centuries between Babur's death in 1530 and Awrangzeb's in 1707, the concept of the Mughal tomb turns full circle from the orthodox, to the Timurid revival, to the radically innovative, and then back again.[34] The identification of these three themes in the history of Mughal tomb architecture allows each of these six imperial mausolea to be considered in its own

light rather than to be judged solely against the Taj Mahal in its popular role as the paragon of Mughal architecture.

The tombs constructed for Akbar and Jahangir, for example, can thus be appreciated for their truly revolutionary design and not as "failed" victims of an architectural "retrogression." Just as importantly, the Taj Mahal itself can be seen not as the climax of an interrupted evolution, but as a conscious revival of an earlier style with its inherent political symbolism reinforcing Shah Jahan's view of himself as the "second Timur." This pattern of revival and innovation, and its enduring dialogue with orthodox tenets, is highly informative with respect to the use of the past in Mughal architecture. It shows how in the case of funerary architecture the Mughals considered the past as something to be appropriated and adapted at will rather than polished generation by generation to an absolute perfection. In other words, ideology took precedence over purely formal considerations.

Notes

1 Nur al-Din Jahangir Padshah, *Tuzuk-i Jahangiri*, trans. Alexander Rogers, 2 vols. (1909–14; rpt. Delhi, 1968), 1:152.

2 For the renewed interest in the Mughals as Timurids, see Michael Brand and Glenn D. Lowry, *Akbar's India: Art from the Mughal City of Victory* (New York, 1985); Thomas W. Lentz and Glenn D. Lowry, *Timur and the Princely Vision: Persian Art and Culture in the Fifteenth Century* (Los Angeles and Washington, DC, 1989) pp. 319–24.

3 Jahangir, *Tuzuk-i Jahangiri*, 1:52.

4 Koran, 5:31.

5 Timur might originally have planned to be buried in his Dar al-Siyadah at Shahrisabz before he made Samarqand his new capital; see Lisa Golombek and Donald Wilber, *The Timurid Architecture of Iran and Turan*, 2 vols (Princeton, 1988), 1:68.

6 For a detailed description and analysis of the Gur-i Amir, see Golombek and Wilber, *Timurid Architecture*, 1:260–63 and vol. 2, fig. 27.

7 Lentz and Lowry, *Timur and the Princely Vision*, p.324.

8 Zahir al-Din Babur Padshah, *Babur-nama (Memoirs of Babur)*, trans. Annette Beveridge (1922; rprt. Delhi, 1979). Babur also described a number of examples of India's architecture and visited several tombs after arriving in Delhi.

9 Abu'l Fazl, *Akbarnama*, trans. H. Beveridge, 3 vols. (1902; 2nd rprt. Delhi, 1979), 1:275–76.

10 See, for example, Syad Muhammad Latif, *Agra Historical and Descriptive* (1896; rprt. 1981), p.189. More information about the name and history of this garden can be found in Ebba Koch, "Notes on the Painted and Sculpted Decoration of Nur Jahan's Pavilion in the Ram Bagh (Bagh-i Nur Afshan) at Agra," *Facets of Indian Art*, ed. Robert Skelton et al. (London, 1986), pp.51–65.

11 Gulbadan Begam, *The History of Humayun (Humayun-Nama)*, trans. Annette Beveridge (1901; rprt. Delhi, 1972), pp.110–11.

12 Mirza Kamran visited his father's grave in Agra just after Humayun's defeat at the battle of Chausa in 1539 (Gulbadan Begam, *History of Humayun*, p.138); for evidence of the body's being in Kabul by 1544, see Jawhar Aftabchi, *Tazkirat al-Vaqi'at*, trans. Charles Stewart (1832; rprt. Delhi, 1972), p.83. For a study of the site with plans, see Maria Teresa Shephard Parpagliolo, *Kabul: The Bagh-i Baburi* (Rome, 1972).

13 Qazvini, *Padshahnama*, as translated and quoted in a translator's note to the *Babur-nama*, p.lxxx. Ruqayya Sultan Begam (d. 1626) was a granddaughter of Babur who, as Akbar's first wife, brought up Shah Jahan as a child.

14 Abu'l-Fazl, *Akbarnama*, 2:102.

15 This was one case where any sibling rivalry for succession was entirely overshadowed by external threats to Mughal power.

16 For detailed analyses, with plans, of Humayun's tomb, see Glenn D. Lowry, "The Tomb of Nasir ud-Din Muhammad Humayun," PhD diss., Harvard University, 1982, and idem, "Humayun's Tomb: Form, Function, and Meaning in Early Mughal Architecture," *Muqarnas* 4 (1987): 133–48. In the latter article (p.136), Lowry rejects the popular belief that the tomb was built by Humayun's widow Haji Begam.

17 Abu'l-Fazl, *Akbarnama*, 2:489; 'Alad al-Qadir Bada'uni, *Muntakhab at-Tavarikh*, trans. G. S. A. Ranking et al. (1898–99; reprt., Delhi, 1973), 2: 135.

18 For the Timurid connection, see John D. Hoag, "The Tomb of Ulugh Beg and Abdu Razzaq at Ghazni, a Model for the Taj Mahal," *Journal of the Society for Architectural Historians* 27, 4 (1968): 234–48; Lisa Golombek, "From Tamerlane to the Taj Mahal," *Essays in Islamic Art and Architecture in Honour of Katherina Otto-Dorn*, ed. A. Daneshvari (Malibu, Calif., 1982), p.49; and Lowry, "Humayun's Tomb." For the Tughluk connection, see ibid., p. 136.

19 Most writers seem to follow James Fergusson, who provided no evidence for his claim to this effect: *History of Indian and Eastern Architecture* (1876; revised ed. 1910; rprt. Delhi, 1972), 2:298.

20 Smith, *Akbar's Tomb*, pp.33–34.

21 Fergusson, *History*, 2:298–302.

22 Mu'tamad Khan, *Iqbalnama-i Jahangiri*, partially trans. in H. M. Elliot and John Dowson, *The History of India, as Told by Its Own Historians*, 8 vols. (1867–77; rprt. Allahabad, 1981), 6:436.

23 Muhammad Salih Kanbu, *'Amal-i Salih*, trans. and quoted in Muhammad Baqir, *Lahore Past and Present* (Lahore, 1984), pp.423–24.

24 For an early (1910) discussion of this question, see J. P. Thompson, "The Tomb of the Emperor Jahangir," in *Selections from Journal of the Panjab Historical Society*, ed. Zulfiqar Ahmad, 3 vols. (Lahore, 1982), 1:31–49.

25 For more details about the Shahdara complex, see James L. Wescoat, Jr., Michael Brand, and M. Naeem Mir, "The Shahdara Gardens of Lahore: Site Documentation and Spatial Analysis," *Pakistan Archaeology* 25 (forthcoming). A more comprehensive volume on the subject is also currently under preparation by Brand and Wescoat.

26 For textual and epigraphic sources on the Taj Mahal, see W. E. Begley and Z. A. Desai, *Taj Mahal: The Illumined Tomb* (Cambridge, Mass., 1989). For a more speculative analysis of the Taj Mahal's possible symbolism, see W. E. Begley, "The Myth of the Taj Mahal and a New Theory of Its Symbolic Meaning," *Art Bulletin* 61 (1979): 7–37.

27 Abd al-Hamid Lahori, *Padshahnama,* quoted and trans. in Begley and Desai, *Taj Mahal,* pp.9–10.

28 Ibid., pp.81–82.

29 The inscriptions, designed by Amanat Khan, are fully listed in Begley and Desai, *Taj Mahal,* pp.187–246. See also, W. E. Begley, "Amanat Khan and the Calligraphy on the Taj Mahal," *Kunst des Orients* 12 (1978–79): 5–60.

30 S. M. Azizuddin Husain, ed., *Kalimat-i-Taiyibat (Collection of Aurangzeb's Orders): Inayatulla Khan Kashmiri* (Delhi, 1982), p.47.

31 Saqi Must'ad Khan, *Ma'asir-i'Alamqiri,* trans. Sir Jadunath Sarkar (Calcutta, 1947), pp.309–10.

32 Fergusson, *History,* 2:289.

33 As an example of direct Mughal borrowing from the past, Muhammad Waris relates in his *Padshahnama* that Shah Jahan's architects consciously emulated Akbar's jami masjid at Fathepur Sikri (completed in 1571–72) when planning his jami masjid in Delhi in the 1650's: Ebba Koch, "The Architectural Forms," in Michael Brand and Glenn D. Lowry, eds., *Fatehpur-Sikri* (Bombay, 1987), p.146, n.3.

34 The symmetry in this pattern is intriguing: Babur's tomb (orthodox), Humayun's (Timurid revival), Akbar's (radically innovative), Jahangir's (radically innovative), Shah Jahan's (Timurid revival), and Awrangzeb's (orthodox).

12

Timeless Symbols: Royal Portraits from Rajasthan 17th–19th Centuries

Vishakha Desai

Introduction

What does it mean to paint a portrait of a ruler? Is the pre-eminent objective to create a physical likeness of the subject, or is it to situate the subject within a specific tradition of kingship? Desai explores these queries in the context of South Asian court painting. She focuses on Rajput royal portraits; that is, paintings created of and for the *rajas* (kings) who ruled the northwestern regions of India between the seventeenth and nineteenth centuries. Specifically, by examining how artists depicted facial features and employed perspective and composition, Desai links the development of portraiture to longstanding traditions of Rajput royal authority.

The term Rajput denotes the Hindu warrior caste that made up the rulers of various western Indian desert regions and the Punjab Hills to the north. From the sixteenth through the mid-nineteenth centuries these kingdoms were vassal states of the Mughal Empire (1526–1858). Exhibiting varying degrees of friendliness and resistance to the Mughals, the Rajput *rajas* retained autonomy over their locality as long as they provided military and financial support to the empire. Each of the major Rajput courts, including the kingdoms of Mewar, Marwar, Bundi, and Bikaner (all mentioned by Desai), supported a royal painting workshop, in which artists created illustrated manuscripts and single-page paintings for the king, royal family, and nobles. Images

Vishakha Desai, "Timeless Symbols: Royal Portraits from Rajasthan 17th–19th Centuries,' pp. 313–16, 320–6, 337–42 from Karine Schomer et al. (eds), *The Idea of Rajasthan*. Delhi: Manohar, 1994.

116

from Rajasthan and the Punjab Hills share characteristics such as an emphasis on similar subject matters. Additionally, artists frequently moved between the various kingdoms and the Mughal court, taking painting practices with them and thereby bringing a certain amount of consistency to all Indian painting of the period. Nonetheless, each court workshop maintained a recognizable artistic style. In fact, art historians often refer to each kingdom's painting tradition as a "school" (the Mewari school of painting, for example) in order to signify the distinctiveness of a region's tradition. In this article, Desai discusses several individual Rajasthani courts, but also views Rajput portrait painting as sharing certain traits that she then analyzes as a whole.

By tracing the development of Rajput portraiture between the seventeenth and nineteenth centuries, Desai demonstrates how court artists appropriated elements from Mughal painting traditions and slowly modified them to suit Rajput conceptions of royal authority. Making a distinction between "empirically oriented portraiture" and other types of portrait painting, Desai also reminds us that artistic categories such as "portraiture" are not universal, made up of a set checklist of characteristics, but are culturally contingent, shaped by the needs of the particular society.

One of the most important cultural consequences of the interaction between the Mughal and Rajput courts was the development of Rajput portraiture in Rajasthan,[1] beginning in the first half of the 17th century. Previously, the production of images under Rajput patronage had consisted primarily of illustrations of religious and literary manuscripts such as the *Bhagavata Purana*, *Ramayana*, and the *Ragamala*. Now, the Rajput rulers also began to commission paintings of themselves, alone or in a courtly setting – watching a performance, hunting, sitting in a *darbar*, or smoking a *huqqa*.

In a culture that had traditionally emphasized connections with the past and the eternal qualities of life rather than empirical observation of everyday reality, pictorial representation of an individual's reign was something entirely new. In order to understand this development in Rajasthani painting, we need not only to examine its antecedents and distinctiveness, but also to understand it in the broader context of Rajput culture. Conversely, a careful analysis of these portraits can provide us with a better understanding of Rajput cultural concepts and values.

Though pictorial representation of individual Rajput rulers was a new phenomenon, the literary and bardic accounts give us a fairly clear picture of how ideal kings were defined and understood. In this literature, whose viewpoint is reflected in James Tod's *Annals and Antiquities of Rajasthan*, the chief characteristics which define a model ruler are his genealogy, his courage in defending the honor of his land and lineage, and his munificence. It is important that a ruler be brave (*vira*), magnanimous (*udara*), and generous (*dani*). His kindness to his subjects and his role as protector of his people (*lokapala*) are also emphasized. These bardic descriptions are characteristically exaggerated in their praise and adulation

of a virtuous king, the emphasis being not so much on the specific actions of the ruler as on general attributes of kingship and on a Rajput ruler's traditional role as a virtuous inheritor of his ancestors' rule and land.[2]

This stress on the timeless virtues of kingship and the notion of a king's role as hereditary protector of his subjects stand in sharp contrast to the notion of an ideal ruler as described in the Mughal chronicles. Study of the *Akbarnama* and the *Tuzuk-i Jahangiri* reveals a strong emphasis on the absolute authority of the king. "King of kings", "Glory over the head of mortals", or "Paramount over famous sovereigns and mighty" are the characteristic descriptive phrases.[3] Additionally, the fact that such historical chronicles, integral to Mughal notions of history and of a ruler's legitimacy, are completely absent in the Rajput world also suggests a very different view of time and history. By and large, the Rajput view, rooted in certain fundamental concepts of Hindu thought, does not emphasize specificity of events, or even the personalities shaping the events. It is this lack of interest in the observation and recording of actual events and activities, and in the specific description of physical attributes of historical personages, combined with the absence of the concept of a ruler's absolute authority, which account for the lack of physiognomically-specific royal portraiture in pre-Mughal India.

With the advent of imperial Mughal culture under the emperor Akbar and his successors, the Rajput rulers of Rajasthan came in close contact with another way of looking at the world. This new view was infused with Akbar's preoccupation with the establishment of his authority in the form of incessant documentation of his actions, and his genuine interest in the observation of the actual world of nature, events, and individuals – a view which had given rise to and shaped the whole development of Mughal portraiture.

In examining the Rajput tradition of royal portraits that grew out of contact with the Mughals, there are two central questions. First, what aspects of Mughal portraiture were adopted by the Rajput court painters, what themes and elements were borrowed only selectively, and what was left out altogether? Secondly, what is the significance of the selection and adoption process in the context of traditional Rajput cultural values?

The 17th Century

It is not surprising that the earliest Rajput portraits are greatly indebted to Mughal prototypes. The degree and nature of the Mughal influence varies from court to court, depending on the Rajput ruler's relationship with the Mughals, his willingness to adopt new ideas and fashion and his artists' awareness of and ability to create new kinds of pictures. Thus, some of the early portraits are directly based on Mughal works and may have been done by Mughal artists who had migrated from Delhi. Others are in the Mughal idiom but reflect Rajput sensibilities. A third group borrows only the concept of rendering likenesses from

the Mughal tradition but develops a much more thoroughly Rajput vision, with only a slight trace of Mughal style.

The earliest known group of Rajput portraits come from areas that had developed strong political connections with the Mughal empire at a fairly early stage. Thus, Bikaner, Bundi and Marwar are among the most important centers of early portrait painting in the Mughalized idiom. Raja Rai Singh of Bikaner (r. 1571–1611) had succeeded in breaking away from the state of Marwar and in establishing an independent kingdom only with the help of Akbar, who successfully invaded Marwar in 1569 and guaranteed Rai Singh free possession of Bikaner (Tod 1971: II, 958). The alliance was further strengthened by the marriages of Rai Singh and Akbar to princesses of Jaisalmer who were sisters (ibid., II, 1133). Maldeo of Marwar (r. 1532–68) had been defeated by Akbar in 1568–9, but a close connection between Marwar and the Mughal emperor was established by Maldeo's successor Udai Singh, who sought Mughal support to weaken the claims of his bother to the Marwar throne (ibid., II, 959–61). For Rao Surjan Singh of Bundi (r. 1533–*c*.1575), an alliance with Akbar after the fall of his fort at Ranthambhor in 1569 meant freedom from vassalage to the Rana of Mewar (ibid., III, 1480–2).

Significantly, each of these Rajput rulers opted to accept Mughal sovereignity with the hope that he would gain power over or independence from his Rajput foes. In other words, the actions of these rulers were determined by their attitudes toward their own world, the Rajput world, with little regard for the resultant subjugation to the Mughal throne. They responded to Akbar's political and military overtures in order to support their own new claims or settle old scores within the context of a quintessentially Rajput world. Similarly, it can be argued that the Rajput adoption of Mughal portrait conventions was not simply a formal or pictorial development but the result of a conscious selection process whereby new conceptual and visual ideas were incorporated into a pre-existing Rajput framework.

Early portraits from these three kingdoms consist primarily of single figures, bust and "balcony" portraits, equestrian images, and occasionally of entertainment scenes.[4] The earliest of these images were most likely painted by the artists at the Mughal court while others were painted by artists who may have migrated from the imperial centers to the regional Rajput courts. For example, a line drawing of Raja Karan Singh of Bikaner (r. 1631–69/71), dating from the mid-17th century, is attributed to a leading Muslim artist trained in the Mughal idiom.[5] In its sensitive treatment of the face, particularly the eyes, modeling around the chin, delicate hair line, and the three-dimensional folds of the garment, this lifelike sketch is very close to contemporary Mughal works. Lack of stylization and the freshness of the picture suggests that it was done from life. Such an execution would not have been possible for an artist who was not used to transforming observations from the physical world into a convincing visual image on the two-dimensional surface of paper. It is unlikely that in the first half of the 17th century, this transformation could have been achieved by a court artist not trained in the Mughal tradition.

While Bundi, Bikaner and Marwar adopted the concept of portraiture from the Mughals at an early stage, the court of Mewar was one of the last major centers to accept this empirically oriented art form. One of the last Rajput states to surrender to the Mughals and accept their sovereignty, Mewar was culturally conservative as well, extolled by later eras for having preserved traditional Rajput values rather than adopting Mughal ways.

The earliest known Mewari portraits, based largely on contemporary Bundi images, date from the reign of Rana Raj Singh (r. 1652–80; Topsfield 1980: 10). Significantly, these images form a very small part of the Mewar painters' repertoire, and the Mughalized style of these pictures does not seem to have had a significant impact on the more prolific production of religious and literary manuscript illustrations. For manuscripts, artists continued to use the traditional, hieratic style with only minor modifications. Both the illustrated manuscripts and the secular court pictures were commissioned by royal patrons, and it is very likely that they were painted by the same group of court artists. From the study of Mewari painting at the end of the century it is clear that Mewar artists, unlike their contemporaries at Bundi and Bikaner, did not infuse all of their pictures with Mughalized idioms. Rather, they selectively borrowed motifs and styles when appropriate for a particular theme or subject. Just as in the political history of the 17th century, Mewar's stance was one of conservatism and resistance to the new order, in the realm of painting as well, it can be argued, Mewar exhibited the characteristic Rajput pattern of selective adaptation to the outside world without any fundamental departure from the traditional world view.

This pattern of selective borrowing, present to varying degrees in the different traditions of Rajasthani painting, is most evident in the conspicuous absence of historical or event-specific portraits. By contrast, a large number of the portraits of Mughal emperors come from historical manuscripts such as the *Jahangirnama* and the *Padshahnama*. Even the *darbar* scenes showing these emperors are usually illustrations of specific events described in the chronicles (Desai 1985: 12–14). The answer to this lack of historical portraits in 17th-century Rajasthani painting lies in the Rajput character itself. As suggested earlier, Rajputs were accustomed to a traditional Indian view of temporal reality as only a small part of a universe with infinite time cycles. What appealed to them were the notions of timelessness and of an enduring link between the present and the past. Their notion of history was bardic, with no inclination to separate facts from legends, or historic present from mythic past. For them, there was no great virtue in emphasizing historical description over visionary or idealized expression. Even under the strong influence of 17th-century Mughal empiricism, these quintessentially Rajput rulers resisted the Mughal notions of kingship that emphasized the temporal power and the historical position of rulers. The 17th-century Rajput rulers selected and patronized those aspects of Mughal portrait painting which could be adapted to their own concept of royalty, while avoiding others which were alien to their world view.

120

The 18th Century

In the 18th century, portraits and works on other secular themes greatly increased at the Rajput courts, gradually eclipsing religious and literary manuscript illustrations. By the second quarter of the century, depictions of rulers in a variety of settings, ranging from Holi celebrations to hunting scenes, became predominant themes. Stylistic innovation and artistic excellence are clearly evident in works on these courtly subjects, whereas the manuscript illustrations of the period appear increasingly formulaic and repetitive. However, this new emphasis on secular or courtly subjects does not mean that the royal portrait tradition in Rajasthan was coming under a stronger influence of the Mughal tradition. On the contrary, most innovations in 18th-century Rajasthani court portraiture had little to do with the Mughal tradition. Instead, it was at this time that royal portraiture in Rajasthan truly came of age.

A late bloomer in the portrait tradition, Mewar became the leading center of contextual portraiture in the first half of the 18th century. This change is first evident in the paintings from the reign of Rana Amar Singh II (b. 1672, r. 1698–1710). Even before coming to the throne, Amar Singh seems to have been an active patron, commissioning portraits of himself in the Mughalized *grisaille* style.[6] However, from around 1705 onward, paintings from his reign display a new vision of courtly themes. *Maharana Amar Singh Celebrating Holi with his Courtiers* (Fig. 12–1) exemplifies this new tradition of contextual portraits. In a luxuriant garden filled with cypresses and richly foliated trees, the haloed Maharana, larger in scale than everyone else, presides over the formal Holi celebrations. Such large panoramic depictions of rulers had no precedent in Mughal painting. Even though the image may represent a specific Holi *darbar*, there is little suggestion in the composition of a specific moment in time. One feels as if this is a prototypical representation of a Holi *darbar*. Rather than depicting a particular historical moment, it is imbued with a sense of timelessness. And yet the individualization of figures and their careful placement suggests that the artist has attempted to record the scene carefully. His observation is further corroborated by the detailed inscription on the reverse which identifies the scene as the celebration of Phag (Holi) in the royal pavilion of the Sabrat Vilas garden. Also given are the names of every figure in the picture, including those of the musicians. Although the detailed inscription imparts a sense of specificity to the scene, thus recalling the Mughal aesthetic preference for empirical observation, its content as well as the painting's spatial organization are radically different from Mughal examples.

When we compare the Amar Singh *darbar* with that of the Mughal emperor Jahangir, both appear formal and hierarchical. The central placement of the haloed rulers and the devices that set them apart from other figures, have similarities. However, conceptually and spatially these images are products of two very different worlds. In the Mughal *darbar* the hierarchy is established in

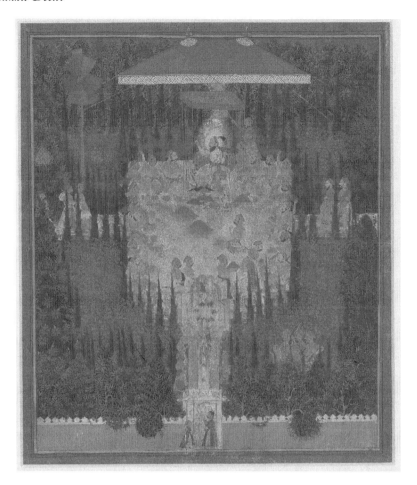

Fig. 12-1 Maharana Amar Singh Playing Holi with Courtiers. Udaipur, *c.*1708. 47 × 40.5 cm. Opaque watercolor on paper. Reproduced courtesy of National Gallery of Victoria, Melbourne, Felton Bequest.

a linear placement of the figures. Closest to the emperor are members of his immediate family and his most trusted advisors.[7] As we move away and downward from the locus of power we meet such petty functionaries as the accountant of the elephant stables. In characteristic Mughal fashion, the only seated person in the composition is the emperor himself: all authority emanates from him and everyone else is subservient to him.

The Amar Singh *darbar* displays a radically different spatial organization and a correspondingly different hierarchical system. The closest members of the Maharana's family – the heir-apparent Sangram Singh, and Maharaja Umed Singh, the closest and seniormost relative of the Maharana – are placed not near the ruler, but at the cardinal points of the square. Seated closest to the ruler are the priest and the seniormost grandees of the vassal states (*thikanas*) of Mewar. Although the Maharana is distinguished from others by a halo and such royal emblems as the shield, fly whisk, and *huqqa*, he is seated among equals. In sharp

contrast to the Mughal *darbar*, where all but the emperor are standing, the Maharana's courtiers are all shown seated as well. The standing figures in the Mewar painting, primarily attendants, servants and musicians, are clearly from inferior social groups. Instead of the purely linear hierarchy and absolute power accorded the Mughal emperor in the *darbar* of Jahangir, *Rana Amar Singh Celebrating Holi* suggests a more spatially arranged system of power in which the Rajput ruler acknowledges the support and power of his feudatories, who are fellow clansmen. He sees himself as a "first among equals."

Portraits of this kind, set in distinctively Rajput contexts, began with the reign of Amar Singh and continued to be produced in increasing numbers throughout the century. In Mewar, the focus was on large panoramic pictures of Maharanas celebrating festivals, watching dance and music performances, or hunting with full regalia (Desai 1985: 66–70, Topsfield 1980: 81–135). Stylistically, these pictures display a somewhat confusing combination of superficial Mughal conventions and predominantly Rajput features. For example, following the Mughal tradition, there is some attempt at rendering perspective in the architectural backgrounds of these pictures. However, more often than not, the diagonal lines suggesting depth diverge rather than converging on one point, and create an effect of aerial or isometric perspective. Such bird's-eye views of palace interiors and courtyards allow the artists to include a large amount of anecdotal imagery. Details – an attendant dozing off, another one fanning a fire, a courtier offering a flower – give an air of observed reality to such pictures. However, it would be impossible to observe such microscopic forms within large panoramic scenes in the real world. The artist in this tradition paints what he knows, not what he sees, or rather, he translates what he sees into what he knows, and then proceeds to create a conceptual rather than a perceptual view of the world. This is in keeping with the Rajput predilection for universal rather than temporal visual symbols.

Such an approach allows the artist not to feel bound by a "rational" view of things or by naturalistic conventions for creating compositions. Ultimately, it makes him better suited to visualize the conceptual framework of his Rajput patrons. Indeed, multiple viewpoints and sequential actions within a single composition are a reflection of the non-empirical tendencies of the Rajput and traditional Hindu world view. For all their visual details, these court portraits are more like archetypal visualizations of a given scene. As B. N. Goswamy has observed, "one senses that in rendering a moment the painter is not losing sight of the moments that have gone by and those that are yet to come" (in Desai 1985: xxi). Much as in the illustrations of literary and religious manuscripts, the emphasis in these pictures is on clarity and comprehension of the narrative.

The lack of specificity in relation to historical or linear time in these picures of court life is also seen in the treatment of individual figures. Facial expressions and specific physical appearances form only a minor part of the distinguishing characteristics of an individual. In most cases, we identify the rulers through attributes such as the halo, ornaments, clothing, and weapons. Often, eyes are idealized, and

it is through the outlines of a figure's forehead, nose or chin that we begin to differentiate between individuals. That almost all of these figures are rendered in profile, devoid of specific human emotions and without any sense of temporal connection with the viewer, also lends a sense of timelessness to them. It is fair to say that such figures are treated as idealized iconographic symbols of royalty in the same way as images of deities. Even though the royal figures are historical and have the potential to be carefully observed, the artists at the Rajput courts again and again turn to ageless conventions to add a touch of generality to their specific rendering of a given patron. Indeed, the Rajput patrons seem to have preferred such an idealized and selective rendering of their lives, often in direct contradiction with the harsh political realities of their times.

Conclusion

Through this survey of royal portraiture in Rajasthan it is possible to understand not only the essential visual characteristics of this important genre of Indian painting, but also offer suggestions regarding the Rajput character as reflected in the visual development and conceptual framework of the pictures.

The idea of portraying likeness in an empirical sense, "the way a man is seen," is not indigenous to Rajput culture, or for that matter to the traditional Indian world view. Developed under the patronage of the Mughal emperors Akbar and Jahangir, this concept of empirically determined and psychologically sensitive portraiture was selectively adopted by the Rajasthani courts in the Mughal orbit. After an initial stage of emulation, the tradition was gradually assimilated to become a thoroughly Rajput phenomenon. Rather than challenging or changing fundamental Rajput assumptions, portraiture was ultimately used to illustrate the traditional Rajput notions of idealized kingship.

The notions of verisimilitude, and of the specific physical and psychological state of the sitter, were avoided in favor of the universally recognized iconographic attributes and features of the ideal king. The identity of the ruler and his power were thus established in broadly defined historical and societal terms rather than through illustrations of specific times and events in his reign. Even when the artists at the Rajput courts set out to document a specific event, or capture the likeness of a living ruler, they incorporated the age-old prescriptive conventions of painting into their vision. Observation of a specific scene or a specific ruler was not abandoned, but was adjusted to include the patron's and the painter's knowledge of an ideal ruler in an ideal setting. In other words, only those elements of empirical reality were used which did not challenge the archetypal, ahistorical nature of courtly depictions, and could enhance the realms of metaphoric meaning. The meticulous manner in which artists rendered details also emphasized conceptual rather than perceptual interest in the subjects and objects of paintings, imparting a sense of timelessness, and ultimately revealing very little

of the psychological state or personal predicaments of the individuals being portrayed.

Cultural analysis and study of the historical development of royal portraits in Rajasthan reveals the traditional and conservative nature of both Rajput painting and Rajput society. When new painting themes and, through them, new ideas were introduced or accepted, they were channeled through a selective adoption process. Even when necessary changes were made, either consciously or unconsciously, fundamental cultural principles were not altered. Without a dynamic social and political structure which could face new realities, confront challenges, or relish innovative aesthetics, Rajput culture, with its traditional adherence to age-old conventions, was more likely to alter the form and nature of such "exotic" themes as empirically oriented portraiture and incorporate them into long-held beliefs rather than be altered by them.

Notes

1 The term "Rajput" painting refers simultaneously to works created at the Rajput courts of Rajasthan, Central India, and the Punjab Hills, and to the style of these pictures, which is usually defined in contradistinction to imperial Mughal painting. For further discussion of the stylistic features of Rajput painting, see Coomaraswamy (1916: 5–12). In the present essay, the term "Rajput" painting is used when the pictures are discussed stylistically and culturally. In the discussion of the works in their geographic context, "Rajasthani" painting or "painting at the Rajput courts of Rajasthan" is used to further differentiate between the two main geographic areas of Rajput painting, Rajasthan and the Punjab Hills.
2 For a detailed discussion of traditional Indian portraiture with its emphasis on the cognitive attributes of the ruler, see Goswamy (1986: 193–202).
3 For selected examples of such phrases, see Beveridge (1912: I, 85, 223) and Rogers and Beveridge (1968: I, 33–4, 225).
4 Though stylistically datable to the first half of the 17th century, none of these early portraits is actually dated. For examples see Desai (1985: 28–31).
5 From the available names of the court artists from Bikaner in the 17th century, it seems that many were Muslims. In the inscription on the earliest dated Bikaneri work, it is mentioned that the leading artist, Ali Raza, had come from Delhi. It is likely that other Muslim artists also migrated in mid-century. For further information on Bikaner artists, see Khandalavala et al. (1960: 48–51) and Krishna (1985: 23–7).
6 *Grisaille* refers to a style of painting which, using only shades of gray and black, tries to create an effect of three-dimensionality. Mughal artists first used it in the late 16th century while emulating similar effects in European prints which had recently reached the Mughal court.
7 The only exception is Prince Parwiz, the saluting figure in the center. For a detailed discussion of the identification of the scene, see Desai (1985: 13–14).

References

Beveridge, Henry (trans.) (1912) *The Akbarnāma of Abu-l-Fazl*, 3 vols. Calcutta: Asiatic Society of Bengal (1st edn 1897–9).

Coomaraswamy, Ananda K. (1916) *Rajput Painting*. London: Oxford University Press.

Desai, Vishakha N. (1985) *Life at Court: Art for India's Rulers, 16th–19th Centuries*. Boston: Museum of Fine Arts.

Goswamy, B. N. (1986) "Essence and Appearance: Some Notes on Indian Portraiture." In Robert Skelton et al. (eds), *Facets of Indian Art*, pp. 193–202. London: Victoria and Albert Museum.

Khandalavala, Karl, Moti Chandra, and Pramod Chandra (1960) *Miniature Painting from the Sri Moti Chand Khajanchi Collection*. New Delhi: Lalit Kala Akademi.

Krishna, Naval (1985) "Bikaneri Miniature Painting Workshops of Ruknuddin, Ibrahim and Nathu." *Lalit Kala* 21: 23–7.

Rogers, Alexander (trans.) and Henry Beveridge (ed.) (1968) *The Tuzūk-i Jahāngīrī; or, Memoirs of Jahangir*, 2 vols, 2nd edn. New Delhi: Munshiram Manoharlal (1st edn 1909–14).

Tod, James (1971) *Annals and Antiquities of Rajasthan*, 3 vols, 3rd edn. New Delhi: Motilal Banarsidass (1st edn 1829–32).

Topsfield, Andrew (1980) *Paintings from Rajasthan in the National Gallery of Victoria*. Melbourne: National Gallery of Victoria.

13

Indian Images Collected

Richard Davis

Introduction

Richard Davis's chapter, and indeed his entire book, addresses the question of the post-history of an art object: where does it travel and how do the meanings attached to it change? In this excerpt Davis focuses on a single object, *Tipu's Tiger* (late eighteenth century, Karnataka, India), now housed in the Victoria and Albert Museum in London. Beginning with the iconographic significance attached to the object by its patron, the Islamic ruler of the southern Indian Mysore kingdom, Tipu Sultan (r. 1782–99), Davis follows the object from its status as a prize for the conquering British, to its role as a curiosity in the East India Company's London museum.

The *Tiger*'s history is directly bound to the history of British colonization of India, which began in earnest in the seventeenth century, in the form of missionaries and merchants. At that time, India was largely controlled under the auspices of the Mughal empire (1526–1858). In the eighteenth century, the British crown gave monopolistic control of trade to the East India Company, which competed with the Dutch and the French trade interests in the region and grew increasingly powerful over the century. In 1757, the British won the Battle of Plassey and were granted the title of *diwani*, or minister of revenue, by the Mughal emperor, thereby officially marking the British entrance into Indian governance.

In the southern regions the political picture continued to be unstable, as the French vied for power with the British. Haydar Ali (1761–82), Tipu's father, usurped the throne of Mysore from its previous rulers, the Wodeyars (1565–1761). Haydar Ali and Tipu Sultan expanded the kingdom, but were defeated by the expanding British East

India Company in 1799. In 1858, following a wide-scale uprising on the part of Indian soldiers employed by the Company, the British crown officially took over the rule of India, deposing the Mughal emperor in favor of the British Queen, and beginning what is called the British Raj (1858–1947).

Davis's text traverses this history and examines differing modes of display across the centuries since the *Tiger* was made. Issues of audience reception, shifts in attitude as to what constitutes "Indian art," and the politics of repatriation of objects all intersect in this one object. How South Asia is represented today depends on an understanding of how it was presented in the past; Davis shows how colonial histories impact our present understanding of this region.

The Tiger in Tipu's Court

In the newly renamed Jawarhalal Nehru Gallery of Indian Art in the Victoria and Albert Museum, London, safely enclosed within a glass case, resides an impressive six-foot effigy (Fig. 13–1). A tawny male tiger, all claws extended, crouches atop a wooden man lying stiffly. The light-complexioned man wears a red coat and a black, wide-brimmed hat, clearly marking him as a European of the eighteenth century. His eyes are wide open in distress. The tiger meanwhile sinks his teeth right into the man's throat. On the left flank of the tiger, a hinged wooden flap

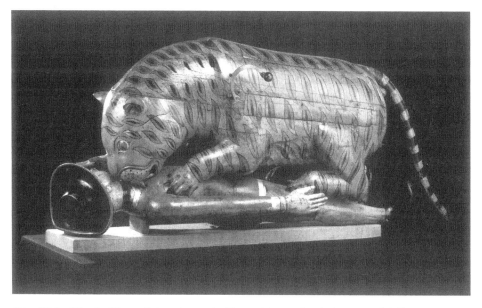

Fig. 13-1 Tipu's Tiger. Painted wood effigy with mechanical organ. Sri Rangapattana, Karnataka, eighteenth century. Victoria and Albert Museum, London.

128

has been let down, allowing viewers to see within the tiger a row of eighteen buttons with musical pipes behind each – for the Tiger is, at the same time, an organ. Also from the tiger's left shoulder protrudes a crank handle. When one turns the crank the man raises his left arm in futile supplication, and the apparatus emits sounds of a tiger roaring and a human groaning.

Joining "Tipu's Tiger" in the glass case is a variety of other objects that represent and evoke the eighteenth-century south Indian court of Tipu Sultan. Viewers see a beautiful cotton floor spread embroidered in silk flowers and tendrils, a burgundy velvet saddle cloth embellished in silver-gilt thread, a white muslin full-length court coat from Tipu's wardrobe, a steel curve-bladed sword with Persian inscription in gold lettering identifying it as a personal sword of Tipu, and sundry other objects including a helmet, a walking cane, a telescope, and a pocket watch of European manufacture. Three small paintings depict Tipu, a soldier of his guard, and a scene from his palace at Sri Rangapattana (Anglicized as Seringapatam). Almost lost among the larger objects, one may also detect a small gold medal, on which the British lion is shown overcoming a prostrate tiger. The medal, with its totemic representation of British victory, was awarded to those who served in the Sri Rangapattana campaign (Mayo 1897: 134–45). Overturning the iconography of "Tipu's Tiger," this small medal evokes the event that made the entire display possible, for virtually all the objects in the case were taken by British military forces as loot after their victorious storming of Sri Rangapattana in 1799.

Of course the Tiger was not made with museum display in mind, and it has not always been in the Victoria and Albert Museum. The Tiger was fabricated in the late eighteenth century for the Islamic ruler of Mysore, Tipu Sultan Fath Ali Khan (r. 1782–1799), probably by local Indian artisans working with a French instrument maker. Quite possibly they were following the iconographic instructions of the sultan himself.

Tipu's father, Haydar Ali Khan, was an enterprising general who took control of the kingdom of Mysore from its Wodeyar ruler, Krishnaraja II (1734–66) in 1761. Both Haydar Ali and his son and successor Tipu were vigorous, inventive, and ambitious rulers who sought to expand the personal powers of the sovereign within their state and to extend its boundaries without. In the latter aim they took advantage of the declining ability of the Mughal center to control subordinate rulers throughout the subcontinent during the eighteenth century. Within a few years, Mysore's expansionist policies and increasingly effective military capacities brought it into conflict with another expanding south Indian polity, the British East India Company based in Madras. Between 1767 and 1799 Haydar Ali and Tipu Sultan fought four wars with the British. During the first Anglo-Mysore war of 1767–1769, Haydar Ali reached the gates of Madras and forced the British to accept his proposals for a truce. In the second war of 1780–1784, the Mysore forces decisively defeated the British at Pollilur and besieged Madras by controlling and denuding the surrounding territories, until the British general Eyre

Coote led the British to victory at Porto Novo in 1781. Haydar Ali died of an illness during this war in 1782.

Both Haydar Ali and Tipu Sultan were parvenu Sunni Muslim rulers of a predominantly Hindu south Indian kingdom. The current Mughal emperor in Delhi, primary legitimating source of authority still in the eighteenth century, did not acknowledge the new Mysore rulers, but because Mughal power was declining Tipu was able to declare himself "Padshah" [emperor] and take on most of the defining marks of this status without suffering Mughal retribution. Nevertheless, Haydar Ali and Tipu needed to establish themselves as legitimate and proper sovereigns within the complex society of southern India. To do this they employed many of the traditional incorporative strategies of new rulers in India, such as patronizing the religious institutions of all significant communities within their territories and conducting inclusive rituals that involved subordinate rulers and local elites. They also selected ruling symbols with a keen sense of rhetoric. It is in this context, as Kate Brittlebank argues in her recent revisionist studies of Tipu Sultan's cultural politics, that Tipu's choice of the tiger as a personal and dynastic insignia appears most significant (Brittlebank 1993, 1994, 1995).

Iconography of the tiger permeated Tipu's court. Tipu's soldiers wore uniforms decorated with tiger stripes. Royal weaponry showed the mark of the tiger: swords had tiger hilts, muskets had brass tigers for their gunlocks, and mortars were cast with tiger-head muzzles. Tipu's coins showed tiger stripes, and the ceremonial staffs reserved for high officials were mounted with silver tiger heads. His green silk banner of state was decorated with a calligraphic design in the form of a stylized tiger face, spelling out "The Lion of God is Conqueror." Tipu's magnificent throne stood on tiger legs, and featured at its front a massive tiger with head of gold and teeth of crystal, surrounded by smaller tiger heads.

British observers at the time understood this promiscuous reiteration of a single symbolic motif to be a matter of Tipu's personal choice, unique and idiosyncratic. They believed Tipu identified himself as a tiger, and to support this they often repeated a statement ascribed to him: "in this world he would rather live two days like a tiger, than two hundred years like a sheep" (Beatson 1800: 153–54). Perhaps Tipu did see his own life of ferocious exertion and constant military campaigning as similar to that of a tiger. However, as Brittlebank shows, in the late medieval south Indian dispensation within which Tipu operated, the tiger was a multivalent signifier, and Tipu's choice would have been prompted more by strategic concerns than personal predilection.

Ruling dynasties in medieval India regularly chose distinctive insignia. The tiger is recurrently associated with royalty in India. More specifically, two prominent dynastic predecessors of Tipu had employed the tiger as their insignia – the Cholas who ruled much of southern India from the late tenth through early thirteenth centuries, and the Hoysalas of Dvarasamudra who supplanted the Cholas and Chalukyas in Karnataka in the late twelfth through early fourteenth centuries. By his reuse, then, Tipu implicitly aligned himself with two earlier Hindu (and mainly Shaiva) imperial formations of south India. Significantly, the

Wodeyars did not use the tiger as an emblem. Their royal iconography leaned toward Vaishnava symbols, such as the boar, the discus, the garuda, and especially the double-headed eagle. Tipu had one of his guns decorated with a heel plate depicting two tigers devouring a double-headed eagle, to convey Haydar Ali's and Tipu's usurpation of Wodeyar rule in Mysore in clear totemic code (Wiginton 1992: 73).

At the same time, the tiger linked Tipu within an Islamic context to Ali, cousin and son-in-law of the Prophet Muhammad and fourth caliph of the early Islamic community. Honored by all Muslims as a great warrior, Ali is particularly venerated by Shias as Muhammad's true successor. Ali is known as the "lion of Allah" (*asad allah*), but most Indian languages do not draw a strong linguistic distinction between "lion" and "tiger," so it was not incongruous for Tipu's banner to spell out "lion of God" with the visual form of a tiger mask. For Tipu the words *asad allah* would equally have meant "tiger of God." A devoted Muslim warrior, Tipu took Ali as "the guardian genius, or tutelary saint, of his dominions; as the peculiar object of his veneration, and as an example to imitate" (Beatson 1800: 155). Not coincidentally, the name of Tipu's father, Haydar, the title Muhammad bestowed on Ali, also means "lion" (or tiger), so Tipu's devotion also connoted filial piety as well.

Moreover, Brittlebank argues, both Hindu and Muslim traditions in medieval south India associated the tiger with a religious notion of divine power. Medieval Indian political theory understood that the power of kings to rule their earthly dominions was fundamentally drawn from divine sources. In late medieval south India, divine power (*shakti*) was most directly instantiated for Hindus in the form of fierce warrior goddesses such as Durga, Kali, and the many local goddesses referred to as Amman or Mariamman. Durga rides a lion (or tiger) as she goes into battle against the demon Mahishasura, and many of the village goddesses in the Mysore region are known as Huliamman, the "tiger goddess." Within a south Indian Indo-Muslim setting, divine power (*barakat*) manifested itself through the figure of the martial *pir*, the saint-martyr. Like their Hindu goddess counterparts, Sufi pirs frequently rode lions (or tigers) as their mounts, and as zoomorphic extensions of their inhering energies. In practice the cults of Hindu goddesses and Muslim pirs were not clearly divided. They employed a shared vocabulary of symbols and common ritual strategies, and both sought to gain access to the divine energy of *shakti* or *barakat* on behalf of their worshipers. By his choice of the tiger, Tipu surrounded himself with the animal form of divine power common to the two most prominent communities of his realm.

In its iconographic composition, "Tipu's Tiger" referred back most immediately to the genre of hunting pictures common to both Islamic and Hindu court traditions in late medieval India. Typically these paintings depict rulers in the act of pursuing or slaying powerful wild animals, most often tigers. Representing the potency of the ruler in his (or her) moment of triumph, such paintings not only illustrated the popular royal pastime, but also figured as allegories of dominion.

But in Tipu's version, it would appear, positions are reversed. The hunter gets captured by the game. The tiger now denotes the royal patron, overturning the conventional iconography to assume a victorious crouch atop the supine British soldier.

With his Tiger, then, Tipu adeptly employed an insignia that would speak to the various communities that constituted his kingdom. Within his symbolic universe, the musical Tiger effigy he kept in his hall of music represented a clear iconic expression of the victory he envisioned of himself, his polity, and the forces that acted through them over his most inveterate opponent, the British. Unfortunately for Tipu and his Tiger, symbolic representations of the future do not always bring about their own fulfillment.

Colonial Styles in Collecting and Display

After three inconclusive Anglo-Mysore wars, it was the ambitious Richard Wellesley, arriving as governor-general in 1798, who initiated the fourth campaign, which would lead to Tipu's decisive defeat and the annexation of most of his territories under effective British control. Claiming evidence of negotiations between Mysore and France, Wellesley ordered British forces against Tipu's fortress capital of Sri Rangapattana in 1799. Tipu died during the siege. Wellesley's victory not only solidified British control in southern India, but also created a sensation back in England, involving as it did a dramatic victory over a famously fearsome Indian potentate as well as an indirect defeat of the enemy closer to home, Napoleonic France. In addition, the British defeat of Tipu set the Tiger and many other objects from Tipu's palace along a course that would lead them to new homes in the colonial capital.

The Looting of Sri Rangapattana

After the British troops had successfully stormed the fortress, and the body of Tipu Sultan himself was found, the night of May 4 was given over to a general rampage and pillage of the city. One estimate places the value of the pillage during the night at Rs 45 lakhs [Rs 4,500,000]. The next morning it was left up to young Colonel Arthur Wellesley, the future duke of Wellington, to restore some semblance of order and military discipline, and he did this with zeal.

> Nothing could have exceeded what was done on the night of the 4th. Scarcely a house in the town was left unplundered and I understand that in the camp jewels of the greatest value, bars of gold, etc. etc., have been offered for sale in the bazaars of the army by our soldiers, sepoys, and followers. I came in to take the command on the morning of the 5th, and by the greatest exertion, by hanging, flogging, etc. etc., in the course of that day I restored order among the troops, and I hope I have gained the confidence of the people. (Wellington 1858: 212)

So reported Col. Wellesley in a dispatch to his older brother Richard, the governor-general.

The treasures that survived this initial pillaging of Sri Rangapattana were classified as "prize," and with all the army eager to partake, a Prize Committee of seven officers was quickly formed to collect, evaluate, and apportion the captured booty. The agents were astonished by what they found: they collected the equivalent of 600,000 pounds in coins, jewels valued at 360,000 pounds, along with richly worked cloth, inlaid furniture, Persian carpets, ornamental weaponry, and much else. The total value of the prize came to something on the order of 1,600,000 pounds.

These two movements in the emptying out of Tipu's palace illustrate nicely the distinction that the British sought to draw between "plunder" and "prize." As we have already seen in medieval Indian settings, looting may be a common activity among many wartime victors, but it is also a social practice deeply imbricated with cultural premises and values. Various looting parties organize their activities differently within their differing dispensations. For the eighteenth-century British, the Mutiny Act and the Articles of War enacted by Parliament after the Restoration classified individual plundering not only as a form of theft but also of desertion, since undisciplined looting might disrupt the integrity of troops during battle. Unregulated plunder could be punished by a maximum sentence of death (Gregorian 1990: 66). Therefore it was not out of line for Col. Wellesley to hang four subaltern pillagers in the interest of stopping the plunder of Sri Rangapattana.

Prize was a different matter. With victory attained, the commanding officer was instructed to appropriate the property belonging to the defeated opponent; this was "booty," not "pillage." Following an organized procedure of assessment and usually an on-site auction, booty was transformed into "prize money" for distribution to the troops, in proper order according to ranks. If plundering involved individual, disorderly, and predatory activity subverting the terms of disciplined military arrangements, prize involved collective, orderly, hierarchical distribution rearticulating the established social order of the military itself.

British officers held two conflicting notions concerning the most proper utilization of prize. Some valued it for its symbolic value, while others saw it primarily as a means of paying troops. Some British officials – particularly the brothers Wellesley – recognized that certain objects closely associated with the person of Tipu Sultan, such as his robes, his ceremonial weaponry, and his throne, could act as especially appropriate signifiers for their victory over Tipu and their incorporation of his territories into the British domain. The governor-general, aware of the political basis of his appointment, hoped to circulate such objects upward in the colonial chain of authority. Insofar as possible he attempted to reserve them as "presents" for the Crown and the London officers of the East India Company. The Prize Committee, on the other hand, felt primary responsibility to the troops outside its tent, and wished to monetize all.

The object that would turn out to have the greatest symbolic resonance for the British public, however, was not a traditional item of regalia, and it was never presented to royalty. Perhaps the fact that "Tipu's Tiger" was not made of precious materials spared it from the Prize Committee. Wellesley circulated it upward in the colonial chain of command, to the Board of Directors of the East India Company. In the memorandum accompanying the effigy, Wellesley noted that Tipu Sultan "frequently amused himself with a sight of this emblematical triumph of the Khoudadaud [Tipu's 'God-given domain'] over the English Sircar" (East India Company 1800: 344), making clear that the object should be viewed in a symbolic or "emblematic" manner.

Wellesley had suggested that the Tiger should be sent to the Tower of London, presumably for some emblematic imprisonment, but the Company Board had other ideas. In 1799 the directors decided to set up an Oriental library and museum in their impressive new building, the East India House on Leadenhall Street. This is where "Tipu's Tiger" was put on display in 1808. It quickly became the most celebrated object in the building.

The Tiger in the East India House

During the early nineteenth century, as the British solidified their colonial control in India, the quantity of Indian objects present in England increased markedly. There were many places in London where the English public could satisfy its curiosity by viewing the world of objects made available through the British imperial endeavor. As Ray Desmond (1982: 33–35) has shown, captured arms and armor were on display in the Royal Asiatic Society museum and in the Tower of London; the Royal United Services Institution displayed armaments also, and had Tipu's uniform. The Linnean Society museum featured natural history specimens from South Asia. The London Missionary Society maintained a "Missionary Museum" on Blomfield Street, which displayed, as trophies of conversion, "the idols given up by their former worshippers from a full conviction of the folly and sin of idolatry." One could see there the image of Shiva that Ramjee Pramanik had flung down from its temple in Rammakal Chowk. Temporary dockside displays popped up regularly as East Indian merchant ships unloaded new cargoes. Of all these sites for Indian display, however, the India Museum, or "Oriental Repository," in the East India House was by far the most comprehensive. "Tipu's Tiger" was the best-known object of the India Museum, and indeed, in Richard Altick's judgement, "one of the most famous individual exhibits in London show history" (1978: 299).

Museum buildings act as frames for objects displayed within. Responses to particular objects are guided, enhanced, and contained within the parameters of expectation and possibility structured by the building itself and the organization of its exhibitions. So, to understand the response of the nineteenth-century British

public to a work like "Tipu's Tiger," it is important also to consider its new home. As a site where objects appropriated from defeated opponents were redisplayed, the India Museum of East India House differed markedly from the Chola temple at Gangaikondacholapuram built by Rajendra and from Mahmud's great mosque in Ghazna. The British seldom if ever placed wartime loot on display in what they considered religious buildings, just as they did not officially plunder the religious institutions of those they defeated. Yet the India Museum also differed markedly from the modern museums to which we have become accustomed.

East India House was primarily a secular place of business, which also contained a museum and library. The East India Company expanded and virtually rebuilt the old India House on Leadenhall Street in 1796–1799, to reflect the increased scale of Company operations and wealth. The new building was an imposing neoclassical structure with classical style porch and pediment. John Bacon designed the tympanum frieze, an allegorical depiction of King George III in Roman costume defending Britannia and its commerce with the East. Inside, the main downstairs rooms were devoted to the business of the East India Company. The museum and library were located in peripheral quarters, initially in the east wing and later in rooms upstairs (Britton and Pugin 1828: 2.77–89; Platt 1843: 5.49–64; Miller 1852: 96–102; Foster 1906; Archer 1986).

The implicit hierarchy of business over learning, and of Western form over Indian substance, was reinforced by the decorative scheme employed in the downstairs rooms. An allegorical chimney-piece by Michael Rysbrack showing Britannia receiving the riches of the East dominated the Grand Court Room. The Revenue Committee Room featured a ceiling painting executed by Spiridion Roma, again representing Britannia receiving riches from the East. Here Britannia sits elevated on a rock, denoting the firmness of the Empire, guarded by a lion. Female allegorical figures of India and China approach her from below, holding out their offerings for Britannia's delectation. India presents a crown surrounded by pearls and rubies, while China offers porcelain and tea. Behind them two other Asiatic figures bring their presents. In the background an Indian merchant ship signifies the commercial source of these riches. In the same room was Benjamin West's historical painting of Robert Clive receiving the grant of *diwani* from the Mughal. Mustered around the niches of the General Court Room were sculptural figures of East India Company heroes, such as Clive, Stringer Lawrence, and George Pocock, decked out in Roman military costume.

As a reflection of taste, the art on display in the business rooms in East India House confirmed the "solidly British image" maintained by the Company directors. Mildred Archer points this out: "Although their profitable dealings were all with the East, there was no whiff of 'the exotic' in their House – no Indian miniatures, no inlaid furniture or textiles were on view, no export wares such as Chinese porcelain or wall-papers In the public rooms and offices of their own 'House', as in its architecture, the Directors preserved a 'safe' British image" (1986: 4). More than this, these works by European artists presented an iconographical validation and naturalization of the British colonial enterprise in India.

135

The repeated analogy with Imperial Rome provided the British Raj its proper historical antecedent. The artworks reminded their viewers of the tremendous profitability of the relationship for England. Jewels simply overflow the basket offered by India as Britannia inspects one of the pearl necklaces. Yet the artists did not illustrate rule or riches as things taken from Indian subjects; India gave these things to Britannia, as if these were simply her due.

The more curious of Britannia's colonial acquisitions were on display in the museum. Established when the Leadenhall Street house was expanded in 1799, and first directed by one of the great scholars of British Orientalism, Charles Wilkins, the India Museum was a secular site in which the people of England could visually encounter the multitudinous and bizarre objects of the world made available through their empire-building adventures. Its collection was truly heterogeneous:

> a long-nosed tapir and birds with exotic plumage from Java; cases crammed with iridescent insects; the "Babylonian Stone" and five bricks which a label credulously described as being "the original bricks which the Israelites were compelled to make without straw"; a fragment of a Roman tessellated floor; an Oriental opulence of gold and silver ornaments, pearls and gems; spun and woven silks and woolens, canopies, carpets and rugs hanging and draped everywhere; and a glimpse of some of the plunder from the battle of Seringapatam – the golden tiger's head footstool from the throne of Tipu Sultan and, most popular exhibit of all, his musical mechanical Tiger. (Desmond 1982: 2–3)

In the clear dualism of the East India House, where the downstairs business rooms envisioned British sovereignty, the upstairs museum offered a synecdoche of India as colony. England's most comprehensive repository of Indian objects portrayed India as exotic, miscellaneous, opulent, ahistorical, and subordinated.

Audiences bring with them their own ideas and understandings of the world, their own wishes and fantasies, when they view objects in a museum. This mental set also frames the way those objects are seen and received. Due to its great popularity, "Tipu's Tiger" figures in a large number of early nineteenth-century guidebooks, travel sketches, and literary works, so we can gain a good sense of how its new English audience in the Indian Museum responded to the Tiger.

The primary descriptive term British observes used for the Tiger was "curious." The term reminds us of earlier European "cabinets of curiosities," and the Indian Museum with its zoological collections, exotic manufactured products, and odd bits and pieces of all sorts certainly was a culture-specific descendent of those sixteenth- and seventeenth-century forerunners of the modern museum. In early nineteenth-century usage, though, "curious" also had the more condescending connotation of bizarre, unintelligible, or infantile. The Tiger was treated as a toy, a "childish piece of musical mechanism," worthy only of condescension and perhaps amusement. In Barbara Hofland's 1814 novel *A Visit to London*, for instance, the young heroine Emily visiting the India House is momentarily frightened by the "harsh, moaning sound" emanating from the Tiger. The calm,

mature librarian tries to reassure her that it is only a toy, but Emily asks to be taken home immediately (Desmond 1982: 26). John Keats, who most likely saw the Tiger when he was turned down for a job by the East India Company, incorporated the "man-tiger-organ" into his satirical poem "Cap and Bells": the odd object here belongs to the emperor of the faeries, Elphinon (Mann 1957).

If it were seen only as a childish mechanism from India, however, there would have been no reason for the Tiger's great fame. The object had two other things going for it. The musical Tiger resonated with associations to recent events the British public knew well, and the clear "emblematic" composition of the effigy made it a particularly appropriate figure for symbolic and ironic reinterpretation.

All observers reinscribed the Tiger into the well-known narrative of Tipu's ferocious, tigerlike opposition to the British and his eventual subjugation by heroic British forces. Throughout the Anglo-Mysore Wars, and especially after the fall of Sri Rangapattana, England was deluged with memoirs, poems, drama-tizations, and paintings retelling the story of Tipu's obstinacy and his demise. In Anne Buddle's term, a veritable "Tipu-mania" took hold of London. At least six plays dramatized the story of Tipu. British participants in the Mysore Wars related their experiences in volume after volume, and Tipu himself appeared in fictional versions by Meadows Taylor and Walter Scott. British painters in India, and those who had never set foot there, rendered the great scenes of British victory. By far the most grandiose representation was a "Great Historical Picture" of the "Tak-ing of Seringapatam" painted by Robert Ker Porter, then nineteen years old. In a frenzy of work Porter covered more than 2,500 square feet of canvas with his epic subject in just six weeks' time, and placed the panorama in the Lyceum (Forrest 1970: 315–27; Buddle 1989, 1990).

Bringing this as part of their cultural literacy, British audiences saw Tipu's own identification with the tiger and his alleged attachment to the musical Tiger as material evidence of his audacity, treachery, and cruelty, a "proof of the tyrant's ferocity" (Mogridge n.d.: 152). As James Forbes (1813: 4.185) commented, "A human being, who could pass his hours of relaxation and amusement in this savage manner, may be easily supposed to have enjoyed the death of a European who unhappily fell into his power, whether effected by poison, sword, or bow-string." Not only Tipu was implicated here, however. The infantilism and crude-ness of Tipu's toy Tiger could also be generalized to represent the character of *all* Oriental despots who opposed British rule: "Whether made for Tippoo himself or for some other Indian potentate a century and a half earlier," commented one observer, "it would be difficult to convey a more lively impression of the mingled ferocity and childish want of taste so characteristic of the majority of Asiatic princes than will be communicated at once by an inspection of this truly barbar-ous piece of music" (Society for the Diffusion of Useful Knowledge 1835: 319–20). In the late eighteenth and early nineteenth centuries, the notion of "Oriental despotism" as the characteristic mode of Indian governance served as an import-ant justification for the imposition of British rule. Here, it would seem, was the material embodiment of an Oriental despot's mentality (Cohn 1987: 208–12).

In Tipu's music room, the Tiger devouring the redcoat no doubt signified an anticipated future victory over his primary south Indian rival. British observers of the time liked their allegorical compositions clear and unambiguous, and they could easily project how Tipu himself would have interpreted the iconography of the effigy. Appropriated and domesticated upstairs in the East India House, however, its signification shifted for British viewers. "Tipu's Tiger" could stand as an ironic representation of the Indian despot's imagined victory overturned by British forces. British soldiers who fought at Sri Rangapattana received medals depicting the British lion overcoming the Tiger of Mysore, but the Tiger in the museum offered a way to participate vicariously in the activity of empire building. Those back home could playfully turn the crank of "Tipu's Tiger" and, more courageous than little Emily, overcome all fears of this now-subdued enemy. At the same time, the Tiger confirmed the moral judgement of Asiatic character and Indian political culture that justified British conquest.

Exhibits may evoke different responses among differing audiences, of course. As a "community of response," British visitors to the India Museum in the first half of the nineteenth century were remarkably consistent in their responses to and comments about "Tipu's Tiger." But what about other viewers? Fortunately, one Indian visitor, Rakhaldas Haldar, kept a diary while studying in London during 1861–1862. Homesick, he visited the India Museum often during his year abroad, but with decidedly mixed emotions: "I am just returning (3½ p.m.) from a visit to the India Museum; my 6th or 7th visit. It was painful to see the state chair of gold of the late Lion of the Punjab with a mere picture upon it; shawls without Babus; musical instruments without a Hindu player; jezails and swords without sipahis and sawars; golden ornaments without wearers; and above all hookahs without the fume of fantastic shapes" (1903: 57). Haldar does not speak in his journal of the Tiger, but the golden state chair he observed had a similar background.

The historical resonance of the Tiger for nineteenth-century English audiences led them to a narrative of British victory and a moral condemnation of native Indian rulers. For an Indian visitor like Rakhaldas Haldar, however, objects in the India Museum like the Sikh royal throne with only a picture on it evoked the life of home, yet by their very incompleteness and detachment from human usage they also reminded him painfully of his own separation from that living reality.

References

Altick, Richard D. (1978) *The Shows of London.* Cambridge, MA: Harvard University Press.

Archer, Mildred (1986) *The India Office Collection of Paintings and Sculpture.* London: British Library.

Beatson, Alexander (1800) *A View of the Origin and Conduct of the War with Tippoo Sultaun.* London: G. and W. Nicol.

Brittlebank, Kate (1993) "Curiosities, Conspicuous Piety and the Maker of Time: Some Aspects of Kingship in Eighteenth-century South India." *South Asia* 16(2): 41–56.

—— (1994) "The Making of a Padshah: Tipu Sultan's Search for Legitimacy in the Context of Eighteenth-century South India," PhD dissertation, Monash University, Clayton, Victoria, Australia.

—— (1995) "*Sakti* and *Barakat*: The Power of Tipu's Tiger," *Modern Asian Studies* 29(2): 257–69.

Britton, John, and A. Pugin (1828) *Illustrations of the Public Buildings of London*, 2 vols. London: J. Taylor.

Buddle, Anne (1989) "The Tipu Mania: Narrative Sketches of the Conquest of Mysore," *Marg* 40(4): 53–70.

—— (1990) *Tigers Round the Throne: The Court of Tipu Sultan (1750–1799)*. London: Zamana.

Cohn, Bernard S. (1987) "African Models and Indian Histories." In *An Anthropologist among the Historians and Other Essays*, pp. 200–23. Delhi: Oxford University Press.

Desmond, Ray (1982) *The Indian Museum, 1801–1879*. London: Her Majesty's Stationery Office.

East India Company (1800) *Copies and Extracts of Articles to and from India, Relative to the Cause, Progress, and Successful Termination of the War with the Late Tippoo Sultaun*. London: East India Company.

Forbes, James (1813) *Oriental Memoirs: Selected and Abridged from a Series of Familiar Letters Written during Seventeen Years' Residence in India*, 4 vols. London: White, Cochrane, and Co.

Forrest, Denys (1970) *Tiger of Mysore: The Life and Death of Tipu Sultan*. London: Chatto and Windus.

Foster, William (1906) *A Descriptive Catalogue of the Paintings, Statues, etc., in the India Office*, 3rd edn. London: Eyre and Spottiswoode.

Gregorian, Raffi (1990) "Unfit for Service: British Law and Looting in India in the Mid Nineteenth Century," *South Asia* 13: 63–84.

Haldar, Rakhaldas (1903) *The English Diary of an Indian Student, 1861–62*. Dacca: The Asutosh Library.

Mann, Phyllis G. (1957) "Keats's Indian Allegory," *Keats–Shelley Journal* 6: 4–9.

Mayo, John Horsley (1897) *Medals and Decorations of the British Army and Navy*, 2 vols. Westminster: Archibald Constable and Co.

Miller, Thomas (1952) *Picturesque Sketches of London*. London: Office of the National Illustrated Library.

Mogridge, George (n.d.) *Old Humphrey's Walks in London and Its Neighbourhood*. London: Religious Tract Society.

Platt, J. C. (1843) "The East India House." In *London*, edited by Charles Knight, pp. 5.49–64. London: Charles Knight and Co.

Society for the Diffusion of Useful Knowledge (1835) "Tippoo's Tiger," *The Penny Magazine* 4 (15 August): 319–20.

Wellington, Duke of (ed.) (1858) *Supplementary Despatches and Memoranda of Field Marshall Arthur Duke of Wellington, KG*. London: John Murray.

Wiginton, Robin (1992) *The Firearms of Tipu Sultan, 1783–1799*. Hatfield: John Taylor Book Ventures.

14

Image as Presence

Janet Gyatso

Introduction

While theoretically Buddhism promotes detachment from the material world, in certain Buddhist traditions, paintings, statues, and other richly ornamented objects play central roles in religious life. This is perhaps most visible in the form of Buddhism practiced in Tibet from the seventh century onwards. In this piece Janet Gyatso explores the sources and reasons for the power of images in Tibetan Buddhism. By examining their physical and spiritual properties, ritual settings, and uses, including storage and transport procedures, Gyatso ultimately locates the images' power in their ability to invoke the presence of the divine.

Buddhism came from India to Tibet in the seventh century and was fully developed in the region by the tenth or eleventh century. The specific form of the religion adopted by Tibetans was Tantric Buddhism or Vajrayana, "Diamond Vehicle." Tantric Buddhism stresses enlightenment through meditation, ritual, and master–disciple relationships, involving initiations into increasingly higher levels of understanding. The focus of such rituals is quite often an image of a divine being, and Tibetan Buddhism includes a complex pantheon of deities. The various figures, each having a peaceful and terrifying aspect as well as a consort and a family, embody a particular cosmic force or aspect of enlightenment (*nirvana*). Thus, an elaborate iconographic system is necessary to recognize the various beings. Additionally, Tibet developed a strong monastic tradition, centering on a hierarchy of priests (*lamas*), who hold political as well as spiritual power. From the seventeenth century until the mid-twentieth century the pre-eminent monastic sect was the order of the Dalai.

Janet Gyatso, "Image as Presence," pp. 171–6 from Valrae Reynolds, *From the Sacred Realm: Treasures of Tibetan Art from the Newark Museum.* Munich, London, New York: Prestel, 1999. The Newark Museum, 1999.

Viewers may admire Tibetan Buddhist works for their beauty and craftsmanship, thus granting them status as fine artworks, or viewers may study the works for their elaborate iconography signifying their role as religious icons. Gyatso, however, reminds us that these objects were not created as art for art's sake, nor were they merely symbolic representations of a specific deity. In their original contexts, the images operated as vehicles for enlightenment by bringing together the mundane and sacred worlds, by embodying divinity, and by making the intangible tangible. As such, their significance lies as much in how their intended viewers mentally and physically interacted with them as it does in the images' visual characteristics. Yet, at the same time, the specific iconographic prescriptions of the images were directly linked with, and intended to ensure, their religious power, highlighting the symbiotic relationship between form, meaning, and viewer interaction.

In the Tibetan religious context, a work of art that is a Buddhist image (*kudra*) is not merely a symbolic representation of an ultimate Buddhist truth. Nor is it simply an icon, a rendering of the ideal form of a member of the Buddhist pantheon. It is both of those things but, to the extent that it embodies the form of the Buddha or deity, the image also conveys the presence of that Buddha in its own right.

The canonical sources for the various forms of the Buddha interpret stance, body color, facial expression, hairstyle, number and positions of limbs, clothing, ornaments and accoutrements as manifestations of certain principles of enlightenment. In some ways these elements function as mediating symbols, referring to the ultimately formless, indeterminate nature of the enlightenment experience itself. The sword in the hand of Manjushri shows his severance of emotional attachment, Vajrayogini's three eyes indicate her omniscient vision of past, present and future; the green hue of Tara's skin color expresses her wisdom-as-efficacious-action. There are also measurement grids for the bodily proportions appropriate to each genre of Buddhist deity. However, the referential function of these iconographic prescriptives is secondary. Ultimately, what is being referred to, or symbolized, is the ground of enlightenment, and that is not something which exists prior to, or independent of, its concrete appearance in the world. In accordance with the tenets of Mahayana Buddhism, *nirvana* is never separate from the vow to appear in the world to benefit all beings. In this important sense, Tibetan Buddhist aesthetics of form, color and design are based in enlightenment – the shape of the Buddha's body *is* the act of Buddhahood. The image, partaking in and enacting the proportions, colors and attitudes of an aspect of *nirvana*, becomes an instantiation of that aspect itself. The very perception of those attributes is thought to remind, or put the viewer in mind, of his or her own inherent enlightenment. Thus is the image always more than a substitute for the presence of the Buddha or deity; it radiates its own presence, which for the religious perceiver is the same as that of the Buddha.

The canons for the Buddha/deity's iconography are used primarily for performing visualization meditation (*sadhana*). The key concept here is that the

141

practitioner is not ultimately different from the Buddha. It is only through deluded thinking that such a duality is conceived. Visualization is seen as a technique to reinvoke the presence of the "actual" Buddha (*jnanasattva*) in the practitioner's own body and experience (*samayasattva*). In this sense, the practitioner's body is analogous to the material statue or painting: it becomes a support, or receptacle, for embodiment (*kuten*) in which the living experience of enlightenment is activated.

Thus does the monk or lay aspirant imagine that he or she has become the Buddha – physically, verbally or mentally. Moreover, the entire world is visualized as being the Pure Land, the realm of the Buddha, and all of its contents as expressions of that Buddha. When the practitioner of *sadhana* meets with an image of the Buddha in the real world, it serves specifically as a reminder of one's endeavor to identify the mundane world with that of the Buddha. For this practice, the painting or statue serves as a model and aid in the development of the ability to visualize. Gazing at the image is recommended as a way of improving the clarity of the mental image produced during the meditation period.

Although the sacred presence of a Buddhist image is already accomplished merely by the fulfillment of iconographic requirements, presence is further invoked in a variety of ritual settings. The spirit of a painting or statue is especially important for initiation ceremonies (*abhishekha*, Tibetan: *wang*) in which students are formally introduced to the Buddha/deity and its *sadhana*. The appropriate image, in a prominent position on the altar, is the focus of the rite. During the initiation, the actual Buddha/deity is invited to enter the image and reside there throughout the ceremony. The lama visualizes the image as the real Avalokiteshvara, or Tara, or Amitabha, and at several points explicitly asks the students to share this imaginative projection. This ritualized visualizing of presence then valorizes the disciple's ceremonial meeting with the Buddha/deity-as-physical-image.

A similar sort of invocation is performed regularly for the images of the central Buddhas and protective deities of a monastery or sect. In monastic institutions it is the responsibility of the monks to propitiate these deities daily. Music, offerings and prayers of praise ensure the continued presence and blessings of the deity in the institution.

In many ways the very history of the image is a factor in its vivification: in what rituals the image has been employed, what monasteries have kept it, and especially what lamas have been in contact with it. The effects of having the visualized presence of the Buddha projected onto the image are cumulative. This begins with the very first ritual involving the image, the consecration ceremony, which is performed immediately after its construction. The image is animated for religious use by a lama, who imagines and projects the spirit of the actual Buddha/deity onto the work of art. Symbolic of this animation is the inscription of the mantric syllables *Om ah hum* on the backs of paintings, just at the spots where the corresponding psychic centers (chakra) of the deities depicted on the

paintings are animated by incribing a mantra while statues have relics or texts placed within their bodies

other side occur. For statues, this is further enacted physically by the depositing of sacred relics, *mantras* and texts inside the statue's body. In particular, relics imbue the statue with their own presence as physical traces of another embodiment of *nirvana*. A "soul pole" (*sog shing*) is also implanted inside statues, providing a central psychosomatic channel. Thus, in the case of statues, not only is its outer form that of the Buddha, but its inner, hidden contents physically repeat the pattern of Buddhahood. Later, the fact that the image was consecrated in these ways is kept in mind by the religious viewer, and this knowledge enhances and enriches his or her perception of the image.

When the image comes to be involved in rituals, and is the object of meditative concentration by accomplished practitioners, its religious value increases in the eyes of the community. And when an image is said actually to have come to life – to have spoken to a meditater or to have performed some action (of which there are many stories in Tibet) – it is seen as having a powerfully numinous presence.

There is, further, the factor of the painting or statue's physical being as such. The spiritual presence of a religious image is enhanced by the material out of which it is made. Precious substances, for Tibetans, are concrete analogies of spiritual value (just as despised substances are synonymous with what is repellent in the world). It is for this reason that statues are encrusted with jewels, and paint pigments mixed with crushed gems and rare medicines. Rosary beads are made from seeds, bones or stones that are chosen to correspond to the type of visualization practice for which the beads will be used. Similarly, the power of the symbolic form of a ritual thunderbolt (*vajra*) or dagger (*kila*) becomes that much more real and awesome when it is made of the treasured meteorite metal (*namchag*). Again, votive images are thought to commemorate the deceased that much more effectively when their material includes the cremation ashes.

Because, for these reasons, the religious work of art embodies sacred presence, it possesses for Tibetans the ability to "grant blessings" (*chinlap*). This is disseminated in a variety of ways: most physically, it occurs in the contact between the devotee's body (usually at the top of the head) and the image. The meeting of bodies is seen as a concrete instantiation of a shared moment in time and space, an intersection of history. There is also the idea that physical contact transmits a spiritual value. The transmission of the blessing can be effected by the lama, who touches the aspirant's head with the image, or by the aspirant alone, who can simply lift the image to his or her own head.

Physical contact with an image is particularly significant during the initiation ritual. Here, the lama's placing of the image on the head of the student becomes a symbolic enactment of the student's right to meditatively assume the form of the Buddha, a right which is granted just in that moment of ritual touching. The contact has other meanings as well. It symbolizes the student's link with the lineage of practitioners who have meditated on that same Buddha in the past. It also signifies the student's awe and respect for the Buddha, if for no other reason than because the contact occurs with the student physically subordinate to

the image. Again, when a lama places the weighty *vajra* on the head of the aspirant, exerting a gentle pressure, it reminds the student, by analogy, of the gravity of the *tantric* vows taken during the initiation and of the heavy consequences if those vows are broken.

Not only does the image physically grant blessings to a person, it also imparts an auspicious cast to its environment. The presence of a holy image renders its immediate surroundings a sacred space. On the large scale, the placement of images and their temples in the landscape relates to ancient ideas about the spiritual nature of Tibet's geography. Some myths conceive of the topography as a dismembered demon. In an important story connected to the establishment of Buddhism in Tibet, primitive Tibet-as-supine-demoness was subdued by the erection of temples, and images at key points on the demoness's body; those structures functioned to pin down the country-demoness, civilizing her by means of the new Buddhist presence.

The long-range perspective of sacred topography might also explain the construction of colossal Buddhist statues, often of the future Buddha Maitreya, at various spots in Tibet. Such monuments mark the country as a realm of Buddhism, and function both to herald the coming enlightenment, and to gather and focus meditative attention. The powerful effect of a Buddhist image on its location continued to be a prime motivation for the building of such structures in Tibet. One of the principal projects of the fifteenth-century saint-engineer Tangtong Gyalpo was the erection of *stupas* and temples at key points (*metsa*) in Tibet, in order to tame unruly forces.

The presence of a particularly holy image makes its site the focus of pilgrimage. The Jowo Rinpoche image in the Jokhang is an outstanding example; pilgrims prostrate their way there from hundreds of miles away. The climax of their journey will often be a trance experience in the image's presence. In Tibetan biographical literature, there are numerous stories of adepts who have received messages from the Jowo and other images.

Monasteries or villages possessing an important image will take great care in its protection and maintenance; its loss or damage would be thought to have grave consequences for the welfare of the local inhabitants, as if the very life force of the area were threatened. Usually the monastic community or a lay lama is responsible for such an image's physical upkeep. On special occasions, they will also display the image in processions or make it accessible to the public.

On a smaller scale, installing Buddhist art in a room or building is thought to affect that place in a similarly positive manner. A sacred image is often the first thing to be placed in a new house, even before personal belongings. By keeping the image there, the ongoing presence of that deity is maintained in the home. The effect, in the *tantric* imagination, is that the entire house becomes the abode of the deity.

The conviction that a deep interaction occurs between images and their surroundings is reflected in the Tibetan predilection to construct structures to enclose images. Clearly, this is not only to protect the art work; statues and

holy objects sometimes have a surprising number of multiple cases and wrappings that far exceed the practical need for shielding or padding. Rather, there is the widespread conviction that images require a seat, a domicile. When possible, statues will have a metal box (*ga'u*) in which they can be kept. For larger images, the temple or shrine room in its totality is the image's seat. In addition, small structures may be built on the roof of a house or monastery to contain images of the protector of that building (*gonkhang*). Other "houses" on rooflines are just solid shapes that simply provide a symbolic structure for the presence of the protector (*tenkhang*).

The image inside the house will be installed on an altar, located in a protected and physically high spot in the building, preferably on the top floor. The altar table itself is usually a complex structure of various levels, which allows the images to be placed on the upper levels. On the lower levels are arranged offerings and the symbolic seven cups of water. The water cups are filled every day and emptied the same evening. Other offerings, such as flowers, candles and incense, are common. Personal effects or significant objects may also be put near the image, in order to attract the image's blessing.

Behavior towards an image is the same as it would be if the living Buddha or deity were present. A large part of the protocol concerns bodily position, directionality, and the hierarchy of bodily parts. Profound significance is attached to the parallel that is thought to obtain between top and bottom in the physical sense, and high and low in the sense of spiritual value. An example of this attitude is the widely observed rule that only a person's head or hand should be pointed towards an image; never the feet. When approaching the image, devotees convey deference by assuming a slightly bent posture, with the palms of the hands held together near the middle of the chest, in the symbolic gesture of reverence. The more elaborate bodily expression of respect is the full prostration, practiced upon entering a temple or altar room, or at the beginning of a meditation or ritual session. Three prostrations are standard, but Tibetans will also perform them for protracted periods as a means of purification. The common sight of Tibetans prostrating themselves on wooden boards outside the Jokhang Temple, even to this day in Lhasa, is an instance of this practice.

The devotee can draw near to the image after prostrations, for the purpose of "receiving the image's blessings", as well as to see and appreciate the work of art at close range. Again, the deferential posture is assumed while approaching. One may seek physical contact by bowing the head and touching the top of one's crown to the lower portion of the image, or to the edge of the table where the image is displayed. When remaining in the artwork's presence, the religious Tibetan sits cross-legged on a level that is below that of the object. In a less structured situation than a ritual or sermon, but one that nevertheless puts the devotee in prolonged proximity to the image, there is further protocol. Smoking, arguing, or any sort of action deemed negative in Buddhism, are considered inappropriate in the image's presence.

The same expression of respect through physical positioning is observed when moving a religious art object. The image is always held head up. It is carried by a part of the bearer's body that is auspicious – in the hands, or perched on the head or shoulder, but never under the arm. If it falls, it is immediately picked up and touched to the carrier's head.

When images are borne in procession, the bearers will sometimes be seen to have a cloth or mask covering the mouth. This is to prevent the impure breath of the bearer from intruding into the pure atmosphere radiated by the image. Such a procession is usually preceded by incense carriers, who prepare the air through which the image will pass with auspicious scents. More elaborate parades are accompanied by music, thought to please the Buddha deity. Special vehicles carry the holy presence, and umbrellas and other standards add further pomp and awesome splendor, announcing the approach of a living Buddhist truth: the same measures that are taken when a living lama passes in procession. An image is packed with much care when it is to be transported for a long distance. In addition to wrapping and protecting the object, efforts are made to ensure that the image will remain head up while in transit. The container holding the object is never set on the ground, but rather is placed in a position of honor, upon its own seat or a high shelf in the vehicle. have they ever gone on planes?

When an image is to be disposed of, this is done with cognizance of its spiritual significance. Paintings, as well as texts or illustrated pages or religious writing, or even doodles of a Buddha figure, are not thrown into a trash can. Rather they are interred in *chortens* or hollow places in images, or are burnt solemnly. If the image was particularly revered, even a small piece of it will be treasured. Damaged metal or clay images will be kept in storerooms, treasuries, or used to consecrate other statues. The older relics link the new image with the history of the previous, and revive it with the same spiritual presence. This occurred recently in a small village in Eastern Tibet when fragments of a destroyed metal image were saved and used to consecrate the new image.

In general, the treatment of images as though they were actual, living Buddhas or deities is not limited to the credulous or uneducated. On the contrary, the most highly literate Buddhist scholar or accomplished yogin will maintain this reverential attitude. For the religiously sophisticated, this attitude is informed by an understanding of the psychological and aesthetic impact of the viewing of images. It is precisely the theoretical knowledge of *tantric* Buddhism that allows full appreciation of the work of art – a consciously devised tool to evoke intimations of the sacred, and of enlightenment.

15

Excerpts from *Making Merit, Making Art: A Thai Temple in Wimbledon*

Sandra Cate

Introduction

The following reading examines the roles played by Thai Buddhist temple murals from the sixteenth century onwards in constructions of religious practices, state ideology, and Thai cultural identity. The reading consists of two excerpts from cultural anthropologist Sandra Cate's study of the murals at Wat Buddhapadipa, a Thai temple in Wimbledon, England. Between 1984 and 1992, twenty-six Thai artists, including the two lead artists Panya Vijinthanasarn and Chalermchai Kositpipat, painted the temple's interior in a "neo-traditional" manner that combined scenes from the Buddha's life and Buddhist cosmology with references to contemporary culture and politics. By placing the images in their larger cultural, social, and historical contexts, Cate explores the relationship between modernity, tradition, religion, and art, as well as the local and the global.

 The two passages included here are from the third chapter of *Making Merit, Making Art*, "Thai Art and the Authority of the Past," which briefly outlines the historical development of Thai Buddhist murals. Many of the earliest surviving Thai murals date to the mid-sixteenth century and the Ayutthaya Era (1350–1767), during which the Thai monarchy began to look outwards and incorporate itself into a larger world order. During the early Rattanakosin Era, beginning with the coronation of

Sandra Cate, "Making Merit, Making Art," pp. 48–56, 64–8, 174–7, 180–1 from *Making Merit, Making Art: A Thai Temple in Wimbledon*. Honolulu: University of Hawaii Press, 2003. Reprinted by permission of the University of Hawaii Press. © 2003.

147

the Chakri king Rama I (r. 1782–1809), murals reached what many scholars consider Thai painting's artistic apogee. The reign of King Mongkut (r. 1851–68) inaugurated a period of Westernization that traditionally marks the end of the "classical" period of mural painting, though, as Cate points out, the incorporation of foreign elements into Thai art was not, in fact, new.

The first half of the excerpts featured here examines the ways in which sixteenth-through nineteenth-century painters used style, content, and composition to aid in the religious function of the murals. Cate notes shifts in style, including the incorporation of foreign figures and, eventually, single-point perspective, as well as a shift in the space occupied by the murals – from private to increasingly public spheres. This transformation overlaid the religious aspects of the paintings with sociopolitical meanings. The second half deals with the "neo-traditional" art that dominated the Thai art market in the 1990s and is featured at Wat Buddhapadipa. Cate explains how painters adopted the tradition of Buddhist mural painting to critique present situations as well as to indicate a uniquely Thai identity in a global age. This marker of Thai identity, however, quickly became a commodity to be consumed by tourists and businessmen.

Cate's tracing of Thai Buddhist murals' development from the "classical" age to the "neo-traditional" one highlights the appropriation of stylistic elements, whether foreign or past, in the art and points out some of the ways in which artists employ spatial constructions and style to construct "imaginary" and "real" worlds. The reading also speaks to the role of Buddhism as arbiter of moral order, and to the ways in which cultural identity and tradition can become politicized as well as commodified.

Murals as Art: Constructing "Tradition"

Numerous art scholars have elaborated at great length and with eloquence on the visual conventions that distinguish traditional Thai mural painting: linearity, two-dimensionality, and a decorative surface.[1] In Thai painting, line defines form. Boisselier wrote, "The search for beauty of form and quality of line comes before all other considerations" (1976, 41). Flowing, curving lines and flat coloring create the bodies of deities, monks, and nobles alike; all appear to transcend the material reality of muscle and weight. Figures appear in unnatural postures. The absence of light and shadow frees them from any specific location in diurnal time (Krug 1979), thereby increasing their otherworldly, transcendent nature. In this way, artists paint Thai figures – and important animals such as the elephant – as idealized, atemporal beings. These stylistic qualities contribute to a conceptual (rather than perceptual) basis for such painting, in which artists paint an imagined, symbolic universe of beings and landscapes rather than the "natural" world apprehended through the senses.[2]

The two-dimensionality of mural space creates a flat narrative surface, which sustains the viewer's attention upon familiar characters enacting oft-told events in tableau-like settings. Artists locate these events in imaginary landscapes, generic settings such as "palace," "temple," or "forest." Exceptions are those scenes from the lives of the Buddha that possess identifiable features. A herd of deer, for example, identifies the park at Sarnath where the Buddha delivered his first sermon. Artists render scenes multiperspectively: from a "bird's-eye" perspective or a parallel one, with walls and figures overlapped to indicate varied placement within the scene. Mural surfaces are further flattened through lavish decorative patterning, sometimes of the background but especially in dress and architectural ornamentation. Linearity, multiple perspectives, and decorative elements work to negate a space that extends beyond the surface. All that is important exists on a single, highly elaborated plane.

These stylistic conventions that define Thai painting tradition reach their apogee in the "classical" period of Thai art, considered by art historians to range from the late eighteenth to the mid-nineteenth centuries. The dating of this period coincides with the Rattanakosin (or Bangkok) era, inaugurated by the establishment of the Chakri monarchy in 1782. Thai painting flourished as the first of the Chakri kings, Rama I, embarked upon ambitious temple building and restoration projects. This classical period actually encompasses numerous stylistic and iconographic changes, but narratives of Thai art history end the period abruptly with the introduction of overtly Western artistic forms around 1850. Wenk, for example, describes this trajectory:

> The depiction of traditional themes had, through a number of intermediate stages, gradually developed in such a way as to constitute a national school of painting in which these themes had at last found their most perfect expression in accord with the artistic talents of the Thai people. Then came the age of the copyists, who were no longer able to fill the old forms with life. (1975, lxi)

Focusing on changing relations in Thai society yields greater dynamism in Thai mural painting practices. From its inception, Thai Buddhist mural painting exhibits an ongoing appropriation of "foreign" artistic styles, materials, and technologies. Indeed, Buddhism itself, as well as the many stylistic and iconographic conventions in art that developed in Buddhist India, could be characterized as a "foreign import." Changing temple spatial practices that engender new social meanings for murals in public spaces suggest another source for iconographic innovations. Any or all of these loci of change index expanding and shifting social relations between Thais and others, and between patrons, artists, and their audiences. For example, as artists have obtained access through trade or travel to new pigments – chemically produced dyes from China or acrylics from the West – the palette in Thai temple murals has widened and brightened from the relatively muted tones obtained from the earth and plant-based pigments available in the Ayutthaya era. As scholars have discussed in other arenas of Thai

149

culture, appropriation itself has been characteristic of Thai cultural processes. This has been generally characterized as a Thai reworking of foreign elements in which Thais incorporate such elements into distinctive and preexisting "Thai" contexts and, through some magico-alchemic transformation, render these foreign elements "Thai."[3] This is not to claim that such transformations occur without contest; negative assessments of the intensely colored acrylic-based palette used at Wat Buddhapadipa suggest otherwise.

During the late seventeenth century, Ayutthayan-era mural painters became aware of Persian styles of decoration through a burgeoning trade with that region and began to incorporate Persian-style delicate floral motifs into the backgrounds of mural scenes. In the early 1800s extensive interactions with China through political and cultural missions and immigration resulted in the flourishing of Sinic elements within Thai art. Artisans utilized Chinese mosaic techniques with tile and porcelain fragments and adopted Chinese stone guardian figures and Chinese motifs in masonry and wood decorations for temple roofs, pillars, and windows. Muralists – many probably Chinese artisans themselves – reworked landscapes with Chinese elements: highly stylized rocks, cockleshell waves, and gnarled flowering trees. Chinese floral arrangements appear as mural motifs or as individually framed paintings hung around the perimeter of many temples that sometimes obscure the mural scenes behind them.[4] Scholars such as Boisselier absorbed such innovations into their basic tenets of classical or traditional Thai painting; such appropriations themselves are seen to become Thai in their enhancement of a two-dimensional decorative mural surface. However, only with the introduction of artistic elements considered to be "Western" – naturalistic landscapes, realistic figural representation, and linear perspective that threaten the the integrity of the decorative surface – do scholars call into question the "Thai-ness" of mural painting.

Spatial Practices

From the fourteenth century onward, murals gradually shift in location from private devotional spaces to public instructional ones, from inaccessible crypts in *stupa* or *chedi* to *viharn* and *ubosot* – the buildings where monk and laypersons interact. These shifts in location change the position of murals vis-à-vis other architectural and sculptural elements in religious space. Once positioned for public viewing and instruction, murals mediate in new ways the relationship between the patron and/or artists and their audience. Using the location *of* murals themselves as primary evidence, set within particular historical contexts of change in Thailand, one might argue that the social functions of murals have not changed so much as multiplied to accommodate new historical subjectivities experienced by Thai monarchs and citizens. The painting of space *in* murals follows the political, economic, and social engagements of the kingdom with

a wider world of other state powers, instituting new visual dialogues between ruler-as-mural-patron and viewers-as-citizen subjects.

In assessing the signification of the shift in location of murals to public spaces, we might consider Wyatt's analysis of the rise of Ayutthaya in the fourteenth century as constituting a "fundamental change in international outlook" (1984, 62). The rulers of this kingdom looked to more expansive horizons, beyond the kingdoms of regional rulers, to acknowledge an "international community of states." Ayutthayan rulers sought to consolidate their power through military engagements and heightened diplomacy, the expansion and control of international trade, especially with East Asia, and the spread of an invigorated Theravada Buddhism out of Sri Lanka. This new worldview entailed both new identities and the transformation of consciousness on the part of the diverse peoples who lived and traded in the kingdom (Wyatt 1984).

The murals at Wat Ratchaburana in Ayutthaya, the earliest extant murals in Thailand, are located deep within previously sealed crypts. That the crypts also contained numerous votive tablets suggests that the murals were probably painted as devotional offerings (*tawai buchaa*)[5] or to make the Buddha manifest, rather than as decoration or pedagogy – the two functions often attributed by scholars to Thai temple murals.[6] Ayutthayan-era kings instituted *sangha* [monastic] reforms that invalidated other religious traditions and brought the *sangha* under direct state control. They transformed religious festivals and annual pilgrimages – the pilgrimage to the Buddha's Footprint (Phra Phutthabat) in Saraburi provides one example – into celebrations of kingship. All of these activities are painted into temple murals, which by the end of the seventeenth century appear in buildings designed for public interaction between illiterate lay worshipers and monks. Paintings in the daily spaces of monastic life provide not only evidence of a "new type of political order" in the kingdom of Ayutthaya, but, in a performative sense, contribute to the construction of that order. In murals, the Thai see themselves both as Buddhist subjects and as historical ones.

Into the middle of the sixteenth century, historical research and extant murals suggest that early temple paintings, including those at Wat Ratchaburana, consisted largely of rows of seated figures of previous Buddhas (Pacceka Buddhas) and disciples, and, infrequently, the Buddha himself. Symbols often separate these figures – a tiered parasol, a *chedi* [reliquary structure], or a bodhi tree – that in early Buddhist art substituted for iconic representations of the Buddha in human form. By the middle of the seventeenth century, mural painters were filling the walls of public *wat* [temple] buildings with a more complex program. They placed registers of deities known as the celestial assembly (*thepchumnum*) high above windows, clearly demarcated by the zigzag lines (*sen phlaeng*) that become conventional in Thai murals. Painted in poses of worship and respect as their eyes turn toward the presiding Buddha image installed at the back of the space, the celestial assembly encourages mimetic response on the part of the viewers below.

Another shift toward the modeling of bodily practices in murals occurs during the reign of King Mongkut in the mid-nineteenth century, another period of

151

radical monastic reform resulting in the establishment of the Thammayut sect. During Mongkut's reign, temple murals become more didactic, to include scenes depicting modes of religious worship and practices central to the monastic life, and to provide visual instruction in *vinaya* discipline for both monks and layper-sons.[7] At Wat Maha Phruttharam in Bangkok, for example, murals depict the thirteen *dhuthong*, the ascetic practices required of a monk while on religious pilgrimage. Similarly, at Wat Kanmatuyaram the doors of the *bot* [ordination hall] are painted with the foods both tabooed and allowed to monks.

As murals "go public," painters include scenes from the historical life of the Buddha and from the Jataka tales (his past lives) below the celestial assembly, between windows, and on the walls behind and opposite the presiding Buddha image at eye level of the templegoers. These visual narratives, which detail the Buddha's perfection of moral virtues on his path toward enlightenment, aid monks as visual prompts and illustrations in teaching the Dhamma [doctrine] to illiterate laypersons. As well as instructing monks, specific mural images encourage mimesis by templegoers. In murals in a sacred setting, the depiction of calendrical festivals, especially local ones, encourages laypersons to interpret their own participation in such festivals as merit-making, thereby reinforcing that particular Buddhist worldview. Renditions of the Phra Wesandorn Jataka (*maha-chat*) on contemporary temple walls serve a similar purpose – they stress meritorious aspects of giving, especially by laypeople to the *sangha* and the *wat* itself. In Thai temples, the presiding image often portrays the moment of "calling the earth to witness." This style of Buddha, known as the Buddha Maravijaya, recalls the night of his enlightenment as he recounts his many meritorious acts in order to defeat the demon Mara. Murals depicting the defeat of Mara and the enlightenment of the Buddha on the wall opposite the presiding image establish the context for this gesture – Buddha's final battle with Mara, who represents all material temptations. These visual enactments of key moments in the Buddha's biography construct a frame in which viewers might consider their own struggles, sufferings, and attachments to the material world.

Murals and the State

Just as murals foster particular state-sanctioned forms of worship and religious practice, and serve as visual reminders of the *bun*, or merit, of the rulers who sponsored them, they also legitimize certain visions of the state. The dialogic relationship between ruler and subject, depicted in and mediated through temple murals, assumes greater importance in the early Chakri dynasty. As well as consolidating and extending their political control over surrounding principalities and sultanates, the Chakri kings attempted to reinvigorate Siamese public life with the ideals of the Buddha through temple restorations, new construction, rewriting of important Buddhist texts, and vast new literary productions. During the

reign of Rama I in the late 1700s – a period of restoration of the Siamese kingdom
following the sacking of Ayutthaya in 1767 – temple muralists began to paint the
Traiphum (Three Worlds), or the Buddhist cosmology, on the wall behind the
presiding Buddha image. In the context of royally commissioned public space,
the painted *Traiphum* asserts congruence between the Buddhist cosmos and the
sociopolitical order, an assertion characteristic in the architecture and administra-
tive organization of many premodern kingdoms in Southeast Asia and believed to
ensure harmony and prosperity (Heine-Geldern 1942). According to many Thai
scholars, the *Traiphum* symbolically represents the social order visually and
textually – although they have never agreed whether this order is primarily a
hierarchy of spiritual attainment or a justification of social difference. In the arena
of popular consciousness and political ideology, the text of the *Traiphum* has been
interpreted as setting forth implicit relationships between "merit and power."
The many levels of the cosmology have been seen to mark (and, some claim,
justify) inequities of social position due to material wealth, power, and status,
since these attributes are thought to reflect accumulated merit. Thus to the extent
temple murals functioned didactically, "It was by means of these visual portrayals,
as well as the teachings of monks, that most Siamese learned how they fitted into
the Buddhist cosmos" (Reynolds 1976, 211).

As visually organized on temple walls, the *Traiphum* constitutes one primary
indigenous vision of human and divine space. The *Traiphum* cosmos and its levels
read as a vertical hierarchy, from bottom (the nether regions of hell) to top (the
arupa loka, or world without form). This strong verticality holds in the visual
organization of individual scenes as well, and not just in the *Traiphum*. Through-
out Thai murals, verticality organizes individual scenes and the placement of
beings. *Theweda* (angels) and deities, celestial attendants, and nobles appear in
the upper registers of mural plans. In individual scenes of temples and court, they
are positioned higher than servants and ordinary humans. Stylistic rendition
further reinforces moral distinctions: divine beings are idealized, linear forms
free from the constraints of material embodiment. Their impassive facial expres-
sions and formal posture and gestures indicate their emotional detachment.
Scenes of daily life appear in the margins of Thai murals: toward the bottom, or
outside palace or temple walls. There, ordinary humans, rendered freely and with
a wide range of facial types and bodily expression, engage in fighting, loving,
trading, playing, gossiping, eating, and drinking. The lesser position of humans is
voiced linguistically as well – Thai scholars call these regions *phaap kaak*, meaning
"the dregs."[8]

In the Ayutthayan era of the early to mid 1700s, *farang*, or Western foreigners,
appearing for the first time in Thai murals, on lacquer cabinets, and carved onto
temple gables were often represented in the guise of *deva* (gods), *theweda*
(angels), or as fantastic creatures like the half-human, half-bird *kinnaree*. Temple
mural painters customarily included different types of *farang* soldiers – the *sipsong
phasaa* (literally, twelve languages) who fight in Mara's army.[9] In later murals,
depictions of Christian missionaries or showily dressed soldiers carrying big guns

represent potential invasion, or a threat or disturbance to a Siamese way of life. Other *farang* (French engineers, for example), arriving in steamships, offer new technologies and opportunities for trade, wealth, and display. Thai soldiers dressed in American Civil War-era military clothing anticipate a later mass adoption of Western styles of dress by the Thai populace.[10] The Siamese ambivalence toward the presence of these Westerners and others is indicated to some degree by their positioning within the murals – in earlier eras as *theweda* or even monks, then as soldiers in Mara's army tempting the Buddha, and in the nineteenth and twentieth centuries as tourists or sinners in hell. Portrayals of theatrical entertainments, military formations, or commerce suggest the range of cultural influences brought into Thailand by foreigners, their status and roles in various constellations of power within Thai society, and the nature of engagements of the Thai state with foreign powers.

Mural programs diversify in the late eighteenth to mid-nineteenth centuries to include themes drawn from literature, other domains of everyday knowledge, and history. At Wat Buddhaisawan in Ayutthaya the artists painted scenes of recent history, most notably the voyage of the Somdet Phra Buddhakhosachan, the spiritual mentor of King Phetracha, to Sri Lanka to obtain important Buddhist knowledge. Scenes of this journey further associate the patron of the murals with a revitalization of Buddhism from Sri Lanka and depict a new temporality – not Buddhist history, but royal history – a history shared by and perhaps participated in by viewers of these very paintings. These scenes were contemporary, as they depict architectural styles of that period, boats with cannons, and new technologies of state power.[11] For rulers seeking a moral legitimacy as righteous kings (*dhammaraja*), temple murals communicate authoritative visions of the known world as much as an imagined moral universe.

Mural painting became a powerful site where ruling powers could assert an independent and modern Siamese identity to visiting foreigners, as well as to their own subjects. Mural painters increasingly portray a "historicized" reality tied to the present moment: royal processions, important military campaigns, and travels by dignitaries.[12] In addition to the depiction of contemporary life and political events in murals, patrons also commissioned the painting of "history" in Thai murals, in a period when "having a history" meant "having a culture" – both preconditions for the attainment of *siwilai*.[13] Murals that had concerned the past of the Buddha gradually included both the present of the viewers and their history as well, an accretion of temporal references.

The Real and the Imaginary

> What dramatic effects ensue when people stop imagining space in terms of orderly relations of sacred entities and start conceiving it with a whole new set of signs and rules? (Thongchai 1994, 36)

Beginning in the mid-nineteenth century, King Mongkut embarked upon a mission to fully "civilize" the Siamese populace, in part by fostering a worldview that incorporated Western ideas of rationality and science – especially astronomy and geography. However, Mongkut drew sharp distinctions between worldly matters and spiritual affairs. In 1867 his minister of foreign affairs published the *Kitchanukit* ("a book explaining various things"), which argued that while Western knowledge of geography and astronomy represented the "true knowledge of the natural world," Buddha's teachings remained the sole source of moral and ethical truth (Reynolds 1976). This distinction found visual expression in murals painted during his reign, especially those painted by Khrua In Khong. Perhaps inspired by European and American prints circulating in Siam at this time of expanding interaction with Western powers, Khrua In Khong introduced three-dimensionality into Thai painting. At Wat Boromniwat, he transposed Dhamma allegories into Westernized settings with peoples in Western styles of dress. These murals – where the buildings are European in style and perspective, but where Siamese angels fly in the skies – constitute a radical gesture toward the ideas of mid-nineteenth-century *siwilai*, [civilizing reforms promoted by Thai elites], exploring new, modern positions of Siamese subjects among the peoples of the world. At Wat Benchamabophit (painted *c.*1900–5) another muralist recorded the king's interest in astronomy by including a cameo portrait of Mongkut viewing an eclipse at Nakhon Khiri.

Historians of Thai painting consider the introduction of single-point perspective and forms of painterly "realism" by Khrua In Khong and others to have shattered the unity of flat narrative space, thereby ending the classical era. Boisselier, for example, writes, "This period is marked by the appearance in Thai painting of ideas peculiar to Western art and the hopeless attempt to synthesize two diametrically opposed conceptions" (1976, 119). The vertical and two-dimensional moral hierarchy that dominated Thai murals gives way to horizontal expanses that suggest geographical ("true") space and physical location.[14] At first these far-off distances appear as Thai, or nonspecific. Gradually, muralists began to reference the actual spaces of the other: Western paddleboats and Chinese trading junks enter Thai waters, arriving from far-off lands. These new elements parallel developments in map-making representing material spaces of the earth (Thongchai 1994). Such maps implicitly recognized macrospaces – larger regions of which the particular map represented only a part.

Pictorial realism in the painting of people and space describes another dimension in the shifting social worlds of these Thai artists. Thai muralists have long painted small animals of the forest naturalistically, a style appropriate to the creatures that inhabit lower levels of the moral universe. People appear in degrees of naturalism, from the extreme stylization and idealization of deities and royalty, discussed above, to the more expressive, individualistic features of the ordinary village folk. Silpa Bhirasri noted that in older Thai murals, common people engaged in quotidian activities of fishing, selling, fighting, playing, and loving accurately reflect how the viewers themselves lived in those times; but he also said

155

that this style of realism is "proper to Thai art, it is not Western style realism," as it remains two-dimensional (Silpa Bhirasri 1959, 18).

Throughout the classical period of Thai temple paintings, artists created a uniquely Thai space inhabited by Thai conceptions of divine beings and common people, and Thai renderings of fantastic creatures – the dragon-like *naga*, the *yaks*, or giants, the *singha*, or lion-like creature, or the half-human, half-bird *kinnaree* (Wenk 1975; Boisselier 1976). The painters may have depicted scenes of the historical Buddha's life in ancient India, but these renderings appear in localized imaginary landscapes with indigenous architecture, trees, flowers, and animals. The entertaining scenes of daily life take place in traditional Thai houses, on Thai piers, in Thai boats. The expansive distances painted toward the top of mural scenes – framed by forests, rock formations, mountain ranges, the sea – are vague, indeterminate, and universal.

The transformation of the "imaginary" into the "real" first takes place in the depictions of space. Elements of landscape and setting evolve gradually from the purely decorative devices (*sen phlaeng*) that organize compositional space toward the naturalistic depiction of a place. Stylized trees – often painted in Chinese style with small twisted trunks and branches laden with blossoms – and the distortions and exaggerations of mountains and rocks, characteristic of Thai painting in the early Bangkok period, become more lifelike in scale and rendering by the mid-nineteenth century. Flowers that decorate background spaces in early murals gradually give way to naturalistic clouds, sky, the hint of changing light, and the specific visual effects of time. The introduction by Khrua In Khong and other mid-nineteenth-century muralists of single-point perspective applied to both landscape and architectural structures further creates naturalized places, as does the introduction of a horizon and figures painted on a diminishing scale to create depth.

An important function of perspective in painting – beyond rationalizing the representation of objects and peoples in space – is its manipulation of the perceptual faculties of the viewer to achieve important effects of illusion, of narrative or structural focus, of a heightened spirituality. Perspective, by organizing a "point of view," explicitly acknowledges the viewer, making him or her an active participant in the art process. While nineteenth-century Thai muralists – whose interests were never really those of scientific principles of representation – may have applied perspective awkwardly and inconsistently, their use of it did apply a "modern" and "Western" look to Thai temple murals. They create an aura of "civilization" around Thai Buddhist activities and bring others – viewers and foreigners – into Thai mural space. These transformations alter the nature and reading of visually depicted space in murals. Shaped by Thai Buddhist cosmological conceptions of levels of beings, characters of different moral status in the same scene in older Thai murals inhabit a visual hierarchy of personage and place. In the horizontal dimension, beings of different karmic realms co-inhabit the same spaces, although deities remain distinct from lesser beings by their larger size. The visual hierarchy that dominates premodern murals breaks down where linear perspective is consistent, as figures tend to be read according to their placement in space rather

than their moral status. *Traiphum* space becomes geopolitical space, evidence of changing Thai subjectivities.

Neotraditional Thai Art

As in countries throughout the world, the emergence of a "neotraditional" art category in Thailand must be tied to specific historical contexts that encourage the self-conscious evaluation of cultural identity in art and in artistic modes of production. At issue here is how the art and individual artists deemed neotraditional – the locally defined category made prominent by the work of Panya and Chalermchai at Wat Buddhapadipa – came to dominate the Bangkok art scene in the early 1990s. While critical reception of much of this art ranges from lukewarm to ice-cold, during the white-hot art market of the late 1990s, neotraditional art was among that most eagerly sought by Thai buyers. Why?

The massive presence of Americans in Thailand during the Indochina War, the dominance of Japanese investment, and booming international tourism in the 1960s and 1970s fueled new discourses on "Thainess" and a backlash against abstract international styles seemingly devoid of specifically Thai cultural content.[15] Artistic trends of this period that sought to reorient contemporary art range from the "Floating Market" school – referring to tempera renditions of floating markets, festivals, and folk games – to the art that engaged with issues of political repression and social injustice during the political crisis of 1973–6, loosely clustered as "Art for Life."[16] Major artists such as Thawan Duchanee, Pratuang Emcharoen, Angkarn Kalayanapongse, and Pichai Nirand turned toward Buddhist themes and motifs in a deliberate "break with the Thai abstractionists' endeavors to create and preserve the autonomy of pure and high art" (Apinan 1992, 226). The artistic concerns of this group serve as the immediate antecedents of the neotraditionalism of Panya and Chalermchai that sought to bridge the past of Thai art with the present of international modern art.

For these artists, a "return to the past" meant exploring Buddhism as the basis for critiquing contemporary conditions of Thai modernity, as well as claiming a nativist position for their work. Thawan, noted for his muscular style and use of animal imagery, painted monks as gorillas, commenting upon perceptions of an increasingly corrupt *sangha*. In his *Thosochat* series (1974–6), Thawan gave Buddha's battle with Mara updated relevance as an attack on the values of Western popular culture in which the Buddha defeats Rambo, Conan, Superman, Batman, Lone Wolf, Clint Eastwood, and Arnold Schwarzenegger, all Western "good guys" (Apinan 1993b, 227). Other artists returned to the temple itself – abstracted into pure architectural form (in the work of Preecha Thaothong, for example) or as site of contemplation and tranquility (in the paintings of Surasit Saokhong). The cumulative impact of these and other similar artists – still holding central positions in the contemporary Thai art world – is the reconstruction of

157

"Thai art" as Buddhist art. This achieved dual cultural objectives: artists could "be Thai" while utilizing abstract, expressionist, and other "non-Thai" painting styles. They could also adopt an implicit or explicit stance of critique by invoking the authority of an ultimate Thai master teacher, the Buddha himself.

These moves toward an artistic redefinition of "Thainess" found increasing commercial success with an expanding domestic art market, the proliferation of new venues for exhibition and sales, and media coverage of art and art events. Beginning in the 1960s, artists felt encouraged pursuing careers as painters.[17] Annual art competitions, such as the Bangkok Bank's Bua Luang, promoted artists' concerns with "Thai" art by establishing separate categories for "Thai traditional" art (*thai praphenii*, or Thai customs, or *sinlapa thai*, Thai art) and modern art (*sinlapa ruam samai*). The administration of Silpakorn University also responded by establishing the "Thai Art" curriculum at the university in 1978, institutionalizing the "process of instilling the concept of cultural identity into one's thinking as an important aspect necessary for creating works of art regardless of time and place" (Somporn 1995).

The muralists who painted Wat Buddhapadipa were among the earliest graduates of this new "Thai art" curriculum at Silpakorn University. Chalermchai was one of two students in the first graduating class, Panya one of four in the second graduating class. In an unpublished interview that illuminates his specific views of the past, Chalermchai explains the divisions in the Thai art world during the late 1970s:

> I thought it was important to know about *farang* art, but I thought it was important for Thai people to know Thai art too. But Damrong's group tended to pay a lot of attention to *farang* art; they never paid attention to Thai art. *It seems like they look down on their own ancestors' spirits.* It isn't right. It made me promise myself that one day I would make them realize this.
>
> I am the one who is strong enough to encourage artists to do Thai style and encourage people to realize the value of Thai art. I want artists to think in a new way; to create a new contemporary Thai style based on our own traditions. It will narrow the gap between Silpakorn graduates who follow *farang* art and traditional art. We will be in the middle. (Phillips 1987, emphasis added)[18]

Chalermchai and Panya organized the "Thai Art 80" art group and exhibition in 1980 at the Bhirasri Institute of Modern Art. Media coverage of that event heralded it as the beginning of the neotraditional art movement in Bangkok.[19] At Visual Dhamma Gallery run by Alfred Pawlin, an expatriate Austrian committed to showing contemporary art that communicated Buddhist teachings, the 1984 exhibition "Visual Dhamma" bridged the two generations of artists. Thawan, Pratuang, and Pichai, artists of the older generation, worked in both abstract and representational styles but did not refer directly to classical mural painting styles. Panya and Chalermchai represented the emerging neotraditional group. Chalermchai worked in tempera, utilizing the two-dimensional flatness of mural

painting in scenes of lay templegoers. Panya, who had trained with Tan Kudt, experimented with printmaking and acrylics but often quoted mural scenes. In large part because of the Wat Buddhapadipa project that immediately followed the "Visual Dhamma" exhibition, neotraditionalists in Thailand became associated with art derived from mural painting, although many of the artists so labeled, including some in the original "Thai Art 80" show, had never worked on murals. In the artwriting about Chalermchai and Panya in the mid-1980s, a distinguishing characteristic of their work was seen to be the "fresh application of the mural style," one which would "help counter a rampant Western modernism that was threatening the best of the old in Thai art" (Mead 1986).

The neotraditional category of art emerges from an intellectual space where artistic production is interpreted and given value. In that space, art historians claim that Western elements (Western dress, architecture, linear perspective, and naturalism) have "contaminated" the classical qualities of temple murals. Cultural discourse maps "modern" art as "Western," while the "Thai" qualities of art are seen to adhere in either depictions of village life or in Buddhist themes, content, and style. Thus as a linguistic construction, the neotraditional mediates between classic/modern and Western/Thai. However, Thai artists and writers resist the notion that "being in the middle" between Thai and Western, traditional and modern, is merely syncretic blending. Somporn Rodboon, a Thai art historian and curator at Silpakorn University, argues that neotraditional represents the "cultivation of aspects of traditional art that were previously left underdeveloped. Artists who work in this style attempt to represent a modern form through the aesthetic values of the past in a way that is suited to modern conditions" (1995, 15). Others give primacy to the claims made by the neotraditional for authority over the past. John Clark, an Australian art historian who studies the contemporary art of Asia, argues that the rhetorical intent of the neotraditional category attempts "to re-invent the context from which that legitimacy [of past forms and techniques] is drawn," a legitimacy presumably "unspoken and unified," set within court and temple (1995). In Thailand, that context is Buddhist, animating a morality and sense of truth beyond the reach of Western science and modernity, the distinction made by King Mongkut.

Thainess: Identity and Commodity

Murals or easel paintings done in mural styles now constitute an important element in Thai interior design schemes. Builders of large hotels in Bangkok design and furnish them in the bland, international corporate styles familiar to travelers the world over. Mural-style painting – on ballroom ceilings, on the walls lining the lobby's grand staircase, or mounted on carved panels standing in the reception area – serves to situate these otherwise anonymous public spaces in

Thailand. Mounted and framed canvas panels of Thai mural-style painting grace the lobbies of hospitals, restaurants, and office buildings. According to one scholar, traditional painting styles in these commercial settings serve as a "sign, not a symbol" of Thai identity, signs that function "just to attract customers." In her view, a fully "Thai" space emerges out of a combination of light, architecture, and use of space. Mural panels placed in the lobby are insufficient (Somporn, personal communication, 1995).

Even multinational fast-food chains, with distinctive corporate identities de-fined by logos, graphics, color schemes, spatial layouts, and server uniforms, have appropriated Thai mural-style painting. At the McDonald's at Bangkok's World Trade Center, Ronald McDonald cavorts with Thai *theweda* in murals above the counters and on the walls between tables. This process of differentiation, while seemingly culture-specific, remains contained within the imperatives of con-sumerism. "Culture" (in this case Thai murals) serves as commodity packaging, wrapping a product in local colors and designs.[20]

In the context of international tourism, designers feature mural-style painting in brochures and tourist guides.[21] While temples and murals themselves have become primary tourist attractions in Thailand, mural paintings have also been transformed into commodities in service to the tourist industry, as souvenir refrigerator magnets, or to create distinctively Thai packaging – as that used by the Jim Thompson Silk Company. Scenes from Thai murals have entered the stream of globalized commodities as well – in one case to substantiate the "Cultural Richness of Asia" on boxes of Kleenex facial tissues.

In lightly stamping a public space (or corporate commodity) as "Thai" with replicas of mural painting, this style of art mediates between the global and the local. Such art renders the forms of global capitalism (the McDonald's restaurant) "culture friendly," making imported forms welcome to a local public. The corporate appropriation of (or institutional support for) art forms is one mode by which they claim cultural legitimacy; sponsoring key Buddhist rituals is an-other.[22] In addition to sponsoring juried contests and amassing important col-lections, the direct commissioning of such art for corporate or bank headquarters was an obvious next step, such as the murals painted by Panya at the Siam Commercial Bank, completed in 1995.

When compressed into the visual conventions of, say, the Third Reign temples represented by Wat Suthat or Wat Suwannaram, or the Lanna-style figures of Wat Phumin, Thai mural painting does constitute a distinctive artistic style. The more frequently reproduced, the more immediately identifiable as "Thai" this style becomes in international visual culture. Similarly, the bold graphic designs of Sumbanese *ikat* fabric have become one shorthand visual symbol of Indonesian identity, and the kilim rug designs symbolic of Turkey. As a recognizable artistic style that relies on a distinctive use of line to create form and on themes of religious worship, royal splendor, local temple festivals, and romanticized village life, Thai mural painting remains obstinately not-Western and not-modern. That this distinction establishes a basis for claiming such representations of Thai

cultural forms to be Orientalist (whether imposed from without or as a kind of self-Orientalizing) is arguable, but not really my point here. In international visual culture, Thai art is marked as "Other," as unique, and as worthy as cultural currency in the marketplace of images and goods.

Categories

The "classical," "modern," "Thai art," "traditional," and "neotraditional" categories largely relate to art production at the center in Bangkok, or by the monarchy and elite. They do not adequately account for the mural painting that has continued in up-country temples, or in Bangkok in new public spaces, or with the introduction of ideas of conservation and restoration. The artists at Wat Buddhapadipa did not pick up a form of production known to them only in history books or remaining in decaying traces on temple walls. They emerge from a continuity of practice lying somewhere outside the preferred categories of modern art production.[23] Most of the artists who worked at Wat Buddhapadipa had exposure to the materials, techniques, and approaches of mural painting at Poh Chang and the other vocational schools they attended before entering Silpakorn. In addition, as one of their leaders, Panya had worked on mural conservation projects and as an apprentice of Tan Kudt. These experiences, as much as the ideologies of creativity and experimentation, have shaped his views of "art" as product and as praxis.

Despite the essentializing and compressive force of the word "traditional" and its derivative, "neotraditional," the practice of Thai mural painting has been a dynamic one. Yet while mural painting continued, it did so in the margins of dominant art discourse in Thailand. Extant temple murals became subject to new discourses. Filtered through agencies of the state and other institutions of modernity, such as banks and international arts agencies, they have been repositioned in official narratives of Thai "art," "history," "identity," and "heritage." At the level of state institutions, concerns shifted from the production of temple murals to their documentation, conservation, and restoration – activities that further maintain a disjuncture between the "past" and the "modern." Along with major architectural monuments and the ceramics produced at Ban Chiang, temple murals have become visible tokens of the Thai past and currency in the cultural politics of the present. The representational nature of murals as well as their ubiquity, I would argue, has given them a special place in the public construction of Thai identity, both to the Thais themselves and in projections of a Thai identity globally. The changes visible in both theme and style on temple walls mirror changing relations within Thai society and between Thailand and the world. In certain other respects they do not merely reflect change, but as the outcome of productive activities that mobilize technologies, ideas, and social relations, they comprise some of the substance of those transformations.

The recontextualization of Thai architecture, sculpture, and painting – from temple to heritage park and tourist attraction, from religious space to museum vitrine, from temple wall to coffee-table book and tourist trinket – has extended into the realm of commodity exchange and corporate culture. Whether projects of heritage and commoditization desanctify explicitly religious imagery and/or attenuate specific kinds of power adhering in revered images remains an open question. The alterations to an image of an image – the photograph of the statue of Silpa Bhirasri – and the protests at Silpakorn University it provoked animated tensions and ambiguities toward commoditization, the position of the individual artist within Thai society, and the authority of the "past" specifically articulated in the father-like master/student relationships.

Notes

1 These scholars include Silpa Bhirasri (1959), Lyons (1960), Wenk (1975), Boisselier (1976), Ginsburg (1989), and Ringis (1990). The elements of tradition these scholars enumerate also apply to related genres of manuscript painting and cabinet lacquer work.

2 The dichotomy between the "conceptual" and the "perceptual" cannot be sustained to the point of positing a mind/body split that would somehow sidestep the visual faculties of painters. I use these terms, as have Thai art writers and artists, to differentiate an emphasis on the visual enactment of an idea from attempts to render elements and locations of the "real world."

3 Chetana's 1993 essay traces out parallel transformations in Thai literary production. Scholars have recognized "localization" as a long-standing trope in Southeast Asian studies. See Wolters (1999, 73–75). The nature and significance of these localizing or indigenizing processes dominate theoretical discussions of contemporary Southeast Asian art – see Clark (1993, 1997) and the essays in *Traditions/Tensions* (Asia Society 1996).

4 See Boisselier (1976, 104–106) and Apinan (1992, 3) for further analysis of "Sino-mania" in Thai art in the early nineteenth century, a result of the influx of Chinese artisans, King Rama III's personal interest in things Chinese, and the patronage of temples by Sino-Thai merchants.

5 Wannipa 1994, personal communication. M. L. Pattaratorn Chirapravati (2000) analyzes the findings at Wat Ratchaburana.

6 Brown (1997) analyzes the spatial positioning of many early Buddhist narrative carvings and their arrangement in "non-narrative" order. I accept the thrust of his argument that early carvings of the Buddhist Jatakas were probably not intended to be didactic or instructional.

7 The *vinaya* is the list of restrictions and prescriptions adhered to by devout Buddhists. Monks observe the most number of *vinaya* rules.

8 Gordon (1996) assumes such scenes have no religious significance because of their marginality and lack of overt ideological content, in contrast to the scenes of temple and court. The very marginality of such scenes, I would argue, is ideological, as it positions common folk in the visual moral hierarchy painted into Thai murals. The

doctrinal meanings of the *phaap kaak* scenes are overshadowed by their historical significance – for it is these scenes that scholars look to for visual documentation of past practices of dress, hairstyles, tattooing, architecture, customs of religious worship, forms of entertainment, and social relations.

9 The multiculturalism of attacking armies does reflect the actual composition of the Thai military. The armies of the Chakri monarchs in the nineteenth century (especially during the reign of Rama III) were largely non-Thai: Vietnamese (as artillery), Mon (as infantry), and Khmer and Lao (King's Guards). Cham and Malay dominated the Thai navy. As the Thai military during the reigns of Rama III and Rama IV functioned largely as instruments of internal political consolidation rather than as defenders from external aggression, these mural representations raise questions as to the moral positioning of the armies in a Buddhist context (see Battye, cited in Anderson 1978, 202). At Wat Buddhapadipa, an association of state warfare with the evils of Mara is quite explicit, as the war weapons of modernity (AK-47s, bazookas, missiles) constitute many of the weapons of Mara's army. These tokens of Western technology emblematize "modernity" in a general way, much as the Western-outfitted army itself did.

10 No Na Paknam (1986) illustrates and discusses many of these examples.

11 Boisselier 1976. Ishii (1993) discusses the introduction of new weaponry from the Portuguese during this period.

12 See Ringis (1990, 116) and the Muang Boran books on temples built or painted in the reigns of Mongkut and Chulalongkorn (the fourth and fifth reigns), when these changes in murals accelerate. King Chulalongkorn commissioned scenes from the life of the Ayutthayan king Naresuan, who defeated Burmese invaders in 1593, for Wat Suwanadaram in Ayutthaya. At the royal palace, murals at the Song Panuat chapel depict King Chulalongkorn's own travels in Europe and Asia and the renovations of the *chedi* that he sponsored at Nakhon Pathom.

13 In the context of nineteenth-century emerging nationalisms in Europe, being civilized meant "having a culture" (Handler 1985), materialized through the discovery and display of "old things" that supplement written texts and oral histories. King Mongkut's discovery of a pillar containing Inscription Number One, a long passage reputedly inscribed during the reign of King Ramkhamhaeng, provided material evidence of a long-standing Siamese past, connecting Mongkut's reign and that of other Bangkok kings to the ancient kingdoms of Sukhothai and Ayutthaya. Cary (1994) documents Mongkut and Chulalongkorn's growing interest in the collection and display (in museums) of Siamese historical artifacts.

14 Khrua In Khong and his contributions to Thai mural painting are analyzed in Listopad (1984) and Muang Boran (1979).

15 See Kasian (1996) for an engaging analysis of changing signification of "Thainess" from the 1960s and 1970s, when discourses on "Thai" identity were largely anchored to the Thai nation, to the time of this research, when "Thai" identity was expressed in consumption and brand names.

16 The "Floating Market" school really responded to the art market that developed to serve tourists in the 1960's and 1970s.

17 See Smithies (1978) for a comprehensive description of the Bangkok art world in the 1960s; Piriya (1981), Somporn (1995a), Phillips (1992), and Apinan (1992) also discuss the important institutions affecting Thai art from the 1960s into the 1990s.

Henderson provides an extensive analysis of the structures of the 1990s art world in Bangkok and their effect in "enabling or confining creativity" (1998, 3).

18 Damrong Wong Uparaj was a prominent faculty member at Silpakorn University, painting abstract versions of rural landscapes and village scenes. The "group" (*klum*) is a fundamental aspect of sociality in the Thai art world. Chalermchai's reference to "spirits of the ancestors" touches upon Thai views of the authority of the teacher and his own Sino-Thai background. His mention of being "in the middle" alludes to the Buddhist value of the Middle Way.

19 One Thai art historian, writing in English, credits the early generation of artists – Thawan, Pratuang, Pichai, and Angkarn – for establishing the "New Traditional Art" movement (Somporn 1995a).

20 Numerous scholars have written on the commoditization of "culture" in an era of international tourism and globalized capitalism; indeed, it characterizes postmodernity (e.g., see Jameson 1992 [1984]).

21 See, for example, the cover of Lonely Planet's fifth edition of *Thailand*.

22 The work of Gray (1991, 1992) provides an insightful and provocative analysis of the Sino-Thai banks' sponsorship of the *kathin* ritual at royal temples.

23 In an essay comparing neotraditional art in Japan and Thailand, J. Clark identifies three divergences in the movement in Thailand – those of "academic borrowings," "cultural charlatans," and of those "more humble" and "without bombast," no doubt referring in part to Tan Kudt and his apprentices, his own children, and their mural teams. Such muralists seek to "bring forward from the past what they think is genuinely theirs now, aware of loss, aware of new plenitudes" (1995). While generally admiring of the Wat Buddhapadipa murals, Clark expresses critical disdain for the subsequent work of Panya and Chalermchai.

References

Anderson, Benedict R. O'G. 1978. "Studies of the Thai State: The State of Thai Studies." In *The Study of Thailand*, ed. Eliezer B. Ayal. Athens, Ohio: Ohio University Center for International Studies, Southeast Asian Program (Papers in International Studies, Southeast Asia Series no. 54), 193–247.

Asia Society. 1996. *Traditions/Tensions: Contemporary Art in Asia*. Exhibition catalog. New York: Asia Society Galleries.

Boisselier, Jean. 1976. *Thai Painting*. Tokyo, New York, and San Francisco: Kodansha.

Brown, Robert. 1997. "Narrative as Icon: The *Jataka* Soires in Ancient Indian and Southeast Asian Architecture." In Juliane Schober, ed. *Sacred Biography in the Buddhist Traditions of South and Southeast Asia*. Honolulu: University of Hawaii Press, 64–109.

Cary, Caverlee. 1994. "Triple Gems and Double Meanings: Contested Spaces in the National Museum of Bangkok." PhD dissertation, Cornell University.

Chetana Nagavajara. 1993. "Literature in Thai Life: Reflections of a Native." Paper delivered at the Fifth International Conference on Thai Studies, University of London, School of Oriental and African Studies, July.

Clark, John 1993. "Open and Closed Discourses of Modernity in Asian Art. In John Clark, ed. *Modernity in Asian Art*. The University of Sydney East Asian Series no. 7. New South Wales, Australia: Wild Peony, 1–17.

Clark, John, ed. 1995. "Neo-Traditional Art." In *10 Years of the Tan Kudt Group*. Exhibition catalog. Bangkok: Place of Art.

Ginsburg, Henry. 1989. *Thai Manuscript Painting*. Honolulu: University of Hawaii Press.

Gordon, Alec. 1996. "Thai Historical Mural Paintings of Women as Evidence of Change in Thai Society." In *Proceedings of the Sixth International Conference on Thai Studies, Volume I, Traditions and Changes at Local/Regional Levels*. Chaian Mai, Thailand, 14–17 October, 135–48.

Gray, Christine E. 1991. "Hegemonic Images: Language and Silence in the Royal Thai Polity." *Man* 26: 43–65.

Gray, Christine E. 1992. "Royal Words and Their Unroyal Consequences." *Cultural Anthropology* 7(4): 448–63.

Handler, Richard. 1985. "On Having a Culture: Nationalism and the Preservation of Quebec's *Patrimoine*." in *Objects and Others*, ed. George Stocking. Madison: University of Wisconsin Press, 192–217.

Heine-Geldern, Robert. 1942. "Conceptions of State and Kingship in Southeast Asia." *The Far Eastern Quarterly* 2: 15–30.

Ishii, Yoneo. 1993. "Religious Patterns and Economic Change in Siam in the Sixteenth and Seventeenth Centuries." In *Southeast Asia in the Early Modern Era: Trade, Power, and Belief*, ed. Anthony Reid. Ithaca and London: Cornell University Press, 180–94.

Jameson, Fredric. 1992 [1984]. "Culture: The Cultural Logic of Late Capitalism." In *Postmodernism, or, The Cultural Logic of Late Capitalism*. First published in the *New Left Review* 146: 59–92.

Kasian Tejapira. 1996. "The Postmodernization of Thainess." In *Proceedings of the International Conference on Thai Studies, Theme II: Cultural Crisis and the Thai Capitalist Transformation*. Chiang Mai, Thailand, 14–17 October, 385–403.

Krug, Sonia. 1979. "The Development of Thai Mural Painting." In *Artistic Heritage of Thailand*. Bangkok: National Museum Volunteers, 171–84.

Listopad, John A. 1984. "The Process of Change in Thai Mural Painting: Khrua In Khong and the murals in the *Ubosoth* of Wat Somansa Vihara." Master's thesis, University of Utah.

Lyons, Elizabeth. 1960. "A Note on Thai Painting." In *The Arts of Thailand: A Handbook of the Architecture, Sculpture and Painting of Thailand (Siam)*, ed. Theodore R. Bowie. Bloomington: Indiana University Press, 166–75.

Mead, Phillip. 1986. "The Spirit in Thai Art." *Living in Thailand*, March.

Muang Boran Publishing House (aka The Ancient City Company). 1979. *Khrua In Khong's Westernized School of Thai Painting*. Bangkok: Muang Boran Publishing.

No Na Paknam. 1986. *Farang nai sinlapa thai* (Foreigners in Thai Art). Bangkok: Muang Boran.

Pattaratorn Chirapravati, M. L. 2000. "Treasures from Wat Ratchaburana: Interpretation and Studies of Buddhist Imagery." Paper delivered at the annual meeting of the Association for Asian Studies, 9–12 March, San Diego.

Phillips, Herbert P. 1987. Unpublished interview with Chalermchai Kositpipat, Bangkok, Thailand, 13 March.

165

Poshyananda Apinan. 1992. *Modern Art in Thailand during the Nineteenth and Twentieth Centuries.* Hong Kong: Oxford University Press.

Poshyananda Apinan. 1993. "The Development of Contemporary Art of Thailand: Traditionalism in Reverse." In Caroline Turner, ed. *Tradition and Change: Contemporary Art of Asia and the Pacific.* St Lucia, Queensland, Australia: University of Queensland Press, 3–24.

Reynolds, Craig J. 1976. "Buddhist Cosmography in Thai History, with Special Reference to 19th Century Culture Change." *Journal of Asian Studies* 35(2): 203–20.

Ringis, Rita. 1990. *Thai Temples and Temple Murals.* Singapore, Oxford, and New York: Oxford University Press.

Silpa Bhirasi (Corrado Feroci). 1959. *The Origin and Evolution of Thai Murals.* Catalog for exhibit "Photographs of Mural Paintings," Silpakorn University Gallery. Bangkok: Fine Arts Department.

Somporn Rodboon. 1995. "History of Modern Art in Thailand." In Furuichi Yasuko and Nakamoto Kazumi, eds, *Asian Modernism: Diverse Development in Indonesia, the Philippines, and Thailand.* Tokyo: The Japan Foundation Asian Center, 243–56.

Thongchai Winichakul. 1994. *Siam Mapped: A History of the Geo-Body of a Nation.* Honolulu: University of Hawaii Press.

Wenk, Klaus. 1975. *Mural Paintings in Thailand.* Zurich: Inigo Von Oppersdorff Verlag.

Wolters, O. W. 1999 [1982]. *History, Culture, and Religion in Southeast Asian Perspectives,* rev. edn. Ithaca, NY: Cornell University, Southeast Asia Program Publications, Southeast Asia Program, in cooperation with Institute of Southeast Asian Studies, Singapore.

Wyatt, David. 1984 [1982]. *Thailand: A Short History.* New Haven, CT, and London: Yale University Press.

16

The Artist as Charismatic Individual: Raja Ravi Varma

Partha Mitter

Introduction

In the following reading, art historian Partha Mitter analyzes the work of the late nineteenth-century artist Raja Ravi Varma (1848–1906). The excerpts included here form part of Mitter's larger study of artistic development between 1850 and 1922, the formative period of Indian nationalism. Varma was the most famous artist of his day, and his art and career exemplify many of the changes taking place in Indian culture at the time. By the second half of the nineteenth century, British imperial power, either indirectly through the auspices of the East India Company or directly through the British crown, had held sway over the Indian subcontinent for over a century. Elite Indian society had absorbed much of Victorian culture and Western attitudes to India. Yet the period also witnessed a growing sense of Indian nationalism, including a pride in its history and culture.

Unlike most previous South Asian painters, who came from humble backgrounds and were considered artisans, Varma was a "gentleman-artist." Born to an aristocratic family in the south Indian state of Kerala, Ravi Varma cultivated his image as an artist, eventually becoming a celebrity during his lifetime. In 1894 he and his brother, C. Raja Raji Varma, set up a lithographic press to produce high-quality color prints of Varma's oil paintings. These prints, particularly the images of Hindu gods and goddesses, became popular throughout India and made Ravi Varma a household name.

Partha Mitter, "The Artist as Charismatic Individual: Raja Ravi Varma," pp. 179–80, 199–202, 205–7, 215–18; 406, 411–13, 415 from *Art and Nationalism in Colonial India, 1850–1922*. Cambridge: Cambridge University Press, 1994. Reprinted by permission of Cambridge University Press and Professor Partha Mitter.

Varma drew on his solid knowledge of classical Sanskrit literature to produce paintings that glorified India's ancient past and Hindu traditions. For example, he produced several paintings depicting scenes from the playwright Kalidasa's classic work, *The Recognition of Shakuntala* (c.fifth century CE). The play, a love story in which the maiden Shakuntala and the King Dushyanta fall in love, are separated by a curse, and are finally reunited, provided Varma with the perfect vehicle for his emotion-filled works. Varma adopted a Western salon painting style favored at establishments like the Royal Academy in London, which from the mid-eighteenth through late nineteenth centuries was the arbiter of taste in British art. This salon style drew on the historicism and drama found in the art of the eighteenth-century British painter Sir Joshua Reynolds, one of the founders of the Royal Academy, and the seventeenth-century Italian Baroque painter Guercino, among others. As Mitter explains, for a variety of reasons this style was well received by Varma's British and Indian viewers.

Shortly after the artist's death in 1906, the Indian intellectual elite, in their quest for a nationalistic mode of art, began to favor a very different painting style from that of Varma. With this change, the critical view of Varma's paintings fell. Thus, Varma's career captures a particular moment in the relationship between painting, colonialism, and nationalism in India and highlights the changing role of the artist in South Asia. The reading also addresses the appropriation of foreign elements and the reuse of the past in the search for a cultural identity.

I spent the entire morning looking at Ravi Varma's pictures. I must confess I find them really attractive. After all, these pictures prove to us how dear our own stories, our own images and expressions are to us. In some paintings, the figures are not quite in proportion. Never mind! The total effect is compelling.

Rabindranath Tagore, *Chhinna Patrabali* 1893

The glittering career of Raja Ravi Varma (1848–1906) is a striking case study of salon art in India – the 'artistic genius' who embodied the virtues expected of an academic artist. In the year following his death, *Modern Review* described him as the greatest artist of modern India, a nation builder, who showed the moral courage of a gifted 'high-born' in taking up the 'degrading profession of painting'.[1] It is curious in retrospect that the artist also hailed by the Raj as the finest in India, never crossed the threshold of an art school. Nor did he originate in an urban environment. Ravi Varma Koil Tampuran was born on 29 April 1848 into an aristocratic family in the remote province of Kerala. The Varmas of Killimanoor were allied by marriage with the rulers of Travancore.

Today it is hard to imagine the reputation enjoyed by Varma during his lifetime. The death of 'the famous Indian artist' was announced on 25 December 1906 in *The Times* of London.[2] He was courted as assiduously by the Raj as by the Indian

maharajas, whilst cheap prints of his Hindu deities hung in every home. These prints, which are still an essential ingredient of popular culture, are derided by modern critics as bad art. To the untutored Indian, however, they have lost none of their charm. Ravi Varma's spectacular canvases influenced the pioneers of the Indian cinema, Dadasaheb Phalke and Baburao Painter, much as Victorian art inspired the Hollywood director D. W. Griffith. The opulent beauties of Indian cinema and calendars can lay a claim to their descent from Varma's heroines.[3]

To be sure, the high compliments paid by the English rulers were often demanded by social etiquette. Yet official approval in some cases went beyond the demands of *politesse*, or even *noblesse oblige*. Lord Curzon, the 'most superior' Viceroy [British head of India], put the official seal of approval on Ravi Varma's works as a 'happy blend of Western technique and Indian subject and free from Oriental stiffness'.[4] He recognised Varma as 'one who for the first time in the art history of India, commenced a new style of painting'.[5] Curzon of course favoured the Indian nobility. The Prince of Wales on his visit to India in 1875–6 expressed 'great pleasure in [Varma's] works, [and] was presented with two of them by the Maharaja of Travancore'.[6] The Duke of Buckingham, sometime Governor of Madras, enthusiastically acquired Varma's painting based on Kalidasa's *Shakuntala*. A later Governor, Lord Ampthill, wrote to Varma's son on his death: 'when I think that I would not see Ravi Varma in this world any more my heart is filled with sorrow'.[7] There was a further bond here. Ampthill, who was painted in masonic regalia by Varma, expressed his pleasure that the artist's son was part of the brotherhood. The Portuguese plenipotentiary at Goa was equally warm in praise of his own portrait: 'it did not belie the good reputation that you have earned in the Salon of Bombay . . . [for] the correctness of the design and the exactness of the touches'.[8]

Among all early academic artists, only Varma stood out as 'a legend in his own time'. Rabindranath spoke for the western-educated generation when he stated: 'In my childhood, when Ravi Varma's age arrived in Bengal, reproductions of European paintings on the walls were promptly replaced with oleographs of his works'.[9] The age to which Varma belonged, and which he mirrored so faithfully in his work, is gone, and memory is dulled by the miasma of adulation and prejudice surrounding his reputation. One has to go back to history to grasp the revolutionary implications of his achievements. To nineteenth-century Indians Ravi Varma's history paintings epitomised the magic that was naturalism.

From Colonial Artist to National Idol

Grand history-painting for the nation

Narrative art was not new to India. But illusionist painting as a vehicle for story telling by presenting 'a frozen moment', was a western invention. Indians were moved by the melodramatic and the sentimental, a predilection to be found in full

measure in Varma. Almost all his compositions, apart from formal portraits, bore sentimental captions in the salon tradition.

Of all narrative art, none was more admired by the Royal Academy than paintings with lofty moral lessons. The encouragement of history painting, the most 'dignified' branch of the art, followed the growth of 'civic humanism' because it was seen to promote public interest. For Reynolds, history painting, like Classical rhetoric, enabled us to recognise our true and universal nature and raised art above manual dexterity.[10] Unsurprisingly, the English rulers were keen to introduce the genre for the moral upliftment of their subjects, since Indian miniatures could never stir the soul. It is not recorded if Ravi Varma heard Lord Napier's address to Indian artists on the powers of history painting.[11] At all events, the stage was already set for his début in this area.

History painting was no less logical a choice for the Indian intelligentsia. Indian art of the period was steeped in historicism, the restoration of the past emerging as a sacred duty for the nationalist. Varma was the first Indian painter to evolve a new language of narrative art, aimed at what Reynolds called sending 'the imagination back to antiquity'. Yet, as someone raised on the Victorian mimetic canon, Varma saw nothing incongruous in using it for his 'authentic' re-creations of the Hindu past.[12]

As with the 'olympians', so with Varma the line between history and myth was thinly drawn. In any case, *Puranas* still form some of the most important sources for Indian history. Varma was not the first Indian history painter; in 1871 Tinkari Mukherjee had submitted a work inspired by a Sanskrit classic to the nationalist fair in Bengal, some seven years before Varma's famous *Shakuntala*. But Varma was unrivalled in his strategy for re-creating a romantic past, founded on Sanskrit classics. First, Varma was well versed in Sanskrit, his Brahman father's legacy.[13] Secondly, his literary 'historicism' was in line with the ideals of high art in the West. If the slightly 'fussy' reconstructions of Varma seem contrived to us, 'historicism' was the favourite pastime of history painters. David was the first artist to re-create the Classical world through meticulous 'archaeological' details.[14]

Let us take Varma's quest for ancient India: after winning the important Baroda commission of history paintings, he went on a tour of India, excited by the prospect of discovering ancient costumes. Soon he was forced to conclude that Muslim rule had obliterated all traces of the ancient mode of dressing.[15] The failure of Varma's 'archaeological' enterprise had to do with his colonial outlook. In his youth, his knowledge of ancient art derived almost entirely from *The Hindu Pantheon* by Edward Moor, a pioneer work in the British 'discovery of Hinduism'. Varma, like many educated Indians of the time, was yet to discover ancient art, then coming to light through archaeological researches. On their visit to Karle, the brothers treated the scanty clothing of Buddhist figures as objects of mild curiosity, but not appropriate for Ravi Varma's 'proper' heroines from Sanskrit literature.[16] One can guess that Varma's reading of Kalidasa ignored the explicit passages as unsuited to his age.

170

Equally, the Varmas found Rajput and Mughal miniatures at Baroda alien to their taste. 'In some pictures there is such imagination but there are also decorative features', wrote Raja. While copying Udaipur miniatures, he noted that there was 'little of nature [in them], painted in the old conventional style, face, profile and the feet turned in the same direction'. By contrast, the brothers were thrilled to see a Rembrandt owned by a European, concluding shrewdly that it was a copy, for they had seen it reproduced elsewhere. While it is true that miniatures were not so familiar in Kerala, the brothers' reaction reveals the influence of colonial aesthetics.[17]

Ravi Varma's new iconographic programme drew copiously on the epics, the *Puranas* and the plays of Kalidasa and other Sanskrit authors. The painter even engaged a traditional narrator, whose photograph survives, to ransack the classics. This practice of consulting *pandits* for advice on iconography was common, especially among Pahari painters. However, even when using the classics, Varma carefully selected the stories that plucked the beholder's heartstrings. The appeal of his heroines, for instance, lay in the fact that they were not iconographic types, but palpable, desirable human beings. The British public too in this period preferred paintings that melted 'the soul into a tender participation of human miseries'.[18] Varma's first public showing of such a tender episode was a perennial favourite: *Shakuntala's Love Epistle to Dushyanta*.

This sentimentality went hand in hand with a new image of voluptuous women, a blend of Kerala and Guercino. Varma's outlook was different from the typology of romantic love in Rajput miniatures, where emotions were treated as literary conceits according to the moods they expressed. Varma's Shakuntala was a pretty young Kerala girl lying on the ground, writing a love letter – a concrete situation as opposed to the generalised emotion of traditional painting. This lent a new conviction to the epic scenes to which the beholder could readily relate. Yet the paradox inherent in a contemporary scene in the guise of the past reminds us of the quip about the Victorian Alma-Tadema: whatever he painted, it was always four o'clock tea at the thermal springs. Convinced of the universality of his Victorian work, Varma did not see the need to turn to an Indian painting style. This 'Victorian-ness' was reinforced by his captions that quoted from English classics, such as from Byron for *Arjuna and Subhadra*. The 'universalism' was not necessarily alien to Indian sensibility, for both traditions favoured melodrama and sentimentality. Not only did the Duke of Buckingham acquire *Shakuntala*, but the great demand for the picture led to several versions by Varma. Monier Williams used one for his translation of the Sanskrit play.[19]

The grammar of Ravi Varma's historicist works

Aristocratic taste graduated from portraits to history painting almost entirely through Ravi Varma's efforts. Following Baroda's lead, the states of Mysore and Trivandrum commissioned large-scale mythological works. The painter devised his own complex iconographic programme of literary inspiration by studying the Royal Academy Annuals, adapting a landscape here, modifying an

architectural interior there, as backdrops to his epic characters, much in the fashion of Victorian high art. Vast canvases on grand themes, *nobles et sentimentales*, were the rage in Paris, London and Vienna.[20]

Were Varma's works based on figure drawing, the *sine qua non* of European art in the last century? It is doubtful if the Varmas ever had the chance to practise it. Even in Indian art schools, figure drawing was not introduced in earnest until the 1920s. Ravi Varma owned a life-size 'articulated figure', which enabled him to check the proportions and fix the poses. But nude models, we know, were difficult to recruit; attempts to hire a draped model in Hyderabad had ended in a fiasco. Raja discusses the general topic of figure drawing and his unconventional method of studying the human form:

> The row on the lake [Pichola] of a morning is interesting to an artist; the ghats or beautiful stone steps are filled with bathers of both sexes. The women who walk along the streets are so closely veiled, [yet they show] themselves almost naked and indulge in bathing or washing without any sign of modesty.[21]

Of course, both brothers depicted semi-nude figures, but Ravi's partially-draped figures were not always convincing. Unlike his sure grasp of a draped model, the drawing of women's breasts shows weakness, as in the *Matsyagandha* (Mysore). In the Baroda *Matsyagandha* or in prints such as *Tilottama* or *Pamini*, European Classical figures were adapted for the purpose. Varma's inexperience is surprising in view of the fact that even in Ravi Varma's time in Kerala, respectable Nair women appeared in public with uncovered breasts.[22]

How were these paintings planned by Varma? *The Triumph of Indrajit*, to take a typical example, is an amalgam of indigenous and western elements: the rhetorical postures, the hyperbolic gestures, notably the enlarged pupils of the eyes, are none other than the mimetic conventions of the Kathakali dance-drama of Kerala.[23] Varma signals social hierarchy in his narrative by skin colour: the aristocratic protagonists are lighter, while the menials are various shades of black. The exceptions are demon kings, who, in the epic tradition, are non-Aryan aborigines. Of course, Sanskrit literature sanctions the depiction of lower orders as dark-skinned. But was Varma also inspired by European Orientalists, whose paintings thrived on similar contrasts?[24] Social differences are even more pronounced in Varma's women, which suggests the encroaching new mores of Victorian evangelism. The aristocratic heroine is not only modestly covered in a sari but wears a blouse as well. In contrast, maidservants and aboriginal women are in various states of nudity. The attendants in these works, unlike the main actors, who hold the centre stage, are the silent chorus to the melodrama unfolding before them; they are the liveried retainers of the princely states.[25]

While Varma adopted nineteenth-century historicism, the cultural specificity of his paintings is equally significant. He chose the grammar of the salon, but the gloss he put on it was recognisably Indian. This 'pictorial' language gave him the power to represent a colonial experience: life in the princely courts as he knew it;

past history imagined as present melodrama. Varma's elaborate interiors reproduced endlessly the pomp and circumstance of the courts of Trivandrum, Baroda, Mysore and others. Sometimes Varma was tempted to reproduce actual details of European paintings. In *The Triumph of Indrajit* (1903), the guard on the top right-hand corner reminds us of Ludwig Deutsch's *The Nubian Guard* (1895). The Orientalist connection is reinforced by the *deshabillée* Indrani, the Indian Juno, who is being molested by a black menial, recalling the voyeuristic paintings of exotic slave markets.[26]

Varma's images of the past are *tableaux vivants* in which great human dramas unfold; as such they betray the influence of the Parsi theatre in Bombay. The brothers were avid theatregoers, enjoying both English and indigenous productions. One of their admirers was the visiting American actor, Edmund Russell, who often invited them to the theatre. It was this influence of the stage that lent an air of fancy-dress parade to Varma's canvases. But then the pictorial language of salon art was anything but natural. We know that Victorian painters were similarly associated with the theatre.[27]

The End of an Era

By the end of his life, Ravi Varma had attained his goals as a national hero. Tacitly accepted as the painter to the Raj, he was the only artist to receive the ultimate imperial accolade, Kaiser-i-Hind. At the same time, Varma was fêted by the Congress as the painter who helped in nation-building. In 1903 the brothers were invited to judge the fine arts section of the Industrial Exhibition of the Congress in Madras.[28]

During Ravi Varma's lifetime patriotism and loyalty to the Empire had not yet become irreconcilable categories. Raja noted the subdued atmosphere in Bombay at Queen Victoria's death, a token of the affection in which 'the great white mother' was held in India.[29] When Curzon envisaged a national gallery of notable men as befitting the deceased Queen, he naturally thought of Varma. In April 1901, Varma wrote to Curzon from Udaipur, offering two portraits and two historical subjects, as well as a donation to the Imperial Fund. 'I shall spare no pains to collect authentic information [for the four paintings]. I came here a few days ago to make sketches and studies of local scenery, ancient arms and accoutrements', he added. The project never materialised, for the Varmas soon died and Curzon left India in disgrace after the Partition of Bengal. Only one of the portraits for the gallery, that of Tanjore Madhava Rao, is in the Victoria Memorial in Calcutta. Late in 1904, on a visit to Mysore, Raja became seriously ill with an abdominal complaint; he died on 4 January 1905. Ravi Varma died on 2 October 1906 aged fifty-eight, two years before his planned retirement in the Hindu fashion. The news of his death was in the evening edition of the *Times of India*. With Ravi Varma ended the optimistic phase of colonial art in India.[30]

Today only the awards, the official commissions and the eulogies of Ravi Varma are remembered. Time has effaced the memory of any setbacks he may have suffered, creating an impression of the relentless progress of a genius. Yet even at the height of his career, Varma did not always receive a favourable press. It was not his easy success but his gifts, organisation, and the changing artistic situation in India that took him to the summit of colonial art. Unlike traditional painters, Varma showed a remarkable ability to improve upon received ideas, to grasp a situation clearly and to act upon it swiftly. His lively curiosity is evident with regard to languages, for instance. Varma began to learn English and German late in life after he had mastered Indian languages. In the last year of his life, in the midst of ill health and sadness, he could write to Ramananda asking for a Bengal primer.[31]

Ravi Varma's example created an aura around the profession. He enjoyed a popularity transcending class, language and region that has not been equalled since.[32] The final word about this pioneer westerniser rests with Rabindranath, who spent a whole morning scrutinising his pictures:

> The secret of their appeal is in reminding us how precious our own culture is to us, in restoring to us our inheritance. Our mind here acts as an ally of the artist. We can almost anticipate what he is about to say...It is all to easy too find fault with him. But we must remember that it is a lot easier to imagine a subject than to paint it. A mental image, after all, has the freedom to be imprecise. But if that mental image has to be turned into something as concrete as a picture, with concern for even the minute aspects of representation, then that task ceases to be facile.[33]

Notes

1 *Modern Review*, I, 1–6, Jan.–Jun. 1907, 84.
2 *The Times*, 25.12.1906. Varma has either been idolised or judged by modernism that fails to see his importance. Recent essays on Varma include T. Guha Thakurta ('Westernisation and Tradition in South Indian Painting in the Nineteenth Century: The Case of Raja Ravi Varma 1848–1906', *Studies in History*, II, 2 (n.s.), 1986, 165–196) and G. Kapoor, 'Ravi Varma: Representational Dilemmas of a Nineteenth Century Painter', *Journal of Arts and Ideas*, Nos 17–18, June 1989, 59–75.
3 D. G. Phalke's spectacular film, 'Raja Harishchandra', shows Varma's inspiration. On Phalke, E. Barnouw and S. Krishnaswamy, *Indian Film*, Oxford, 1980, 10–21; G. Sadoul, *Dictionnaire des Cinéastes*, Paris, 1965, 177. C. Wood, *Olympian Dreamers*, London, 1983, 129 and 253 on Alma-Tadema and Edwin Long's influence on the director, Griffith, especially Long's *Babylonian Marriage Market*. Goddesses in popular prints are indebted to Varma's ideal.
4 Curzon quoted in Anonymous, *Ravi Varma the Indian Artist*, Allahabad (1902), 10. There is strong evidence that this undated authorised biography is by Ramananda Chatterjee.
5 *Victoria Memorial Correspondence*, I, Calcutta, 1901–4, 114a.

6 *The Times*, 25.12.1906.

7 P. N. N. Pillai, *Artist Ravi Varma Koil Tampuran Artist Prince*, 1912, the first Malayalam biography, reproduces Ampthill's letter of 3.12.1906.

8 Letter of Gomez da Costa, ADC to the Portuguese Governor-General, Palace de Cabo, of 15.4.1894 (Raja Varma's Diary).

9 R. Tagore, 'Pitrismriti', in B. Choudhury, *Lipir Shilpi Abanindranāth*, Calcutta, 1973, 81.

10 J. Reynolds, Discourse Xiii, speaks of history painters and Classical landscapists in the same vein, In E. G. Holt, *Michelangelo and the Mannerists: The Baroque and the Eighteenth Century* (Volume 2 of *A Documentary History of Art*), New York, 1958, 281. By the late eighteenth century artists like Benjamin West had moved to national history from Classical themes. H. Honour, *Neoclassicism*, London, 1968, 32ff. J. Barrell, *Political Theory of Painting from Reynolds to Hazlitt*, New Haven, 1986, 2 and 95 on civic humanism.

11 Napier's address quoted in W. G. Archer, *India and Modern Art*, London, 1959, 21; Barrell, *Political Theory*, 24 on art and rhetoric.

12 L. Poliakov, *The Aryan Myth*, London, 1971. J. M. Crook, *The Greek Revival*, London, 1972. G. E. Daniel, *A Hundred Years of Archaeology*, London, 1950, on the reconstruction of the past in the West connected with nationalism. Reynolds' comment with reference to Poussin, Holt, *Michelangelo and the Mannerists*, 287.

13 J. Bagal, *Hindu Melār Itibritta*, Calcutta, 1968, 24–5, quoting *Sulav Samāchar* (21.2.1871). K. M. Varma, *Ravi Varma: A Sketch*, Trivandrum, n.d., 8–11. F. Haskell, 'The Manufacture of the Past in Nineteenth-Century Painting', in *Past and Present in Art and Taste*, New Haven, 1987, 75–89, on the history painter's insistence on precise information, including use of contemporary material that bore on the subject.

14 Boulanger women were supposed to have inspired Varma. J. Harding, *Artistes Pompiers*, London, 1979, on French academic artists and Wood, *Olympian Dreamers*, on British ones. The most important theoretician of artistic historicism was Jacques-Louis David. At the opening of the exhibition of his painting on the Sabine Women, he spoke of the importance of recovering the customs and institutions of the past, thus inaugurating the 'archaeological' approach to art, E. G. Holt, ed., *From the Classicists to the Impressionists* (Volume 2 of *A Documentary History of Art*), New York, 1958, 4. On David, W. Friedlander, *David to Delacroix*, Cambridge (Mass.), 1963.

15 *Prabāsi*, I, 8–9, 300.

16 Raja Ravi Varma Diary (RRV), 2.6.1897. Moor's Krishna left an indelible impression on Varma, as seen in his Krishna, N. B. Nayar, *Raja Ravi Varma*, Trivandrum, 1953, 33. On Moor, Mitter, *Monsters*, 178.

17 Nayar, *Raja Ravi Varma*, 86. RRV, 31.3.1901; 14.3.1902.

18 Barrell, *Political Theory*, 59. Photograph in Nayar, *Raja Ravi Varma*, pl. 15. I am grateful to B. N. Goswamy for the information on traditional Punjab painters.

19 On Alma-Tadema, Wood, *Olympian Dreamers*, ch. 3. On types of heroines, there is no specific work, but see works by W. G. Archer on Rajput miniatures. Varma's two versions of *Shakuntala Writing Love Epistle to Dushyanta*, a seated one in Madras as well as the birth of Shakuntala were widely diffused in prints. I have not been able to trace the original of the Buckingham Shakuntala lying on the ground. On the seated

20 In addition to the Baroda fourteen, there are nine large-scale *Puranic* compositions at Mysore, but fewer in Trivandrum.

21 RRV, 20.6.1901. Nude modelling did not become the norm in art schools before the 1920s.

22 Raja Varma had a better grasp of the undraped human figure as seen in his painting in Madras. Ravi Varma's most frequently used model was Kasi Bai, a Goanese Hindu (mss cat. of Sri Chitra Art Gallery, Trivandrum).

23 E. M. J. Veniyoor, *Raja Ravi Varma*, Trivandrum, 1981, 2.

24 This comes out clearly in *Captive Sita, Ravanu and Jatayu* (Mysore) and *Victory of Indrajit* (Mysore).

25 *Shakuntala's Love Epistle to Dushyanta* is a good example, as well as *Captive Sita*, where the ogresses are nude to the waist. Evangelical influence as part of western-isation took the form of Victorian blouses and petticoats, the fashion for which was set by the Brahmos in Calcutta and Parsis in Bombay.

26 The mixture of voyeurism and sado-masochism was a favourite of the Orientalist painters. Varma's contrasts between light and dark skin owe directly to Gérôme (M. Verrier, *The Orientalists*, London, 1979, 127, but also Chassériau and other French artists in P. Jullian, *The Orientalists*, Oxford, 1977); L. Nochlin on Gérôme's stereotypical presentation of the orient ('The Imaginary Orient', *Art in America*, May 1983, 122ff.). While European artists were constructing an imaginary orient, Varma, an Eastern artist, appropriated this image for his own image of ancient India.

27 RRV, 28.9.1903; 29.10.1903; 15.1.1895. Wood, *Olympian Dreamers*, 123 on Alma-Tadema's interest in the theatre.

28 Quoted in Nayar, *Raja Ravi Varma*, 180. RRV, 25.12.1903–1.1.1904.

29 RRV, 23.1.1901. On Victoria as a potent symbol of empire, S. Weintraub, *Victoria*, London, 1987.

30 Victoria Memorial Correspondence, I, 1901–4, 114a. RRV, 2.4.1901; see above, ch. 4, p. 155 and below, ch. 8, p. 294. Nayar, *Raja Ravi Varma*, chs 20 and 21 on the deaths of the brothers.

31 Letter (22.8.1906), reproduced in *Prabāsi*, Yr. VI, 7, 1313 (1906), 412.

32 T. N. Mukharji, *Art Manufactures of India*, Calcutta, 1888, 15. The diary gives a clear picture of the brothers' social standing. Wherever they went they were visited by local dignitaries, including the English Resident. They received a baby elephant from the Mysore ruler, bought another one for Rs 3000 (RRV 10–11.2.1903) and were promised yet another by the Kollengode ruler (RRV 9.1.1903).

33 R. Tagore, *Chhinna-Patrābali*, 12 May 1893, *RR*, 11, 106

17

The "East–West" Opposition in Chandigarh's Le Corbusier

Vikramaditya Prakash

Introduction

When the Punjab was split in two by the 1947 partition of the Indian subcontinent into the countries of India and Pakistan, the Indian government immediately set out to found a new, wholly modern capital city for the state. The result was the city of Chandigarh, built largely between 1951 and 1964. Two American urban planners were Chandigarh's first designers, but after the unexpected death of one of them, the Indian government recruited Swiss-French architect Le Corbusier (1887–1965), renowned for his stark, abstract, sculptural buildings and uncompromisingly modern designs. Vikramaditya Prakash, the author of this reading, is an architect who grew up in Chandigarh; his father was a member of the team of Indian architects who assisted Le Corbusier on the city's construction. Thus, Prakash has an intimate connection to Chandigarh, and in a recent book on the city he seeks to analyze its conception.

The particular excerpts included here are from the first chapter of Prakash's book, which lays out the historical background of the city's founding and introduces the readers to the main actors in its creation – chiefly Le Corbusier and Jawaharlal Nehru (1889–1964), India's first prime minister who governed the newly independent nation from 1947 to 1964. In the excerpts Prakash also presents several crucial theoretical issues underlying his study and important to the study of modern Asian art more

Vikramaditya Prakash, "The 'East–West' Opposition in Chandigarh's Le Corbusier," pp. 5–9, 11–18, 21, 25–6 from *Chandigarh's Le Corbusier: The Struggle for Modernity in Postcolonial India*. Seattle and London: University of Washington Press, 2002. Reprinted by permission of The University of Washington Press.

broadly, such as whether or not modernity is a universal category, and to whom, if anyone, it belongs.

Le Corbusier is considered one of the founders of modern architecture in the West, and therefore art historical analyses often celebrate the capital, one of Le Corbusier's few large-scale projects to be built, as a key example of the architect's *oeuvre*. In contrast, other studies of the city cite its many shortcomings – such as the buildings' unsuitability to a monsoon climate, the design's mistaken assumption that most of the population would have access to motorized transportation, and the lack of planning for population growth – as evidence of its incompatibility to South Asian cultural and environmental needs. Prakash, instead, reads Chandigarh as bringing together various visions of modernity, embracing the complexity of the political and artistic moment in Indian history.

> *Long years ago we made a tryst with destiny, and now the time comes when we shall redeem our pledge, not wholly or in full measure, but very substantially. At the stroke of the midnight hour, when the world sleeps, India will awake to life and freedom. A moment comes which comes but rarely in history, when we step out from the old to the new, when an age ends, and when the soul of a nation, long suppressed, finds utterance. It is fitting that at this solemn moment we take the pledge of dedication to India and her people and to the still larger cause of humanity.*

Jawaharlal Nehru, first prime minister of independent India; speech given to the constituent assembly at midnight on 14–15 August 1947, when India became independent.

On 14–15 August 1947, at the stroke of the midnight hour, when Pakistan and India became independent after two hundred years of colonial rule, their triumph was marred by religious communal violence. The departing British had decided to partition colonial India to create a new country – Pakistan – intended to safeguard the future of the Muslim minority. Six hundred years of Muslim rule had resulted in the conversion of roughly a quarter of India's 400 million inhabitants to Islam. They were spread everywhere, intricately woven into the social textile of India's cities and villages. Now they were deemed distinct and incompatible, and ordained to be separated into their own country. The desire to catalogue and classify had always been a hallmark of British colonial administration. It imparted a sense of order. The partition was its final outcome, and in a certain sense, its logical conclusion.

In June 1947, Sir Cyril Radcliffe, a well-known English barrister, was chosen for the unenviable task of re-drawing the colonial map. He knew little about India and had no history of any association with things Indian. That is precisely why he was chosen, to project his impartiality. His task was to slough off two sections, separated by a thousand miles, and call them Pakistan. The

various princes, who were nominally independent, were left to choose their own affiliations.

The lives of 88 million people were directly affected by the partition. As the news spread, and the partitioning maps were known, millions of Muslims and non-Muslims suddenly found themselves on the wrong side of the dividing line, in the wrong cities and villages. They were given seventy-three days to prepare for their new lives. More than 13 million left their homes, packed what little they could take, and headed for their new countries as refugees.[1]

En route, more than a million people were massacred by their counterparts in a series of bloody reprisals. The causes of what is now called "ethnic violence" are diverse. While reprisals have a way of gathering momentum entirely on their own, centuries of Hindu–Muslim neighborly co-existence must also have nurtured deep layers of resentment and distrust. At the anxious hour of an uncertain future, the official certification of difference as irreconcilable and absolute may have served as a scapegoat, a vent for fears and anxieties.

The states of Bengal and Punjab were those worst hit. They were partitioned through the middle, into East Bengal (Pakistan) and West Bengal (India), and into West Punjab (Pakistan) and East Punjab (India). In West Bengal's largest city, Calcutta, the violence wore on. Mahatma Gandhi, the chief architect of India's nonviolent path to freedom, started the sixteenth of his famous protest fasts. He swore not to eat until all the violence stopped in the city. At seventy-seven, Gandhi's body was frail and declined fast. But his strategy worked, yet again. After three days, as local Hindu and Muslim leaders gathered around Gandhi, the city became silent. The slaughter ceased, but thousands already had been murdered.[2]

Punjab was not so fortunate. Nehru sent the military out to escort the over-crowded trains laden with refugees that were coming over the border. But they were largely ineffective. Untempered by a Gandhian miracle, in Punjab tens of thousands more were killed, and millions were left refugees bereft not only of their erstwhile homelands, but often of their extended families and livelihoods as well.

It was in the immediate aftermath of partition, for reasons both practical and symbolic, that Chandigarh was conceived. While West Bengal retained the new colonial city of Calcutta, East Punjab, quid pro quo, surrendered Lahore, its ancient capital, to Pakistan. Lahore was one of the old economic and cultural centers established by the Mughals in the seventeenth century. For three hundred years it had been the center of the Punjab. Now it was capital to only half the state, on the Pakistan side.

Immediately after independence, the government of Indian East Punjab (henceforth simply "Punjab"), which was already coping with a gigantic refugee problem, also had to start functioning without an administrative center and capital city. While temporary lodging for the government was found in Shimla, the hill-station that was the old summer capital of the colonial government, a hunt to determine a new capital for the state was immediately undertaken by the

179

State Government. The most expedient and cost-effective solution was to adopt an existing city as the new capital and simply build new legislative buildings. Many were proposed. Amritsar, the largest Punjabi city with the revered Sikh shrine the Golden Temple, was the logical choice, but it was deemed to be too close to the Pakistani border and therefore vulnerable to attack. Patiala, another erstwhile capital to a Punjabi dynasty, was another possibility, but it was perceived to be geographically too removed from the heart of Punjab. Ambala, a relatively new British military cantonment, was also considered, but it was thought to be too small and insignificant to project the image of a capital worthy of replacing Lahore.

In March 1948, the government of Punjab, in spite of numerous cautions against the enormous expenditure involved, finally decided to build a new capital city for itself. Not much is documented about the exact logic of the decision, but Nehru's opinion on the matter was clearly instrumental. For Nehru, the rehabilitation of Punjab, both practical and symbolic, required the making of a grand new city. He chastised the State Government for delaying the decision:

> Right from September 1947 the Government of India has been laying great stress on the urgency of this matter from every point of view, practical as well as psychological. In a sense the rehabilitation of East Punjab centers round it and yet because of doubt and uncertainty and repeated changes of policy and decision, nothing so far has been finalized. ... To go on waiting for large grants from the Centre is not a worthwhile policy. ... I would strongly suggest to you to go ahead with this matter even though you do not get any financial support from the Centre.[3]

In the end, according to P. L. Verma, the chief engineer of Punjab, the critical reason to build a new city was not practical but symbolic. "None of the existing cities of Punjab," he recalled, "possessed sufficient magnificence and glamour to make up for the psychological loss of Lahore suffered by the strife-stricken but proud Punjabis."[4]

A true child of the midnight hour, Chandigarh was thus encumbered with great expectations. "Like the rising of the Phoenix from the ashes of its own fire" was the slogan of the motley group of architects, engineers, and bureaucrats from three continents that was assembled to build the city.[5] Retrospectively, one can sense that the hubris of independence must have been invested with gusto in an attempt to nullify the disaster of partition.

Nehru's Postcolonial Modern

With the decision to make a new capital in place, the work of actually making Chandigarh was undertaken with a sense of urgency. A site for the project was selected right away, but in mid-1949 it was changed to its present location

in an effort to reduce the number of people that the project would displace. Even so, twenty-four villages and 9,000 residents were forced to give up their land and relocate. They actively protested their displacement, but the project went forward, driven by the optimism and determination of the central government.

Chandigarh was named after one of the existing villages, which had a temple dedicated to the Hindu goddess Chandi. Chandi-garh means the abode/stronghold of Chandi, who is a manifestation of Shakti, the ubiquitous female principle in the Hindu cosmogony. As time proceeds through its inevitable and recurrent circles of creation and destruction, Chandi is the energy, the enabling force of transformation and change. Her participation, in one form or another, is mandatory at all events of any significance. The inherent auspiciousness of her presence must surely not have escaped the Hindu officials who picked the site.[6]

This Chandi temple still exists, but remains un-remarked and un-noticed since it is located on the outskirts of Chandigarh, and is in no way integrated into the general master plan or architecture of the city. This is no doubt because the blinding commandment that defined Chandigarh's identity from its very inception was that it had to be a "modern" city. With finely crafted oratory, at the inaugural ceremony of Chandigarh, Nehru declared grandly: "Let this be a new city, unfettered by the traditions of the past, a symbol of the nation's faith in the future."[7]

In Nehru's grand plan, Chandigarh had to reflect the modern aspirations of the new Indian nation. Nehru's views of development differed significantly from those of his mentor, Mahatma Gandhi. While both of them agreed that colonization had resulted in the destruction of indigenous industries and livelihoods, they differed considerably on the critical question of what was to be done next. Gandhi, influenced by Ruskin, Thoreau, and Tolstoy, considered industrialization to be an evil in itself and wanted the self-sustaining village to be the fundamental economic and social unit of the new nation. Nehru wanted to pursue aggressive industrialization, controlled by a centralized welfare state, to catch up with the developments of the West. With Gandhi's death in January 1948 – early in the history of the new Indian nation – the Nehruvian doctrine prevailed.

For Nehru, modernity and Chandigarh had to be inextricably yoked to a vision for the future. He sent out a clear signal. Although it was meant to replace the ancient city of Lahore, there was to be no place for nostalgia in Chandigarh. He did not want an existing old city to embody the new nation because he believed that oldness, with its overwhelming weight of tradition, held India down. Deeply influenced by colonial perceptions, Nehru was convinced that it was static traditional practices, which had not adequately responded to change, that had caused India's colonization.

This perception was a consequence of the internalization of the experience of colonization. Of the various stereotypes of colonial ideology, perhaps none was

as pervasive, and persuasive, as the projection that it was a modern, enlightened, and dynamic young West that had succeeded in colonizing and dominating an ancient, superstitious, venerable but effete, desirable but corrupt India – a result of its unfortunate entanglement with a decrepit and dysfunctional past.

From the West's point of view, the colonial mission was legitimized as sharing the fruits of Enlightenment, spreading "universal" principles of liberty, equality, democracy, reason, science, etc. The inherent political contradiction between the egalitarian objectives of the Enlightenment and the hegemonic character of colonization was justified as the only way to deliver the colony into modernity, that might otherwise remain hobbled by the weight of tradition. This contradiction was romanticized as the "white man's burden."

The modernism of the postcolonial Nehruvian state, then, was the reciprocal response of the colonized, the self-empowering act of dissolving contradiction by simultaneously rejecting and appropriating the unsolicited gift of colonization. For Nehru, the repudiation of the colonizer did not also entail the repudiation of the promises of the colonial enterprise. When Nehru proclaimed that Chandigarh must be a modern city, his claim was not different in substance from that made earlier by the colonist. But since it was made by Nehru in the name of an independent nation state, it was fundamentally different in form, and thereby, in legitimacy. The ideological motivation behind the making of modern new cities in numerous post-colonies, such as Brasilia in Brazil, Islamabad in Pakistan, and Sher-e-Bangla Nagar in Bangladesh, was similar in nature.

Modernization, thus, was a mimicry of the colonial project, of the aims and aspirations of colonization, imitated and re-legitimized by the English-educated, Indian elite. If Orientalism was a discourse of the Orient, by and for the Occident; nationalism was its stepsister, a mimicry of the Occident, by and for the post-colony. It was, in this sense, the quintessential postcolonial project.

Mimicry and imitation, however, do not ensure that the end product will always be identical to the original. Quite the contrary. Mimic-men always have their own understanding of what they are mimicking – they see the world through their own interpretive lenses. That is what they aim to highlight. Thus while they may all agree on what they are imitating, the imitations can be significantly different and even contradictory.

In addition, the representatives of the originals, the standard-bearers of the West in our case, always claim ownership of the real truth of the content: the "true" goals of modernization. This is their legacy of the colonial experience – their continuing burden of the civilizing mission. In the postcolonial context however, it runs the heightened risk of being clouded by flattery, since the "natives" are now perceived to be acting entirely of their own volition – voluntarily admiring the West.

All this makes for great expectations, greater possibilities of disappointment, and much confusion. Such is the story of the making of Chandigarh.

Translating the Nehruvian Vision into Architecture ⎯⎯⎯⎯

The difficult task of translating Nehru's lofty expectation of Chandigarh, as of India, fell to functionaries of the state, the bureaucrats and the politicians, who mostly relied on foreign models and experts to show the way. In fact, the all-important decision to make Chandigarh according to an early twentieth-century English utopian urban planning model, was made by the first bureaucrat put in charge of the capital project, A. L. Fletcher. The city's first architect-planners, the Americans Albert Mayer and Matthew Nowicki, were handed a brief that not only detailed the extremely low densities and the individualized bungalows that were required, but also explicitly cited the Garden City Movement as the principal ideology that was to be manifested in Chandigarh.

But, of course, it was the city's second team of architects and planners, hired after the unexpected death of Nowicki in 1950, who are remembered best for their association with Chandigarh. This was the team led by Le Corbusier (1887–1965), the famous Swiss-French architect, the man whose name is canonized as a central figure in the history of modern architecture. He was the author of the Master Plan, and the vast Capitol Complex, where the major institutions of state are located – the High Court, Legislative Assembly, Secretariat, and the unbuilt Governor's Residence (Fig. 17–1). In addition, he prepared the guidelines for the commercial center, and in an adjoining sector, he built a museum and a school of art.

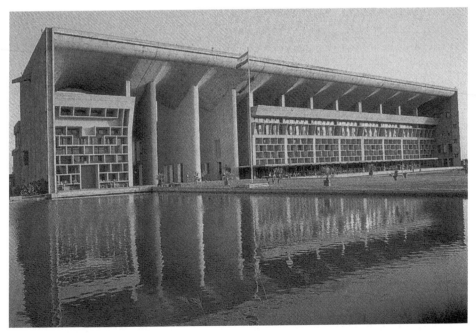

Fig. 17-1 High Court, Chandigarh, 1951–5. Photograph by V. Prakash.

The majority of the buildings within the city (other than those developed privately) were designed by Pierre Jeanneret, Maxwell Fry, and Jane Drew, assisted by a design team of nine Indian architects and planners. Jeanneret was Le Corbusier's cousin, and had been brought into the project by the latter, as the full-time resident architect. Besides supervising Le Corbusier's buildings, Jeanneret designed a number of the larger housing types of Chandigarh, and also many of the important administrative buildings such as the administrative center of the University, the State Library and the Estate Office. The English husband and wife team of Fry and Drew was responsible for most of the government housing in Chandigarh. The job of the nine Indians – M. N. Sharma, A. R. Prabhawalkar, B. P. Mathur, Piloo Moody, U. E. Chowdhury, N. S. Lamba, Jeet Lal Malhotra, J. S. Dethe, and Aditya Prakash – was essentially to assist the foreign team, although in time they were given projects of their own. The huge engineering team assigned to execute the project was headed by P. L. Verma, while P. N. Thapar served as chief administrator.

Housing designs for Sectors 22 and 23 were the first to be developed. As most of Chandigarh's original housing was intended for government employees, it was decided that the housing construction costs would be determined by a set percentage of a government employee's income. Accordingly, Jeanneret, Fry, and Drew devised 13 (later 14) "types" of housing based on a spectrum of incomes from those of employees earning less than Rs 50 per month to that of the Chief Minister. Each design was given a designation with a number (denoting the economic sector for which it was envisioned) paired with a letter (indicating the architect who designed it): Type 13J or 14M, for example. All the designs were visibly "modern," exhibiting stark geometries broken only by sunscreening devices like deep overhangs and recesses, perforated screens and open verandahs. There was even a "frame-control" system devised to regulate all the construction that was privately developed.

Chandigarh was originally designed for a population of 500,000. Fifty years after its birth, it already had a population of 900,000 – almost double its anticipated size – while large satellite towns, Panchkula and S.A.S. Nagar, have developed just beyond the administrative boundaries of the city. In the years to come, the larger Chandigarh metropolitan area is expected to be home to a population of almost 2 million.

Nehru and Le Corbusier

Of all the architects, however, it is Le Corbusier's name that is most famously associated with Chandigarh. One of the icons of utopian modernism, Le Corbusier embodied the image of the hero-architect, battling against the fortresses of old, forging a brave new world, whatever the odds. By the time he came to India, his books were well known and his skyscrapered cities, pristine and precise, were an

integral part of the daily palette of the modern movement in architecture, not only in Europe but in North and South America as well. Even though none was actually built, they embodied futuristic thinking, with a straight-lined, no-nonsense style that connoted visions of high scientific rationality and mechanized perfection. Le Corbusier had the reputation of being both the standard bearer as well as an iconoclast, and his designs for some of the most prestigious twentieth-century projects, such as the League of Nations and the United Nations building, were simultaneously controversial and established icons of the modern movement in architecture. For Nehru's call for modernity, there could have been no better respondent, even though Le Corbusier's choice as the chief architect and planner of Chandigarh was essentially accidental and last minute.

By the 1950s, when Le Corbusier came to Chandigarh, he was still very much a visionary, but was far from the technology-modernist that his reputation presaged. He was, indeed, a somewhat jaded man. Although modern architecture was closely identified with his person, Le Corbusier considered its true mission irreparably compromised. Modern life, driven by greed and profit, had, according to him, come disconnected from what he called the "fundamental facts" of nature. His ideal of the modern man was derived from a Rousseauesque image of the noble savage, an innocent in a pastoral world, uncorrupted by civilization.[8] He considered it the true mission of modern architecture to reestablish the aesthetic and poetic forms necessary for the liberation and deliverance of this modern man. This involved thinking of architecture as a technology, quite literally a machine that enables daily human life to be in harmony with the stars, the sun, the earth, the rivers, and other forces of nature.

At its core, Le Corbusier's mission was redemptive and eschatological, and Chandigarh was, in his expectation, his true, and possibly last, opportunity to achieve his objective. There seemed to be a vindication at hand:

India, that humane and profound civilization ... At the end of the race, 1951 at Chandigarh contact [is] possible with the essential joys of the Hindu principle: brotherhood, relationship between the cosmos and living things: Stars, nature, sacred animals, birds, monkeys, and cows, and in the village children, adults and old people, the pond and the mango trees, everything is present and ... poor but proportioned.[9]

"Poor but proportioned" – Le Corbusier's enchantment with India's "humane and profound civilization," far from leading him to question the need to even modernize, only served to reassure him of the veracity of his vision of a true modernism:

India has, and always has had a peasant culture that exists since a thousand years! ... But India has not yet created an architecture for modern civilization (offices, factories, buildings). India is suddenly jumping into the second era of mechanization. Instead of sinking into the gropings and errors of the first era we will be able to fulfill our mission; give India the architecture of modern times.[10]

185

As we know, however, Le Corbusier had not been invited to India to celebrate the bucolic possibilities of the "Hindu" agrarian culture. Rather he had been expressly charged with the mission to embody a third world nation's self-conscious visions and aspirations for the future. For Nehru, the India of 1947, with its villages and bullock carts, was not a picture of the "essential joys" of life. Rather it was the embodiment of the desolation and backwardness that had led to two hundred years of colonial rule, that had prevented India from participating in the forward march of modernity.

The situation therefore was fraught with contradictions. Although Le Corbusier and Nehru agreed that Chandigarh had to be a "modern" city, and cemented a close friendship around that agreement, their outlooks never quite melded. While Le Corbusier's modernism was nostalgic of a poor and primitivistic India, Nehru's modernism aspired to an unbridled liberalization from the shackles of poverty and primitivism. For Nehru, under the influence of colonization, modernism was a strategic catalyst of growth and change – the West on tap rather than on top. For Le Corbusier on the other hand, Chandigarh was his opportunity to fulfill the unrealized potential of an ideological investment – the resuscitation of a dying modernism through an old fantasy.

Critical Historiography

As the largest built project of a celebrated French modern architect, Chandigarh can, of course, easily be claimed for the West. Most of such claims consist of dismissing or eulogizing Chandigarh as an extension of Le Corbusier's œuvre, entirely disassociated from its Indian, third world, non-Western culture-scape. Based solely on superficial readings of form, the majority of scholarship on Chandigarh tends to scold Le Corbusier and the rest of the team of architects, along with the Indians who hired them, for callously importing a modernism from the West without thinking through its appropriateness for the Indian climes and contexts.[11] The only concession they generally offer is that Chandigarh's conception represents an attempt to overcome the sense of inferiority felt by the Nehruvian nation-state, which, coming straight out of colonization, advocated the unbridled imitation of the West. For them, Chandigarh was a mistake, a mask of shame.

While such readings are not entirely untrue, their perspective, I would argue, is much too one-dimensional.

Although Chandigarh is an icon of modern architecture, it is, after all, in India and was built by and is occupied by Indians. How, then, can one rescue Chandigarh's history from Eurocentrism and rehabilitate it as Indian history – not just in its putatively "Indianized" elements, but in toto, with all its Western aesthetic?

Modern architecture has always and inevitably been considered a Western bequest, because its origins lie in Western history. Origins, however, are not ends, and therefore are not the only ways of deriving identity and ownership. There are other equally valid ways, such as adoption, participation, and appropriation. But origins are often presupposed to be the "natural" basis of identity. As a consequence, important histories of non-Western modernism, as non-originary .claims, remain untold and misunderstood. These are my interests in this book – to claim and to explain Chandigarh's modernism not just as modern architecture, or modern Indian architecture, but as a non-originary Indian modern architecture. Adopted and appropriated by many, modern architecture, like all other cultural texts, belongs to the location where it is practiced, by Western or non-Western architects.

In other words, this book is a deconstruction of modernism, both as a Western and a non-Western construct. The important questions of historiography, I would argue, often do not lie in determining origins, but in assembling situational explanations, coherences whose validity can be judged within the context of their production, rather than against principles that are claimed to be foundational and universal. This is critical historiography – an assemblage of situational explanations, a textual strategy of reading.[12]

Understood as a cultural text, architecture has many existences in the differing social, cultural, and political perceptions of its authors, users, and interpreters. There is always something of a gap between the unconveyed aspirations and desires of the client, the secret inspirations and fascinations of the architect, and the distracted yet judgmental perceptions of the users. As such, an architectural construction is a multinucleated field, a complex mesh of signs, a creative document that simultaneously has an internal logic of its own and is created by and understood in the context in which it is situated.

My historiographical method works with the active possibility that the various elements that went into the making of Chandigarh contested, contradicted, and even at times erased one another. What Nehru and the administrators of Punjab wanted, what Le Corbusier wanted to build and what he actually succeeded in having built, and what the inhabitants of Chandigarh understood they got, were distinct and different, even as they combined to produce the semblance of a singular event. The final design contained traces of the conflicts generated by the forces that went into its making.

Notes

1 About 6.2 million Muslims left India for Pakistan, and about 7.5 million Hindus and Sikhs came the other way. Ravi Kalia, *Chandigarh: In Search of an Identity* (Carbondale and Edwardsville: Southern Illinois University Press, 1987), p. 1. Kalia's book is based on extensive primary research and is currently the most authoritative source for facts and information on Chandigarh.

2 For a compelling account of the events of partition, see Larry Collins and Dominique Lapierre, *Freedom at Midnight* (New York: Simon and Schuster, 1975).

3 Nehru's letter to the Chief Minister is dated September 1949 and concerns latter-day waffling by the State Government on issues of financing. It nevertheless conveys Nehru's opinion from the very beginning. Quoted in Kalia, *Chandigarh*, p. 10.

4 According to a personal interview with Ravi Kalia; see ibid., p. 3.

5 Interview with Aditya Prakash, September 1999. Also quoted in Aditya Prakash, *Reflections on Chandigarh* (New Delhi: Navyug Traders, 1983), p. 1.

6 One of the survey maps in the Chandigarh Museum shows that there was a village named Chandigarh on this site.

7 Quoted by Norma Evenson in *Chandigarh* (Berkeley: University of California Press, 1966).

8 For an insightful assembly of the argument see Adolf M. Vogt, *Le Corbusier, the Noble Savage* (Cambridge, MA: MIT Press, 1998).

9 From *Le Corbusier Sketchbooks*, Vols. 1–4 (New York and Cambridge, MA: The Architectural History Foundation and MIT Press, in collaboration with the Foundation Le Corbusier, 1981), Vol. 2, Sketch no. 448–449.

10 Quoted from Madhu Sarin, *Urban Planning in the Third World* (London: Mansell Publishing Limited, 1982), p. 44.

11 See Evenson, *Chandigarh*, p. 196; Sarin, *Urban Planning in the Third World*, p. 197; and Kalia, *Chandigarh*, p. 198.

12 I developed this argument earlier in my "Identity Production in (Post)Colonial 'Indian' Architecture: Hegemony and Its Discontents in C19 Jaipur" (PhD diss., Cornell University, 1994), which has been cited by Mark Jarzombek in "Prolegomena to Critical Historiography," *Journal of Architectural Education* 52.4 (May 1999): 197–206.

18

Skyscraper Competition in Asia: New City Images and New City Forms

Larry R. Ford

Introduction

Ford's essay analyzes the reasons for large-scale architectural projects in Southeast and East Asia beginning in the 1970s and continuing through the 1990s. He examines the symbolic and pragmatic factors contributing to skyscraper building and probes the ways this seemingly generic international architectural form is adapted to different Asian contexts.

The period of the 1970s to 1990s in countries and city-states like Malaysia, Singapore, Hong Kong, and even China was one of readjustment, turmoil, and – in some cases – booming economies. At the end of this period in July 1997, a series of currencies in Southeast Asia faltered and then precipitously fell over the course of the following months. What economists had labeled as the "tiger" economies of countries from Thailand to the Philippines became reframed as "the Southeast Asian economic crisis." While economists and social scientists still debate the causes for this so-called boom and its subsequent bust, the real estate speculation so central to much of the prosperity reshaped cities such as Kuala Lumpur (Malaysia), Singapore, Hong Kong (China), and Shanghai (China). Other political shifts within this region shaped architectural development as well, including the division of the Malay peninsula in 1965, which marked the independence of Singapore, a city-state, from

Larry R. Ford, "Skyscraper Competition in Asia: New City Images and New City Forms," pp. 123–33, 140–2, 144 from Lawrence J. Vale and Samm Bass Warner Jr (eds), *Imaging the City: Continuing Struggles and New Directions.* New Brunswick, NJ: Center for Urban Policy Research, 2001. Reprinted with permission.

Malaysia, and the handover of the British colony of Hong Kong to mainland China in 1997.

Issues of relevance to contemporary scholars of urban space, such as the rise of the "midtown" as an alternative center for business activity, are here reframed in an Asian context. The essay also discusses how architects and patrons sent messages of national pride and identity through these skyscrapers. Because skyscrapers represent modernity as well as a link to the West, countries in Southeast Asia turned to them to legitimize their place in the world economy while simultaneously making the architectural form their own, local version of "the modern." Ford's essay contextualizes these Southeast Asian structures, providing a foundation for further discussion of globalization, modernity, nationalism, and the processes of appropriation.

For a variety of reasons, most of the major cities on the Asian side of the Pacific Rim have chosen to use signature skyscrapers to house the majority of their newly constructed office space as well as related hotel and convention facilities. The result has been the emergence of impressive skylines surpassed only by those of some of the larger corporate centers of North America. This building trend in the new financial centers of Asia has had both symbolic and pragmatic dimensions. The pragmatic – the simple need for lots of new space – is the easiest and most straightforward to discuss, but it is completely intertwined with the symbolic. Cities need major office buildings, first-class hotels, and modern shopping facilities, as well as improved infrastructure and housing; in addition, there is also a fascination in Asia with having the newest, fanciest, tallest, largest, and most modern and innovative buildings and landscapes in the world.[1] The reasons for this are many and complex, including perhaps the response to colonial subjugation coupled with a strong work ethic and the perceived need to symbolically join the global economy. The full story may be beyond the scope of this brief essay. I will, however, make an attempt to explore the topic.

The Reach for the Sky: North American Precedents

The competition between Singapore and Kuala Lumpur is particularly interesting because it replicates, fifty years later, the kind of intercity skyscraper competition that emerged in the United States during the building boom of the 1920s.[2] The skyscraper office building, although technically invented in Chicago during the 1880s, first began to take the form of outrageously tall signature towers in New York City during the early years of the twentieth century. The Singer Building (1906), for example, rose to 612 feet at a time when few other buildings were half as high. It was meant to be an advertising symbol, giving assurance to those buying sewing machines around the country that the company was strong and highly visible. But the skyscraper was not the domain of private businesses alone. The New York City Municipal Building (1915), which at more than five hundred feet

tall gave symbolic power and authority to the municipality, paved the way for governments as well as businesses to create impressive skylines. For more than a decade, such landmark buildings were confined largely to New York City, but by the booming twenties, dozens of American cities were ready to compete for skyline supremacy in their own states or regions. Rational need had little to do with it. The Empire State Building, for example, was built by a consortium headed by former New York governor Al Smith; the group simply wanted to erect the tallest tower in the world. Completed in 1931, the famous icon remained partly empty for much of the Depression. Still, many other cities were joining in the game.

In every case, the new towers provided not only symbolic centers for their respective downtowns but functional centers as well. Were these skyscrapers needed in the sense that market forces required very high densities? The answer is, probably not.

Skyscraper Competition in Asia

In 1966, Jean Gottmann posed the question, "Why the skyscraper?"[3] That question seems to be a very important one for this discussion. For example, whereas the current trend in many American cities is for corporations to head for the woods and locate in edge cities or greenfield sites, this may not be possible or desirable in most Asian cities. In Hong Kong, for example, it is the satellite towns that are having the most trouble, as high-order business seeks the cozy connections of the central district while mass production heads further into China. The Asian reliance on personal interaction and handshakes over a brandy makes the isolated telecommuting world so often hyped in the United States seem wildly inappropriate. There are also physical constraints. In Singapore, suburban office parks are unlikely due to the small size of the country and a serious lack of space. Indeed, Singapore plans to double the size of its present very compact downtown by filling in the adjacent harbor.[4]

Even in more spacious cities, cultural traditions, congestion, lower rates of automobile ownership, and a whole range of differences in the spatial organization mean that corporate headquarters "out in the woods" are not really an option. For such cities, skyscraper megaprojects may be the best response to the need for high-quality space. Sprawl and isolation are not often options in either the relatively poor hinterlands of Chinese cities or the wealthy but train-dependent edges of Japanese cities. Scholars must be careful, therefore, not to assume too quickly that skyscrapers built in cities and/or districts with low land values and little congestion are merely symbolic. Asian skyscrapers may be evidence of a continuing demand for the kind of face-to-face contact and intense personal relationships that no longer characterize North American business dealings. Asian skylines may well reflect the old combination of functional and symbolic motivations, but in new and different ways.

Many of the stories about North American skyline competitions are now being retold, with variations, in the cities of Asia. For more than thirty years, for example, since the breakup of the former state of Malaya, there has been an intense rivalry between Singapore and Kuala Lumpur. Singapore was the first to create an impressive urban skyline, in part because of the very real need for concentrated activity in the tiny city-state. Today, Singapore has a very Western-style central business district that seems more akin to Toronto than to a traditional Asian metropolis. While the compact downtown bristles with towers, mostly built by banks and other private financial institutions, there is no dominant theme building that gives a unique identity to the city. Indeed, strict planning guidelines have resulted in the three tallest buildings being exactly the same height (an impressive 919 feet). Still, the skyline has played a very important role in the image of the city in business- and tourist-oriented promotional literature over the past two decades. Skyscrapers are used to convey a dual message: first, Singapore is open for business; second, although it has exotic elements, it is basically a clean, modern tourist destination with all the comforts of home.

Kuala Lumpur is a very different kind of city. While the old downtown is somewhat constrained by topography, the city has sprawled over many square miles, and new business centers have arisen in outlying areas. Although it has been necessary to construct large amounts of office space for the new global economy, there is no obvious need for skyscrapers and other megastructures. The fact that Singapore has an impressive skyline, however, requires that Kuala Lumpur have one too. The twin Petronas Towers of Kuala Lumpur (at present the tallest twin buildings in the world at 1,483 feet) provide perhaps the best example of using the skyscraper as both a symbol of participation in the new global economy and a symbol of a unique cultural identity.[5] When Petronas (the national oil company that occupies one of the towers) announced the design competition for its new headquarters, there were two requirements to be met – the building(s) had to be the tallest in the world, and the project had to include Islamic (preferably Malaysian Islamic) design elements (Fig. 18–1). The twin towers of the winning American architect, Cesar Pelli, succeed on both counts. They are very tall, and they display a modern yet Islamic motif that makes them immediately unique and recognizable. Designed by an Argentine-born American and constructed by Japanese and Korean firms using American materials, Malaysian supervisors, and a great many Indonesian and Bangladeshi laborers, they also epitomize the globalization of landscape production. Think globally, build locally.

The towers, each with nearly two million square feet of space, are the theme buildings for a much grander scheme called Kuala Lumpur City Center (KLCC). The creation of KLCC involves converting a former racetrack into a central park and lake surrounded by dozens of new skyscrapers. The base of the Petronas Towers includes a huge horizontal structure that houses a cultural complex

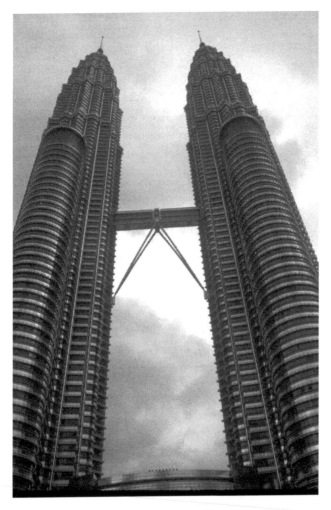

Fig. 18-1 Petronas Twin Towers, Cesar Pelli and Associates, 1997. Kuala Lumpur, Malaysia. Photograph by Deborah Hutton.

complete with a symphony hall and art gallery, as well as a mix of retail and recreational uses. Modern hotels and luxury condominiums are being built nearby. When completed, the new City Center, along with the nearby Golden Triangle, will be the new downtown for the Malaysian capital. As in American cities seventy years ago, towers are being used symbolically to anchor and provide a powerful image for a new node of activity. They may also provide the close and cozy internal arrangements and cultural embellishments necessary for business dealings in Islamic Asia. For example, there are prayer rooms throughout the building, an amenity that might not be available in other business settings.

The irony of China

The cities of China offer perhaps the most ironic and interesting examples of the changing urban landscapes of Asia. Clearly, the city to emulate is Hong Kong.

In cities where land is in short supply, usually it is in the best interest of local governments to find and/or create spaces for megaprojects in order to increase the tax base. In Hong Kong, existing policies make land availability an even more crucial matter. For example, taxes are generally low (and it is argued that many get out of paying taxes altogether). At the same time, Hong Kong relies on the construction and maintenance of one of the most expensive urban infrastructures in the world – including subway and highway tunnels under the harbor and a new airport. Much of the funding comes from land leases, especially from the creation of fill land that can be used for monumental skyscrapers and other megaprojects in highly desirable locations. Since the 1970s, one-fourth of Hong Kong's harbor has been reclaimed. The landfill projects that are in greatest demand are those closest to the traditional central area. In addition, land has been created seaward of the Wanchai District (an old tenement area associated with the popular book and movie *The World of Suzie Wong*) only a mile or so from the core of the city. This "midtown" district is now home to a massive new convention center, luxury hotel facilities, and the city's tallest skyscraper. In many ways, it is a second downtown – and one that has meant profits for local government.

Hong Kong now has not only some of the tallest skyscrapers in the world (two above 1,200 feet) but more very tall buildings than any city outside of North America. It is the only city in Asia with a large and dense clustering of towers à la Manhattan. In spite of recent economic problems, it is very likely that, when it comes to building, the sky is the limit. For example, the old airport at Kai Tak, which closed in July 1998, will be redeveloped as a new midtown in Kowloon. The area will no longer have height restrictions, so the impressive skyline of Victoria may well be matched by a competing center across the harbor. Hong Kong Harbor may be reduced to a narrow canyon.

Just as Kuala Lumpur has sought to emulate (and surpass) Singapore, so too have some of the cities of China sought to be new and improved versions of Hong Kong. First among these is Shanghai. By the 1930s, Shanghai had one of the first downtown business skylines outside of North America. The mini-skyscrapers constructed by Victor Sassoon along the Bund represented the arrival of the Western city in mainland China and were used extensively as symbols for a city that had relatively little in the way of traditional Chinese architectural monuments. After three decades of Maoist anti-urban ideology, during which time Shanghai was condemned as bourgeois and passé, the city is once again developing a world-class skyline.[6] From a practical point of view, there is little doubt that a massive amount of new office space is needed. As recently as 1990, for example, both Beijing and Shanghai had only about as much office space as downtown Dayton, Ohio, and much of that was nearly obsolete. Communist China was to be a land of rural agriculture and industry, and the urban infrastructure was

largely ignored. But global cities cannot consist of hovels, and international financiers do not operate out of sheds, so something had to be done.

There is some irony in the adoption of what many have described as the quintessential symbol of American capitalism – the skyscraper – by the still technically communist Chinese government. After all, the traditional aesthetic of China was essentially horizontal, with few structures over two stories. It was this aesthetic that Chairman Mao used extensively in expanding Beijing's Tiananmen Square. The rise of the Shanghai skyline represents more than a practical necessity; it is a very important ideological leap. Given a combination of huge population, thirst for international investment, and single-minded purposefulness in creating a new symbolic landscape, China may one day become the skyscraper capital of the world.

There are other cultural–symbolic issues as well. While Hong Kong, Singapore, and the cities of China have largely opted for modern (and postmodern) towers, cultural factors are sometimes important. For example, Feng Shui elements cannot be ignored in China, and there is a strong preference for certain numbers – eighty-eight stories is an ideal height for a major tower (Petronas Towers, Jin Mao Tower), whereas forty-four is to be avoided. In addition, Asian cities have sometimes sought a unique cultural identity through architecture. This has involved exploring connections to both the future and the past. In Japan, for example, designers have tended to push the envelope when it comes to new and wildly original shapes and forms. From the older Ginza to the new Teleport Town, Tokyo bristles with unusual buildings that have come to be associated with a "Japanese look." At the other extreme, many of the cities of Indonesia have experimented with oversized versions of traditional house types for use by banks, government offices, and especially hotels. Malaysia currently occupies a middle position, with many buildings referencing either traditional culture or a tropical setting in rooflines, shading patterns, and materials. The vast majority of new buildings everywhere, however, are simply modern. Both large corporations and government agencies tend to prefer skyscrapers that symbolize their competitiveness with New York and Chicago rather than local traditions and sense of place.

Identity, access, and personalization

At the macrolevel, urban skylines seem to be popular in most of the cities of Asia. They are featured on postcards and T-shirts, and art classes full of small children visit sites that enable them to view, sketch, and color the towers of the town. In spite of what seems to be a kind of uniform pride in the progress and prosperity symbolized by the new buildings, it is likely that there are some real differences in perceptions of the negative aspects of skyline development. In Singapore, for example, the skyline is generally seen as benign, especially now that neighboring districts are protected by strict historic preservation ordinances; it is coherent, controlled, and confined. Strict zoning keeps the towers "in their place,"

195

protecting residential areas. In Jakarta, on the other hand, skyscrapers have been built along major thoroughfares adjacent to low- and middle-income *kampungs* [neighborhoods]. The towers there often represent increasing congestion, rising land values, and eventual displacement of residential populations. Displacement is also a very real threat in Hong Kong and Kuala Lumpur as new skyscraper districts are carved out of former low-income neighborhoods. In Hong Kong, some of the highest towers are residential buildings and symbolize the capturing of central-city living space for the elite.

But these problems are found in dynamic cities all over the world. The really interesting variations in skyscraper use occur in the spaces between buildings at street level. The relative political calm and social conformity of Singapore, for example, facilitate access to the lobbies and plazas around the towers for social and civic events. Downtown Singapore has sidewalks, food hawker stalls, and a plentiful supply of small green spaces and trees. The skyscrapers may exude power and authority from a distance, but at street level, they are comparatively friendly. While strict zoning guidelines make it difficult to personalize these spaces with makeshift commercial or social paraphernalia, they are heavily used by a variety of people. The plazas and stairways in front of towers are used for everything from wedding pictures to Girl Guide meetings.

In Hong Kong, there are extreme variations from district to district. In the central district, a network of highways separates the Bank of China and its neighbors from the livelier districts nearby. On the other hand, in the Wanchai district, a new "Times Square" has been created and linked to nearby market stalls and alleys. There, skyscrapers have served to create functional as well as visual nodes. In Jakarta, the landscape is more problematic. For physical (swampy soil) and political reasons, many of the skyscrapers are spaced far apart and are surrounded by large plazas with driveways, fountains, and parking. There is little interface between the buildings and the street. Sometimes the compounds are gated, or at least guarded, and access by "the masses" is difficult. Here, skyscrapers suggest "keep away," and design reinforces the power relations inherent in the close juxtapositioning of towers and shanties. While street vendors may try to locate as close as possible to the buildings so as to serve the occupants as they emerge, they are usually forced by the setback designs to keep their distance. Sidewalks tend to be narrow and poorly maintained, as the elite arrive by car. For most residents of a city, street-level design and usage have more meaning than the architectural symbolism and sheer height of the tower.

Conclusion: Skyscrapers and the Image of the Asian City —

Building has slowed a bit in Asia, but the processes leading to the creation of global landscapes will not remain dormant for long. Yet, it seems the more things change, the more they remain the same. I feel at home in Asia. Jon Jerde, the

architect who designed Horton Plaza in San Diego, created a somewhat similar project in Fukuoka, Japan. Altoon Porter Limited remodeled Fashion Valley Shopping Center in San Diego and is now doing a mall in Hong Kong. The towers of Cesar Pelli can be seen in Cleveland, Charlotte, Kuala Lumpur, and Hong Kong, and all of them are within sight of a McDonald's. Yet these cities are not all the same; they are not becoming homogenized. Global trends are being played out in a number of local ways, and curious hybrids abound.

The images of the cities are changing as well. Large Asian cities are no longer widely perceived as anachronistic and backward places teeming with peasants and animal-drawn carts. In spite of recent economic crises, the gleaming skylines of Asia are forcing the world to take notice. Locally, the new towers are giving identity to recently developed midtown districts that did not exist only a few years ago. Places such as Pudong, Kai Tak, and Kuala Lumpur City Center are joining Midtown Manhattan and Boston's Back Bay as new districts defined by towering icons. It is too soon to say just what long-term impacts these buildings and districts will have on the ways local residents see and use the city, but it is clear that there are some new hybrids in the making.

Notes

1 Pacelle, M. 1996. Asia major: hot market, big egos draw top architects to tall buildings. *Chicago Tribune*, April 14: 3Q.
2 Ford, L. 1994. *Cities and Buildings: Skyscrapers, Skidrows, and Suburbs*. Baltimore, MD: Johns Hopkins University Press.
3 Gottmann, J. 1966. Why the skyscraper? *Geographical Review* 56: 190–212.
4 Urban Redevelopment Authority. 1996. *New Downtown: Ideas for the City of Tomorrow*. Singapore: Urban Redevelopment Authority.
5 Pelli, C., C. Thornton, and L. Joseph. 1997. The world's tallest buildings. *Scientific American* (December): 92c–101.
6 Murphy, R. 1980. *The Fading of the Maoist Vision: City and Country in China's Development*. Andover, MA: Methuen; Olds, K. 1997. Globalizing Shanghai: the "global intelligence corps" and the building of Pudong. *Cities* 14, 2: 109–23.

Part II
East Asia

Selected Periods and Dates

China

Shang dynasty	*c.*1500 to *c.*1050 BCE
Zhou dynasty	*c.*1050–256 BCE
Qin dynasty	221–206 BCE
Han dynasty	202 BCE to 220 CE
Period of Division	220–581 CE
Tang dynasty	618–907
Song dynasty	960–1279
Northern Song	960–1127
Southern Song	1127–1279
Yuan dynasty	1279–1368
Ming dynasty	1368–1644
Qing dynasty	1644–1911
Republic of China	1912–1949
People's Republic of China	1949 to present

Japan

Asuka period	542–645
Nara period	710–794
Heian period	794–1185
Early Heian	794–951
Middle Heian	951–1086
Late Heian	1086–1185
Early Feudal period	1185–1573
Kamakura period	1185–1333

Muromachi period	1392–1573
Momoyama period	1573–1615
Tokugawa (Edo) period	1615–1868
Modern period	1868 to present

Korea

Choson dynasty	1392–1910

19

The Nine Tripods and Traditional Chinese Concepts of Monumentality

Wu Hung

Introduction

Wu Hung's prolific scholarship encompasses periods of Chinese art history from the very ancient to the most contemporary. This introduction to his larger work on Shang (1500–1050 BCE) and Zhou (1050–221 BCE) Dynasty bronzes addresses the central art historical concept of "the monument." Wu argues that monumentality must be contextualized within a specific historical moment of a particular culture's history. In order to understand monumentality fully, one must investigate how that concept changes over time as a culture also changes. He draws on the mytho-historical tale of the nine tripods to explore how ancient Chinese bronzes were indeed monumental for the culture that produced them; to do so, he uses the story as a metaphor for this "history of monumentality."

In the context of Shang and Zhou China, the nine tripods, despite or perhaps because of their illusory and mythical nature, participate actively in history to determine the legitimacy of the current ruler. When the ruler is legitimate, the tripods are "heavy" vessels (*zhongqi*) and do not move. When a leader loses that legitimacy, the tripods become light and move easily to the rightful ruler. Wu extends this historical centrality of the nine tripods to bronzes as a whole, based on their role within Shang and Zhou Dynasty society as ritual vessels. Like the nine tripods, these vessels articulate the hierarchical relationships among people within ancient Chinese society

Wu Hung, "The Nine Tripods and Traditional Chinese Concepts of Monumentality," pp. 1–10 from *Monumentality in Early Chinese Art and Architecture*. Stanford: Stanford University Press, 1995. Reprinted by permission of Professor Wu Hung.

201

– relations such as those between father and son, king and servant. Authority and legitimacy for a ruler or anyone framed by those hierarchical relationships arises from the medium (bronze), the decoration on the vessels, and rituals the vessels enable. Wu demonstrates that art takes an active historical, societal, and political role in ancient China. Even beyond the ancient Chinese context, however, this chapter shows that rather than simply reflecting events, art shapes them.

My use of *monumentality* as the organizing concept of this study calls for some explanation. I chose it, rather than the more common word *monument*, because its relative abstractness offers flexibility for interpretation and because it is not overburdened with preexisting connotations. The word *monument*, as so often encountered in tourist guides and other writings, is frequently associated with giant, durable, solemn structures in public places – the Arc de Triomphe, the Lincoln Memorial, the Statue of Liberty, the Mount Rushmore National Memorial, and the Monument to the People's Heroes in Tiananmen Square. Such associations imply a conventional understanding of the monument based on size, material, topology, and location – anyone passing a granite obelisk or a bronze statue would call it a "monument" without knowing anything about it. This common wisdom is shared by artists and art historians. Many scholars, for example, consider the art of monuments synonymous with "monumental architecture" or "public sculpture," an unspecified equivalence underlying their discussion of monuments.[1] Some avant-garde artists who attack traditional "official" art also focus on conventional monumental images. Claes Oldenburg thus designed a series of "anti-monuments," including a pair of scissors that parodies the Washington Monument: "The scissors are an obvious morphological equivalent to the obelisk, with interesting differences – metal for stone, humble and modern for ancient, movement for monumentality."[2] The quintessential official monument is once again defined in terms of permanence, grandiosity, and stillness.

It remains questionable, however, whether this seemingly universal understanding sums up every sort of "monument" from every time and place, or whether it is itself a historical construct conditioned by its cultural origin. Indeed, it has been challenged by some writers even in the West. For example, in "The Modern Cult of Monuments: Its Character and Its Origin" (1902), the Austrian art historian and theoretician Alois Riegl attributed monumentality not only to "intentional" commemorative monuments, but also to those "unintentional" ones (such as ruins) and any object possessing "age value."[3] A yellowed historical document would readily fall into this last category. Following a different line, the American scholar John Brinckerhoff Jackson noticed the widespread desire after the Civil War to declare the Gettysburg battlefield a "monument": "This was something unheard of: an immense, populated landscape of thousands of acres of fields and roads and farmhouses becoming a monument to an event which had taken place there." Such reflections led him to conclude that a monument can take any form. It certainly does not have to be an intimidating structure and does

not even have to be a manufactured object – "A monument can be nothing more than a rough stone, a fragment of ruined wall as at Jerusalem, a tree, or a cross."[4]

Riegl's and Jackson's views oppose the conventional understanding of the monument. To them, topology and physical appearance count little in identifying a monument; what makes a thing a monument is its essential ability to memorialize and commemorate. As thought-provoking as this assertion is, it fails to account fully for individual monuments, especially their tangible forms. It lends itself to abstract discourses on memory and history but contributes only indirectly to analyses of art and architecture. Historians who deal with concrete forms (these would include art, architectural, and cultural historians) have to find a third position between empiricism and metaphysics. Their observation of a monument must take into account its function as well as its visual properties. Thus the following questions were posed at a 1992 conference at the University of Washington, entitled straightforwardly "The Monument": "What is a monument? What are the common denominators that constitute monumentality? Is it inherent in size, in power, in mood, in specific temporality, in perdurability, in place, in immortalization? Are concepts of the monumental transhistorical, or have they evolved or radically shifted in the modern period?"[5]

The organizers of the conference felt it necessary to raise these questions because, according to them, "no common ground has been established to account for the phenomenon of the monument in a cross-disciplinary and broadly theoretical way."[6] But if one believes (as this author does) that the phenomenon of the monument (or the phenomenon of anything) is never "transhistorical" and "transcultural," then one must describe and interpret such phenomena historically and culturally. Rather than attempting to find another universal "common ground" that accounts for various kinds of monuments in a "broadly theoretical way," a more urgent and plausible goal is to historicize the phenomenon of the monument – to explore indigenous concepts and forms within well-defined cultural and political traditions, to contextualize these concepts and forms, and to observe conflicting notions and manifestations of the monumental in specific situations. Such case studies, not general abstractions or syntheses, will broaden our knowledge of the monument and will prevent culturally biased theoretical formulations. This is why I propose to treat the monument strictly as a historical issue, and why I need first to define the geographical, chronological, and cultural scope of my study: in the following pages, I examine the concepts of monumentality and the forms of monuments in the specific context of ancient China from prehistorical times to the period known as the Northern and Southern Dynasties.

Here I use the two concepts – *monumentality* and *monument* – to indicate two interrelated levels in my discussion. Both terms derive from the Latin word *monumentum*, meaning to remind and to admonish. But in my usage, *monumentality* (defined in *Webster's New International Dictionary* as a "monumental state and quality")[7] sustains such functions of a "monument"; a physical monument can survive even after it has lost its commemorative and instructive significance.

203

The relationship of monumentality to monument is thus close to that of *content* and *form*. This explains why only an object possessing a definite monumentality is a functional monument. *Monumentality* thus denotes memory, continuity, and political, ethical, or religious obligations to a tradition. This primary meaning underlies a monument's manifold social, political, and ideological significance. As scholars have repeatedly stated, a monument, no matter what shape or material, serves to preserve memory, to structure history, to immortalize a figure, event, or institution, to consolidate a community or a public, to define a center for political gatherings or ritual communication, to relate the living to the dead, and to connect the present with the future. All these concepts are obviously important for any understanding of art and architecture as social and cultural products. But these are nevertheless empty words until they are historically defined. Moreover, even when a particular type of monumentality is defined, it remains an isolated phenomenon until it is linked with other kinds of monumentality into a dynamic historical sequence. I call this sequence a "history of monumentality": it reflects the changing notion of memory and history.

This transformation in meaning is reflected and expressed by the development of monuments – physical entities that embody and realize historical monumentality. Like the concepts and notions they signify, the tangible properties of a monument – shape, structure, medium, decoration, inscription, and location – constantly change; there is absolutely nothing we can categorically label a standard "Chinese monument." In other words, my identification of various forms of ancient Chinese monuments and their historical relationship is supported by my discussion of different conceptions of monumentality and their historical relationship. These forms may or may not agree with our conventional idea of monumental images. In either case, their qualification as monuments must be justified by their function and symbolism in ancient Chinese society. More important, they must not be viewed as isolated types of monuments but as products of a continuous development of symbolic forms, which I call a "history of monuments."

By combining the history of monumentality and the history of monuments into a single narrative, I hope in this book to discover the essential developmental logic of ancient Chinese art and architecture up to the appearance of educated artists and private works of art. Before this moment, all three major traditions of Chinese art and architecture – the ancestral temple and ritual vessels, the capital city and palaces, the tomb and funerary paraphernalia – resulted from large religious or political projects. Instead of pleasing a sensitive viewer, they reminded the public of what it should believe and how it should act. All can be qualified as monuments or components of monumental complexes. By identifying their monumentality, we may find a new way to interpret these traditions and thereby to reconstruct early Chinese art history. To demonstrate this, let us begin by exploring perhaps the oldest Chinese concept of monumentality, a concept revealed most clearly in an ancient myth about a set of legendary bronze tripods.

204

In the year 605 BCE, an ambitious lord of the southern state of Chu went on an expedition near the Zhou capital at Luoyang. The campaign was not aimed to show his loyalty toward the Zhou royal house, which had been reduced to puppet status and was constantly threatened by the feudal princes' increasing demands for political power. In this case, the lord's disloyalty was first shown by his holding military maneuvers near the capital. The submissive Zhou king sent a minister named Wangsun Man to bring "greetings" and gifts to the troops. The lord of Chu immediately questioned the minister: "Could you tell me how large and heavy are the Nine Tripods?" This seemingly innocent question aroused Wangsun Man's famous speech recorded in *Master Zuo's Commentaries on the Spring and Autumn Annals* (*Chunqiu Zuo zhuan*):

> The Tripods do not matter; virtue does. In the past when the Xia dynasty was distinguished for its virtue, the distant regions put their *things* [*wu*] into pictures and the nine provinces sent in copper as tribute. The Tripods were cast to present those *things*. One hundred different *things* were presented, so that the people could distinguish divine from evil.... Hereby a harmony was secured between the high and the low, and all enjoyed the blessing of Heaven.
>
> When the virtue of Jie [the last king of the Xia] was all-obscured, the Tripods were transferred to the Shang dynasty, and for six hundred years the Shang enjoyed its ruling status. Finally King Zhou of the Shang proved cruel and oppressive, and the Tripods were transferred to the Zhou dynasty.
>
> When virtue is commendable and brilliant, those which are small will be heavy; when things come to be crafty and decrepit, those which are large will be light. Heaven blessed intelligent virtue, and on this its favor rests. King Cheng [of the Zhou] fixed the Tripods in the Zhou capital[8] and divined that the Zhou dynasty should last for thirty reigns, over seven hundred years. This is the Zhou's mandate from Heaven. Though now the Zhou has lost its past glory, the decree of Heaven is not yet changed. The weight of the tripods cannot yet be inquired about![9]

This passage has been frequently quoted as a valuable source for the "meaning" of ancient Chinese bronze art. Scholars have often focused their attention on the term *things* and have interpreted and translated it as "totems," "emblems," "symbols," "decoration," or "animal sacrifices" to suit their various arguments, but I suggest that the significance of this record goes far beyond an iconographic reference. What this passage implies is, above all, an ancient *monumentality* in Chinese culture, and the essence of an entire artistic genre called *liqi* or "ritual art."

The implications of the Tripods exist on three different levels corresponding to the three paragraphs of this passage. First, the Nine Tripods as a collective monument were made to commemorate the most important political event in ancient China: the establishment of the Xia, which initiated a series of "dynasties" and separated traditional Chinese history into two broad periods. Before this moment, it was thought, various regional groups fought for political dominance; after this moment, a centralized power appeared and assumed a position to give

orders to subsidiary authorities. The Nine Tripods thus fall into Riegl's general category of an *intentional monument*, which is commemorative in nature. On the other hand, the Nine Tripods not only commemorated a past event but also legitimated and consolidated the consequence of the event – the implementation of a centralized political power over the whole country. Wangsun Man expressed this idea symbolically. According to him, the tripods bore the *things* of various regions. These regions were Xia's allies. The act of sending their *things* to the Xia demonstrated their submission to Xia authority. The engraving of their *things* on the tripods meant that they had entered into a single political entity. Wangsun Man stated this idea even more clearly when he said that after the Tripods were made, "people could distinguish divine from evil": all the tribes and kingdoms belonging to the Xia alliance were identified (by the Tripods) as "divine," whereas all enemy tribes and kingdoms (whose *things* were absent from the Tripods) were considered "evil."

This may have been the original impulse behind the creation of the Tripods. But as soon as these ritual objects came into being, their significance, or monumentality, changed. They became something that could be possessed, and indeed this new theme dominates the next part of Wangsun Man's political rhetoric. Here we find the second symbolism of the Tripods: these objects had become a symbol not only of a particular political power (the Xia) but of Power itself. It was thought that any dynasty would inevitably perish (as Wangsun Man asserted, the Zhou was mandated to last no longer than thirty reigns), but the centralization of political power – hence the Tripods – would persist. Correspondingly, the changing possession and location of the Tripods indicated the transmission of political power from one dynasty to another. (Thus, Wangsun Man said: "When the virtue of Jie was all-obscured, the Tripods were transferred to the Shang dynasty, and for six hundred years the Shang enjoyed its ruling status. Finally King Zhou of the Shang proved cruel and oppressive, and the Tripods were transferred to the Zhou dynasty.") From the Xia to the Shang and then to the Zhou, possession of the Nine Tripods coincided exactly with the succession of the Three Dynasties. The transmission of the Tripods thus became synonymous with the progression of History.

The broadening symbolism of the Tripods leads finally to the third significance of these objects: they and their transmission were not so much the *consequence* of historical events as the *prerequisite* for historical events. Theoretically, the distinguished virtue of a dynasty led to its mandate, which was then demonstrated by its creation or possession of the Tripods. In actuality, however, this logic was reversed: because a ruler possessed the Tripods, he was certainly virtuous and ought to enjoy Heaven's favor. This is why the ambitious lord asked about (in fact, asked *for*) the Tripods, and this is also why Wangsun Man answered: "Though now the Zhou has lost its past glory, the decree of Heaven is not yet changed. The weight of the Tripods cannot yet be inquired about!" His argument may be summarized this way: although the Zhou is declining, it is still the possessor of the Nine Tripods; hence it is still the legitimate ruler of

China, hence it still retains Heaven's mandate, and hence it is virtuous and morally unshakable. The Zhou's control of the Tripods had become the sole prop for its survival; for the ambitious lord, obtaining the Tripods would be the first step toward dynastic power.

As a collective political monument, the physical properties of the Nine Tripods both agree with and differ from those of a monument in a conventional, modern understanding. As mentioned earlier, a monument, or more precisely an "intentional" monument, is usually considered a manufactured form of durable materials that bears signs "to preserve a moment in the consciousness of later generations, and therefore to remain alive and present in perpetuity."[10] The legendary Nine Tripods conform to this basic definition: they were made of the most durable material available at the time, and their engraved signs registered the establishment of the First Chinese dynasty. But beyond this, the Nine Tripods were perhaps unique. First, the material of the Tripods was not only the most durable but was also the most prized. During the Three Dynasties, only the ruling classes possessed bronze. Moreover, Wangsun Man especially emphasized that people from China's nine provinces had presented the bronze used to make the Tripods. This implies that the symbolism of bronze lay not only in its solidity, durability, and preciousness but also in its origins and in the process of the Tripods' manufacture. When bronze from various places was mixed and cast into a single set of ritual vessels, it was understood that those who presented the material were assimilated into a single unity. As we have noted, the same logic also underlay the practice of engraving the *things* of these places on the Tripods.

Second, the word *monument* is often associated with colossal constructions whose giant size dominates public view. But as bronze vessels, the Nine Tripods could not possibly have been taller than two meters, and they were transportable from one location to another to correspond with a change in the dynastic succession.[11] We may say that their condensed form and their portability made the Tripods important; it was not their imposing size that made the ideas they represented grandiose. As Wangsun Man attested, "When virtue is commendable and brilliant, those which are small will be heavy; when things come to be crafty and decrepit, those which are large will be light." This is also why in ancient China all ritual bronzes were called "heavy vessels" (*zhongqi*), a term referring to their political and psychological importance, not to their physical size and weight. We read in the *Book of Rites* (*Li ji*) that "when one is holding a ritual article belonging to his lord, though it may be light, he should seem unable to sustain it."[12]

Third, the form of a monument is often related to the characteristics of permanence and stillness. The Nine Tripods, however, were believed to have an "animate" nature. The last part of Wangsun Man's speech has been translated: "When the virtue of Jie was all-obscured, the Tripods were transferred to the Shang.... Finally King Zhou of the Shang proved cruel and oppressive, and the Tripods were transferred to the Zhou." But the meaning of the original text is by no means so definite. In particular, the verb *qian* can be interpreted both as "to

be transferred" and "to transfer itself"; and in fact the syntax of the sentences seems to encourage the second reading (a word by-word translation of the two sentences, *ding qian yu Shang* and *ding qian yu Zhou* would be "the tripods move to Shang/Zhou").

Another version of the Tripod legend makes this even more explicit: it is recorded in the *Mozi* that a divination was made before casting the Tripods and a divine message appeared on the tortoise shell: "Let the Tripods, when completed, have a square body and four legs. Let them be able to boil without kindling, to hide themselves without being lifted, and to move themselves without being carried so that they will be used for the sacrifice at the field of Kunwu." The diviner, whose name was Wengnan Yi, then interpreted the oracle: "Oh! like those luxuriant clouds that float to the four directions, after their completion the Nine Tripods will move to three kingdoms: when the Xia clan loses them, the people of Yin [i.e. Shang] will possess them, and when the people of Yin lose them, the people of Zhou will have them."[13] Comparing the Nine Tripods to drifting clouds, Yi's metaphor clearly suggests that these divine objects generated their own movement (or transmission) – that the various dynasties could possess them only because the Tripods were willing to be possessed by these legitimate owners.

This "animate" quality of the Nine Tripods was even further mystified during the Han dynasty: people began to think that they could not only generate their own movement but also possessed consciousness: "The Tripods are the essence of both substance [*zhi*] and refinement [*wen*]. They know the auspicious and the inauspicious and what continues and what perishes. They can be heavy or light; they can be at rest or in motion. Without fire they cook, and without drawing water they are naturally full.... The divine tripods appear when a ruler rises and disappear when a ruler falls."[14] As I discuss later in this book, this "animate" quality was not a metaphysical conception but a visual one. This quality is directly related, on the one hand, to the general idea of "metamorphosis" in early Chinese ritual art, and on the other hand, to actual decoration on bronzes, which favors protean images.

Fourth, it seems surprising that the Nine Tripods, the most important political monument in ancient China, were actually a set of vessels. Unlike a conventional monument, which often fulfills no practical function, the Nine Tripods were used for cooking in sacrifices. They were therefore functional objects in religious communication with certain divine beings, most likely the spirits of deceased ancestors.[15] The Tripods commemorated not only the ancestors who originally created and acquired these ritual objects (i.e., their establishment of the Three Dynasties) but also all previous kings who had successfully maintained the Tripods in the royal temple (and had thus proved a dynasty's continuing mandate from Heaven). The political symbolism of the Tripods could be sustained over the several hundred years of a dynasty precisely because the *memory* of these ancestral kings was constantly renewed through ancestral sacrifices. Since only royal descendents could hold such sacrifices, any *user* of the Tripods was self-evidently the inheritor of political power.

208

Finally, unlike a conventional monument, whose grandeur is often displayed on public occasions, the Nine Tripods were concealed in darkness. In fact, many ancient writings, including Wangsun Man's statement, suggest that only because the Tripods were hidden and unseen could they maintain their power. We know that during the Shang and Zhou, ritual bronzes were kept in ancestral temples at the center of cities where the ruling clan held all important ceremonies. Such a temple, described in ancient texts as "deep" and "dark," functioned to structure a ritual process leading toward the ritual bronzes concealed deep inside, where only the male members of the ruling clan were allowed to enter. Outsiders were firmly forbidden to approach these vessels because this would have implied access to political power. This is why the Nine Tripods remained silent symbols of authority during the Xia, Shang, and Western Zhou, and why they suddenly became the focus of public interest during the Spring and Autumn and the Warring States periods after the Zhou royal house had declined and local kingdoms were competing for political dominance. The Chu lord's inquiry about the Tripods' "weight" in 605 BCE, initiated a series of similar events.[16] In 290 BCE, for example, Zhang Yi, the prime minister of Qin, proposed an attack on two towns in central China: "Once this is done, our troops will reach the outskirts of the Zhou capital.... The Zhou's only way to survive would be to submit its secret Nine Tripods and other precious symbols. With the Nine Tripods in our control, official maps and documents in our possession, and the Zhou King himself as hostage, the Qin can thereby give orders to all under Heaven and no one would dare disobey."[17]

But according to the *Intrigues of the Warring States* (*Zhanguo ce*), the Zhou did manage to survive without losing its treasures. This was again accomplished through a clever minister's eloquence on the mysterious Tripods. It is said that not only the Qin but other powerful kingdoms such as the Qi, the Chu, and the Liang cast covetous eyes on the Tripods. The Zhou minister Yan Shuai first made use of Qi's desire for the vessels to upset Qin's plan. He then traveled to the east, persuading the king of Qi to believe that even if he could have the Tripods (as the Zhou had promised him), it would be impossible for him to move these monumental objects to his kingdom in Shandong:

> The Tripods are not something like a vinegar bottle or a bean-paste jar, which you can bring home in your hand.... In the past, when the Zhou king conquered the Shang and obtained the Nine Tripods, he ordered 90,000 people to draw each of them [to the Zhou capital]. Altogether 810,000 people, including officials, soldiers, master workers, and apprentices, were involved, and all kinds of tools and instruments were employed. People thus take this event as a most thoughtful and well-prepared undertaking. Now, even assuming that Your Majesty could gather enough men to pull the Tripods, which route could you take to bring them home? [The country is divided and all the kingdoms located between the Zhou and the Qi are eager to possess the Tripods; their lords would certainly not allow you to ship the Tripods through their land.] I worry that your desire will only bring trouble.[18]

In retrospect, we realize that in his defense of the Zhou's possession of the Tripods, Wangsun Man of the late seventh century BCE was still relying on the Zhou's mandate and moral authority; Yan Shuai of the early third century BCE however, resorted to a physical exaggeration of the size of the secret Tripods. His words remind us of other instances in which the lack of empirical experience with an object helps confound any real sense of its size and proportions. For example, Barbara Rose has observed in her study of modern Western artworks:

> Our idea of the monumentality of Picasso's works is not dependent on actual scale; in fact, in my case an appreciation of their monumentality was largely a result of never having seen the originals, but of having experienced them as slides or photographs. In this way, the comparison with the human body never came up, so that the epoch-making 1928–29 *Construction in Wire*, although a scant twenty inches high in actuality, was as large as the imagination cared to make it.[19]

Unlike Picasso's masterpiece, only verbal descriptions of the Tripods were available, allowing even freer exaggeration of these mysterious objects in imagination and expression. Also unlike the modern case, access to the Tripods was tightly controlled by law; an insider's knowledge of these secret objects thus became his means of possessing and exercising power. This is perhaps why Yan Shuai's account, though obviously fictional, still helped stop the king of Qi's plan to obtain the Tripods. On the other hand, Yan's emphasis on the Tripods' physicality was something new and alien to the traditional concept of the vessels' monumentality: he no longer described them as self-animated divine beings but as immobile, stupendous physical entities, each of which had to be drawn by an army of 90,000 people. The Tripods were now literally "heavy vessels," an expression originally denoting their extraordinary political significance invested in a limited material form. Likewise, whereas Wangsun Man was still confident enough to refuse the Chu lord's inquiry about the "weight" of the Tripods ("The weight of the Tripods cannot yet be inquired about"), Yan Shuai volunteered information about the Tripods' "weight" and based his whole rhetoric on exaggerating it. Such differences reflect a crucial change in the concept of monumentality during the Eastern Zhou, when China was undergoing a transition from the archaic Three Dynasties to the imperial era. In fact, Yan Shuai's account represented a final effort to save the Tripods by supplying these old political symbols with the symbolism and forms of new types of monuments. In this sense, the original monumentality of the Nine Tripods had been rejected, and they, as material monuments, would soon disappear: when the Zhou dynasty finally fell, they also vanished into a river.[20]

The story of the Nine Tripods is probably sheer legend: although many ancient writers recorded and discussed the Tripods, no one ever claimed to have seen them and could thus describe them in detail. Nothing seems more unsuitable for an art-historical inquiry than such elusive objects. But to me, their value as historical evidence lies not in their physical form, not even in their existence, but in the myth surrounding them. Instead of informing us what the Nine

Tripods were, the ancient authors told us what they were supposed to be. They were supposed to commemorate an important historical event and to symbolize political unity and its public. Concealed in the royal temple, their location defined the center of the capital and the country; the common knowledge of their location made them a focus of social attention. They could change hands, and their possession by different owners, or their "movement" from one place to another, indicated the course of history. They took the form of a cooking utensil but exceeded the utilitarian usage and productive requirements of any ordinary vessel. Most important to an art-historical inquiry, they demonstrated their unique status through physical attributes including material, shape, and surface patterns. Since all these implications of the Nine Tripods are crucial to our understanding of extant ancient bronzes and other ritual objects, these legendary objects help us discover not only a forgotten concept of monumentality in ancient China, but also a new perspective in interpreting the whole tradition of *liqi* (ritual paraphernalia) or *zhongqi* ("heavy" vessels), which dominated Chinese art from late Neolithic times to the end of the Three Dynasties.

Notes

1 This understanding is implied in Georges Bataille's description in his 1929 article "Architecture": "Thus great monuments are erected like dikes, opposing the logic and majesty of authority against all disturbing elements: it is in the form of cathedral or palace that Church or State speaks to the multitude and imposes silence upon them" (see Hollier 1992: 47). In the early 1940s, S. Giedeon wrote articles criticizing what he called "pseudomonumentality" and promoting "new monuments" that would express "man's highest cultural needs." Both terms refer to architectural form (Giedeon 1958: 22–39, 48–51). Two of the most recent studies on monuments also limit their focus to "monumental architecture," which, according to their authors, is "more or less monstrous exaggeration of the requirement that architecture be permanent" (Harbison 1991: 37; Trigger 1990: 119–20).

2 Quoted in Haskel 1971: 59. For a related discussion, see Doezema and Hargrove 1977: 9.

3 Riegl 1903. For discussion of Riegl's theory, see Forster 1982; Colquhoun 1982.

4 Jackson 1980: 93, 91.

5 Conference program by Marian Sugano and Denyse Delcourt. The conference, sponsored by the Center for the Humanities of the University of Washington, was held in Seattle, Feb. 27–29, 1992.

6 Ibid.

7 *Webster's New International Dictionary*, s.v. "monumentality."

8 The original science is "King Cheng fixed the Tripods in Jiaru." In Eastern Zhou texts, *Jiaru* refers to the locality of the Zhou capital and sometimes to the capital itself; see Tang Lan 1979: 3–4.

9 Trans. based on Legge 1871: 5.292–3.

10 Riegl 1903: 38.

11 The largest extant bronze vessel, the Si Mu Wu tripod of the late Shang, is 52.4 inches tall and weighs 1929 pounds.

12 *LJ*, 1256; trans. based on Legge 1967: I.100. Different dates have been suggested for the *Book of Rites*. Most likely, this book was compiled during the early Han; see Legge 1967: I.xlvi. Since my discussion here concerns some general principles of early Chinese religion and art, *LJ* and other later documents are used as secondary sources complementing archaeological evidence.

13 *Mozi*, 256.

14 *Ruiying tu*, 10a. Sun Ruozhi, the author of this omen catalogue, lived in the post-Han era, but a similar inscription is found on the Wu Liang Shrine built in 151 CE. See H. Wu 1989: 236. For a longer discussion of the Nine Tripods legend, see ibid., 92–6.

15 Most inscribed bronze vessels from the Shang and Western Zhou were dedicated to deceased ancestors. As David N. Keightley (1978: 217) has stated, the religion of the ancient Chinese was "primarily a cult of the ancestors concerned with the relationships between dead and living kin."

16 In addition to the two passages discussed below, other records about the feudal lords' desire for the Nine Tripods can be found in *Zhanguo ce*, 19, 21; *SJ*, 163. See Zhao Tiehan 1975: 129–32.

17 *SJ*, 2282.

18 *Zhanguo ce*, 22–3.

19 Rose 1968: 83.

20 *SJ*, 1365. But Sima Qian also offered a different account: the Nine Tripods were seized by the Qin during its attack on the Zhou in 256 BCE (*SJ*, 169, 218, 1365). Ban Gu, however, dated this event to 327 BCE (*HS*, 1200). See Zhao Tiehan 1975: 135–6.

References

Colquhoun, A. "Thought on Riegl." In K. W. Forster, ed. 1982. *Monument/Memory. Oppositions* special issue, 25: 79–83.

Doezema, M., and J. Hargrove. 1977. *The Public Monument and Its Audience*. Cleveland: Cleveland Museum of Art.

Forster, K. W. 1982. "Monument/Memory and the Morality of Architecture." In K. W. Forster, ed. 1982. *Monument/Memory. Oppositions* special issue, 25: 2–19.

Giedion, S. 1958. *Architecture, You and Me*. Cambridge, Mass.: Harvard University Press.

Harbison, R. 1991. *The Built, the Unbuilt and the Unbuildable: In Pursuit of Architectural Meaning*. Cambridge, Mass.: MIT Press.

Haskel, B. 1971. *Claes Oldenburg: Object into Monument*. Pasadena, Calif.

Hollier, D. 1992. *Against Architecture: The Writings of Georges Bataille*. Cambridge, Mass.: MIT Press

HS: Han shu (History of the Former Han), by Ban Gu. Beijing: Zhonghua shuju, 1962.

Jackson, J. B. 1980. *The Necessity for Ruins*. Amherst: University of Massachusetts Press.

Keightley, D. N. 1978. "The Religious Commitment: Shang Theology and the Genesis of Chinese Political Culture." *History of Religions* 17, 3/4: 211–25.

Legge, J. 1871. *The Chinese Classics*. 5 vols. Vol. 5: *The Ch'un Ts'ew, with the Tso Chuen*. Oxford: Clarendon Press.

——. 1967 [1885]. *Li Chi: Book of Rites*. 2 vols. New York: University Books.

LJ: Li ji (Book of rites). References are to Kong Yingda, *Li ji zhengyi* (The correct interpretation of the *Book of Rites*). In *Shisanjing zhushu*, 1221–696.

Mozi (Writings of Mozi). References are to Sun Yirang, *Mozi xiangu* (The *Writings of Mozi*, with supplementary annotation). Zhuzi jicheng 4.

Riegl, A. 1903. "The Modern Cult of Monuments: Its Character and Its Origin." Trans. K. W. Forster and D. Chirardo. In K. W. Forster, ed. 1982. *Monument/Memory*. *Oppositions* special issue, 25: 20–51.

Ruiying tuji (Annotated illustrations of good omens), by Sun Ruozhi. In Ye Dehui, *guangutang suozhushu* (Books catalogued in the Guangu Hall). Xiangtan: Ye family, 1902.

SJ: Shi ji (Historical records), by Sima Zian. Beijing: Zhonghua shuju, 1959.

Tang Lan. 1979. "Guanyu 'xia ding' " (About the "Xia dynasty tripods"). *Wen shi* (Literature and history) 7: 1–8.

Trigger, B. G. 1990. "Monumental Architecture: A Thermodynamic Explanation of Symbolic Behaviour." In R. Bradley, ed., *Monuments and the Monumental*. *World Archaeology* special issue, 22,2: 119–32.

Wu Hung. 1989. *The Wu Liang Shrine: the Ideology of Early Chinese Pictorial Art*. Stanford: Stanford University Press.

Zhanguo ce (Intrigues of the Warring States), by Liu Xiang. Sibu congkan.

Zhao Tiehan. 1975. "Shuo jiuding" (On the Nine Tripods). In *Gushi kaoshu* (Examining and reconstructing ancient history). Taibei: Zhengzhong shuju, 120–40.

20

Shang and Zhou Bronze Inscriptions

Introduction

The texts that follow are translations of inscriptions found on Chinese bronze vessels from the Shang (c.1500–1050 BCE) and Western Zhou (1050–721 BCE) periods. As discussed in Wu Hung's essay in this volume, these bronzes played an important role in rituals meant to establish social interrelations – between the current generation and the ancestors, kings and their subjects, or similar. These inscriptions reveal the reasons for casting bronze vessels, while demonstrating a gradual shift in meaning as the inscriptions' importance rose during the transition from the Shang Dynasty to the Western Zhou.

The inscriptions either connect the patron with the ancestors or relate the patron to the current ruler, sometimes doing both. Filial piety, or respect for one's ancestors, centered on the use of ritual vessels. A family's success rested on the reputation established by the ancestors. Thus, propitiating one's predecessors through the use of ritual food and wine presented in the appropriate vessels formed a crucial part of maintaining an advantageous position within the societal system.

Inscriptions on vessels from the early Shang Dynasty are fairly simple, usually including no more than a clan sign or insignia to indicate familial connections. Later Shang inscriptions include slightly more information, noting the patron's name and

"Shang and Zhou Bronze Inscriptions," p. 59 from Wu Hung, *Monumentality in Early Chinese Art and Architecture*. Stanford: Stanford University Press, 1995. Reprinted by permission of Professor Wu Hung. "Shang and Zhou Bronze Inscriptions," translated by Constance A. Cook, pp. 15–16 from Deborah Sommer (ed.), *Chinese Religion: An Anthology of Sources*. Oxford: Oxford University Press, 1995. ©1995 by Oxford University Press, Inc. Used by permission of Oxford University Press, Inc.

the name of the ancestor in whose name the bronze was cast. By the time of the transition into the Western Zhou Dynasty, inscriptions had become more elaborate, as seen here on the late Shang "Bucket of Xiaozi Feng" inscription, which includes a narrative of the events leading up to the casting of the bucket. Later inscriptions continue this elaboration.

As the inscriptions lengthen in detail and specificity, the decoration on these vessels becomes simpler and more abbreviated. Thus, in the mid-Shang Dynasty, when inscriptions remain single characters, the surfaces of the bronze vessels are covered with decoration usually centering on the so-called "taotie" design that references an animal head with eyes, horns, and ears, symmetrically arranged around a central ridge. By the early Western Zhou dynasty, decoration shrinks on the vessels, sometimes leaving areas smooth, at other times covering the surface with low-relief patterns. In some cases, the decoration focuses on the inscription itself. The inscription thus becomes the main conduit of information, rather than any other representational or decorative motif. Alongside medium and shape, inscriptions communicate the importance of these objects as ritual vessels (*liqi*).

Bowl of Li (Li Gui) (Early Western Zhou Period)

In the first quarter of the eighth month, the King arrived at the Temple of Zhou. The Duke of Mu guided me, Li, into the Middle Court, to stand facing north. The King commanded the attendants to present me with scarlet cloth, black jade, and a bridle, saying: "By these tokens, govern the Royal Officers and the Three Ministers – the Seneschal, the Master of Horse, and the Master of Artisans." The King commanded me, saying: "For the time being, take charge of the lieutenants of the Six Regiments [the army of the West] and of the Eight Regiments [the army of the eastern capital, Chengzhou]." I, Li, bowed to the floor and made bold to answer that I would proclaim the King's trust by casting precious vessels for my gentle ancestor Yi Gong. I said, "The Son of Heaven's works defend our empire everlastingly! I prostrate myself before him and vow to be worthy of my forebears' faithful service."

Bucket of Xiaozi Feng (Late Shang Period)

On the day *yisi* [day forty-two], the Zi official commanded Xiaozi Feng first to take the Ren people to the Jin region. Zi gloriously presented Feng with two strings of cowrie shells and said, "The cowries are to recognize your accumulated merit." Feng used them to make a sacrificial vessel for Mother Xin. This was in the twelfth month, when Zi said, "I command you to go to the Ren region." [Clan sign.]

215

Square Beaker of Mai (Early Western Zhou Period)

The king commanded our leader, the Archer Lord of Jing, to leave Pei. The Archer Lord went to Jing. In the second month, the Archer Lord went to visit the court at Ancestral Zhou without incident. He met with the king, who performed the wine libation and ritual sacrifice to the royal ancestors at Hao capital. On the next day, while residing at Biyong pool, the king boarded a boat to perform the Grand Rite. The king shot at a Great Peng bird and caught it. The Archer Lord boarded a boat with red flags and followed. The Grand Rite was completed. On this day, the king had the Archer Lord enter the Inner Chamber. The Archer Lord was presented with a dark-colored engraved dagger-ax. When the king was residing at An, on the bank of the Biyong pool, on the evening of the day *si* the Archer Lord was presented with two hundred households of barefoot slaves, with chariots and horses that the king used, and with a bronze chariot piece, a cloak, an apron, and some shoes. Upon returning to Jing, the Archer Lord presented the Son of Heaven's gifts and reported to his ancestors without incident. With respectful demeanor, I quiet the Archer Lord's spirit and display filial offerings to the Archer Lord of Jing. I, Scribe Mai, was presented with bronze from leader Archer Lord. I, Mai, in extolling the Archer Lord of Jing's merit, use it to make a treasured sacrificial beaker vessel in order to make offerings to those who give and receive at the Archer Lord's temple and in order to display the luminous mandate. This was in the year that the Son of Heaven gave gifts to Mai's leader, the Archer Lord. May his progeny have eternal life without end and use this vessel to receive virtuous power, to pacify the many associates, and to present memorial feasts to those mandated ones who flit back and forth.

Tureen of Shenzi Ta (Early Western Zhou Period)

Ta said: "Bowing and bumping my head, I dare to summon and report to our Deceased Father. You, Deceased Father, command your troubled Shenzi Ta to make a libation at the Zhou lords' temple. I step up to the two lords and do not dare but perform the libation. Praise to all the lords whose achievements pacify the spirit of my Deceased Father and thereby make him manifest. He illustriously received the mandate. Oh! It was my Deceased Father who longed for the former kings and former lords, who had conquered the Yin and reported to their ancestors the stunning success. Thus, my Deceased Father was able to go even farther! Now I, Shenzi, may tranquilly embrace the protective good fortune of the many lords. Oh! Your Shenzi gains merit and satisfaction in the Lord's grace. I, Shenzi, from beginning to end have accumulated stores of goods to make this sacrificial tureen to feast Lord Yi and to make the many

lords descend. May you take up and pity your Shenzi Ta and make me fortunate. I use the tureen to make my life auspicious; I use the tureen to pacify the lords so that I may live long. I, Ta, use the tureen to embrace and aid our many younger brothers and grandsons to enable them to emulate and learn from their father, this son of yours."

Bell of Liang Qi (Late Western Zhou Period)

Liang Qi said: "Oh greatly manifested Brilliant Ancestors and Deceased Father, stately and solemn, orderly and protective, who were able to make their powers wise and who strenuously served the former kings, gaining accumulated merit without loss! I, Liang Qi, having from the start followed and modeled myself on the luminous virtuous power grasped by my Brilliant Ancestors and Deceased Father, respectfully serve the leader, the Son of Heaven, from dawn to dusk. The Son of Heaven entrusted me, Liang Qi, into his service as a Country Lord Grand Governor. Taking this opportunity, the Son of Heaven has fondly awarded Liang Qi's merit. I, Liang Qi, daring to respond to the Son of Heaven's greatly manifest gift, extol his grace and avail myself of it to make a harmonious bell for my Brilliant Ancestors and Deceased Father. Clang! Clang! Clong! Clong! Ding! Ding! Dong! Dong! I use it to summon down and give pleasure to the Former Accomplished Ones. I use it to pray for peace, pleasure, riches, spiritual aid, and extensive benefits. May the Brilliant Ancestors and Deceased Father, majestically residing above, never cease to send down to me great and plentiful good fortune in abundance, such abundance! I use it to protect and glorify myself and to inherit from them the eternal mandate. I, Liang Qi, will ably serve the Brilliant Kings for ten thousand years without limit, and with extended long life I shall eternally treasure this bell."

Tureen of Liang Qi (Late Western Zhou Period)

The Chief Ritualist of Food, Liang Qi, made an honored sacrificial tureen for his Brilliant Deceased Father, Hui Zhong, and his Brilliant Deceased Mother, Hui Yi. I use it to follow after them and to present memorial feasts and filial offerings. I use it to pray for extended long life, extended long life without limit, for a hundred sons and a thousand grandsons. May my progeny eternally treasure it and use it to present memorial offerings.

21

A Magic Army for the Emperor

Lothar Ledderose

Introduction

In *Ten Thousand Things*, Lothar Ledderose, a leading scholar of Chinese art and calligraphy, analyzes the use of modular units in ancient, medieval, and early modern Chinese art. Ledderose argues that modular systems, which necessitated standardization and organization but also made possible a near infinite variety of forms, allowed Chinese artisans to create copious amounts of high quality objects. The particular chapter featured here discusses one of the best known works of ancient art, the terracotta army of the First Emperor of Qin (r. 221–210 BCE).

History records *Qin shi huangdi*, or the First Emperor of the Qin Dynasty, as the leader who unified China under a central government and introduced a variety of standardizations, from currency to measurements to roadways. History also remembers the emperor for being a cruel megalomaniac obsessed with immortality. Without the ruler's exacting control and personal authority, the empire he founded quickly crumbled, lasting only four years past his death. The technical and administrative achievements of his reign, however, remained, marking a turning point in Chinese history.

Chinese archeologists are still excavating *Qin shi huangdi*'s massive tomb, begun as soon as he became leader of the then local Qin kingdom in 247 BCE and unfinished at the time of his death in 210 BCE. Life-sized, minutely detailed terracotta warriors, lined up in perfect military formation and numbering over 7000 in total, guard the emperor in the afterworld. The lifelike appearance of the figures has led some scholars to believe that they functioned as "portraits" of individual soldiers. Ledderose,

Lothar Ledderose, "A Magic Army for the Emperor," pp. 51–4, 57–63, 68–73, 218–20 from *Ten Thousand Things: Module and Mass Production in Chinese Art*. Princeton: Princeton University Press, 1998. © 2000 by the Trustees of the National Gallery of Art, Washington DC, published by Princeton University Press. Reprinted by permission of Princeton University Press.

by giving a detailed description of the tomb, probing its historical and cultural context, and investigating the construction means used, presents a very different conclusion.

Ledderose's discussion of the emperor's terracotta army focuses on the production methods of the artisans and thereby brings to the fore the logistics that go into making a monumental artwork. By highlighting the technology used, however, the reading does not minimize the role of creativity in art, but instead reconsiders where creativity lies. Moreover, by linking the warriors' production to the standardization, centralization, and militarization going on during the Qin dynasty, the author underscores the relationship between artistic production and societal developments at large.

Of the many sensational archaeological excavations made since the founding of the People's Republic of China in 1949, the most sensational of all was the discovery of the terra-cotta army near the tomb of China's First Emperor. The First Emperor was one of the most powerful men in Chinese history and, indeed, in world history. Originally the king of the state of Qin, he ruthlessly obliterated the other states of his day and unified the realm in 221 BCE, thereupon calling himself Qin Shihuangdi, the First August Emperor of Qin. The pattern of empire he established lasted for more than two millennia into the present century, and the name of his dynasty, Qin, is said to have given its name to China.

The most extraordinary fact about this archaeological find is a quite simple one: buried were not a few, or even a few dozen, lifelike soldiers but several thousand. About two thousand figures have been unearthed so far, and it is estimated that there are more than seven thousand altogether.

The figures are not only lifelike but life-size, of various types, including armored and unarmored infantrymen, standing and kneeling archers, cavalrymen with horses, charioteers, petty officers, and commanders. Armored infantrymen appear most often. Each held a spear or halberd in his right hand, and some possibly held a sword in their left hands. The charioteers wear caps that indicate their rank as officers and extend both arms forward to grasp the reins. The standing archers, with turned bodies, are dressed in simple and light uniforms that allowed for speed and maneuverability. The kneeling archers wear waist-length suits of scaled armor that simulates leather; their arms are flexed for cradling the crossbow. All details of the clothing, the armor, and the faces are modeled with great care, down to the stippled tread of the sole of the archer's sandal.[1]

The lifelike quality of these warriors must have been even more striking when they were still painted with their original colors, which indicated precisely the different parts of their dress. When these figures are unearthed, their colors are still visible. Upon excavation, however, most of the pigment adheres to the surrounding earth and not to the figures. Moreover, once exposed to air, the lacquer in which the pigments are embedded tends to crumble rapidly,

reducing the colors to powder. Only traces last thereafter. Only recently has a method been found to stabilize the polychrome coating.[2] Because the problems of conservation remain unsolved, excavation work now proceeds at a slow pace.

The following discussion of this army, which the emperor commissioned for his tomb, will consider three questions: What was done? Why was it done? And how was it done?

What Was Done?

The Necropolis

The Grand Historian Sima Qian (born 145 BCE) gives a detailed account of the tomb in his *Records of the Historian* (*Shiji*), which he completed in 91 BCE.[3] Work began as soon as the future emperor ascended the throne as king of Qin in 247 BCE, when he was thirteen years old. It is believed that the king, as was customary, put his chancellor in charge of designing the royal tomb and supervising construction. This was Lü Buwei (died 235 BCE), who had been a trusted adviser to the king's father.

In 237 BCE, Lü Buwei fell from grace, and Li Si (*c*.280–208 BCE), one of the ablest men of his time, followed as chancellor. He was instrumental in implementing the unification of the empire and in forging its administrative structures. He is personally credited with creating the stately, tectonic Small Seal Script for the imperial steles that were set up to glorify the emperor's unification of the realm. These steles set a precedent for the millions of stone steles that followed in succeeding centuries. It seems that Li Si also took extraordinary measures to prepare a worthy tomb for his ruler. It was probably he who, in 231 BCE, turned the area around the tomb into a government district with its own administrative center, named Liyi (District of Li) after the nearby Mount Li. The people in this district were responsible for the construction and later for the maintenance of the imperial necropolis.[4]

After the king became emperor in 221 BCE, the design for his tomb seems to have been expanded to a much larger scale. As the series of military campaigns had come to an end, large numbers of conscripts became available, and more than seven hundred thousand men from all parts of the realm were recruited to build the emperor's palace and his tomb. Most of them were forced laborers, slaves, and prisoners, "men punished by castration or sentenced to penal servitude," in the words of the Grand Historian.[5] Work on the terra-cotta army probably started at this time.

In 212 BCE, Li Si had thirty thousand families resettled to the district,[6] but when the emperor died two years later construction stopped at once, even though his tomb compound was not yet finished. The laborers at the palace also ceased

work to join the men at the tomb. All seven hundred thousand of them heaped earth on it during the following year.[7]

Today a large tumulus still occupies the center of the compound. This artificial hill has the shape of a truncated pyramid, with a base of approximately 350 meters. The original height is said to have been about 115 meters. Erosion has taken its toll and reduced the tumulus to its present height of 76 meters, or less. The exact location of the emperor's tomb was thus known throughout history, even after the walls and halls above ground had decayed, since nobody could overlook the tumulus.

Bushes and trees planted since adorn and protect the hill because Chinese archaeologists have decided not to excavate the tomb in our time. Knowing what wonders wait for them once they open the ground, they also know that they would be unable to preserve properly what they might find.

In a famous passage, Sima Qian tells us of the tomb's content:

As soon as the First Emperor became King of Qin, excavations and building had been started at Mount Li, while after he won the empire more than seven hundred thousand conscripts from all parts of the country worked there. They dug through three subterranean streams and poured molten copper for the outer coffin, and the tomb was filled with models of palaces, pavilions and offices, as well as fine vessels, precious stones and rarities. Artisans were ordered to fix up crossbows so that any thief breaking in would be shot. All the country's streams, the Yellow River and the Yangzi were reproduced in quicksilver and by some mechanical means made to flow into a miniature ocean. The heavenly constellations were shown above and the regions of the earth below. The candles were made of whale oil to ensure their burning for the longest possible time.

The Second Emperor decreed, "It is not right to send away those of my father's ladies who had no sons." Accordingly all these were ordered to follow the First Emperor to the grave. After the interment someone pointed out that the artisans who had made the mechanical contrivances might disclose all the treasure that was in the tomb; therefore after the burial and sealing up of the treasures, the middle gate was shut and the outer gate closed to imprison all the artisans and laborers, so that not one came out. Trees and grass were planted over the mausoleum to make it seem like a hill.[8]

[margin: expresses patriarchy]

[margin: Many were sealed in the tomb before their time]

The tomb thus contains a microcosm, an ideal model of the realm over which the emperor had ruled and intended to continue to rule after his death. Doubtless it will be difficult for any future excavator to preserve quicksilver streams and heavenly constellations. Indeed, the tomb may have been looted long ago. The Grand Historian talks about the destruction wrought upon the Qin empire and its capital Xianyang in 206 BCE by General Xiang Yu: "Xiang Yu led his troops west, massacred the citizens of Xianyang, killed Ziying, the last king of Qin, who had surrendered, and set fire to the Qin palaces. The conflagration raged for three whole months. Having looted the city and seized the women there, he started east."[9]

[margin: may have been looted]

221

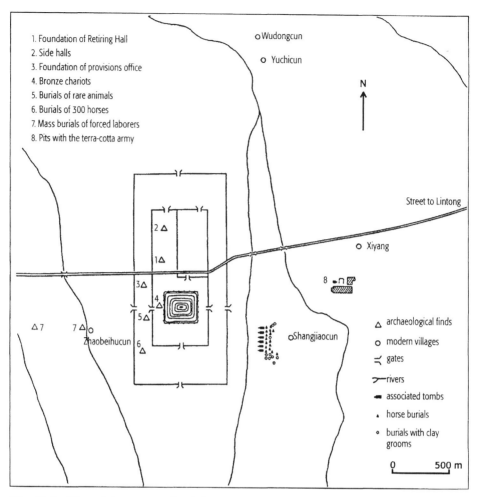

1. Foundation of Retiring Hall
2. Side halls
3. Foundation of provisions office
4. Bronze chariots
5. Burials of rare animals
6. Burials of 300 horses
7. Mass burials of forced laborers
8. Pits with the terra-cotta army

o Wudongcun

o Yuchicun

N

Street to Lintong

o Xiyang

8

oShangjiaocun

△ archaeological finds

o modern villages

≍ gates

⌐ rivers

◄ associated tombs

▲ horse burials

o burials with clay grooms

0 500 m

△7 7△o
Zhaobeihucun

Fig. 21-1 Plan of the necropolis of the First Emperor of Qin.

General Xiang Yu is also said to have dug up the emperor's tomb. At the same time he may have destroyed the underground pits housing the terra-cotta army. Excavations have revealed that they have been burned.

The Army in its Pits

The most spectacular burial outside the tomb proper is, of course, the terra-cotta army. The Grand Historian does not mention it, nor does any other historical source. Its discovery in 1974 came as a complete surprise. There is a cluster of four separate pits 1,225 meters east of the outer wall. Pit no. 1, which is 230 meters long and 62 meters wide, contains the main army in battle formation with more than 6,000 figures of warriors and horses. Pit no. 2, with various cavalry and infantry units as well as war chariots, has been explained as representing a military guard. The small pit no. 3 is the command post, with high-ranking officers and subordinates and a war chariot drawn by four horses. Several of the figures lack

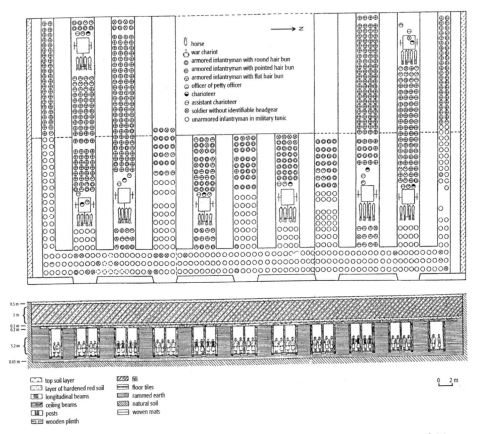

Fig. 21-2 Ground plan and cross-section of pit no. 1, tomb of First Emperor of Qin.

heads, which are believed to have been stolen by grave robbers as early as the Qin or the Han period.[10] Pit no. 4 did not contain any figures and was probably left unfinished by its builders. Together, the four pits seem to represent a complete garrison: pit no. 1, the right army; pit no. 2, the left army; pit no. 4, the middle army; with the headquarters in pit no. 3.[11]

The pits' architectural structures were devised for solidity and permanence (Fig. 21–2). The outer walls and the walls between the eleven parallel corridors in pit no. 1 consist of pounded earth. The earthen walls were originally held in place by wooden frames that also supported the roof beams. The roof, in turn, carried a layer of reddish mortar and a layer of earth three meters thick. The floor was also made of pounded earth as hard as cement, and altogether covered by some 256,000 tiles. It has been calculated that about 126,940 cubic meters of earth were moved to excavate the pits, and that 8,000 cubic meters of timber were needed.[12]

The solid wooden construction must have been finished before the figures were put into place; otherwise their installation would have been too dangerous. At the front side of the pit, ramps have been identified down which the figures were hauled into the long, probably torch-lit corridors. This prompts an intriguing

thought: nobody, not even the First Emperor, ever saw the terra-cotta army in its entirety. The breathtaking view of the now world-famous columns of soldiers only became possible after excavation in 1974. Obviously, the army did not need to be seen to serve its purpose. It was enough that it was there, like inner organs concealed in a human body.

Beams and tiles provide clues for dating the terra-cotta army. The Grand Historian mentions that timber for the emperor's palace and his tomb was shipped from the region of present-day Sichuan and from the state of Chu.[13] The sturdy pine wood in the subterranean pits is believed to have come from these southern parts of the empire, and this probably happened only after unification, when the emperor had the finest material from all parts of the country at his disposal. Chu was subjugated only in 223 BCE.

Stamped characters in many of the floor tiles identify their makers. The character meaning "metropolitan" (*du*) is an abbreviation for "Metropolitan Boats" (*duchuan*), a factory under the commander of the capital (*zhongwei*). The character for "palace" (*gong*) is an abbreviation for "Palace Water" (*gongshui*), a factory that was part of the imperial manufactures (*shaofu*) and responsible for all kinds of waterworks. Both factories seem to have made tiles only after the unification.[14]

Of the mighty timber construction only traces of ash remain. As mentioned, it is believed that general Xiang Yu, when looting the First Emperor's capital Xianyang in 206 BCE, also set his necropolis on fire. The burning beams collapsed and subsequently the earth slid down and smashed all the terra-cotta figures. None has come to light intact.

The army in pit no. 1 was set within the corridors in rows of four soldiers, many of them clad in heavy armor, all modeled in clay. In six of the corridors, wooden war chariots, each drawn by four terra-cotta horses, are spaced in regular intervals among the infantry. The army is facing east. Three rows of warriors form the vanguard, two rows protect the army at its sides, facing north and south respectively, and a rear guard of three rows faces backward.

The movements of this awesome fighting machine would have been controlled by audible signals from drums and bells, which have been found at the site. When the drum sounded once, the magic army moved forward, on the second drum roll, it attacked. On the sound of the bell, the troop stopped, and when the bell rang again, it retreated.[15]

The figures were kiln fired between 900 and 1050 degrees centigrade.[16] At this relatively low temperature, the unglazed clay remains porous and is called "terra-cotta," literally baked earth. Although several kilns for making tiles and other utensils have been explored in the area of the necropolis, no kiln for firing the figures has yet been excavated.[17] About two hundred meters to the southeast of pit no. 1, fragments of terra-cotta figures indicate a kiln site that is estimated to have been large enough for firing two horses or six warrior figures at a time.[18]

After firing, painters applied a lacquer coating colored by brilliant pigments. (Lacquer is a natural resin obtained in small quantities by preparing the sap

224

acquired by tapping various lacquer trees (*Toxicodendron verniciflua*). The trees grow in tropical and subtropical areas, and were native to southern China. As lacquer is highly resistant to water, heat, and acids, it is well suited for protecting objects and is also amenable to surface decoration. Carefully made war gear from many areas in East Asia often bore a lacquer coating to protect it from rot and rust. Chinese examples from the centuries preceding the unification of the empire include armor made principally of lacquered leather. Most of the armor molded on the terra-cotta soldiers represents leather armor. With their lacquer coating, the terra-cotta figures became more durable and seemed even more "real."

To completely coat thousands of large clay figures in lacquer is an astounding achievement in itself, but certainly not beyond the imagination of an emperor, whose son once considered lacquering all the city walls of his capital.[19] In some areas of the figures, such as the faces, two separate coatings were applied. The mineral pigments were also mixed with lacquer and painted with a brush on top of the coating. The geometric patterns are very intricate, like those of the textiles of the period.[20]

The terra-cotta figures carried real weapons, such as spears, halberds, dagger axes, swords, crossbows, and arrows. Almost five hundred weapons and more than ten thousand scattered arrowheads have been found in pit no. 1. Save for four iron pieces, all weapons were cast of bronze. Some of the blades are still razor sharp.[21]

The lock mechanism of the crossbows is ingeniously devised. After the archer discharged his arrow he brought the lock back into the original position by quickly jerking the bow backward. The four mechanical parts are cast with such precision that they fit together perfectly. The tolerance for error lies within fractions of a millimeter. It was this precision that helped the Qin state overpower the rival feudal states.

Yet precision alone was not enough. It had to be matched by the ability to produce large quantities of weapons. The Qin could do this, too. Indeed, their weapons industry was another early example of mass production in China. It is known from inscriptions on the weapons that many came from state factories capable of churning out huge numbers of technically perfect products.[22]

Mass production of weapons started in Qin long before the time of the First Emperor. Inscriptions began to appear in the middle of the fourth century BCE, the law decreeing that each weapon had to be inscribed.[23] For more than a century these inscriptions identified the chancellor as supervisor of weapons production, testimony to the importance attached to the weapons industry. The weapons carried by the terra-cotta army date from the early years of the king's reign to 228 BCE. As later weapons have yet to be found, they may all have been used by real warriors before being entrusted to the hands of the clay soldiers.

As late as 239 BCE the chancellor was still named as the supervisor, but at this date the names of individuals from lower ranks in the production hierarchy began to appear on the weapons as well. The inscription on one such blade reads: "17th year [230 BCE]. Government Workshops, produced by master Yu, worker Diao." The characters for "Government Workshop" (*sigong*) occur once more on the

225

other side of the blade and on the guard as well. Engraved on the shaft is the serial number: "Series *zi*, five-nine."[24]

The Government Workshops produced not only weapons but also carriages and utensils for everyday use. Their products are among the first in China on which an individual inscribed his name. It would certainly be naive to try to detect budding individualism here, nor do the names indicate any personal pride on the part of the maker. These inscriptions had only one purpose: quality control.

This visit to the First Emperor's necropolis has shown that it was laid out like the palace of a living emperor, with the private quarters under the tumulus and a main hall above with various palace offices, a pleasure garden, horse stables and carriages, tombs of family members and loyal retainers, and with a mighty army, ready to attack any intruder.

on the swords, charrets & other earthy items

Why Was It Done?

This question calls for another, closer look at the historical situation. Unification of the empire doubtless was the single most outstanding event of the period, if not of Chinese history.[25] Many other efforts preceded, accompanied, legitimized, and glorified this event. Building the imperial tomb was one of them. This political context explains the grand scale of the project and the unusual efforts lavished on the terra-cotta army. Moreover, and more specifically, the builders of the necropolis were continuing a time-honored tradition of royal tomb building. The First Emperor or his chancellors may have wished to reinforce this tradition, or to give it a new direction, but they could not abandon it, and did not want to do so. Two separate sets of factors thus determined the design of the necropolis, the historical situation and a tradition of furnishing rulers' tombs.

Standardizing Society

Of all the emperors that ever considered themselves to be the mightiest man in the world at a particular time in history, the First August Emperor of Qin was perhaps the only one who was right. His power was rivaled but not matched by the ruler of the Maurya dynasty in India – which was just past its prime under Emperor Ashoka (about 274–232 BCE) – and perhaps by the nascent Roman Empire. The Romans, however, had yet to face the battle at Cannae in 216 BCE, a severe setback on their way to achieving eventual supremacy over the Mediterranean Sea. When the king of Qin unified China in 221 BCE he could hardly have had any knowledge of those empires in other parts of the ancient world. Yet he brought under his control all the civilized world known to him, and thereby – unknown to him – created the mightiest empire on the globe, the largest in both area and population.

During the Period of the Spring and Autumn Annals (*Chunqiu*; 722–481 BCE), the area of China, although in name still under the control of the rulers of the

Zhou dynasty, was split up into rivaling feudal states engaged in constant warfare. Indeed, the following period (453–221 BCE) is called the Period of the Warring States (*Zhanguo*). The Qin established their power base in the eighth century BCE in what had been the original heartland of the Western Zhou. This allowed them to view themselves as the Zhou's legitimate heirs. The First Emperor even claimed to succeed the Yellow Emperor and other mythical rulers of remote antiquity. In the middle of the fourth century, the feudal state of Qin was still rather small, but then it expanded forcefully in all directions. Only seven states were left when the First Emperor became king of the Qin state in 247 BCE. The young king soon pursued a policy of the iron fist. In 230 BCE he embarked on a decade-long series of military campaigns, conquering the remaining feudal states one after the other. Within two years after his principal rival, the culturally superior southern state of Chu, succumbed in 223 BCE. Yan and Qi, the last northern states, had also fallen.

Many factors came together to allow for Qin's success. Among the technological advances made during the previous centuries, smelting, forging, and casting iron had developed apace. (In the West, iron was not cast until the fourteenth century CE.) Farmers began to use iron ploughs, which allowed them to break the earth deeper and faster, thereby boosting agricultural production. Blades for spades and hammers were also fabricated of iron.

Metal technology was equally vital for producing weapons, the very tools by which the Qin destroyed their neighbors. Crossbows and other deadly weapons in the hands of the terra-cotta soldiers show how successful the Qin were in this domain. Yet other feudal states had made advances in iron and weapon technology as well. The crossbow was actually invented in Chu, and the swords of the states of Wu and Yue in the lower Yangzi region were praised throughout the realm for their supreme quality. Qin, however, surpassed all other states when it came to organizing masses of people and coordinating their efforts toward ambitious goals, in the civil as well as the military sphere.

In the civil sphere, law and order were Qin's major values. Households were organized in units of five and ten and were held jointly responsible for misdoings committed by any member. A law code promised draconian punishments but also equal justice to everyone. The code, fragments of which archaeologists have discovered written on bamboo slips, has been ranked among the most influential legal systems in world history.[26]

The Qin administrators knew how to foster efficiency through standardization. They developed commerce by regulating weights and measures and the axle lengths of carts; they forged a monetary union by standardizing coins; and they created a uniform system of script.

Extensive building activity also testified to the Qin's capability in successfully organizing huge labor forces. After ascending the throne, the First Emperor embarked on a number of large construction projects that served to consolidate political, commercial, and cultural unity, and to glorify his achievements. He connected existing portions of walls built by some feudal states thereby

anticipating in effect what has become the most famous of all Chinese monuments: the Great Wall. A network of highways radiating from the capital of Xianyang linked together faraway places in the new empire. One such road that has been archaeologically identified led from Xianyang straight north over a distance of eight hundred kilometers into present-day Inner Mongolia. Canals were renovated and newly dug, completing a system of waterways from the Yellow River in the north to the Huai River in the south. The emperor had a giant palace, called Apanggong, built for himself, which, although destroyed soon after construction, has been remembered since as the epitome of ostentatious architecture. Last, but not least, the emperor could look forward to moving into the greatest necropolis China had seen to date.

How Was It Done?

The logistical problems in procuring material and men must have been considerable. A sufficient supply of clay, firewood, lacquer, and pigments had to be constantly available at the necropolis. Although none of the workshops and kilns have been located so far, the figures were presumably formed, fired, and painted near the pits to avoid costly and hazardous transportation of the semi-finished or finished products. Only a well-observed sequence of steps in the production process and a tight schedule could guarantee that work went smoothly.

No less demanding was the task of organizing the labor force. Once the workers were recruited, they had to be fed and given shelter. Their efforts had to be coordinated and the results supervised. Moreover, the makers of the terracotta army were but a small group among several hundred thousand busy men at the site. There is no doubt that all this activity necessitated detailed planning and an organizational framework.

The Workforce → makers of drainage pipes

What kind of workers could possibly have had the experience necessary to fire such large clay figures in such quantities? The answer: the makers of drainage pipes! An impressive drainage system made of clay was found under the provisions office in the necropolis and under the Qin palace. The technique used to make the drainage pipes must have been similar to the technique for making circular torsos, legs, and arms from slabs of clay rolled into tubes.

Inscriptions confirm this observation. The foremen of the palace workshops used to stamp their names on floor tiles and roof tiles. Some of the same names have been discovered on the terra-cotta figures.[27] This indicates that the makers of the terra-cotta army, rather than being sculptors, were potters who knew how to manufacture ceramic architectural parts.

228

The inscriptions on the terra-cotta figures also enhance our understanding of the organization of the workforce. When the first 1,383 warriors and 132 horses were excavated, archaeologists gathered preliminary statistics. They counted 477 inscriptions. The characters had either been incised with a stylus or stamped before firing, mostly on inconspicuous parts of the body. Two hundred thirty inscriptions consist of serial numbers only. Most frequently, one finds the numbers five (40 times) and ten (26 times). This indicates that the figures were counted in groups of five and multiples of five, as was customary with real men in civil and military administration.[28]

Altogether, on 249 figures the names of 85 different foremen appear. Eleven of them preface their names with the character meaning "palace" (*gong*). Once again, this is an abbreviation for the Palace Water factory and also is seen on floor tiles of the pit. The foremen in this factory usually stamped the inscription into the soft clay with a seal, for example: "[Foreman] Jiang of the Palace" (*gong Jiang*).

A second group of 23 foremen put a place-name in front of their names. In all but three cases it is the capital Xianyang. One such inscription reads "[Foreman] Ge of Xianyang" (*Xianyang Ke*). This type of inscription is always incised and never stamped, which makes it somewhat less official than a seal imprint. It is believed that these masters came from local factories.

The third group is the largest, comprising 48 men who neither added the name of a factory nor a place-name to their own names. Most of these names occur only once. Those men probably also belonged to either one of the first two groups.

The inscriptions reveal that staff members from state factories and workers from local workshops pooled their efforts in one big project. This is common in later periods, too, for example in Han-dynasty lacquer workshops or Qing-dynasty porcelain factories. Typically, workers from state factories set standards of quality and enjoyed a somewhat better position than private workers. They were allowed to use seals and were given a higher proportion of the work. The names of the eleven men from the palace workshops are found on 87 figures; two of them made 21 figures each. By contrast, together all 23 local foremen produced only 56 figures.

Yuan Zhongyi, the chief excavator of the terra-cotta army, has described stylistic differences between the figures made by the two groups. Not surprisingly, the figures from the palace factories are more static, their bodies more sturdy, and their expressions stern and heroic. They also show a more consistent level of workmanship and greater stylistic uniformity. Figures from local workshops are more varied in their postures and faces, and tend to be more realistic. Yuan Zhongyi even talks about the styles of individual masters.[29]

It was hardly artistic pride, however, that caused the foremen to put signatures on the figures they had made, nor did those who commissioned the figures look at signatures in this way. As in the case of the weapons, quality control was the sole purpose of the inscriptions. The numbers served to verify how many

229

figures had been completed; the names guaranteed the quality of craftsmanship. If the overseers found a figure to be faulty, they were able to track down a man whom they could hold responsible. Precise laws specified the fines in such cases.[30]

The foremen did not work alone, of course. They probably had the status of masters (*gongshi*), and each of them controlled a team of perhaps ten workers.[31] The 85 foremen identified so far would then have directed 850 men. Since many terra-cotta figures have not yet been excavated, presumably more names of foremen will come to light. The total workforce may have comprised a thousand men. Assuming they set up shop only after the unification of the empire in 221 BCE and continued until the emperor's death in 210 BCE, they would have completed more than 7,000 figures in eleven years, or close to 700 figures in one year, which is quite conceivable for a workforce of about a thousand men. Yet in the first years the workers certainly produced less than the average, due to their lack of experience. Firing figures of such dimensions was tricky, especially as the thickness of the clay walls varied considerably, and in the kiln the figures shrank in size by about 10 percent. Presumably there were frequent misfirings.

Assembling the Figures

Valuable as they are, the inscriptions do not say what the workers actually did, which can only be inferred by closely examining the figures. The foremen and their many subordinates worked within the framework of a well thought out production system. Each of the figures of the standing warriors weighs between 150 and 200 kilograms, and normally consists of seven major parts: a plinth, the feet, the legs below the garment, the torso, the arms, the hands, and the head.[32] The workers first modeled each part separately and then fitted them together. They luted the arms to the body with wet clay, then inserted the prefabricated head into the opening at the neck where they secured it with wet clay, too. Because the figures are assembled from set parts, they have the appearance of mannequins.

When fabricating cylindrical parts, such as torsos and arms, the workers first kneaded clay into thick slabs that they then rolled into tubes. In other cases they built up the circular forms from coils of clay. They also formed the wet clay in molds composed of dried or fired clay. Although not employed for all parts of the body, molds were an important means by which to standardize and speed up production. The molds for the plinths may have been made of wood in the shape of a flat open box, a simple device the workers would have known from making tiles. The basic form of a head was put together from two halves formed in hemispherical molds. Usually the seam runs vertically over the head in front of or behind the ears. Still visible on a head that broke at the seam is the imprint of the hand of the worker who pressed the wet clay into the negative mold. Heads of horses were similarly formed with paired molds.

230

Once the basic form of the figures was completed, the workers took additional clay to shape details such as those on the shoes and the armor. The greatest care was lavished on the heads. The workers attached or reworked by hand the headgear, hair, ears, eyebrows, eyes, mustaches, and lips. Some parts, like the ears, were formed in molds first. Similarly, the ears and forelocks of the horses were preformed in standardized shapes.

A division of labor certainly existed. The signatures indicate that one foreman and his team were responsible for making an entire figure up to the point when it was handed over for firing. Beginners in the team or laborers of little skill could perform simple jobs like preparing and mixing the clay or forming the plinth. Experienced team members may have concentrated on more delicate tasks such as modeling the faces. The firing was undoubtedly a job for specialists, as was painting the fired figures.

Correct timing must have been vital. The different parts of the body had to be joined when the clay was neither too hard nor too soft. The heavy torsos, for example, could only be hauled onto the legs after they had dried to such a degree as to be sufficiently firm. On the other hand, reworking had to be done while the clay was still somewhat damp. The members of the team had to set up their schedule accordingly. Probably they could solve these problems more easily when they worked on several figures simultaneously. One explanation for the frequency of serial numbers that are multiples of five could be that five figures were made at a time.

Thus, there were no long assembly lines with many workers, each performing one small operation. Rather, the team under each foreman formed its own small, self-contained assembly line that saw a figure through all the production stages. Nevertheless, the teams worked according to similar blueprints. All workers assembled their figures from the same small number of basic parts. There were variations, to be sure. The shoes could be fixed to the plinth, for example, and the lower legs could be made from rolled slabs or coiled clay. Yet the basic structure remained the same.

Uniformity is also evinced in the measurements. The respective parts of each clay body have similar dimensions, although oversize limbs or heads appear from time to time. The overall height of the standing soldiers, including the plinth, varies between 180 and 195 centimeters, the length of the feet from 25 to 29 centimeters, the circumference of the torsos from 85 to 107 centimeters, the breadth of the head from about 19 to 23 centimeters, and the length of the face, normally, from 19 to 20 centimeters.[33] The soldiers thus are large, but life-size. This is confirmed by the fact that they carry real weapons, and it is also apparent in comparison to the size of the clay horses. The variations in all measurements remain within a consistent range.

Even more important, only a small and quite limited repertoire exists of different types for all parts of the figures. The authors of the archaeological report have, for example, identified three types of plinth, two types of feet, three types of shoes and four types of boots, two types of legs, eight types of torso, and two types of armor, each category having three subtypes. The most elaborate

[handwritten margin note: relativity all of the soldier are around the same dementian]

[handwritten note at bottom: can tell the soldiers were made by different crafismen b/c there were different types of torose, feet, legs ect.]

231

repertoire exists for the heads, for which the report identifies eight different types.[34] The components of the face are also standardized and the number of types is limited.[35]

In spite of this uniformity of the body parts, the army still conveys an overall impression of extraordinary variety, for two reasons: first, although standardized, the parts are joined together in a multitude of combinations. This allows for large numbers of units that differ from one another. Following the authors of the report in distinguishing eight types of heads, and further, identifying various types of eyebrows, lips, mustaches, and so forth, one soon arrives at a huge number of possible combinations. Second, the workers went over the figures and their parts by hand. They had to do this anyway in places where they luted parts of the body with wet clay. Again, the possibilities are exploited most fully in the faces. The makers reworked the physiognomical features when attaching small parts such as eyebrows or mustache, and they added further structure through the use of small incisions. In this way they achieved the truly endless variety that was necessary to make the army appear real.

We are not, however, dealing with portraits, as the English text of the report wants us to believe.[36] By definition, a portrait must attempt resemblance of an individual in a comprehensive creative process. A production method that divides figures and faces into standardized parts does not operate within the holistic concept of a personality that cannot be divided – the "individual."

Yet it was precisely the creative achievement of those who designed and made the terra-cotta army that they developed a system that allowed them to assemble the figures from a limited number of clearly defined parts. These parts of the body are modules, as a final look at the hands will confirm.

The workers formed the hands separately and then inserted them into the open sleeve, sometimes affixing them with a plug. Among the approximately fifteen thousand hands of the terra-cotta soldiers, there are only two main types: hands with extended fingers, and hands with bent fingers. The standing warrior shows these two types.[37]

Hands with a flat palm were made in two molds. A break can reveal the original joints. The joint often runs horizontally through the hand and the fingers.[38] Both parts were fitted together while the clay was still soft, and probably bonded by liquid clay or slip. One mold could also be used to form the back of the hand and the fingers and another mold was employed for the inner palm and the lower part of the thumb.

Hands with bent fingers are half open in order for them to hold a weapon or another object. Palm and fingers could first be made separately in molds and then joined together.[39] Or two molds were used, one for the palm with the thumb, and one for the back side of the hand and its bent fingers up to the second joint. The fingertips were then modeled separately and joined to the rest of the hand.[40]

The angle at which the finished thumb was affixed to the hand varied. Thus it was possible to make different types of hands for different functions, as the hand

232

of the kneeling archer demonstrates. Moreover, varying with the angle of the arm, the same hand type could be used for different functions. The standing archer also has the familiar hand with stretched fingers. A chariot driver holds the reins in a hand with bent fingers. Although there are only two basic types of hand, all hands look different because they have been worked over before firing.

The observations on the hands can be summed up thus: the hands are prefabricated parts; they are composed of several elements; their measurements are standardized; the number of types is very limited; and the same type of hand can assume a different function in a different context. Hence the hands are modules. The same applies to the other parts of the body of the warrior figures.

Only the use of modules made possible the most extraordinary feat of the terracotta army: the enormous quantity of diverse figures. Only by devising a module system could their makers rationalize production to such a degree that, with the material and time available to them, they were able to meet the expectations of the emperor – the creation of a magic army that would protect his tomb for eternity.

use of modules is how this all went down

Notes

1 Maxwell K. Hearn in Fong, ed., *Great Bronze Age*, 370, fig. 127. See also Ledderose and Schlombs, eds., *Jenseits der Großen Mauer*, 282, fig. 229.

2 Thieme et al., *Zur Farbfassung der Terrakottaarmee.*

3 Sima, *Shiji*, 6:265. Translation in Yang and Yang, trans., *Selections*, 186.

4 Sima, *Shiji*, 6:232. Yang and Yang, trans., *Selections*, 163. Cf. Yuan, "Qindai de shi, ting taowen," 96 (reprint p. 77). Yuan, "Qin ling bingmayong de zuozhe," 60–61 (reprint pp. 201–202).

5 Sima, *Shiji*, 6:256. Yang and Yang, trans., *Selections*, 179. For the legal status of the workers, see Liu Yunhui, "Lishan tukao."

6 Sima, *Shiji*, 6:256; Yang and Yang, trans., *Selections*, 179.

7 Sima, *Shiji*, 6:268 f.; Yang and Yang, trans., *Selections*, 189. Cf. Yuan, "Qin Shihuang-ling kaogu jiyao," 143 (reprint pp. 19–20).

8 Sima, *Shiji*, 6:265. Yang and Yang, trans., *Selections*, 186.

9 Sima, *Shiji*, 7:315. Yang and Yang, trans., *Selections*, 221.

10 Personal communication by professor Yuan Zhongyi, October 1995.

11 Yuan, *Qin Shihuangling bingmayong yanjiu*, 69.

12 Ibid.

13 Sima, *Shiji*, 6:256. Yang and Yang, trans., *Selections*, 179.

14 Yuan, *Qin Shihuangling bingmayong yanjiu*, 69 f.; and Yuan, *Qindai taowen*, 43–45.

15 According to the text *Wei Liao zi*, which may date from the third century BCE. See Weigand, *Staat und Militär*, 115. Quoted by Chun-mei Tschiersch in Ledderose and Schlombs, eds., *Jenseits der Großen Mauer*, 83.

16 Yuan, *Qin Shihuangling bingmayong yanjiu*, 351.

17 Qin yong kaogudui, "Qindai taoyao yizhi."

18 Yuan, *Qin Shihuangling bingmayong yanjiu*, 352.

19 Sima, *Shiji*, 126:3203. Yang and Yang, trans., *Selections*, 408.

20 Wang Xueli, *Qin yong zhuanti yanjiu*, 508–21. Detailed report on the pigments by Thieme et al., *Zur Farbfassung der Terrakottaarmee*, and Lin, "Lack und Lackver-wendung."

21 *Qin Shihuangling bingmayong keng*, vol. 1, 249.

22 Yuan, "Qin zhongyang duzao de bingqi." Wang Xueli, *Qin yong zhuanti yanjiu*, 374–419. Li, Xueqin, *Eastern Zhou and Qin*, 234 f.

23 Hulsewé, *Remnants*, 59.

24 See *Qin Shihuangling bingmayong keng*, vol. 1, 265, 268.

25 Bodde, "State and Empire of Ch'in," 20.

26 Translation by Hulsewé, *Remnants*. See also Heuser, "Verwaltung und Recht."

27 Some 170 tiles with seals have been found. For lists of the names, see Yuan, "Qin ling pingmayong de zuozhe," 53, 56 (reprint pp. 186, 192); Yuan, *Qindai taowen*, 19; and Yuan, *Qin Shihuangling bingmayong yanjiu*, 354, 361.

28 Yuan Zhongyi first discussed the inscriptions in "Qin ling pingmayong de zuozhe." The archaeological report of the excavation, *Qin Shihuangling bingmayong keng*, vol. 1, 194–207, 433–43, comprehensively treats all inscriptions found in pit no. 1 up to 1984. Yuan's treatment in *Qindai taowen*, 13–26, is briefer but takes into account the inscriptions from pits nos. 2 and 3 as well. He basically repeats the same numbers in his *Qin Shihuangling bingmayong yanjiu*, 352–65. The following numbers are based on Yuan's *Qindai taowen*.

29 Yuan, "Qin ling pingmayong de zuozhe," 57–60.

30 Hulsewé, *Remnants*, 110 f.

31 For the legal position of the *gongshi*, see Hulsewé, *Remnants*, 62. For his responsi-bilities, see Yang Jianhong, "Cong Yunmeng," 89.

32 Qin yonggeng kaogudui, "Qin Shihuangling pingmayong keng chutu de taoyong." *Qin Shihuangling bingmayong keng*, vol. 1, 163–83.

33 Detailed lists with exact measurements in *Qin Shihuangling bingmayong keng*, vol. 1, 349–75.

34 Ibid., 110–14, 127–38, 142–56, 163–70.

35 Von Erdberg, "Die Soldaten," 228, defines four types of mustache. The excavators now count twenty-four types of beard. Personal communication by Professor Yuan Zhongyi, October 1995.

36 *Qin Shihuangling bingmayong keng*, vol. 1 (English text p. 498). The assertion that the faces of the soldiers are portraits has already been refuted by von Erdberg, "Die Soldaten." Kesner, "Likeness of No One," discusses theoretical aspects of the issue. For a systematic treatment of portraiture, see Seckel, "Rise of Portraiture," and his comprehensive study, *Porträt*.

37 The report *Qin Shihuangling bingmayong keng*, vol. 1, 181, identifies four types of hands: (1) a hand with stretched fingers made in two molds; (2) a hand with bent fingers made from molds; (3) a hand that is mostly covered by the sleeve; and (4) a hand with bent fingers in which the fingertips are modelled and attached to a palm made from molds.

38 *Qin Shihuangling bingmayong keng*, vol. 2, 161, fig. 5.

39 Corresponds to type 2 in note 37 above.

40 Corresponds to type 4 in note 37 above

234

References

Bodde, Derk. "The State and Empire of Ch'in." In *The Cambridge History of China*, vol. 1, *The Ch'in and Han Empires, 221* BC *–* AD *220*, edited by Denis Twitchett and Michael Loewe. Cambridge: Cambridge University Press, 1978, 20–102.

Croissant, Doris. "Der unsterbliche Leib: Ahneneffigies und Reliquienporträt in der Porträtplastik Chinas und Japans." In *Das Bildnis in der Kunst des Orients*, edited by Martin Kraatz et al. Stuttgart: Franz Steiner Verlag, 1990, 235–68.

Fong, Wen C., ed. *The Great Bronze Age of China: An Exhibition from the People's Republic of China*. Exh. cat. New York: Metropolitan Museum of Art, 1980.

Heuser, Robert. "Verwaltung und Recht im Reich des Ersten Kaisers." In *Jenseits der Großen Mauer*, edited by Lothar Ledderose and Adele Schlombs. Gütersloh and Munich: Bertelsmann Lexicon Verlag, 1990, 66–75.

Hulsewé, A. F. P. *Remnants of Ch'in Law: An Annotated Translation of the Ch'in Legal and Administrative Rules of the 3rd Century* BC *Discovered in Yün-meng Prefecture, Hupei Province in 1975*. Leiden: Brill, 1985.

Kesner, Ladislav. "Likeness of No One: (Re)presenting the First Emperor's Army." *Art Bulletin* 77, no. 1 (March 1995): 115–32.

Ledderose, Lothar and Adele Schlombs, eds. *Jenseits der Großen Mauer*. Gütersloh and Munich: Bertelsmann Lexicon Verlag, 1990.

Lin, Chunmei. "Lack und Lackverwendung im frühen China." In *Entwicklung und Erprobung von Konservierungstechnologien für Kunst- und Kulturgüter der Provinz Shaanxi/VR China, Jahresbericht 1993*, 41–45. Munich: Bayerisches Lindesamt für Denkmalpflege, 1993.

Liu Yunhui. "Lishan tukao" (Investigation about the corvée laborers at Mount Li). *Wenbo* 1985, no. 1, 52–54.

Qin Shihuangling bingmayong keng: Yihao keng fajue baogao, 1974–1984 (The pits with the terra-cotta army in the necropolis of the First Emperor of Qin: Excavation report of pit no. 1, 1974–1984), edited by Shaanxi sheng kaogu yannusuo and Shihuangling Qinyongkengkaogu fajuedui, 2 vols. Beijing: Wenwu Press, 1988.

Qin yong kaogudui. "Qindai taoyao yizhi diaocha qingli jianbao" (Brief report on investigating and cleaning Qin-period kiln remains). *Kaogu yu wenwu* (1985, no. 5): 35–39.

Qin yongkeng kaogudui. "Qin Shihuangling pingmayong keng chutu de taoyang taoma zhizuo gongyi" (The technology for manufacturing the terra-cotta figures and horses unearthed from the pits of the terra-cotta army in the necropolis of the First Emperor of Qin). *Kaogu yu wenwu* (1980, no. 3): 108–19.

Seckel, Dietrich. "The Rise of Portraiture in Chinese Art." *Artibus Asiae* 53 (1993): 7–26.

Sima Qian. *Shiji*, 130 juan. Beijing: Zhongua shuju, 1962.

Thieme, Christine et al. *Zur Farbfassung der Terrakottaarmee des I. Kaisers Qin Shihuangdi: Untersuchung und Konservierungskonzept*. Bayerisches Amt für Denkmalpflege, Forschungsbericht 12/1993. Munich: Bayerisches Amt für Denkmalpflege, 1993.

von Erdberg Consten, Eleanor. "Die Soldaten Shih Huang Ti's – Porträts?" In *Das Bildnis in der Kunst des Orients*, edited by Martin Kraatz et al. Stuttgart: Franz Steiner Verlag, 1990, 221–34.

Wang Xueli. *Qin yong zhuanti yanjiu* (Special topic research on the Qin dynasty figures). Xian: San Qin Press, 1994.

Weigand, Jorg. *Staat und Militär im alten China: Mit Übersetzung des Traktates von Wei Liao über Staat und Militär.* Bonn: Wehling Verlag, 1979.

Yang, Hsien-yi, and Gladys Yang, trans. *Selections from Records of the Historian by Szuma Chien*. Beijing: Foreign Languages Press, 1979.

Yang Jianhong. "Cong Yunmeng Qin jian kan Qindai shougongye he shangye de rugan wenti" (Some questions concerning light industry and commerce in the Qin dynasty, as seen in the Qin-dynasty legal code from Yunmeng). *Jiang Han kaogu* (1989, no. 2): 87–92.

Yuan Zhongyi. "Qin zhongyang duzao de bingqi keci zongshu" (General account of engraved inscriptions on Qin weapons made under central supervision). *Kaogu yu wenwu* (1984, no. 5): 100–12.

—— "Qin ling bingmayong de zuozhe" (The makers of the terra-cotta army in the Qin necropolis). *Wenbo* (1986, no. 4): 52–62.

—— *Qindai taowen* (Inscriptions on ceramics of the Qin dynasty). Xi'an: San Qin Press, 1987.

—— "Qin Shihuangling kaogu jiyao" (Summary of the archaeology at the necropolis of the First Emperor of Qin). *Wenwu yu kaogu* (1988, nos 5–6): 133–46.

—— *Qin Shihuangling bingmayong yanjiu* (Research on the terra-cotta army in the necropolis of the First Emperor of Qin). Beijing: Wenwu Press, 1990.

22

The Tigress

Arya Shura

Introduction

Tales of the Buddha's past lives, or *jataka* tales, were written and collected in a variety of contexts in India and disseminated across Asia. The tale of the starving tigress, which follows, comes from a Sanskrit "garland of *jatakas*" or a *jatakamala* written in approximately the fourth century CE by Arya Shura, a figure we know little about. Illustrations of this tale can be found at the excavated caves at Dunhuang in northwestern China in the mid-sixth century, on the seventh-century Tamamushi shrine in Japan, on the ninth-century edifice of Borobudur in Java, and in other locations across East and Southeast Asia. The themes of self-sacrifice, renunciation of worldly life, and kingly virtue intersect in this tale, qualities that make it a good choice for powerful Buddhist patrons.

From Arya Shura's retelling of the tales (read through Khoroche's translation) it is clear that he paid close attention to language and employed a lyrical touch in transmitting these *jatakas*, something not often seen in earlier tales written in Pali (see the Great Ape Jataka and the Deer Jataka in this volume). Arya Shura used both prose and verse to compose his tales, switching back and forth between them depending on the context. Dialogue was usually written in verse; description, particularly of natural or cosmological scenes, was in prose. He also switched between the two to emphasize important moments in these stories, and employed alliteration, echoing, and at times wordplay, something common in Sanskrit. While Khoroche chose not to indicate where Arya Shura switches between prose and verse, he does communicate the playful lyricism of the original Sanskrit.

As the *jatakas* were meant to teach lay practitioners and the broader Buddhist community about the morals and values of Buddhism, Arya Shura incorporates several

Ārya Śūra, "The Tigress," pp. 5–9 from Peter Khoroche (ed.), *Once the Buddha Was a Monkey: Ārya Śūra's [Shura's] Jatakamala*. Chicago and London: Chicago University Press, 1989. Reprinted by permission of The University of Chicago Press.

themes into his retelling of this story. He begins by giving the tale a framing narrative, indicating that he heard the tale from his own teacher, and goes on to describe the Buddha's behavior in his past life as exemplary. These two elements resonate with Buddhist practice: following a teacher and following the model of the Buddha himself. The story concludes through the voice of one of the Buddha's followers, or students, again reinforcing the teacher–student model, and the framing narrative closes by drawing the overarching moral of the story out for the reader or listener. These narrative devices help to focus attention on the ideals of self-sacrifice, renunciation, and virtue, while also revealing a very intimate and detailed picture of human interactions.

This personalizing of broader Buddhist themes made the *jatakas* very popular for the sculptural or painting program on many monuments – they communicate esoteric concepts to the viewer through accessible narratives. These narratives, however, shift as they move from culture to culture; the seemingly stable words presented here are merely transcriptions of oral texts, which themselves may have developed from viewers examining sculptural or painted representations of these stories. Each visual narrative related to this story thus will be slightly different, depending on the patron's wishes, the text (if any) the artist referred to, and the exigencies of medium and physical context of the work.

Already in his previous incarnations the Lord was wont to lavish disinterested affection on all beings, identifying himself with every living creature. And that is why one should have complete faith in the Lord Buddha.

Tradition tells of a particular exploit performed by the Lord in a previous incarnation, and the story of it was told by my own teacher, a teacher of the three-jeweled[1] Buddhist faith, a teacher respected for his own good life and fine stock of virtues.

While still a Bodhisattva, the Lord already blessed mankind with a stream of kindnesses: he gave generously, spoke lovingly, and instigated goodness. All this followed from the supreme vow[2] he had taken, and was vouched for by his wisdom.

Once he is said to have been born into a great brahman family which had attained eminence simply by being content to perform the duties expected of it and by leading a sober life. He received the traditional series of sacraments – the various rites, from birth onwards, marking his development. His native intelligence and special tutelage, his thirst for knowledge and love of work, soon made him master of the eighteen branches of knowledge[3] and of all such skills as were not incompatible with his family position. [5] Among brahmans he was revered like the Veda itself, among the ruling class he was honoured as a king, to the common people he seemed like Shakra[4] in person, and to those in quest of knowledge like a helpful father. His good fortune and outstanding personal qualities earned him considerable respect and repute, as well as material rewards. But from these the Bodhisattva could derive no pleasure, committed as he was to the path of renunciation and fully absorbed in the study of the Law.[5] [6] To one whose awareness had become completely clear in the course of previous lives, worldly pleasures could only seem like so many evils. He therefore shook off worldly ties as though they were an illness and went to grace some lonely retreat.

[7] There, with a detachment and serenity made perfect by wisdom, he seemed almost to reproach mankind, whose persistent wrongdoing bars it from the wise man's peace of mind. [8] His kindly presence had a calming effect on the wild beasts, who stopped preying on each other and began themselves to live like hermits. [9] Because he was so transparently good, so self-disciplined, content, and compassionate, even strangers felt affection for him, just as he felt affection for them. [10] His needs were so modest that he was innocent of turning his holy status to advantage. Indeed, he had rid himself so thoroughly of any desire for fame, fortune, or comfort that even the gods were inclined to look upon him with favor. [11] Men heard that he had renounced the world, were captivated by his fine qualities, and abandoned family and possessions to go to him for instruction, as though that in itself were final bliss. [12] He powerfully impressed upon these pupils the need to behave with integrity, to cultivate their moral sense, never to let their attention be distracted, to be detached, and to concentrate their thoughts on friendliness and the other cardinal virtues.[6]

His flock of disciples had swollen in numbers. Almost all had attained perfection. The way to enlightenment had been laid down, and mankind set on the right road to renunciation. The gateway to perdition was shut, the paths to bliss opened into broad highways.

Then it was that the Noble One went out with Ajita, his disciple at that time, to enjoy the world about him. His walk took him through the dells and thickets that are conducive to meditation. [13] There, in a mountain cave, he noticed a tigress so overcome by the pangs of giving birth that she was too weak to move. [14] Her eyes were hollow with hunger, her belly horribly thin, and she looked upon her whelps, her own offspring, as so much meat, [15] while they, trusting their mother and without a qualm, sidled up to her, thirsty for milk. But she menaced them with ferocious roars, as though they were strangers. [16] The Bodhisattva remained calm at the sight of her, but compassion for another creature in distress made him shake like Himalaya in an earthquake. [17] It is remarkable how the compassionate put a brave face on things when they themselves are in dire trouble – but tremble at others' distress, however slight. Though emotion gave emphasis to his words, the Bodhisattva spoke to his disciple in tones that by force of pity were subdued but that also showed his exceptional character.

"My dear boy, [18] look how futile it is, this round of birth and rebirth. Starvation forces this beast to break the laws of affection. Here she is, ready to devour her own offspring. [19] Oh! how fierce is the instinct for self-preservation, such that a mother can be willing to eat her own young. [20] How can one allow this scourge to continue unabated – this self-love which prompts such atrocities? Go quickly and search everywhere for something to appease her hunger, before she does harm to her young ones or to herself. In the meantime I too will try to stop her from resorting to violence." Ajita promised to do so and set out on his quest for food.

After despatching his disciple on this pretext, the Bodhisattva began to reflect: [21] "Why search for meat from some other creature when there is my entire body available right here? It is a matter of luck whether or not the boy succeeds in

239

finding any meat, and meanwhile I may be losing an opportunity to act. Besides, [22] this body is only so much matter. It is frail, without substance, a miserable ungrateful thing, always impure. One would be a fool not to welcome the chance of its being useful to someone else. [23] There can only be two reasons for taking no notice when someone else is in difficulties: selfish concern for one's own well-being, or sheer helplessness. But I cannot be happy as long as there is someone who is unhappy. And anyway, how can I take no notice when it is in my power to help? [24] Suppose there were some criminal in abject misery and I took no notice of him even though I could be of help. It would be the same as committing a crime: I would burn with remorse, like deadwood in a forest fire. [25] Now, suppose I fell down this mountainside; my lifeless corpse might serve to prevent this creature from killing her young and save the whelps from the advances of their mother. And, what is more, [26] this would be an example to those who strive for the good of the world, an encouragement to those who falter, a delight to those who are practiced in charity, a powerful attraction to noble hearts. [27] It will bring despair to the great hosts of Mara,[7] joy to those who love the fine qualities of a Buddha, and be a source of shame to those who are wrapped up in their own affairs and whose souls are ravaged by greed and selfishness. [28] It would inspire faith in those who follow the Better Way[8] and would confound those who sneer at renunciation. It would clear the broad highway to heaven and please all men of generous heart. [29] I might also thereby fulfil my dream of some day being of help to others even if it meant sacrificing my life, and so come closer to perfect enlightenment. Besides, [30] neither ambition nor desire for fame nor a longing for heaven nor the position of king nor even endless bliss for myself underlie my concern – nothing except to assure the well-being of others. [31] By doing this may I gain the power always to bring happiness to mankind and at the same time to remove its sorrow, just as the sun has power to bring light and banish darkness. [32] Whether I am seen, heard, or remembered, or am talked of as a result of personal contact, may I in every way benefit all creation and assure it unfailing happiness."

[33] On making this decision to be of use to another creature, though it cost him his life, he felt a surge of joy, then astounded even the calm minds of the gods by hurling himself down.

The sound of the Bodhisattva's body as it fell to earth aroused the curiosity and impatience of the tigress. On the point of slaughtering her young, she paused, looked around, and, catching sight of the lifeless corpse, immediately bounded over and began to devour it.

Meanwhile his disciple had in fact found no meat, and returned, wondering where his teacher had got to. As he peered around he caught sight of the tigress eating the Bodhisattva's lifeless body. But any feeling of grief or sorrow was countered by amazement at such an extraordinary deed. Somehow he seemed to be voicing his regard for the Bodhisattva's goodness in the words that he now spoke to himself: [34] "Oh! how compassionate the Noble One has shown himself to those in distress, how indifferent to his own well-being. In him noble conduct has reached its apogee, while the renown and glory of its adversaries lies

240

crushed. [35] Oh! what supreme love he has shown – bold, fearless, and full of goodness. Oh! how his body, which was of no mean worth, is now effectively an object of the highest regard. [36] Kind by nature, and as firm as the ground, how intolerable to him were the misfortunes of others! How his valiant deed shows up my own waywardness. [37] Certainly there is no need to pity the world now that it has such a protector in him. Well may Mara groan in troubled apprehension of defeat. Homage in the highest to this blessed Being who is a refuge to all creation, whose compassion is unbounded, whose goodness is immeasurable, who is a Bodhisattva for the good of the world.''

He then informed his fellow students of what had happened. [38] Amazement showed in the faces of those disciples and of the whole hierarchy of beings,[9] when they heard of this deed. And the ground that contained the treasure of his bones was strewn with showers of garlands, fine apparel, ornaments, and sandal powder.

So, then – remembering how already in his previous incarnations the Lord was wont to lavish disinterested affection on all beings, identifying himself with every living creature, one should have complete faith in the Lord Buddha.

Notes

Editors' note: numbers in square brackets refer to the corresponding verse numbers in the original.

1 *The three jewels*: the Buddha, his teaching (*dharma*), and the community of monks (*samgha*).
2 *Supreme vow*: to become a Buddha.
3 *Eighteen branches of knowledge*: four Vedas, six Vedangas, Puranas, Mimamsa, Nyaya, Dharma, and four Upavedas.
4 *Shakra*: 'the powerful', originally an epithet (and synonym) of Indra, lord of the gods.
5 *The Law*: Dharma – 'the way things are' and so 'what is right', 'religion', 'duty', and in the specialized Buddhist sense, 'the Buddha's teaching', 'the Law'.
6 *The cardinal virtues*: love (*maitri*), compassion (*karuna*), sympathetic joy (*mudita*), and disinterestedness (*upeshka*).
7 *Mara*: god of love and sensual pleasure (and death), the Bodhisattva's main adversary, corresponding in some ways to Kama in the Hindu tradition.
8 *The Better Way*: or 'the best vehicle' (*yanavara*), i.e. the Mahayana, as opposed to the Hinayana and Pratyekabuddhayana – the three 'vehicles' to salvation.
9 *The whole hierarchy of beings*: gods, heavenly spirits (*gandharva*), earthly spirits (*yaksha*), and snake spirits of the underworld (*naga*).

23

The Six Laws of Xie He

for judging / criticizing art

Introduction

China has one of the longest traditions (if not *the* longest tradition) of art criticism anywhere in the world. Texts about painting, therefore, play an essential role in the study of Chinese visual culture and art history. The following passage comes from *The Six Laws* (*liu fa*), written by the painter and critic Xie He (c.500–35 CE). Scholars have long considered this text to be one of the classic writings on Chinese painting. In it, Xie He lays out six criteria for judging the work of a painter. He then ranks a series of acclaimed artists from earlier periods according to these canons, dividing them into six classes. The excerpt here includes the laws as well as the first and second classes, allowing one to see how Xie He applied his standards to specific artists.

The linguist William Acker translated the text featured here. Other scholars have also published translations, and each version presents a slightly different reading of Xie He's criteria. The brevity and nebulous nature of the laws add to interpretive discrepancies. For example, the first law, perhaps the most ambiguous of the group, states that works must have *qiyunshengdong*. The phrase begins with the word *qi*, literally meaning "breath," or the spirit that the Chinese believed endowed things with life and energy. Acker translates the full phrase as "spirit resonance which means vitality." Alexander Soper interprets it as "animation through spirit consonance," and James Cahill as "engender[ing] a sense of movement through spirit consonance." Others have read it as "spirit harmony." Not only does each translation provide a slightly different interpretation, but furthermore, the ways in which an

Xie He, "The Six Laws of Xie He," pp. 3–15 from William Acker and Reynolds Beal (eds), *Some T'ang and Pre-T'ang Texts on Chinese Painting*. Leiden: E.J. Brill, 1954.

individual viewer may see "spirit resonance" and "vitality" or "spirit harmony" and "animation" embodied in a particular painting can vary immensely. Of course, this ambiguity also allows for wide applicability.

The Six Laws of Xie He occupy a central place in the history of Chinese art. Xie He did not, in fact, create the individual principles, which are mentioned in writings by earlier art critics. What he did was to bring them together and turn them into a system for evaluating paintings, one that became enormously influential. Later Chinese writers included Xie He's six laws in their commentaries on painting, and subsequent painters strove to incorporate the principles into their work. Today, many art historians, connoisseurs, and artists continue to judge Chinese paintings according to these criteria, providing potent evidence of the extent to which early writings on Chinese painting shaped later artistic development and scholarship.

The Guhua Pin Lu or Old Record of the Classifications of Painters by Xie He of the Southern Qi Dynasty

Now by classification of painters is meant the (relative degree of) superiority and inferiority of all painters. But of all who draw pictures[1] there is not one but may illustrate some exhortation or warning, or show (the causes for) the rise or fall (of some dynasty), and the solitudes and silences of a thousand years may be seen as in a mirror by merely opening a scroll.

But while painting has its six elements, few are able to combine them all together, and from ancient times until now each (painter) has excelled in one (particular) branch. And what are these six elements? First, Spirit Resonance which means vitality; second, Bone Method which is (a way of) using the brush; third, Correspondence to the Object which means the depicting of forms; fourth, Suitability to Type which has to do with the laying on of colors; fifth, Division and Planning, i.e. placing and arrangement; and sixth, Transmission by Copying, that is to say the copying of models.

Only Lu Tanwei and Wei Xie completely combined all of these.

But whereas works of art may be skilful or clumsy, the art-sense[2] knows no ancient and modern, so respectfully relying upon remote and recent (sources), and following their critical judgements, I have made my decisions and established a hierarchy of merit. And indeed, if (the scope of) what has been transmitted about this is not wide, it is because concerning the origins (of the art) the tradition merely has it that they proceeded from gods and immortals, and there is none who has heard or seen them.

1. the picture has a life/presence
2. used the brush in the bone method
3. depicts correct forms
4. sutible colours used
5. planning of the objects placement is evident
6. copying or incorporating ideas from previous works

243

The First Class

Five Men

Lu Tanwei → only one to use all 6?

He served Mingdi of Song in the Five Dynasties[3] period and was a native of Wu.

He fathomed the principles (of Nature) and exhausted the nature (of man). The matter is beyond the power of speech to describe. He embraced what went before him, and gave birth to what succeeded him; and from ancient times up till now he stands alone. Nor is he one whom even (the most) fervent enthusiasm could (adequately) praise. For is he not simply the pinnacle of all that is of highest value? He rises beyond the highest grade, and that is all that there is to be said. Therefore it is only by injustice that I place him in the first class.

Cao Buxing

In the time of Wu of the Five Dynasties he served Sun Quan. He was a man of Wuxing.

The works of Buxing are scarcely any of them still preserved. Only in the Secret Pavilion[4] a single dragon and that is all. Considering its noble character,[5] how can one say that his fame was built upon nothing.

Wei Xie → him too ···

Of the Five-Dynasty Jin[6] period.

With (Wei) Xie the summariness of the ancient painters was for the first time (replaced by) elaboration. He came near to being proficient in all the Six Elements at once, and although one may not say that he was perfect in the subtleties of form, he did attain to a high degree of vigor of expression. He towered on high, standing astride the crowd of (other) great men; a peerless (master of the) brush, he swept the world clean (of competitors).

Zhang Mo and Xun Xu

In noble quality and atmospheric feeling they attained the utmost in subtlety and partook of the divine. They seized only the essence and soul, and left the bone method aside.[7] If one sticks to their manner of rendering objects, then one will still not see this pure essence (in their work). But if one takes them from (a point of view) beyond the forms, only then may one enjoy their rich quality to the full. And this may be called a delicate and subtle matter.

The Second Class

Three Men

Gu Junzhi

In soul resonance and nervous energy he did not come up to the wise men of earlier times, but in refinement and delicacy, painstakingness and detail he sometimes surpassed the most discerning men of the past. He was the first to develop the old and make the patterns for the new. Both in the laying on of colours and the delineation of form he was the originator of new ideas, just as Pao Xi was the first to amend the Trigrams, and Shi Zhou the first to reform the method of writing. He once built a tower of several stories which he used as his atelier. At times when the wind and rain blustered or lowered, he would on no account take up his brush. But on days when the skies were favourable, and the air was crisp, then and then only would he colour the tip (of his brush with ink). He would climb up into his tower and remove the ladder, so that his wife and children seldom saw him. The painting of (the genre) cicadas and sparrows began with Xunzhi, and during the Daming era (457–464) of the Song dynasty no one under Heaven dared to dispute his supremacy.

Lu Sui

His style-tone was impetuous and volatile; and the atmosphere (of his paintings) is like a whirlwind. With every dot and every sweep, the movements of his brush were always unusual. Since (works by him) that have been handed down to our times are indeed very few, they are what may be called rarely seen scrolls, and therefore they are regarded as treasures.

Yuan Qian

Compared with Lu (Tanwei) he is lofty and aloof, but in subtlety of portraying people he remains inferior in beauty to the former sage. He thought only of keeping to his master's methods, and was quite without new ideas. However, a slight flaw in the jade of (Bian) He[8] could scarcely cause it to be worth less than the price of ten walled cities.

Notes

1 The point which Xie He wishes to make here is that his classifications affect only the artistic quality of the work of the various men he is about to treat of, and have nothing

to do with moral values. To paraphrase his meaning: My classifications, says he, are exclusively based on the artistic merit of the work of the various painters, and in judging them I do not take the presence or lack of edifying sentiments in their subject matter into account, because, after all, any painter (however mediocre) has the power to edify, and all paintings (however poor) have the power to recall the past.

2 The word *yi* is here used in its meaning of talent or ability but in this case it refers especially to artistic ability implying also artistic *sensibility*. It certainly does not mean simply "art" as others have taken it, for in that case the "remote and recent sources" of the context below would be meaningless in relation to what goes before. I think this sentence may be paraphrased as follows: – Whereas works of art may differ widely in their quality, artistic ability is always the same, and this is why I have relied upon the statements of old writers (the truth of which I cannot verify by personal examination of the works upon which they based their judgements) as well as upon opinions of more recent men. I believe that by artistic ability he also implies artistic sensibility, and that it is the powers of appreciation of the "remote sources" which he has relied upon to which he here refers.

3 Here, of course, the *Qian Wu Tai* or Former Five Dynasties. During the Tang Dynasty the Song (420–478), Qi (479–501), Liang (502–556), Chen (557–588), and Sui (589–618) were so called. The Emperor Ming of the Liusong reigned from 465–472.

4 The *Bige* or Secret Pavilion was the place in the imperial palace grounds where pictures and manuscripts and secret records were kept, thus the Imperial Library. Since Han [202 BCE to 220 CE] times it was presided over in all the dynasties by an official called *bi shu jian*, Director of the Imperial Library.

5 The expression *feng gu* (lit. wind bone), like most expressions of this sort in which the Chinese language is so extraordinarily rich, is impossible to render accurately with any single English phrase. The *Sea of Phrases* says that it indicates loftiness and nobility of character. The word *gu* (bone) like the English word backbone means character, though not only of a man but also of works of art – prose or poetry, calligraphy or paintings. It is more difficult to be sure just which of the many extended meanings of *feng* (wind) should be understood here, but it is probably a meaning close to the one defined as the civilizing teachings of the Sages: spiritual truths that have the power to influence men to good hence also spiritual influence or power.

6 The end of the Jin dynasty when it coexisted for a time with the Liusong dynasty (420–478) which was the first of the Former Five Dynasties.

7 Bone Method: the second of the Six Elements.

8 Bian He was a man of the state of Chu of the Spring and Autumn Period (late Zhou) who found a huge piece of unpolished jade on Jingshan and brought it to present to King Li of that country. But the King regarded him as an imposter and had his left foot cut off. When King Wu ascended the throne Bian He came once more to offer his jade to the King, but it was again thought an imposture, and his right foot was cut off. At the ceremony of King Wen's ascension of the throne Bian He came once more, and sat hugging the jade and weeping. The King sent people to ask him why he wept and he answered: "Tell the King that his subject does not weep because of his mutilations, but because this precious stone was called a common rock, and this true gentleman an imposter. That is the cause of my grief." The King had a jade-worker polish the stone and it was found to be jade as Bian He had said. He was enfeoffed as Marquis of Lingyang, but never went to claim his land.

24

The Taming of the Shrew: Wang Xizhi (303–361) and Calligraphic Gentrification in the Seventh Century

Eugene Y. Wang

Introduction

The centrality of writing in Chinese culture combined with a Confucian-based correlation between the quality of one's brushstrokes and one's character have bestowed calligraphy with an exalted position in the hierarchy of Chinese arts from at least the third century CE onwards. In the following reading, Eugene Wang examines the work of Wang Xizhi (303–61, sometimes also given as 307–65), a legendary early Chinese calligrapher. By comparing the best known example of Wang Xizhi's *oeuvre*, *The Preface to the Orchid Pavilion*, to a letter that was unknown in China until the late nineteenth century, Eugene Wang argues that the qualities attributed to the calligrapher largely developed in the seventh century in response to sociopolitical changes taking place.

Wang Xizhi lived during what is sometimes referred to as China's Period of Division, when the country was split among several competing dynasties. Wang was born to an elite family at the court of the Eastern Jin Dynasty (317–420), and his elevated position allowed him to cultivate his brushwriting skills. Wang was accomplished in all

Eugene Y. Wang, "The Taming of the Shrew: Wang Hsi-chih [Wang Xizhi] (303–361) and Calligraphic Gentrification in the Seventh Century," pp. 133–9, 143–8, 158–63, 166 from Cary Y. Liu, Dora C. Y. Ching, and Judith G. Smith (eds), *Character and Context in Chinese Calligraphy*. Princeton: Princeton University Press, 1999. © by the Trustees of Princeton University.

three script types of the era – cursive, running, and regular – and his work was actively collected by the time of his death. Later commentaries, which played central roles in the appreciation and practice of calligraphy, list Wang Xizhi and his son, Wang Xianzhi (344–88), as the greatest of calligraphers. Yet very few original writings by either of the "Two Wangs" survive. Most specimens are copies, predominantly tracings and rubbings made during the early Tang dynasty (618–907). During the seventh century, calligraphy was the unparalleled king of the arts, practiced by most members of the elite, including the Tang emperors, and the "Two Wangs" were the inspiration for all good calligraphers. The Tang emperor Taizong (r. 626–49) was particularly taken by Wang Xizhi's work, reputedly even having the *Preface to the Orchid Pavilion* entombed with him. Thus, the picture that we have of Wang Xizhi today is filtered through the Tang dynasty view of him.

Eugene Wang's discussion of Wang Xizhi addresses the afterlife of an artist's body of work, bringing to the fore the continuous reuse and refashioning of the past to suit the needs of a particular time. The reading also presents methodologies for analyzing and appreciating Chinese calligraphy, along with some of the inherent difficulties in the study of the medium.

No other calligrapher has cast as profound and enduring a spell over the Chinese imagination as Wang Xizhi (303–361). This is explained, in part, by the fact that Wang's calligraphy formally condenses, or stylistically sublimates, a deep-seated Chinese moral sensibility schooled in a Confucian culture. The moral profile of a Confucian gentleman as "a well-balanced admixture of native substance and acquired refinement"[1] has traditionally been used to characterize Wang Xizhi's calligraphic style.[2] The calligraphy attributed to Wang in the final years of his life is said to embody a "tranquil disposition" that is "neither extreme nor fierce" (*buji buli*) and possess an "unassertive and graceful appearance concealing a strong and solid inside."[3] No other work better exemplifies these qualities than *Preface to the Orchid Pavilion* (Lantingxu), dated 353, in which Wang records the changing sentiment from elation to a delicious melancholy on an outing with a group of noble scholars and officials amid the idyllic landscape of southeast China. In keeping with the mellow mood of the story, the calligraphy itself imparts a measured ease and grace, thereby betraying "a tranquil disposition." Through the calligraphy, Wang projects a persona of refined and gentlemanly self-control.

The *Preface to the Orchid Pavilion* has come to epitomize the entire Wang Xizhi canon.[4] The canon, however, is largely an artifice. No single original work of calligraphy in Wang Xizhi's own hand has survived. The extant works said to be by him are either tracing copies or ink rubbings from the original carvings or from later carved recensions several times removed from the original.[5] The canonization of Wang Xizhi, which has had a lasting effect on the history of Chinese calligraphy, did not occur until the seventh century, nearly three hundred years after Wang's death. These circumstances, combined with the long process of perpetuating Wang's legacy through repeated copying and reproductions, has

resulted in an image of Wang Xizhi that bears the indelible mark of willful selections and layered reinterpretations and reconfigurations.[6] Wang Xizhi has become what we now believe him to be: an author with a quiescent sensibility and a calligrapher with a graceful style, as represented by the *Orchid Pavilion*. The name Wang Xizhi signifies not so much a historical presence as an understated calligraphic mood and a placid disposition.

The Letter on the Disturbances (*Sangluan tie*) as an Art-Historical Embarrassment

The image of Wang Xizhi and his calligraphy, however, may need to be revised once we consider a work by him that was spared the excessive paring and pruning that befell the majority of the calligraphy associated with his name. A tracing copy of a letter written by Wang late in his life and now known as the *Letter on the*

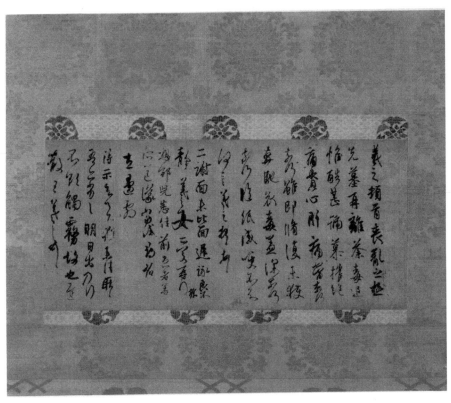

Fig. 24-1 Wang Xizhi (303–361), Letter on the Disturbances (*Sangluan tie*). Seventh-century Tang dynasty copy. Ink on paper, 28.7 × 63 cm. Reproduced courtesy of the Museum of the Imperial Collections, Sannomaru Shozokan.

Disturbances (*Sangluan tie*; Fig. 24–1) was taken to Japan in the eighth century or earlier.[7] None of the known Chinese catalogues produced before the nineteenth century, beginning with the first official one compiled by Chu Suiliang (596–658), mentions this letter, which remained unknown in China until as late as 1892 when Yang Shoujing (1839–1915) published it in the form of an ink rubbing in *Model Calligraphies from the Linsu Garden* (Linsuyuan Fatie).[8]

Wang Xizhi wrote the letter in response to the news that his ancestral tombs in northern China had been devastated by natural catastrophies:

> I, Xizhi, am writing with reverence. Amidst the extremity of the chaos, my ancestral tombs have once again been ravaged. My heart goes out toward them, and I wail, rant, and choke to death. I am filled with pain, my heart is broken. Tormented as I am, what can I do? What can I do? Though they were repaired in no time, I have not had the chance to rush there [to attend to them]. The grief gnaws deeply into me. What can I do? What can I do? Faced with the paper, choking with tears, I do not know what to say. Yours sincerely, Xizhi.[9]

The text of the letter is an unrestrained outpouring of anguish and pathos, and these feelings appear to be echoed in the style of the calligraphy as well. Starting with an emotionally charged staccato, the austere, crisp strokes seem to register a mounting pain. In this opening section, the brush tip is reined in forcefully at the end of each closing stroke, suggesting the calligrapher's self-control and firm hand while coping with intense emotional stress. As the letter proceeds, however, stoic restraint gives way to the onset of grief and anguish which results in the release of pent-up emotion reflected in the impulsive closing strokes. By the end of the letter, the characters no longer maintain a distinct running-script form but instead are jumbled one-stroke arabesques of cursive script, as if calligraphically acting out the "choking" grief and registering the presence of the writer at a moment of tearful agony.

The *Letter on the Disturbances* stands in sharp contrast to the *Orchid Pavilion*. The former unleashes a distraught response to a personal disaster, while the latter evokes calm thoughts and a sense of melancholy occasioned by the gathering of friends in a serene setting. One is grief incarnate, the other composed restraint. According to the modern scholar Han Yutao, the wailing and excessive mourning in the *Letter on the Disturbances* makes the received notion of Wang Xizhi highly suspect. Where in the letter do we find, asks Han, the "tranquil disposition" that is "neither extreme nor fierce"?[10] The significance of the letter, once it is fully considered, may prove to be iconoclastic. It does not add to the Wang Xizhi canon, but challenges it. It is not just another "Wang Xizhi"; it may well be the "Other Wang Xizhi" The notion of Wang as the calligraphic embodiment of the Confucian ideal of temperateness may well turn out to be historically untenable.

We must proceed cautiously, however, before reaching such a radical conclusion. We are likely, if not careful, to be ensnared by a pitfall peculiar to the art of calligraphy. In inferring behavioral resonances from calligraphic forms – the

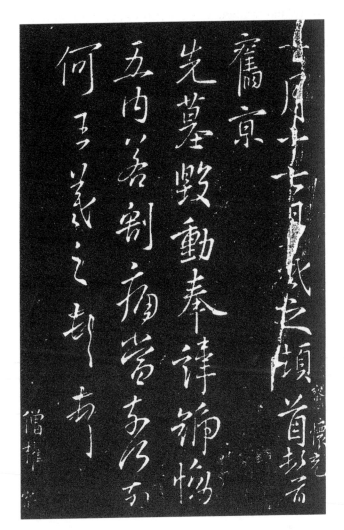

Fig. 24-2 Wang Xizhi (303–361), Old Capital Letter (*Jiujing tie*). Ink rubbing. From *Baojinzhai fatie xuan* (Shanghai: Shanghai guji shudian, 1979), 7–8.

dispositions of brushstrokes, the overtones of gestural manners, and so forth – we must be aware that the discursive content can color our perception of the calligraphic forms. As a letter expressing sorrow, the *Letter on the Disturbances* may predispose us to see correspondences between its textual content and visual texture. For example, knowing that the character *tong* denotes "pain," we are likely to read that understanding into the written character and see the thrusting angularity of the strokes as enacting a figure writhing in agony. Here perception is colored by cognition; in other words, *seeing* how characters behave may be inseparable from *knowing* what they mean. If, on the other hand, we bracket the discursive content and try to describe the calligraphic strokes in purely

[handwritten margin note:] the brush strokes can be the result of either style or emotions or really even both

251

objective stylistic terms and then measure them against the epistolary content, we might reach other conclusions. The reined-in stroke endings may just as well suggest the Confucian ideal of restraint and composure, despite the calligrapher's inner turmoil. However, this perception is also not free from underlying assumptions; it is already preconditioned by the conventional characterization of Wang Xizhi's calligraphy as that which displays a "tranquil disposition."

Unmoored to a historical context, neither of these two perceptual approaches – the content-laden or the content-free – stands well on its own. The art-historical interest in calligraphy rests largely in the interaction between a calligraphic form and a period perception generated by and attached to it. Historically speaking, calligraphy is no more than an "interpretive grid," to borrow a term from Yve-Alain Bois – a physical and formal structure suggesting and corresponding to a mental construct onto which one can map out a field of "semantic registers."[11]

Conflicting Characterizations: Gentleman or Warrior?

The body of descriptive text inspired by Wang Xizhi's calligraphy – in the form of quotations, stylized observations, memorable one-liners, and flights of rhetoric – has not always been a harmonious chorus of praise. It contains fragmented verbal relics that register the tortuous process in which Wang Xizhi was canonized, and jarring notes occasionally leap out. They add credence to the perceived difference between the *Orchid Pavilion* and the *Letter on the Disturbances* – the smooth refinement of the former versus the raw energy or archaic plainness of the latter – that is often cited in the modern debate over the authenticity of the *Orchid Pavilion*.[12] While the "tranquil disposition of a gentleman" has become the standard profile of Wang Xizhi's calligraphy, an alternative characterization built upon the trope of a "brave warrior" was once in use but has gradually lost its currency. In the medieval rhetorical scheme of binary oppositions, the "brave warrior" is often juxtaposed with the "gentleman":

> They surge with fury, are roused to passion –
> Oh, how like the brave warrior [*zhuangshi*]
> But in their dignified gentility, and gentle amiability
> They also resemble the gentleman [*junzi*].[13]

It is precisely this complementary opposition between the brave warrior and the amiable gentleman that constitutes the dual strands in the description of Wang Xizhi's calligraphy. One Tang critic describes Wang's calligraphy in this way:

> Xizhi's calligraphy is like a brave warrior unsheathing his sword to dam the waters and stem their flow. A dot he placed at the top is like a rock falling down from a high

precipice. A horizontal stroke he made is like a cloud sweeping across a thousand miles. A slanting *na*-stroke he dashed is like the roar of wind and thunder. A vertical stroke he wrote is like a ten-thousand-year-old withered vine ... and tigers crouching across the phoenix's gateway ... like dragons leaping through Heaven's door.[14]

In the context of Tang calligraphic discourse that tends to cast Wang's calligraphy in a graceful disposition, this view of his writing strikes one as refreshingly perverse in its characterization of Wang's calligraphy in terms of the "warrior" trope. The description draws upon two different sources. One is the Liang emperor Wudi (r. 502–49) observation that "the propensity of his [Wang's] characters is sturdy and muscular, like dragons leaping through Heaven's door and tigers crouching across the phoenix's gateway."[15] The other source is a colophon, allegedly written by Wang Xizhi, to the "Battle Formation of the Brush," an apocryphal text attributed in Tang times to Madam Wei (Wei furen; 272–349), Wang's reputed teacher in his later hagiographies.[16] The colophon, which was also attributed to Wang in the Tang period,[17] emphasizes the analogy between the arts of calligraphy and war: "Brush is knife; ink, armature; water and inkstone, fortresses. ... The holding of the brush forebodes the auspicious and ominous. ... The twists and turns of the brush are killings and slayings."[18] Even if we dismiss the attribution, we nonetheless can regard the colophon as part of the discursive formation associated with the image of Wang Xizhi in the Tang period.

The strong, forceful personality of Wang Xizhi as projected in such early sources reinforces the rather militaristic view of calligraphy associated with him. In a chapter on personality traits in Liu Yiqing's (403–444) *A New Account of Tales of the World* (*Shishu xinyu*), Wang Xizhi is listed under the category "backbone" (*gu qi*), not the category "gentility" (*shaorun*).[19] Similarly, in another description, Wang is "celebrated for having backbone and intestinal fortitude" (*Yi gu geng cheng*).[20] He was said to have had the audacity to point his finger at the back of the emperor and call him a "snob," a dauntless act that caused the emperor to turn around and comment: "There is no lack of sharp-tongued people in the world after all."[21] Wang Xizhi's official biography in the *Jin History*, allegedly written by the Tang emperor Taizong (r. 626–49), betrays an unwitting inconsistent use of the sources despite the emperor's wish to cast the calligrapher in a certain light. Wang's political career is documented through his letters, which reveal an outspoken and spirited individual. This image of Wang contradicts that of the refined artistic persona constructed from various anecdotes. Not that the character of the historical Wang Xizhi has to fit the artistic persona reflected in his calligraphy, but we should be aware that the image of the historical figure as it has come down to us today is itself a textual entity and part of the general discourse surrounding Wang Xizhi. Its distinction from the moral persona derived from Wang Xizhi's calligraphic style is itself an eloquent testimony to the arbitrariness of the constructed artistic persona attached to the name of Wang Xizhi.

as a person Wang was very outspoken instead of genteel like his calligraphy

253

Civility over Militarism

why is this in here?

The opposition in calligraphic discourse between figurative descriptions of genteel moderation and muscular swaggering parallels the tension between civility (*wen*) and militarism (*wu*) during the reign of Emperor Taizong of the Tang who came to the throne in 626 as a young military general. With the consolidation of the new dynasty, the emperor became acutely aware of the need to rule by civil order rather than by military might and draconian regimentation.[22] He regretted his blind "faith in military power in [his] youth and his ignorance in learning" the Way of the ancient sages.[23] Heeding his courtier Wang Gui's criticism of the new regime's "primacy of militarism over learning,"[24] Taizong willingly embraced the proposal of his counselor Wei Zheng to "terminate militarism [in order] to cultivate civility."[25] "I have indeed conquered the world with military prowess," the emperor confessed, "but it takes civil virtues to pacify the universe."[26] Instead of keeping the company of valiant generals from the northwest, as he had in his early military career, the emperor now spent long hours with scholars from the southeast.

The Taizong court assiduously promoted the acculturation of Confucianism throughout the country.[27] "My only liking is for the Way of Yao, Shun, Zhou, and Confucius," the emperor professed. "It is what wings are to a bird and water is to fish, the loss of which means death. There is not one moment when one can go without it."[28] Confucian temples were built in every prefecture and county. Distinguished Confucian scholars were actively courted and recruited to serve in various eminent posts in the imperial court. Special literary institutes, such as the Institute for the Advancement of Literature (*Hongwen guan*), were established to host literary talents. The imperial collection and collation of classical texts took on an urgency unprecedented since Han times. Standard exegetical commentaries on canonical Confucian classics were carried out at the emperor's decree. Ritual protocols were carefully designed, and a standardized educational system consisting of the National University (*taixue*) and schools at the prefecture and county levels was established with a curriculum focused on the Nine Classics of the Confucian canon.

was Wang hosted & learned about?

Against this backdrop, it is easy to appreciate why the *Essay on Yue Yi* (*Yue Yi lun*) and the *Orchid Pavilion*, with their genteel and mellow content and style, appealed to Emperor Taizong.

Calligraphy and Mourning

The revival of Confucianism in the early Tang galvanized the question of the calligraphic representation of mourning, as expressions of joy and sorrow were at the heart of the theory of representation in Confucian thought. Emotional stirrings often lead to symbolic expressions, as in music. Traditional Confucians

254

regard such expressions as a measurement of the success or failure of a government. Thus we read in the *Book of Rites* (*Li Ji*):

> Hence, the airs of an age of good order indicate composure and enjoyment. The airs of an age of disorder indicate dissatisfaction and anger, and its government is perversely bad. The airs of a state going to ruin are expressive of sorrow and [troubled] thought. There is an interaction between the words and the airs [of the people] and the character of their government.[29]

In the *Book of Rites* rulers are urged to regulate society through ceremonies and music – and, by extension, the arts. Human nature is understood to be essentially still, yet has the propensity to be stirred by external things. According to traditional Confucian teaching: "But for their [affections of] grief, pleasure, joy, and anger there are no invariable rules."[30] Therefore, it falls to the ruler to fashion a rational music to control the eruptions of raw emotions. The purpose of the "institution of ceremonies and music" is not to "satisfy the desires of the appetite and of the ears and eyes; [it is] intended to teach the people to regulate their likes and dislikes and to bring them back to the normal course of humanity."[31] Consequently, "on occasions of great sorrow," people may have "their rules according to which they express grief. The manifestations, whether of grief or joy, are all bounded by the limits of these rules,"[32] so that "the strong phase showed no excess such as anger, and the weak phase showed no shrinking like that of pusillanimity."[33] The ideal form of expression is to have "joy without wantonness and sorrow without breakdown,"[34] a Confucian disposition famously defined as "mild and gentle, sincere and good" (*Wenrou Dunhou*).[35]

All of this was mapped onto the realm of calligraphy in the seventh century. Emperor Taizong's obsession with calligraphy was apparently an integral part of a larger campaign to revive Confucian culture. Wang Xizhi was installed as the paragon of calligraphy mainly because the formal aspects of the style associated with him were seen as the perfect embodiment of the aesthetic and moral qualities set forth in Confucian thought. The moralization of calligraphic forms remained half-implicit and largely untheorized, yet its indelible impact was felt in Taizong's time. A few decades after Taizong's death, Sun Guoting, a former Administrative Supervisor in Wu prefecture, wrote a full-fledged Confucian explication of calligraphy. His *Treatise on Calligraphy* is an eloquent exposition of what must have by that time become accepted wisdom. Sun Guoting saw calligraphy as a display of the human disposition. It is essential to understand, Sun said, that "when a gentleman establishes himself he is obliged to cultivate the fundamentals."[36] The "fundamentals" (*ben*), as defined by a courtier in Taizong's court, are the qualities of "Equilibrium and Harmony" (Zhonghe),[37] a reference to the classical Confucian dictum from the *Book of Rites*: "When there are no stirrings of pleasure, anger, sorrow, or joy, we call it the State of Equilibrium. When those feelings have been stirred, and all in their due measure and degree, we call it the State of Harmony."[38] As a result, good calligraphy should capture the qualities of

a gentleman through what Confucius describes as "a well-balanced admixture of native substance and acquired refinement,"[39] with Equilibrium and Harmony serving as the ultimate standard. Calligraphy indeed can "give shape to joy and sorrow," and this is best achieved when "writers dignify their calligraphy with elegant spirit and soften it with delicate moisture, animate it with dry strength, and blend it with relaxed refinement."[40] The appeal of Wang Xizhi's calligraphy, as it was reconstructed in the Tang period, is precisely its embodiment of balanced moderation, its display of a "tranquil disposition" that is "neither extreme nor fierce," and its "unassertive and graceful appearance concealing a strong and solid inside."[41]

A large body of Wang Xizhi's calligraphic work, as recorded in Tang period catalogues, consists of letters expressing sorrow, grief, and anxiety in response to illness, social disturbances, separation from friends or family, or the death of family members and friends. Upon hearing sad news, Wang typically responded with these expressions: "the pain has reached [my] Five Viscera";[42] "[my] sadness and distress are hurting"; "[I] lost control of [myself] in the deep sorrow";[43] or "[I] put down the brush, drenched in tears."[44] A Tang epistolary manual typically contains such formal expressions of sorrow as the following:

> Letter to grandchildren from a son bereft of his parents: Misfortune has descended on us unexpectedly. Your. ... parents have passed away. Sadness and pain are piercing. We cannot control ourselves. Now life will be harder for your generation. Woe is me. What can I do? What can I do?[45]

To employ such expressions in ritual communication is one thing, but to render their discursive content into a calligraphic representation and regard it as a work of art is quite another. The latter elevates the epistolary expressions from real-life situations to the realm of symbolic representation; it calls attention to the stylized posturing of the calligraphic act itself, and, in so doing, betrays dispositions that either meet or fall short of the Confucian standard of "sorrow without self-injury" (*ai er bu shang*). Furthermore, the meaning of such epistolary calligraphy is in the eye of later beholders. The Song scholar Ouyang Xiu (1007–1072) succinctly articulates this situation:

> What is called a model-book compendium [fatie] is nothing more than exchanges between family members and friends, such as messages of condolences, inquiries after one's health, or correspondences with those from whom one is separated. These are normally no more than a few lines. Initially, no special meaning was intended [in the calligraphic execution] yet the untrammeled brushwork and lingering moods are all [visible in] the unreserved wielding of the brush – now beautiful, now ugly – in a variety of gestural manners. Unfolding the scrolls or opening the letters, one feels the palpable presence [of the writer]. At first glance, one is almost startled and overwhelmed; the more one looks at them, the more infinitely variegated are their diverse moods and manners.... The later generations ... can imagine the personality of the author.[46]

The *Letter on the Disturbances* would not have squared well with seventh-century calligraphic taste. With the early-Tang revival of Confucianism and the ideal of gentlemanly restraint, the use of an intentionally dramatic style of calligraphy in the context of mourning would probably have been perceived as alien and unruly. Since funerary memorial tablets had in the past invariably been written in formal standard script, in the early Tang the discursive content of a memorial text would have been sufficient to express mourning. In this period, one would have been hard pressed to read emotional overtones in the calligraphic form itself.

Apart from the fact that it was relatively unknown until recent times, there is not sufficient contextual evidence to explain how this work escaped the taming that characterized the Tang canonization of Wang. We can surmise that it is a relic from the tumultuous Eastern Jin period, three hundred years earlier than the Tang. Surviving into the Tang period, the *Letter on the Disturbances* seems to have been neglected as a major work by Wang Xizhi, partly because its forceful ruggedness and uninhibited quality did not mesh well with the tendency in the early Tang to gentrify, civilize, and tame Wang Xizhi. Moreover, the notion of a calligraphic form enacting and dramatizing the extreme emotional expression of mourning, or any demonstration of feeling, lay outside the sensibilities and gentrified taste of the period. Even Yan Zhenqing's (709–785) *Draft of the Eulogy for Nephew Jiming* (*Jizhi Jiming Wengao*), the calligraphic epitome of the expression of mourning, had to wait until the Song dynasty (960–1279) to find an appreciative audience.[47] In this regard, the *Letter on the Disturbances* was ahead of its time in comparison to the genteel sensibility of the *Orchid Pavilion*. That the *Letter on the Disturbances* is *not* the *Orchid Pavilion* is a reminder that the latter has blinded us to the possibility of an alternative reading of Wang Xizhi. Knowing the gentrifying ethos of the early Tang in which Wang Xizhi was reconfigured, it becomes clear that the *Letter on the Disturbances* had to remain elsewhere as the eternal "Other Wang Xizhi."

Notes

1 Liu Baonan, ed., *Lunyu zhengyi*, in *Zhuzi jicheng*, 8 vols (Shanghai: Shanghai Shudian, 1986), v. 1, 7:125; translation based on D. C. Lau, *The Analects* (London: Penguin Books, 1979), 83.

2 Sun Guoting, *Shupu* (Treatise on calligraphy), in *Lidai shufa lunwen xuan* (Shanghai: Shanghai shuhua chubanshe, 1992), 124.

3 Ibid., 129. Translation based, with modifications, on Chang Ch'ung-ho and Hans H. Frankel, *Two Chinese Treatises on Calligraphy* (New Haven and London: Yale University Press, 1995), 12.

4 For a succinct assessment of the historical significance of the *Orchid Pavilion*, see Lothar Ledderose, "Chinese Calligraphy: Its Aesthetic Dimension and Social Function," *Orientations* 17, no. 10 (October 1986), 39–40.

5 See Lothar Ledderose, *Mi Fu and the Classical Tradition of Chinese Calligraphy* (Princeton: Princeton University Press, 1979), 1–44; Amy McNair, "The Engraved

Model-Letter Compendia of the Song Dynasty," *Journal of the American Oriental Society* 114, no. 2 (1994), 209–25; Amy McNair, "Engraved Calligraphy in China: Recension and Reception," *The Art Bulletin* 77, no. 1 (March 1995), 106–14.

6 Lothar Ledderose has long pointed out that the formation of the Wang tradition involved three factors: (1) the calligraphers who provided the model of notable aesthetic quality and stylistic novelty; (2) the critics who provided evaluations and descriptive terminology; and (3) the connoisseurs and historians who established a corpus of "authentic pieces." Lothar Ledderose, "Some Taoist Elements in the Calligraphy of the Six Dynasties," *T'oung Pao* 70 (1984), 253.

7 Two scrolls of calligraphy, the *Letter on the Disturbances* (*Sanluan tie*) and *Gong Shizhong tie*, both in ink on white hemp paper, are kept respectively at the Japanese Imperial Household and Ikutokukai, Tokyo. Each scroll consists of three unrelated letters Wang Xizhi wrote on different occasions. The first of these scrolls, known as the *Letter on Disturbances*, consists of seventeen lines of text. The first eight lines constitute the text of the *Letter on Disturbances*, the next five a fragment of another letter, and the last four a fragment of yet another letter. The calligraphy was produced through the method known as *xiangta* or *tamo*, a process in which the outlines of the characters were traced from Wang Xizhi's original work and then meticulously inked in, resulting in a close copy. The scroll bears the stamp of the Japanese imperial seal of the Enryaku period (782–806), suggesting that it was in Emperor Shomu's collection in the Nara period (710–794). Emperor Shomu is said to have been particularly fond of the scroll and often placed it to the immediate right of his throne. Upon his death, the scroll was donated to the Todaiji, in Nara, along with other imperial treasures. The calligraphy was thus brought to Japan sometime before the mid-Tang period, probably by the monk Jianzhen (Ganjin, 688–763). It bears the signatures of Xu Sengquan and Yao Huaizhen, two notable Liang dynasty (502–557) court copyists, which indicates that the Tang copy was based on works that had been authenticated by Liang court connoisseurs. See Nakata Yujiro, "So-ranjo," in Inoue Yasushi et al., *Shodo geijutsu* (Art of calligraphy) (Tokyo: Chuo Koronsha, 1971), v. 1, 200–201; Nakata Yujiro, ed., *Chinese Calligraphy*, trans. and adapted by Jeffrey Hunter (New York and Tokyo/Kyoto: Weatherhill/Tankosha, 1983) 168–69; Han Yutao, "A Study of Wang Xizhi's *Sangluan tie*" (in Chinese), *Zhongguo shufa* 2 (1990), 18–20; Wang Yü-ch'ih, "The *Sangluan tie*: The Location of the 'Ancestral Tombs' and the Time of its Writing" (in Chinese), *Shufa yanjiu* 47, no. 1 (1992), 81–87; Taniguchi Tetsuo and Sasaki Takeshi, *Rantei no jo ronso yakuchu* (Translation and annotation of the Preface to the Orchid Pavilion) (Tokyo: Chuo Koron Bijutsu Shuppan, 1993), 148–49.

8 Nakata Yujiro, *O gishi o chushin to suru hojo no kenkyu* (A study of model letters related to Wang Xizhi) (Tokyo: Nigensha, 1970), 262, fig. 157; Liu Tao and Tang Yinfan, *Zhongguo shufa shi* (History of Chinese calligraphy) (Beijing: Zhongyang meishu xueyuan, 1995), 64.

9 Nakata Yujiro, *Chinese Calligraphy*, pl. 16. The translation is mine.

10 Han Yutao, "A Study of Wang Xizhi's *Sangluan tie*," 81–87.

11 Yve-Alain Bois, "The Use Value of 'Formless'," in Yve-Alain Bois and Rosalind Krauss, *Formless: A User's Guide* (New York: Zone Books, 1997), 21.

12 Qi Gong, "The Cult of the *Orchid Pavilion* Ought to be Broken," in *Lanting Lunbian* (Debates over the "Preface to the Orchid Pavilion") (Beijing: Wenwu chubanshe, 1973), 69.

13 Wang Bao, "Rhapsody on the Pan Pipes," in Xiao Tong, comp., *Wenxuan* (Shanghai: Shanghai guji chubanshe, 1986), v. 2, 17:786; David R. Knechtges, ed. and trans., *Wenxuan or Selections of Refined Literature* (Princeton: Princeton University Press, 1996), v. 3, p. 239.

14 "Tangren shuping" (Tang critics' commentary on calligraphy), in Zhen Si, ed., *Shuyuan Jinghua*, in Lu Fusheng et al., eds, *Zhongguo shuhua quanshu*, 11 vols (Shanghai: Shanghai shuhua chubanshe, 1993), v. 2, 454a; Ma Zonghuo, ed., *Shulin Zaojian* (Beijing: Wenwu chubanshe, 1984), 6:53–54.

15 *Chunhuage tie* (Tianjin: Tianjin guji chubanshe, 1996), 5:228; appendix 47.

16 Wei Shou, "Bizhen tu," *Lidai shufa lunwen xuan*, 21–23. For a study of the treatise, see Richard M. Barnhart, "Wei Fu-jen's *Pi Chen T'u* and the Early Texts on Calligraphy," *Archives of the Chinese Art Society of America* 18 (1964), 3–25.

17 See Zhang Yanyuan, *Fashu Yaolu*, in *Zhongguo shuhua quanshu*, v. 1, 32a–33a.

18 Ibid., v. 1, 32b.

19 Liu Yiqing, *Shishuo xinyu*, in *Zhuzi jicheng*, v. 4, 136.

20 Fang Xuanling, comp., *Jin shu* (Jin History) (Beijing: Zhonghua shuju, 1974), 80:2093.

21 *Shishuo xinyu*, 25:215.

22 The *Jiu Tang shu* (Old Tang history) is explicit about the emperor's resolve to change his image as ruler of the empire: "The Emperor pacified the world with his military prowess. Battling winds and braving rains he had little leisure for poetry and calligraphy. Now that he succeeded the throne, he sought out the loyalists and virtuous … and in his leisure hours, paid attention to literature and history." Liu Xu et al., eds, *Jiu Tang shu*, 16 vols (Beijing: Zhonghua shuju, 1975), 73: 2600.

23 Liu Su, *Da Tang xinyu* (Beijing: Zhonghua shuju, 1984), 9:133.

24 Wu Jing, *Zhenguan zhengyao* (Shanghai: Shongwu yinshuguan, 1934), 1:26.

25 Sima Guang, *Zizhi tongjian* (Beijing: Zhonghua shuju, 1956), 193:6085.

26 *Jiu Tang shu* 28:1044.

27 See the chapter on "Cultivation of Confucianism" in *Zhenguan zhengyao* 7:1–8.

28 *Zizhi Tongjian* 192:6054.

29 James Legge, trans., *Li Chi, Book of Rites* (New York: University Books, 1967), v. 2, 93–94.

30 Ibid., v. 2, 107.

31 Ibid., v. 2, 96.

32 Ibid., v. 2, 107.

33 Ibid., v. 2, 108.

34 *Lunyu zhengyi* 3:62; translation based, with modification, on D. C. Lau, *Confucius, The Analects*, 70.

35 Legge, *Li Chi*, v. 2, 255.

36 Sun Guoting, *Shupu*, 125; translation by Chang and Frankel, *Two Chinese Treatises on Calligraphy*, 4.

37 A courtier in Taizong's court defined the "fundamentals" as "moderation and harmony consistute the fundamentals." *Zizhi tongjian* 192:6052.

38 Legge, *Li Chi*, v. 2, 300.

39 *Lunyu zhengyi* 7:125; translation based on D. C. Lau, *Confucius, The Analects*, 83. Sun Guoting, *Shupu*, 124.

40 Sun Guoting, *Shupu*, 126; translation based on Chang and Frankel, *Two Chinese Treatises on Calligraphy*, 6.

41 Sun Guoting, *Shupu*, 129; translation based, with modifications, on Chang and Frankel, *Two Chinese Treatises on Calligraphy*, 2, 24.

42 *Fashu Yaolu* 10:103b.

43 Ibid. 10:106b.

44 Ibid. 10:115b.

45 Du Youjing, *Xinding shuyi jing*, in numbered Pelliot manuscripts from Dunhuang in the Bibliotèque Nationale, Paris, no. 3637.

46 Ouyang Xiu, "Colophon on the Epistolary Calligraphy of Wang Hsien-chih of Chin," in *Ouyang wenzhong gong ji* (The complete works of Ouyang Xiu) (Shanghai: Shangwu yinshuguan, 1933), v. 3, 15:127.

47 See Amy McNair, *The Upright Brush: Yan Zhenqing's Calligraphy and Song Literati Politics* (Honolulu: University of Hawaii Press, 1998), 44–50.

25

Ise Jingu

William H. Coaldrake

Introduction

Coaldrake's essay focuses on Ise, a major Shinto site in Japan, and explores why it has
long been central to Japanese history, politics, and identity. Ise's founding dates
before the Heian period (794–1185), but it has been rebuilt every twenty years
since then. Thus Ise presents us with a conundrum: if it is not a permanent building,
can it be monumental? And why is Ise ritually rebuilt every twenty years when such a
short cycle is unnecessary? Coaldrake explores the religious, political, and architec-
tural reasons for the quandaries presented by Ise, examining ritual practices, archi-
tectural forms, and patronage patterns at the site.

Reading Ise has always posed difficulties because of its existence across
time periods. Religions such as Shinto change over time, as do political forces, and
as a result Coaldrake must juggle the meaning of this structure when first built pre-
Heian, in the tenth century under Heian rule, and in contemporary times. During
the Heian period, for example, Shinto was not the only major religion in Japan –
Buddhism had been imported from China several centuries before and had become a
Japanese religion. Buddhist temples were arranged with a series of walled enclosures
and multiple buildings serving specific purposes, including the pagoda, the lecture
hall (*kodo*), and the main golden hall (*kondo*). Beginning in the seventh century,
Buddhism was used to consolidate political power, and by the Heian period, Chinese
Confucian political theory had also become a major part of Japanese political
organization. Shinto, linking the imperial family to the sun goddess Amaterasu,
adapted to these additional cultural forces, borrowing elements from the Buddhist
temple structure to organize shrine architecture and acknowledging Confucian

William H. Coaldrake, "Ise Jingu," pp. 20–42 from *Architecture and Authority in Japan*. London
and New York: Routledge, 1996.

261

hierarchies in the way access is granted to the shrine areas. Ise, therefore, was in architectural dialogue with other religious and political foundations during the Heian period.

While all architectural structures adapt to changing historical circumstance, and one can fruitfully study the history of a building after its initial conception, Ise represents a monument that has both figuratively and literally changed over time, creating a category of monumentality dependent on ritual rebirth and renewal. *purpose:* Linking the Japanese emperor with the sun goddess, and serving as the symbolic political center for Japan, Ise overshadows other permanent structures in its monumentality. Rebuilding legitimizes the rule of the patron, as each generation must sponsor the ritual in order to secure power. Coaldrake offers a reading of political power through a particular framework of monumentality, one that lies at the intersection of religion, vernacular architecture, and centuries of history.

Character of the Site and Buildings

The generic term 'Ise' or 'Ise Shrine' refers to a large institution consisting of numerous shrines and lesser sanctuaries distributed around a narrow, verdant, coastal plain on the east coast of the Kii peninsula in Mie prefecture. The area is blessed by warm sunshine even in mid-winter, and crossed by the fast-flowing Isuzu River. A visitor gazing over the landscape shrouded in the mists of early morning could well be persuaded to believe in the presence of benign deities. The shrine dedicated to Amaterasu is known officially as the *Ko daijingu* or 'Imperial Shrine' but from the Heian period has been referred to generally as the Naiku ('Inner Shrine'). The other principal shrine, dedicated to Toyouke, is officially called the *Toyouke daijingu* or the Geku ('Outer Shrine'). The Inner Shrine is situated well inland from the coast, while the Outer Shrine is some five kilometres to the northwest and closer to the sea. Originally the two shrines were unrelated, the Toyouke shrine being of more ancient foundation than that dedicated to Amaterasu, but, together with a number of other local shrines, they were incorporated into a unified institution in the ninth century.[1] In addition to the two main shrine complexes, Ise now encompasses close to 120 separate shrines including a number of tiny sanctuaries dedicated to the spirit of a single rock or the deity of some clear bubbling spring.

Only after a reasonable acquaintance with the buildings and the layout of the shrine sites is it possible to appreciate the role of the Inner Shrine at Ise in the history of authority. It is especially important to understand the way in which the Inner Shrine communicates with the visitor and worshipper as an integrated built and natural environment. It is laid out on a site which slopes gently upwards from the rapidly running water of the Isuzu River towards the low hills which in turn ascend abruptly out of the edge of the coastal plain. It is approached across a great bridge constructed from fragrantly scented cypress wood (*hinoki*). At each end of the bridge is a large *torii*, the open gateway which is the universal symbol of

262

a Shinto sanctuary in Japan, with principal pillars measuring almost one metre in diameter. The visitor proceeds from the bridge to the right or southwards along a broad avenue strewn with gravel and flanked by carefully tended gardens. Some 200 metres further on another great *torii* is encountered, and beyond it there is the large stone basin for ritual purification of mouth and hands, a feature common to all Shinto shrines. From this point cedars (*sugi*) some 80 metres in height, and an occasional zelkova elm (*keyaki*), close in around the visitor, creating a sense of primal force and majesty. The approach path, now surfaced with small grey pebbles, swings around in an easterly direction through another *torii*. Thick moss covers the aged rocks beside the path. In these rocks and trees the native *kami* or spirits are traditionally thought to dwell. This is a living sanctuary of animistic belief.

One hundred metres from the last *torii* the path snakes around to the south and then back to the north, bringing the visitor to an enclosed compound 100 metres north–south and 60 metres east–west. This is the inner sanctuary itself. The most immediately notable feature of the compound is the way in which it is elevated some 4 to 5 metres above the level of the approach path. This is accomplished by assembling two layers of large rocks into a retaining wall, much in the manner of medieval castle foundations, so that the final approach is made by mounting 21 stone steps to an outer fence of horizontal boards. Beyond lies another small fence guarded by a timber-frame gatehouse with a thatched roof of moss-encrusted river reed (*kaya*). A fine silk curtain hangs across the entrance to the gate, marking the point of intersection between the profane and the sacred, beyond which traditionally only members of the imperial family and priests of the shrine may proceed. Here the visitor may make obeisances and offer prayers, and glimpse something of the sacred precinct beyond as it rises gently away to disappear from sight behind a second gateway which affords access to the inner sanctum. Grey pebbles cover the surface of the compound, with white rocks forming the path leading the way to the sanctuary buildings. The ridge of the main sanctuary building, or Shoden, may be glimpsed from this vantage point, rising above the protecting gateway and surmounted by towering forked finials known as *chigi*. Some 4 to 5 metres in length and sheathed in gilded bronze, these *chigi* gleam in the sunlight like a portent of the presence of the Sun Goddess herself.

The inner sanctum, which is hidden from view, contains three separate structures organised axially north–south. At the centre is the Shoden, and behind it, to either side of the axis, are two smaller sanctuary buildings. The pillars and walls are made of Japanese cypress and the straight gable roofs are thatched with *kaya*. The ridge-poles are lined with cylindrical wooden billets known as *katsuogi* ('bonito fish timbers'), a name which refers to their distinctive bonito-like shape, and are surmounted by the projecting finials. At each end of the buildings are external pillars which rise from the ground to support the ridge-poles. All of the pillars are sunk deeply into the earth. The Shoden is 15 metres long, 10 metres wide and 9.7 metres in height measured to the top of the ridge

course. A wooden staircase at the front is covered by a simple gabled roof in the same style as the main roof itself.

Set beside the inner compound and covered with white pebbles is the Alternate Site where the main buildings will be erected during the next periodic renewal of the shrine. At the centre is a small wooden hut erected to protect the heart pillar (*shin no mihashira*) over which the Shoden of the new shrine will be raised in the next rebuilding.

The rebuilding process, known as *shikinen sengu* ('the transfer of the god-body to a new shrine in a special festival year'), spans eight years and consumes approximately 13,600 cypress trees yielding some 10,000 cubic metres of timber. Originally these trees were available in plentiful supply in the surrounding region but since the thirteenth century forests have become seriously depleted and the requisite supplies of timber have had to been procured from the more distant mountains of the Japan Alps in the province of Kiso. The Kiso River, flowing into Ise Bay, provided a ready means of transport for the logs which skilled loggers floated down the river through its hazardous gorges and rapids.

The rebuilding of Ise involves a protracted succession of 32 major ceremonies. It commences with the *Yamaguchi-sai*, or expiatory prayers offered to the *kami* of the mountain where the sacred trees selected for the reconstruction are to be felled, and culminates with the ritual transferral of the sacred mirror from the old to the new precinct, after which the superseded buildings are dismantled.

The Outer Shrine is located five kilometres to the northwest of the Inner Shrine. The layout of the site and architecture of the buildings are similar in most respects to those of the Inner Shrine, as is the importance of the inner compound and the provision of an Alternate Site for periodic rebuilding. There are, however, certain subtle variations in the siting and characteristics of the buildings arising from deliberate distinctions in authority drawn architecturally between the Inner and Outer Shrines. For example, the Outer Shrine is approached across a sacred bridge but the sentinel *torii* are little more than half the height of those marking the entry to the Inner Shrine. *Torii* are also set at strategic points along the approaches to the main compound, but the approach itself is different in character to that of the Inner Shrine: the way is flat and more direct, the trees less imposing and physically encroaching, the atmosphere not so awe-inspiring as at the Inner Shrine. The compound itself is approximately the same size as the Inner Shrine and also aligned axially north–south. However, it is set on the same level as the approach path, not elevated by stone-faced embankments. The buildings contained therein are thus more readily visible to the casual observer.

Architectonics of Imperial Authority at Ise

How, then, is authority expressed and defined in this complicated shrine precinct with its distinctive buildings and elaborate process of periodic renewal?

The impression created by the Inner Shrine is powerful and elemental, the unpainted timbers and the thatched roofs affirming close affinity with the natural world. There is no apparent distinction between authority imperial and authority spiritual, between the powers of the natural world and the powers of imperial governance. All are organically interrelated, each aspect reinforcing the other in a relationship which has been refined to a high degree of visual expression and stylistic abstraction over the centuries.

The *Nihon Shoki* records that it was at this place that Amaterasu first came to earth, having proclaimed that 'the province of Ise, of the divine wind, is the land whither repair the waves from the eternal world, the successive waves. It is a secluded and pleasant land. In this land I wish to dwell.' The account then continues by stating explicitly that 'in compliance with the instruction of the Great Goddess, a shrine was erected to her in the province of Ise. ... It was here that Amaterasu first descended from Heaven'.[2]

It is a deeply seated Japanese belief that the *kami* select certain places where they will descend to earth, thereby rendering them holy. People come to these sacred sites, generation after generation, to commune with the gods, to make offerings of the harvest of mountain and sea to them, and to give thanks. In early Shinto practice the places where the particular gods had their abode were not necessarily marked by buildings or special structures; the *kami* could establish their dwelling places in trees, rocks or waterfalls. Sometimes a simple building was constructed as the gods' temporary home as a sign of gratitude for their presence. At Ise the role of the Inner Shrine buildings has been to house Amaterasu in the form of the sacred bronze mirror, which, together with the curved jewel and sacred sword, comprise the three imperial regalia. Throughout the countries of ancient Asia the mirror was regarded as one of the most important symbols of authority, closely associated with the worship of the sun whose light its burnished bronze surface reflected so brightly. At Ise we find the persistence of this association, with the enshrined mirror serving as the physical manifestation of Amaterasu.[3] Accordingly, the Inner Shrine has served as the locus for the multitude of ceremonies of oblation, thanksgiving, purification and offering necessary for her propitiation. It was not until the late seventh century that the association of the Ise site with Amaterasu and the imperial family was formalised. Thereafter it was to serve as the focus for the religious rites of the imperial institution. To the present day, important events, such as coming of age and weddings of members of the imperial family, and above all the death of an emperor and the enthronement of his successor, are reported to the ancestral spirit at the shrine with due solemnity and ceremony.

Pragmatic methods have been employed to achieve inspired effects to express the religious and ruling authority of Ise. Once explained they lose something of that mystery essential to their purpose. Authority is established by recourse to a dual strategy of spatial segregation and partial revelation. The inner compound is separated from the plane of mortal beings in a hierarchy of spatial transitions. The first of these is accomplished by means of the elevation of the compound high

265

above the level of the approach path. It is no accident that the final approach is up a series of steeply rising steps. Here the mortal plane is permitted to rise to meet the gods, in studied contra-distinction to the use of a completely flat site for the inner compound of the Outer Shrine.

A series of wooden fences and gateways removes the inner sanctum, in which Amaterasu resides, into the unapproachable distance, with the Shoden hidden from view apart from the merest glimpse of the top of its finials. The singular significance of what lies within is emphasised by the arbitrary denial of entry; the partial revelation of the roofs of the buildings grants the beholder a glimpse of the world beyond while making clear that the ultimate truths are reserved for those privileged to enter the inner sanctum. The privilege to enter this sanctum and act as intermediary between this world and the world of the gods of creation and nature was traditionally confined to the members of the imperial institution. Access to the inner sanctum has thereby become one of the most important rights and acts of authority in Japanese civilization.

Hierarchy in authority is enacted through a finely calibrated hierarchy of access through gateways of obeisance. At first the series of open *torii* along the approach path signify the accessibility of that which lies immediately beyond to all who proceed along the way, while making it clear that a place of great authority is drawing closer. Folk-belief also confers on these gateways the role of perches for the large sacred fowls who arrive as messengers of the gods at daybreak.

At the inner sanctuary there are four separate ritual spaces reserved for obeisances (*sampai*) performed by worshippers. These spaces are ranked hierarchically by status and defined physically by the four fences and gateways surrounding the main sanctuary building. An imposing *torii* allows all visitors to pass through the outer fence or Itagaki to make obeisances at the eaves of the roofed gateway which guards entry through the second fence or Outer Tamagaki. Passage through this gateway is reserved for members of the imperial family and, in modern practice, for the Prime Minister and elected representatives of the people at national, prefectural and local level. Local mayors and members of assemblies worship at the inner eaves of the Outer Tamagaki, while the representatives of prefectural government, as well as 'living national treasures' stand at the *torii* halfway towards the Inner Tamagaki. The Prime Minister worships directly in front of this gateway while the imperial family progresses further up the gentle slope of the compound to make obeisances under the outer eaves of the gateway through the Inner Tamagaki. The crown prince and crown princess, as heirs to the throne, customarily proceed through the Inner Tamagaki to pray at the eaves of the Mizugakimon, the gateway set into the innermost fence surrounding the Shoden. A special dispensation to proceed through the innermost gateway in order to worship directly in front of the steps of the Shoden is given on the occasion of the marriage of the crown prince and crown princess. Under normal circumstances, however, the privilege of entering the innermost space of the shrines is reserved for the reigning emperor and empress and the Chief Priestess (*Saishu*) of the

shrine. The emperor and empress make their obeisances separately and successively at the foot of the steps of the Shoden. Immediately after the enthronement ceremonies, however, they are each permitted to climb the steps to worship on the verandah of the Shoden in front of the main door. In this way passage through a hierarchically ordered sequence of gateways becomes a carefully calibrated enactment of ritual order within the hierarchy of authority.[4]

The use of a series of fences to protect the inner compound reflects the early Japanese practice of constructing a succession of fences around centres of local power. A typical example is the use of multiple palisades around the eighth-century fortification of Tagajo, located to the immediate northeast of the modern city of Sendai. The Inner Shrine of Ise today employs a total of four fences but historically the number of fences changed in response to the circumstances of authority. According to the *Ko daijingu gishiki-cho* of 804 AD, which records details of the rebuilding of the shrines following arson which destroyed much of the complex in 791, there was a total of five fences around the compound in the ninth century. In the fourteenth century, during the imperial succession struggles known as the Nambokucho (1318–92), the three outer fences were lost, and despite subsequent attempts to reinstate the missing fences, there were only two fences around the compound for much of the eighteenth and nineteenth centuries. Obeisances were made standing under the eaves of the gateway of what is now known as the Inner Tamagaki. In the periodic rebuilding completed in 1869, a year after the restoration of imperial government, the Itagaki and Outer Tamagaki, the two outer fences, were rebuilt to restore the site to its pre-1318 configuration. This had the effect of enhancing the dignity of the emperor by further distancing the inner sanctum of Ise from the outside world, at the same time as creating a special place for obeisances by the Prime Minister as official representative of the new government at the Inner Tamagaki. This can only be described as an interesting exercise in political fence-mending.[5]

Gateway architecture at Ise may owe much to Chinese precedent, with the gatehouses guarding the inner sanctum being structurally identical to those protecting temple and palace compounds in Nara, but the Shoden, with its two flanking treasuries and the smaller halls used for daily offerings of food and drink, developed directly from Japanese vernacular architecture of the pre-Buddhist age. The special character of these buildings is explicable only in terms of the origins of this architectural style in vernacular building forms, and by the process by which these were transformed under the patronage of state authority over many generations of renewal at the same site.

The form of the principal Ise buildings is derived from the unadorned raised-floor structures in use from proto-historical times for storing rice throughout the wet-rice agricultural regions of Asia.[6] Archaeological excavations in Japan, along with unsophisticated depictions of buildings incised into cast bronze bells, prove that buildings of this type, with sunken pillars, raised floors, plank walls interlocked in the manner of a log cabin, and thatched roofs with rafters projecting at each end

and lashed together for strength, were accorded special significance. The main buildings of both shrines are based on this vernacular form, with their raised floors protecting their important spiritual contents in the way that village granaries protected the harvested rice from moisture and rodents. The covered wooden steps at the centre front of the Shoden were originally necessary as a way of carrying the harvested rice into and out of the granary.

In early agrarian Japanese society it was inevitable that the importance of the granary should be deeply embedded in community consciousness. It was the focal point for festivals, particularly the autumn harvest celebrations. It was then only a short step to transferring belief in the beneficence of the gods to the specific buildings which housed the grain of life. Grain represented the product of the forces of nature – rain and water, and above all the miracle of growth and regeneration. Moreover, in any traditional village community the raised-floor storehouse was the sturdiest, most impressive and carefully constructed building.

For all these reasons it was natural and logical that the Yamato court should make the raised-floor storehouse the abode for Amaterasu. It is not surprising, therefore, that recent archaeological excavations have established that the use of the raised-floor building type at Ise for religious purposes was the rule rather than the exception in early Japan. Such buildings were geographically widespread throughout the populated regions and an intrinsic part of the festivals of local ruling authority. They were typically erected inside ceremonial enclosures within the palisaded headquarters of the most powerful chieftains. There are other significant indications of widespread observance in proto-historical times of ritual practices similar to those followed at Ise. For example, stone pebbles like those employed at Ise to signify a sacred area were used to cover the ceremonial enclosure containing a raised-floor building at the fifth-century Mitsudera I site, near Takasaki, Gumma prefecture, on the western periphery of the Kanto Plain.[7] Similarly, the Makimuku II and III phase sites, at the foot of Mount Miwa in Nara prefecture, near present-day Sakurai city, included a raised-floor building 4.4 by 5.3 metres in plan with pillars approximately 20 centimetres in diameter. It was orientated east–west, in keeping with the theory that this was the principal axis employed in the site planning of early Shinto sanctuaries, and not north–south. Moreover it included the same structurally fossilised ridge-pole pillar and central pillar as are used at Ise. The building was enclosed by a fence and was almost certainly flanked by two smaller raised-floor structures.[8] With the single exception of orientation it is difficult to envisage a more precise correlation in structure, style and site layout with the inner compounds of the Ise Shrine.

One of the most intriguing features of the Shoden of both the Inner and Outer Shrines is their ridge decoration. Much of the visual impact of the buildings is derived from the forked finials and cylindrical billets set on the ridges because of their visibility from beyond the compound fences. The finials are abstracted representations of the projecting tips of the gable-end rafters used in early

thatched roofs. The ridge billets are a similar reference to pre-Buddhist architecture. The clay *haniwa* model houses, which were placed on the outer surfaces of the burial mounds of clan chieftains of the Tumulus period, show how heavy wooden cylinders were placed along the ridges of larger buildings to weigh down the peak of the gable and seal it against rain or prevent strong winds blowing the roof apart. By the sixth century, written records establish that these billets had become symbols of status, and government regulations restricted their use to homes of high-ranking members of the ruling class.[9]

The ten billets on the ridge of the Shoden of the Inner Shrine and the nine used on the same structure of the Outer Shrine were thus indications of high status, with the former clearly ranked more highly than the latter. They may also represent elemental folk belief concerning gender, so important in early Shinto and reinforced by Chinese *yin-yang* principles introduced at a later date. There could be some correlation between even numbers and female gender and odd numbers and male gender. In the final analysis Ise does consist of two main shrines, one dedicated to a female god and the other to a male deity. In the amalgamation of the two institutions mythological gender may have played a more important role in their symbolism than has heretofore been acknowledged.

[handwritten margin note: the billets show status, this technique is used w/ the Shrines. 9 on the Outer, 10 on the Inner. possibly a correlation b/t ♂ a ♀]

Despite every effort to maintain the physical form of the Ise Shrine through each rebuilding process, there was a slow mutation of the architectural style from the functional to the abstract. Nishina Shimmeigu, in Omachi, Nagano prefecture, the oldest extant shrine built in this style, reflects the simpler functional logic of the earlier Ise building style. It was last rebuilt in 1636, as part of the nationwide observance of the cult of Amaterasu, under the patronage of the local daimyo of Matsumoto. With its single, large ridge-pole, finials made up of the projecting ends of the principal rafters and absence of gilded bronze ornament, this exquisite small shrine hints at the elemental quality of earlier Ise.[10]

Another example of the increasing abstraction of architectural form at Ise is to be found in the small Halls of Daily Offering (*Mikeiden*). The joinery which links the timbers of the walls in these two buildings consists of interlocking tenons which recall the robust 'log-cabin' construction (*azekura-zukuri*) used for the walls of early Japanese storehouses and the buildings of Ise probably until medieval times.[11] These tenons are now no longer structural but are retained in fossilised form as part of the official iconography of the Ise style.

The architectural form of the Outer Shrine, being less important politically, has consequently been subject to less attention and less rigorous renewal practices. Its Shoden has a more elementary arrangement of pillars and beams supporting the rafters of the roof than has the Inner Shrine, and longitudinal head-ties are placed directly on top of the principal cross beams. This is a simpler method of construction than that employed for the Inner Shrine, where the longitudinal tie-beams are set beneath the cross beams, requiring complex joinery and calculation of dimensions. The intention may have been to make the slope of the roof of the Inner Shrine steeper and more impressive.

Periodic Renewal and Authority

Whatever the status symbolism of different parts of the Ise buildings and the role of the integrated architectural strategy in representing authority through hierarchical distinctions, periodic rebuilding of the entire shrine complex has added a special dimension to the relationship between architecture and authority at Ise. Periodic renewal sustained through most of recorded history has not only ensured the survival of its physical form but does much to explain its religious and political significance.

3. reasons for continued rebuilding There are three reasons for this seemingly extraordinary commitment of energy and resources to the periodic rebuilding of a religious edifice. The first is architectural, the second religious and the third political. In the eighth century, during the period of consolidation of state authority, the original architectural and religious reasons were to be overwhelmed by a powerful political imperative.

1. The first, architectural reason is, quite simply, the ephemeral nature of many of *architectural* the materials used for the construction of the shrine buildings. These buildings have been subject to the same inexorable process of deterioration as is experienced by any farmhouse made from similar exposed timbers and thatch. The reed thatch of the roofs, although carefully shaped and manicured to the dictates of its elite patrons, still rots in the same manner as any ordinary roof composed of reed, straw, or wooden shingles. Similarly, the practice of inserting the pillars directly into the ground renders them ready victims to rotting and white ants. In the tightly-knit communities of the Bronze and early-Iron Age where these construction practices originated, cooperative rebuilding of individual structures including community storehouses took place in the course of each generation.

2. The second reason for the periodic renewal of Ise flows logically from the first: *religious* the process of decay and renewal inherent in its architectural forms was seen as an affirmation of the cycles of nature which are central to Shinto belief. The rebuilding process became a metaphor for the cycle of growth, decay, death and rebirth to be found in every aspect of the physical universe, ranging from agriculture to life itself. The rebuilding of Ise, together with early Shinto buildings generally, became a form of existential affirmation. It also constituted ritual purification: cleanliness was indeed next to godliness in Shinto, for uncleanliness and decay represented defilement. This belief was reflected in the early Japanese practice of abandoning the palace headquarters upon the death of the ruler in order to avoid defilement, and the subsequent creation of a new, specially purified palace as the seat of authority. Likewise, the pure, clean image of the buildings in Shinto architecture is essential to the preservation of the sanctity of the site for the gods. Purity was to be achieved through ritual, and it transformed the practical need to replace decaying building materials into a high spiritual obligation to renew shrine architecture as a place suitable for the habitation of the gods.

The periodic rebuilding of the Grand Shrine of Ise is the supreme example of architectural process transformed into religious ritual, the sanctification of an

architectural rationale of replacement. Correct ritual ensures the protection of the *kami*. This character is evident in each of the 32 principal rituals and ceremonies which are performed during the eight years of the rebuilding operation. These ceremonies are faithfully re-enacted at each rebuilding in the form standardised by the early tenth century. Many are described in detail in the *Engi-shiki*, one of the earliest extant written records of imperial court etiquette compiled in the Engi era (901–922) and itself based on the earlier *Ko daijingu gishiki-cho* ('record of ceremonial procedures for exchanging shrines') of 804 CE.[12]

However the religious meaning of renewal goes far beyond the formal ceremonies and rituals. At Ise the actual practices of rebuilding take on the essence of sacred ritual. The pragmatic acts of the reconstruction process become an offering or oblation to the gods. Each stroke of an adze and every cut of a saw is presided over by master carpenters who have been specially purified for their sacred task, while many of the rituals of renewal are ceremonial enactments of carpentry practices. In other words, building practice at Ise is more than a mere extended metaphor for religious belief; it has become a religious act in its own right. The cutting of the wood and the planing of its surfaces are performed with something of the sacramental nature of the breaking of bread and the drinking of wine in Christian practice. The practical and the common in each instance is elevated by commitment and faith to the level of the highest spiritual ritual. The building process is seen as a perfect oblation for the imperfection and impurities of the physical world – virtually a 'rite by which supernatural grace is imparted' – the definition of a 'sacrament' in Christian belief. The power of any building made by such transcendental means to influence the conduct and actions of others, central to the definition of authority, is all the mightier as a consequence. Indeed, it is absolute in the religious sense.

This brings us to the third or political reason for periodic renewal of Ise. It is **3. political** here at Ise that we find the point of departure from other sites sacred to Shinto belief and practice. The association of the state with the periodic renewal of Ise, a process initially necessitated by the impermanence of the building materials and sanctioned by Shinto theology, was indispensable to the consolidation and ultimately the character of imperial authority. It was this political imperative which was to subsume the architectural and religious rationale.

That familiar mixture of politics and piety is apparent even in the circumstances of the official recognition of Ise as the shrine to Amaterasu. An imperial succession struggle broke out in 672, and the eventual victor in the armed conflict, who subsequently became the Emperor Temmu in the next year, is reported to have worshipped and made obeisance in the direction of the Ise site as he rode out to the decisive battle.[13] Regular rebuilding of Ise was formalised as a state responsibility during Temmu's reign (673–686). From 685 onwards this emperor began the systematic centralisation of state authority, a process in which architecture played an important role. Under Temmu the government took over responsibility for sponsoring and supervising the periodic rebuilding of Ise, the first state-sponsored rebuilding being completed in 690, four years after his

death. A century later it was to be the authority of the Emperor Kammu (r. 781 – 806) which completed the first comprehensive formalisation of Shinto rites, including the rites of renewal of Ise, as part of state administration. It was also Kammu's vision of a systematically ordered ruling authority, with officially pre-scribed ceremonies and close associations with both Buddhism and Shinto, which was responsible for the bureaucratic consolidation of Ise and its rites within the practices of the imperial state. In 792, a fire caused, it is thought, by robbers, destroyed much of the Inner Shrine and offered a convenient opportunity for the government to regulate its rebuilding practices. The *Ko daijingu gishiki-cho* was the result, to be followed a century later by further formulation as part of the *Engi-shiki*.[14] In every detail of construction and consecration recorded in these official manuals a sense of order is apparent. The attention to detail, down to the last beam and metal stud, was more than the familiar manifestation of religious zeal for strict compliance with intricate liturgy. It is evidence of a powerful political determination to reinstate the Shinto *kami* alongside Buddhist deities by the provision of copious ritual. With these formal codifications the practice of Shinto rites, including the ritual renewal of the Ise buildings, became part of the official practices of government. Moreover, as a result of the ritual rebuilding, Ise became part of the definition and revelation of imperial authority, and by its Shinto character, evidence of a determination to confer a stronger indigenous character on government after a period of powerful Chinese influence.

It was from this carefully formulated and officially imposed position at the heart of eighth- and ninth-century government that the architectural forms and build-ing practices of Ise were to be transformed into a representation of the sacerdotal authority which sanctioned the imperial order and to become the intermediaries between this order and the natural and supernatural world. By reason of this insistent pressure maintained by ruling authority, the periodic rebuilding of Ise was performed more frequently and comprehensively than architectural necessity alone dictated. Only the rethatching of roofs is essential every 20 to 25 years in this region of Japan. The timbers are quite another matter. The cypress wood used for all the structures is one of the most durable of all building materials. The surfaces are polished to a dull gleam by the action of the planing knives used in traditional carpentry so that water actually beads on the surface of the wood instead of being absorbed by the timber. A structure made of such superlative material and with such dedicated technique would easily last twice the officially designated span of 20 years. Moreover, in the eleventh century the principal pillars of the Shoden were 80 centimetres in diameter and a contemporary account boasts that these would normally be expected to last 'one hundred years without rotting'.[15]

The sustained and regular re-creation of Ise over the course of many gener-ations attests to the authority of two particular traditions: the multiple-stranded craft tradition, which has effected the physical task of rebuilding, and the patron-age of the imperial institution. Physically the periodic renewal has been made possible by the hereditary infrastructure of carpenters, thatchers, metal-workers,

weavers and dyers, ceremonial saddle-makers, sculptors, lacquer experts and tool smiths. The continuity of the many and varied craft traditions necessary to maintain and renew the myriad buildings of Ise has been vital to the survival of the shrine as an architectural entity. However the key reason for this architectural survival has been the special financial, political and ideological support of the imperial institution. The 20-year renewal observed at Ise was certainly not the exception in Shinto institutions. As already noted, physical decay of materials and the need for religious purity were universal facts. Regular 20-year rebuilding programmes were observed in a large number of institutions. Sumiyoshi Taisha in Osaka carried out systematic rebuilding over a period of more than 500 years from 928 until 1434, and subsequently at less regular intervals until 1810. At Kasuga Taisha in Nara, rebuilding at intervals of from 5 to 33 years has occurred 46 times between 1099 and the present day. The Kamo shrines in Kyoto also observed periodic renewal until 1864, although the intervals were more irregular, a variation of a mere 3 years to 144 years being recorded by local documents.[16]

It is not the observance of the rebuilding process *per se*, but the authority of the imperial institution, which has maintained the tradition of periodic rebuilding far more consistently than that of any other shrine complex in Japan, which sets Ise apart from other shrines. There was a switch from completing the rebuilding in the 20th year, as laid down in the *Engi-shiki*, to completing the rebuilding after 20 years from 1343 onwards, but the only protracted break in that long continuity occurred as a result of the complete breakdown of authority during the period of civil war following the outbreak of the Onin Rebellion in 1467. The buildings completed in 1462 were to stand, slowly rotting to point of collapse for 123 years. The rebuilding cycle was revived to suit the political ends of Toyotomi Hideyoshi and then the Tokugawa, reaffirming the indispensability of Ise to ruling authority in Japan.[17]

[handwritten margin note: real reason for the existance of the Shrine today: politically important figures have the authority to support the Shrine, essentially patrons.]

Notes

1 The two shrines were treated as separate entities in the earliest known written record of the ceremonies carried out at Ise, the *Ko daijingu gishiki-cho* and *Toyouke-no-miya gishiki-cho* of 804 CE. In the *Engi-shiki* of 927 CE these records are integrated into a single section (Book IV), and the 'Shrine of the Great Deity' (*Omikami-no-miya*) and the Toyouke Shrine are treated as part of the same institutional entity, together with 40 other minor shrines. See Felicia Gressit Bock (trans. and ed.) *Engi-shiki. Procedures of the Engi Era*, Book I–V, Tokyo: Sophia University, 1970, pp. 44–56, 123–150.

2 Adapted from W. G. Aston, *Nihongi, Chronicles of Japan from the Earliest Time to A.D. 697*, London: George Allen and Unwin, 1956, p. 176. (First published as a *Supplement to the Transactions of the Proceedings of the Japan Society*, London, by Kegan Paul, Trench, Trubner, 1896.)

3 Tange and Kawazoe draw attention to the early practice of suspending bronze mirrors from sacred *sakaki* trees to welcome the emperor as an example of the direct

association of these mirrors with imperial authority. See Kenzo Tange and Noboru Kawazoe, *Ise: Prototype of Japanese Architecture*, Cambridge, MA: MIT Press, 1965, p. 175.

4 Information supplied by Ise Jingu Shicho.

5 See further E. Satow, 'The Shinto Temples of Ise', *Transactions of the Asiatic Society of Japan*, First Series, 1874, pp. 113–119. For analysis of the documentary sources for architectural change at Ise see Fukuyama Toshio, 'Jingu no kenchiku to sono rekishi', in Gomazuru Junshi (ed.) *Jingu. Dai rokujukai jingu shikinen nengu*, Tokyo: Shoga-kukan, 1975, pp. 118–132.

6 The thesis that the form of the Ise sanctuary buildings was based on the vernacular storehouse was first advanced by Fukuyama Toshio who, with his mentor Sekino Masaru, conducted the excavation of the Toro site in the immediate postwar era. Fukuyama drew attention to the close similarity between the Mikeiden of the Outer Shrine of Ise and the reconstruction of a typical rice storehouse at Toro by Sekino. There is no question of the similarity between the two building styles but some caution is necessary regarding the architectural detail because Ise itself was under periodic reconstruction at the same time as the Toro excavations. As a result there may have been some over-enthusiasm for the parallels.

7 Tatsumi Hirokazu, *Taka-dono no kodaigaku. Gozoku no kyokan to oken no saigi*, Tokyo: Hakusuisha, 1990, pp. 10–32.

8 See further Ishino Hironobu, 'Rites and Rituals of the Kofun Period,' *Japanese Journal of Religious Studies*, 1992, vol. 19, nos 2–3, pp. 193–194.

9 Jingu shicho (ed.) *Koji ruien*, Tokyo: Jingu shicho, (reprint) 1936, vol. 52, p. 1005.

10 Nishina Shinmeigu is registered as a National Treasure by the Japanese government. See further Ota Hirotaro (ed.) *Nagano-ken no kokuho juyo bunkazai: kenchikubutsu hen*, Matsumoto: Kyodo shuppansha, 1987, pp. 77–79, 244–245.

11 Tange and Kawazoe, pp. 168–169.

12 See Felicia G. Bock, especially Book IV and note 95.

13 Aston, *Nihongi*, pp. 301–381. Note especially p. 307. This struggle is also recounted in Tange and Kawazoe, pp. 198–200.

14 Book IV, 'The Shrine of the Great Deity in Ise'.

15 *Shunki*, 10th day, 8th month, 1040. Quoted in Ota Hirotaro, 'Shikinen zoteisei shiko,' *Kenchikushigaku*, no. 19, September, 1992, pp. 94, 107.

16 Ota Hirotaro, 'Shikinen zoteisei no chosa hokoku', *Kenchikushigaku*, no. 18, March 1992, pp. 33–45.

17 Ibid., p. 3. The other disruptions to the regularity of the rebuilding interval occurred after fire (792 – after seven years); the change of capitals from Nara to Kyoto (810 – after 18 years); in the middle of the Heian period for reasons which are unclear (1057 – after 17 years), in the fourteenth century during the period of disputed imperial succession (1364 – after 21 years, and 1391 – after 27 years); at the turn of the seventeenth century with the establishment of the Tokugawa shogunate (1609 – after 24 years), and as a result of World War II (1953 – after 24 years). See ibid., pp. 33–45.

26

Proclamation of the Emperor Shomu on the Erection of the Great Buddha Image

Introduction

Scholars consider the *Nihon Shoki* or *Chronicle of Japan*, written in 720, to be the earliest official Japanese history (a slightly earlier work, *Kojiki*, or *Record of Ancient Matters*, from 712 provides information on the prehistoric period, but in a more mythic than historic manner). The *Nihon Shoki*, which combines myth and factual information, covers Japanese history from its beginnings through the seventh century in a manner reaffirming the legitimacy of the imperial clan. It became the first of six national histories documenting the period up to 887. Historians composed the second of these, the *Shoku Nihongi*, or *Chronicle of Japan, Continued*, in 797. This history covers from 697 to 791 and contains, among other things, the proclamation that follows. In it, Emperor Shomu (r. 724–49), the forty-fifth ruler of Japan, orders the construction of a colossal gilt-bronze statue of the Buddha as part of his larger campaign to link together the state and Buddhism. Emperor Shomu's proclamation brings to light much about the power of monumental religious images, the resources needed to build such works, and the relationship between the state and Buddhism in Japan.

Buddhism was introduced to Japan from Korea and China in the sixth century. During the Nara period (710–974), the religion spread throughout the country, along with other influences from the mainland, including Confucian-based statecraft, city planning, and the Chinese system of writing. In fact, officials composed the histories listed above in Chinese. Emperor Shomu actively encouraged Buddhism and Sinification. He instigated the construction of a network of Buddhist monasteries and nunneries throughout Japan and in 743 ordered the casting of a Great Buddha (Daibutsu). The idea of patronizing a monumental Buddhist statue derived from the

"Proclamation of the Emperor Shomu on the Erection of the Great Buddha Image," pp. 104–5 from Ryusaku Tsunoda, William Theodore de Bary, Donald Keene, *Sources of Japanese Tradition*, Volume 1. New York: Columbia University Press, 1958.

practices of Chinese rulers, who commissioned large-scale images (such as the seventh-century colossal rock-cut sculptures at Longmen) as a way of placing their country under the protection of Buddhism while also legitimizing their reigns.

Work began on the Daibutsu in 743 at a temple near Shōmu's palace in the short-lived capital Shigaraki. When Shomu returned to the capital city of Nara two years later, the statue was moved there as well. The emperor and his advisors chose a large site on the eastern edge of Nara to construct a Buddhist complex, called Todaiji or Great Eastern Temple, which would house the Daibutsu in its main image hall. The construction of Todaiji, whose image hall is considered by many to be the largest wood building in the world, involved huge amounts of labor and resources. The making of the statue, which eventually reached 53 feet in height and 250 tons in weight, was also a massive undertaking. Artists completed the major portions of bronze casting by 749, and although the statue was not fully finished until 771, artisans had done enough of the gilding and details by 752 to hold the eye-opening ceremony. This grand event, during which a priest painted the pupils of the Buddha's eyes, signified the start of the image's religious life. Shomu, who in 749 had abdicated the throne to his daughter in order to devote himself to Buddhism, invited Buddhist dignitaries from China and India to take part in the ceremony. The complex of Todaiji and its image hall still stand; however, fire has twice severely damaged the Daibutsu, once in the twelfth century and again in the sixteenth. The image that a visitor sees today, therefore, is largely a seventeenth-century reconstruction.

From *Shoku Nihongi*, in *Rikkokushi*, III, 320–1

Having respectfully succeeded to the throne through no virtue of Our own, out of a constant solicitude for all men We have been ever intent on aiding them to reach the shore of the Buddha-land. Already even the distant sea-coasts of this land have been made to feel the influence of Our benevolence and regard for others,[1] and yet not everywhere in this land do men enjoy the grace of Buddha's Law. Our fervent desire is that, under the aegis of the Three Treasures, the benefits of peace may be brought to all in heaven and on earth, even animals and plants sharing in its fruits, for all time to come.

Therefore on the fifteenth day of the tenth month of the fifteenth year of the Tempyo reign [743], which is the year of the Goat and Water Junior,[2] We take this occasion to proclaim Our great vow of erecting an image of Lochana Buddha in gold and copper. We wish to make the utmost use of the nation's resources of metal in the casting of this image, and also to level off the high hill on which the great edifice is to be raised, so that the entire land may be joined with Us in the fellowship of Buddhism and enjoy in common the advantages which this undertaking affords to the attainment of Buddhahood.

It is We who possess the wealth of the land; it is We who possess all power in the land. With this wealth and power at Our command, We have resolved to create this venerable object of worship. The task would appear to be an easy one, and yet a lack of sufficient forethought on Our part might result in the people's being put to great trouble in vain, for the Buddha's heart would never be touched if, in the process, calumny, and bitterness were provoked which led unwittingly to crime and sin.

Therefore all who join in the fellowship of this undertaking must be sincerely pious in order to obtain its great blessings, and they must daily pay homage to Lochana Buddha, so that with constant devotion each may proceed to the creation of Lochana Buddha.[3] If there are some desirous of helping in the construction of this image, though they have no more to offer than a twig or handful of dirt, they should be permitted to do so. The provincial and county authorities are not to disturb and harass the people by making arbitrary demands on them in the name of this project. This is to be proclaimed far and wide so that all may understand Our intentions in the matter.

Notes

1 Cardinal Confucian virtues which here signify the spread of Confucian ethics as exemplified by the Imperial rule.
2 Year designation according to the Chinese sexagenary cycle.
3 Though to Western minds it might seem impious that the Cosmic Buddha himself could be so created, in the Kegon philosophy the particular and the universal are one and inseparable, so that an image properly conceived with a devout realization of the Buddha's true nature might stand for the Buddha himself.

27

Of Nature and Art: Monumental Landscape

Wen C. Fong

Introduction

The following excerpt from art historian Wen C. Fong's study of Chinese painting and calligraphy discusses the rise of monumental landscape painting in the mid-tenth through mid-eleventh centuries. The paintings are termed "monumental" both because of the actual size of the hanging scrolls, which typically measure five to six feet in height, and because of the authority and scale given to nature in the pictures. Fong explores the relationship between such landscape paintings and neo-Confucianism, a philosophical movement first developed during the Tang dynasty (618–907) that gained favor among the learned elite of the Song dynasty (960–1279), who were also the producers and viewers of landscape painting. Neo-Confucianism, which combined the ideas of Confucianism with Buddhist and Daoist beliefs, stressed self-cultivation as well as the inherent unity and order of all things, best grasped through introspection and intuition.

In tandem with the rise of neo-Confucianism, many other technological, economic, and social changes took place during the Song dynasty, altering the arts and culture. For example, a new emphasis on learning arose during the Northern Song (960–1127), in part because of the increasing availability of printed books. The prominence given to education along with changes in the governmental system led to the rise of a scholar-official class. Landscape painting, embodying many of the changes taking

Wen C. Fong, "Of Nature and Art: Monumental Landscape," pp. 71–2, 74–83 from *Beyond Representation: Chinese Painting and Calligraphy 8th–14th Century.* New York and New Haven: The Metropolitan Museum of Art, Yale University Press, 1992.

place, became central to the culture of this new intellectual elite class, which sought to balance Confucian-based service to the state with the ideal of scholarly, reflective seclusion (see the following excerpts from Guo Xi's writings).

Paintings denote meaning in a variety of ways. Northern Song monumental landscape painting, as Fong explains, was not explicitly narrative or iconographic, but expressed a particular philosophy, morality, and, ultimately, view of the world. Thus, this reading touches on the relationship between philosophy, nature, and art, as well as man and nature, as perceived by the rising class of scholar-artists in Song China.

Writing about landscape painting in the West, Kenneth Clark noted that "in times when the human spirit seems to have burned most brightly the painting of landscape for its own sake did not exist and was unthinkable."[1] This observation seems also to be borne out in the East. The development of Chinese landscape painting, "paintings of mountains and rivers" (*shanshuihua*), occurred during the Wei, Jin, and Six Dynasties eras (220–589) and the Five Dynasties period (907–60), China's two long intervals of political disunity, when poets and artists, disenchanted with the world of human affairs, turned away to seek a realm of spiritual enlightenment.

In the West, the human spirit has always shone most brilliantly in the expression of the creative will and in the pursuit of individualism; in the East, the human will is subsumed under a larger principle, one that is expressed through a profound belief in communion with nature, a cosmic vision of man's harmonious existence in a vast but orderly universe. The unique expression of this vision is found in the monumental landscape painting of the early Northern Song (960–1127), whose development coincided with that of Neo-Confucianism, the resurgence of the ancient moral philosophy, at a time of vigorous idealism among the most creative class in society, the newly risen scholar-officials.

Bounded by mountain ranges and traversed by two great rivers, the Yellow and the Yangtze, China's natural landscape has played an important role in the shaping of the Chinese mind and character. The sparsely inhabited mountains are both a reminder of a simpler past, of truth unquestioned and nature unspoiled, and a spiritual refuge, where moral values can be cultivated and harmony with nature restored. From very early times the Chinese, unlike Western Europeans, who considered untamed nature inimical to human society, imagined the mountains an earthly paradise, the abode of the immortals. Thus did the early fifth-century poet Tao Qian envision, in his famous fable of the Peach Blossom Spring, the blossom-covered mountain valley as an ancient utopia, free of warfare and social turmoil.[2] After the breakup of the Han Empire, during the fourth and fifth centuries, the influence of Daoism and Buddhism led artists to turn to nature in their desire to express themselves in a spiritual domain. Several centuries later, in the wake of the devastation of the Tang capital, Chang'an, by the An Lushan rebellion, the poet Tu Fu (712–770) sounded his immortal lament,

the landscape in china has done a lot to shape chinese character

279

> The country is shattered,
> But the mountains and the rivers remain![3]

Indeed, throughout Chinese history, in times of both war and peace, landscapes of "rivers and mountains" (*jiang-shan*) have nurtured and reinvigorated the Chinese spirit.

Landscape painting first developed as illustration for narratives and poetry. Paintings of trees and rocks became an independent genre during the late Tang period, in the eighth and ninth centuries. During the tumultuous Five Dynasties era, in the early tenth century, recluse scholars fleeing to the mountains saw the tall pine tree as an image of the virtuous man in the wilderness. They began to paint a symbolic landscape, with the great pine at the center of a moral universe. Then, in the early Northern Song dynasty, the mordant, bleak spirit of the recluse painter, first expressed in the gnarled pine trees, was transformed and projected by professional court painters into a heroic, epic landscape style. This early Northern Song vision of eternity, a timeless, archetypal landscape, lasted about one hundred years, from the middle of the tenth through the middle of the eleventh century.

Neo-Confucianism and Landscape Painting

It was Buddhism that first introduced, from India, a system of metaphysics and a coherent worldview more advanced than anything hitherto known in China. With Buddhist thought, scholars of the Six Dynasties period engaged in philosophical discussions of truth and reality, being and nonbeing, substantiality and nonsubstantiality.[4] Beginning in the late Tang and early Northern Song, Neo-Confucian thinkers rebuilt Confucian ethics on Buddhist and Daoist metaphysics. A principal tenet of Neo-Confucian philosophy holds that the universe has a basis in morality. Because Neo-Confucian moral philosophy defines the human mind as engaged with the nature of being, the traditional focus of learning was self-cultivation. To the extent that the "mind" (*xin*) reflects the perfect "principles" (*li*) of nature, man can achieve union with the ultimate "principles" of cosmic creativity only by realizing the innate moral mind within the self.

The late Tang Neo-Confucian scholar Li Ao (died *c.*840), borrowing a phrase from the Confucian classic *The Great Learning*, described his approach to learning and self-cultivation as *gewu zhizhi*, "the investigation of things leading to the perfection of knowledge." The phrase, however, does not imply modern scientific method. Shao Yong (1011–1077), a leading eleventh-century thinker, defined objective learning as "observing things in terms of things" (*yiwu guanwu*). Shao proposed that things should be observed "with the mind" and "in light of their own principles," rather than with the eye, since only the mind can perceive underlying principles. Man's observation of the world should therefore reflect

280

the principles of nature and remain unclouded by egocentric human emotion (*qing*).[5]

The unity of man and heaven (*tianren hei*), man as the co-creator rather than as merely a creature of the universe, is a key Neo-Confucian concept. In the words of the eleventh-century philosopher Zhang Zai,

> By expanding one's mind, one is able to embody the things of the whole world. If things are not embodied, it is because the mind has excluded them. . . . As [the sage] views the world, there is in it no one thing that is not his own self.[6]

It is through embodied (*ti*) thinking and reflection and the dynamic interchange between the observer and the thing observed that man is able to grasp the workings of the universe.

Paintings of trees and rocks as embodiments of nature's principles first appeared as an independent genre in Tang painting. Rocks, as "kernels of energy" and "bones of the earth," isolated and immovable, symbolize potency, while trees, which are born of seeds but grow into gnarled, dragonlike forms, symbolize enduring life.[7] The Tang master Zhang Cao (active *c.*766–78) painted rocks and trees with unusually expressive brushwork, "using a blunt-tipped brush and sometimes rubbing with his fingers on the surface of the silk."[8] The description of Zhang's painting technique recalls that of the inspired "untrammeled class" (*yipin*) of painters, who are reputed to have practiced the somewhat unorthodox working method of flinging ink onto silk and spreading it on the surface by means of their hair or hands.[9] In such a painting, it was not so much the composition of the work that was deemed important as the feeling of spontaneity and mystic oneness with nature. Zhang described his own painting as

> A reaching outward to imitate Creation,
> And a turning inward to master the mind.[10]

This description can be said to sum up the philosophical approach of the Chinese landscape painter. Looking to nature he carefully studied the world around him, and looking to himself he sought his own response to nature. The interactive relationship between the two, as expressed by the term *waizhong*, "outer/inner" or "exterior/interior," is circular and dynamic; as the artist sought to describe the external truth of the universe, he discovered at the same time an internal psychological truth.

After the fall of the Tang, in the early tenth century, many scholars retreated to the mountains. Living in secluded hermitages or Buddhist temples, they attended to their spiritual needs, studying, painting, and thinking about nature and the universe. These scholars would become China's first great landscape masters. Jing Hao (*c.*870–*c.*930), a Neo-Confucian scholar who went to live in Mount

Taihang, in central Hopei Province, was the first to formulate a coherent theory of Chinese landscape painting. In his essay "Notes on Brush Method," Ching makes a clear distinction between physical likeness (*si*) and truth (*zhen*):

> [A picture that attains] likeness achieves the physical form but leaves out the life breath of the subject, while in [a picture that attains] truth the life breath and inner qualities of the subject are fully present.[11]

For Jing, the painter of truth is a "sage" capable of "divining the emblems of objects and grasping their essence" (*du wuxiang er quqizhen*).[12] The word "emblem," or *xiang*, comes from the ancient divination classic the *Book of Changes*, a manual by which the future is predicted by the manipulation of sixty-four hexagrams (diagrams composed of six broken or unbroken lines).[13] The hexagrams, as "emblems," are archetypes of physical forms (*xing*).[14] By "divining emblems," Jing referred to the representation of true, or archetypal forms, rather than merely the physical qualities of objects.

In viewing landscape painting as a magical diagram of cosmic truth, Jing Hao nevertheless followed a rational approach of "investigation ... leading to the perfection of knowledge":

> One must understand the archetype, the emblem of each thing. When a tree grows, it follows its own received nature. . . . The pine tree, [for example,] from its beginnings, may bend as it grows, but will never appear crooked. Sometimes it is dense with foliage, sometimes sparse, neither blue nor green. As a sapling it stands upright, its budding heart already harboring noble ambitions. Once it has grown taller than all the other trees, even when its lower branches bow down to the earth, they never touch the common ground. Its layered branches spreading in the forest, it has the air of a dignified and virtuous gentleman.[15]

"The emblems of the mountains and the rivers," continues Jing, "are mutually generative, their breath forces causing each other to grow."[16] In landscape painting, Jing sees generating and regenerating forms and forces, endlessly transformed in the changing light and mists of the seasons. Through the painter's rigorous method of selection and elimination, these are re-combined and re-presented, each time in a complete and newly organized harmony. "Only when you are able to forget about the brush and ink will you achieve true landscape."[17]

By perceiving in the pine tree the human characteristics of a virtuous gentleman, the recluse scholar-painters believed they had discovered in nature the moral order that had been lost in the human world. The first of the early Northern Song landscape masters, Li Cheng (919–967), who was born in Qingzhou, Shangdong Province, was a descendant of the Tang imperial family. An aristocrat fallen on hard times, Li is said to have painted desolate scenes of wintry forests because "men of virtue are now found only in the wilderness."[18] Although no original

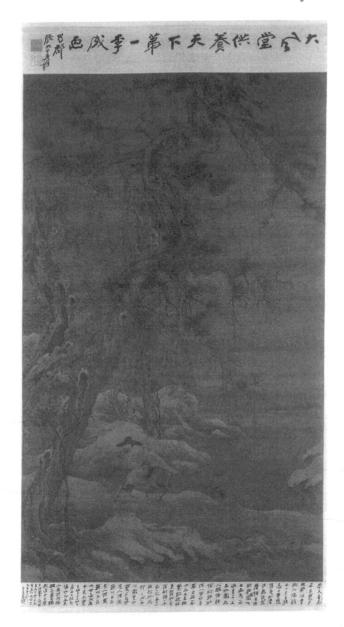

Fig. 27-1 After Li Cheng (919–967), *Travelers in a Wintry Forest*, early twelfth century. Hanging scroll, ink and color on silk, 161.6 × 100 cm. Metropolitan Museum of Art. Purchase, Fletcher Fund and Bequest of Dorothy Graham Bennett, 1972 (1972.121).

work by Li has survived, we know that his influence was extensive. *Travelers in a Wintry Forest* (Fig. 27–1) is a large early twelfth-century hanging scroll after a composition by Li that is mentioned by the eleventh-century scholar-artist Mi Fu in his *History of Painting*.[19]

As an illustration of the Confucian scholar's renunciation of worldly affairs, *Travelers in a Wintry Forest* recalls the episode in the life of the Buddha, Prince

283

Siddhartha, when, in his Great Going Forth in search of enlightenment, he entered a deep forest. In the painting, the scholar on a donkey and his two servant companions on foot are shown huddling against the cold as they make their way through the pine forest along a snow-covered riverbank. In both their configuration and their social relationship to one another, the wanderers are echoed in the frozen forest, in which a giant pine tree, symbol of the virtuous gentleman, is surrounded by more "lowly" vegetation – small trees, shrubs, and bamboos.[20] The rhythmic forms of the trees and the cloudlike snow-covered boulders reflect and re-create the bearing and gestures of the figures in their fluttering draperies. Not in accord with the term "landscape" – a painting "of mountains and rivers" – the true subject of Li's painting is the great pine. Drawn with the meticulous and caring detail of a great portrait, the tree symbolizes the Neo-Confucian concept of *junzi*, the uncommon, exceptional gentleman. The shape of the great pine is unusual and complex; its needles remain constant, enduring the harshest of winter's onslaught. Like a great man, the tree, in Jing Hao's words, "may bend [from suffering] as it grows, but will never appear crooked." In its youth, "its budding heart [harbors] noble ambitions." As it ages, it grows in stature, climbing higher than all other trees. Finally, it is individual and superior, for "even when its lower branches bow down to the earth, they never touch the common ground." Indeed, for the Neo-Confucianist, the recluse scholar was the true sovereign of the moral earth, as the great pine was the lord of the lofty mountains.

In the composition after Li Cheng, the beautifully wrought vegetation around the central pine ranges from early sprouting brush to lush trees in full maturity to a shattered old tree trunk, composing a microcosm of the natural cycle of growth and decay, while the great pine standing tall symbolizes constancy and eternal truth. Mi Fu compared the "drawn but elegant" face of the scholar – the painter's self-portrait – with that of the Tang poet Meng Haoran (689–740), a victim of earlier political vicissitudes. This reference to past suffering injects a note of poignancy into the picture, though the artist's own unyielding will is reflected by the stoic silence of the wintry forest.

Although the highly realistic depiction of the tree and figure, as well as the way the silhouetted boulders and slopes are sequentially unified in space, dates the execution of *Travelers in a Wintry Forest* to the early twelfth century, the powerful conception of the composition relates the painting directly to Li Cheng, the "master of a hundred generations."[21] As a work of the midtenth century, Li's anthropomorphized landscape – in which close-up views document in detail the myriad activities of nature – mediates halfway between narrative illustration and monumental landscape representation. Despite the solemnity of its theme, the vibrancy and intelligence of the imagery and the enjoyment in the execution are so much in evidence that it is easy to see why later masters – most notably, Guo Xi, Luo Zhichuan, Zhao Mengfu and Ni Zan – continued to be inspired both by the conception and by the style of this remarkable work.

284

Monumental Landscape Painting

During the early Northern Song dynasty, emperors, noblemen, and scholar-officials, as well as successful merchants, decorated the walls and screens of their palaces and homes with monumental landscape paintings. In 992, for example, the southern landscape master Juran (active *c*.960–95) – an expatriate from the vanquished Southern Tang court of Li Yu – was called to the Northern Song imperial palace, in Bianjing, to decorate the Jade Hall in the Institute of Academicians of the Imperial Chancellery. And in 1023–31, a six-paneled landscape screen by Yan Su (died 1040) was placed in the center of the same hall.[22]

As architectural decoration, earlier monumental wall paintings had served a ritual function. The Institute of Academicians, under the Tang, was originally decorated with magical symbols of the universe, the Ocean Surrounding the Dragon Mountain. In the early Northern Song, the Jade Hall had been first decorated on the east, north, and west with a continuous wall painting of dragons in water, executed from 980 to 983 by another southern expatriate painter from Li Yu's court, Dong Yu (active *c*.960–90).[23] The replacement in 992 of the central portion of Dong Yu's composition at the north end of the Jade Hall with a landscape by Juran was, therefore, an important departure, inaugurating the tradition of decorating ceremonial halls of state with monumental landscapes that depicted "the vastness and multiplicity of Creation itself."[24]

In the Liao mausoleum at Qingling, in eastern Mongolia, dating to about 1030, wall paintings representing the four seasons are found at the four cardinal points of the circular burial chamber: spring to the east, summer to the south, autumn to the west, and winter to the north. Two lines of geese, flying counter-clockwise, are seen departing for the south in the autumn and returning north in the spring. As an elegiac theme for funerary wall decoration, landscapes symbolized the cyclical movement of nature from birth to growth to decline and death and rebirth.

Rejecting the overtly narrative and symbolic, early Northern Song landscape masters focused on the representation of great mountain peaks, the "bones" and structure of the earth, as the true iconic image of nature. The famous masterpiece *Travelers Among Streams and Mountains*, by Fan Kuan (active *c*.990–1030), epitomizes this new interest. Fan Kuan, a native of Shensi Province, first studied the styles of Guan Tong (active *c*. 907–23; a follower of Jing Hao) and Li Cheng, after which, declaring that it was "better to study nature and, still better, to follow one's heart,"[25] he retired to the mountains to pursue his own inspiration. In *Travelers Among Streams and Mountains*, a large hanging scroll more than six feet in height, the great mountain peak, standing high on the shoulders of two supporting peaks, dominates the composition as the emblem of the universe. Although these great mountain forms are simple, generalized triangular masses with enveloping parallel folds, the depiction, with its pointillistic "raindrop" texture pattern and scrubby foliage on the peaks, vividly captures the landscape

peculiarities of Shensi in northwest China, where trees and brush grow in wind-deposited soil on rocky mountaintops. Individual rocks and trees are viewed frontally, as discrete, additive motifs, and the treatment of space is compartmentalized. The vertical composition proceeds from front to back in three separate stages – the foreground with its minute human figures, the middle distance with massive trees, and the background with towering mountains – each with its own suggested ground plane tilting away from the viewer at a different angle. Conceived as a series of images, and read part by part and motif by motif, the great landscape represents not an actual view of nature but a conceptual vision of the macrocosmic universe.

To emphasize the vastness of nature and its infinite capacity for expansion, Guo Xi advises the painter to suggest rather than to delineate completely:

> If one wishes to make a mountain appear high, one must not paint every part of it or it will seem diminished. It will look tall when encircled at mid-height by mist and clouds. If one wishes to describe a stream that stretches afar, one must not paint its entire course; only when its course is shaded and interrupted will it appear long.[26]

According to Guo Xi's definition, Fan Kuan's *Travelers Among Streams and Mountains* shows a high-distance view in the rocky landscape mode. In Fan's painting, it is the diminutiveness of the human figures that amplifies the sizes of the trees and mountains. Lilliputian figures are seen at the foot of an immense deciduous forest, while mountain peaks of cosmic proportions tower above. The use of a leaping scale exponentially heightens the impression of size and distance. The blank areas between the three distances serve as perceptual respites, inviting the viewer to roam freely through a space that is infinite because it is unmeasured and immeasurable.

Notes

1 Kenneth Clark, *Landscape into Art* (New York: Icon, 1979), p. ix.
2 For Tao Qian's "Peach Blossom Spring," see Herbert A. Giles, *Gems of Chinese Literature*, 2nd edn (London: B. Quaritch, 1923), pp. 104–5.
3 Du Fu, *Du Gongbu Shiji* (The Poems of Du Fu) (Hong Kong: Zhonghua shuju, 1972), vol. 1, p. 38.
4 See Kenneth K. S. Ch'en, *Buddhism in China: A Historical Survey* (Princeton: Princeton University Press, 1964), pp. 133, 182.
5 See Fung [Feng] Yu-lan, *A History of Chinese Philosophy*, translated by Derk Bodde (Princeton: Princeton University Press, 1952–3), vol. 2, pp. 465ff.
6 See ibid., p. 491.
7 See John Hay, *Kernels of Energy, Bones of Earth: The Rock in Chinese Art*, exhib. cat. (New York: China House Gallery, China Institute in America, 1985); and Richard Barnhart, *Wintry Forests, Old Trees: Some Landscape Themes in Chinese Painting*, exhib. cat. (New York: China House Gallery, China Institute in America, 1972)

8 See Zhang Yanyuan, *Lidai minghua ji* (Record of Famous Paintings in Successive Dynasties; completed 847), in Yu Anlan, ed., *Huashi congshu* (Compendium of Painting Histories) (Shanghai: Renmin meishu chubanshe, 1963), vol. 1, *juan* 10, p. 121.

9 See Shimada Shujiro, "Ippin gafu ni tsuite," *Bijutsu lenkyu* 161 (1950), p. 267; translated by James F. Cahill, "Concerning the I-p'in Style of Painting, I," *Oriental Art* 7, no. 2 (Summer 1961), p. 68.

10 See under Zhang Cao, in Zhang Yanyuan, *Lidai minghua ji*, in Yu Anlan, *Huashi congshu*, vol. 1, *juan* 10, p. 121.

11 See Yu Juanhua, *Zhongguo Hualun Leiban* (Classified Compilation of Writings on Chinese Painting) (Hong Kong: Zhonghua shuju, 1972), vol. 1, p. 605; for an English translation, see Kiyohiko Munataka, *Ching Hao's "Pi-fa-chi": A Note on the Art of Brush* (Ascona, Switz.: Artibus Asiae, 1974), pp. 12, 21 n. 14.

12 Ibid.

13 See Fung Yu-lan, *History of Chinese Philosophy*, vol. 2, especially pp. 435–42, 454–64.

14 See Willard J. Peterson, "Making Connections: 'Commentary on the Attached Verbalizations' of the *Book of Change*," *Harvard Journal of Asiatic Studies* 42, no. 1 (June 1982), pp. 67–116.

15 See Yu Juanhua, *Zhongguo Hualun Leiban*, vol. 1, p. 607.

16 Ibid.

17 Ibid., p. 608.

18 Deng Chun, *Huaji* (A Continuation of the History of Painting; preface dated 1167), in Yu Anlan, *Huashi congshu*, vol. 1, *juan* 9, p. 71.

19 Mi Fu, *Huashi* (History of Painting); quoted in Chen Gaohua, ed., *Song Liao Jin huajia shiliao* (Historical Source Materials on the Painters of the Song, Liao, and Jin Dynasties) (Beijing: Wenwu chubanshe, 1984), p. 161.

20 See Barnhart, *Wintry Forests, Old Trees*, pp. 16–17, 28.

21 See Wai-kam Ho, "Li Ch'eng and the Mainstream of Northern Sung Painting," in *Proceedings of the International Symposium on Chinese Painting, National Palace Museum, Taipei, 18–24 June 1970* (Taipei, 1972), pp. 251–83. In dating *Travelers in a Wintry Forest* to the early twelfth century, we follow the analytical scheme as proposed in Wen C. Fong et al., *Images of the Mind: Selections from the Edward L. Elliott Family and John B. Elliott Collections of Chinese Calligraphy and Painting at the Art Museum, Princeton University*, exhib. cat. (Princeton: Art Museum, 1984), pp. 20–22, figs 13–15. According to this analysis, landscape composition from about 700 to about 1300 developed in three distinct stages. In the first stage, additive motifs recede in separate sequences (*c.*700–*c.*1050); in the second, motifs range back in a continuous sequence (*c.*1050–*c.*1250); and in the third, elements are integrated spatially along a continuous ground plane (*c.*1250–*c.*1300). In *Travelers in a Wintry Forest*, the snow-covered mountain slopes that range from the foreground into the background are stacked up vertically on the picture plane. This method of suggesting continuous recession without an integrating ground plane dates the painting to the early twelfth century.

22 See Hiromitsu Ogawa, "Inchu no meiga" (Famous Paintings in the Academy), in *Chugoku kaigashi ronshu: Suzuki Kei sensei kanreki-kinen* (Essays on Chinese Painting in Honor of Professor Suzuki Kei's Sixtieth Birthday) (Tokyo: Yoshikawa Kobunkan, 1981), pp. 23–85.

23 Ibid., p. 34.
24 A phrase used to describe a work by the early Northern Song master Yan Wengui; see translation by Alexander C. Soper of *Kuo Jo-hsü's Experiences in Painting (T'u-hua chien-wen chih): An Eleventh Century History of Chinese Painting Together with the Chinese Text in Facsimile* (Washington, DC: American Council of Learned Societies, 1951), p. 173, n. 504.
25 *Xuanhe huapu* (Catalogue of the Imperial Painting Collection During the Xuanhe Era; preface dated 1120), in Yu Anlan, *Huashi congshu*, vol. 1, *juan* 11, p. 117.
26 See Yu Juanhua, *Zhongguo Hualun Leiban*, vol. 1, p. 639.

28

Guo Xi's Writings on Landscape Painting

Introduction

Guo Xi (after 1000–c.1090) was one of the most important landscape painters of China's Northern Song dynasty (960–1125). In this text, he describes how a painter should consider landscape, from the mood of the image to advice on painting. While scholars dispute whether this text was actually written by Guo Xi himself, it illustrates several concerns of one group of monumental landscape painters of the eleventh century. This text could stand as both a personal "artist's statement" and a larger aesthetic statement about one aspect of eleventh-century painting.

In an art historical framework that placed calligraphy and poetry above painting, this text links landscape to techniques of painting bamboo, a crucial subject matter for the scholar-painter as it symbolized the scholar and allowed accomplished calligraphers to demonstrate their skill at brushwork. Guo Xi also discusses different types of mountains, clouds, and vistas in order to highlight those that best capture the experience of the scholar-hermit who retreats to the mountains for escape from the bureaucratic city life. Chinese elite culture at this time valued the figure of the scholar-hermit: a man whose knowledge of calligraphy, poetry, and art earned him a high place within the governmental civil service, but who simultaneously yearned to pursue these crafts outside of tedious city life. These painters did not sell their works for money, for ideally their poetry and painting were pure intellectual pursuits. Thus sometimes they are called amateur painters, or literati.

Guo Xi, "On Landscape Painting," pp. 150–4, 168–9 from Susan Bush and Hsio-Yen Shih (eds), *Early Chinese Texts on Painting*. Cambridge: Harvard University Press, 1985.

For all of the rhetoric of separation from worldly concerns, even Guo Xi's statements here describe "nature" as a space inhabited by humankind, with pathways, hermits' dwellings, and temples on the mountainside. Thus nature is not something separate from humanity. Indeed, natural forms are used constantly to represent human relationships and hierarchies: a large mountain towers just as a great nobleman does. While the literati seem to disengage from worldly affairs, then, their approach to the representation of landscape reinscribes political relationships and becomes a comment on human society as much as on nature.

While Guo Xi also concerns himself with directing painters to depict seasons accurately – to capture seasonal moods – and while he indicates that one should paint while looking at an actual landscape, he does not mean that landscapes should necessarily portray a *particular* mountain or vista. Thus the goal of landscape painting is not the accurate representation of a specific space, but the representation of a mood, idea, or symbolic theme. Guo Xi indicates that one should paint what one sees, not what one knows to be there; his directions lead painters to acknowledge the atmospheric interference of mist, clouds, and distance rather than painting every pine needle on every tree.

This lyrical discussion of the proper approach to landscape painting presents just one philosophy circulating in the eleventh century. Guo Xi's words can be read as one painter setting the boundaries for what good painting should be according to his own philosophy. Thus, the text reads as a polemic of sorts, part of a dialogue among literati of the time: an argument for and valorization of Guo Xi's particular approach to landscape painting.

The Significance of Landscape

Guo Xi (after 1000–c.1090)

In what does a gentleman's love of landscape consist? The cultivation of his fundamental nature in rural retreats is his frequent occupation. The carefree abandon of mountain streams is his frequent delight. The secluded freedom of fishermen and woodsmen is his frequent enjoyment. The flight of cranes and the calling of apes are his frequent intimacies. The bridles and fetters of the everyday world are what human nature constantly abhors. Immortals and sages in mists and vapors are what human nature constantly longs for and yet is unable to see. It is simply that, in a time of peace and plenty, when the intentions of ruler and parents are high-minded, purifying oneself is of little significance and office-holding is allied to honor. Can anyone of humanitarian instinct then tread aloof or retire afar in order to practice a retreat from worldly affairs? And, if so, will he necessarily share the fundamental simplicity of [legendary] recluses such as Xu You [associated with] Mount Ji and the River Ying, or participate in the lingering

renown of [the Han Dynasty's] Four Old Men of Mount Shang?[1] Their songs, such as the "Ode to the White Pony" and the "Hymn to the Purple Fungus,"[2] are of what has passed away and is unattainable. But, are the longing for forests and streams, and the companionship of mists and vapors, then to be experienced only in dreams and denied to the waking senses?

It is now possible for subtle hands to reproduce them in all their rich splendor. Without leaving your room you may sit to your heart's content among streams and valleys. The voices of apes and the calls of birds will fall on your ears faintly. The glow of the mountain and the color of the waters will dazzle your eyes glitteringly. Could this fail to quicken your interest and thoroughly capture your heart? This is the ultimate meaning behind the honor which the world accords to landscape painting. If this aim is not principal and the landscape is approached with a trivial attitude, it is no different from desecrating a divine vista and polluting the clear wind.

There is a proper way to paint a landscape. When spread out on an ambitious scale it should still have nothing superfluous. Restricted to a small view it should still lack nothing. There is also a proper way to look at landscapes. Look with a heart in tune with forest and stream, then you will value them highly. Approach with the eyes of arrogance and extravagance, then you will value them but little. Landscapes are vast things. You should look at them from a distance. Only then will you see on one screen the sweep and atmosphere of mountain and water. Figure paintings of gentlemen and ladies done on a miniature scale, if held in the hand or put on the table, may be taken in at one glance as soon as they are opened. These are the methods of looking at paintings.

It is generally accepted opinion that in landscapes there are those through which you may travel, those in which you may sightsee, those through which you may wander, and those in which you may live. Any paintings attaining these effects are to be considered excellent, but those suitable for traveling and sight-seeing are not as successful in achievement as those suitable for wandering and living. Why is this? If you survey present-day scenery, in a hundred miles of land to be settled, only about one out of three places will be suitable for wandering or living, yet they will certainly be selected as such. A gentleman's thirst for forests and streams is due precisely to such places of beauty. Therefore, it is with this in mind that a painter should create and a critic should examine. This is what we mean by not losing the ultimate meaning ...

Someone learning to paint flowers puts a plant into a deep hole to look at it from above. This shows the flowers fully in the round. Someone learning to paint bamboos selects one branch as the moonlight reflects its shadow on a plain white wall. This brings out its characteristic form. Is there any difference in learning to paint a landscape? You must go in person to the countryside to discover it. The significant aspects of the landscape will then be apparent. To discover the overall layout of rivers and valleys in a real landscape, you look at them from a distance. To discover their individual characteristics, you look at them from nearby.

Clouds and vapors in a real landscape differ through the four seasons. They are genial in spring, profuse in summer, sparse in autumn, and somber in winter. If a

painting shows the major aspect and does not create overly detailed forms, then the prevailing attitude of clouds and vapors will appear alive. Mists and haze [on mountains] in a real landscape differ through the seasons. Spring mountains are gently seductive and seem to smile. Summer mountains seem moist in their verdant hues. Autumn mountains are bright and clear, arrayed in colorful garments. Winter mountains are withdrawn in melancholy, apparently asleep. If a painting shows the major idea without distracting signs of technique, then the atmospheric conditions will seem correct.

Wind and rain in a real landscape can be grasped when seen from a distance. Near to, you may be fascinated by the motion but will be unable to examine the overall pattern in the confused flow. Shade and light in a real landscape can be comprehended if seen from a distance. From nearby your grasp will be narrowed and you will not obtain a picture of what is hidden and what revealed by light and dark. On mountains, figures indicate paths and roads; look-out pavilions indicate scenic spots. On hills, vegetation is light or dark to differentiate respective distances; streams and valleys are cut short or continuous to differentiate depths of recession. On the water, fords, ferries, and various bridges hint at human activity; fishing skiffs and tackle hint at human interests.

A great mountain is dominating as chief over the assembled hills, thereby ranking in an ordered arrangement the ridges and peaks, forests and valleys as suzerains of varying degrees and distances. The general appearance is of a great lord glorious on his throne and a hundred princes hastening to pay him court, without any effect of arrogance or withdrawal [on either part]. A tall pine stands erect as the mark of all other trees, thereby ranking in an ordered arrangement the subsidiary trees and plants as numerous admiring assistants. The general effect is of a nobleman dazzling in his prime with all lesser mortals in his service, without insolent or oppressed attitudes [on either part].

A mountain nearby has one aspect. Several miles away it has another aspect, and some tens of miles away yet another. Each distance has its particularity. This is called "the form of the mountain changing with each step." The front face of a mountain has one appearance. The side face has another appearance, and the rear face yet another. Each angle has its particularity. This is called "the form of a mountain viewed on every face." Thus can one mountain combine in itself the forms of several thousand mountains. Should you not explore this? Mountains look different in the spring and summer, the autumn and winter. This is called "the scenery of the four seasons is not the same." A mountain in the morning has a different appearance from in the evening. Bright and dull days give further mutations. This is called "the changing aspects of different times are not same." Thus can one mountain combine in itself the significant aspects of several thousand mountains. Should you not investigate this?

In spring mountains, mists and clouds stretch out unbroken and people are full of joy. In summer mountains, fine trees offer profuse shade and people are full of satisfaction. In autumn mountains, bright and clear leaves flutter and fall, and men are full of melancholy. In winter mountains, dark fogs dim and choke the

scene, and men are full of loneliness. To look at a particular painting puts you in the corresponding mood. You seem in fact to be in those mountains. This is the mood of a painting beyond its mere scenery. You see a white path disappearing into the blue and think of traveling on it. You see the glow of setting sun over level waters and dream of gazing on it. You see hermits and mountain dwellers, and think of lodging with them. You see cliffs by lucid water or streams over rocks, and long to wander there. To look at a particular painting puts you in the corresponding frame of mind, as though you were really on the point of going there. This is the wonderful power of a painting beyond its mere mood.

Linquan gaozhi (ji) (The Lofty Message of Forest and Streams, *LCKCC*), "Advice on Landscape Painting." *Zhongguo hualun leibian* (*Classified Compilation of Chinese Theories of Painting*), ed. Yu Jian hua (Beijing: Zhongguo Gudian Yishu Chubanishe, 1957).

Atmosphere and Spatial Recession

Kuo Hsi (after 1000–c.1090)

A mountain without haze and clouds is like spring without flowers and grass. If a mountain is without clouds, it is not refined; without water it is not charming. Without paths it is not living; without forests it is not growing. Without deep distance it seems shallow; without level distance it does not recede and without high distance it stays low.

Mountains have three types of distance. Looking up to the mountain's peak from its foot is called the high distance. From in front of the mountain looking past it to beyond is called deep distance. Looking from a nearby mountain at those more distant is called the level distance. High distance appears clear and bright; deep distance becomes steadily more obscure; level distance combines both qualities. The appearance of high distance is of lofty grandeur. The idea of deep distance is of repeated layering. The idea of level distance is of spreading forth to merge into mistiness and indistinctness.

Figures in the three distances appear as follows. Those in the high distance are clear and distinct; in the deep distance they are fine and tiny; in the level distance they are remote and undisturbed. If they are clear and distinct then they cannot be short. If they are tiny then they cannot be tall. If they are remote then they cannot be large. Such are the three distances.

Mountains have three degrees of size. A mountain appears larger than a tree and a tree larger than a man. If a mountain is not greatly larger than a tree then it is not large at all. The tree which is not greatly larger than a man is not large at all. In comparing the size of a tree against the size of a human figure you begin with the leaves. In comparing the size of a human figure against a tree you begin with the

293

head. A number of leaves can be approximated to a human head. A human head can be made in the size of a bunch of leaves. The sizes of figures, trees, and mountains, all acquire their standard in this manner. Such are the three degrees of size.

You may wish to make a mountain high, but if it is visible throughout its entirety it will not appear high. If mists enlock its waist, then it will seem high. You may wish the river to flow afar, but if it is visible throughout its entirety, then it will not appear long. If hidden sections interrupt its course, then it will appear long. If a mountain is visible in its entirety, not only will it no longer reach its height through soaring aloft, but you might as well paint a giant pestle. If a river is visible in its entirety, not only will it no longer go afar through twisting and bending, but you might as well paint an earthworm.

The streams and hills and woods and trees in the center twist and wind and are arranged to come forward from the distance. If you do not avoid these details, they will satisfy the viewer's nearby scrutiny. The level plains and lofty ranges to the sides are linked together in successive layers and disappear into misty obscurity. If you do not overlook these distances, they will stretch to the utmost the beholder's far vision. [According to Wang Wei:] "Distant mountains have no texture strokes; distant water has no waves; distant figures have no eyes." They do not really lack them, but merely seem to do so.

LCKCC, "Advice on Landscape Painting," pp. 639–640.

Notes

1 Xu You refused the throne when offered it by the mythical emperor Yao; see Bernard Karlgren, *Legends and Cults in Ancient China, Bulletin of the Museum of Far Eastern Antiquities*, 18 (1946), 292. The "Four Old Men" or "Four Greybeards" retired from the world in protest against the Qin Dynasty, but re-emerged to support the rightful Han heir. See Burton Watson, *Records of the Grand Historian of China* (New York: Columbia University Press, 1961), 1, 146–149.

2 For the "Ode to the White Pony of the *Shijing* (Book of Poetry)," see James Legge, *The Chinese Classics* (Hong Kong: Hong Kong University Press, 1960), IV, 299–300. The "Hymn to the Purple Fungus" is said to have been composed by the "Four Old Men" when in retirement.

29

Jocho's Statue of Amida at the Byodoin and Cultural Legitimization in Late Heian Japan

Samuel C. Morse

Introduction

Images of the Buddha must adhere to certain iconographic features – such as elongated earlobes – specified in Buddhist texts. Thus, all statues of the Buddha bear some similarities. Yet stylistic developments across time and geography have resulted in diverse aesthetic representations of the Buddha. Indeed, there are only a few instances when Buddha images remained stylistically stagnant over a significant time period, and typically that stasis resulted from identifiable political or religious circumstances. In this reading, Morse addresses the question of why Japanese sculptures of the Buddha, after a period of artistic evolution between the eighth and eleventh centuries, remained largely uniform and unchanging from the second half of the eleventh through the twelfth centuries. Statues made at that time, corresponding with the late Heian period (1068–1185), were closely based on the celebrated Amida Buddha sculpted in 1053 by the renowned Jocho, for the Fujiwara clan's private temple, the Byodoin, in Uji, Japan.

Scholars typically divide the Heian period (named for the new capital city, Heian-Kyo, or present-day Kyoto, founded in 794), into three phases: Early (794–951), Middle (951–1086), and Late (1086–1185). During the Middle Heian period, the Fujiwara family held sway, essentially ruling Japan in the name of the emperor. Two of the most powerful patriarchs were Fujiwara no Michinaga (966–1027) and his son,

Samuel C. Morse, "Jōchō's Statue of Amida at the Byōdo-in and Cultural Legitimization in Late Heian Japan," pp. 96–103, 106–13 from *Res* 23 (Spring 1993).

Fujiwara no Yorimichi (992–1074), who had the Byodoin built. During this period, Pure Land Buddhism, or Jodo, which focused on the worship of the Amida Buddha who watched over Western Paradise, became popular among the nobility. Genshin (942–1017), a monk of the Tendai sect of Buddhism who helped to make Amida worship popular among Japan's elite, articulated the delights of Western Paradise as a blissful setting recalling the sumptuous environment of the Heian court. Byodoin, a three-dimensional representation of the Pure Land with Jocho's Amida at its center, embodies the Fujiwaras' spiritual beliefs, as well as their temporal power.

During the late Heian period, Fujiwara power decreased, with the imperial family regaining control in Kyoto, and local clans running the outer provinces. The fragmentation of power increased over time, resulting in two rebellions and, finally, the Genpei Civil War of 1180–5, which brought the Heian period to an end.

Morse's study deals with the Middle and Late Heian periods. He first examines the specific political, religious, and artistic circumstances surrounding Jocho's creation of the Byodoin Amida Buddha sculpture and then examines its legacy as well as the reasons for its potency. The reading also addresses the role of cultural legitimization in the decentralization of state rule and probes the interconnections between spiritual, aesthetic, and political power. Rather than focusing solely on a moment of artistic change and asking why it happened, as scholars often do, Morse seeks out a period when things stayed the same and asks why. His study demonstrates not only that such artistic phases are equally revealing as periods of innovation, but also that they resulted from artists and patrons who were quite conscious of, and interested in, the power of art.

The sculpture of the late Heian period (1068–1185) is characterized by the appearance throughout Japan of an unprecedented number of works in a unified style distinguished by extreme idealization and great elegance. During this era of considerable social change, the period between the ascendancy of the Fujiwara family and the rise of the military clans, sculptors and their patrons across the nation rejected stylistic innovaton. Instead they favored images that replicated as closely as possible the formal qualities of the Buddhist sculpture that had been produced in Kyoto during the first half of the eleventh century. The sculptural idiom to which they were making reference, called the *wayo*, or "native style" by modern scholars, and the *honyo*, or "true style" by eleventh-century patrons, is represented by the seated *Amida, the Buddha of Infinite Light* (Skt. Amitabha), the main image of the Phoenix Hall at the Byodoin.

The popularity of faith in Amida's powers of salvation and the desire to be reborn in that deity's magnificent Western Paradise among the aristocracy of the middle and late Heian period, as well as the renown of the Byodoin *Amida*, have resulted in the association of the native style with aristocratic patronage and images of the Buddha of Infinite Light. Yet, throughout the period the *wayo* was favored by patrons of all classes for images of a great variety of iconographic types, and seated statues of the Historical Buddha, Shaka (Skt Shakyamuni), and the Healing Buddha, Yakushi (Skt Bhaishajyaguru), in this sculptural idiom were

produced with considerable frequency. Nevertheless, only the few extant metropolitan works from the period (all statues of Amida) have been analyzed in detail.

Furthermore, although scholars have focused attention on the formulation of this sculptural idiom, they have not fully investigated the reasons for its popularity during the late eleventh and twelfth centuries. Except for the well-known statues in the Konjikido at Chusonji in Hiraizumi in far northern Japan, the vast number of formally similar statues to be found outside of Kyoto have often been ignored, thereby leaving one of the largest groups of Japanese sculpture essentially unstudied.[1] This important development in the history of Japanese sculpture needs to be placed in its context; and the circumstances surrounding the formulation and perpetuation of a frozen image type in late Heian Japan also must be examined. Unlike other traditions of frozen images, such as that of the Sinhala Buddha in Thailand or the legendary "First Image" of the Buddha, which were closely linked to issues of political authority or historical veracity, the perpetuation of the *wayo* for the better part of two centuries involved an attempt to appropriate one of the greatest artistic achievements of the Heian court in order to assert cultural legitimacy at a time of considerable social and political change.

In 1053, the sculptor Jocho (? –1057) completed what was to become one of his most influential works, the seated *Amida* in the Phoenix Hall of the Byodoin at Uji, south of Kyoto. The statue was carved from Japanese cypress (*hinoki*) in the technically exacting joined wood-block technique in which multiple blocks of wood first were shaped and hollowed, and then assembled to produce the final image. This carving method, perfected by Jocho, facilitated the rapid production of monumental images because for the first time in the history of wooden sculpture in Japan, image size was not constrained by the size of the available blocks of wood.

The Byodoin *Amida* is characterized by an extreme idealization of both the facial expression and the forms of the body. The solemn grace of the image is heightened by its stable relaxed pose and its perfect body proportions. The placement of each fold of the shallowly carved robe has been carefully calculated. The garment neither exaggerates the volumes of the body nor conceals them, thereby allowing the attention of the viewer to focus on the face. Furthermore, the half-closed downcast eyes give the statue a benign serenity unknown in any extant contemporary work.

The *Amida* is of the standard "sixteen-foot" (*joroku*) type and is the focal point of the lavishly embellished interior of the Phoenix Hall. The image sits on a high, multilayered pedestal and totally dominates the interior space. Behind the deity towers a huge gilded mandorla [flame-like halo] intricately carved and arrayed with small statues of bodhisattvas in adoration; and suspended from the ceiling is an ornate wooden canopy also covered with gold leaf. Attached to the upper walls are fifty-two small statues of priests, heavenly musicians, and bodhisattvas in rhythmical poses meant to represent Amida's entourage. The mandorla, canopy,

and pedestal as well as the fifty-two small statues all were produced by Jocho and his workshop.

The hall and its ornamentation are equally lavish – complex brackets cluster under the eaves and false corridors extend to either side. Although much of the original polychromy is now discolored or has flaked off, all surfaces originally were painted vermilion and many of the interior beams and brackets were ornamented with floral arabesques in bright greens, blues, purples, and reds. Intricate gilded metal fittings cover nail heads and the ends of rafters and beams. On the lower walls and interior of the doors are nine paintings depicting Amida in the attitude of Welcoming Descent (*raigo*), revealing himself to those with sincere faith at the moment of their death, and on the fixed partition behind the statue is a depiction of Amida's Western Paradise. The entire structure was erected on a small island in an artificial pond that had been excavated to follow the shape of the Sanskrit letter *A*, the first syllable in the name of Amitabha.

Amidist doctrines stressed faith in the deity's powers of salvation that were invoked through the chanting of Amida's name (*nembutsu*) or the contemplation and visualization (*kanso*) of Amida and his retinue in his paradise or Pure Land. This latter practice was particularly popular among the aristocrats of the eleventh and twelfth centuries. In fact, the Byodoin was intended to be an evocation of the splendors of the Western Paradise Amida in this world. Unlike earlier Buddhist structures, the Phoenix Hall faced east. When one worshiped the image from the far side of the pond, as was commonly done at the site, Amida appeared in all his glory as if in his heavenly paradise. Contemporary chroniclers commented that "[it was as if] the wonderful appearance of the Pure Land had been moved to the spot."[2]

The formulation of this indigenous image type marked the culmination of a long process of assimilation and transformation of Chinese sculptural styles. This evolution had begun in the last decades of the eighth century when Buddhist sculptors abandoned lacquer, bronze, and clay – all materials that had been popular on the continent – in favor of wood as the primary medium of their craft. The availability of wood throughout Japan, its negligible cost, and the ease with which it could be worked all contributed to its rapid adoption during the ninth century.

The Phoenix Hall was the most important structure of an extensive sanctuary founded by Fujiwara no Yorimichi (992–1074) on the site of the villa of his father, Fujiwara no Michinaga (966–1027). Michinaga and his son were the two most powerful of the long line of Fujiwara regents who controlled Japan politically between 967 and 1068. The period of Fujiwara hegemony was one of intense cultural creativity in painting, sculpture, calligraphy, and, in particular, the literary arts. The great aristocratic age of the Heian capital reached its apogee during the rule of Michinaga. The figure whose court generally is considered to have provided the model for Murasaki Shikibu's famous novel *The Tale of Genji*, Michinaga used his unrivaled authority to satisfy his extravagant tastes for ostentatious residences and lavish ceremonies.

Michinaga expressed his deep devotion to the Buddhist faith by making pilgrimages to sacred places throughout Japan, by founding temples, and by

commissioning numerous statues. In 1019 he took Buddhist vows, but rather than begin a life of retirement, Michinaga threw his energies into the construction of his own private monastery. Named the Hojoji and eventually consisting of structures dedicated to all the popular Buddhist deities, this temple was the culmination of Michinaga's career as a patron and an extravagant manifestation of his wealth and power.

The first building to be erected at Hojoji was not the Main Hall dedicated to the Esoteric Cosmic Buddha, Dainichi (Skt Mahavairochana), but a subsidiary structure that housed nine statues of Amida. The primacy given to Amida by Michinaga reflected a major change that was occurring in the Buddhist beliefs of the age. The Tendai doctrines that provided the focus of the religious practices of the court and aristocracy were highly eclectic in nature and had long accommodated Pure Land teachings. However, the rapid rise in the popularity of worship of Amida and desire for rebirth in his Western Paradise in the early eleventh century can be traced directly to the appearance of *The Teachings Essential for Rebirth* (*Ojo yoshu*), written by the Tendai monk Genshin (942–1017). Composed in a few months between 984 and 985, *The Teachings Essential for Rebirth* describes the horrors of hell and the glories of the Western Paradise that can be attained through unbending faith in the compassion of Amida.

The doctrines espoused by Genshin struck a responsive chord among members of the aristocratic elite and in particular, Michinaga. For example, in 1002 the regent began studying Tendai rituals that included the recitation of the name of Amida for ninety days, and in 1004 he ordered Fujiwara no Yukinari (971–1027), his closest adviser and a superb calligrapher, to transcribe a copy of *The Teachings Essential for Rebirth* for him.[3]

In a society where discriminating taste and emotional sensitivity were of utmost importance, it is not surprising that devotion to Amida by Michinaga and subsequently by other aristocrats of the late Heian period was expressed primarily in aesthetic terms. The elegant descriptions of Amida and his Western Paradise included in Genshin's text were not only to be evoked in one's mind but to be re-created in this world as well. Buddhist services were admired for their lavish display rather than for their philosophical content. Nowhere is this aestheticized religious outlook of the Heian aristocrat more explicitly expressed than in *The Pillow Book of Sei Shonagon* written by a lady-in-waiting at the court:

> A preacher ought to be good looking. For, if we are properly to understand his worthy sentiments, we must keep our eyes on him while he speaks; should we look away, we may forget to listen. Accordingly an ugly preacher may well be the source of sin.[4]

Aesthetic experience took precedence over religious transcendence.[5]

Michinaga was the first person of any real political power to embrace Pure Land doctrines with ardor.[6] Since the early years of the eleventh century, all the Buddhist ceremonies he sponsored were tinged with a strong Pure Land element.

By 1019, the year Michinaga took the tonsure and began construction of his Nine Amida Hall, Pure Land beliefs had deeply permeated the lives of the upper classes in the capital. The goal of the devout was not enlightenment, as it had been in the past; rather, the dominant religious sentiment of the day was desire for contentment in this world and rebirth in Amida's opulent paradise in the next.

The appearance of *The Teachings Essential for Rebirth* and the surge in popularity of belief in the Pure Land coincided with the development of an awareness of the imminent arrival of the period of the End of the Buddhist Law (*mappo*). Chinese and Japanese Buddhists had long believed in three periods of the degeneration of Buddhism after the death of the Historical Buddha.[7] The third period, when only faith in the powers of Amida could provide salvation, had been calculated to begin in 1052, one year before the completion of the Byodoin. The particular aestheticism of the Heian court fostered a pessimistic worldview among the residents of the capital, reinforced by belief in the rapidly approaching End of the Buddhist Law and further strengthened by Genshin's eloquent descriptions of the Pure Land of Amida.[8] Working in this atmosphere, Jocho and his father, Kojo (active 990–1020), developed an elegant, restrained style of imagery that reflected the aesthetic ideals of Michinaga and his contemporaries.

In fact Kojo had begun his career working directly for Genshin. Genshin believed that art could be a highly effective means to convert people to faith in Amida. Given the monk's convictions concerning the importance of art, it seems highly likely that Kojo's imagery would have incorporated something of his patron's artistic ideals. Between 990 and 995, the sculptor produced a life-sized image of Shakyamuni for the Ryosenin, a small temple founded by the monk on Mount Hiei, and in 1001 he directed the production of an Amida triad for Genshin at the Kedaiin, another subtemple on the mountain.[9] Subsequently, Kojo began working for Fujiwara no Yukinari, and through this association by the early years of the eleventh century, Kojo was receiving commissions directly from Michinaga and his family.

The culmination of Kojo's career came when he received the commission for nine statues of Amida for the Muryojuin, the name given to the Nine Amida Hall at Hojoji. Working with his son, Jocho, Kojo produced statues that satisfied Michinaga's worldly pretentions as well as his other-worldly aspirations.[10] Once Michinaga had discovered Jocho's prowess, the regent exclusively employed the young sculptor to produce the statues for the other halls at the Hojoji. After Michinaga's death, Jocho continued working for his son Yorimichi and his daughter Shoshi, also known as Shotomonin (988–1074), who inherited their father's love of luxuriant display. Except for one brief excursion to Nara to replace statues that had been lost in a fire at Kofukuji, the great eighth-century monastery, Jocho worked almost exclusively for Michinaga, Yorimichi, and their immediate circle until his death in 1057.

By 1050 the construction of Hojoji was essentially complete, and two years later, the year that the period of the End of the Buddhist Law was thought to have begun, Yorimichi started a lavish temple building project of his own on the site of

his father's villa on the banks of the Uji River. The sanctuary, named the Byodoin, included a complex reconstruction of Amida's Western Paradise as its focus. The completion of the hall and its statues the next year marked the culmination of Yorimichi's career as a patron and Jocho's career as a sculptor. When the structure was dedicated on the fourth day of the third month of 1053, contemporary chroniclers marveled at its beauty:

> The Regent and Great Minister of the Left, [Yorimichi] founded the Great Hall of the Byodoin. In it he installed a *joroku* statue of Amida Buddha. One hundred eminent monks prayed, [and the dedicatory] ceremony was held in conjunction with a Suvarnaprabhasa service (*misaie*). The statue and its ornamentation is unequalled in both the past and the present.[11]

One generation after Jocho's death, his style, as epitomized by the *Amida* at the Byodoin, had begun to influence the appearance of Buddhist imagery in the capital and provinces alike. By the beginning of the twelfth century, it had become the dominant sculptural idiom throughout Japan.

The history of Buddhist sculpture during the first 250 years of the Heian period is characterized by consistent stylistic evolution and artistic experimentation. In contrast, the sculpture of the late Heian period develops in a dramatically different fashion and displays exceedingly slow stylistic change.

The distinctive characteristics of the sculpture of the late Heian period can be illustrated through a number of comparisons of the large number of works in the Jocho idiom produced during this time. The *Amida* at the Hokongoin, a temple in the capital founded by the consort of Toba, the third of the retired emperors, is a prime example of an image in the Jocho style produced during the second quarter of the twelfth century.

Even a cursory glance reveals its direct links to Jocho's masterpiece in the proportions of the body, the arrangement of the drapery, and the placid introspective expression. A more careful examination indicates the extreme codification of that style in the taut surfaces of the body, the stylized pleats of the garment, and an absence of the deep spirituality with which Jocho imbued his image.

The absence of clearly definable patterns of formal change during the late Heian period can be elucidated further through a comparison of two less well known works from that period that possess dated inscriptions. Both the *Amida* at the Jodoin in Kyoto inscribed with a date corresponding to 1096, and the *Amida* inscribed with a date corresponding to 1154, now housed at Mitakiji in Hiroshima, but originally from a temple at the southern edge of Osaka Prefecture, follow the Jocho prototype. The arrangement of the drapery folds and the proportions of the bodies are almost identical. In spite of minor formal variations, these two works display almost no evolution in style despite the sixty years that separate them. The resemblances among these statues, selected essentially at random from the large number of stylistically similar works, demonstrate the unquestioned authority of Jocho's style and the extent of its influence on

sculptors and patrons in the far reaches of the country by the middle part of the twelfth century.

Jocho's three most famous commissions were the statues he made with his father for the Hojoji of Michinaga; the statues for the Byodoin commissioned by Yorimichi; and a single Amida statue commissioned during the 1050s by Fujiwara no Kunitsune (985–1067), an obscure provincial official, and housed at a hall that bore his name located within the grounds of his residence at the western edge of the Heian capital.[12] Since the entire Hojoji complex was lost to fire in 1058, Jocho's works there did not directly affect the stylistic development of sculpture of the late Heian period. The Amida commissioned by Kunitsune, no longer extant today, as well as the statue in the Phoenix Hall, however, were well known during the late eleventh and early twelfth centuries.

The authority the two works possessed and the influence they exerted on patrons and artists alike can be gathered from numerous contemporary records. For example, in 1054, Fujiwara no Sukefusa (1007–1057), a low-ranking court-er, visited the residence of Kunitsune and viewed Jocho's statue. He described the image, which must have closely resembled the *Amida* at the Byodoin, in the following terms:

> Later, following one another, we went to the property in the possession of Minister Kunitsune in the Saiin district. He had constructed his residence there as well, in front of which was an irregularly shaped pond which was elegant and extremely beautiful. The structure was solemn and lovely and would have to be described as the most luxurious. Within [the compound] was a large hall in which he had enshrined a "sixteen-foot" Amida Buddha. Its appearance was like that of the full moon. The solemnity and beauty of this image was truly impressive and beyond praise. There was also a bath house which in places had been decorated elegantly. People of great wealth can do whatever they wish. Whenever I come across a situation like this I am always disturbed by the fact that I can never do what I would like to do.[13]

Just over forty years later in 1096, Retired Emperor Shirakawa (1054–1129; r. 1072–1086), the most powerful political figure of his age, visited the Kunitsu-nedo. He had made the pilgrimage to worship in front of Jocho's statue there because its appearance was considered to be superior to that of any other image in the capital.[14]

Shirakawa was one of three abdicated emperors who dominated court and political life during the last hundred years of the Heian period. Frustrated by more than two hundred years of political subjugation of the court by the Fujiwara regency, the retired emperors attempted to reassert a preeminent political role for the imperial institution. Yet it is important to note that their distaste with Fujiwara rule did not extend to the artistic manifestations of the era of Fujiwara hegemony. Paradoxically, the cultural achievements of the mid-Heian period were to be emulated, not scorned.

302

Not to be outdone by their Fujiwara predecessors politically or culturally, the retired emperors embarked on extensive temple building projects of their own to demonstrate their own heightened aesthetic sensibilities and their piety. Shirakawa in particular was an active patron. In 1077 he founded the Hosshoji, which was modeled directly on Michinaga's Hojoji, but even grander in scale. Although perhaps an exaggeration, during his lifetime he is said to have commissioned the astonishing number of more than 5,470 Buddhist paintings, 5 monumental Buddhas, 126 "sixteen-foot" Buddhas, 66 "eight-foot" Buddhas, more than 3,150 life-sized Buddhas, more than 2,930 Buddhas less than three feet in height, 7 halls, 21 pagodas, and more than 446,630 miniature pagodas.[15] Moreover, both Shirakawa and his successor Toba were devout believers in the powers of Amida, and following the example of Michinaga, both erected Amida halls adjacent to their residences.[16]

The architectural historian Fukuyama Toshio has calculated that, on the average, during this seventy-year period one temple was founded every five years, and one hall was founded every year, all of which required an extraordinary number of images. The sculptors who produced the images for these halls were primarily members of the powerful In and En schools, which traced their lineage directly back to Jocho. The schools had been founded in the late eleventh century by second-generation disciples Injo (? –1108) and Ensei (? –1134). During the first four decades of the twelfth century, sculptural production in the capital was dominated by Choen (? –1150) and Ken'en (active 1115–1155), the second- and third-generation masters of the En school, who worked almost exclusively for the retired emperors and members of their families. Works by them filled the halls of the "Six Sho" temples in the Shirakawa district of the capital and the many halls at the Toba Detached Palace.[17]

In this atmosphere of frenzied sculptural production, the authority of Jocho's images at the Kunitsunedo and the Byodoin was unquestioned. In the fourth month of 1134, Retired Emperor Toba (1103–1156; r. 1107–1123) instructed his chief political adviser, the courtier Minamoto no Morotoki (1075–1136), to begin preparations for the construction of a hall dedicated to Amida at the site of the Toba Detached Palace to the south of the capital on the main thoroughfare to Nara. Dedicated in the third month of 1136 and called the Shokomyoin, the project was an extravagant copy incorporating architecture, painting, and sculpture based directly on the Phoenix Hall at the Byodoin.

Morotoki's diary, the *Choshuki*, contains detailed entries relating the manner in which the hall was constructed and the sculptures and paintings housed in it were produced. His comments reveal the close control that patrons exerted over the artists of the period. The sculpture at the Shokomyoin was supervised by Ken'en, the head of the En school at the time, whereas most of the painting was done by the Buddhist painter, Ogen (active 1114–1135).[18] Jocho's *Amida* provided the model for the main image, and the small statues of attendants in adoration provided the models for the twenty-six bodhisattvas and the twenty-five

bodhisattvas in adoration that were attached to the interior walls above the frieze rails in a manner similar to the original.

The important role played by Jocho's statue in determining the appearance of the new temple can be gathered from a discussion between Morotoki and the Retired Emperor. The conversation took place at the imperial palace before the ridgepole of the Shokomyoin had been raised:

> I spoke again, "What type of supplemental images (*kebutsu*) should be used for the mandorla? Should they be Apsarases or should [the mandorla] be arabesque? Most of Jocho's Buddhas have mandorlas with Apsarases. Should this one be similar?"
>
> The Retired Emperor spoke, "From the time of Jocho to the present era all the finest Buddhist statues have mandorlas with Apsarases. Should we not do the same?" ...
>
> The Retired Emperor said, "The Attendants in Adoration above the frieze rail should be copied from those at the Byodoin, however, should they not be greater in number?"[19]

To ensure that the ornamentation of the new structure would not deviate from that of the famous hall in Uji, Morotoki soon thereafter dispatched a group of artists to study the Byodoin. He writes in his diary:

> At the Hour of the Snake I went to the Imperial Palace. I had Morofumi report the following [to the Emperor]. Tomorrow, Junior Assistant Minister of the Ministry of Ceremony, Kuniyoshi will probably go to Uji to copy the ornamentation of the Buddha. If that is the case, would it not be convenient to also send the Buddhist sculptor Ken'en, the painter Ogen, and the artisan Suesada to study carefully the construction of the hall, the appearance of the image, the pedestal and the mandorla, the paintings on the pillars and the rainbow beams, the appearance of the Attendants in Adoration and the measurements of the Phoenixes on the ridge pole?[20]

On their return, Kuniyoshi, another official supervising the project, reported that they had discovered that the preliminary sketch for the ornamentation of the canopy had the measurements wider than those of the original.

A few days later the emperor himself visited the Byodoin. On seeing Jocho's statue of *Amida* and an image of Fudo in the main hall that was said to be by Kojo, the emperor decided to make additional changes to the lacquer altar and the pedestal of the image under construction for the Shokomyoin. <u>Nothing was left to the artists' discretion.</u>

Morotoki was exacting in assuring that the appearance of the new complex would follow that of the Byodoin as closely as possible. Sketches for the ornamentation did not meet the expectations of the emperor and were rejected. Nor did the main image of Amida escape Morotoki's criticisms:

> I went to look at the statue. In general it was an ordinary statue like others of the day. It was not particularly good, nor was it particularly poor. I instructed him to fix certain places on it and then I returned home.[21]

304

The following day the Emperor came to see the statue and questioned Morotoki about its suitability. Morotoki indicated that the statue was extremely beautiful, but the face should look downward a bit more and the garments were extremely roughly carved. He records that Ken'en understood the criticisms and agreed to recarve the statue. One person in attendance, however, commented that the nose of the statue was extremely small. Morotoki countered by saying that the nose of Jocho's statue at the Kunitsunedo was small as well, whereupon Ken'en prostrated himself on the ground in relief.[22]

The main image of the Shokomyoin was not the only statue to be based on Jocho's works. On the tenth day of the sixth month of 1134, Morotoki went to view the statue at the Kunitsunedo accompanied by two members of the In school. He recorded the visit in his diary:

> At the Hour of the Sheep I summoned the Buddhist Sculptor Incho and took him to the hall of the late minister Kunitsune in the Saiin district. [At the hall] was a statue carved by the Buddhist Sculptor Jocho which throughout the realm is considered to represent the true style (*honyo*) of Buddhist image.... This golden image of a Buddha was just what a real Buddha would have looked like.[23]

During this visit, Incho (active 1130–1165), his brother Inkaku (active 1110–1150), and their disciples took measurements of Jocho's statue in sixty-six places. In fact, they were so exacting in their work that by nightfall they had yet to measure the pedestal or count the number of folds on the statue's robe.[24] Morotoki did not indicate his reasons for measuring Jocho's statue in such detail. Yet, at the time Morotoki was also supervising the production of statues of the Five Buddhas for the pagoda at the Hokongoin. It seems likely that the courtier intended for the two sculptors to make direct reference to the dimensions of one of Jocho's best-known images for this commission.[25]

Unlike other sacred images in the Buddhist tradition, such as the sandalwood "First Image," known throughout the Mahayana world, or the Sinhala Buddha in Thailand, the authority of Jocho's style has no direct theological justification. Consequently, the reasons for the widespread adoption of the Jocho image type must be sought in the circumstances surrounding the formulation of the style itself and the way in which religious piety was expressed in aesthetic terms throughout the late Heian period. Nevertheless, the anthropologist Stanley J. Tambiah's analysis of the importance of the Sinhala Buddha for legitimizing the dynastic succession of the kings of Thailand provides a useful model for a better understanding of the reasons behind the popularity of Jocho's imagery.

Tambiah convincingly argues that "what matters most to the pious Buddhist is the continued maintenance of Buddhist religion and civilization, even though the continuity is achieved through the replication and renewal of earlier forms."[26] He then goes on to discuss how the possession of the Sinhala Buddha or a copy after the "original" by Thai kings provided them with a means to legitimize their position, and concludes by stating, "The Buddha statue as a palladium is a

product of the circumstances of its making and the authority given it by its makers, sponsors and patrons. In this sense history is imbedded and objectified in it."[27] Although the Jocho style was never used to claim political legitimacy in the manner of the Sinhala Buddha, commissioning statues in imitation of the sculptor's most famous works does seem to have been an important means for asserting cultural legitimacy throughout the late Heian period.

During the first half of the eleventh century, Michinaga and Yorimichi had exercised total control over the mechanism of government, yet to support their lavish tastes and extensive temple-building projects they had to rely on provincial authorities to provide them with materials and labor. For the regents, political control of the provinces was secondary to the need for money and goods to support their lavish temple-building projects. The retired emperors who sought to reassert the authority of the imperial institution during the late Heian period also found it necessary to rely on provincial warlords and governors to help them control their Fujiwara rivals.

As the political authority of the capital decreased during the late Heian period, the provincial representatives of the imperial house and courtiers in the capital acquired considerable power.[28] Despite their position as the controlling political and economic force during the late Heian period, the provincial governors and warlords desperately wanted to emulate the way of life of the Heian court. Their goal was to integrate themselves into the metropolitan establishment rather than to overthrow it. In the provinces political power was incomplete without the cultural authority of the capital, and as a result the provincial governors sponsored the construction of temples and the sculpting of imagery.

The years of the rule of Michinaga and Yorimichi marked the apogee of the glory of the Heian court. By the time of Yorimichi's death, the tranquility that had dominated the lives of the elite in the capital was beginning to come to an end. The destruction caused by constant fires, pestilence, and bands of marauding monks from Mount Hiei as well as a series of wars in northern Japan, must have convinced the residents of Kyoto that the period of the End of the Buddhist Law was indeed at hand. As a result, not only did they seek refuge from the widespread instability by placing their faith in Amida, but they also began to look back on the glorious early decades of the eleventh century with considerable nostalgia.

As early as the middle decades of the eleventh century, when Akazome Emon (active 980–1040) is thought to have written *A Tale of Flowering Fortunes*, Michinaga was seen as representing the aristocratic ideal. In fact, some modern scholars consider the middle part of the chronicle to be little more than a carefully conceived glorification of his exploits.[29] Michinaga's extensive temple-building projects, his pilgrimages to sacred places, and his acts of devotion, such as commissioning copies of *The Teachings Essential for Rebirth*, must have resulted in his being viewed as the ideal aristocratic Buddhist patron as well.

Throughout the eleventh century, *The Tale of Genji* was widely read, and the society described in it already was viewed as the classical age of refinement and elegance. The allure of the culture of the capital to those in remote parts of Japan is succinctly described in the opening passage of the *Sarashina Diary*.

> I was brought up in a part of the country so remote that it lies beyond the end of the Great East Road. What an uncouth creature I must have been in those days! Yet even shut away in the provinces I somehow came to hear that the world contained things known as Tales, and from that moment my greatest desire was to read them for myself. To idle away the time, my sister, my step-mother, and others in the household would tell me stories from the Tales, including episodes about Genji, the Shining Prince; but, since they had to depend on their memories, they could not possibly tell me all I wanted to know and their stories only made me more curious than ever. In my impatience I got a statue of the Healing Buddha built in my own size. When no one was watching, I would perform my ablutions and, stealing into the altar room, would prostrate myself and pray fervently, "Oh, please arrange things so that we may soon go to the Capital, where there are so many tales, and please let me read them all.[30]

Not only were the society and the man who symbolized its glories venerated, but the achievements of the Heian court served as artistic models as well. The calligraphy of Yukinari, Michinaga's confidant, the writings of Lady Murasaki and Sei Shonagon, and the poems of the great early anthologies *Kokinshu* and the *Wakan roeishu* were held in high esteem throughout the late Heian period. In both the capital and provinces alike, knowledge of them conferred cultural legitimacy and the mantle of the refined aestheticism of the aristocratic society that produced them. As the main sculptural expression of this period of native cultural achievement, it was only natural that Jocho's sculptural style as epitomized by the Amida statues at the Byodoin and the Kunitsunedo would be recognized as the "true style."

All the extant statues commissioned by the powerful aristocratic and imperial patrons and produced by the most influential sculptors in the capital during the late Heian period follow Jocho's prototype in their formal qualities. Moreover, all were finished in the most ostentatious manner possible with lacquered or gilded interiors. Five of the finest statues in the Jocho idiom were carved by sculptors of high rank based on the Jocho style; yet, despite the high reputations of the artists, none of these statues is signed.[31] As is clearly revealed by the noblemen's diaries quoted above, patrons in the capital were little concerned with artistic originality. They sought statues that imitated Jocho's prototype as closely as possible. By ordering direct copies of Jocho's most famous works – the statues of Amida at the Byodoin and the Kunitsunedo – they were identifying themselves with one of the most magnificent artistic achievements of the time of Michinaga and Yorimichi, sculpted at a time when the authority of the capital was unquestioned.

Notes

1 Inoue Tadashi has written on a small segment of this large body of statuary in "Kanto no Jocho yoshiki" (The Jocho Style in the Kanto Region), in Kuno Takeshi, ed., *Kanto chokoku no kenkyu* (Sculpture of the Kanto Region) (Tokyo: Gakuseisha 1961), pp. 23–40. Mizuno Keizaburo has written on the metropolitan statues in this group, which date from the twelfth century; see Mizuno Keizaburo, "Inseiki no zozo meiki o meguru ne san no mondai" (Two or Three Points on Inscriptions Relating to the Production of Images During the Period of the Retired Emperors), *Bijitsu kenkyu* no. 195 (July 1974), pp. 13–25. See also Sherwood Moran, "The Statue of Amida," *Oriental Art* 6, no. 2 (1960), pp. 49–55. The exhibition "Buddhist Sculpture from Mid-Eleventh to the End of the Twelfth Centuries" (*Inseiki no butsuzo – Jocho kara Unkei e*) held at the Kyoto National Museum in the spring of 1991 represents a further step in rectifying this problem.
2 Koen; ?–1169, *Fuso ryakki*, Kuroita Katsumi, ed., *Shincho zoho kokushi taikei* (Outline of Japanese History, expanded and revised edition), vol. 12 (Tokyo: Yoshikawa kobunkan, 1932), pp. 297–298. Entry for 1061 (Kohei 4), 10.25.
3 Fujiwara no Yukinari, *Gonki, Shiryo taisei*, rev. edn (Tokyo: Rinsen shoten, 1965), vol. 1, p. 243, entry for 1004 (Kanko), 9.17.
4 Ivan Morris, ed., *The Pillow Book of Sei Shonagon* (New York: Columbia University Press, 1967), p. 33.
5 The close relationship between religion and aesthetic experience has been widely discussed. See in particular: George Sansom, "The Rule of Taste," in *A History of Japan to 1334* (Stanford: Stanford University Press, 1958), pp. 178–196; Ivan Morris, *The World of the Shining Prince* (London: Oxford University Press, 1964), pp. 117–135, 205–210; Inoue Mitsusada, *Nihon Jodokyo seritsushi no kenkyu* (A Study of the Formation of Pure Land Buddhism in Japan) (Tokyo: Yamakawa shuppan, 1966), pp. 117–120.
6 For example, the temples founded by the three previous regents, Gokurakuji of Fujiwara no Mototsune (836–891), Hosshoji of Fujiwara no Tadahira (880–949), and the Hokoin of Fujiwara no Kaneie (929–990) all lacked conspicuous Pure Land elements. See Inoue Mitsusada, pp. 94–96.
7 For a discussion of the rise in popularity of the doctrine of *mappo*, see Hori Ichiro, *Folk Religion in Japan* (Chicago: University of Chicago Press, 1968), pp. 101–105.
8 Sansom, pp. 218–228.
9 Mizuno Keizaburo, *Daibusshi Jocho* (The "Great Buddhist Sculptor" Jocho), *Nihon no bijutsu*, vol. 164 (Tokyo: Shibundo, 1980), pp. 48, 50.
10 The statues perished when the Hojoji burned in 1058; however, their appearance is described in *A Tale of Flowering Fortunes*, a historical account of the glories of the Fujiwara regents:

> Gazing toward the images themselves, the nuns first beheld a sixteen-foot statue of Amitabha, shining with peerless holy radiance. The color of the protuberance on his head was a deep blue, and the white tuft between his eyebrows, curling smoothly to the right, seemed as huge as five Mount Sumerus. His blue-lotus eyes were as wide as the four great seas; his lips were like *bimba* fruit. His

figure was splendidly majestic, and his purple-gold visage illumined the very ends of the earth, shining with the boundless radiance of an unclouded autumn moon. His ethereal, pure body was endowed with all the signs and attributes; his halo shone with the intermingled radiance of countless hundreds of millions of transformed buddhas. This was indeed the representation of a being who had achieved 10,000 virtues untainted by illusion . . . Such was the appearance of a single buddha. It is beyond the power of the mind to conceive or the mouth to describe the splendid impression created by all nine in a row.

William H. and Helen Craig McCullough, *A Tale of Flowering Fortunes* (Stanford: Stanford University Press, 1980), pp. 567–568.

11 Koen, *Fuso ryakki*, p. 293; entry for 1053 (Tenki 1), 3.4.

12 For a discussion of the statue at the Kunitsunedo, see Mori Hisashi, "Saiin Kunitsu-nedo Amida nyorai zo" (The Statue of Amida at the Kunitsunedo in the Saiin District), reprinted in *Nihon bukkyo chokokushi no kenkyu* (Studies on the History of the Buddhist Sculpture of Japan) (Kyoto: Hozokan, 1970), pp. 202–211.

13 Fujiwara no Sukefusa (1007–1057), *Shunki, Shiro taisei* (Compendium of Documents), rev. edn, vol. 4 (Tokyo: Rinsen shoten, 1965), pp. 305–306, entry for 1054 (Tenki 2), 5.3.

14 The emperor's visit was recorded by Fujiwara no Munetada (1062–1141) in his diary; see *Chuyuki*, vol. 1, *Shityo taisei* (Compendium of Documents), vol. 9 (Tokyo: Rinsen shoten, 1965), p. 340; entry for 1096 (Eicho), 3.15.

15 The figures are from the *Chuyuki*, vol. 6, p. 73, entry for 1129 (Daiji 4), 7.15. No statues remain that can be associated directly with Emperor Shirakawa's numerous temple-building projects. The seated Yakushi at Saikyoji is thought by some scholars to be from Hosshoji, but that is by no means certain. It does, however, follow the Jocho style.

16 Inoue Mitsusada, *Nihon kodai kokka to bukkyo* (Buddhism and the State in Ancient Japan) (Tokyo: Iwanami shoten, 1971), p. 182.

17 The "Six Sho" Temples in the Shirakawa district included Hosshoji (Emperor Shirakawa, 1077), Sonshoji (Emperor Horikawa, Shirakawa's son, 1102), Saishoji (Emperor Toba, 1118), Enshoji (Emperor Toba's consort, 1128), Joshoji (Emperor Sutoku, Toba's son, 1139), and Enshoji (Emperor Konoe, another of Toba's sons, 1146); and the temples at the Toba Detached Palace: the Shokongoin (Shirakawa, 1101), Jobodaiin (Toba, 1129), Shokomyoin (Toba, 1136), Anrakujuin (Toba, 1137), and Kongoshinin (Toba, 1154).

18 Although no works by Ogen remain, he seems to have been one of the most active Buddhist painters in the first half of the twelfth century working not only for Toba but for his consort as well. See Hirata Yutaka, "Ebusshi Ogen ni tsuite" (Concerning the Buddhist Painter Ogen), *Mikkyo zuzo*, no. 5 (October 1987), pp. 1–13.

19 Minamoto Morotoki, *Choshuki, Shiryo taisei* (Compendium of Documents), vol. 7 (Tokyo: Maigai shoseki K.K., 1934), pp. 190–191; entry for 1134 (Chosho) 4.10.

20 Ibid., p. 195; entry for 1134 (Chosho) 5.1.

21 Ibid., p. 202; entry for 1134 (Chosho) 6.3.

22 Ibid., pp. 202–203; entry for 1134 (Chosho) 6.4.

23 Ibid., p. 205; entry for 1134 (Chosho) 6.10.

24 Ibid., pp. 205–206; entry for 1134 (Chosho) 6.10.

25 I wish to thank Professor Mizuno Keizaburo for clarifying this passage for me.
26 Stanley J. Tambiah, *The Buddhist Saints of the Forest and the Cult of Amulets* (Cambridge: Cambridge University Press, 1984), p. 240.
27 Ibid., p. 241.
28 Cornelius J. Kiely, "Estate and Property in the Late Heian Period," in John W. Hall and Jeffery P. Mass, eds, *Medieval Japan* (New Haven: Yale University Press, 1974), pp. 114–118.
29 McCullough and McCullough, pp. 23–24.
30 Ivan Morris, trans., *As I Crossed the Bridge of Dreams* (New York: The Dial Press, 1971), p. 41.
31 The *Amida* and *Attendant Bodhisattvas* now at the Sokujoin in Kyoto, originally commissioned by Fujiwara no Toshitsuna for his Fushimido around 1094; the *Amida* now at Manjuji, generally thought to have been commissioned by Emperor Shirakawa as the main image of the Rokudo Mido in 1098; the *Amida* that is the main image of Hokaiji thought to have been carved in the same year; the *Amida* at the Anrakujuin sculpted by an En school artist for Emperor Toba in 1139; and the *Amida* at the Hokongoin mentioned above. See Mizuno, 1974, pp. 13–25.

30

"The Oak Tree," from *The Tale of Genji*

Murasaki Shikibu

Introduction

The Tale of Genji is an early eleventh-century novel of fifty-four chapters written by the court lady Murasaki Shikibu. Often called the first novel ever written, it explores the psychological and social intrigues of the Heian period in Japan (794–1185). The novel has been illustrated hundreds of times since the eleventh century; the earliest known illustration is a set of scrolls from the first half of the twelfth century. It follows the story of Genji, the Shining Prince, as he causes and participates in various conflicts at the imperial court. Genji's exploits include falling in love with and seducing the Emperor's consort Fujitsubo, which results in him fathering the baby then taken to be the son of the emperor himself. These storylines strike us as somewhat like soap opera when we extract them from their narrative context; in the text, however, the stories are rife with emotion, honor, and the struggle to abide by the unwritten rules of the court. Characters are continually torn by their desires, whether carnal or not, and their responsibilities to other people, living or dead.

The Oak Tree chapter is the culmination of actions the characters have taken in past chapters. Genji has celebrated his fortieth birthday, and has several consorts and wives. He has just married the Emperor's daughter, the Third Princess, who has entered Genji's Rokujo Mansion. During a game in the courtyard of the Mansion, Kashiwagi, who is married to the Second Princess and is the son of Genji's best friend To no Chujo, catches a glimpse of the Third Princess and becomes obsessed. He steals her cat and schemes with her attendant Kojiju to get access to her. When another of

Murasaki Shikibu, "The Oak Tree," pp. 636–50 from Edward G. Seidensticker (ed. and trans.), *The Tale of Genji*. New York: Knopf, 1987.

Genji's women, Murasaki, falls ill, Genji accompanies her to the Nijo palace to help her to recover. Indeed, Murasaki's illness may be the result of her distress at yet another woman in Genji's circle. Kashiwagi takes advantage of Genji's absence and various festival preparations to get into the Third Princess's apartments and force himself on her. Their union produces a child, Kaoru, born in the Oak Tree chapter. This storyline parallels the earlier narrative of Genji and Fujitsubo, and in many ways marks a karmic turn for Genji, as he must acknowledge Kaoru as his son while knowing that the child is not his. He forced the emperor to do the same many years before; his life has come full circle.

Scholars of *The Tale of Genji* describe the tone of the novel as nostalgic: Genji was a shining prince, and his life story signifies the decline of an earlier time. The Oak Tree chapter comes towards the end of Genji's life (he dies five chapters later), and illustrates some of this melancholy sadness for the glory that has been lost. The novel also has a particularly measured narrative pacing while communicating things as dramatic as illicit sexual encounters and death. This overarching tone encapsulates the courtly rules of communication and interpersonal relationships that shape the characters' interactions. The Heian court was a very structured and hierarchical place, governed by the bounds of acceptable behavior. For a man to even catch a glimpse of a woman's face was a major breach of those boundaries, and messages about personality and emotion were more properly transmitted through gestures, clothing, perfume, and poetry. Words and phrases contain double meanings, puns, and references to other poetry, both Chinese and Japanese. Most of the names in the text are not the characters' given names, but are descriptive epithets that relate to the narrative. Kashiwagi, for example, means oak tree, and we see the oak referred to several times in this chapter in reference to him.

Principal Characters

AKIKONOMU. Daughter of a former crown prince and the Rokujo lady. Consort of the Reizei emperor. First cousin of Genji and Asagao.

FUJITSUBO. Daughter of a former emperor, consort of Genji's father, and mother of the Reizei emperor.

GENJI. Son of the emperor regnant at the opening of the tale.

KAORU. Thought by the world to be Genji's son, but really Kashiwagi's.

KASHIWAGI. Son of To no Chujo and father of Kaoru. Married to the Second Princess, daughter of the Suzaku emperor.

KOJIJU. A woman in attendance upon the Third Princess.

SECOND PRINCESS. Daughter of the Suzaku emperor and wife of Kashiwagi.

SUZAKU EMPEROR. Genji's brother.

THIRD PRINCESS. Daughter of the Suzaku emperor, wife of Genji, and mother of Kaoru.

The princess' are his nieces...

To no Chujo. Son of a Minister of the Left and Princess Omiya and brother of
Aoi. Father of Kashiwagi, Kobai, Kumoinokari, Tamakazura, and the Omi lady.
Yugiri. Son of Genji and Aoi.

The New Year came and Kashiwagi's condition had not improved. He knew how
troubled his parents were and he knew that suicide was no solution, for he would
be guilty of the grievous sin of having left them behind. He had no wish to live
on. Since his very early years he had had high standards and ambitions and had
striven in private matters and public to outdo his rivals by even a little. His wishes
had once or twice been thwarted, however, and he had so lost confidence in
himself that the world had come to seem unrelieved gloom. A longing to prepare
for the next world had succeeded his ambitions, but the opposition of his parents
had kept him from following the mendicant way through the mountains and over
the moors. He had delayed, and time had gone by. Then had come events, and for
them he had only himself to blame, which had made it impossible for him to show
his face in public. He did not blame the gods. His own deeds were working
themselves out. A man does not have the thousand years of the pine, and he
wanted to go now, while there were still those who might mourn for him a little,
and perhaps even a sigh from *her* would be the reward for his burning passion. To
die now and perhaps win the forgiveness of the man who must feel so aggrieved
would be far preferable to living on and bringing sorrow and dishonor upon the
lady and upon himself. In his last moments everything must disappear. Perhaps,
because he had no other sins to atone for, a part of the affection with which Genji
had once honored him might return.[1]

The same thoughts, over and over, ran uselessly through his mind. And why, he
asked himself in growing despair, had he so deprived himself of alternatives? His
pillow threatened to float away on the river of his woes.

He took advantage of a slight turn for the better, when his parents and the
others had withdrawn from his bedside, to get off a letter to the Third Princess.

"You may have heard that I am near death. It is natural that you should not
care very much, and yet I am sad." His hand was so uncertain that he gave up any
thought of saying all that he would have wished to say.

"My thoughts of you: will they stay when I am gone
Like smoke that lingers over the funeral pyre?

"One word of pity will quiet the turmoil and light the dark road I am taking by
my own choice."

Unchastened, he wrote to Kojiju of his sufferings, at considerable length. He
longed, he said, to see her lady one last time. She had from childhood been close
to his house, in which she had near relatives.[2] Although she had strongly disap-
proved of his designs upon a royal princess who should have been far beyond his
reach, she was extremely sorry for him in what might be his last illness.

"Do answer him, please, my lady," she said, in tears. "You must, just this once. It may be your last chance."

"I am sorry for him, in a general sort of way. I am sorry for myself too. Any one of us could be dead tomorrow. But what happened was too awful. I cannot bear to think of it. I could not possibly write to him."

She was not by nature a very careful sort of lady, but the great man to whom she was married had terrorized her with hints, always guarded, that he was displeased with her.

Kojiju insisted and pushed an inkstone towards her, and finally, very hesitantly, she set down an answer which Kojiju delivered under cover of evening.

To no Chujo had sent to Mount Katsuragi for an ascetic famous as a worker of cures, and the spells and incantations in which he immersed himself might almost have seemed overdone. Other holy men were recommended and To no Chujo's sons would go off to seek in mountain recesses men scarcely known in the city. Mendicants quite devoid of grace came crowding into the house. The symptoms did not point to any specific illness, but Kashiwagi would sometimes weep in great, racking sobs. The soothsayers were agreed that a jealous woman had taken possession of him. They might possibly be right, thought To no Chujo. But whoever she was she refused to withdraw, and so it was that the search for healers reached into these obscure corners. The ascetic from Katsuragi, an imposing man with cold, forbidding eyes, intoned mystic spells in a somewhat threatening voice.

"I cannot stand a moment more of it," said Kashiwagi. "I must have sinned grievously. These voices terrify me and seem to bring death even nearer."

Slipping from bed, he instructed the women to tell his father that he was asleep and went to talk with Kojiju. To no Chujo and the ascetic were conferring in subdued tones. To no Chujo was robust and youthful for his years and in ordinary times much given to laughter. He told the holy man how it had all begun and how a respite always seemed to be followed by a relapse.

"Do please make her go away, whoever she might be," he said entreatingly.

A hollow shell of his old self, Kashiwagi was meanwhile addressing Kojiju in a faltering voice sometimes interrupted by a suggestion of a laugh.

"Listen to them. They seem to have no notion that I might be ill because I misbehaved. If, as these wise men say, some angry lady has taken possession of me, then I would expect her presence to make me hate myself a little less. I can say that others have done much the same thing, made mistakes in their longing for ladies beyond their reach, and ruined their prospects. I can tell myself all this, but the torment goes on. I cannot face the world knowing that he knows. His radiance dazzles and blinds me. I would not have thought the misdeed so appalling, but since the evening when he set upon me I have so lost control of myself that it has been as if my soul were wandering loose. If it is still around the house somewhere, please lay a trap for it."[3]

She told him of the Third Princess, lost in sad thoughts and afraid of prying eyes. He could almost see the forlorn little figure. Did unhappy spirits indeed go wandering forth disembodied?

"I shall say no more of your lady. It has all passed as if it had never happened at all. Yet I would be very sorry indeed if it were to stand in the way of her salvation. I have only one wish left, to know that the consequences of the sad affair have been disposed of safely. I have my own interpretation of the dream I had that night and have had very great trouble keeping it to myself."

Kojiju was frightened at the inhuman tenacity which these thoughts suggested. Yet she had to feel sorry for him. She was weeping bitterly.

He sent for a lamp and read the princess's note. Though fragile and uncertain, the hand was interesting. "Your letter made me very sad, but I cannot see you. I can only think of you. You speak of the smoke that lingers on, and yet

> "I wish to go with you, that we may see
> Whose smoldering thoughts last longer, yours or mine."

That was all, but he was grateful for it.

"The smoke – it will follow me from this world. What a useless, insubstantial affair it was!"

Weeping uncontrollably, he set about a reply. There were many pauses and the words were fragmentary and disconnected and the hand like the tracks of a strange bird.

> "As smoke I shall rise uncertainly to the heavens,
> And yet remain where my thoughts will yet remain.

"Look well, I pray you, into the evening sky. Be happy, let no one reprove you; and, thought it will do no good, have an occasional thought for me."

Suddenly worse again, he made his way tearfully back to his room. "Enough. Go while it is still early, please, and tell her of my last moments. I would not want anyone who already thinks it odd to think it even odder. What have I brought from other lives, I wonder, to make me so unhappy?"

Usually he kept her long after their business was finished, but today he dismissed her briefly. She was very sorry for him and did not want to go.

His nurse, who was her aunt, told Kojiju of his illness, weeping all the while.

To no Chujo was in great alarm. "He had seemed better these last few days. Why the sudden change?"

"I cannot see why you are surprised," replied his son. "I am dying. That is all."

That evening the Third Princess was taken with severe pains.

Guessing that they were birth pangs, her women sent for Genji in great excitement. He came immediately. How vast and unconditional his joy would be, he thought, were it not for his doubts about the child. But no one must be allowed to suspect their existence. He summoned ascetics and put them to continuous spells and incantations, and he summoned all the monks who had

shows the standard for when a birth will happen

315

made names for themselves as healers. The Rokujo mansion echoed with mystic rites. The princess was in great pain through the night and at sunrise was delivered of a child. It was a boy. Most unfortunate, thought Genji. It would not be easy to guard the secret if the resemblance to the father was strong. There were devices for keeping girls in disguise and of course girls did not have to appear in public as did boys. But there was the other side of the matter: given these nagging doubts from the outset, a boy did not require the attention which must go into rearing a girl.

What ...

But how very strange it all was! Retribution had no doubt come for the deed which had terrified him then and which he was sure would go on terrifying him to the end. Since it had come, all unexpectedly, in this world, perhaps the punishment would be lighter in the next.

Unaware of these thoughts, the women quite lost themselves in ministering to the child. Because it was born of such a mother in Genji's late years, it must surely have the whole of his affection.

The ceremonies on the third night were of the utmost dignity and the gifts ranged out on trays and stands showed that everyone thought it an occasion demanding the best. On the fifth night the arrangements were Akikonomu's. There were robes for the princess and, after their several ranks, gifts for her women too, all of which would have done honor to a state occasion. Ceremonial repast was laid out for fifty persons and there was feasting all through the house. The staff of the Reizei Palace, including Akikonomu's personal chamberlain, was in attendance. On the seventh day the gifts and provisions came from the emperor himself and the ceremony was no less imposing than if it had taken place at court. To no Chujo should have been among the guests of honor, but his other worries made it impossible for him to go beyond general congratulations. All the princes of the blood and court grandees were present. Genji was determined that there be no flaw in the observances, but he was not happy. He did not go out of his way to make his noble guests feel welcome, and there was no music.

The princess was tiny and delicate and still very frightened. She quite refused the medicines that were pressed upon her. In the worst of the crisis she had hoped that she might quietly die and so make her escape. Genji behaved with the strictest correctness and was determined to give no grounds for suspicion. Yet he somehow thought the babe repellent and was held by certain of the women to be rather chilly.

"He doesn't seem to like it at all." One of the old women interrupted her cooings. "And such a pretty little thing too. You're almost afraid for it. And so late in his life, when he has had so few."

The princess caught snatches of their conversation and seemed to see a future of growing coldness and aloofness. She knew that she too was to blame and she began to think of becoming a nun. Although Genji paid an occasional daytime visit, he never stayed the night.

"I feel the uncertainty of it all more than ever," he said, pulling her curtains back. "I sometimes wonder how much time I have left. I have been occupied with

my prayers and I have thought that you would not want to see people and so I have stayed away. And how are you? A little more yourself again? You have been through a great deal."

"I almost feel that I might not live." She raised her head from her pillow. "But I know that it would be a very grave sin to die now.[4] I rather think I might like to become a nun. I might begin to feel better, and even if I were to die I might be forgiven." She seemed graver and more serious than before, and more mature.

"Quite out of the question – it would only invite trouble. What can have put the idea into your head? I could understand if you really were going to die, but of course you are not."

But he was thinking that if she felt constrained to say such things, then the generous and humane course might be to let her become a nun. To require that she go on living as his wife would be cruel, and for him too things could not be the same again. He might hurt her and word of what he had done might get abroad and presently reach her royal father. Perhaps she was right: the present crisis could be her excuse. But then he thought of the long life ahead of her, as long as the hair which she was asking to have cut – and he thought that he could not bear to see her in a nun's drab robes.

"No, you must be brave," he said, urging medicine upon her. "There is nothing wrong with you. The lady in the east wing has recovered from a far worse illness. We really did think she was dead. The world is neither as cruel nor as uncertain as we sometimes think it."

There was a rather wonderful calm in the figure before him, pale and thin and quite drained of strength. Her offense had been a grave one, but he thought that he had to forgive her.

Her father, the Suzaku emperor, heard that it had been an easy birth and longed to see her. His meditations were disturbed by reports that she was not making a good recovery.

She ate nothing and was weaker and more despondent. She wept as she thought of her father, whom she longed to see more intensely than at any time since she had left his house. She feared that she might not see him again. She spoke of her fears to Genji, who had an appropriate emissary pass them on to the Suzaku emperor. In an agony of sorrow and apprehension and fully aware of the impropriety, he stole from his mountain retreat under cover of darkness and came to her side.

Genji was surprised and awed by the visit.

"I had been determined not to have another glance at the vulgar world," said the emperor, "but we all know how difficult it is for a father to throw off thoughts of his child. So I have let my mind wander from my prayers. If the natural order of things is to be reversed and she is to leave me, I have said to myself, then I must see her again. Otherwise the regret would be always with me. I have come in spite of what I know they all will say."

There was quiet elegance in his clerical dress. Not wanting to attract attention, he had avoided the livelier colors permitted a priest. A model of clean simplicity,

thought Genji, who had long wanted to don the same garb. Tears came easily, and he was weeping again.

"I do not think it is anything serious," he said, "but for the last month and more she has been weak and has eaten very little." He had a place set out for the emperor before the princess's curtains. "I only wish we were better prepared for such an august visit."

Her women dressed her and helped her to sit up.

"I feel like one of the priests you have on night duty," said the emperor, pulling her curtains slightly aside. "I am embarrassed that my prayers seem to be having so little effect. I thought you might want to see me, and so here I am, plain and undecorated."

She was weeping. "I do not think I shall live. May I ask you, while you are here, to administer vows?"

"A most admirable request, if you really mean it. But the fact that you are ill does not mean that you will die. Sometimes when a lady with years ahead of her takes vows she invites trouble, and the blame that is certain to go with it. We must not be hasty." He turned to Genji. "But she really does seem to mean it. If this is indeed her last hour, we would certainly not want to deny her the support and comfort of religion, however briefly."

"She has been saying the same thing for some days now, but I have suspected that an outside force has made her say it. And so I have refused to listen."

"I would agree if the force seemed to be pulling in the wrong direction. But the pain and regret of refusing a last wish – I wonder."

He had had unlimited confidence in Genji, thought the emperor, and indications that Genji had no deep love for the princess had been a constant worry. Even now things did not seem to be going ideally well. He had been unable to discuss the matter with Genji. But now – might not a quiet separation be arranged, since there were no signs of a bitterness likely to become a scandal? Genji had no thought of withdrawing his support, it seemed clear, and so, taking his apparent willingness as the mark of his fidelity and himself showing no sign of resentment, might the emperor not even now make plans for disposing of his property, and appoint for her residence the fine Sanjo mansion which he had inherited from his father? He would know before he died that she had settled comfortably into the new life. However cold Genji might be he surely would not abandon her.

These thoughts must be tested.

"Suppose, then, while I am here, I administer the preliminary injunctions and give her the beginnings of a bond with the Blessed One."

Regret and sorrow drove away the last of Genji's resentment. He went inside the princess's curtains. "Must you think of leaving me when I have so little time before me? Do please try to bear with me a little longer. You must take your medicine and have something to eat. What you propose is very admirable, no doubt, but do you think you are up to the rigors it demands? Wait until you are well again and we will give it a little thought."

But she shook her head. He was making things worse.

Though she said nothing, he could imagine that he had hurt her deeply, and he was very sorry. He remonstrated with her all through the night and presently it was dawn.

"I do not want to be seen by daylight," said the Suzaku emperor. He summoned the most eminent of her priests and had them cut her hair. And so they were ravaged, the thick, smooth tresses now at their very best. Genji was weeping bitterly. She was the emperor's favorite, and she had been brought to this. His sleeves were wet with tears.

the 3rd princess is now a nun...

"It is done," he said. "Be happy and work hard at your prayers."

The sun would be coming up. The princess still seemed very weak and was not up to proper farewells.

"It is like a dream," said Genji. "The memory of an earlier visit comes back and I am extremely sorry not to have received you properly. I shall call soon and offer apologies."

He provided the emperor with an escort for the return journey.

"Fearing that I might go at any time," said the emperor, "and that awful things might happen to her, I felt that I had to make provision for her. Though I knew that I was going against your deeper wishes in asking you to take responsibility, I have been at peace since you so generously agreed to do so. If she lives, it will not become her new vocation to remain in such a lively establishment. Yet I suspect that she would be lonely in a mountain retreat like my own. Do please go on seeing to her needs as seems appropriate."

"It shames me that you should find it necessary at this late date to speak of the matter. I fear that I am too shaken to reply." And indeed he did seem to be controlling himself only with difficulty.

News of the birth seemed to push Kashiwagi nearer death. He was very sad for his wife, the Second Princess. It would be in bad taste for her to come visiting, however, and he feared that, whatever precautions were taken, she might suffer the embarrassment of being seen by his parents, who were always with him. He said that he would like to visit her, but they would not hear of it. He asked them, and others, to be good to her.

His mother-in-law had from the start been unenthusiastic about the match. To no Chujo had pressed the suit most energetically, however, and, sensing ardor and sincerity, she had at length given her consent. After careful consideration the Suzaku emperor had agreed. Back in the days when he had been so worried about the Third Princess he had said that the Second Princess seemed nicely taken care of. Kashiwagi feared that he had sadly betrayed the trust.

"I hate to think of leaving her," he said to his mother. "But life does not go as we wish it. Her resentment at the promises I have failed to keep must be very strong. Do please be good to her."

"You say such frightening things. How long do you think I would survive if you were to leave me?"

She was weeping so piteously that he could say no more, and so he tried discussing the matter of the Second Princess with his brother Kobai.[5] Kashiwagi

was a quiet, well-mannered youth, more father than brother to his youngest brothers, who were plunged into the deepest sorrow by these despairing remarks. The house rang with lamentations, which were echoed all through the court. The emperor ordered an immediate promotion to councillor of the first order.

"Perhaps," he said, "he will now find strength to visit us."

The promotion did not have that happy effect, however. He could only offer thanks from his sickbed. This evidence of the royal esteem only added to To no Chujo's sorrow and regret.

A worried Yugiri came calling, the first of them all to offer congratulations. The gate to Kashiwagi's wing of the house was jammed with carriages and there were crowds of well-wishers in his antechambers. Having scarcely left his bed since New Year, he feared that he would look sadly rumpled in the presence of such finery. Yet he hated to think that he might not see them again.

Yugiri at least he must see. "Do come in," he said, sending the priests away. "I know you will excuse my appearance."

The two of them had always been the closest of friends, and Yugiri's sorrow was as if he were a brother. What a happy day this would have been in other years! But of course these wishful thoughts accomplished nothing.

"Why should it have happened?" he said, lifting a curtain. "I had hoped that this happy news might make you feel a little better."

"I am very sorry indeed that I do not. I do not seem to be the man for such an honor." Kashiwagi had put on a formal cap. He tried to raise his head but the effort was too much for him. He was wearing several pleasantly soft robes and lay with a quilt pulled over him. The room was in simple good taste and incenses and other details gave it a deep, quiet elegance. Kashiwagi was in fact rather carefully dressed, and great attention had obviously gone into all the appointments. One expects an invalid to look unkempt and even repulsive, but somehow in his case emaciation seemed to give a new fineness and delicacy. Yugiri suffered with him as he struggled to sit up.

"But what a pleasant surprise," said Yugiri (though brushing away a tear). "I would have expected to find you much thinner after such an illness. I actually think you are better-looking than ever. I had assumed, somehow, that we would always be together and that we would go together, and now this awful thing has happened. And I do not even know why. We have been so close, you and I – it upsets me more than I can say to know nothing about the most important matter."

"I could not tell you if I wanted to. There are no marked symptoms. I have wasted away in this short time and scarcely know what is happening. I fear that I may no longer be in complete control of myself. I have lingered on, perhaps because of all the prayers of which I am so unworthy, and in my heart I have only wanted to be done with it all.

"Yet for many reasons I find it hard to go. I have only begun to do something for my mother and father, and now I must cause them pain. I am also being remiss in my duties to His Majesty. And as I look back over my life I feel sadder than I

can tell you to think how little I have accomplished, what a short distance I have come. But there is something besides all this that has disturbed me very much. I have kept it to myself and doubt that I should say anything now that the end is in sight. But I must. I cannot keep it to myself, and how am I to speak of it if not to you? I do have all these brothers, but for many reasons it would do no good even to hint of what is on my mind.

"There was a matter which put me at cross purposes with your esteemed father and for which I have long been making secret apology. I did not myself approve of what I had done and I fell into a depression that made me avoid people, and finally into the illness in which you now see me. It was all too clear on the night of the rehearsal at Rokujo that he had not forgiven me. I did not see how it would be possible to go on living with his anger. I rather lost control of myself and began having nervous disturbances, and so I have become what you see.

"I am sure that I never meant very much to him, but I for my part have been very dependent on him since I was very young. Now a fear of the slanders he may have heard is my strongest bond with this world and may be the greatest obstacle on my journey into the next. Please remember what I have said and if you find an opportunity pass on my apologies to him. If after I am gone he is able to forgive whatever I have done, the credit must be yours."

He was speaking with greater difficulty. Yugiri could think of details that seemed to fit into the story, but could not be sure exactly what the story had been.

"You are morbidly sensitive. I can think of no indication of displeasure on his part, and indeed he has been very worried about you and has said how he grieves for you. But why have you kept these things to yourself? I should surely have been the one to convey apologies in both directions, and now I suppose it is too late." How he wished that they could go back a few years or months!

"I had long thought that when I was feeling a little better I must speak to you and ask your opinion. But of course it is senseless to go on thinking complacently about a life that could end today or tomorrow. Please tell no one of what I have said. I have spoken to you because I have hoped that you might find an opportunity to speak to him, very discreetly, of course. And if you would occasionally look in on the Second Princess. Do what you can, please, to keep her father from worrying about her."

He wanted to say more, it would seem, but he was in ever greater pain. At last he motioned that he wanted Yugiri to leave him. The priests and his parents and numerous others returned to his bedside. Weeping, Yugiri made his way out through the confusion.

Kashiwagi's sisters, one of them married to Yugiri and another to the emperor, were of course deeply concerned. He had a sort of fraternal expansiveness that reached out to embrace everyone. For Tamakazura he was the only one in the family who really seemed like a brother. She too commissioned services.

They were not the medicine he needed.[6] He went away like the foam upon the waters.

The Second Princess did not after all see him again. He had not been deeply in love with her, not, indeed, even greatly attached to her. Yet his behavior had been correct in every detail. He had been a gentle, considerate husband, making no demands upon her and giving no immediate cause for anger. Thinking sadly over their years together, she thought it strange that a man doomed to such a short life should have shown so little inclination to enjoy it. For her mother, the very worst had happened, though she had in a way expected it. Her daughter had married a commoner, and now everyone would find her plight very amusing.

Kashiwagi's parents were shattered. The cruelest thing is to have the natural order upset. But of course it had happened, and complaining did no good. The Third Princess, now a nun, had thought him impossibly presumptuous and had not joined in the prayers, but even she was sorry. Kashiwagi had predicted the birth of the child. Perhaps their strange, sad union had been joined in another life. It was a depressing chain of thoughts, and she was soon in tears.

The Third Month came, the skies were pleasant and mild, and the little boy reached his fiftieth day. He had a fair, delicate skin and was already showing signs of precociousness. He was even trying to talk.

Genji came visiting. "And have you quite recovered? Whatever you say, it is a sad thing you have done. The occasion would be so much happier if you had not done it." He seemed near tears. "It was not kind of you."

He now came to see her every day and could not do enough for her.

"What are you so worried about?" he said, seeing that her women did not seem to know how fiftieth-day ceremonies should be managed in a nun's household. "If it were a girl the fact that the mother is a nun might seem to invite bad luck and throw a pall over things. But with a boy it makes no difference."

He had a little place set out towards the south veranda of the main hall and there offered the ceremonial rice cakes. The nurse and various other attendants were in festive dress and the array of baskets and boxes inside the blinds and out covered the whole range of colors – for the managers of the affair were uninhibited by a knowledge of the sad truth. They were delighted with everything, and Genji smarted and squirmed.

Newly risen from her sickbed, the princess found her heavy hair very troublesome and was having it brushed. Genji pulled her curtains aside and sat down. She turned shyly away, more fragile than ever. Because there had been such regrets for her lovely hair only a very little had been cut away, and only from the front could one see that it had been cut at all. Over several grayish singlets she wore a robe of russet. The profile which she showed him was charming, in a tiny, childlike way, and not at all that of a nun.

"Very sad, really," said Genji. "A nun's habit is depressing, there is no denying the fact. I had thought I might find some comfort in looking after you as always, and it will be a very long time before my tears have dried. I had thought that it might help to tax myself with whatever unwitting reasons I may have given you for dismissing me. Yes, it is very sad. How I wish it were possible to go back.

322

"If you move away I shall have to conclude that you really do reject me, with all your heart, and I do not see how I shall be able to face you again. Do please have a thought for me."

"They tell me that nuns tend to be rather withdrawn from ordinary feelings, and I seem to have been short on them from the start. What am I to say?"

"You are not fair to yourself. We have had ample evidence of your feelings." He turned to the little boy.

The nurse and the other attendants were all handsome, wellborn women whom Genji himself had chosen. He now summoned them for a conference.

"What a pity that I should have so few years left for him."

He played with the child, fair-skinned and round as a ball, and bubbling with good spirits. He had only very dim memories of Yugiri as a boy, but thought he could detect no resemblance. His royal grandchildren of course had their father's blood in their veins and even now carried themselves with regal dignity, but no one would have described them as outstandingly handsome. This boy was beautiful, there was no other word for it. He was always laughing, and a very special light would come into his eyes which fascinated Genji. Was it Genji's imagination that he looked like his father? Already there was a sort of tranquil poise that quite put one to shame, and the glow of the skin was unique.

The princess did not seem very much alive to these remarkable good looks, and of course almost no one else knew the truth. Genji was left alone to shed a tear for Kashiwagi, who had not lived to see his own son. How very unpredictable life is! But he brushed the tear away, for he did not want it to cloud a happy occasion.

"I think upon it in quiet," he said softly, "and there is ample cause for lamenting."[7]

His own years fell short by ten of the poet's fifty-eight, but he feared that he did not have many ahead of him. "Do not be like your father":[8] this, perhaps, was the admonition in his heart. He wondered which of the women might be in the princess's confidence. He could not be sure, but they were no doubt laughing at him, whoever they were. Well, he could bear the ridicule, and a discussion of his responsibilities and hers in the sad affair would be more distressing for her than for him. He would say nothing and reveal nothing.

The little boy was charming, especially the smiling, happy eyes and mouth. Would not everyone notice the resemblance to the father? Genji thought of Kashiwagi, unable to show this secret little keepsake to his grieving parents, who had longed for at least a grandchild to remember him by. He thought how strange it was that a young man so composed and proud and ambitious should have destroyed himself. His resentment quite left him, and he was in tears.

"And how does he look to you?" Genji had taken advantage of a moment when there were no women with the princess. "It is very sad to think that in rejecting me you have rejected him too."

She flushed.

"Yes, very sad," he continued softly.

> "Should someone come asking when the seed was dropped,
> What shall it answer, the pine among the rocks?"

She lay with her head buried in a pillow. He saw that he was hurting her, and fell silent. But he would have liked to know what she thought of her own child. He did not expect mature discernment of her, but he would have liked to think that she was not completely indifferent. It was very sad indeed.

Notes

1 The soliloquy contains allusions to at least five poems.
2 Kashiwagi's nurse is her aunt.
3 *Tales of Ise* 110: "In longing my soul has ventured forth alone / If you see it late in the night, please seek to trap it." There were ways of catching errant spirits.
4 It was thought a grave sin to die in childbirth.
5 Textual difficulties make it possible that this is either Kobai or a younger brother.
6 Anonymous, *Shuishu* 665: "My sickness comes from unrequited longing / The medicine I need is brewed from heartvine." There is the usual pun on *aoi*, "heartvine" and "day of meeting," and there is the further association with the Kamo festival, which provided the occasion, in the preceding chapter, for Kashiwagi's first meeting with the Third Princess.
7 Bo Juyi, Collected Works, XXVIII, on the birth of a son in his old age: "I think upon it in quiet. There is ample cause for joy, and ample cause for lamenting."
8 From the same poem.

31

The Unity of the Three Creeds: A Theme in Japanese Ink Painting of the Fifteenth Century

John M. Rosenfield

Introduction

In the following reading, the art historian John M. Rosenfield examines the meaning behind "The Unity of the Three Creeds," a popular theme in fifteenth-century Japanese *suiboku* (ink) painting. The "Three Creeds" are Confucianism, Daoism, and Buddhism, belief systems that, along with the technique of ink painting and numerous other artistic practices, Japanese culture appropriated from China. Rosenfield examines the historical and literary significance of the theme in China and then Japan, linking it to cultural developments of the Muromachi period (1336–1573).

Artistic advancement, but also volatile politics and constant warfare, marked the Muromachi period. For nearly two and a half centuries the Ashikaga family ruled Japan through a series of shoguns (military leaders), whose headquarters were in the Muromachi district of Kyoto, thus giving the era its name. The eighth Ashikaga shogun, Yoshimasa (1436–90), while a weak ruler, was an important patron of the arts. Many scholars consider his reign to mark the height of *suiboku* painting as well as *gozan bunka*, or *gozan* culture.

The term *gozan*, literally meaning "the five mountains," originally referred to a group of Zen Buddhist temples in and around Kyoto supported by the shogunates of

John M. Rosenfield, "The Unity of the Three Creeds: A Theme in Japanese Ink Painting of the Fifteenth Century," pp. 205–17, 224–5 from John Whitney Hall and Toyoda Takeshi (eds), *Japan in the Muromachi Age*. Ithaca, NY: East Asia Program, Cornell University, 2001 [1977]. Reprinted by permission of John M. Rosenfield.

the Kamakura (1185–1336) and Muromachi periods. The monks at these temples devoted themselves to studying literature and poetry from Song dynasty China (960–1279), and then transmitted their knowledge to the ruling military class. This interplay of Chinese Song ideas with Zen Buddhist and shogun principles fostered *gozan* culture, named after the temples in which it developed. The culture, flourishing during the fourteenth and fifteenth centuries, included *suiboku* painting as well as *no* theater, flower arranging, the tea ceremony, and poetry. Although they were made by monks, the subject matters of the *suiboku* paintings, which were done in monochromatic ink emphasizing brushwork, were not strictly religious, but covered a wide range. Typically a *san*, an inscription in poetry or prose, accompanies the scene or figures, and may have been written by the artist or added by someone else. Prominent *suiboku* monk-painters included Josetsu (active fifteenth century), a Chinese artist who moved to Japan; Tensho Shubun (d. 1460), who studied with Josetsu; Oguri Sotan (active fifteenth century), a student of Shubun; and Sesshu Toyo (1420–1506), another student of Shubun.

By examining the meaning of the Unity of the Three Creeds in China and then in Japan, Rosenfield touches on three different time periods: Muromachi Japan and Song dynasty China, as well as fourth- and fifth-century China, when the figures featured in the Unity of the Three Creeds would have lived. The reading also addresses the relationship between text and image and the relationship between Chinese and Japanese artistic development.

During the lifetime of Yoshimasa, the eighth Ashikaga shogun, Japanese ink painting (*suibokuga*) became a coherent, fully mature pictorial language in both artistic and social terms.[1] Despite its foreign origins, this art form had reached the point where it could express the basic cultural values of the leaders of Japanese society. Members of the Ashikaga family were enthusiastic collectors and patrons of painting; Yoshimochi, the fourth shogun, was himself an accomplished artist. Ink painting was seriously practiced in several ranking Zen monasteries of Kyoto and Kamakura, and the taste for ink painting was adopted by provincial samurai and monks. By the 1450s paintings of eloquence, subtlety, and high technical proficiency were being executed by men under the tutelage of the Sokokuji monk Tensho Shubun, who is thought to have served Yoshimasa as *goyo eshi*, or official court painter.

Ink painting was also closely related to other forms of expression in a broad but unified cultural movement that had appealed to the Japanese intelligentsia from the thirteenth century onward. The unity of this movement has been widely recognized by scholars and its parts well defined, but to my knowledge the only overall name it has been given is *gozan bunka* (*gozan* culture), or *gozan bungei* (*gozan* art), which is not entirely satisfactory. It deserves a name as broad and meaningful as the term "Renaissance" in Western history, for it was equally inclusive and equally consistent intellectually. It was also equally enduring, for it flourished despite the civil wars of the sixteenth century as one of the most central features of Japanese civilization. The scope of this movement ranged from philo-

sophic speculation to the shape of the implements of daily life; it included state symbolism, architecture, garden design, painting, calligraphy, essays and poetry, the establishment and spread of the Zen Buddhist community, the *no* drama, the tea ceremony and flower arrangement, and the collection and manufacture of ceramic ware.

Although ink painting was only one part of this larger complex, it reflected almost all the other parts, and its symbolic content was extremely varied. Its iconic motifs came from traditional Mahayana Buddhist art, Zen Buddhist traditions, Confucian and Daoist legends, Chinese nature poetry, and Japanese poetic traditions. Despite this diversity in subject matter, the vast majority of ink paintings and their inscriptions prior to the 1470s were made by Zen Buddhist monks. Whether true to the severe monastic discipline, as most were, or monks in name only, these painters expressed in their works values that were not exclusively those of Zen Buddhism but were part of the broader *gozan* cultural matrix of which Zen itself was a part.

The meanings of Japanese ink painting, as in any other pictorial language, were conveyed in two different ways: symbolically through the verbal content of the subjects depicted (often reinforced by poems and comments written on the paintings themselves) and nonverbally through the nuances of expression imparted by the artist's choice and handling of his materials. I should like in this essay to focus on the former, the symbolic or verbal content, without denying the importance of the purely visual dimension.

It is not yet possible to make a complete iconological review of all themes of Japanese *suibokuga*; this would demand the labor of several lifetimes. As a test case, however, I will explore here fifteenth-century examples of one major theme that appears steadily throughout the history of Sino-Japanese ink painting well into the modern era, that of the Unity of the Three Creeds – Buddhism, Confucianism, and Daoism.[2] This test case will suggest some of the nuances of meaning possessed by paintings of the Higashiyama era, some of the historical perspectives of the Kyoto artists, their awareness of Chinese painting and poetry, and something of the matrix of consciousness from which their perception of art emerged.

As is true for other didactic motifs in *suibokuga*, we begin to grasp the conceptual meaning of the Three Creeds theme only after analyzing many examples and after considering its historic origins. Even then, the student must inevitably contend with a certain amount of uncertainty. Inscriptions on paintings are often difficult to decipher accurately and then to translate and interpret in English. They often contain puns, with double and triple meanings, or references to obscure Chinese poems. Inscriptions recorded in *gozan* literary texts were sometimes inaccurately copied; whole stanzas have been lost or a single character altered enough to distort the meaning of an entire poem. In addition, the verbal content of paintings of the Unity of the Three Creeds was often intentionally obscure. Such themes were heavily tinged with irony, contradiction, and paradox. They depended on the use of metaphor and, above all, incompleteness, obliging

the observer to form his own conclusions to an unfinished chain of thought or to complete in his imagination a picture that is undetailed and indefinite. One does not find in suibokuga the hieratic and strictly logical symbolic system of a Buddhist mandala or a French Gothic cathedral façade; the symbols in *suibokuga* are often indirect, understated, or purposely concealed. Nonetheless, the symbolism was meant to be understood.

Despite such interpretive difficulties, the theme of the Unity of the Three Creeds is particularly important because it expresses a point of view that pervades the entire *gozan* aesthetic system. The paintings on this theme express the principle of the fundamental unity of man, nature, and society and of political-ethical, religious, and artistic concerns. It is a principle that dissolves the boundaries between the sacred and the profane, the self and the nonself, the animate and the inanimate, the beautiful and the ugly, between social classes and between nations. The principle of the transcendental oneness or identity of all things has ancient roots in the metaphysics of both Mahayana Buddhism and Daoism; but, as in many other elements of the Muromachi cultural movement, this old notion is given new and effective application.

The paintings on the theme of unity illustrate yet another important feature of Muromachi art, and that is its secularism. During the fifteenth century, the mainstream of Japanese painting was finally and conclusively freed from its subservience to traditional Buddhist art. The appearance of a truly secular imagery in *suibokuga* – birds, animals, flowers, topographic landscapes, Confucian and Daoist figures – marked the final fading away as a major creative art form of the international tradition of hieratic painting that had flourished since the introduction of Buddhism to Japan. This is a great watershed, a point of demarcation in Japanese cultural history remarkably similar to that in the West between the arts of the Renaissance and those of Medieval Christianity from which they emerged.

Finally, the paintings on the theme of unity give evidence of the appearance in the Higashiyama period of the ideology of the Chinese *wenren* or *literati* tradition. The ideal of the *wenren*, an ancient one in Chinese civilization, was that of the amateur of the arts whose pursuit of personal cultivation must be free from all external compulsion. The model *wenren* would be a man with a private income or a political sinecure, who was poet and painter, antiquarian and collector, living simply and informally in a rural setting, treasuring above all the circle of his friends – their warm comradeship in walking trips, drinking parties, and poetic gatherings – avoiding involvement in political and social affairs. Despite the long prevalence of the *wenren* ideal, it did not produce a distinct school of painting in China until the fifteenth century and the emergence of such men as Shen Zhou (1427–1509) and Wen Zhengming (1470–1559). Not only did these painters consciously pursue the life style of the literati, they also developed a pictorial style that was a scholarly review of modes of the past done often with a simplicity and artlessness that sustained their pose as amateurs. In Japan the *wenren* movement became an organized, articulate force devoted to the literati style of painting only

didn't catch on in china really

in the mid- and late-Edo period, when it nurtured such giant talents as Yosa Buson, Ike no Taiga, or Uragami Gyokudo. Nonetheless the ideal gained currency and had a palpable influence in the fifteenth century, as an analysis of the emblems of the Unity of the Three Creeds will show.

The Three Laughers of the Tiger Ravine

The concept of the Unity of the Three Creeds was symbolized in painting by three motifs so closely related that, on occasion, they cannot be distinguished one from the other: the Three Laughers of the Tiger Ravine, the Men of the Three Creeds Tasting Vinegar, and the Patriarchs of the Three Creeds. The most familiar of the emblems is that of the Three Laughers, illustrated in this essay by an inscribed painting of the second half of the fifteenth century (see Fig. 31–1). As an allegory set in circumstances remote from fifteenth-century Kyoto, its main figures were famous in ancient Chinese cultural history: the Buddhist monk Huiyuan (334–416), the poet Tao Yuanming (*c*.365–427), and the Daoist scholar and wonder-worker Lu Xiujing (*c*.406–477). Their biographies were well known to the Japanese monks of the Muromachi period, and we must familiarize ourselves with certain details in order to understand their symbolic value.

Huiyuan was born in northern Shansi and given a sound education in both Confucian and Daoist classics.[3] At the age of twenty-one, he heard the celebrated Buddhist theologian Daoan expound the doctrine of Perfection of Wisdom. He was so deeply impressed that he declared Confucianism, Daoism, and other schools of philosophy to be no more than chaff and became Daoan's disciple. In 373, Huiyuan established himself south of the Yangzi on Mount Lu. Remaining in his Hermitage of the Eastern Grove, he exerted a strong personal influence on the spread of Mahayana Buddhism in South China. Once established at Mount Lu, Huiyuan lived strictly by the monastic regulations. His official biography states that during the more than thirty years in which he lived there his shadow never left the mountain; his steps never reentered the profane world. When seeing off guests or taking a walk, he would make the Tiger Ravine the limit beyond which he would not go.

Tao Yuanming (Tao Jian) was born into a gentry family of Kiukiang south of the Yangzi.[4] Although his family had fallen onto hard times, he was educated in the Six Classics and entered official service. But he soon retired to live as a farmer, refusing to have further dealings with officialdom. He proclaimed that his instinct was all for freedom; he would tolerate no discipline or restraint. He would rather endure hardship, hunger, and cold than do things against his will. "Whenever I have been involved in official life," he once wrote, "I was mortgaging myself to my mouth and belly." As a poet-recluse, he lived a simple life near the southern slopes of Mount Lu, cultivating his fields and his favorite flower, the yellow

329

chrysanthemum. He was a contemporary of Huiyuan; however there is no record of the two men having met.

Tao Yuanming's poetry, in its simplicity and straightforward style, was a source of inspiration to later Chinese literati. It was also long known and studied in Japan. Of the three men depicted in the Three Laughers paintings, Tao was probably the most familiar to Japanese, assuming something of the role of prototype for the literati ideal.

The third of the Three Laughers was a pioneer in compiling the canon of Daoist religious texts and in organizing its doctrines.[5] Lu Xiujing, a native of Wuxing in Chekiang province, learned Daoist fortunetelling and prognostication at an early age. Becoming a mountain-dwelling ascetic, he visited famous mountain retreats in search of Daoist texts and in 424–425 sold medicines from village to village. Finally, in 453, he set up a simple, solitary retreat at Mount Lu near a waterfall. Lu was noted as an eloquent opponent of Buddhism.

In its simplest form, the allegory of the Three Laughers tells that one evening, after Tao and Lu had visited Huiyuan in his hermitage on Mount Lu, the monk walked with them as they were returning home.[6] Lost in conversation, Huiyuan inadvertently crossed the bridge over the Tiger Ravine and at that moment a tiger roared. Suddenly realizing that Huiyuan's vow had been broken, the three burst into laughter. In paintings of the theme, Huiyuan is often shown wearing the patchwork robe of a Buddhist monk, Tao Yuanming a leopard-skin cape, and Lu Xiuching a tiny cap. On occasions, a servant boy is shown watching the event.

The legend of the Three Laughers seems to have been accepted as a truthful account in 1072 by a court official, Chen Shunyou, in his *Record of Mount Lu (Lushanji)* and thereafter passed quickly into general currency. The oldest record of a painting of the theme dates from approximately the same time. The Song poet Su Dongpo (1036–1101) wrote an inscription on a painting of the theme found on the walls of a villa of his patron Ouyang Xiu (1007–1072). The painting, long since lost, was attributed to the eccentric master Shike, active at the end of the tenth century.[7] Su Dongpo's inscription may be translated:

> They three
> are sages;
> In gaining the concept
> words are forgotten.
> Instead they utter
> a stifled laugh
> In their pleasure
> and innocence.
> Ah! this small boy
> watches them
> As the deer
> watches the monkey.
> You! What do

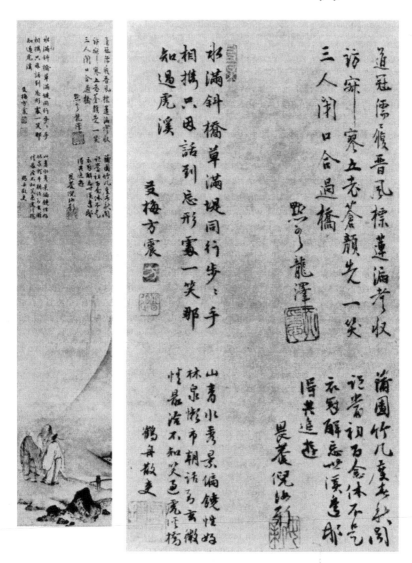

Fig. 31-1 The Three Laughers of the Tiger Ravine, c.1500. With detail of inscription on the right. Ink on paper. Asano Collection, Tokyo.

any of you know?
Your very laughter
fills the world.
What is despicable?
What is admirable?
Each laugh
is that laugh.
One cannot know
which of you is superior.

Su Dongpo and his circle of eminent friends around the beginning of the twelfth century were the most specific point of origin for the subsequent Japanese imagery of the Three Laughers. This may be seen in another early example of the theme, a poem from Su Dongpo's close friend Huang Dingjian (1045–1105). Composed in 1102, this poem was based on an earlier one by the famous Chan monk and painter Chanyue of the late Tang–early Five Dynasties period, who lived for many years in the Hermitage of the Eastern Grove on Mount Lu. Huang began with an explanatory preface in prose, then quoted Chanyue's verse:

> The monk Huiyuan, dwelling on the slopes of Mount Lu, observed the rules of pure asceticism and fanatically refused the honeyed water which might have saved his life. However, when composing poems, he would turn to wine and drink with Tao Yuanming. When he bade farewell to his guests, whether they were high or low in rank, he would not cross the Tiger Ravine. However, when accompanying Lu Xiujing, the Daoist sage, he went a hundred steps beyond and, giving a great laugh, then parted from him. Chanyue's poem went as follows:

> > Being fond of Tao the Senior Official,
> > he drunkenly plodded onward;
> > Bidding farewell to Lu the Daoist
> > he tottered at a snail's pace,
> > And crossed the Ravine to buy wine,
> > breaking all his solemn precepts.
> > What kind of person is the monk
> > who would do such a thing?

> Whereupon I [Huang Dingjian] have written the following imitation:

> > When greeting Tao Yuanming
> > he would take a cup of wine;
> > When bidding farewell to Lu Xiujing
> > he crossed the Tiger Ravine;
> > His heart, which held all learning,
> > was pure like a mirror.
> > That of the ordinary man, drunk
> > on the things of this world, is like dirt.[8]

Antecedent to this theme of unity, of course, had been centuries of competition between the three creeds in China, a vast topic outside the scope of this essay. The Confucians, for example, had long complained that Buddhism was a foreign creed based on legends that were irrational, extravagant, and unverifiable; that its monasteries took men out of service to society; that it was hostile to orderly government and the system of family-state loyalty. Attempts to minimize or reconcile points of difference were made again and again. In the mid-Tang period, especially in Chan Buddhist circles, doctrines of the equivalence of the three creeds became fashionable and thus served as a background for the

enthusiasm shown for the idea by the Northern Song literati. But always in the background of this theme was the harsh historical fact that Buddhism had been persecuted repeatedly in China; especially damaging was the suppression of 845 by the Emperor Wuzong, who was inspired in this by Daoists.

Japanese Buddhists were well aware of this conflict, but neither Confucianism nor Daoism had the authenticity and status in Japan that they possessed in China. Arguments about the relative merits of the creeds were secondhand reflections of an issue that was much more serious on the mainland. Moreover, by the fifteenth century the argument had subtly changed in character. While traces of the earlier religious disputes may be seen in the later poems and paintings, the three creeds had come to be subordinated to a higher principle, namely, the ideology of the Chinese literati. It is this principle which is particularly evident in the Japanese examples of the Muromachi era.

Dating no later than 1492 is the painting of the Three Laughers reproduced in Fig. 31–1.[9] Although the painter's name is unknown, his style is close to the Oguri school which had emerged from the circle of Tensho Shubun. Above the painting are four poems that were added at presumably the same time in a formal gathering or ceremony. Each poem comments on the theme of the painting and adds a twist to its meaning. The upper right corner, normally the place of most prominence, is here occupied by an inscription by Moku'un Ryutaku,[10] a well-known figure in *gozan* literary circles:

> A man in a Daoist hat,
>> a man in Confucian shoes
>> in the style of Jin;[11]
> As the lotus clock marks
>> the passing hours,[12]
>> the old ones gather to visit
>> at the lonely hermitage.
> Near Wulao Peak[13]
>> the monk's wizened face
>> is the first to break out
>> in laughter.
> The three men together,
>> saying nothing of it,
>> together cross the bridge.

The second poem is by Yubai Hoshin, a monk not recorded among major *gozan* figures:

> Water rushing under
>> the makeshift bridge;
>> the embankment choked
>> with weeds;
> Walking together

> step by step,
> leading each other
> by the hand.
> Discussing things
> of deepest profundity,
> and forgetting
> all formalities,[14]
> Then they laugh,
> realizing that
> they have crossed
> the Tiger Ravine.

The third inscription (lower right), the most difficult to translate, was written by a monk with the unusual name Ian Geijoshin:

> Seated meditating
> on a mat of rush,[15]
> leaning against
> an arm-rest of bamboo,
> they have passed the seasons
> in self-cultivation.
> But from the moment
> they hear
> each other speak
> all anxieties cease.
> When wearing
> their formal garb
> they had not understood
> unworldliness.[16]
> Past the boundary
> marked by the Ravine
> they are able
> to continue their ramble.

The last poem is by an unidentified man, perhaps a Chinese, who signed his name Kakushu Sanri:

> On the verdant mountain
> with sparkling streams,
> the vista opening
> richly to one side;
> By natural inclination
> they prefer secluded woods and springs,
> and cannot abide the vexations
> of official life.
> Their conversation reaches
> profound subtlety;

> their sentiments attain
> the utmost harmony.
> Without knowing it,
> and in laughter,
> they cross the bridge
> at the Tiger Ravine.

It will be noted that these inscriptions contain a willful contradiction. The poem of Moku'un states that Huiyuan intentionally violated his vow and laughed before he crossed the bridge. The second and fourth poems describe the men crossing the bridge unwittingly. But on a more fundamental issue all poems are in agreement: the three men represent Buddhism, Confucianism, and Daoism. The third poem, however, states that if the men retain their formal identities as Buddhist, Confucian, or Daoist they will not "understand unworldliness." "Unworldliness" is thereby offered as a condition of thought and life that is higher than any of the three creeds. Thus a major overtone of the Three Laughers motif here is not simply that representatives of three creeds are united, but that they are united by awareness of a higher reality that transcends the original beliefs. Huiyuan violates his most solemn and historically prominent vow as a monk. Tao Yuanming is a poor representative of the Confucian social ethic, since he gave up official life to become an eccentric recluse devoted to gardening, drinking, and poetry. All of this is permitted in the name of a transcendental higher reality.

If the three creeds are unified by recognizing a higher principle, I have not found a name given to that principle. None of the four poems translated above names it. In fact a specific, concrete answer would not be in keeping with the spirit of this tradition of thought. The higher reality or principle can be understood, however, in a negative and partial way. By crossing the Tiger Ravine, the men gain freedom from narrow orthodoxy. The Three Laughers symbolize spiritual and intellectual freedom guided by the principles of nonduality and nondiscrimination.

Clearly in Japan the complex system of religious and artistic activities which takes the name of *gozan bungei* rested heavily on a lineage of ideas that can be traced directly back to late eleventh-century China, to the circle of Su Dongpo, Huang Dingjian, Foyin Chanshi, and the painters Mi Fu, Li Gonglin, and Wang Shen. This group included Chan monks and was considerably influenced by the so-called Southern tradition of the sect. The group gave impetus to a cultural movement – informal and humanistic – that imparted a new meaning to the ancient ideal of the man of letters, the *wenren*. In this view, the amateur artist (poet-calligrapher-painter-scholar-musician) embodied the highest of all human attainments. Through his superior character and intellect, he rises to the rank of artist-philosopher. The professional artist who works mechanically from old copybooks and is content to satisfy the demands of his patrons is a poor thing by comparison. The true artist seeks spontaneity and directness, not technical perfection, and will defend his freedom – personal, intellectual, and

335

artists with out reservation or who were controled were highly reveared.

spiritual – against encroachment from any source. His spirit is exalted by his experiences in nature, by his love of the arts of the past, by the comradeship of his friends, and by the good, clear wine that helps him break the bonds of anxiety and worldly care.

With the fall of the Northern Song government in 1126, the *wenren* ideals were sustained in the Southern Song state and its capital at Hangzhou. There, in the last half of the twelfth and the early thirteenth centuries, the movement attained a brilliant flowering, more so in painting than in poetry. The artists were of diverse vocation: laymen, members of the court painting academy (*huayuan*), and monks of the nearby Chan and Tiantai monasteries. (The term *wushan*, meaning *gozan*, comes from the fact that the Chan monasteries were administered under a system of that name.) A central figure in the artistic circle was Wuzhun Shifan, abbot of the Chan monastery atop Jingshan. Meanwhile, in Japan, the Zen sect had come into its own as a separate and favored order. Along with the establishment of Zen temples in Kamakura and Kyoto, the *wenren* tradition was communicated to Japan as part of the *gozan* monastic and cultural tradition.

In Japan, with the support of the Kamakura and Ashikaga shogunal regimes and the powerful Zen monasteries, the *gozan* system achieved a stronger impact than it had attained in China, and its heritage in later centuries was more enduring. Ink painting developed on the model of Southern Song masters such as Mu Qi and Ma Yuan, whose imagery became a classic ideal for later generations in Japan, and the Southern Song style persisted there at the time when, in China, the more individualistic *wenren* style was chosen by the most original and creative painters.

Historically the *gozan* (*wushan*) cultural system in both Southern Song China and Muromachi Japan was buttressed by the doctrine of the Unity of the Three Creeds. Under this doctrine, there was no contradiction between the ruler's concern for civic welfare, the monk's preoccupation with spiritual salvation, and the poet's search for private insight. All shared common goals, and the ruler who supported the monastic establishment as well as a circle of poets and painters had promoted the principles of right conduct.

In China, however, the *gozan* cultural system declined rapidly after the Mongol conquest, the impoverishment of the Chan community, and the rise in the Ming period of the *wenren* as the dominant ideal for cultivated men. In Japan, the very success and long life of the *gozan* cultural system, and the continued vitality of the great Zen monasteries of Kyoto, postponed by two centuries the day when the literati school would emerge as a separate, well-defined artistic movement.

Notes

1 Two introductory books have appeared recently in English. Tanaka Ichimatsu, *Japanese Ink Painting: Shūbun to Sesshū*, The Heibonsha Survey of Japanese Art (Tokyo,

1972); and Matsushita Takaaki, *Ink Painting*, The Arts of Japan (Tokyo, 1974), vol. 7. See also Jon Carter Covell, *Under the Sea of Sesshū* (New York, 1941).

2 The importance of the theme is noted by Matsushita, pp. 47–53. See also Haga Koshiro, *Chusei Zenrin no gakumon oyobi bungaku ni kansuru kenkyu* (Tokyo, 1956). My essay has also made extensive use of Uemura Kanko, "On Viscount Suematsu's Study in the Thought of the Three Religions," *Kokka*, nos 338, 340, 341 (July, September, October 1918).

3 Tsukamoto Zenryu, in *Eion kenkyu*, ed. Kimura Eiichi (Kyoto, 1962), 2: 3–87; *Gao sengjuan: Taisho shinshu daizokyo*, 6: 357.3–361.2 (or pp. 240ff. in the English translation by E. Zurcher, *The Buddhist Conquest of China* [Leiden, 1959]).

4 James Hightower, *The Poetry of T'ao Chien* (Oxford, 1970).

5 Kimura, *Eion kenkyu*, 2: 384–433.

6 The historical basis of the legend is explored carefully by Nawa Ritei, *Geibun*, 15, no. 5 (1922).

7 Shike was a satirical painter originally from Chengdu and active around 965 in Kaifeng. A master of the *yipin* (untrammeled) style, he loved to shock and disturb his audience through his paintings. See Oswald Siren, *Chinese Painting* (New York, 1965), 1: 160–165; and Shimada Shujiro, *Bijutsu kentyu*, no. 161 (1950). The latter was translated by James Cahill and appeared in *Oriental Art* 7, no. 2 (1961): 66–74; 8, no. 3 (1962): 130–137; 10, no. 1 (1964): 19–26.

8 *Ko Sankoku*, in Kurata Junnosoke, ed., *Kanshi taikei* (Tokyo, 1967), 24: 217–219.

9 *Kokka*, no. 385 (1922).

10 Moku'un Ryutaku was a native of Harima who came to Kyoto at the age of ten, became an active scholar, and lived for a long period at Kenninji. He was a prolific poet, and his inscriptions are found on many paintings of the last two decades of the fifteenth century.

11 The Eastern Jin dynasty, 317–420.

12 A water clock made of lotus leaves, devised on Mount Lu by Huiyao, a disciple of Huiyuan.

13 One of the southern peaks of Mount Lu.

14 A Daoist phrase indicating the point where one no longer recognizes distinctions in experience.

15 A circular mat used in Buddhist monasteries when sitting in meditation.

16 Literally "forget the world," that is of daily affairs and formalities, routine and obligation.

32

Symbolic Virtue and Political Legitimation: Tea and Politics in the Momoyama Period

Kendall H. Brown

Introduction

In this chapter, Brown focuses on the relationship between art and politics during the Momoyama period in Japan (1568–1600 or 1615). He examines the tea ceremony as it reinforced the legitimacy of the shoguns, the military class governing Japan at the time. While the societal importance of tea differs in Chinese and Japanese contexts, during the Momoyama period in Japan, Chinese culture served as a marker of high status: an appreciation of Chinese culture and political theory indicated a person of refinement and education. Chinese imports such as Confucian societal and political principles (mentioned in the reading) organized relations between aristocrats, samurai (warrior/lords), and other lesser groups. Brown's chapter examines the rituals and meanings of a particular type of tea ceremony practiced during the Momoyama period and connects it to the Japanese interest in representations of Chinese recluses, or hermits.

Brown illustrates the particular type of reclusive lifestyle that the Japanese (and indeed the Chinese) admired. Getting away from the court into the mountains heightened a sense of refinement and shifted the elite's focus from sometimes empty court rituals into the intellect and behaviors of those emulating the hermit life. Recreating this sense of refinement, even if one could not journey to the

Kendall H. Brown, "Symbolic Virtue and Political Legitimation: Tea and Politics in the Momoyama Period," pp. 58–69 from *The Politics of Reclusion: Painting and Power in Momoyama Japan*. Honolulu: University of Hawaii Press, 1997. Reprinted by permission of The University of Hawaii Press. © 1997.

mountains, was a crucial element of Momoyama court and samurai culture. The rise of the "*wabi-sabi*" aesthetic in this period is directly linked to the emulation of the hermit life. *Wabi* means "solitary and poor," while *sabi* indicates a taste for the old. Paired together they form a valued quality for art – both visual and literary – that sought out lowly materials, and treasured the weathered and worn.

Brown links these seemingly abstract aesthetic concepts with physical spaces, such as the setting of the tea ceremony, and political interactions. The tea ceremony produced architectural forms called *shoin*, which were suited to particular refined practices of display while simultaneously embodying the *wabi-sabi* aesthetic through modest size and lowly materials. In his discussion of the tea ceremony, Brown draws together many strands of Japanese culture and the use of ritual more broadly, touching on the importance of Zen Buddhism, the use and form of gardens in relation to the *wabi* aesthetic, and the importance of liminal spaces for moments of transition and overturning societal norms. He also demonstrates how such refined and seemingly abstract actions as performing a tea ceremony might have real-world political implications when it comes to territorial battles and the manipulation of class distinctions.

The Patronage of Tea

The breadth and depth of tea patronage is surely testament to its wide-ranging appeal and manifold role in Momoyama society. Tea was practiced by all members of Momoyama society with the wealth sufficient to build and stock a teahouse (*chashitsu*), and time enough to engage in tea gatherings (*chakai*). More to the point, tea was virtually a required avocation for any man who sought access to the highest levels of Momoyama society or wished to style himself a person of importance.[1] Just as men of the medieval age desired the fictive mantle of the *tonseisha* or hermit, Momoyama men sought the sobriquet of *chajin* or tea adept. In the last decades of the sixteenth century and first decades of the seventeenth, tea became a national sacrament. As such, it was avidly pursued by Zen priests, wealthy merchants, aristocrats, and warriors alike. The contributions to tea by merchants, particularly the connections of the Sakai merchants Tsuda Sokyu (d. 1591) and Sen Rikyu to Daitokuji, are well documented.[2] Similarly, tea was long supported by aristocrats, from the Sumiya teahouse built on Mushanokoji in central Kyoto by the courtier and *renga* poet Sanjonishi Sanetaka (1455–1537)[3] to the various teahouses built by Prince Toshihito (1579–1629) at Katsura villa.[4]

For priests and aristocrats, tea was only one of several avenues of cultural expression, but for military men, tea was the preeminent sign of cultural accomplishment. In the words of Mary E. Berry, "The tea ceremony absorbed the military community and became its most common, and competitive, form of entertainment."[5] As the mark of a cultured gentleman-warrior, the acquisition

[handwritten margin note: For military men, the tea ceremony showed cultural accomplishment.]

339

and dispensation of tea vessels, as well as the strategic hosting of tea gatherings, has been much analyzed in Momoyama military culture. Oda Nobunaga (1534–82), for instance, confiscated tea wares from defeated enemies or conquered cities, then gave much of this booty to his generals as rewards.[6] Toyotomi Hideyoshi (1536–98) was noted for holding tea gatherings after battlefield victories or to cement new alliances.[7] His Grand Tea Gathering at Kitano in 1587 represents the hegemon's attempt to consolidate his rule over the people of Kyoto by display of his accomplishments in tea. In the apt phrase of Louise Cort, "Hideyoshi conquered Kyoto with tea just as surely as Nobunaga did with fire and the sword."[8] At the most mundane level, military leaders often employed tea gatherings to bring together opposing camps and to create ceremonies over which they, or their prestigious tea masters, could preside.[9] In 1585, upon receipt of the title of regent (*kanpaku*), Hideyoshi, accompanied by Rikyu, demonstrated his new status by serving tea to the emperor Ogimachi (r. 1557–1586) at the Imperial Palace.[10]

While specialists in Momoyama history and scholars of tea have dilated on the overtly political dimensions of the military patronage of tea, the genuine understanding and appreciation of tea by military men has often received short shrift. When we downplay the extent to which *samurai* considered tea as a real or at least symbolic release from social pressure, we are likely to overlook how the aesthetics of reclusion implicit in tea could serve as a subtle expression of the cultural right to rule. At the deepest level, tea became a potent symbol of social superiority only after its patrons could make a convincing claim to understand the rejection of normative social values which, as we shall demonstrate, are essential to tea ideology in the Momoyama period. Among all of the hegemon's potential assertions of political legitimacy based on cultural accomplishment, the most compelling claim to virtue is that which posits the rejection of the very power it seeks to hold. In short, the old Confucian ideal of political legitimacy based on virtue – that the man who can be trusted with power is the man who disdains power – could be neatly demonstrated through the practice of *wabi*-style tea, precisely because it is based on symbolic world rejection.

In the Momoyama period, tea was not merely enjoyed, it was employed as a tool of political legitimation. Yet, tea was a real avocation: an opportunity for temporary release from the myriad pressures felt by men working to maintain power or those struggling to gain it. At the same time, tea offered a means of advancing one's political interests. While men of all classes found useful tea's combination of aesthetic escapism and political pragmatism, for the military rulers who bore the real pressures of leadership, tea was indispensable. Among the many teamen (*chajin*) *samurai*, Hideyoshi provides a good model of the military tea adept who seems to have wrung from tea every drop of personal satisfaction and political advantage. In his important essay "Chanoyu and Momoyama: Conflict and Transformation in Rikyu's Art," Theodore Ludwig details how, for instance, during the late summer at the end of an enervating Kyushu campaign, Hideyoshi

hosted a number of intimate tea gatherings as compelling diversions from war-fare. Held in small, *soan*-style *chashitsu*, complete with simple flower arrange-ments and humble utensils, and including only two or three of Hideyoshi's closest tea advisors, these *chakai* had little direct political value; yet, this "aesthetic mode of life" must surely have refreshed the weary Hideyoshi.[11]

At his Osaka and Fushimi castles, Hideyoshi built a number of tearooms in different sizes and styles. The famous three-mat golden tearoom at Osaka Castle, which had been dismantled and taken to the Imperial Palace for Hideyoshi's tea with the emperor, served as a virtual display case of Hideyoshi's collection of "famous wares" (*meibutsu*). Most tea gatherings were held in spaces such as the small Yamazato tearoom in the "mountain village enceinte" (Yamazatomaru).[12] At Fushimi Castle, built in 1594, the Yamazatomaru was greatly expanded – now including gardens, an artificial lake, arbors, moon-viewing platforms, *no* stages, and two teahouses – so as to recreate the idealized countryside inside the castle walls.[13] The theme of "private cultivation in retirement"[14] expressed at the Yamazato complex at Fushimi suggests the degree to which tea offered a real opportunity for escape into a physical and psychological space where the patron could forget the blood and bile of military and political battles as he enjoyed the pleasures offered by devotion to nature, scholarly pursuits, like-minded *chajin*, and the elegant beauty of the teahouse.

In the Momoyama period, men of position used tea both as a method of political manipulation and as a means of civilized escape in a brutalized age. Yet this simple dichotomy obscures the deeper and more subtle sociopolitical signifi-cance of tea; namely, that tea transformed the values of aesthetic reclusion into ritual practice, and this codified and commodified ersatz eremitism could be displayed – literally and figuratively – as a sign of ultimate cultural accomplish-ment that, in turn, helped legitimize those who held or sought power. By engaging in a ritual that inverts the normative social experience, the participants in tea gatherings could claim to possess that brand of Confucian political theory that posited the rejection of power as one key aspect of the right to rule. Just as the Greek historian Thucydides held that "Of all manifestations of power, re-straint impresses men most," Momoyama political culture indicates that of all the ways of showing public virtue, the guise of the aesthete-recluse was the most impressive.

The Physical and Symbolic Structure of Tea

To understand the way in which political tensions could be expressed and ultim-ately resolved in tea, it is necessary to analyze the practice of tea in Momoyama in respect to its physical forms and their conceptual underpinnings. Tea was not a monolith but a living organism, which evolved into different and often hostile

schools, each with its own practice, theory, and set of "sacred" texts. In form as well as function, the opulent *basara* tea of the mid-Muromachi was nearly as different from restricted *wabi* tea of Momoyama as *wabi* tea was different from the accommodating *daimyo* tea espoused by Kobori Enshu (1579–1647) in the mid-seventeenth century.[15] The evolution of tea corresponded to the requirements of its patrons, and it is no coincidence that *wabi* tea reached its zenith in the Momoyama period.

In *wabi* tea of the Momoyama period there is no single set of values or practices. The tea advocated by Rikyu in the 1570s and 1580s, and continued in the next decades by his conservative disciples, is different from that espoused between 1590 and 1615 by his apostate pupil Furuta Oribe (1543–1615).[16] Even Rikyu's own practice of tea for Hideyoshi varied dramatically. For instance, his tea gatherings for Hideyoshi ranged from the showy affair of 1585 in the glittering golden tearoom to the subdued intimacies held beginning 1582 in the crepuscular Taian at the Myokian.[17] Yet, despite variations in the forms and functions of tea gatherings, the dominant form of Momoyama period *chanoyu* was the *wabi* style, and its characteristic manifestation was the small, rustic *soan* teahouse.[18]

Although each *soan* teahouse had a unique design and each tea gathering had a distinct character resulting from its combination of guests, the vessels and art objects used, and the season, weather, or time, nonetheless we can distinguish an overarching style and ethos of *wabi* tea. The physical and symbolic structure of *wabi* tea discussed here is an ideal. No matter the ulterior political and economic motives that may have stimulated teamen to host or attend tea gatherings, when they crossed the threshold of the *soan*, they entered into a make-believe world; when they lifted a bowl of tea to their lips, they partook in a shared fiction.

This ideal of *wabi* tea – the beliefs of the protagonists in this fictional world – is reconstructed from extant Momoyama and early Edo teahouses as well as from primary texts on tea. The following descriptions of *soan chashitsu* reflect the design of standing Momoyama teahouses such as the Taian at Myokian and the Karakasatei and Shiguretei at Kodaiji. In addition to this physical evidence, several texts on tea allow us to enter the minds of tea adepts and trace their thoughts. The important texts of *wabi* tea include *Yamanoue Sojiki*, the 1589 diary of Rikyu's contemporary Yamanoue Soji (1544–1590),[19] and *Nanporoku* (Record of Nanpo), the teachings of Rikyu as supposedly set down in 1593 by his disciple Nanpo Sokei (dates unknown).[20]

Besides the writings of Rikyu's Japanese followers, Portuguese Jesuits living in the Kyoto area wrote lengthy and, perhaps, more objective accounts of tea. João Rodrigues, a fluent Japanese speaker with broad experience among the powerful Japanese of the Momoyama period, was well acquainted with several of Rikyu's followers. Rodriques' long accounts of tea – found in his *Arte de Cha* and in the opening of chapter 35 in his *História* – demonstrate how thoroughly Rikyu's ideals of *wabi* tea had permeated Momoyama culture.[21]

Rodrigues' opening paragraph to chapter 35 in *História* presents a good summary of the aesthetic and conceptual core of *wabi* tea, which he, in Momoyama fashion, calls *suki*:

> Now everything used in the gathering – house, path, meal, utensils – must be adapted and matched to what *suki* professes, that is, the solitude and rustic poverty of a hermit. There should not be anything glossy or rich-looking; everything should be natural, comely, lonely, nostalgic, agreeable. Nature has endowed things with an elegance and grace which move the beholder to a feeling of loneliness and nostalgia, and a discernment of these qualities constitutes one of the main features of *suki*.[22]

good description

Rodrigues goes on to describe the planting of trees in the garden to achieve a feeling of natural artlessness. Then he lists the principle features of *suki* (or *wabi*-style tea) as cleanliness, rustic poverty, solitude, and awareness of subtlety. These qualities produce the qualities of modesty and integrity that, in turn, result in an affair where "the great nobles can mix with the lesser gentry without lessening their dignity thereby, for *suki* is a kind of rustic relaxation in the countryside."[23]

Rodrigues' account is valuable not only for the trenchant description of *wabi* but also for the analysis of how the artificially created effect of nature, with the implications of purity and world rejection, functions as a coy type of social rejection in which status distinctions are obscured even as they are preserved. As Rodrigues' description makes clear, the paradox of aesthetic reclusion – in which renunciation of society is achieved through attachment to values such as love of nature, scholarly pastimes, friends, and rustic beauty – is embedded in the very fiber of *wabi* tea. Tea embodies the antithetical values of world rejection and world affirmation characteristic of Momoyama culture.

Theodore Ludwig applies anthropologist Victor Turner's theories of ritual antistructure to *wabi* tea to show how it reduced conflict and promoted consensus in Momoyama society by positing a symbolic rejection of that society, which, in fact, allowed for its continuation. As a communal ritual that creates an antistructure where members of different social classes and ranks are temporarily made equal (or nearly so) in the pursuit of a shared experience, the tea gathering subverts the social order but, by doing so within the circumscribed context of ritual, serves as an outlet for social tensions.[24]

For Turner, the creation of a ritual antistructure – in essence, a temporary alternative social order – is based on liminality, communitas, symbolic poverty, display and veneration of sacred objects, and the secret rehearsal of a sacred history.[25] The *wabi*-style tea gathering presents an excellent model of ritual antistructure: the symbolic journey through the *roji* garden and entry into the *soan* tearoom create a state of liminality in which the participants are cut off from the outside world; the tea gathering itself creates communitas, as the guests and host intimately engage in conversation and the drinking of tea; the small-scale, grass-thatched *soan* is emblematic of poverty; the tea wares and scrolls used and exhibited serve as virtually sacred objects; and the discussion of venerable themes

associated with the tea vessels and the calligraphy or painting scrolls hung in the *tokonoma* constitute the rehearsing of a venerable history.

It is precisely this symbolic density of the *wabi* tea experience that creates a multiplicity of potential meanings. For military leaders, the mask of the aesthetic hermit was a powerful expression of cultural accomplishment and thus an effective way of demonstrating *kogi*. Yet, for those out of power, patronage of tea demonstrated a cultural right to rule equal to that of the military hegemons. Moreover, the relative leveling of social distinctions implicit in the ritual antistructure of *wabi* tea called into question the prevailing social order.[26] Because the symbolic antistructure of tea is also the informing concept behind many Momoyama hermit-theme paintings, it is useful to analyze in depth how Turner's concepts of ritual antistructure – liminality, ritual poverty, communitas, use of scared objects, and secret rehearsal of the past – inform the construct of aesthetic reclusion.

The ritual experience, for Turner, is defined first and foremost by the idea of liminality. Liminality refers to symbolic or actual behavior signifying separation of an individual or group from the normative social structure. In the liminal experience, the participant casts off his or her ordinary identity and takes on the "liberating mask" of a ritual actor. As such, the "liminar" is "divested of the outward attributes of structural position, set aside from the main areas of social life in a seclusion lodge or camp, and reduced to an equality with his fellow initiands regardless of their political status."[27] Although Turner is writing about West African religious ceremonies, he could be describing the ideals of tea in Momoyama Japan.

In ritual liminality, movement toward a new fictional status is conceived as a make-believe journey. If liminality is a state of passage, then travel is the perfect model for, or replication of, the liminal state. Turner finds liminality in rituals that take place in seclusion and, more obviously, in pilgrimages that remove the participant from everyday constraints even as they allow him or her to reenact (physically and symbolically) a sacred journey.[28] The tea gathering, with its preamble through the *roji*, begins with a ritual pilgrimage through nature as a prelude to seclusion in the *chashitsu*, where the ritual is performed.

The role of the *roji* in tea is similar to the natural setting of the Seven Sages and the Four Graybeards in Momoyama painting. By suggesting the liminality essential to ritual antistructure, the *roji* in tea and landscape setting in painting constitute a crucial element of aesthetic reclusion. Because no *roji* survive intact from the Momoyama period, we will have to base our analysis of the ideal on the *roji* as reconstructed from early-seventeenth-century *roji* and texts such as *Nanporoku*. According to the *Oboegaki* (Memoranda) chapter of *Nanporoku*, Rikyu first attributed positive values to this transitional space, and from his time the characters for "dewy ground" and "dewy path" were used.[29] The implication of dew is the freshness and purity associated with water. *Nanporoku* stresses that the *roji* should be watered just before the arrival of guests, during the break in the tea gathering, and again before the guests depart in order that it always be kept in a pristine state.[30]

The idea that the *roji* was a pure ground where the tea adept could be reborn aesthetically, if not socially and spiritually, is further evidenced by the likely entrance to many *roji*. Basing his opinion on diary accounts describing tea gatherings, Kumakura Isao has argued that many *roji* were entered through a type of small gate that resembled the "crawl door" (*nijiriguchi*) entrance characteristic of *soan*. Passing through this tiny door produced the sensation of entering "a utopia conceived as another world in the mountains,... a place which, although in the city, gave the appearance of remote mountains and deep valleys."[31]

Inside the *roji*, a number of design features were employed to create the effect of a path leading to a hermit's hut deep in the mountains. Because *roji* were small, usually squeezed into an urban plot or within the precincts of a temple or castle enceinte, the *roji* designer had to deploy a variety of symbols to suggest a mountain wilderness. For instance, in order to traverse the few meters of most Momoyama *roji*, guests were often invited to slip into special *geta*[32] and even hold a "*roji* staff" (*roji tsue*), an elegant version of the walking stick used when hiking in the mountains.[33] The stepping-stones (*tobiishi*), deployed first in the Momoyama period, are likely meant to evoke a rocky mountain path, just as the "sleeve-brushing pine" (*sodezuri matsu*) – planted so close to the path that one brushes past it – suggests that the tea adept has penetrated deep into the mountains.

The most symbolically significant feature of the *roji* is the *tsukubai*, a low handwashing basin (*chozubachi*) surrounded by several stones. In *Nanporoku*, Rikyu is quoted as saying that the first act in the *roji* is to rinse one's hands to "wash off the stains of worldly dust."[34] The *tsukubai*, its name derived from the verb *tsukubau*, "to squat," is placed low so one has to bend down as if rinsing in a mountain stream.[35] With its obvious conflation of purification with the experience of nature, the *tsukubai* epitomizes the *roji*.

The forest of symbols found in the *roji* helps suggest the state of liminality essential to the ritual eremitism of tea. According to *Nanporoku*, the great purpose of the *roji* is to wash away "worldly defilement" (*seji no kegare*) so that host and guest may meet mind to mind (*jikishin*).[36] In short, the liminal path through nature is a prerequisite to communitas. Turner identifies two ways in which the emphasis on nature is critical to liminality: first, if social structure is the product of human culture, the emphasis on nature suggests a negation or erasure of social order; second, once freed from the shackles of social structure, nature serves to "regenerate" the new status of the participant by suggesting alternative structures of life.[37] As a metaphoric journey through the mountains to a hermit's hut, the experience of the *roji* cleanses the tea adept of his worldly identification and prepares him for rebirth as an aesthete-recluse inside the *soan* teahouse.

By creating artificial barriers and then passing through them, by adding symbols of natural purity and then acknowledging them, tea practitioners fashioned a highly artificial but effective evocation of the liminal experience of journeying through a mountain wilderness. If the gate at the entry to the *roji* symbolizes

leaving the mundane world, garden shrubbery the mountain flora, and the *tsukubai* a limpid stream, then – in the make-believe world of tea – the *soan* is the hermit's hut hidden den deep in the wilderness.[38] As the movement through the *roji* is a ritual pilgrimage, the entry into the tea hut represents the culmination of the physical and metaphorical journey. Both the location of the tea gathering and its preeminent physical manifestation, the *soan chashitsu* is the preeminent symbol of liminality as well as of the ritual poverty and communitas that lie at the heart of *wabi* tea.

In that liminality is a state of detachment from ordinary society, the entrance to most *soan* teahouses makes clear the idea of rebirth into a new realm. Rikyu is generally credited with developing the *nijiriguchi* entrance that necessitates access to the *soan* by crawling on one's hands and knees through the small opening. This highly contrived ingress to the *soan*, reminiscent of the birth process, expresses the symbolic importance of the teahouse. Moreover, the small size of *nijiriguchi* meant that military men could not enter the *soan* wearing their clearest emblem of status – their swords. Thus, a sword rack (*katanakake*) was placed to the side of the *nijiriguchi*. Although participants in tea gatherings certainly were well aware of the status of other participants, the divestiture of swords and symbolic rebirth engendered by the *nijiriguchi* point to the ideals of liminality and communitas characteristic of *wabi* tea. Key to both concepts is ritual poverty.

The liminal state enhances communitas in part by the importance accorded poverty. According to Turner, "Liminal poverty, whether it is a process or a state, is both an expression and instrumentality of communitas."[39] With neither the status qualifications nor possessions of men of power, impoverished men such as peasants, beggars, and hermits can easily be assigned the symbolic role of representing fundamental human values. Thus, to maximize the sense of communitas between participants in the ritual process, signs of rank or other status distinctions must be minimized or eliminated. Mimicking the condition of the poor is a simple way of denying the normative social structure and of creating the optimal conditions for communitas.[40]

Whereas in Turner's West African societies the most conventional symbols of poverty were the clothes of beggars or outcasts,[41] in the ersatz eremitism of *wabi* tea, the rustic *soan* teahouse was the preeminent symbol of poverty and, by extension, of communitas. No matter the actual costs of *soan* teahouses (which were very high indeed), the symbolic renunciation of wealth and concomitant denial of social status in this architecture provide the *wabi* tea gathering with a spirit of poverty that, in theory, allows tea men to meet as equals. By comparison, in the larger, more elaborate and multipart *shoin* tearooms favored by Kobori Enshu, the eremitic fantasy is a more distant memory, and the ideal of communitas is substantially compromised.

The definitive architectural manifestation of *wabi* ideals is the Taian teahouse, likely designed by Rikyu at Hideyoshi's request. After approaching along a simple path that serves to heighten the feeling of withdrawal from the mundane world, guests enter the Taian through a *nijiriguchi*. Once inside, guests find themselves

engulfed in an other-worldly darkness and an almost impossibly small room. In total size, the Taian is four-and-one-half *tatami* mats, the standard dimensions for a *soan*. Yet, because two mats are used for two one-mat preparation spaces and a half-mat is employed for the *tokonoma*, the space for the *chakai* is only two mats (less than two meters square). One of these mats includes a built-in charcoal brazier, further reducing the area available for sitting.

Inside the Taian, daylight becomes twilight. The only natural illumination comes from three small windows covered with paper on a bamboo lattice. Rather than seeking to offset the lack of available light, the treatment of the interior emphasizes the chill and desiccated mood. The walls, plastered roughly so that bits of straw emerge, include areas where the plaster is broken off to reveal the lattice infrastructure. The lowest portion of the walls is covered with paper (*washi*), which sets off the rough surface above. In the same rustic vein, the supporting pillars are made of rough-cut, unfinished wood. The ceiling is constructed of a bamboo lattice with an infill of woven reeds, smoke-dried to increase the feeling of age. Only in a ritual where poverty is considered a virtue could such a tiny, dark, and aggressively humble interior be considered the pinnacle of aesthetic experience.

The defining feature of the Taian, and all other *soan*, is the grass-thatched roof, from which this type of teahouse takes its name. The grass-thatched *soan* is a recreation of the hermits' huts long championed in Japanese prose and poetry.[42] Just as the mountain location and humble materials of the hermit's hut indicated his detachment from mundane concerns, the artificial wilderness of the *roji* and the contrived (and costly) poverty of the *soan* were designed to show the tea adept's ostensible rejection of society. In chapter 33 of his *História*, João Rodrigues notes that in distinction to "ordinary social dealings," tea "is a secluded exercise in imitation of solitary hermits who have retired from social concerns."[43]

If the *soan* is a type of fictionalized and aestheticized hermit's retreat, then the activity that takes place within it may be considered an equally imaginative brand of aesthetic reclusion. Of course, the practice of tea was always directly colored by political and financial considerations, and these worldly concerns were nowhere more apparent than in the collecting of tea utensils, ceramics, calligraphy, and painting to be used or displayed in the tearoom. Although very much commodities to be bought, sold, or taken by force if circumstances allowed, these artistic creations may also be considered as "sacred objects," the presence of which serves to bring together the participants of the ritual.

At the level of anthropological ritual, or "deep play" in Geertzian terms, the objects collected so avidly by tea adepts served as the regalia of an aesthete-recluse. This is not the place to survey Raku ware and the various other types of ceramics and utensils championed by Rikyu and his followers,[44] but suffice it to say that in general the same ideals of simplicity, naturalness, and seeming poverty that characterized the *soan* applied to tea wares. Tea ceramics – at least as interpreted by professional masters such as Rikyu – concentrated the essential values of the *wabi* aesthetic into discrete objects. Treasured as "famous objects" (*meibutsu*) in catalogs and diaries, and venerated on the *tokonoma, chigaidana* (staggered

shelves), or *daisu* (utensil stand) in teahouses, the paraphernalia of tea became one of its core attractions.

The ritual experience, for Turner, is distinguished not only by shared belief in sacred objects but also by the rehearsal of a sacred history. The gathering in the *soan* is clearly the reenactment of the meeting of hermits, which had been venerated in Japan since the time of Otomo Yakamochi and the copying of the *Senzui byobu*, and in China from the times of the Seven Sages and the Four Graybeards. Yet, as with ritual actors in many cultures, for tea adepts in late-sixteenth- and early-seventeenth-century Japan, it was not enough to recreate the activities of ancient models in routine or ritualized forms.

The experience of the originators of the eremitic tradition became more compelling when it was "represented in stereotyped or liturgical form."[45] Thus, calligraphy samples by, or paintings of, paradigms of aesthetic reclusion as diverse as Saigyo and Tao Yuanming became a standard feature of tea gatherings. Paintings of the Seven Sages of the Bamboo Grove and the Four Graybeards of Mt Shang may well have served as visual parallels for the ritual aesthetic reclusion of tea. Moreover, the creative acts of collecting artworks, studying them, and arranging them in the teahouse were akin to the emphasis on scholarly pastimes associated with the aesthete recluses of the past.

The *wabi* tea gathering was, above all else, an intimate and shared experience. While *chakai* before and after the late sixteenth century often involved groups of five or more men, *wabi* tea gatherings usually consisted of two, three, or four men, including the host – the *soan* was designed to accommodate no more. As the preceding paragraphs have indicated, the tea gathering featured discussion of the various artistic treasures together with, in João Rodrigues' words, "peaceful contemplation of the things of nature."[46] While diaries reveal that tea gatherings were sometimes composed of political rivals or uneasy allies, if we are to believe texts such as *Nanporoku* and *Yamanoue Sojiki*, the conversation was intended to be as genteel as Rodrigues indicates.

Besides conversation about some feature of the *roji* or a new scroll, the other primary activity of the tea gathering was the communal partaking of specially prepared libations. In addition to the thick tea, a light meal, even some wine, and a thin tea were often provided. Tea gatherings thus involved the intimate sharing of drink and food. In sharp contrast to tea in both earlier and later periods, the *wabi* style of Rikyu was based on the host carefully making a bowl of tea and then humbly proffering it to his guests. In the rustic intimacy of the *soan* teahouse, the collective fantasy of the *wabi* tea ritual created the potential for communitas between the participants.

Notes

1 Unlike the modern age, in which tea largely is practiced by women, in the Momoyama period the world of tea was essentially a world of men.

2 See Haga Koshiro, *Sen no Rikyu* (Tokyo: Yoshikawa kōbunkan, 1978), and Kuma-kura Isao, *Sen no Rikyu: Inquiries into His Life and Tea,"* trans. Paul Varley, in Paul Varley and Kumakura Isao, eds., *Tea in Japan: Essays on the History of Chanoyu* (Honolulu: University of Hawai'i Press, 1984).

3 Sanetaka's four-mat teahouse, Sumiya, was remodeled from his country residence. According to contemporary descriptions, the courtier planted trees and arranged rocks around the structure to recreate the effect of being in nature. It is described in the entry for the sixth month of Bunka 2 (1502) in Sanjonishi Sanetaka, *Sanetaka koki* (Tokyo: Zoku gunsho ruiju kanseikai, 1935, 23–24. It is discussed in Moriya Takeshi, "The Mountain Dwelling within the City," *Chanoyu Quarterly* 56 (1989): 11, and Murai Yasuhiko, "The Development of *Chanoyu*: Before Rikyū," trans. Paul Varley, in Varley and Kumakura, eds., *Tea in Japan*, 24.

4 Among the many studies of Katsura, Akira Naito's *Katsura: A Princely Retreat* offers a good discussion of the retreat as an expression of tea ideals (trans. Charles Terry [Tokyo: Kodansha International, 1977]).

5 Mary Elizabeth Berry, *Hideyoshi* (Cambridge: Harvard University Press, 1982), 224.

6 A good example of this practice is recounted in Ota Gyuichi's *Shincho koki* (The Annals of Nobunaga) (1:4) and repeated in V. Dixon Morris, "The City of Sakai and Urban Autonomy," in Elison and Smith, eds., *Warlords, Artists, and Commoners,* 53.

7 Many of these specific gatherings are discussed in Theodore Ludwig, "*Chanoyu* and Momoyama: Conflict and Transformation in Rikyu's Art," in Varley and Kumakura, eds., *Tea in Japan*, 85–89.

8 Louise A. Cort, quoted in Elison, "Hideyoshi, The Bountiful Minister," in Elison and Smith, eds., *Warlords, Artists, and Commoners,* 239. For a study of the event, see Cort, "The Grand Kitano Tea Gathering," *Chanoyu Quarterly* 31 (1982): 13–43. For a discussion of the Kitano tea gathering within Hideyoshi's strategy of cultural legitimation, see Berry, *Hideyoshi*, 189–192.

9 See Beatrice Bodert-Bailey, "Tea and Counsel: The Political Role of Sen Rikyu," *Chanoyu Quarterly* 41 (1987): 25–34.

10 See Kumakura, "Sen no Rikyu: Inquiries into His Life and Tea," in Varley and Kumakura, eds., *Tea in Japan*, 35–36.

11 Ludwig, "*Chanoyu* and Momoyama," 85. The information on the tea gathering in Kyushu is drawn from the entries in *Sotan nikki* for Tensho 15 (Ludwig, "*Chanoyu* and Momoyama," 88–89).

12 Several members of the Mori clan were hosted at the rustic Yamazato room in 1585, as were a small group of Jesuits several years later. The priest Luis Frois described the room as filled with paintings showing natural scenes and figures from the ancient history of China and Japan. (See Michael Cooper, *They Came to Japan* [Berkeley: University of California Press, 1965], 136.) In *Sotan nikki*, Kamiya Sotan (1553–1635) describes the room in his diary for 1587, but does not mention any paintings. (See Kuwata Tadachika, ed., *Shinshu chado zenshu* [Tokyo: Shinjusha, 1956], 8:202–203; and Sen Soshitsu, ed., *Chado koten zenshu,* [Kyoto: Tankosha, 1958], 6:228).

13 Although no good descriptions of the teahouses survive, the two teahouses rebuilt at Kodaiji when Hideyoshi's widow Kitamandokoro took up residence there in 1606 are said to have been moved from Fushimi. See Horiguchi Sutemi, *Soan chashitsu,* vol. 83 of *Nihon no bijutsu* (Tokyo: Shibundo, 1973), for a discussion of the Karakasatei (Chinese-Umbrella Pavilion) and the Shiguretei (Rain Pavilion).

14 Berry, *Hideyoshi*, 230.

15 For introductory essays on *basara* tea, see H. Paul Varley and George Elison, "The Culture of Tea: From Its Origins to Sen no Rikyu," in Elison and Smith, eds., *Warlords, Artists, and Commoners*, and Murai, "The Development of Chanoyu," in Varley and Kumakura, eds., *Tea in Japan*. For an overview of Enshu's *daimyo* tea, see Kumakura Isao, "Kan'ei Culture and *Chanoyu*," trans. Paul Varley, in Varley and Kumakura, eds., *Tea in Japan*.

16 For an introduction to Rikyu's disciples – the so-called Group of Seven – including Oribe, see Murai Yasuhiko, "Rikyu's Disciples," *Chanoyu Quarterly* 66 (1992): 7–35.

17 Arguments attributing the Taian to Rikyu's design and Hideyoshi's patronage are given in Nakamura Masao, "Myokian Taian oboegaki," [full citation missing from original] and Itoh Teiji, "Sen Rikyu and Taian," *Chanoyu Quarterly* 15 (1982): 7–20. Good photos and a plan are found in Kawakami Mitsugu and Nakamura Masao, *Katsura rikyu to chashitsu*, vol. 15 of *Genshoku nihon no bijutsu* (Tokyo: Shogakkan, 1967), 96–101. The golden tearoom, as reconstructed at the MOA Museum of Art, Atami, is reproduced in Murai Yasuhiko, "A Biography of Sen Rikyu," *Chanoyu Quarterly* 61 (1990): 39.

18 In the previous pages, we have already mentioned the several small *soan* where Hideyoshi relaxed after his Kyushu campaigns, as well as the *soan* teahouses built in the Yamazatomaru at Osaka and Fushimi Castles.

19 Published in Sen Soshitsu, ed., *Chado koten zenshū*, vol. 6 (Kyoto: Tankosha, 1956), 101–103.

20 Published with annotation in Sen Soshitsu, ed., *Chado koten zenshu*, vol. 4. The oldest copy of the manuscript was owned by tea man Tachibana Jitsuzan (1655–1708), who claimed to have received it from a descendant of Sokei. The rather murky history of the text has led some scholars to surmise that Jitsuzan may have written the text himself, basing it on the teachings attributed to Rikyu by later followers of the Sen schools. Despite the much-debated origin of *Nanporoku*, few scholars have gone so far as to question the long-held opinion that it generally reflects the philosophy of Rikyu or, at least, that of his closest and most avid disciples.

21 Both are translated in full in Michael Cooper, *This Island Japan* (Tokyo: Kōdansha International, 1973). The writings on tea by Rodrigues and other Jesuits are discussed in Michael Cooper, "The Early Europeans and Tea," in Varley and Kumakura, eds., *Tea in Japan*.

22 Translated by Cooper, "The Early Europeans and Tea," 128–129.

23 Ibid., 129–130.

24 Ludwig, "*Chanoyu* and Momoyama," 95.

25 Victor Turner's ideas on ritual antistructure are developed in *Dramas, Fields and Metaphors: Symbolic Action in Human Society* (Ithaca: Cornell University Press, 1974).

26 Probably for this reason the styles of tea developed by Oribe and Enshu evolved many ways of preserving status distinctions even while maintaining the fiction of world rejection. Not only did these seventeenth-century tea styles – often called *daimyo-cha* to indicate their congeniality to military patrons – allow for the greater display of the host's treasures, but the hierarchical arrangement of seating reinforced status distinctions. For instance, while Oribe extended the *roji*, dividing it into outer (*sotoroji*) and inner (*uchiroji*) sections to symbolize better movement from the mundane outer

world to the sacred inner realm of the *chashitsu*, the waiting arbor in the outer *roji* was provided with footrest stones (*fumiishi*), with different sizes demarking the place and status of each guest.

27 Turner, *Dramas, Fields and Metaphors*, 232.

28 Ibid., 208.

29 Before this, *roji* was written with characters that merely indicate a "path," without any special significance. Because the characters "dewy ground" are used in the *Lotus Sutra* to indicate an "open ground" of emancipation, Rikyu's choice of the same characters has the implication of spiritual liberation. For further discussion, see Dennis Hirota, "Memoranda on the Words of Rikyu, *Nanporoku* Book I," *Chanoyu Quarterly* 25 (1980): 33.

30 Hirota, "Memoranda of the Words of Rikyu, *Nanporoku* Book I," 34. In section 33 of the *Oboegaki*, Rikyu is quoted as saying, "A *chanoyu* gathering is impossible unless people can escape from this mundane world to place free of defilement" (translated by Varley, "Purity and Purification in the *Nampo Roku*," *Chanoyu Quarterly* 48 [1989], 16).

31 Kumakura, "Sen no Rikyu," 52–53.

32 João Rodrigues reports this custom in *Arte de Cha* (see Cooper, "The Early Europeans and Tea," 127).

33 A *roji tsue* designed by Rikyu is illustrated in Kyoto kokuritsu hakubutsukan, *Sen no Rikyuten* (Kyoto: Kyoto kokuritsu hakubutsukan, 1990), 28.

34 Translated by Hirota, "Memoranda of the Words of Rikyu, *Namporoku* Book I," 33.

35 The function of the *tsukubai* recalls the hand-washing basin at Shinto shrines and is symbolically reminiscent of the river that pilgrims forded before entering the Naiku at Ise Jingu. The seventeenth-century *roji* at Omote senke, Kyoto, includes an actual stream. In *The Garden Art of Japan*, Masao Hayakawa writes that by making the guest bend low to wash his hands and mouth, the *tsukubai* makes him "aware of his own psychological tensions, and through this act, to rid himself of them" (trans. Richard L. Gage [New York: Weatherhill, 1973], 172).

36 Varley, "Purity and Purification in the *Nampo Roku*," 9–10.

37 Turner, *Dramas, Fields and Metaphors*, 208.

38 For a similar summary of the symbolic roles of the *roji* and *soan*, see Teiji Itoh, *Space and Illusion in the Japanese Garden*, trans. Ralph Friedman and Masajiro Shimamura (New York: Weatherhill, 1973), 84.

39 Turner, *Dramas, Fields and Metaphors*, 232.

40 Ibid., 243.

41 In some mid-seventeenth-century tea gatherings, participants changed into special dress in a changing room located in the outer *roji*.

42 In *The World of the Japanese Garden* (New York: Weatherhill, 1968), 192, Lorraine Kuck suggests that the *soan* is "an echo down the centuries" of Bo Juyi's Grass Cottage on Mt Lu.

43 Translated by Cooper, "The Early Europeans and Tea," 124.

44 Among the many good sources on the ceramics and utensils associated with *wabicha* is Kyoto kokuritsu hakubutsukan, *Sen no Rikyu ten*.

45 Turner, *Dramas, Fields and Metaphors*, 248.

46 Cooper, "The Early Europeans and Tea," 124.

33

Practices of Vision

Craig Clunas

Introduction

Craig Clunas, a leading scholar of Chinese art from the Ming dynasty (1368–1644), addresses the question of what it meant to "look at a picture" in Ming China. This includes exploring who had access to the artworks as well as how the designated viewers physically and intellectually looked at the images. As Clunas explains, pictures – meaning paintings in the form of hanging scrolls and handscrolls, but also images on ceramics, textiles, furniture, and print books – formed an important part of the period's growing emphasis on luxury goods. Significantly, this rise in patterns of consumption is one of the factors that leads historians to classify the Ming period as "early modern."

In his discussion of Ming viewing practices, Clunas focuses primarily on elite art: hanging scrolls and other paintings collected and frequently made by the landed, educated class often referred to as the literati. This class of (primarily) men, centered in the Suzhou region of China, formed the upper echelons of Chinese society. They considered themselves scholars, calligraphers, and amateur artists, as well as connoisseurs, and many amassed impressive collections of paintings. For them, such works formed an important aspect of their collective and individual identities. At the end of the excerpt, Clunas contrasts their viewing practices with those of the peasant classes.

Clunas uncovers viewing practices both through an examination of Ming-period images featuring people looking at pictures and by analyzing various Chinese textual sources, from individual artists' writings to Ming-era encyclopedias listing legendary artworks and artists. Through these texts, Clunas identifies the most common

Craig Clunas, "Practices of Vision," pp. 111–20 from *Pictures and Visuality in Early Modern China*. Princeton: Princeton University Press, 1997. © 1997 by Craig Clunas. Reprinted by permission of Princeton University Press.

Chinese terms for looking. In addition to addressing class structures and Ming attitudes to painting, he presents pictures not as static objects apart from, or just reflecting, the culture of the time, but as actively involved in affirming cultural and societal relationships.

Ways of Looking

Roland Barthes' famous demand for a 'history of looking' might be criticized by now for its rather naive-seeming presumption that there would be *a* history of looking, rather than culturally specific multiple histories of looking. This subject has scarcely been addressed at all with regard to the extremely rich material on the history of visuality in China, and the present attempt can be no more than a sketch of what needs to be done and the questions posed. We need to take up the challenge that Peter Wagner derives from [Pierre] Bourdieu, when he asserts:

> For the eye of the beholder is not a given constant; it is the product of institutional settings and social forces constituting that which Bourdieu labels the 'habitus'. It is by historicizing the categories of thinking and perceiving in the observer's experience, not by dehistoricizing them in the construction of a transhistorical ('pure') eye, that we can arrive at an adequate understanding of understanding.[1]

What was the understanding in the Ming period of what it meant to 'look at' a picture? Given that 'picture' is a complex term, it will be no surprise to engage with the claim that 'looking' was no less complex, and similarly represented by a number of different terms, whose deployment and semantic spread we can barely begin to apprehend without a great deal more work.

It is important to keep hold of the fact that before vision can take place, however it is conceptualized, opportunities for vision must present themselves. The question of who gets to look, where and when, must be considered together with what there was to look at. In some cases it might be purely geographical distance that prevented viewing of some particular thing; Zhang Dafu writes of how 'The Zhanyuanfang of the Jingdesi has sixteen images (*xiang*) of lohan, which are traditionally from the brush of Guanxiu. I have heard of them for twenty years, and today happened to be passing and managed to inspect seven of them'.[2] The writings of the Ming élite are full of such accounts of works which they 'managed to see'. But more usually it was social distance, rather than geographical, which stood in the way of 'managing to see' some famous picture, especially with the abandonment of the mural format by major artists, and the concomitant rise of more intimate types of picture. In the Ming, what you saw depended on who you were, and who you knew, also on what time of the year you were viewing the work. It is an assumption, but a reasonable one, that seasonal

and festival factors may have governed which pictures from a collection were brought out to be shown to visitors; if you visited Xiang Yuanbian in summer you did not look at 'winter subjects' such as plum blossoms. This opens up the possibility of understanding Carlo Ginzburg's 'iconic circuits' in the Chinese setting as seasonal rather than geographical. When it came to 'painting' (*hua*), the formats of handscroll, hanging scroll and album leaf gave the owners of the physical objects a control over the viewing of the representations which was different from that enjoyed by the patron of the larger forms of contemporary painting in Europe. There, access to the space where the picture was (even though this was restricted on the grounds of status or gender) gave access to the picture. In China, where there was no space where the picture continuously 'was', every act of viewing was also an act of social interaction. The great Wen Zhengming, touchstone of taste for the Suzhou élite, was frequently visited by his younger friend He Liangjun who describes what must stand for thousands of such élite interactions over paintings, if at a particularly rarefied level.

> Hengshan [= Wen Zhengming] was particularly fond of the criticism of calligraphy and painting. Whenever I visited him, I would always go with something from my collection. The master would examine it for the whole day, and would also produce items that he owned to the best of his abilities. He would often come into his study bearing four scrolls, and when they had ben unrolled he would go in and change them for another four, untiring even though we went through several complete changes.[3]

Such accounts are so ubiquitous as to have become almost invisible, but this example from among so many is worth pausing to consider. It shows, for example, the importance of reciprocity. He Liangjun is shown pictures from Wen's collection so freely precisely because he would 'always go with something from my collection'. Expecting to see but not to show was neither good manners, nor likely to be successful. Indeed it seems likely that the particular place of painting and the viewing of painting in the lives of the Ming elite was made possible precisely by the portability of the pictures they valued, and the ease with which any important work could be transported to an occasion of viewing. Another obvious point emerging from the passage is that looking was, at least ideally (and Wen's behaviour for the admiring He always embodies the ideal) both limited and intense. A few pictures are looked at for a long time, and the visitor does not see the total scope of the collection, stored in a room different from the one where it is viewed, a room not accessible even to an intimate. There is a reticence of vision here that we shall see more fully expressed in the ideal as the Ming period goes on, an élite reticence which runs directly counter to, and is in tension with, the expanded sphere of the pictorial found in things like books, and on figuratively decorated ceramics, lacquer, textiles and other luxury goods.

Ming pictures that show gentlemen looking at pictures (and which must be taken as representations of ideal circumstances, not as documentary evidence) always stress the collective nature of looking, and it is rarer to see an image of someone looking at a picture entirely by themselves. In an album leaf which is by the early sixteenth-century professional master Qiu Ying, the small number of pictures on the table is in contrast with the great heaps of archaic bronzes standing ready for connoisseurly perusal.[4] And in an illustration to an early seventeenth-century drama,[5] which shows gentlemen studying a picture for sale in a relatively modest antique shop, two heads are bent simultaneously over the scroll which the shopkeeper holds up. It seems highly likely that many acts of élite looking were indeed precisely acts of communal looking, occasions on which élite values were exchanged, tested, reasserted and spread to members of the younger generation. It is for occasions like this that the encyclopedias such as *Shan tang si kao* are perhaps designed, giving those without extensive collections of their own the cultural capital necessary to participate from the fringes in the presence of their elders and betters.

Another factor should be noted resulting from the physical nature of the formats of painting, and that is the necessity of servants to their manipulation. They are present in both images mentioned above in the former bringing in another picture at the bottom right, and in the latter (the shopkeeper is effectively a servant) holding the picture up. 'Hanging scrolls' as they are known to curators today are not often represented in Ming painting as actually hanging on the walls. Much more often they are shown being held aloft by servants on forked poles. This not only limited the amount of time a scroll could be examined (even servants have a limit on how long they can hold something up), but it also emphasized that it was people with servants who were able to look in the socially appropriate manner.

But what was that manner? What are the figures actually doing? In the broadest sense what they are doing is covered in Ming usage by the term *shang jian*, a binome meaning both 'discriminate on the grounds of quality' and 'tell true from false'.[6] Several late Ming texts give more precise prescriptions on what they *ought* to be doing, and on how pictures ought to be (and ought not to be) looked at. These rules and prescriptions had antecedents which went back at least to the thirteenth century.[7] The *Hui miao*, a text with a Preface dated 1580, contains a fairly typical list of 'Rules (or 'Methods') for contemplating painting' (*Guan hua zhi fa*), opening with what was probably sound advice: 'When you see a shortcoming do not sneer at it, but seek out a strength; when you see dexterity do not praise it but seek out artlessness....'[8] The social constraints requiring viewers to find something to praise can well be imagined, and explain the often uninformative nature of the colophons which were added to pictures or their mountings during these acts of collective viewing. However, perhaps the most startling analogy, and one which is repeated in a number of texts, is that between looking at a painting and looking at a woman. 'Looking at a painting is like looking at a beautiful woman (*mei ren*)', says the *Hui miao*, in a formulation

[handwritten margin note: looking at art was almost in itself a social gathering.]

[handwritten note at bottom: looking at art is often compared to looking at women.]

355

which quite startlingly anticipates the idea of the 'gaze', and its development in feminist theory in recent art-historical debate.[9] Women were certainly considered as the objects of a connoisseurly gaze in the Ming, ranked and appraised like other forms of élite male consumption.[10] Other Ming texts make exactly the same connection between women and artworks, which heads for example the miniature essay on 'Connoisseurship' in the 'Treatise on Superfluous Things' of Wen Zhenheng:

> Looking at calligraphy or painting is like facing a beautiful woman, one must not have the slightest air of coarseness or frivolity. For the paper or silk of old paintings is brittle, and if one does not do it right when rolling them they can very easily be damaged. Nor must they be exposed to wind or sunlight. One must not look at pictures by lamplight, for fear of falling sparks, or lest candle grease stain them. If after food or wine you wish to contemplate a hand scroll or hanging scroll, you must wash your hands with clean water, and in handling them you must not tear them with your fingernails. Such prescriptions it is not necessary to enumerate further. However one must seek not to offend in all things, and avoid striking a forced air of purity. Only in meeting a true connoisseur, or someone with a deep knowledge of antiquity can one enter into converse with them. If you are faced with some northern dolt do not produce your treasures.[11]

The topos that 'looking at a painting is like looking at a beauty' appears again in the very influential *Shan hu wang hua lu* of 1643, in its section quoting earlier writers on painting. It gives what may be the earliest citation of the phrase, from the writings of Tang Hou (active *c*.1320–30), who made the somatic connection even more explicit; 'Looking at painting is like looking at a beautiful woman. Her air, her spirit, her "bones" are there beside her flesh.'[12] In all these texts, there are a number of words for the act of vision itself, which now needs to be examined more closely. One of these is *kan*, the simple verb 'to see' which every foreign student of Chinese learns in or shortly after the first lesson; in Modern Standard Chinese *Wo kan ni* means 'I see you.' Effort is not necessarily involved. If an object is there, a person will see it. However as used by a late Ming writer like Wang Keyu looking and seeing are not the same thing where painting is concerned. For him, *kan hua*, 'looking at painting', is not a natural physiological act but a learned skill, analogous to the way in modern Chinese *Wo kan shu* means not 'I see the book' but 'I read the book.' He is explicit about the socially limited suitability of 'looking at painting'; 'Looking at painting is basically suitable for the gentleman (*shi da fu*)', who have the financial resources to collect and the 'strength of eye' (*mu li*) to appreciate. He further states, 'The methods for looking at painting cannot be grasped in one attempt …', and he speaks of 'looking at painting' as something that needs to be 'studied' (the word is *xue*).[13] He also, at least implicitly, explains what will happen if the skills are not mastered:

> When people nowadays discuss painting they know nothing of the spiritual subtleties of brush method and spirit consonance, but first point out the resemblances;

resemblances are the viewpoint of the vulgar. ... When people nowadays look at painting they mostly grasp the resemblances, not realising that resemblance was the least important thing for the men of antiquity. ...[14]

↳ this still applys today

The vulgar, the uneducated, will look and will see the wrong things, or the trivial things. But at least they can look, if inadequately. There is another word for the act of regarding a picture in the Ming, which is more restricted in its usage, but richer in its connotations. This better looking, which I have rather unsatisfyingly expressed in the immediately preceding translations with the English word 'contemplate', is conveyed in Chinese by the word *guan*. When Zhang Dafu finally managed to see the lohan scrolls by Guanxiu, this was what he did to them. When Wen Zhenheng talks about purifying oneself after food or drink it is in order to 'contemplate' a scroll. The word has a presence in colloquial as well as highly literary forms of written Ming Chinese; when Master Han sets about studying the corpse of Li Ping'er to paint her portrait, the text says he *da yi guan kan*, literally 'struck a gaze and looked'.[15] Wang Keyu quotes separate rules (*fa*) to do with 'contemplating' painting, which involve the separate 'contemplation' of the sixth-century Six Laws of Xie He, the venerable and enigmatic prescriptive basis for so much later writing on art. These are not visual objects, certainly not things the vulgar can see with their eyes. Even the élite may fail in the act of contemplation; 'When people nowadays contemplate paintings they do not know the Six Laws, but just open the scroll and then add some comment or appreciation. If someone asks them the finer points they do not know how to reply...'.[16]

This act of *guan*, 'contemplation', is therefore for Ming élite theorists the performative part of visuality, beyond the merely physiological. It brings with it connotations of spiritual practice that link it to the written religious traditions of Buddhism and Daoism, as well as to active forms of the religious life which were of ancient origins, but which were infused with new vitality in the late Ming. Scholars of religion who have studied this have tended to use the term 'visualization' to translate *guan*, and this will be adhered to in the immediately following discussion. The sense of *guan* as 'to scrutinize, to examine carefully' predates the introduction of Buddhism to China, and the formative stages of Daoism as a religion, appearing in the first–second-century dictionary *Shuo wen jie zi*.[17] The question of priority between the two religious systems with regard to the meditative techniques which came to be known under the name does not need to concern us here. What is clear is that, by as early as the fourth century, the idea of 'visualization', often in the form of visualizing cosmic journeys, was central to the religious practices of the Shangqing 'Supreme Purity' School of Daoism. Through internal vision, the adept could assemble within the body vast cosmic forces, and hosts of deities in all the detail of their complex and numinous iconography. This idea in its turn is an element in some of the earliest of Chinese theorizing about representation and the image, theorizing which retained its force in the late Ming.[18] 'Insight meditation', which the French

scholar Isabelle Robinet uses to translate *guan* or *neiguan*, is described by her as 'the active, conscious introspection of one's own body and mind'. She has stressed that what is being discussed in the Shangqing texts with regard to visualisation 'cannot be conceived in Western terms as some sort of intellectual or moral introspection, but must be understood in a very concrete way … to represent is not simply to evoke but also to create'.[19] And it is this sense of active performance that seems crucial to the concept in all its uses. It is equally present in the Buddhist tradition, permeating the major text to deal with the practices of visualization, the *Guan wu liang shou jing*, or 'Sutra on the Visualization of the Buddha of Immeasurable Life', a fifth-century work that does not have antecedents in the canonical Buddhist literature of India, but is either a translation into Chinese from a lost Central Asian original, or else an original composition in Chinese.[20] Here *guan* 'visualization' or 'contemplation' formed one of the two key practices of the 'Pure Land' tradition of Buddhism; along with oral recitation of the name of the saviour these practices were fully alive in the late Ming. For the great renewer of Buddhism in the late Ming, the monk Yunqi Zhuhong (1535–1615), the 'Sutra on the Visualization of the Buddha of Immeasurable Life', was one of a limited number of texts which novices in the monasteries he founded were required to memorize, and one of the three Pure Land sutras on which public lectures were regularly given, lectures attended by many members of the élite with whom Zhuhong was on social terms.[21] This gave the Buddhist notion of visualisation a continuing presence in Ming culture, although the precise degree of its impact outside the monastic context needs more research.

There is further evidence that the ancient Daoist understanding of visualization was still circulating in the Ming period. The wealthy Hangzhou merchant, playwright and connoisseur Gao Lian, in his 'Eight Discourses on the Art of Living' (1591), lists Daoist books as among those which are an essential part of any gentleman's library, and he makes explicit use of one of the key texts in his discussion of 'Prescriptions for Enlightening the Eyes and Ears'. He quotes the early sixth-century 'Declarations of the Perfected' (*Zhen gao*) by Tao Hongjing (456–536) as follows: 'In seeking the Way you must first ensure that eyes and ears are quick of apprehension, this is the chief matter. For ears and eyes are the ladder in the search for the True, the door to gathering up the Divine – they bear on acquisition and loss and the discrimination between life and death'. Gao goes on to give his own prescriptions for further empowering the eyes, through a form of massage which after two years will allow the adept to read in the dark, and which will achieve the inner alchemical transformation of the 'eye god' (*mu shen*).[22] The point is that the 'Declarations of the Perfected' is one of the central texts describing visualization practices, which are also visible elsewhere in Gao Lian's prescriptions for a long life through such techniques as 'ingestion of the pneuma of the sun and of the essence of the moon', both of which involve visualizing (*cun*) the relevant heavenly body within one's own physical frame.[23] Although *guan* is not used explicitly by Gao Lian in the sense of visualizing meditation, it is at least possible

that the term had some of those shadings for others like himself who were steeped in the classic Daoist texts where it is so prominent.

One other Ming word for the act of engaging visually with a picture must be examined, and that is *du*, with the modern dictionary definition 'to read'. The notion of *du hua*, 'reading a painting' may seem strikingly modern in an age when under the impact of methodologies derived from literary studies it is common to refer to a picture as 'a text'. The presence of written inscriptions on so many Chinese pictures (turning them into the 'iconotexts' studied by Peter Wagner) may make this identification even stronger, as may the numerous statements on the common origins of writing and picturing current in the Ming and discussed above. However we must be wary of giving an unacknowledged primacy to the notion of text over image, when by *du hua* Ming writers may not be using an analogy or metaphor, but drawing attention to a common type of action. The question of motion is crucial with regard to vision here. The idea of *du*, 'reading', above all implies a subject whose vision is moving, scanning the characters of a text or the surface of a picture. Importance was attached not to the legibility of the image but to the act of moving the eye across the surface, particularly of the hand scroll as it is sequentially made visible in the act of unrolling. The presence of duration in Ming ideas of visuality is important here, the idea that pictures could not by their physical nature be taken in all at once. By contrast *guan* is a subject whose vision is fixed, who may penetrate deeper, see more or see further *into* something, rather than across it. In a striking example of this quoted by Shigehisa Kuriyama, the Bronze Age King Hui of Liang had his thoughts read by one Chunyu Kun, of whom a later writer commented; 'The intention was inside the breast, hidden and invisible, but Kun was able to know it. How? He contemplated (*guan*) the face to peer into the mind'.[24]

The terms *kan, guan,* and *du* all appear in the studio names (names chosen by the adult male himself) of individuals in the Ming and Qing Dynasties.[25] Only one individual has a studio name using *kan*, fourteen have one containing the element *guan*, and eight have one using *du* (usually in the form *du shu*, which may mean 'studying calligraphy' just as much as 'reading books'). To be sure, this is too small and random a sample for anything very meaningful to be extracted from it, but a fruitful line of enquiry might be to consider ways of looking stratified by class or status, with *guan* as a more élite way of looking, whether at a picture, a waterfall or the moon (the connoisseurly discrimination contained in the term *shang jian* is quite explicitly a social attribute). Scholars contemplate, while peasants (along with women, children and eunuchs) just look. Certainly there is a very different relationship to pictures from that shown by an anonymous sixteenth-century artist, depicting an itinerant seller of pictures displaying his wares to a village audience. In the former pictures, members of the élite lean into the album leaves and the hanging scroll they are inspecting, their body language speaking of an active engagement, as well as of concentrated and focused intelligences. By contrast, the unsophisticated peasants react with

[handwritten margin notes: difference élite contemplate while peasants just look / whichis even visualized in paintings]

amazement and even horror, one woman covering her face as another hides behind her body, and a young girl turns away. Their bodies stiffen at the sight of the terrifying visage of Zhongkui, queller of demons, since for them the picture is real, they are the uneducated who remain at the level of 'resemblances' and for whom mimesis retains its full and terrifying force.

Notes

1 Peter Wagner, *Reading Iconotexts: From Swift to the French Revolution* (London, 1995), p. 171.
2 Zhang Dafu, *Mei hua cao tang bi tan*, 3 vols (Shanghai, 1986), 1, p. 72.
3 He Liangjun, *Si you zhai cong shuo* (Beijing, 1959), p. 237.
4 Woodblock print from the drama *Yi zhang guan*, 1644–61.
5 Qiu Ying, 'Ranking Ancient Works in a Bamboo Court', from *A Painted Album of Figures and Stories*, first half of sixteenth century.
6 Craig Clunas, *Superfluous Things: Material Culture and Social Status in Early Modern China* (Urbana, IL, 1991), p. 86.
7 For example, in the writing of Zhao Xigu (active *c.*1195–1242); Susan Bush and Hsio-yen Shih, *Early Chinese Texts on Painting* (Cambridge, MA, 1985), pp. 237–9.
8 Mao Yixiang, *Hui miao*, 1 *juan* in *Yishu congbian* 1 *ji*, 12 *ce*, *Mingren huaxue lunzhu*, ed. Yang Jialuo (Taibei, 1975), 11, p. 9. These 'rules' (*fa*) are reminiscent of the 'Rules for reading' (*Du fa*), which begin to appear in the texts of novels in the late Ming period, and the connection between them merits further study within the field of hermeneutics. David L. Rolston, *How to Read the Chinese Novel* (Princeton, 1990).
9 Mao Yixiang, *Hui miao*, p. 12.
10 Wai-yee Li, 'The Collector, the Connoisseur and Late-Ming Sensibility', *T'oung Pao*, LXXXI (1995), pp. 277–8, for an example.
11 Wen Zhenheng, *Zhang wu zhi jiao zhu* (Nanjing shi, 1984), p. 147.
12 Wang Keyu, *Wang shi shan hu wang hua ji* (Shanghai, 1936), p. 139. For the original context of Tang Hou's words (and an alternative translation), see Bush and Shih, *Early Chinese Texts on Painting*, p. 261.
13 Wang Keyu, *Wang shi shan hu wang hua ji*, pp. 135–6.
14 Ibid., p. 137.
15 *Jin ping mei cihua*, 3 vols (Taibei, 1980–1), 11, p. 468.
16 Wang Keyu, *Wang shi shan hu wang hua ji*, p. 141.
17 Isabelle Robinet, 'Taoist Insight Meditation: the Tang Practice of *Neiguan*', in *Taoist Meditation and Longevity Techniques*, ed. Livia Kohn (Ann Arbor, 1989), pp. 159–91 (p. 195).
18 Isabelle Robinet, 'Visualisation and Ecstatic Flight in Shangqing Taoism', in ibid., pp. 159–91 (p. 162). On the links to artistic creation, see Lothar Ledderose, 'Some Taoist Elements in the Calligraphy of the Six Dynasties', *T'oung Pao*, LXX (1984), pp. 247–78; idem, 'The Earthly Paradise: Religious Elements in Chinese Landscape Art', in *Theories of the Arts in China*, eds Susan Bush and Christian Murck (Princeton, 1983), pp. 164–83; and Audrey Spiro, New Light on Gu Kaizhi', *Journal of Chinese Religions*, XVI (1988), pp. 1–17.

19 Robinet, 'Taoist Insight Meditation', p. 196. Isabelle Robinet, *Taoist Meditation: The Mao-shan Tradition of Great Purity*, trans. Julian F. Pas and Norman J. Girardot, Foreword Norman J. Girardot, New Afterword Isabelle Robinet. SUNY Series in Chinese Philosophy and Culture (Albany, 1993), p. 29.

20 Kotatsu Fujita (trans. Kenneth K. Tanaka), 'The Textual Origins of the *Kuan Wuliang shou ching*: a Canonical Scripture of Pure Land Buddhism', in *Chinese Buddhist Apocrypha*, ed. Robert E. Buswell Jr (Honolulu, 1990), pp. 149–73. For a translation, see *The Sutra of Contemplation on the Buddha of Immeasurable Life, as Expounded by Sakyamuni Buddha*, trans. and Annotated Ryokoku University Translation Center under the direction of Meiji Yamada (Kyoto, 1984).

21 Ch'un-fang Yü, *The Renewal of Buddhism in China: Chu-hung and the Late Ming Synthesis* (New York, 1981), pp. 199, 221.

22 Gao Lian, *Yan nian que bing jian* (Chengdu, 1985), p. 36.

23 Ibid., pp. 33–4. On the *Zhen gao* as visualization text, see Michael Strickmann, 'On the Alchemy of T'ao Hung-ching', in *Facets of Taoism: Essays in Chinese Religion*, eds Holmes Welch and Anna Seidel (New Haven, 1979), pp. 123–92 (p. 128). On the pervasiveness of Daoist practices in the Ming elite, see Liu Ts'un-yan, 'The Penetration of Taoism into the Ming Neo-Confucian Elite', *T'oung Pao*, LVII (1971), pp. 31–102.

24 Shigehisa Kuriyama, 'Visual Knowledge in Classical Chinese Medicine', in *Knowledge and the Scholarly Medical Traditions*, ed. Don Bates (Cambridge, 1995), pp. 205–34 (p. 218).

25 Chen Naiqian, *Shiming biehao suoyin*, enlarged and revised edn (Beijing, 1982).

34

Excerpts from *Chinese Imperial City Planning*

Nancy Shatzman Steinhardt

Introduction

The Forbidden City, originally conceived by the Mongol ruler Khubilai Khan (1215–94) and repeatedly rebuilt during the Ming (1368–1644) and Qing (1644–1911) dynasties, remains today the best known Chinese imperial city. The immense, walled, and symmetrically planned space, home to the emperor and center of government for over 600 years, holds a featured place in both tourist itineraries and history books of China. The Forbidden City, however, is not the only planned Chinese imperial city, and as architectural historian Steinhardt demonstrates, the various capitals created throughout China's history share a particular set of characteristics. When carefully examined, these attributes reveal much about the relationship between urban space and the articulation of political power in China.

In this excerpt from her book, which acts as the introduction for the analyses of individual cities that follow, Steinhardt systematically examines the main characteristics exhibited by Chinese imperial urban plans, including walls and other defensive design elements, gridded streets, imperial buildings, and ritual spaces. Steinhardt's observations about these city plans can be applied to a number of other East Asian cities, such as Nara and Kyoto in Japan, also modeled after the Chinese imperial pattern.

The uniformity in Chinese imperial city design, despite dynastic, geographic, and temporal differences, may have resulted from a respect for the past, the strong relationship between Confucian values and statecraft, or the highly developed nature

Nancy Shatzman Steinhardt, "Introduction," pp. 1–19 from *Chinese Imperial City Planning*. Honolulu: University of Hawaii Press, 1990. Reprinted by permission of The University of Hawaii Press. © 1990.

of city planning. Whatever the reason, the original viewers would have come to the spaces with a set of expectations that affected their patterns of viewing and movement. By delineating the typical aspects of imperial cities, Steinhardt helps us to understand those expectations. The standardization and repetition of a particular set of elements also bespeaks the effectiveness of planned imperial cities in manifesting the authority of state as it related to politics, military concerns, economics, and religion, even as dynasties change and new rulers emerge.

One of the immediate directives of the newly founded government of the People's Republic of China in the autumn of 1949 was the redesign of Beijing, the site of a capital for most of the last thousand years of Chinese imperial history. Specifically targeted for overhaul were the city's age-old focus – the 250 acres known as the Forbidden City and the 4.5-kilometer approach northward to it from the south gate of the outer city wall – and former imperial spots scattered throughout the city (Fig. 34–1). After some debate, the new city planners agreed that an international symbol of China like the Forbidden City could not simply be torn down. Yet neither, they decided, would it be appropriate to honor past regimes by leaving unaltered their imperial monuments. Thus was conceived one of the most dramatic architectural transformations of this century: palace square to people's square, a three-dimensional manifestation of "letting the past serve the present."

Although never so tersely stated, the past's service of the present was a central issue in the planning of each of the five dynastic capitals built between the tenth and seventeenth centuries whose ruins are today covered by the metropolis Beijing. Indeed, the search for a spatial arrangement that would symbolize state goals, satisfy but not compromise the needs of the leader, and recognize the ties of a particular regime to its past was not exclusively a goal of Beijing's most famous ruler-planners Khubilai Khan (1215–1294), Emperor Yongle (1360–1424), or Chairman Mao (1893–1976). The ideal capital city plan had been a profound concern of each empire builder and his descendants on Chinese soil; it was an issue discussed and debated by the Chinese government in every age.

Through the centuries very specific and even peculiar imperial whims have been satisfied by capital city plans in China. Still, what has traditionally been viewed as a most impressive feature of the Chinese capital plan is its homage to the past and deference to the imperial planning tradition that has come before it. This bond is so strong that, in spite of the true evolution of the city plan and variations in design that are explained in this book, all Chinese royal cities of the last four thousand years do share certain architectural features regardless of when they were built, their locations, or the nationalities of their patrons.

Yet, for almost as long as imperial city buildings, some of their locations, and certain spaces within the city have been standardized and prescribed, the arrangement of the largest city spaces that encompass them has varied. The number of uniform features is so great, and their similar architectural detail even over the course of thousands of years is at times so striking, that the different possibilities

1. Forbidden City
2. Ancestral Temple
3. Altars of Soil and Grain
4. Altar of Heaven
5. Altar of Earth
6. Altar of the Sun
7. Altar of the Moon
8. Altar of Agriculture (First Crops)
9. North, Middle, and South Lakes
10. Jing Shan (Coal Hill)
11. Confucian Temple
12. National Academy
13. Prefectural Administrative Offices
14. Yamen (county official residences and courts)
15. Granaries
16. Buddhist Monasteries
17. Daoist Monasteries
18. Mosque
19. Provincial Examination Hall
20. Bell and Drum Towers

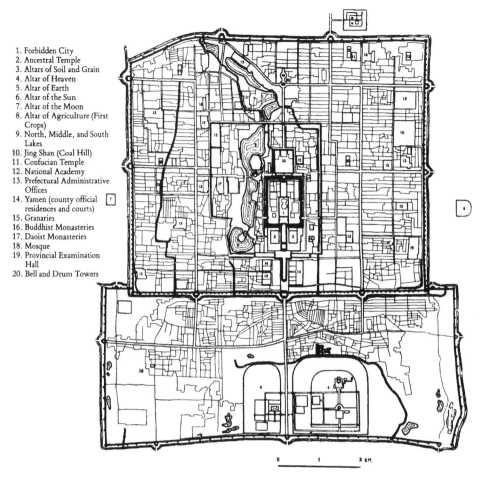

Fig. 34-1 Plan of Beijing from the seventeenth through nineteenth centuries showing imperial and administrative buildings. (*Zhongguo jianzhu jianshi*, Fig. 6–12).

resulting in two-dimensional plans have either gone unnoticed or have been dismissed as inconsequential. In fact, three fundamentally different designs were created for imperial cities in China by the first millennium BCE, and each is traceable for more than another thousand years of Chinese urban planning.

The elements that comprise every Chinese imperial city, and make it recognizable, are not necessarily exclusive to China. Beijing in the fifteenth century or imperial Chang'an in the eighth had palaces, royal monasteries, mausoleums, shrines, altars, parks, government offices, granaries, workshops, treasuries, and libraries, as did Rome, St Petersburg, Constantinople, and Isfahan in their imperial ages. Yet in China the buildings and their locations within the city were preestablished by age-old traditions set forth in revered literature or documents of the classical age.

The reason every Chinese capital including the present one of Beijing is so closely tied to the scheme of earlier rulers' cities can be explained by the particular Chinese

context of the two words imperial and planning. In China as elsewhere the ruler's power and authority were unchallenged, but in China, in addition, an emperor's reign was always compared to the exemplary models of rulership of former emperors and even preimperial dynasts. The form of the capital city and its architecture were just two of the many means the emperor used to display his legitimized position as both ruler and guardian of tradition. The alteration of an accepted design was therefore considered a challenge to the imperial past. The imperial city was such a powerful symbol of rule that a nonnative conqueror would always choose to implement a Chinese design instead of plans more reminiscent of his homeland.

The Chinese ruler was more than an absolute authority. He was the Son of Heaven, an intermediary between human labors and heavenly favor. His virtue and proper performance ensured the stability of the state and guaranteed a pacified world. Although an artisan or engineer was needed to draw the plan, it was only through imperial participation that the city could be constructed. Before laying the foundation for a new city, heaven had to be consulted. The site and date of groundbreaking had to be confirmed by heaven in advance. The city's architecture was often named for auspicious heavenly bodies or lucky numbers.[1]

Planning in a premodern Chinese context meant more than simply the abstract notion that a city scheme was conceived in its entirety from its inception – remarkable though it is that planning was conducted this way over the course of four thousand years of one nation's history. In traditional China, planning also meant that a plan was drawn. The earliest known Chinese site plan is from the first millennium BCE, but literary descriptions of cities suggest that they were conceived as two-dimensional plans even earlier.

The importance of the plans cannot be overemphasized. First of all, they are tangible and specific evidence of the shape and interior spaces of cities. (Size and orientation are not specified on the plans until modern times.) Second, variant plans made in later premodern centuries of earlier cities allow for discriminating comparisons between plans and written records. Plans based on excavation at city sites provide yet another level of comparative accuracy.

In China the imperial city is more than the ruler's capital. It is an institution. It is an articulated concept for which a design is drawn and about which ideology – namely purpose and meaning – has been written, accepted, and transmitted through the ages. All this took place long before most imperial cities as we know them today were built.

Characteristics

A steadfast commitment to the supremacy of an imperial plan established in the remote past underlies all later imperial planning in China. As a consequence, all of the fundamental planning principles should also be uniform. Most of the

characteristics of Chinese imperial planning can be seen in Fig. 34–1, the plan of seventeenth-century Beijing.

The fundamental feature of the Chinese imperial city is four-sided enclosure. Every Chinese imperial city is encased by four outer walls which meet at right angles to form a rectangle. Within the walls are at least one and sometimes two or more sets of walls that define smaller rectangular enclosures. Inside the smaller enclosures palatial sectors are elevated. Until the fourteenth century the material of outer enclosures was most often pounded earth. In later times outer walls were sometimes faced with brick. Smaller enclosures were generally constructed with plaster walls or pillared arcades. The most extensive enclosure of all, the Great Wall of China, was built of pounded earth beginning in the first millennium BCE.

Outer and inner city walls were pierced by gates, the second characteristic of the Chinese imperial city. Often, but not always, three gates were found at each outer wall face for a total of twelve. Ideally, gates of opposite city walls were equidistant from the adjoining wall corners. Inner cities of the imperial capital generally had no more than one gate at each side. One central gate always was placed at a south city wall. Most city wall gates were built for entrance or exit by a land route, usually a major urban thoroughfare, but some imperial cities had sluice gates as well.

Another feature of Chinese imperial city outer walls was the defensive projection, which took the form of a lookout tower or a protective battlement. Lookout towers were built at the four corners of a city and atop city gates, where troops could be quartered. The two types of battlements most common in Chinese imperial cities were *wengcheng* and *mamian*. *Wengcheng* were additional walls built in front of gates. They projected in front of and up to outer wall gates, with their own openings for access to the city. *Mamian,* literally "horse faces," alternately known as *yangma*, were simply additional fortified perimeter space that curved around the outer city wall at intervals, providing no access to the city interior. The use of *mamian* in medieval China is confirmed by an illustration in the eleventh-century military treatise *Wujing zongyao* (Collection of important military techniques). Both defensive *wengcheng* and *mamian* were also used at nonimperial Chinese cities.

The plan of imperial Beijing in Fig. 34–1 shows that major north–south and east–west streets crossed the city at right angles. Often the city roads and avenues ran from a northern to a corresponding southern gate, or from an eastern to a western one, giving way to a design feature that can be called clearly articulated and directed space. The principal north–south thoroughfare ran along a line that passed through the central northern and southern gates of each city wall. Parallel to the gate-initiated streets in both directions were smaller avenues, and parallel to them were *xiang* and *hutong*, east–west and north–south oriented lanes and alleys. The unambiguous articulation of north–south and east–west space was such that even the city's smallest regions were encased by walls or streets that ran perpendicular to one another. Seen from above, the city of Beijing appeared as a checkerboard in maps drawn during the reign of the Qianlong emperor (r. 1736–1796), and the image is still apparent in a twentieth-century photograph of Xi'an, formerly an imperial city.

Orientation of the streets, like the walls, was according to the four cardinal directions – symbolically the clearly demarcated boundaries of the Chinese empire.

The four-sided Chinese city is a physical manifestation of the traditional belief in a square-shaped universe, bounded by walls, with the Son of Heaven at its center. Tradition associates each of the four world quarters and the center with a symbolic animal, color, metal, season (excluding the center in this case), and a host of other phenomena.[2] South, for instance, is the direction of summer, fire, the bird (often a phoenix), and the color vermilion.[3] South is the cardinal direction the emperor faced when seated in his hall of audience, and thus most of the imperial buildings of an imperial city have a southern exposure. Continuing around the square, east is the quadrant of spring, wood, and the azure dragon; north is winter, water, and the black tortoise; west is autumn, metal, and the white tiger. Autumn and white are associated with death in Chinese culture, fall being the season of decay that, after the freezing of winter, will give way to new life and renewal in the spring. Thus tombs are often constructed north or west of the capital, the quadrants of death and decay. The names of imperial city structures also reflect attitudes toward cosmological alignment. At many Chinese imperial cities the palace of the crown prince or another hall is named Taiji, a reference to the polar star, and the Forbidden City of Beijing is known as Zijin Cheng, the Polar Forbidden City.

Four-sided enclosure of the city and cardinal orientation of its major routes lent themselves to the further enclosure of virtually every city sector according to the four cardinal directions. Bounded regions of the city made census taking and population control possible even in the late first millennium BCE. By the time of the seventh through ninth centuries a sophisticated system of one hundred eight walled wards was in place in the capital Chang'an. Just a century later the ward system would be a weak reflection of its former self, but the practice of dividing the city into governmentally controlled spaces that were inhabited predominantly by peoples of one occupational, religious, or ethnic group persisted in Beijing into the twentieth century.

Easy access to a good water supply also is essential to the plan of every Chinese imperial city. In addition to choosing a site near an abundant water source, the Chinese capital was usually surrounded by a moat, and human-directed waterways were channeled into the city. The Three Lakes of Beijing (see Fig. 34–1, no. 9) are an example of an artificial water source dug in the twelfth century that was preserved by each subsequent dynasty.

Vast size may also be considered characteristic of the Chinese imperial city. Until Beijing in the fifteenth century, most Chinese capitals were the largest cities in the world during their times of flourishing. Beijing shown in Fig. 34–1 encompassed an area of 62 square kilometers. In the seventh century the outer wall of the capital Chang'an spanned a distance of 36.7 kilometers. In the Warring States period (481–c.256 BCE) the capital of just one state, Yan, was about 32 square kilometers.

Related to the size of the Chinese imperial city is another feature: its population. Until the fourteenth or fifteenth century most primary Chinese capitals had the largest urban populations in the world. Means of assessing the population of

367

traditional Chinese cities vary from strict reading of local records to educated interpolations of them, and opinions differ about the validity of counting resident military in urban population figures. It is generally agreed, however, that both Chang'an in the eighth century and Beijing at the end of the sixteenth had populations of one million. The tenth through thirteenth century Song dynasty capitals at modern-day Kaifeng and Hangzhou had populations of well over one million; even the early Chinese capitals of Chang'an in the last centuries BCE and Luoyang in the first and second centuries CE had at least three hundred thousand people.[4]

One reason for the huge concentration of people in Chinese capitals was the common imperial practice of relocating masses of the population. If historical texts can be trusted, then at times hundreds of thousands of people were transferred to new capital cities. The lower echelons of society functioned as builders of new imperial projects, the upper classes were state servants, and those in the middle served as merchants, artisans, and commercial agents for the newly transplanted urban population.

Another characteristic of the Chinese imperial city may be called siting. Siting describes the belief that natural phenomena – mountains, wind, water – must be harmoniously interrelated at a site in order to ensure auspicious human existence. The practice of divination for the purpose of determining a positive balance of natural forces before selecting a site is often called *fengshui* or *kanyu*, both sometimes translated as Chinese geomancy.[5] References to the process by which a site was chosen are found in early Chinese written and illustrative records. Aspects of siting that have traditionally been concerns for imperial city builders are the location of protective mountains (or in their absence an artificial hill) to the capital's north and water to the south.

The final characteristic of Chinese imperial city planning has not always been possible to implement, but it should be mentioned. Ideally the Chinese imperial city was planned in entirety from its inception and was constructed beginning with the outer wall. At times building inside the outer wall occurred before the enclosure was complete, but the size and shape of the wall, and thus the enormous size of imperial cities in China, were rarely accidental.

Eleven features thus characterize imperial city planning in China: four-sided enclosure, gates, defensive projections, clearly articulated and directed space, orientation and alignment, the ward system, accessibility of water, vast size, huge population, siting, and building order.

[margin note: the 11 features of Chinese Imperial cities]

Components

The two-word designation "imperial city" calls to mind imperial Rome, St Petersburg, Constantinople, Isfahan, Fatehpur Sikri, and premodern Beijing. The image is one of monumental architecture replete with signs and symbols of the monarch: one or more palaces, imperial cathedrals or other institutions of

kingly faith, mausoleums, and structures of particular cultural significance, be they shrines, altars, or memorials. An imperial city also had its sectors of pleasure and privacy, arenas or gardens, for instance, and all the supporting structures necessary to maintain imperial life such as kitchens, granaries, workshops, treasuries, and libraries.

The Chinese imperial city is part of this group in name, and it shares many of the manmade forms that give an imperial city its image. Foremost among them are the ruler's palace, the architecture of the state religion (in the Chinese city, places for imperial ceremonies directed toward heaven), and royal tombs. Yet two important factors distinguish the Chinese imperial city from the others listed above. First, each of the cities except Beijing is associated with a specific period in a country's history, whereas Chinese sites and their architectural components have endured for millennia. Second, in China the locations of imperial buildings were standard. In fact, the positions of imperial structures are more standardized than the city plans.

A Chinese city cannot be imperial without a palace. In China the word *gong*, usually translated as "palace," refers to a group of palatial halls enclosed by a four-sided wall or covered arcade and interrelated by courtyards and adjoining covered ways or corridors. Palace complexes in premodern China often have three main buildings as their focus. The buildings are oriented toward the cardinal direction south and are located on the major north–south line of the city that encompasses them on at least three sides. Sometimes only the front and back of the three halls are actual structures, each wider in the east–west dimension, and the middle building is replaced by an adjoining covered way. The resulting shape of the three halls, or two halls and corridor, resembles the Chinese character *gong* (a different character than the above-mentioned palace complex), and the architectural arrangement is therefore referred to as a *gong* plan. A *gong* scheme can be seen just above no. 1 in Fig. 34–1.[6]

Two different types of halls are found within the palace precinct of every Chinese imperial city. One is for holding court, imperial audiences, or state ceremonies. The second is a private, residential chamber. In the Chinese city the more public imperial halls are referred to as *chao*, literally "court," often translated as hall of audience. *Chao* stand south (or in front according to Chinese descriptive terminology) of *qin*, the private or residential halls. An imperial city of the magnitude of Beijing in the seventeenth century had more than one of each type of building. There the southern group of three halls forming a *gong* plan were all ceremonial, and the three halls which formed a *gong* scheme behind them were residential. Later the three back halls became ceremonial as well, and residences were moved east and west of the main north–south imperial line.

Since early imperial times working and residential space for government officials was maintained inside the city walls. Initially the official bureaus and the homes of their employees were in the vicinity of the palace compound, and proximity to the emperor was a sign of rank. By the late sixth century, however, the offices of government were enclosed within their own walled city, called

huangcheng – the administrative-city or, more literally, the imperial-city. The imperial-city was distinct from the walled enclosure *gongcheng*, the palace-city, which accommodated only the residential and private halls of the emperor and his immediate relatives. From here on the two walled regions *gongcheng* and *huangcheng* will be translated by the hyphenated terms "palace-city" and "imperial-city" (or administrative-city), respectively.

A large open palace-place (see Fig. 34–1 near nos. 2, 3, and 14) has been a standard component of the Chinese imperial city since the first millennium CE. The focus on the palace-place as the city center is sharpened by a several-mile-long approach to it from due south, a road which is then continued as the major north–south axis through the city. The approach to the palace-place, called the imperial-way (*yudao*), usually has three lanes, one for passage toward the throne, one for passage away from the throne, and a central lane for imperial passage. Palace-place and imperial-way combine in premodern Chinese cities to form a T – clearly visible at the approach to the imperial-city in sixteenth-century Beijing. (See Fig. 34–1 between nos 14.)

Beyond the palace-city were altars for imperial sacrifices. Even though the Chinese emperor was not a devotee of a religion in the Western sense, he did look to the heavens for blessings, and the Chinese people looked to him as their intermediary between heavenly favor and human labors. Therefore, at set times each year the emperor went out from the palace-city to suburban altars to perform sacrifices and to pray to heaven on behalf of earthly concerns. In the first millennium only altars to the imperial ancestors and to soil and grain were built at the imperial city. By the fifteenth century the number of imperial sacrificial spots in the Chinese capital had more than tripled. The altars themselves were often exposed to the heavens, but they were always built inside of walled compounds. The altars of imperial Beijing, shown in Fig. 34–1, are described below.

The Altars of Soil and Grain (She Tan and Ji Tan) (Fig. 34–1, no. 3) were twin altars on the west side of the imperial city, sometimes located directly opposite the Ancestral Temple. On the Soil Altar were placed five colors of earth: vermilion, azure, black, and white at positions corresponding to the four sides. The Grain Altar was covered only with yellow earth.

Altar of Heaven (Tian Tan) is the common name for a group of three structures that still stand at what was the far south, east of the main axis of seventeenth-century Beijing (Fig. 34–1, no. 4). In the sixteenth century the horseshoe-shaped Tian Tan complex included numerous buildings for the emperor's presacrificial preparation and for the storage of ceremonial objects, in addition to the one exposed altar and two covered structures that stand today. By that time sacrifices to heaven had supplanted all other imperial devotion, even sacrifices to the imperial ancestors.[7]

The Altar of Agriculture (Nengye Tan), alternately known as the Altar of the First Crops (Xiannong Tan) (Fig. 34–1, no. 8), was located opposite the Altar of Heaven. Initially this altar was intended for ceremonies honoring the first crops of

the year; in 1532 the emperor added twin altars to heaven and earth and an altar for the worship of the planet Jupiter at the same site.

Other altars of the Chinese imperial city were erected to the earth (Di Tan; Fig. 34–1, no. 5), the sun (Ri Tan; Fig. 34–1, no. 6), the moon (Yue Tan; Fig. 34–1, no. 7), and silkworms (Xiancan Tan), the latter built in the sixteenth century on an island in the West Park (Three Lakes) (Fig. 34–1, no. 9) where the empress performed the rite of cocoon washing.

Different from the exposed suburban altars was the Ancestral Temple (Tai Miao or Zong Miao). It was the main building of an architectural complex entered by the ruler to pay homage to the founder of the dynasty, his wife, and other imperial ancestors, whose names were entered on tablets in the temple. The Ancestral Temple stood to the east of the main axis of the imperial city, left of the audience hall as one faced south (Fig. 34–1, no. 2).

Beginning in the fifth century, temples and great monasteries to Buddhism and Daoism could be seen in Chinese imperial cities. In later centuries religious edifices for less popular foreign faiths were also erected. Often the emperor or his wives and concubines practiced several religions, so neither permanent imperial religious monuments nor standard locations for them were established at the capital. Buddhist temple complexes were called *si* and Daoist monasteries *guan* or *gong* (the same character used for palace complex).

Three temples (*miao*) dedicated to native Chinese heroes were also constant features of the imperial city landscape. The most important was the temple to Confucius. First built in the capital of the state of Lü (today Qufu in Shandong province) immediately following the death of the sage in the fifth century BCE, in later centuries Confucian temples were built in all major Chinese cities. The main hall of a Confucian temple, Dacheng Hall, housed a tablet inscribed with Confucius' name, rather than his statue. Tablets honoring other Confucian disciples could be placed in the same temple complex, or independent temples or temple complexes to the disciples could be built.

Balancing the Confucian, or civil official's, temple in the Chinese capital was a temple dedicated to the military god Guandi and by extension to military officials. The main Guandi Temple in China is in Yuncheng, Shanxi province. A third temple found in every Chinese capital, and in other cities of import, was the City-God Temple (Chenghuang Miao).[8] Thus the Chinese word *miao* can refer to a temple dedicated to a historical or popular legendary figure or to a local god.

Three ritual buildings mentioned in early texts about Chinese imperial cities may be considered components of the planned capital, even though they were not always constructed. Like dynastic altars, the ritual spaces were the sites of imperial ceremonies, but they served other purposes also. Descriptions of the three ritual spaces, and records of their locations in the imperial city, are ambiguous.

The most frequently mentioned imperial ritual space is the Ming Tang, literally "bright hall." It was an ideally conceived multistory structure whose architectural components were circular or square in plan. Ming Tang were built at Chinese cities and in the provinces in the last centuries BCE and the first centuries CE and

occasionally at later times. Initially the Ming Tang was the site of imperial sacrifices, but in time it came to share the space and functions of two other ritual structures.

A ritual space with which the Ming Tang may have shared a location if not an actual structure was known as Bi Yong, literally "jade-ring moat." Bi Yong is referred to in most of the classical Chinese texts that describe the Ming Tang. It is believed to have been a circular, moat-surrounded building. Among its functions was the education of candidates for imperial service. This purpose was taken over in later Chinese capitals by the National Academy (Guozi Jian) (Fig. 34–1, no. 12). Another later imperial city building pertinent to official education was the Imperial Library.

A third ritual space in the Chinese imperial city was the Ling Tai, a platform for observation of the heavens. The role of the Ling Tai, where the emperor ascended for the ceremonial regulation of the calendar, was probably superseded in later times by astronomical observatories. The later observatories were also imperially sponsored building projects.

Reconstructions of the three ritual spaces were proposed and debated at the Chinese court for two thousand years. An important reconstruction by Wang Shiren is based on his belief that a composite ritual hall, one in which the functions of Ming Tang, Bi Yong, and Ling Tai were housed under one roof, was located in the southern suburbs of the imperial city Chang'an at the beginning of the first century CE.[9]

The last structure planned inside the walls of the Chinese imperial city was the freestanding tower. One and often two types of the multistoried structures stood on the main north–south axis of imperial Beijing and certain earlier Chinese capitals (Fig. 34–1, no. 20). The towers housed either a bell or a drum, and their functions were those of urban timekeeping devices. The bell or drum was sounded at regular intervals during the day and night.[10]

Imperial gardens and parks could be found inside any of the capital's walls and occasionally beyond them. Chinese emperors of the last centuries maintained game reserves, both for hunting and for the confinement of exotic animals. Planned gardens and parkland for imperial pleasure were also part of the Chinese imperial city. Beginning in the first millennium BCE, an imperial garden was almost always located directly north of or adjacent to the palace area.

Chinese imperial cities always had designated market areas where nonimperial urban dwellers could shop. The locations and number of these market districts varied from city to city.[11] Although the primary purpose of the Chinese capital was administrative, and separate market towns flourished across the country, often the imperial city was the location of some of the nation's most active commercial districts. Both goods produced in the capital and imported products were available for purchase.

The last component of the Chinese imperial city, the royal necropolis, lay beyond its outer wall. Except for the Mongolian rulers of China, whose graves are at unmarked sites in Mongolia, or final dynastic rulers whose bodies were not

accorded imperial burial by the new dynasty, every Chinese ruler built a tomb near his imperial city but outside the walls.[12] The earliest known royal cemetery survives at Xibeigang, where rulers of the mid-second millennium BCE capital at Anyang were interred. The plans of imperial tombs after Xibeigang are somewhat standard, consisting of a long approach to the burial precinct, a subterranean multichamber grave, and, by the end of the first millennium BCE, a mound covering the subterranean portion and an enclosure around the whole area. Underground tombs were built of brick and stone, permanent materials that presented a dramatic contrast to the timber construction of the Chinese capital. The architectural principles of imperial cities of the dead, however, were borrowed from those of the living.

Notes

1 Many discussions of the emperor's role in society and his relation to heaven and the cosmos are available. A recommended study is Marcel Granet, *La Pensée chinoise.*
2 On these ideas see William Theodore De Bary, et al., *Sources of Chinese Tradition*, vol. 1, pp. 198–204. On the four-sided worldview and its relation to Chinese architecture see Nelson Wu, *Chinese and Indian Architecture*, and Paul Wheatley, *The Pivot of the Four Quarters*, especially pp. 411–476.
3 The Chinese term for this bird is *que* or *qiao* (sparrow). It is often illustrated as a phoenix, more suitable than a sparrow as the representative of the south because of its auspicious connotations. Throughout the text *zhuque* is translated as "vermilion bird."
4 Population figures for China's premodern cities are available in Dong, *Zhongguo chengshi jianshe shi.* G. William Skinner assesses some of the sources of population figures in his introduction to *The City in Late Imperial China*, pp. 3–31.
5 An extensive bibliography is available for the subject of Chinese geomancy. Suggested introductory reading is Steven Bennett, "Patterns of the Sky and Earth," and Andrew March, "An Appreciation of Chinese Geomancy." More extensive treatment of the subject is available in Sophie Clément et al., *Architecture du paysage en Asie orientale*, and an interesting discussion of the lore of *fengshui* is found in J. J. M. De Groot, *The Religious System of China*, vol. 3.
6 The *gong* arrangement is reserved for high-ranking imperial and Buddhist buildings. The *gong* scheme and other patterns of spatial enclosure are discussed in Liu, *Zhongguo gudai jianzhu shi*, 2d ed., pp. 8–13.
7 Howard Wechsler argues that the role of heaven and the importance of heaven worship superseded ancestor worship even in the seventh century. See *Offerings of Jade and Silk*, pp. 107–122. On the role of heaven and heaven worship in Ming China see Jeffrey Meyer, *Peking as a Sacred City.* The Altar of Heaven is discussed in Nancy S. Steinhardt, *Chinese Traditional Architecture*, pp. 140–149; Shan, "Mingdai yingzao shiliao: Tian Tan"; and Ishibashi, *Ten-dan.*
8 The city-god and other folk temples of the Chinese city are discussed in Stephen Feuchtwang, "School-Temple and City God," in G. W. Skinner, ed., *The City in Late Imperial China*, pp. 581–608, and David Johnson, "The City-God Cults of Tang and Sung China."

9 For Wang Shiren's reconstruction of the composite ritual hall see his "Han Chang'an Cheng nanjiao lizhi jianzhu." On this structure see also Yang Hongxun, *Jianzhu kaoguxue lunwen ji*, pp. 169–200.

10 On locations and functions of bell and drum towers see Tanaka Tan, "Jujiro ni tatsu hoji rokaku." Professor Tanaka has provided me with an unpublished manuscript on the subject as well.

11 The relation between commerce and the city is not discussed here. For studies dealing with wards or guilds and trade within them see Denis Twitchett, "The T'ang Market System"; Twitchett, "Merchant, Trade and Government in Late T'ang"; Shiba Yoshinobu, *Commerce and Society in Sung China;* and Sidney Gamble, *Peking: A Social Survey.*

12 For a general discussion of Chinese imperial tombs see Yang, *Zhongguo gudai lingqin zhidu shi yanjiu.*

References

de Bary, Wm. Theodore, Wing-tsit Chan, Burton Watson, et al. *Sources of Chinese tradition*. New York: Columbia University Press, 1960.

Bennett, Steven. "Patterns of the Sky and Earth: A Chinese Science of Applied Cosmology." *Chinese Sciences* 3 (1978): 27–38.

Clement, Sophie, et al. *Architecture du paysage en Asie orientale*. Paris: Ecole nationale supérieure des beaux-arts, 1982.

De Groot, J.J.M. *The Religious System of China*. 6 vols. Leyden: E.J. Brill, 1892–1910.

Dong Jianhong. *Zhongguo chengshi jianshe shi* [History of Chinese city construction]. Beijing: Zhongguo Jianzhu Gongye Press, 1982. 2nd printing, 1985.

Feuchtwang, Stephen. "School-Temple and City God." In G.W. Skinner, ed., *The City in late imperial China*. Stanford, CA: Stanford University Press, 1977.

Gamble, Sidney. *Peking, a social survey conducted under the auspices of the Princeton University Center in China and the Peking Young Men's Christian Association*. New York: George H. Doran Company 1921.

Granet, Marcel. *La Pensée chinoise*. Paris: Editions Albin Michel, 1988.

Ishibashi Ushio. *Ten-dan* [Altar of Heaven]. Tokyo: Yamamoto Book Company, 1957.

Johnson, David. "The City-God Cults of T'ang and Sung China." *Harvard Journal of Asiatic Studies* 45, no. 2 (1985): 363–457.

Liu Dunzhen. *Zhongguo gudai jianzhu shi* [History of traditional Chinese architecture]. Beijing: Zhongguo Jianzhu Gongye Press, 1st edn, 1980; 2nd edn, 1984.

March, Andrew. "An Appreciation of Chinese Geomancy." *Journal of Asian Studies* 27, no. 2 (February 1968): 253–267.

Meyer, Jeffrey. *Peking as a Sacred City*. Taipei: Chinese Association for Folklore, 1976.

Shan Shiyun. "Mingdai yingzao shiliao: Tian Tan" [Historical materials on Ming construction: the Altar of Heaven]. *Zhongguo yingzao xueshe huikan* 5, no. 3 (1935): 111–138.

Shiba Yoshinobu. *Commerce and Society in Sung China*. Ann Arbor: University of Michigan, Center for Chinese Studies, 1970.

Skinner, G. William, ed. *The City in late imperial China*. Stanford, CA: Stanford University Press, 1977.

Steinhardt, Nancy S. *Chinese Traditional Architecture*. New York City: China Institute in America, China House Gallery, 1984.

Tanaka Tan. "Jujiro ni tatsu hoji rokaku" [Towers for keeping time at the crossroads]. *Chyamus* no. 5 (1983): 20–22.

Twitchett, Denis. "Merchant, Trade and Government in Late T'ang." *Asia Major*, n.s. 14, no. 1 (1968): 63–95.

—— . "The T'ang Market System." *Asia Major*, n.s. 12, no. 2 (1966): 202–243.

Wang Shiren. "Han Chang'an Cheng nanjiao lizhi jianzhu yuanchuang de tuice." [Conjectures on the original appearance of the architectural remains of the ritual structures in the southern suburbs of Han Chang'an]. *Kaogu* no. 9 (1963): 501–515.

Wechsler, Howard. *Offerings of Jade and Silk: ritual and symbol in the legitimation of the T'ang Dynasty.* New Haven: Yale University Press, 1985.

Wheatley, Paul. *The Pivot of the Four Quarters: a preliminary enquiry into the origins and character of the ancient Chinese city.* Chicago: Aldine Pub. Co. 1971.

Wu, Nelson. *Chinese and Indian architecture.* New York: George Braziller, 1963.

Yang Hongxun. *Jianzhu kaoguxue lunwen ji* [Collected essays on architectural archaeology]. Beijing: Wenwu Press, 1987.

Yang Kuan. *Zhongguo gudai lingqin zhidu shi yanjiu* [Research into the history of the ancient Chinese tomb system]. Shanghai: Guji Press, 1985.

35

Letters from European Travelers about the Forbidden City: "A Jesuit in Beijing: Louis Lecomte" and "An English Ambassador in Beijing: Aeneas Anderson"

Introduction

Many European travelers wrote detailed accounts of their time in Asia, and for art historians, these sources can provide useful information. Often the visitors recorded details that indigenous accounts took for granted, such as how people moved (or didn't, as the case may be) through architectural and urban spaces or how those spaces were embellished with gardens, furniture, or textiles. At the same time, these travelers' accounts can be problematic. Because the visitors interpreted the new cultures they encountered through their own perspectives and agendas, readers cannot assume the evidence they provide is objective. Sometimes the authors focused on details they found "exotic" or tailored their descriptions to affirm their own cultural superiority. Occasionally some writers completely misunderstood something they saw or based their information on rumor. The following reading contains excerpts from two seventeenth- and eighteenth-century visitors' accounts of the Forbidden City in Beijing (referred to as Peking or Pekin by the travelers), which, as

Louis Lecomte, "A Jesuit in Beijing: Louis Lecomte," pp. 99–100, and Aeneas Anderson, "An English Ambassador in Beijing: Aeneas Anderson," p. 103, from Gilles Béguin and Dominique Morel (eds), *The Forbidden City: Center of Imperial China*. New York: Abrams, 1996. Reprinted by permission of Harry N. Abrams Inc.

the monumental center of Chinese political power during the Yuan (1279–1368), Ming (1368–1644), and Qing (1644–1911) dynasties, was a popular topic for travelers' descriptions.

The first account is by Louis-Daniel Lecomte (1655–1728), a French Jesuit missionary, who in 1685 sailed to Siam (now Thailand) with five other Jesuit mathematicians at the order of Louis XIV. The group then went on to China, arriving in Beijing around 1688, when Emperor Kangxi was ruling the Qing dynasty. Lecomte composed his travel observations as a series of letters written to various members of the French elite and published them in 1697. In the excerpt here, from a letter addressed to an aristocratic woman, Lecomte describes the delegation's visit to the Forbidden City. The second excerpt comes from *A Narrative of a Voyage to China* by Aeneas Anderson, a member of the first British embassy sent by George III to the court of the Qianlong Emperor in 1792–4. Anderson acted as valet for Lord Macartney, the leader of the trip, which was considered a diplomatic failure but an information-gathering success. Almost every member of the British embassy kept a written or visual account of the journey. Of these, Anderson's text, with its lively style, became the most popular, running in two editions after its 1795 publication.

In general, such travelers' accounts, which were frequently reprinted and translated into other European languages, proved popular. The best known and respected texts became the basis for Western knowledge about China for some time. Thus, the passages included here act as historical documents on two levels. They provide detailed descriptions of the Forbidden City, indicating the awe it held for seventeenth- and eighteenth-century visitors. At the same time, they document early Western interest in, and study of, China.

A Jesuit in Beijing

Until then, we had not had the honour of seeing the emperor; the formalities of the *Lipou* (Tribunal of Rites) had to precede our audience; but as soon as the first president of this tribunal had placed us in the hands of our fathers, two eunuchs came to the College to tell the superior to come the next day with all his companions to a courtyard in the palace which he noted down. We were informed of the ceremony that must be observed on these occasions; but we had already become Chinese and there was no difficulty in instructing us.

We had to go in a chair as far as the first gate, from where we crossed on foot eight courtyards of astonishing length, surrounded by buildings of different architecture, but of very mediocre beauty, with the exception of the large square pavilions, built on the communicating gates, which had something grand and monumental about them. These gates, which led from one courtyard to the other, were of remarkable thickness, wide, tall, well-proportioned and built of white marble, whose shine and beauty had been faded by time. A stream of running

water cut across one of these courtyards and could be crossed by several small bridges made of marble that was similar, but whiter and more beautifully carved.

It is difficult, Madame, to go into great detail and to provide a description of this palace that would please you because its beauty lies not so much in the separate pieces of architecture of which it is composed as in an impressive array of buildings and an infinite series of courtyards and gardens neatly laid out, where everything is truly magnificent and shows the power of the master who lives there.

The only thing that struck me, and which seemed to me to be remarkable of its kind, was the emperor's throne. This is the image I have retained of it: in the middle of one of these vast courtyards, one sees a base, or a solid mass of extraordinary magnificence, square and isolated on all sides, with a balustrade, worked in a manner similar to our own taste, running all around its pedestal. This initial base is surmounted by another smaller one, embellished with a second balustrade similar to the first. The construction rises in this manner to five tiers, each one smaller than the others. At the top a large square hall has been built in stone with a roof, covered in golden tiles, resting both on the four walls and a regular succession of large painted columns, which support the structure and contain within the throne of the emperor.

These vast bases, these five white marble balustrades which rise one above the other and which, when the sun shines, seem to be crowned by a palace glittering with gold and varnish, have something magnificent about them, particularly as they are situated in the middle of a great courtyard and surrounded by four groups of buildings. Were one to add to this plan the ornament of our own architecture and the beautiful simplicity that gives relief to our own works, this would perhaps be the most beautiful throne that art ever erected to the glory of the greatest princes.

Louis Lecomte
Un jésuite à Pékin. Nouveaux mémoires sur l'état présent de la Chine, 1687–92

An English Ambassador in Beijing

As I had this day attended the Ambassador, I shall just mention what I saw of the imperial palace, which will be comprised in a very few lines.

It is situated in the centre of the city, and surrounded by a wall about twenty feet [six metres] in height, which is covered with plaster painted of a red colour, and the whole crowned or capped with green varnished tiles. It is said to occupy a space that may be about seven English miles in circumference and is surrounded by a kind of gravel walk: it includes a vast range of gardens, full, as I was informed, of those artificial beauties which decorate the gardens of China. I can only say that

the entrance to the palace is by a very strong stone gateway, which supports a building of two stories; the interior court is spacious, and the range of building that fronts the gateway rises to the height of three stories, and each of them is ornamented with a balcony or projecting gallery, whose railing, palisados, and pillars are enriched with gilding; the roof is covered with yellow shining tiles, and the body of the edifice is plastered and painted with various colours. This outer court is the only part of the palace which I had an opportunity of seeing, and is a fine example of Chinese architecture. The gate is guarded by a large body of soldiers, and a certain number of mandarins of the first class are always in attendance about him.

Of the magnificent and splendid apartments this palace contains for private use or public service; of its gardens appropriated to pleasure, or for the sole production of fruit and flowers, of which report said so much, I am not authorized to say anything as my view of the whole was very confined; but though I am ready to acknowledge that the palace had something imposing in its appearance when compared with the diminutive buildings of the city that surround it, I could see nothing that disposed me to believe the extraordinary accounts which I had heard and read of the wonders of the imperial residence of Pekin.

Aeneas Anderson
A Narrative of the British Embassy in China, 1796

36

The Conventional Success of Chen Shu

Marsha Weidner

Introduction

Weidner's essay explores the works of a single painter, Chen Shu (1660–1736) who defies our expectations of how a woman in the early Qing Dynasty (1644–1911 CE) might become famous. Unlike other well known women painters, Chen was not a relative of a painter, and instead gained renown by being an exemplary Confucian wife and mother. Her story is therefore one of conventionality rather than avant-garde innovation or radical resistance.

The Confucian virtues Chen embodied were newly valued in the early Qing dynasty, as once again China was ruled by a foreign power, the Manchu from the northeast. As a result, a consolidation of Chinese societal norms helped the elite to articulate their connection to a Chinese past and maintain the distinction between the imported rulers and the elite's long, albeit constructed heritage. Model Confucian behavior centered on filial piety, or respect for one's familial elders; Chen Shu embodied this virtue by respecting her husband's late first wife through offerings to her bereaved family, caring for her ill mother-in-law, and taking care of the household with a firm hand when her husband was away. As a virtuous mother, Chen ensured her children's education, even tutoring them herself when local teachers were not available. Her artistic and intellectual pursuits and own needs came after these priorities; even as she lay on her deathbed she insisted her son not compromise his career by attending to her. As Chinese connoisseurs of the time felt that character

Marsha Weidner, "The Conventional Success of Ch'en Shu," pp. 123–4, 129–53 from Marsha Weidner, *Flowering in the Shadows: Women in the History of Chinese and Japanese Painting.* Honolulu: University of Hawaii Press, 1990.

380

and artistic talent were intimately interrelated, Chen's Confucian virtues allowed her to gain fame as a painter.

Weidner's discussion of Chen's paintings reveal the extent of records available for the study of Chinese painting. By the Qing Dynasty, art historical practice in China is fully developed; catalogues of famous painters, biographical texts, and the colophons, or texts attached to the paintings themselves, provide extensive information about the artists, patrons, and aesthetic values of a particular time period. Weidner provides several examples of texts on paintings by Chen herself, as well as by emperors, connoisseurs, and art historians. Many of these reveal, even in their praise of Chen's work, their surprise that a woman might be able to achieve this kind of painterly skill and intellectual attention to art historical models. Weidner also explores the distinction between artists who sold their paintings as a major portion of the family income and those who strove to embody the ideal of the amateur scholar-painter and did not sell paintings. Thus, through the story of Chen Shu, Weidner paints a picture for us of the importance of exemplifying Confucian virtues during the early Qing, contextualizing oneself within art historical precedents, and retaining the valued status of the amateur artist.

The eminence Chen Shu (1660–1736) attained as a painter was unusual for a woman in premodern China. As an artistic, literate daughter of the gentry, however, she is representative of many women of the Qing dynasty who became accomplished poets, calligraphers, and painters. Especially in the lower Yangzi River region, the cultural heartland of late imperial China and Chen Shu's home, these women constituted a significant minority voice within the scholarly art world. Entrée to this world required considerable learning and, because contemporary opinions about women's education were mixed, such learning was available to only a portion of the upper-class female population. The most conservative parents felt that their daughters should confine their activities to needlework and domestic tasks and avoid literary and related pursuits that might interfere with their preparation to be dutiful wives. In more liberal circles, on the other hand, learning could actually enhance a girl's marital prospects. Some men preferred to take educated brides who might share their literary interests and help with the teaching of their children. In Chen Shu's time it was thus relatively common for women of good families to be taught enough to permit them to read edifying books and popular novels, keep records, and write poetry. With this background, quite a few, like their fathers and brothers, went on to take up painting as a pastime and means of self-expression. In doing so they participated in the scholar-amateur tradition that was the mainstream of later Chinese painting.

We know more about Chen Shu than we do about most Chinese women artists because her eldest son, the prominent scholar-official Qian Chenqun, composed a lengthy account of her life and presented a number of her paintings to the Qianlong emperor.[1] Many of the paintings by Chen Shu that were formerly in the Qing imperial collection now belong to the National Palace Museum in

381

Taibei.[2] These works and the biography by Qian Chenqun are the primary materials upon which this study is based.

Qian Chenqun wrote about Chen Shu in the accepted laudatory fashion, employing standard images of idealized womanhood to characterize her as an exemplar of Confucian virtue. Glimpses of the real person can be caught through the clouds of idealization, however, and it is clear that she was an intelligent and strong individual who played a pivotal role in the history of her husband's family. Qian touched only briefly on his mother's painting, but he described some of the circumstances that enabled her to cultivate her talent and, eventually, to influence the artistic development of members of the Qian family of succeeding generations.

Within traditional Chinese society, the worth of a woman was measured by her contributions to her husband's family, but especially by the number and caliber of the children she raised. By this standard, Chen Shu was a worthy woman indeed. Her eldest son's distinguished official career dramatically raised the status of the Qian family, and this prominence was sustained by his sons, grandsons, and great-grandsons, many of whom became noted scholars and officials. Through various means Qian Chenqun also honored his mother's natal family. Not the least of these was his use of their patronymic, Chen, as part of his personal name.[3] Chen Shu's father need not have lamented that she was a girl and so incapable of exalting the family name; through her eldest son she did just that.

Since in the traditional scheme of things Chen Shu's accomplishments as a mother were far more important than her literary and artistic activities, Qian Chenqun did not find it necessary to include much information about her poetry and painting in her biography. He refers only in passing to his mother's childhood interest in painting and to a portrait she did of his first wife. Similarly, in summing up her legacy, he reports, almost as a footnote, that she filled three volumes with poems, but was too modest to permit them to be published, and was so skilled in the depiction of landscapes, figures, and flowers that people vied for her works.[4] Fortunately, we can learn more about her painting from other sources. Examples of her work in all three categories of subject matter remain; a number of her lost paintings are recorded in eighteenth- and nineteenth-century catalogues; and the writings of Zhang Geng and others provide additional information about her iconographic and stylistic preferences.

In figure painting, as her biography would lead one to expect, Chen Shu preferred subjects of an improving sort drawn from history and religion. One of her best-known figural works was an album, *Precepts of the Emperors of Successive Dynasties*, that Qian Chenqun presented to the Qianlong emperor in 1743. This album, which apparently is no longer extant, was placed in the "superior" category by the cataloguers of the imperial art collection. It opened with images of the legendary emperors Fu Xi and Shen Nong, proceeded through emperors of the Zhou, Han, and Tang dynasties, and concluded with Taizu of the Song period. The figures were described in color on silk, and Qian Chenqun wrote explanatory notes on the facing pages.[5]

According to Zhang Geng, Chen Shu also painted such popular figures as the bodhisattva Guanyin, the legendary hero and god of war Guan Yu, and the Daoist immortal Lü Dongbin.[6] The single surviving example of such a work is a hanging scroll of Guanyin done in ink and light colors on paper. Formerly in the imperial collection, it now belongs to the National Palace Museum.[7] In 1771, near the end of his life, Qian Chenqun went to Beijing to participate in the celebration of the eightieth birthday of the empress dowager, and at this time presented his mother's painting of Guanyin to the court. Perhaps he offered it as a birthday gift to the empress dowager; it would have been particularly suitable as such, since the subject is a deity favored by women and the artist was female. Two years later the emperor added a poem to the painting, which is also marked with a full set of imperial seals. The author's inscription reads: "Shangyuan dizi Chen Shu, imitating the brush methods of Zuomen Sun shanren, respectfully painted the image of the Universal Door Bodhisattva [Guanyin] come forth from the sea. On the third day of the second month of spring in the fifty-second year of the Kangxi period [1713]."

The scroll has little in common with most of Chen Shu's other surviving paintings, but this can be attributed to the fact that she executed it in someone else's manner and also drew on stylistic and iconographic conventions long established for the representation of Guanyin. Depicted at home on Mount Potalaka, the deity sits on a rocky outcropping over the water and holds a willow branch in one hand. The rocks are described with dark, modulated outlines, broad wash, and a few "axe-cut" texture strokes in a manner ultimately based on academic landscape painting of the Southern Song, the period in which this type of Guanyin image was definitively formulated. Elements such as the fluid drawing of the wavy contours of the bodhisattva's robe and the hint of archaism in the narrow, rippling fabric folds can be connected to styles popular with late-Ming and early-Qing paintings of religious figures.

The nineteenth-century collector Li Zuoxian recorded a hanging scroll ostensibly by Chen Shu of a very different but no less conventional subject: the return to China of the Han-dynasty woman Cai Yan, known as Lady Wenji. This painting was executed in fine lines and color on silk and inscribed "Qian Shu of the Chen family copying the ancients," a formula found on many of Chen Shu's works. According to Li's description, the moonlit scene was populated with figures standard for the theme – women caring for Wenji's children, a female servant carrying a *pipa* (lute), and grooms resting with their horses in the shelter of an embankment. Wenji was shown seated alone in a tent, with paper, ink stone, and *qin* (zither) by her side. Instead of portraying the more dramatic moments in Wenji's story, such as her tearful farewell to her children or her arrival at home, Chen Shu chose an episode that centered on the musical and literary abilities of her subject, the woman traditionally regarded as China's first great female poet.[8]

The conservatism evident in Chen Shu's figure painting is just as apparent in her approach to landscape. In her large-scale landscapes she followed the lead of Weng Shimin, Wang Hui, and other exponents of the early-Qing orthodox

school, who engaged in the creative imitation of the styles of the old masters. Stylistic references to great works of the past are therefore more important than the naturalistic description of rocks and trees in Chen Shu's mountain scenes. Her favorite model was Wang Meng of the Yuan dynasty. One of her hanging scrolls in his style was designated a work of superior quality when it was recorded in the catalogue of the Qing imperial collection completed in 1745. This painting bore Qian Chenqun's seal, and was probably another of his gifts to the emperor. It does not seem to have survived, but fortunately the catalogue preserves the artist's inscription, which is of interest because it indicates the nature of her involvement with contemporary scholarly artistic issues:

> Qinghui shanren [Wang Hui] once showed me his paintings after Wang Meng's *Mount Hua* and *Sounds of the Mountain Spring in the Pine Valley.* [They are] extremely skillful. Later I saw a copy of *Sounds of the Mountain Spring in the Pine Valley* by Zhangru [Qian An] of my family, which has a sparse, antique elegance. I feel that Qinghui still possessed the mannerisms of a famous master. One autumn day while idling at the window, I chanced upon a matching scene. Alas, I have yet to see an authentic work by Wang Meng. Written and recorded by Nanlou laoren Yongzheng, on the sixteenth day of the ninth month of 1726, in the Yongzheng reign period.[9]

The work was done, then, shortly after Chen Shu returned from her first trip to the capital.

Among Chen Shu's surviving landscapes are two based on paintings by the Yuan master that are still well known today. Her *Imitating Wang Meng's "Dwelling in the Mountains on a Summer Day"* reproduces the mountain and river view of his scroll dated 1368, now in the Beijing Palace Museum; *The Mountains Are Quiet and the Days Grow Long* derives from his *Spring Dawn over Mount Dantai* (*Dantai chunxiao tu*), the composition of which is preserved in two scrolls ascribed to Wang Meng, as well as in a painting with the signature of his early-Ming follower Wang Fu and a seventeenth-century album of reduced-size copies of old masterworks.[10] The originals, or at least close copies of these works by Wang Meng, were famous in orthodox painting circles and were, in fact, recorded by Chen Shu's pupil Chang Keng.[11] Chen Shu employed the forms and arrangements invented by Wang Meng, but did not capture all of the grandeur and remoteness of his scenes. In her versions the mountains are smaller in proportion to the foreground trees; the middlegrounds have been compressed to bring the distant mountains closer to the viewer; and the vistas are complicated by the addition of distant peaks. Such changes, however, were not unique to Chen Shu's interpretations; they can be found in other seventeenth-century treatments of Song and Yuan monumental compositions such as those in the album of copies mentioned above. Since ten years before her death Chen Shu had yet to see an original work by Wang Meng, we might wonder if she ever did. It is possible that both *Imitating Wang Meng's "Dwelling in the Mountains on a Summer Day"* and *The Mountains Are Quiet and the Days Grow Long* were based on late copies

rather than paintings from the master's hand. This might also partially explain the mechanical quality of the execution of the former scroll as seen, for instance, in the monotonous regularity of the medium grey texture strokes and the black *dian* (dots) that cling to the mountains and tree trunks. Despite the twisting pines, the winding mountain range, and the curling "lotus leaf" texture strokes taken from Wang Meng's landscape of 1368, this painting lacks the vitality and animation characteristic of his work. The lulling abstract patterns of the brushstrokes are better compared to those found in some of the landscapes in old manners by artists of the orthodox school.

These scrolls, which now belong to the National Palace Museum, were much appreciated by the Qianlong emperor. He inscribed *The Mountains Are Quiet and the Days Grow Long* in 1785, and wrote on *Imitating Wang Meng's "Dwelling in the Mountains on a Summer Day"* five times, in 1782, 1787, 1789, 1791, and 1793.[12] He wrote twice on another of Chen Shu's landscapes after Wang Meng, a hanging scroll entitled *Reading the* Yijing *in a Mountain Study*. Colophons were also added to this painting by the distinguished officials Dong Gao and Liang Guozhi, and by the powerful Manchu official Heshen.

The artist's own inscription on *Reading the* Yijing *in a Mountain Study* gives this account: "Grasping the brush I wished to imitate Shuming's [Wang Meng] *Reading the* Yijing *in a Mountain Study*, but trusting my hand, unexpectedly I incorporated the brush methods of old master Shitian [Shen Zhou]. Arriving at this peaceful, secluded place, in the hottest days of summer, I am able to forget the heat. Fuan Chen Shu at the age of seventy-five [1734]."[13]

The Tall Pine was yet another of Chen Shu's works that was much appreciated by the Qianlong emperor; he wrote on it four times between 1764 and 1793. The early twentieth-century connoisseur Zhong Yi praised it as follows: "The brushwork in this scroll is antique and elegant, and the ink colors are deliberately applied and harmoniously blended in a manner that combines [elements of styles of] Wen [Zhengming] and Shen [Zhou]. This is a truly outstanding piece of work, one which few of the famous painters of her time could match. It must not be regarded as [merely] a painting from the women's quarters."[14] Chen Shu did not acknowledge a debt to Wen or Shen in her inscription, but simply stated: "The tall pine outside the pavilion is three hundred years old. In a moment of leisure I have depicted it." Nevertheless, the composition, in which an attenuated pine towers over a thatched riverside hut occupied by a lone scholar, recalls numerous narrow, vertical Wu School paintings of similar themes.

Chen Shu is perhaps best remembered for her flower paintings. Like her landscapes, her works in this genre range from formal, straightforward copies of old compositions to light, informal sketches similar to those of the Wu School artists. The latter, arguably the most appealing works in her oeuvre, are well represented by the ten "sketches from life" in an album dated 1713, now in the National Palace Museum.[15] Rendered in direct applications of color, without outlines, these leaves of flowers, vegetables, birds, and insects recall the flower studies of the Suzhou master Chen Shun.

The art of this man with the same family name was of special interest to Chen Shu, and she made this known, in part, by using a seal that stated that she was following his methods.[16] This seal appears on her album of 1713 and elsewhere. Moreover, four of her recorded paintings, all ink monochrome studies of flowers, plants, and fruit, are inscribed as based on Chen Shun's works or methods. Two can still be located: a hanging scroll of a lotus plant in flower, and a handscroll of narcissus flowers and rocks.[17] Since Chen Shu's father-in-law Qian Ruizheng, who died in 1702, compared her art to that of Chen Shun, she must have begun studying the Ming master's methods fairly early in her career. The inscription on the handscroll of narcissus and rocks is evidence of her sustained interest in his art: "Boyang of my family [Chen Shun] had [among his works] a handscroll of narcissus flowers painted in ink. By a rainy window I copied it and rather obtained a relaxed brush quality. Nanlou Laoren Chen Shu at the age of seventy-five [*sui*]."[18] The painting has, unfortunately, been damaged and retouched, further blurring the already smudgy rocks. The plants, however, have an appealing vitality. The narcissus flowers, which bloom in abundance amid bristling leaves, are accompanied by two types of crisp bamboo, one outlined and the other defined by single grey-to-black strokes. The scroll closes with an energetic rendering of plants reminiscent in its boldness of the sketches of late-Ming painter Xu Wei.

Some of Chen Shu's more formal flower-and-bird paintings, such as *The White Cockatoo* of 1721 and *Autumn Wildlife* dated 1700, are based on academic models of the distant past. *The White Cockatoo* (Fig. 36–1), though not inscribed as a copy or imitation, clearly relies on Song-dynasty precedents. In fact, the same composition can be found on a scroll dated 1427 that purports to be a copy of a work by Emperor Huizong of the Song.[19] The precise detail, the accurate yet decorative color, the emphasis on a few exquisite motifs, and the dramatic diagonal composition are all elements typical of the flower-and-bird paintings by Huizong and the artists of his imperial painting academy. The subject too is a courtly one. Pet birds of this type were kept by court ladies. When Chen Shu painted it, she may well have remembered the "Snowy-Garbed Maiden," a white cockatoo that belonged to China's most famous beauty, the Tang dynasty imperial concubine Yang Guefei. This scroll is not recorded in the standard catalogues and bears no collectors' seals, but the artist's seals do match those on the better-documented *Autumn Wildlife*.[20] The two paintings are also similarly rendered in cool colors and delicate outline-and-color techniques. *Autumn Wildlife* was previously in the Qing imperial collection and was recorded in the imperial catalogue completed in 1793. In her inscription for this scroll Chen Shu stated that she was "copying the ancients," but she did not cite a specific model. She might have had any number of Song treatments of this popular auspicious theme in mind, or, possibly, the paintings of birds in landscape settings by the Yuan-dynasty master Wang Yuan.

Among the formal studies of flowers and plants that bear Chen Shu's signature and seals are three brightly colored works on silk: an album of the flowers of the

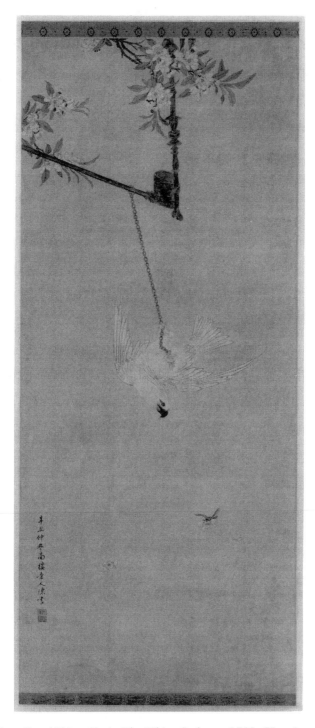

Fig. 36-1 Chen Shu (Ch'en Shu), *The White Cockatoo*, 1721. Hanging scroll, ink and colors on paper, 94.0 × 43.7 cm. The Metropolitan Museum of Art, John Steward Kennedy Fund, 1913 (13.220.31).

four seasons, and two hanging scrolls of New Year's table arrangements – one with a celadon planter and the other with a blue vase and cut branches of flowers.[21] The album, which belongs to the Tokyo National Museum, is dated to the fifteenth day of the first lunar month (Lantern Festival) of 1733, and so was also a New Year's painting. The inscription specifies that the twelve leaves were done "in imitation of [the art of] antiquity." The technical means, including direct applications of color without outlines in the "boneless" manner and subtle gradations of color, connect this album with the academic works of the followers of the great Qing flower painter Yun Shouping. The New Year's hanging scrolls, both dated 1735 and in the collection of the National Palace Museum, are likewise conventional exercises in the decorative manner influenced by the work of Yun Shouping and popular at the Qing court. Questions might be raised about the authenticity of the two paintings. Although they are dated to the same season of the same year and are comparable in format and theme, they are dissimilar in execution. Moreover, they lack the thorough documentation that accompanies other of Chen Shu's works preserved in the imperial collection. It is generally difficult to weed out the unreliable works with Chen Shu's signature because, in her art as in her life, she was both ambitious and conservative; she worked in many genres and styles, but stayed well within the bounds of established traditions.

Numerous late-Ming and early-Qing women from gentry families cultivated painting skills similar to those of Chen Shu. These women were all successful painters and in many cases no less talented than Chen Shu, yet neither their reputations nor their paintings proved as durable as hers. As time passed and most of their works were lost, even artists as accomplished and once famous as Huang Yuanjie, Xu Can, the Zhou sisters, and Wang Zheng gradually slipped into the recesses of history. The female painters whose reputations best withstood the test of time make up a small and socially diverse group. Some, such as Ma Shouzhen, Xue Susu (Xue Wu), Liu Yin (Liu Shi), Gu Mei, and Li Yin, were courtesans or concubines whose enduring fame can be attributed mainly to their romantic biographies and beauty, and only secondarily to their brush skills, which in some cases were considerable. Others, notably Guan Daosheng, Wen Shu, Yun Bing, Ma Quan, and Chen Shu, though politely referred to as "beauties," belonged to the gentry and were members of respected, if not always affluent, families.[22] On the basis of their social standing and artistic achievements, as well as their sustained renown, these last five women can be regarded as the elite of China's female painters.

The women of the gentry, especially, became models for later female painters, and their works were sometimes critically compared. In a colophon written for a fan painting of crabapple flowers by a woman named Zhu Xin, for instance, the famous calligrapher Liang Tongshu observed:

> In my lifetime I have seen many paintings by women. The very best [artists], such as [the wife of] Huang Shizhai [Daozhou], Madame Cai [Shiron or Runshi], and Minister Qian's [Qian Chenqun] mother, Nanlou Laoren [Chen Shu], amply

possess the methods handed down from Xu [Xi] and Huang [Quan]. A sense of antiquity and sincerity inform the beauty and elegance [of their art]. They are not like Wen Shu and Yun Bing of Wu, who were merely known for belonging to a school of seductive charm.[23]

This largely rhetorical comparison ignores important connections between the methods and concerns of these artists, all of whom painted for literati society and were well aware of the achievements of their predecessors in the history of flower painting. Still, there is something to the idea that the paintings of Wen Shu and Yun Bing, which are based on painstaking observation of flowers and plants, display the beauties of nature more seductively than do the works of Chen Shu. Derived from family and local traditions, the styles of Wen Shu and Yun Bing were also undoubtedly affected to some degree by commercial considerations. Art seems to have been a means of livelihood for both women, due to straitened family circumstances, and elegant, decorative treatments of flowers were always in demand. This may even be a subtext of Liang's comparison. Although Chen Shu upon occasion sold her paintings to contribute to the family purse, she does not appear to have depended significantly on the sale of her art or to have painted for the market. Her flower paintings are attractive and in some cases colorful, but on the whole, art history takes precedence over decoration and easy appeal in her oeuvre. Like so many of the male scholar-painters of her period, Chen Shu took a long view of the history of painting and sought to define her position within it primarily through reference to artists of the distant past.

While Chen Shu shared the artistic interests of many men, including members of her own family, she did not stand in the shadow of a male relative or husband, and here again she might be contrasted with other leading female painters. Unlike Wen Shu and Yun Bing, who were descended from the masters Wen Zhengming and Yun Shouping, respectively, and Ma Quan, the daughter of Ma Yuanyu, Chen Shu was not born into a prominent family of painters with well defined areas of specialization and stylistic traditions. And unlike Guan Daosheng, who was the wife of the celebrated painter and calligrapher Zhao Mengfu, Chen Shu was not married to a famous artist. To be sure, she lived in a cultured environment surrounded by people who appreciated and created art, and claimed as an artistic ancestor the much earlier master Chen Shun, to whom she does not appear to have been directly related. Still, family ties do not explain the character of much of her painting. Chen Shu tapped into the broader stylistic and theoretical currents of her time, and even though her father-in-law painted, she became the dominant artistic figure in the family, the one to influence painters of subsequent generations. Whereas Wen Shu, Yun Bing, and Ma Quan emerged within established artistic lineages, Chen Shu can be regarded as the founder of such a line.

A number of young people developed their brush skills under Chen Shu's guidance, starting with her own children, Her son Qian Chenqun was recognized as an artist primarily for his calligraphy, but he also painted. Once he depicted a pine (or pines) for the scholar-official Lu Jianzeng, and this work was subsequently

389

obtained by the collector Zhang Tingji.[24] Chen Shu's youngest son, Qian Zhie, was a more serious painter with a range similar to his mother's. As a youth, he learned from her how to sketch from life (*xiesheng*). He became known for his renderings of plum and narcissus, and in his middle years he admired and studied Ni Zan's method of painting delicate bamboo and strange rocks. Two of his landscape paintings, one in color and the other in ink, were recorded by the late Qing scholar Li Yufen.[25]

Zhang Geng, who also studied with Chen Shu when he was young, similarly took up the subjects and styles she preferred; he drew fine-line figures in ink, sketched flowers in the manner of the Ming master Chen Shun, and did landscapes in orthodox styles. His *Landscape after Wang Meng*, dated 1732, one of his few surviving works, is very like some of Chen Shu's landscapes done around the same time.[26] Qian Zai first learned flower painting from Chen Shu, then later, in the capital, he developed his technique under the influence of Jiang Pu, son of the celebrated court master Jiang Tingxi.[27]

Other recipients of Chen Shu's instruction included her brother's son Chen Yuan,[28] about whom nothing else is known, and a young woman named Yu Guanghui. Yu Guanghui was the granddaughter of Yu Zhaosheng, one of the scholars mentioned earlier as a close friend of the Qian family. The Qian and Yu families were also connected by marriage: one of Yu Zhaosheng's nieces was married to Qian Chenqun. Yu Guanghui is said to have been naturally inclined to painting. When at the age of seven she sketched a branch of flowers on the wall, her grandfather was greatly impressed. Owing to the family ties, she was able to study with Chen Shu and is said to have consequently made great progress.[29]

Through her paintings Chen Shu continued to touch later artists, especially, but not exclusively, her female descendants. Qian Yuling, Chen Shu's great-granddaughter, was skilled in "sketching from life" in her manner. Yuling also obtained instruction from her cousin Qian Zai, and was particularly accomplished at painting plum blossoms.[30] Qian Yunsu, a great-great-granddaughter, was versed in the classics, history, and literature, knowledgeable in medicine, a skillful calligrapher, and a painter who maintained the family tradition.[31] Qian Juying, a daughter of Qian Zai's grandson Qian Changling, painted flowers in Chen Shu's style, was good at small-standard script, and was a able poet. A sample of her work, an ink sketch of plum blossoms dated 1861, survives in a collaborative composition of painting and calligraphy on a gold-flecked paper fan.[32]

Chen Shu's influence extended beyond her family as well. The mid-eighteenth-century court master Jin Tingbao executed an album of paintings "imitating Chen Shu," probably based on one of her works in the imperial collection.[33] And Cheng Jingfeng, a concubine of the art historian Peng Yuncan, is known to have been very fond of Chen Shu's work.[34]

The art historian Jiang Baoling recognized Chen Shu's role as a teacher and her position as an artistic matriarch by comparing her to the Chin-dynasty calligrapher Madam Wei (Wei Shuo), who instructed China's most celebrated master of calligraphy, Wang Xizhi.[35] Chen Shu would have appreciated this, since she

used a seal that read "Madams Wei and Guan are both my teachers."[36] (Madam Guan is, of course, Guan Daosheng.) Chen Shu was like other Chinese women painters, then, in having artistic heroines, but unlike most she eventually became such a figure herself.

In the final analysis, however, the stature Chen Shu attained in the history of Chinese painting is only partially explained by the quality of her art and the number of artists she influenced. The events of her life were equally important, because for Chinese critics a person's character was inseparable from his or her art. The praise that Chen Shu's paintings elicited from connoisseurs on the highest levels of society down through the years was therefore a response to her complete persona: filial daughter, dutiful wife, devoted mother, strict teacher, and talented painter. Had she not been recognized as a woman of great virtue – a highly esteemed matriarch – her art might have slipped into semiobscurity, as did that of many upper-class Ming and Qing women who were good painters but not otherwise memorable figures. Chen Shu distinguished herself by leaving her mark on both society and art.

The artistic personality she revealed in the process, moreover, recommended itself by its orthodoxy. The emphasis she placed on traditional methods and sanctioned models in painting complemented the zeal with which she ostensibly patterned her behavior on that of exemplary women of the past. For a woman in premodern Chinese society art seems to have been no different from other endeavors: high-minded adherence to tradition offered the surest path to acclaim. We should not be surprised or disappointed to find that although Chen Shu was an exceptional woman, she achieved success in the most conventional ways.

Notes

1 Qian Chenqun, *Xiangshu zhai wenji* (Collected prose works of Qian Chenqun), 26:6a–22a, in *Xiangshu zhai quanji* (Complete works of Qian Chenqun) (1885 edn). Other sources of information about Chen Shu's life and work include Li Fu, "Qian mu Chen Taishuren muzhiming" (Epitaph for Chen Lady of Great Virtue, mother of the Qian family), in Qian Yiji, *Guochao Beijuan ji* (Collection of epitaphs and biographies of the Qing dynasty) (Kiangsu shuju, 1893), 149:6919–6920; Zhang Geng, *Guochao huazheng lu* (Record of painters of the Qing dynasty) (preface 1735; reprint, Nagoya: Nagoya Book Shop, n.d.), *xia*: 21b–22a; Arthur W. Hummel, ed., *Eminent Chinese of the Ch'ing Period (1644–1912)* (Washington, DC: United States Government Printing Office, 1943), 99.

2 National Palace Museum, comp., *Gugong shuhua lu* (Record of calligraphy and painting in the Palace Museum) (rev. and enlarged edn, Taibei: National Palace Museum, 1965), 5:556–560; 6:157–158; 8:47, 101–102, 146.

3 Hummel, *Eminent Chinese*, 146.

4 Qian Chenqun, *Xiangshu zhai wenji*, 26:7b, 12a, 20b–21a. The title of Chen Shu's collected poems was *Fuan shigao* (Draft copy of the poems of the Fu [diagram] Retreat). A poem that she composed for a painting of *Yellow Hollyhock(s)* done for

Madam Zou, the mother of the flower painter Zou Yigui (1686–1772), is recorded in Li Junzhi, ed. and comp., *Qing huajia shishi* (Poems and biographies of Qing painters) (Beijing: National Library, 1930), *gui, shang*: 20.

5 Zhang Zhao et al., comps, *Shiqu baoji chubian* (Catalogue of painting and calligraphy in the imperial collection, first compilation) (1745; facsimile edn, Taibei: National Palace Museum, 1971), 755–758.

6 Zhang Geng, *Guochao huazheng lu*, *xia*: 22a.

7 *Gugong shuhua lu* 5:559; Wang Jie et al., comps, *Bidian zhulin xubian* (Catalogue of Buddhist and Daoist paintings and texts in the imperial collection, second compilation) (1793; facsimile edn, Taibei: National Palace Museum, 1971), 320.

8 Li Zuoxian, *Shuhua Jianying* (Reflections on calligraphy and painting) (1871), 22b–23a. For Wenji, see Kenneth Rexroth and Ling Chung, *The Orchid Boat: Women Poets of China* (New York: The Seabury Press, 1972), 4–7, 134; and Irving Yucheng Lo and Wu-chi Liu, eds, *Sunflower Splendor: Three Thousand Years of Chinese Poetry* (Garden City, NY: Doubleday, Anchor, 1975), 36–39.

9 Zhang Zhao et al., *Shiqu baoji chubian*, 451. I am grateful to Dr Irving Lo for his advice on the translation of this and other Chinese texts quoted in this chapter.

10 *Imitating Wang Meng's "Dwelling in the Mountains on a Summer Day"* is recorded in Hu Ching et al., comps, *Shiqu baoji sanbian* (Catalogue of painting and calligraphy in the imperial collection, third compilation) (1816; facsimile edn, Taibei: National Palace Museum, 1969), 2245; *The Mountains Are Quiet and the Days Grow Long* is recorded in Wang Jie et al., comps, *Shiqu baoji xubian* [Catalogue of painting and calligraphy in the imperial collection, second compilation (1793; facsimile edn, Taibei: National Palace Museum, 1971)], 603. For reproductions of the compositions of Wang Meng see: Osvald Sirén, *Chinese Painting: Leading Masters and Principles*, 7 vols (New York: The Ronald Press, 1956–1958) 6:109b ("Passing a Summer Day in the Mountains"); Richard Vinograd, "New Light on Tenth-Century Sources for Landscape Painting Styles of the Later Yüan Period," in *Suzuki Kei sensei kanreki kinen, Chugoku kaigashi ronso* (Collected essays on the history of Chinese painting, in honor of the sixty-first birthday of Professor Suzuki Kei) (Tokyo: Yoshikawa Kobukan, 1981), 16 ("Alchemist's Terrace in the Dawn of Spring"); Pan Tianshou and Wang Bomin, *Huang Gongwang yu Wang Meng* (Shanghai: Renmin meishu, 1958), pl. 15. For the painting by Wang Fu see Sirén, *Chinese Painting* 6:127, or Kathlyn Liscomb, "Wang Fu's Contribution to the Formation of a New Painting Style in the Ming Dynasty," *Artibus Asiae* 48, no. 1/2 (1987): 56 (discussed on p. 46). The album, entitled *Xiaozhong xianda* (The great revealed in the small), is recorded in *Gugong shuhua lu*, 6:71–75; this leaf is reproduced in *Shina Nanga taisei* (Conspectus of Chinese paintings of the Southern School) (Tokyo: Kobunsha, 1936), 14:74. About the attribution of the paintings in this album, see Howard Rogers and Sherman E. Lee, *Masterworks of Ming and Qing Painting from the Forbidden City* (Lansdale, Penn.: International Arts Council, 1988), 156. Other paintings by Chen Shu after Wang Meng recorded in the imperial catalogues include a hanging scroll *Watching the Clouds from Opposite the Waterfall* and a handscroll *Sea of Clouds on Mount Huang*; Hu Jing et al., *Shiqu baoji sanbian*, 3177, 2244. Both are in the National Palace Museum catalogued in the *jianmu*; *Gugong shuhua lu*, 8:101, 47.

11 Zhang Geng, *Tuhua jingyi shi* (Record of essential characteristics of paintings), in *Meishu conshu* (A collectanea of writings on art), Huang Binhong and Deng Shi,

comps (1911–1936, rev. and enlarged edn, Shanghai: Shenzhou guoguang she, 1947), vol. II, 3/2:72–74. Zhang Geng's name also appears on a hanging scroll based on Wang Meng's *Dwelling in the Mountains on a Summer Day*. The painting is dated 1759 and is in the collection of the Metropolitan Museum of Art.

12 *Gugong shuhua lu* 5:557–559; Wang Jie et al., *Shiqu baoji xubian*, 603; Hu Jing et al., *Shiqu baoji sanbian*, 2245.

13 *Gugong shuhua lu* 5:556–557; Wang Jie et al., *Shiqu baoji xubian*, 1751.

14 Chong Yi, *Xuanxuezhai shuhua yumu biji* (Catalogue of paintings seen by the author), *xia* (1921), in *Meishu conshu*, Huang Binhong and Deng Shi, comps, 6/5:154.

15 Wang Jie et al., *Shiqu baoji xubian*, 599; *Gugong shuhua lu* 6:158–159. Other works of the same general type by Chen Shu include the fan painting of mallows, asters, beetle, and butterfly, dated 1735, reproduced in Marsha Weidner et al., *Views from the Jade Terrace: Chinese Women Artists 1300–1912* (Indianapolis: Indianapolis Museum of Art, 1988), 120; and a handscroll of insects, flowers, and a pond in the collection of Zhang Yunzhong, Tokyo, reproduced in Suzuki Kei, *Comprehensive Illustrated Catalog of Chinese Paintings*, 5 vols (Tokyo: University of Tokyo Press, 1982–1983), 4:206–207.

16 "Boyang [Chen Shun] *jia xue*" (Learning from Boyang [Chen Shun] of my family).

17 Wang Jie et al., *Shiqu baoji xubian*, 1752, 2107. *The Lotus Flower* hanging scroll is in the National Museum (*Gugong shuhua lu* 5:560); the handscroll of narcissus flowers and rocks now belongs to the Tokyo National Museum, and is reproduced in Suzuki, *Catalog of Chinese Paintings*, 3:104–105, and in *Sogen Minshin meiga taikan* (Survey of famous paintings of the Song, Yuan, Ming, and Qing dynasties) (Tokyo: Otsuka kogeisha, 1931), 291. The other two paintings are a handscroll of "flowers and plants sketched from life" (Hu Ching et al., *Shiqu baoji sanbian*, 2931) and a "small handscroll of flowers and fruit" (Shao Songnian, *Guyuan Cuilu*, 23b). The former was a work in ink monochrome and inscribed "Copying thirty kinds of flowers and grasses by Boyang shanren [Chen Shun]." The latter, a work in ink on paper, was dated to the spring of 1729; the brushwork was praised by Shao Songnian as strong and free of feminine mannerisms. A hanging scroll of *Plum Blossoms and Narcissi* after Chen Shun (reproduced in *Mingren shuhua* [Calligraphy and painting by famous people] [Shanghai: The Commercial Press, 1920], 2:3) carries the impossible date "Qianlong, 1735, New Year's day"; in the first month of 1735 the Yongzheng emperor was still on the throne.

18 Wang Jie et al., *Shiqu baoji xubian*, 2107.

19 This work is in the collection of the Seattle Art Museum. Another version of this composition signed "Chen Shu" and dated to 1705 is inscribed as in a Song manner. The latter painting, which was brought to my attention by James Robinson, belongs to Far East Fine Arts, Inc., in San Francisco. I have not had an opportunity to examine either it or the Seattle scroll.

20 *Gugong shuhua lu* 5:560; Wang Jie et al., *Shiqu baoji xubian*, 2107.

21 The album is reproduced in Suzuki, *Catalog of Chinese Paintings*, 3:39–40. The hanging scroll with the vase and cut flowers is reproduced in Daphne Lange Rosenzweig, "Official Signatures in Qing Court Painting," *Oriental Art*, n.s. 27, no. 2 (Summer 1981): 187. The painting of the arrangement with a planter is in *Masterpieces of Chinese Painting in the National Palace Museum*, supplement (Taibei: National Palace Museum, 1972), 45.

22 Weidner et al., *Views from Jade Terrace*, 66–70, 88–91, 122–129, 130–136.

23 Tang Souyu, *Yutai huashi, bielu* (Jade Terrace history of painting), in *Huashi congshu* (Collectanea of texts on Chinese painting), Yu Anlan, comp. (Shanghai: Renmin meishu chubanshe, 1963), 4–5.

24 Yu Jianhua, *Zhongguo meishujia renming cidian* (Biographical dictionary of Chinese artists) (Shanghai: Renmin meishu chubanshe, 1981), 1431.

25 Ibid., 1429; Li Yufen, *Ouboloshi shuhua guomu kao* (Records of paintings and calligraphy by Qing artists) (1894), 2:27, in *Meishu congshu*, Huang Binhong and Deng Shi, comps, vol. 25, 5/9.

26 Yu Jianhua, *Zhongguo meishujia*, 831; Li Yufen, *Ouboloshi shuhua guomu kao* 3:3; *Descriptive and Illustrated Catalogue of the Paintings in the National Palace Museum* (Taibei: National Palace Museum, 1968), 108.

27 Yu Jianhua, *Zhongguo meishujia*, 1434.

28 Ibid., 991, 1013.

29 Ibid., 571; Zhang Geng, *Guochao huazheng xulu* (Record of painters of the Qing dynasty, continuation) (n.d.; reprint, Nagoya: Nagoya Book Shop), *xia*: 16a.

30 Yu Jianhua, *Zhongguo meishujia*, 1435.

31 Ibid., 1438.

32 Ibid., 1435; Weidner et al., *Views from Jade Terrace*, 145–147.

33 *Gugong shuhua lu*, 8:155.

34 Yu Jianhua, *Zhongguo meishujia*, 1099.

35 Jiang Baoling, *Molin jinhua* (Comments on contemporary painters) (n.p., 1852), 3:1a.

36 Wei Guan *furen jie wo shi*. This seal is found, for example, on her *xiesheng* album dated 1713 in the National Palace Museum (*Gugong shuhua lu*, 6:158).

37

Artistic Tradition and the Depiction of Reality: True-View Landscape Painting of the Choson Dynasty

Yi Song-mi

Introduction

The Choson dynasty (1392–1910), as the longest and most prosperous period in Korean history, was the setting for many artistic developments. In the following reading, art historian Yi Song-mi examines one of these, the eighteenth-century development of *chin'gyong*, or "true-view," landscape painting. The essay originally comprised part of a volume on Korean art published in 1998 to coincide with the opening of a permanent Arts of Korea Gallery at the Metropolitan Museum of Art in New York. As such it forms an important part of the small but growing body of literature on Korean art in English.

Like Japan, Korea was heavily influenced by Chinese culture. Korean landscape painting practices were based on those developed in Song China (960–1279). Yet, also as in the case of Japan, Korean artists adopted and altered Chinese traditions to suit their own needs. True-view landscape painting, which focuses specifically on Korean sites and brings together a Chinese emphasis on brushwork with a growing attention to naturalism derived from Western art practices, is an excellent example of such appropriation. In order to understand the genre's development and cultural

Yi Song-mi, "Artistic Tradition and the Depiction of Reality: True-View Landscape Painting of the Choson Dynasty," pp. 331–4, 340–7, 349–50 from Judith G. Smith (ed.), *Arts of Korea*. New York: Metropolitan Museum of Art and Harry N. Abrams, Inc, 1998. Reprinted by permission by The Metropolitan Museum of Art. © 1998 by The Metropolitan Museum of Art.

meaning, Yi Song-mi undertakes a three-part analysis. First, she examines the ety-mology of the term *chin'gyong*. She then turns to the intellectual movements under-pinning the artistic tradition, before finally examining the career and works of one specific artist, Chong Son (1676–1759), the leading true-view landscape painter of the eighteenth century.

Thus, this reading discusses the *oeuvre* of one prominent artist set within the larger cultural context of the era, one in which Chinese visual traditions were being appro-priated to suit a growing sense of Korean identity. The reading thereby addresses the strong relationship between land, art, and cultural identity.

In the long span of the Choson dynasty (1392–1910), a general cultural efflor-escence occurred during the reigns of two enlightened monarchs, Kings Yongjo (r. 1724–76) and his grandson Chongjo (r. 1776–1800). Two areas of painting in particular, true-view landscape painting and genre painting, flowered in the eighteenth century, and, indeed, are among the most esteemed achievements of the late Choson period. The former, because of its association with the increasing emphasis on the development of Korean cultural and historical identity, is usually singled out as the expression of the "ethos of Korea." This essay will examine the development and flowering of true-view landscape painting in the late Choson within this larger context.

It is assumed that in the early stages of the development of East Asian painting, most paintings categorized as "landscapes" were not symbolic but representa-tional depictions of the real world. Yet, however much landscape painting might seek to depict actual topography, the artistic representation of the natural world became subject to certain conventions. In China, themes from well-known liter-ary works, such as "Peach Blossom Spring" (*Taohua yuan*), by the early-fifth-century poet Tao Qian (365–427), and "Ode to the Red Cliff" (*Chibi fu*), by the great Northern Song poet and calligrapher Su Shi (1037–1101), were particularly popular painting subjects. In addition, places of exceptional beauty and historical importance in China were reproduced in sets of four, eight, and even nine scenes, the Eight Views of the Xiao and Xiang Rivers being one of the most famous themes. Landscape painting of the early Choson period developed under the influence of such Chinese landscape painting conventions and brush techniques. However, this gradually gave way to a new development in the mid-Choson period, and finally, in the eighteenth century, Korean painters established the more indigenous tradition of true-view landscape painting, which depicts Korean scenery.

Chin'gyong (Ch. *zhenjing*, Jp. *shinkei*), meaning "real scenery," is the Korean term for what has come to be known as "true-view" landscape. In Korea today, the term designates not simply realistic landscape depictions but paintings of Korean sites executed in techniques and in a manner first developed during the eighteenth century to portray specifically Korean scenery.[1] Probably the best example of an eighteenth-century true-view landscape is *Clearing after Rain on*

Mount Inwang, dated 1751, by Chong Son (1676–1759). In this work the artist used bold, sweeping brushstrokes in dark ink to portray the massive rocky faces of Mount Inwang emerging from the mist just after the rain. It was undoubtedly in response to such an image that the noted critic and painter Kang Sehwang (1713–1791), in a recorded colophon to an album of paintings by the artist, wrote: "Chong Kyomjae [Son] excelled in true-view landscape painting of the Eastern Nation [*tongguk chin'gyong*]."[2] The Eastern Nation of which he speaks is, of course, Korea.

The Chinese term for "real scenery" (*zhenjing*) appears as early as the tenth century, in a treatise by Jing Hao (act. *c*.870–*c*.930) entitled *A Note on the Art of the Brush* (*Bifa ji*). In his classification of paintings into four grades (divine, marvelous, strange, and skillful), Jing Hao explains that in paintings belonging to the "strange" class, the traces of the brush and ink are "unfathomable," causing the disparity with real scenery.[3] About a century later, during the Northern Song dynasty (960–1127), we find the term "real landscape" (*zhen shanshui*) in a celebrated treatise on landscape painting by Guo Xi (*c*.1000–*c*.1090), *The Lofty Message of Forest and Streams* (*Linchuan gao zhi*). In the Chinese texts, the terms *zhenjing* and *zhen shanshui* seem to point to exactly what the words mean, a representational depiction of topography. In modern Korean scholarship, however, *chin'gyong sansu* refers not to "real-scenery landscape painting" but instead has the meaning "true-view landscape painting."

To understand what is meant by "true view," it is helpful to review how the expression has evolved over time. Recent studies reveal that during the late Choson period, the word *chin'gyong* was usually written with the character *kyŏng*, meaning "boundary" or "realm," rather than with the character *kyŏng*, meaning "scenery."[4] This character, however, referred not to locations in the real world but to the realm of the immortals (*son'gyong*), indeed one quite apart from the mundane world. Though by the early eighteenth century, the character *kyŏng* (boundary) was replaced with *kyŏng* (scenery), when speaking of true-view landscapes, other connotations adhered to the term.

Chin'gyong is often used interchangeably with *silgyong*, meaning "real scenery." The character *sil* (Ch. *shi*) means "real" but does not commonly imply "truth," in the philosophical sense of the term, as does the character *chin*. In a recent study reviewing a group of words sharing the syllable *chin* – *chinmun* (true writing), *chinsi* (true poetry), *chinhwa* (true painting) – it was found that in the eighteenth-century context these words all imply an ideal artistic state close to that encompassed in the term "workings of heaven" (Kr. *ch'on'gi*; Ch. *tianji*), which has been defined as the "instinctive, natural operation of the artist's mind in a state of inspiration."[5] Therefore, when Korean scholars of the eighteenth century used the term *chin'gyong*, they seem to have had in mind more than "real" scenery; the term encompasses scenery that, while true to actual Korean landscapes, is also the most exemplary and the most ideal in the country, such as that of Mount Kumgang (Diamond Mountain). Located along the east coast in

northern Kang'won Province, in present-day North Korea, Mount Kumgang is indeed well represented in true-view landscape paintings of the eighteenth and nineteenth centuries.

Other words sharing the character *chin* that are not conceptual but more concrete in meaning also shed light on the semantic range of the term *chin'gyong*. The Choson dynasty's palace records of special events (*Togam uigwe*) occurring during the eighteenth and nineteenth centuries provide descriptions of royal weddings as well as the painting and copying of royal portraits, and for each of these events there are detailed lists of the materials used. Among the lists of pigments and inks used in painting screens or portraits, the palace records include sets of contrasting terms employing the initial syllable *tang* or *chin*, for instance, *tangbun* and *chinbun*, or *tangmuk* and *chinmuk*.[6] In Korea and Japan, beginning in the Tang period (618–907), articles of Chinese origin were referred to with the prefix *tang*. Thus, in the above records, *tangbun* refers to Chinese white pigment, as opposed to Korean white pigment; and *tangmuk* to inksticks made in China, in contrast to *chinmuk*, domestically produced inksticks.

The *Dictionary of Korean Terms Written in Chinese Characters* (*Han'guk hanjao sajon*) defines the term *chinmuk* as "ink of the best quality."[7] Thus, in all the words listed above the prefix *chin* would seem not only to refer to things Korean, but also to include a value judgment: things of the best quality. In the historical and cultural context of the late Choson period, the term *chin'gyong sansu*, then, probably refers to painting depicting specifically Korean scenery that is, at the same time, regarded as ideally the most beautiful and the best in the country.

The Intellectual Foundations of True-view Landscape Painting

The overthrow in China of the Ming dynasty by the Manchus in 1644 and the subsequent establishment of the Qing dynasty had an important effect on Korea's cultural awareness. While on the surface the Choson court maintained a cordial diplomatic relationship with the Manchus, the majority of high-ranking Choson scholar-officials, including the court, were at heart loyal to the fallen Ming dynasty.[8] Culturally, Koreans felt far superior to the Manchus. Although they had been disgraced militarily in the Manchu invasion in 1636, Koreans looked down on the Manchu "barbarians" (Kr. *horo*; Ch. *hulu*), who were regarded as lacking in culture and scholarship. Furthermore, in the absence of an heir to the Han Chinese tradition in China, Koreans came to consider themselves the legitimate heirs to that grand cultural tradition, an attitude mainly promoted by such Neo-Confucian scholars as Song Si-yol and his followers, and by a group of scholars known as the Old Doctrine (*noron*) faction.

Korean regard for Han Chinese culture crystallized in the term "minor China" (*so-chunghwa*),[9] which Korea used to refer to itself as heir to that tradition. The term suggests that it was Korea's role faithfully to follow and perpetuate China's cultural and intellectual traditions, but Korean scholar-officials increasingly began to feel new confidence and self-respect concerning their own culture. Regardless of the extent to which the "minor China" concept may have contributed to the development of true-view landscape painting in the late seventeenth and early eighteenth centuries,[10] it certainly provided the Choson intellectual class with an incentive to examine their own history. At this time, for instance, the Choson court refurbished the tombs of the Korean kings going back to the legendary founder, King Tan'gun, and the Silla kings.[11]

Perhaps a more important and certainly more formidable intellectual force, from the late seventeenth century, was the School of Practical Learning (Kr. *sirhak*; Ch. *shixue*). The *sirhak* scholars, who advocated political, economic, social, and educational reforms, took practical affairs as their point of departure, emphasizing not only the traditional humanistic disciplines derived from China, but also social science, natural science, and technology. Their interest in promoting a new understanding of the country's history and culture led to a surge of publications on various aspects of Korean history, literature, language, and geography.

An important scholar in the dissemination of *sirhak* thought was Yi Ik (Songho; 1681–1763), who published a modestly titled but truly encyclopedic work in thirty volumes, *Songho sasol* (Insignificant Explanation by Songho).[12] This work is organized under five broad headings (Heaven and Earth; Myriad Things; Human Affairs; Classics and History; Belles Lettres) and encompasses a wide range of topics in each section. Yi Ik came from an illustrious family of scholars. His grandfather, Sang-ui (1560–1624), traveled to Beijing with Yi Su-gwang in 1611. Yi Ik's father, Ha-jin (1628–1682), was a high-ranking official who went to China in 1678 and brought back with him many books of Western learning that had been translated into Chinese. Yi Ik and his brothers Cham (1660–1706) and So (1662–1723) benefited from this vast collection of volumes, among which were maps of the world and works on astronomy, Catholicism, and Western painting, science, and technology. Yi Ik seems to have been especially impressed by a map of the world that showed China to be but one of five continents, with Korea occupying a portion of northeast Asia. The *sirhak* scholars' comprehension of China's and Korea's geographical position in relation to the rest of the world undoubtedly became one of the main reasons for their rejection of the "minor China" concept as they came to realize that the civilization of China was not the only one deserving of their attention.

The importance of Yi Ik in relation to the development of true-view landscape painting has been pointed out by several scholars.[13] His notations on Western painting reveal a familiarity with paintings brought back from the Qing court by Choson emissaries who had come into contact with the Western learning transmitted to China by the Jesuits as early as the sixteenth century:

Recently, most emissaries to Yanjing [the Manchu capital, now Beijing] have brought back Western paintings and hung them in the center halls of their homes. When looking at these paintings, one should close one eye and, with the other eye, stare at them for a long time so that the buildings and the walls reveal their true shapes [*chinhyong*]. Those who study these paintings in silence say. "This is due to the wonderful techniques of the painter. Because the distance between objects is clearly delineated, one should look at the painting with only one eye." Even in China, this kind of painting has never existed before. These days, I am reading Euclid's *Geometry*, translated into Chinese by Ri Madu [Matteo Ricci]. There it says: "The method of painting lies in seeing things with one's eyes.... One should be precise about measurements of distances and things in order to represent their degrees and true shapes.... Also, when depicting an image, its convexity and concavity have to be rendered, and when depicting a house, there must be light spots and dark spots."[14]

Yi Ik's view that a painting should reflect reality and be a true view of a scene is expressed in his recorded colophon to a painting titled *Nine-Bend [Stream] of Mount Wuyi*, a work that he clearly believed to be a misrepresentation of the actual landscape:

When I look at landscape paintings of the past and the present, I am stunned by their strangeness and falsehood. I am sure that there is no such scenery on earth. They were painted only to please the viewers. Even if ghosts and demons were to roam the entire universe, where in the world would they find such scenery [*chin'gyong*]?[15] These strange paintings can be compared to those who tell lies and embellish words to cheat others. What can one take from them?[16]

Apparently, Yi Ik himself had never visited China and had never seen the unusual features of such sites as Mount Wuyi, the landscape of which is indeed strange and scarcely to be believed. His advocacy of landscape painting that resembles the scenery it depicts was without doubt influenced by the Western paintings that looked "real" to him. Since Yi Ik was not himself a painter, his interest in Western realism remained restricted to criticism and theory, though this general view of the Western approach to painting, or at least the emphasis on actual observation, seems to have been shared by many *sirhak* scholars. A self-portrait by the well-known painter Yun Tu-so (1668–1715), one of the members of Yi Ik's circle of scholars, is further evidence of the growing interest in painting based on actual observation.[17]

This period is also marked by the flourishing of works of historical geography which can be more directly associated with the development of true-view landscape painting. Among them are Han Paek-kyom's (1552–1615) *Tongguk chiri-ji* (Treatise on Korean Geography); Yi Chung-hwan's (b. 1690) *T'aengni-ji* (Ecological Guide to Korea), which can be characterized as cultural geography, as it includes local customs and community values; Sin Kyong-jun's (1712–1781) *Toro-go* (Routes and Roads) and *Sansu-go* (Mountains and Rivers); and the map

of Korea, *Tongguk chido*, produced by Chong Sang-gi (1678–1752) at the command of King Yongjo. The last, in nine sheets (one sheet showing the entire peninsula, and eight showing different provinces), which could be folded into an album, was a pioneer work in that it precisely marked the distance between one place and another. When the eight sheets were spread out and put together, they also formed a large map of the peninsula.[18]

This interest in history and geography in the second half of the Choson dynasty can also be directly associated with the widespread interest in travel to scenic spots, not only to the Diamond Mountain region but also to other parts of Korea. Scholars tended to travel widely, sometimes accompanied by their favorite court painters, and most of them left voluminous travel diaries describing what they saw.[19] Much can be learned from comparing their descriptions with true-view landscape paintings of the same areas.

Whether from the conservative *noron* faction – those scholar-officials who considered Korea a "minor China" – or from the more progressive *sirhak* camp, the intellectual spirit of the age began to converge on an intense study of Korean history, geography, culture, and natural environment. This common effort in defining Korea's historical and cultural identity led in turn to a renewed interest in depicting the topography of Korea, and to the rise of true-view landscape painting.

The Era of Chong Son

The artist traditionally acknowledged as the leading exponent of the new trend in landscape painting in the early eighteenth century is Chong Son (1676–1759), who signed his paintings most often with his studio name Kyomjae, or Studio of Modesty. Chong, from an impoverished family of the *yangban* ruling class, was recommended by Kim Ch'ang-hup (1653–1722) for a position in the royal bureau of painting in Seoul. Despite the fact that he is considered one of the most important painters of the entire Choson period, few facts about his life have been documented. Throughout his long career, he served mostly in the capital except for several local government posts he held from time to time. Late in life, he was honored by King Yongjo, who bestowed on him the official title of the fourth rank in 1754 and the second rank in 1756, despite stiff opposition from scholar-officials at court who felt that his lowly status as a painter made him ineligible for the latter position.[20]

The coterie of scholar-officials instrumental in forming Chong Son's art and thought, especially the development of true-view landscape painting, included three of six brothers of the powerful Kim family of Andong, in North Kyongsang Province – Ch'ang-jip (1648–1722), Ch'ang-hyop (1651–1708), and the above-mentioned Ch'ang-hup, who recommended Chong to the royal painting bureau. Others were Yi Pyong-yon (1671–1751), one of the most accomplished poets of

401

the time; Yi Ha-gon (Tut'a; 1677–1724), a scholar-painter who recorded his views on painting in *Tut'a-ch'o* (Draft Writing of Tut'a); and Cho Yong-sok (1686–1761), a well-known scholar-painter who left an interesting album of genre paintings and who was Chong Son's close friend and neighbor. Cho's admiration for Chong is evident in his colophon to Chong's painting *Three-Dragon Waterfall at Mount Naeyon*, in which he remarks that only after seeing the painting was he able to appreciate the natural beauty of the site. Since many of these scholar-officials lived in the shadow of Mount Paegak, in the northern part of Seoul, and composed poetry as well, this group has been referred to by one scholar as the Poetry Society of Paegak (Paegak sadan), although it never existed formally as such.

As has been pointed out by other scholars, the basic elements of Chong Son's *chin'gyong* style, which began to develop in the 1730s, were derived from Chinese Southern School painting.[21] This school took root in Korea as early as the second half of the seventeenth century, when painting manuals such as the *Jiezi yuan huazhuan* (Mustard Seed Garden Manual of Painting) came to Korea soon after their publication in China. There were also a fair number of Chinese paintings in Korea, brought back by Choson emissaries to the Qing court.[22]

In the true-view landscapes of Chong Son and his contemporaries, the most visible stylistic elements of Southern School painting are the hemp-fiber texture strokes (long, nearly parallel, somewhat wavy brushstrokes used to describe the texture of earth); Mi ink-dots (soft dots of ink of varying size and degrees of tonality applied horizontally to the surface of mountains to represent vegetation), named after the eleventh-century Chinese painter Mi Fu (1052–1107); and folded-ribbon strokes (dry, light strokes created by dragging the brush sideways and turning it at a ninety-degree angle from horizontal to vertical, to depict rocky surfaces). Of these, Mi ink-dots feature most prominently in Chong Son's works throughout his career.

The majority of true-view landscapes of the late Choson period represent aspects of Mount Kumgang, a mountain range replete with symbolism and having various appellations. Located in the northern part of Kang'won Province along the coast of the East Sea, Mount Kumgang covers a large area, its peaks said to number as many as "twelve thousand." The area is customarily divided into three main parts: Outer Kumgang (Oegumgang); Inner Kumgang (Naegumgang); and Coastal Kumgang (Hae-gumgang). The dividing line between Outer and Inner Kumgang is Piro Peak. Sometimes the whole area is simply referred to as Sea and Mountains (*Haeak* or *Haesan*), and painting albums containing a series of views of Mount Kumgang are most frequently called Albums of Sea and Mountains (*Haesan-ch'op*). Since the area is to the east of the Choson capital, Hanyang (Seoul), such albums are also called Albums of Travel to the East (*Tong'yu-ch'op*). In winter, when the rocky peaks are exposed, the mountain is called All Bone Mountain (Kaegolsan), while in the fall, when colorful leaves cover the mountainsides, it is called Autumn Foliage Mountain (P'ung'ak-san).[23]

Although Chong Son lived to the age of eighty-three and left behind an enormous body of work, his dated paintings, which fall between the years 1711 to 1751, are relatively few. The earlier date apparently marks Chong Son's first visit to Mount Kumgang, when he painted the so-called *Album of Paintings of the P'ung'ak Mountain of the Sinmyo Year* [1711]. This album contains thirteen leaves of painting, to which is attached a colophon written in 1867 by a descendant of a certain Peaksok, whom one scholar has identified as Pak T'ae-yu (1648–1746), a high-ranking official during the reigns of Kings Sukchong (r. 1674–1720) and Yongjo. According to the colophon, Pak was accompanied on his second trip to Mount Kumgang by Chong Son, who produced a series of paintings of the mountain for which Pak's friends later wrote poetry.[24] Although the reliability of this late colophon can be questioned, the paintings in the album all show Chong Son's early style, one that is still lacking complete confidence or an individual manner.

Chong Son's second trip to Mount Kumgang the following year is better documented. During this trip, he painted another album of thirty leaves, entitled *Album of Realistic Representations of Sea and Mountains*, which, although no longer extant, is recorded, along with poems by four of Chong Son's contemporaries describing the scenes depicted, in the collected works of various scholar-officials.[25] Chong's third documented trip to the area took place in 1747, when he produced yet another album with the same title. Yi Pyong-yon's colophons to these paintings confirm the dates of Chong's travel. Though records of any other trips to the area between 1712 and 1747 are not known, a recent study shows that Chong painted many images of Mount Kumgang that were most likely based on early sketches.[26]

Chong's favorite composition seems to have been what is known as the Complete View of Mount Kumgang (*Kumgang chondo*), which he painted many times after 1711. Two versions – *General View of Inner Mount Kumgang*, an undated work, and *Complete View of Mount Kumgang*, dated 1734 – display his painting style at two different periods. The basic composition of each work is evident in the different ways in which the structure and surface of the mountain are rendered, rocky or earthen. The low, densely vegetated earthen peaks in the foreground and along the left edge of the paintings serve to emphasize the imposing presence of the steep, barren rocky peaks they frame. Even for someone seeing these paintings for the first time, it is possible to recognize the concepts of yin and yang revealed in them; and Chong Son was known to have studied the *Yijing* (Book of Changes) and applied its principles in his paintings.[27] A recent article has gone so far as to interpret everything in the 1734 painting in terms of yin and yang and the eight trigrams of the *Yijing*. Two of the most obvious features that might lend support to this interpretation are the arched bridge, in the lower left, opposed to the prominent Piro-bong Peak in the far distance. In addition, Chong's inscription curiously is written to form a semi-circle, in the center of which are four characters reading "written in winter of the year *kapsin* [1734]."[28]

It is more instructive to read the artist's poetic inscription:

> Twelve thousand peaks of All Bone Mountain,
> Who would even try to portray their true images?
> Their layers of fragrance[29] float beyond the *pusang* tree;[30]
> Their accumulated *qi* swells expansively throughout the world.
> Rocky peaks, like lotus flowers, emit whiteness;
> Pine and juniper forests obscure the entrance to the profound.
> This careful sojourn, on foot through Mount Kumgang,
> How can it be compared with the view from one's pillow?[31]

The poem at once describes the scene painted and alludes to the profundity associated with Mount Kumgang. The last line is a reference to a famous remark by the fourth-century Chinese painter-theorist Zong Bing (375–443): when he grew old and was no longer able to climb mountains, he planned to cover the walls of his room with images of mountains and, lying on his bed, roam around them with his eyes.[32]

Although the painting and similar works by Chong Son's followers are supposedly true-view landscapes, *Complete View of Mount Kumgang* is instead a conceptualized view of the entire mountain in the tradition of the *Nine-Bend Stream of Mount Wuyi*, which was painted both as one complete view and as nine separate compositions. In this work, Chong combined the age-old tradition of the complete view (*chondo*) with his own visual encounter with the peaks of Mount Kumgang, creating a memorable image to which he added the poem that expressed his thoughts and feelings about the mountain.

Even though *Complete View of Mount Kumgang* is traditional and conceptual, a comparison of this painting with a contemporaneous travel description reveals Chong Son's power of realism. The following is a passage from a travelogue by the literatus Yi Man-bu (1664–1732):

> Before me rise twelve thousand peaks winding sinuously into the distance. Looking at these jagged, craggy peaks soaring into the sky, I am seized with such awe and exhilaration that I feel as if I am immersed in fresh water.[33]

The needlelike peaks were depicted with the distinctive downward brushstrokes (called *Kyomjae sujik chun*, or Kyomjae vertical strokes) that Chong developed during the course of painting Mount Kumgang many times.

Clearing after Rain on Mount Inwang, painted in 1751, is the last dated work by Chong Son. In this he emerges as the most daring and original painter of true-view landscapes. An unusually large horizontal hanging scroll, *Clearing after Rain* shows a well-structured composition of mountain peaks and forests separated by large areas of mist. Mount Inwang rises above the thick clouds after a rain, exposing its brilliant rocky peaks against the sky. Chong Son has used rapidly executed bold brushstrokes of saturated ink to define the rounded peaks of the mountain and the enormous boulders of yellowish-white granite that cover it. A dotted line along the far ridge of the mountain represents the northwestern

portion of the fortress encircling the capital, which lies to the east of Mount Inwang. Much of this fortress is still standing today.

In the middle distance, just below the central peak, smaller rocky peaks alternate with soft, white earthen peaks, which have been covered with rows of pine trees described as simple vertical trunks with a few short horizontal branches, a stylized rendering that became one of the hallmarks of Chong's late landscapes. In order to enliven the earthen peaks, Chong applied Mi ink-dots to indicate clusters of vegetation. The range of tones, from the saturated dark ink to the white color of the paper, and the range of brushstrokes, encompassing traditional Mi ink-dots as well as original sweeping strokes, enrich the visual effect of the painting, leaving the viewer with an unforgettable impression of the mountain.

Notes

1 Ahn Hwi-joon, *Han'guk hoehwa-sa* (History of Korean Painting) (Seoul: Ilchi-sa, 1980), p. 256.
2 O Se-ch'ang, *Kunyok sohwa-jing* (Biographical Dictionary of Korean Calligraphers and Painters) (Seoul: Pomun sojom, 1975 reprint), entry on Chong Son, p. 166.
3 For the most comprehensive annotated English translation of Jing Hao's *Bifa ji*, see Kiyohiko Munakata, *Ching Hao's Pi-fa chi: A Note on the Art of the Brush* (Ascona: Artibus Asiae, 1974).
4 See Yi T'ae-ho, "Choson hugi chin'gyong sansu ŭi paltalgwa t'oejo" (The Development and Decline of True-View Landscape Painting of the Late Choson Period), in *Chin'gyong sansu-hwa* (True-View Landscape Painting) (exh. cat., Kwangju: Kwangju National Museum, 1987).
5 Pak Un-Sun, *Kumgangsan-do yon'gu* (A Study of the Paintings of Diamond Mountain) (Seoul: Ilchisa, 1997), p. 83. For the definition of the Chinese term *tianji*, see Susan Bush, *The Chinese Literati on Painting: Su Shih (1037–1101) to Tung Ch'i-ch'ang (1555–1636)* (Cambridge: Harvard University Press, 1971), pp. 57–58.
6 These terms are found in several official records from 1688 to 1902. See Yi Song-mi, Yu Song-Ok, and Kang Sin-hang, *Choson sidae Ojin Kwan'gye Togam Uigwe yon'gu* (A Study of the Records of the Superintendency for the Painting or Copying of Royal Portraits of the Choson Dynasty) (Songnam: The Academy of Korean Studies, 1997), pp. 25–26, 64.
7 *Han'guk hanjao sajon* (Dictionary of Korean Terms Written in Chinese Characters) (Seoul: Center for Oriental Studies, Tan'guk University, 1995), vol. 3, p. 555.
8 The following publications were consulted for the intellectual background of the seventeenth and eighteenth centuries: Ch'oe Yong-song, *Han'guk Yuhak sasang-sa*, vols. 2–4; Lee Ki-baik, *A New History of Korea*, trans. Edward W. Wagner and Edward Shultz (Seoul: Ilchogak, 1984); Ch'oe Wan-su, "Kyomjae Chong Son chin'gyong sansuhwa-go" (A Study of the True-View Landscape Paintings of Chong Son), *Kansong munhwa*, 21 (1981), pp. 39–60; Kang Kwan-sik, "Choson hugi misul ŭi sasang-jok kiban" (The Intellectual Foundations of the Arts of the Late Choson Period), in *Han'guk sasangsa taegye* (An Outline of History of Korean Thought) (Songnam: Academy of Korean Studies, 1992), pp. 535–92.

9 The term "*so-chunghwa*" can be found in Cho Kumyong's (1693–1737) "Kwanwol-ch'op so" (Preface to the Kwanwol-ch'op Album), dated 1720, in which he writes: "It has been a long time since our Eastern Country called itself *so-chunghwa*." See Ch'oe Wan-su, "Kyomjae Chong Son chin'gyong sansuhwa-go," p. 46. In his essay, however, Ch'oe Wan-su uses the term "*Choson chunghwa*" instead of "*so-chunghwa*."

10 For example, Ch'oe Wan-su considers the "minor China" concept to be the major intellectual force behind the development of Chong Son's true-view landscape painting. Ibid., pp. 46–47.

11 Ibid., p. 47.

12 For a discussion of the content of the book and a biography of Yi Ik, see Han U-gun, "Introduction," in *Kugyok Songho Sasol* (*Songho Sasol* Translated into Korean), vol. 1 (Seoul: Minjok munhwa ch'ujinhoe, 1977/1982), pp. 1–41.

13 Of these, I am especially indebted to Professor Yi Song-mu for his view of Yi Ik's role in late-Choson-period scholarship. His forthcoming paper, "Songho Yi Ik (1681–1763) ui saeng'ae wa sasang" (Songho Yi Ik's Life and Thought), provides a solid background for understanding Yi Ik's position within his scholarly milieu.

14 See "Hwasang yodol" (Convexity and Concavity of Painted Images), in *Kugyok Songho Sasol*, vol. 2, pp. 64–65.

15 Here, the character for *gyong* in *chin'gyong* is that meaning "boundary" or "realm."

16 The colophon appears in Yi Ik, *Songho sonsaeng chonjip* (Complete Works of Songho), vol. 2 (Seoul: Kyong'in munhwa-sa, 1974), p. 401. My English translation is based on the Korean translation of the colophon in Pak Un-sun, *Kumgangsan-do*, pp. 94–95.

17 See Ahn Hwi-joon, *Han'guk hoehwa-sa*, pl. 88. The portrait is in the collection of Yun Hyung-sik, Haenam.

18 The map was made to a scale of 1:420,000. See the entry on "*Tongguk chido*" in *Han'guk minjok munhwa tae paekkwa sajon* (Encyclopedia of Korean Culture), vol. 7, pp. 179–80.

19 See Ch'oe Kang-hyon, *Han'guk kihaeng munhak yon'gu* (A Study of Korean Travelogues) (Seoul: Ilchi-sa, 1982).

20 According to the National Code (*Kyongguk taejon*) compiled in 1485, a painter of the royal painting bureau could not be promoted beyond the sixth rank in the nine-rank system of the bureaucracy. Although there were some exceptions, this rule was generally adhered to. For the case of Chong Son, see *Veritable Records of King Yongjo*, vol. 81, 1754, March, *kapsin* day.

21 Ahn Hwi-joon, "Choson hugi mit malgi ui sansuhwa" (Landscape Painting at the End of the Choson Period), in *Sansuhwa* (Landscape Painting), vol. 12, *Han'guk ui mi* (Beauty of Korea) (Seoul: Chung'ang ilbo, 1982), p. 206; and Ch'oe Wan-su, *Kyomjae Chong Son*, pp. 275ff.

22 Although most Chinese paintings now remaining in Korea in several public and private collections date from the late Qing period, we know from travel diaries and other collected writings that Chinese paintings of the Ming period and earlier were seen by seventeenth- and eighteenth-century Korean scholar-painters. See Yi Song-mi, "Southern School Literati Painting of the Late Choson Period," pp. 183–84.

23 For a detailed discussion of the history of the different names of Mount Kumgang and their meanings and symbolism, see Pak Un-sun, *Kumgangsando*, pp. 14–34.

24 See Yi T'ae-ho, "Choson hugi chin'gyong sansu ui paltalgwa t'wejo." Unfortunately, the poetry section has been separated from the painting. Ch'oe Wan-su, on the other hand, has identified a poem by Yi Pyong-yon as having been written for Chong Son's painting. This assumes that Chong Son was traveling to the area at the invitation of Yi, who was then serving as magistrate of the Kumhwa district, the entrance to the vast Diamond Mountain area. See *Kyomjae Chong Son*, p. 16.

25 For example, in ch. 2 of *Sunam-jip*, the writings of Yi Pyong-song (1675–1735). Yi was the younger brother of Yi Pyong-yon. See Ch'oe Wan-su, *Kyomjae Chong Son*, p. 20.

26 Pak Un-sun points out that Chong's several paintings depicting the Chang'an-sa Temple at different dates all show the arched bridge, Pihong-gyo, very prominently. As documented by several scholar-officials who traveled in the area, however, this bridge was destroyed by flood in about 1723. Pak Un-sun, *Kumgangsan-do*, pp. 136–38.

27 See Pak Chun-won's *Kumsok-chip* (Collection of Epigraphy), quoted in O Se-ch'ang, *Kunyok Sohwajing*, pp. 162–63.

28 O Chu-sok, "Yet kurim iyagi" (Story of Old Paintings), *Pangmulgwan sinmun* (Monthly News of The National Museum of Korea), no. 306 (Feb. 1, 1997), p. 3.

29 "Layers of fragrance" is a translation of *chunghyang*, another name for Mount Kumgang.

30 In Chinese myth, *pusang* (Ch. *fusang*) is an imaginary tree in the Eastern Sea whence the sun rises.

31 My English translation is based on the modern Korean translation in O Chu-sok, "Yet kurim iyagi."

32 This story is recounted in the biography of Zong Bing in Shen Yue (441–513), comp., *Song shi*, ch. 53, Liezhuan.

33 Yi Man-bu, *Chihaeng-nok* (Records of Traveling the Land), Korean trans. by Yi Ch'ang-sop (Seoul: Mongnam munhwa-sa, 1990), p.259. The English translation is taken from Yi Song-mi, "Koreans and Their Mountain Paintings," *Koreana*, vol. 8, no. 4 (Winter, 1994), p. 23.

38

The Meaning of Western Perspective in Edo Popular Culture

Timon Screech

Introduction

Screech's essay addresses the use of Western perspective in Japanese Edo or Toku-gawa period (1615–1868) prints. While Western viewers often assume that one-point perspective is both normal and scientifically correct, perspective even in the context of Western art has specific meanings, and has not always been used consistently or "scientifically." Edo-period printmakers selectively imported aspects of Western perspective, and adapted this strategy for depicting space to the Japanese context. Screech explores the machinations of Japanese art historical thinking, the appropriation of perspective as a particular way of looking, and the physical way in which people view these images.

During the Edo period in Japan, the merchant and artisan classes achieved new affluence and used that wealth to patronize the arts. Whereas earlier patrons such as landowners and samurai had purchased paintings, merchants turned to woodblock prints, many of which depicted scenes of the new urban culture, centered on Edo (now Tokyo). This visual culture favored by the rising merchant class included street scenes, images of famous actors in kabuki plays, interiors of tea houses, and vistas of the Japanese landscape. The dynamic urban space earned the name "floating world" or *ukiyo*, and spawned popular pictures of the floating world, or *ukiyo-e* (e means pictures or images). During this period, the Japanese relationship with the West

Timon Screech, "The Meaning of Western Perspective in Edo Popular Culture," pp. 58–68 from *Archives of Asian Art* 47 (1994). Reprinted by permission of The Asia Society.

ranged from engagement and intellectual curiosity to isolationism. In the seventeenth century, the Portuguese and other Europeans were expelled from the islands, leaving only the Dutch to trade from their small foothold in Nagasaki. The Dutch became one of Japan's key connections to the West; other ideas also filtered through in Chinese translations of European texts.

The Japanese embracing of the perspectival print, or *uki-e* (floating pictures) – a small subset of Edo prints as a whole – occurred in a particular middle- and lower-class context, one in which the physicality of viewing these images in the marketplace and the commercialization of art intersected to make Edo prints a highly effective and popular medium. Screech thus analyzes a "low" form of art, investigating how the "high" Western form of perspective came to represent a particular class of viewer and a particular means of viewing cityscapes in Edo Japan.

Vanishing-point perspective, which had evolved through decades of trial and error in the West, arrived in Japan all in a moment, as a *fait accompli*. When this occurred is unclear. It is possible – indeed likely – that an element of perspectival study had been carried out in the Jesuit painting school set up by Giovanni Niccolo (1560–1626) in 1601, but the evidence of pictures produced at that time suggests that the technique was not systematically applied. It remained for the second quarter of the eighteenth century to witness the rise of a recognised manner of depiction identified as Western perspective. It is the purpose of this essay to assess the meaning of this mode in the popular culture of Japan; a precise plotting of chronologies cannot, here, be essayed, nor can we offer more than one strand in the interpretation and deployment of perspective in Japan.

The Arrival of Perspective

Japanese terms for the new kind of representation were various. *Uki-e* (floating pictures, but not to be confused with *ukiyo-e*) was a common designation; *kubomi-e* (sunken pictures) was also used, though perhaps only in joking contrast.[1] Both words stressed how the picture interacted with its viewers, seeming either to fly up from the page to envelop them, or plunge them down into its deep recesses. Only the former term is used in modern scholarly discourse.

Western art has traditionally considered the "discovery" of perspective as one of its greatest feats. Ever since Vasari, historians have extolled the line of heroes who devised an accurate means of repeating "real" space in two dimensions. In Japan too, many ways of simulating the third dimension had been known since antiquity, but the calculation and rigid application of such techniques had never been thought the definition of good art, much less the primary objective of representation.

Brunelleschi hung a net in the doorway of the Duomo in Florence and drew the Baptistry through it; Northern artists were said to have reproduced outside views by looking through the leaded squares of their casement windows. But Japanese architecture has neither door nor window in the Western sense, and the novel device of perspective, when it arrived in Japan, convinced few with its pretensions to offer a uniquely compelling window onto the world.

Perspective in Japan was hailed as marvellous, but as a marvellous *invention*, not a *discovery*. The distinction is crucial: in it lies determination of whether perspective pictures are deemed to be real or merely observing of codes. The enormous number of conventions that had to be followed by an artist who depicted in perspective militated against acceptance of the style as in any way natural; and the viewer too was hedged about by numerous rules dictating how to view the image properly. Using a perspective picture was, in fact, a complex procedure quite unlike viewing open, empirical space. Shiba Kokan (1747–1818), an early experimenter in Western styles, visited the Dutch East India Company's trading station (or Factory) in Nagasaki with the object of finding out more at first hand. He wrote in 1799 after his return to Edo,

> Western pictures operate on a highly theoretical level, and no-one should view them off-handedly. There is a correct way to look, and to this end, Western pictures are framed and hung up. When viewing them, even if you only intend a quick glance, stand full-square in front. The Western picture will always show a division between sky and ground [the horizon line]; be sure to position this exactly at eye-level, which, generally speaking, will entail viewing from a distance of five or six *shaku* [*c.* 180 cm]. If you observe these rules, things shown near at hand and things shown far off – the foreground and the rearground – will be clearly distinguished and the picture will appear no different from reality itself.[2]

Kokan, a convert to the style, stresses the verisimilitude; but intricate and convoluted, these pictures apparently also needed exegesis – even policing – to have much value.

Kokan wrote two treatises on European art, the *Essay on Western Pictures* (*Seiyo gadan* (from which the above statement is taken) and the *Laws of Western Pictures* (*Seiyo gaho*) of six years later.[3] These were not the earliest such theorisings. The first attempts to formulate the rules of Western depiction had been made by Satake Yoshiatsu (1748–1785), daimyo of Akita in the north of Japan, in a pair of short essays (one illustrated) completed in 1778.[4]

Where Lord Satake derived his knowledge is debated. Satake certainly owned a copy of one study of Western art, and that in its original unexpurgated form. The book concerned, the *Groote Schilderboek* of 1707, was an introductory manual to painting fantastically popular in Europe at the time.[5] The author, Gérard de Lairesse, had been a pupil of Rembrandt, but by his time of writing he had repudiated him to espouse a high and airy French baroque. Lairesse's book was

imported to Japan in several copies, and much studied. Satake, as a man of wealth, was able to procure one, but even Kokan, a commoner and not of samurai status, obtained a copy (he called it the *Konsuto shikirudo buku*), although quite how it fell into his hands is unclear.[6] Lairesse explained in detail how to use lines of recession and vanishing points, as well as a host of other aspects of the Western style, such as shading and the depiction of reflections in water.

Yet Japanese experimentation with perspective can be shown to have predated arrival of these formal treatises by some four decades. Masanobu appears to have arrogated to himself the title of "Inventor" (kongen) of uki-e, although Torii Kiyotada may in fact be more deserving of the name. In either case, the close of the 1730s would seem a plausible moment for the first innovations to have occurred, possibly in several places at once. It seems likely that artists worked on a strictly ad hoc basis, copying and adapting imported pictures without considering overmuch the mathematical implications and laws. Early perspective views suggest that trial and error was the prime didactic tool. Japanese architecture was radically different from that of Europe, but in some ways ideally suited to essays in perspective: most eighteenth-century buildings were of post and lintel type, affording plentiful obliques and parallels that could be taken as ready guide lines; woven tatami mats (the usual floor covering) provided straight markers down which recessions could be easily plotted. Outside space remained more of a challenge, though, as can be seen from, for example, Masanobu's *Taking the Evening Cool by Ryogoku Bridge*.

Perhaps for this reason, indoor scenes predominate in the first uki-e, and sumo tournaments, kabuki plays, and brothels became frequent; their subject matter, note, is also slanted towards the world of popular urban entertainment (a point to which we will return).

Statistical assessment would probably find kabuki scenes to be most numerous during the early period: there was already a huge market for actor prints (yakusha-e) and it was not unnatural that uki-e should have been partially subsumed into it. But other reasons have been offered for the prevalence of stage depictions. Edo theatres began to be roofed only in 1718; tiles were first used from 1724 and only by perspectival rendition could the new ceilings be shown.[7] At any rate, the ability to draw ceilings (from above or below) was much approved of by Lord Satake, who lamented their absence in most Japanese work; he felt uneasy that "foreigners seeing [our] pictures must certainly conclude that palaces in this country are roofless, and wonder how, if they are all like that, we ward off the rain and snow."[8]

Theatre prints are dated on the evidence of the actors appearing on stage or inscriptions on pillars, and assuming this data to be accurate, the first extant example is Masanobu's interior of the Nakamura-za showing a performance of 1745; the first uki-e may, of course, be considerably earlier than the first extant one.[9] Interestingly, Nian's *Guide* included lessons on how to depict theatres, although from a different angle than that adopted by Masanobu.[10]

The Problem of the Medium

Two initial conclusions ought now to be drawn. Firstly, early uki-e were overwhelmingly associated with the world of townspeople's relaxation, particularly in Edo. Secondly, perspective manifested itself less in painting than in prints – certainly, prints vastly outnumbered paintings in the long run. The two issues are, in fact, related: the sumo- and kabuki-going public was more likely to be in the print-buying than the painting-buying bracket.

In Japan as elsewhere, prints were in essence images for those who could not afford paintings. Lord Satake owned some Western etchings which he appears to have treasured, but a samurai home could not properly be ornamented with such things. An urban commoner home, a restaurant, or a teashop, though, could. Modest townspeople pinned or pasted prints to their walls and woodwork without sacrificing their aplomb. Since few European paintings ever arrived in Japan it was inevitable that the Western style (perspective included) was associated almost exclusively with prints.[11] This led to an assessment of the foreign style as pertaining mostly to low-grade products. Had more paintings been imported (Lairesses, Rembrandts, or anyone else's), perspective might have been taken more seriously. The fact is, it generally was not. Gennai told Kokan how "several hundred Dutch copperplate pictures" (certainly all executed in impeccable perspective) had been offered for sale in Japan, but no-one showing the least interest in them, all had been shipped back.[12] Such a fate would not have befallen European easel works.

It was surely for this reason that Tani Buncho (1763–1841), attendant (tsuke) to the Chief Minister of State Matsudaira Sadanobu (1758–1829), wrote,

> I used to have a large number of Western pictures in my collection, but I tend to find them … short on real meaning (*imi*). When you try to appreciate a Western picture on a profound level you always feel there is something lacking.[13]

While Buncho says "pictures" (ga) he must be referring to prints. He finds them trivial. Devoid of brushwork, in East Asian terms they lack meaning, disqualifying them in a way which no amount of illusionistic space-creation could ever overrule. Perspective was tarred with the perceived limitations of the medium of print.

The association of the Western work of art in general with the print was almost total. Take the case of an entry in the *Lexicon of the Primitive Language* (*Bango-sen*), a Japanese–Dutch pocket dictionary published in 1798: the book was the work of Morishima Churyo (1756–1809), a high-ranking samurai who had thumbed Lairesse thoroughly, associated with Gennai, and who knew more about the West than most. Yet Churyo translated *gaku* (framed picture) as *pure-nto* (print), disregarding the phenomenon of painting completely.

If an innate prejudice against prints worked to the detriment of perspective's status, there was also a problem of the kind of print imported. Copperplate reproductions of what in the West would have been regarded as bona fide art

were as rare in Japan as European paintings in oil. The majority of the imports were single-sheet townscape views in the genre known as *veduta* prints. In the home context too, these brightly coloured and attractive pictures were essentially disposable pieces aimed at the ordinary citizen; they provided instant enjoyment, but were not billed as great art.

Veduta themes represented, for the most part, celebrated parts of the cities of Europe, or those far-flung places of empire to which the viewer would never go. They offered an experience of travel to those who could not themselves move. Veduta were at the banal end of what Canaletto was providing for the wealthier classes who actually made tours. Canaletto too, of course, was pooh-poohed in most refined circles, and extolled to a high degree only in England, where visual taste was notoriously crude. His works were often made into prints too (the subtler connoisseur would have thought that the better genre for him anyway).

Veduta prints of Jakarta, say, or Venice were consumed casually in the drawing rooms of Europe from Berlin to Dublin; now the same pictures were enjoyed in Japan too. Extreme perspective was a hallmark of the eighteenth-century veduta style. They exaggerated the magnificence of the vista, the more to excite the viewer, even if at the cost of truth. To see an actual place after becoming acquainted with it from a perspective print is often to witness a sad reduction. Many Japanese assumed these slight pictures to be the sum of landscape art as understood in the West, and perspective townscapes were held to define much of what art meant to Europeans. In his *Lexicon* Churyo translated *seiyo-kei* (Western view) as *perusupekuchifu* (perspective), adding, to aid the user, the Japanese gloss *uki-e*.

The centrality of the veduta to Japanese interpretations of Western pictures must be stressed. The near equation of the two can be seen in the context of a comic illustrated story in the kibyoshi genre by Hirazawa Tsuneyoshi (1735–1813), a samurai and none other than Lord Satake's official representative in Edo (rusui-yaku). Tsuneyoshi, using his penname Hoseido Kisanji, published the book in 1777, just as his daimyo must have been completing the two treatises on Western art. The story, *Nandara the Monk and His Persimmon Stone* (*Nandara hoshi kani no tane*), tells of the exploits of a certain Indian cleric who begins the story by stealing a magical fruit stone that his master, a painter of religious icons, had miraculously received from the Buddha. When ground up and mixed with pigment a little at a time, the stone creates an ink that allows the user to paint with peerless skill. Nandara, possessed of the stone, determines to take advantage of his new-found facility to become adept at foreign styles. He goes at once to Holland to study the elements of Western art. Kisanji's illustrator, Koikawa Harumachi (another samurai, known in his workaday life as Kurahashi), depicts Nandara at this point in a European setting receiving instruction from a (rather Japanised) Dutchman. A large perspectival work rests on an easel, while Nandara copies a miniature portrait roundel. Those are apparently paintings, but the teacher instructs Nandara in the true hierarchies of Western art: he stipulates that only after nozoki-e have been mastered can painting be attempted.[14]

Peeping-pictures

Nozoki-e, literally "peeping-pictures," are largely identical with uki-e. They are crucial to understanding the popular gloss put on perspective in Japan. Nozoki-e are what in the West were called *vues d'optique*. These were a sub-set of veduta prints relying for the full effect of their perspectival scheme on a piece of apparatus known as an optique. The device was a kind of table-top peep-box into which the print was put. A lensed viewing aperture permitted the viewer to see the image inside in isolation, all familiar surroundings cut away and the entire field of vision taken over by the printed scene. *Vues d'optique* were not viewed directly through the lens, but at one remove, reflected in a mirror mounted obliquely. These combined to enhance the clarity of the image and give a sense of really "being there," but it meant the scene had to be printed in reverse.[15] Optiques were on sale right up to the middle of the nineteenth century in Europe and the United States, and were common household furnishings, eventually marketed under the name of zograscopes.

The optique arrived in Japan with the perspective print, though no doubt in smaller numbers. The records of the Dutch Factory in Nagasaki mention the import of a *perspectieff cas* in the winter of 1646. Quite what this was is unclear, but that it was some sort of peeping apparatus is obvious.[16] Kokan commented on the prevalence of optiques in Japan in his day, and Harunobu (d. 1770) showed one in use by a boy and a young girl in a male brothel.[17] Harunobu's device appears to be French, for an identical one made in Paris is still extant in Japan;[18] the print being used with the optique is domestically produced, and represents part of Mt Koya.

Imported optiques were set up at fairs and amusement areas, and people flocked to use them at so much a look. Kodera Gyokucho (active 1818–1837), an indefatigable recorder of popular exhibits in his native city of Nagoya, noted that "peeping glasses brought over from Holland" were on display at the Temple of Daisu-zan in the 1820s; these could be used for sixteen mon a time. In 1788, Kokan had charged exactly double to look through an optique he had devised himself, although whether he was extorting, or the price dropped over time (or whether he offered more pictures to go inside his machine) is hard to tell.[19]

Many Japanese writers on Western art in the latter part of the eighteenth century took it for granted that not only were imported pictures generally veduta scenes, but they were actually mirror-image *vues d'optique*. Kokan, by no means ill informed on the subject, held the crowning success of his attempts to master Western styles was his ability to replicate copperplate etching and thereby to simulate absolutely a European *vue d'optique*. By contrast, the simulation of oil paint occupied for him a position of less prestige. Kokan's first etching was an Edo view (Mimegun in the east of the city), but probably the next year, 1784, saw him making pictures of the Serpentine Lake in the English stately home of Stowe and of a Dutch hospital. These views were not just replications of the *medium* of

etching (as has long been acknowledged), but were surrogates of the *totality* of a Western *vue d'optique*, for they consciously showed precisely the sort of view then being created for use in optiques all across Europe. Indeed, so close is each of Kokan's images to the original scene depicted that pure imagination is precluded, and he must have copied the two plates from imported images (although only the former has been traced to a convincing source).[20]

In the same year that Kokan broke the European monopoly on *vues d'optique*, he explained himself: he stated of his perspective copperplate efforts that, "the principles governing my pictures (gari) are identical with those of the West." This was a statement of triumph, made, note, with exclusive reference to his ability to fabricate pictures for use in optiques. Kokan was pleased to have cracked the difficult task of etching on metal, but his comment is directed only to the reversed peeping-picture genre. Kokan's remark in fact appears on a single-sheet copper-plate print illustrating the three types of optique most current. He went on,

> [Europeans] represent human figures, landscapes, and everything else in the form of uki-e. Pictures are positioned under the optique back to front [as in Harunobu's illustration] ... and you view them reflected in a mirror.

Then he added the hoary summary, "[thanks to this] the landscape and vegetation look just as they do in real life." The Japanese term for the optique, "peep-glasses" (nozoki-megane), was soon substituted for the more memorable "Dutch glasses" (Oranda megane). Uki-e themselves could be called "glasses-pictures" (megane-e) – "glasses" meaning not spectacles but optiques.[21]

Techniques of Viewing

Large numbers of such megane were made in Japan for use with European prints, or with their Japanese derivatives. The many kinds replicated pretty much the variety to be seen in Europe. The emphasis, though, was different for the most common sort in Japan was not the zograscope but a larger device known in English as a raree-show, and in Japanese as a peeping-karakuri (nozoki-karakuri); karakuri means something like a contraption.[22] (Below, I use "peeping-karakuri" interchangeably with "peep-box.")

Scrolls showing the funfairs of Edo and elsewhere routinely depict a peeping-karakuri in action, with crowds gathered to see the views inside. The machine was appropriate for group settings, since unlike the zograscope it was suitable for use in the open air and by several people at once. The box was fully enclosed, with a row of apertures pierced along the front allowing multiple access into the interior. A showman, called the saiku-nin (clever-device operator) ran the box, and had a reputation for being somewhat bullying with the punters: no longer a private affair, these Dutch-glasses were money-making concerns, and economic

viability had to be considered; the peeping-karakuri must have cost something to set up. The Takeda Omi company of automation makers in Osaka fabricated machines, although many must also have been jerry-built by their individual operators. But there were still the pictures to be procured. All this meant a swift (and sanitary) customer turn-around had to be maintained. As a senryu verse had it,

"Give your nose
A proper wipe!"
They say, staring in.
Hana o yoku kami-nasai yo to nozoki ii.[23]

Santo Kyoden, a best-selling writer in the same comic genre as Kisanji, and a person much given to satirising contemporary fads, referred to the peeping-karakuri as something, "otherwise known as the 'do-please-pass-along-at-the-front-there!' "[24] If people were inclined to linger over perspective pictures the showman shooed them on.

One peep-box is conveniently illustrated in a story by Kyoden entitled *Goods You All Know About* (*Gozonji no shobaimono*), published in 1782. One of the "goods" was the peep-box. Up to six customers can view the scene together, and a child is seen crouching down to look. This was the normal posture, which, in the words of an indelicate senryu writer, meant, "looking as if you're trying to fart" (heppiri-goshi).[25] The images are lit through paper screens set horizontally over the top. The drum-beating saiku-nin sounds the roll-up as a jack-in-the-box pops from behind a candle-shade to announce the commencement of the show. The operator, who will probably narrate the scenes, is perched on a case labelled "uki-e." This box (even down to the jack) seems entirely typical of the sort to be seen in urban centres in late eighteenth-century Japan. But the foreign derivation of the booth is stressed, for the advertising board shows a Dutch-like scene of a waterfront with Western figures and a dog (probably it was after seeing such boards that Harumachi made up the easel painting illustrated in *Nandara*).[26] The wings of Kyoden's sign reiterate the imported nature of the vision, reading, "Great Dutch Karakuri" (Oranda o-karakuri).

The peep-box became so popular that the sesquipedalian "nozoki-karakuri" was abbreviated, in Kyoto to nozoki and in Edo to karakuri;[27] the peep-box, then, became quintessential of both the "peep" and the "contraption," with perspective implied under either term.

It is a vexed question what exactly was to be seen in these Japanese perspective boxes. The totality of European *vues d'optique* would probably not have made it to Japan, but then, domestic uki-e added a host of new indigenous subjects. Extant uki-e show a bewildering range. It is interesting to recall that perspective prints were being made in China at this time too, especially in the Suzhou area, and although they were not normally of dimensions suitable for use in a peep-box, they may have been emulated locally in smaller formats.[28]

416

Literary sources suggest more varieties of imagery still. Shikitei Sanba (1776–1822), a rival of Kyoden for the accolade of Edo's favourite novelist, transcribed a peep-box showman's cry in his *Barber's Shop of the Floating World* (*Ukiyo-doko*), a long-ish work published in instalments over eighteen months from 1813:

> Now then everyone, come and have a look! Here's the Factory of the [Dutch East India] Company in Jakarta! There's its look-out post with two pine trees, and you can see right back to those three girls over there. All this contrived inside a little box. And there's more! A Chinaman stands to greet someone from his window; there's a maple tree and a big thick pine. Well? How is it?[29]

It was wonderful, of course.

Western, Imperial, Japanese, Chinese, and Korean scenic views were all to be seen. But given the swift and semi-secret nature of the karakuri peep (those who had not paid up and squatted down would never know what was within), it was perhaps inevitable that more illicit sights were shown too. Pornography may have been a staple. As early as 1730, Hasegawa Mitsunobu remarked of the state of affairs in Osaka that, "although children are said to be the likely clients, viewers are in fact apt to be young ladies hiding their faces behind hats." Fearful of being spotted or hiding their blushing cheeks, the women nevertheless cannot forbear to take a scurrilous look.[30]

A single box contained large numbers of images stacked up and viewed in sequence either to construct a story, or else just as a random pot-luck of exotica. The pictures (we might call them scenes or sets in English), were known as *tei* in Japanese. The selection was suspended out of sight behind the advertising board on top of the box, which in fact doubled as a baffle or a mini-fly tower; the showman dropped the sets down one in front of the other, as appropriate, by pulling cords emerging from the the the side of the booth.

Towards the end of the eighteenth century an additional feature was incorporated; this had great bearing on the popularity of uki-e. I refer to the adoption of a lighting trick allowing sets to be alternately front-lit (the normal way) or back-lit. Hidden slats were fitted beneath the paper roof and swivelled to direct light either before or behind the picture – a technique common in European raree-shows. When used with cut-out pictures whose depicted windows and lamps were snipped away, a daytime scene could turn suddenly into night, with light seeming to shine from inside the buildings. Kyoden mentioned this feature in his *Goods*: "the set shows people enjoying the cool of the day at Shijo-Kawara, but in a flash it will change, and night-time lanterns burn."

Lighting tricks brought sites of nighttime revelry into the domain of uki-e. The pleasure districts of Kyoto (such as Shijo-Kawara) or Edo (the Yoshiwara) were often shown in perspective, and even when cut-outs were not actually used, the scene could be plunged into crepuscular conditions with breath-taking effect. Events from history and literature which had taken place at night entered the repertory. Kyoden's protegé, the novelist Takizawa Bakin (1767–1848), told

excitedly of having seen in a peep-box in Nagoya an illustration of the Night Attack from the famous play the *Treasury of Loyal Retainers* (*Chushingura*).[31] This event was in fact depicted in perspective by many, including Kitao Masayoshi (1764–1824) and Maruyama Okyo (1733–1795). Jippensha Ikku (1765–1831), another much-read comic writer, recorded some peep-box scenes in a compilation of Edo showmen's cries published in 1818. He begins with the saiku-nin in full tilt; the first scene mentioned is the same that Bakin had viewed,

> Well now, well now! Next comes the Eleventh Act of the *Treasury of Loyal Retainers*, after that it's the suicide of O-shichi the greengrocer's girl, and the tragic journey after the Battle of Ichi-no-tani. In the distance you will see Asukayama and nearby there's Itsukushima in Aki. Then it will change to night-time scenes with lanterns, flaming torches and stars; there'll be the ring-hunt held on Mt Fuji, and the firework displays of the Tama-ya and the Kagi-ya.[32]

The show moves apace from *Chushingura* to the famous love-suicide of O-shichi, to an episode from the *Tales of the Heike* (*Heike monogatari*), to a view in Edo, to the floating shrine of Miyajima near Hiroshima (one of the Three Most Beautiful Places – sankei – in Japan), to Yoritomo's famous battue (makigari) of 1193 at which the Brothers Soga took their extravagant revenge, until finally the show closes with night-time depictions of the pyrotechnic extravaganzas hosted annually by two restaurants at Ryogoku in Edo.[33]

The sets replaced each other in the box with proverbial rapidity, as the saiku-nin tugged away at his cords. The speed and frequency of the change-overs in fact was the stuff of legend. Kyoden used the peeping-karakuri as a metaphor for all changeability, and he warned his readers that the human heart (particularly, he says, woman's) is just like a booth in its protean fickleness,

> Just when you think you see Pusan Harbour [in Korea], there it goes, and it's changed to a view of Miyajima in Aki. "Now it's a picture of Paradise!" you say to yourself, but then it shifts to Hell.[34]

The *vue d'optique* is a flibberty-jibbett that offers no vision of any substance. Kyoden sums up: "People's hearts change as fast as autumn skies. Let each be on his guard." Five years later, Kokan appealed again to this metaphysical peep-box,

> If you were to pull the cords of the human heart, you would see changes swifter even than those of [sets in] a karakuri. This is the wages of fortune. Let no-one lower his guard![35]

This anthropomorphic booth occludes real distinctions, whether between right and wrong or heaven and hell, and by jumbling all together in an unstable slew, it erodes the authority of difference.[36] The Western perspective print has been turned into a spokesperson for vanity and flux, and for precisely, appearances over reality; the optique has become a means for viewing the vapid hearts of Edo.

Perspective and Reality

That perspective was thought to be the principal feature of the Western style will, I hope, now be accepted. Lord Satake regarded the prime brilliance of Western representation that "the place at which the power of the human eye gives out is captured," that is, a vanishing point is shown.[37] But other commentators were worried by this too-close equation of Western pictures and uki-e. As the association became all but complete, some cavilled. The uki-e being things of the piccaresque world of the fairground, some felt them liable to bring Western art in toto into disrepute. Kokan himself, despite having done so much to bring the *vue d'optique* into the Japanese arena, was ambivalent,

> People tend to think that Western pictures are only uki-e, but the opinion deserves to be laughed to scorn.[38]

Of course not all Western pictures in Japan were done in perspective, and those who looked could find examples in plenty where the technique was haphazardly applied, or not applied at all. But the rationale for Kokan's objection was that Western art (in his words) "captures reality" (shasei) or "copies truth" (shashin), and perspective *alone* will not be equal to that unless supported by other stylistic conventions. Perspective was just one gun in a well-stocked arsenal. Kokan feared that the epistemology of shashin might be compromised by the over-popularity of uki-e as they galloped far ahead of the rest of the Western technical cannonade. Uki-e were fun, but Western representation was not to be seen, as Kokan put it, as "toys" (ganryo).

Perspective as practised in Japan was indelibly associated with flippant subject matter, and with the chaotic conditions of viewing of the peep-box. Sanba's *Barber's Shop* referred to perspective as creating a "ten-league European gaze,"[39] that is, the pictures even if not *of* the West, entailed looking *in a Western way*. This was a convoluted, anti-empirical gaze, often found to show a totally spurious expansiveness that was precisely counterfactual. Uki-e tended to represent precisely what was *not* true or not real. Perspective can exaggerate a small space into a large one, and all too often uki-e were found to be in cahoots with boastfulness and swell. Many is the illustrated story that runs comfortably on using traditional Japanese spatial configurations only to switch to Western perspective when a flashy or insolent interior is invoked.[40]

Far from replicating life, perspective might establish an inflated sense of space that life might then foolishly learn to aspire to. "Reality" might seek to match itself up to the false majesty of uki-e. The Mitsui shop in Suruga in Edo was built on a street specially constructed to align with Mt. Fuji, so that anyone walking down would see the shop receding into the distance with the sacred mountain rising above; this looked so much like an uki-e that the scene was routinely depicted as one.[41] Turning the fabric of the shogunal city into a mechanism for one's own aggrandisement was arrogant.

Sukeroku, the swashbuckling hero of kabuki legend (and role-model for all of overweening pride), highlighted the propensity of uki-e to pander to hubricious mortals. In a play performed in 1779, the eponymous hero turns his body into a notional peeping-karakuri, making all the world his uki-e: calling upon his cronies to look through the curl of his cue as if it were the viewing hole of a peeping-karakuri, Sukeroku rants,

> A head-band of Edo purple winds about my hair and when you look through my cue you see Awa in Kazusa appearing like an uki-e.[42]

Bluster and uki-e go hand in hand.

Hokusai's view of Fuji from Nihon-bashi from the series *Thirty-Six Views of Mt Fuji* (*Fugaku sanjurokkei*) represents an antithesis to this proud and over-blown uki-e (Fig. 38–1). The print shows the world as it should be, not as the rough and boisterous would have it. The hubbub of the city is seen on the bridge in the foreground, rigidly confined and pinned into its proper subordinate scale; the lowly are arranged transversely so as to be unsusceptible to perspectival treatment. Beyond, the pompous warehouses of the city's merchant elite extend into the distance bearing their identifying markings; these are in perspective, which is not amiss for overblowing is the merchants' nature, and, importantly, the

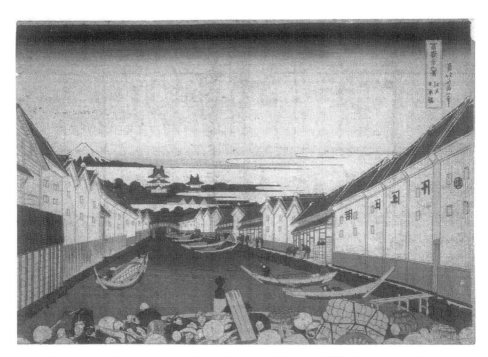

Fig. 38-1 Katsushika Hokusai, Nihon-bashi in Edo (*c.*1832), from the series *Fugaku sanjurokkei*, multicolored woodblock print, H. 24.4, L. 36.5 cm. 1937.0710.130. Reproduced courtesy of the British Museum.

exaggeration of serried godowns of supply heralds plenty, attesting, in fact, to authority's smooth running of the land that has ensured such generous provision. At the rear of the print, though, the turrets of the shogunal castle and the peak of Fuji, the two great symbols of the realm, are discerned; not things of pride or vanity but the noble hubs of the Japanese state and of ancestral culture, these elements remain precisely *not* included in the perspective scheme: Castle and peak, creatures of an altogether grander dispensation, are shown as inaccessible by way of any of the parallels that unite what dwells beneath. The populace is crushed below, the Nation and its monuments spread out above; Western perspective is what governs the middle echelons.

As Hiraga Gennai put it in 1763, "when seeing an uki-e, you think of the Jar Sage."[43] He was referring to the sage who was said to have found a huge paradise inside a little bottle, and to have taken that, not reality, as his dwelling. Peeping into the karakuri box one might find a Heaven, but more likely one would see only an illusionary picture, a nothing of dreaming and displacement, delineated in the mocking sea-logic of imported Western perspective.

Notes

1 Kubomi-e is attested only once, in Ishino Hiromichi, *Esoragoto* (1802).

2 Shibo Kokan, *Seiyo gadan*, in *Nihon shiso taikei* vol. 64 (Iwanami, 1976), p. 494. This essay is also translated in full in Calvin French, *Shiba Kokan* (Weatherhill: New York and Tokyo, 1974), Appendix III. All locations of publication are Tokyo.

3 Seiyo gaho constitutes a section within Kokan's lengthy *Oranda tsuhaku*.

4 Satake Yoshiatsu, *Gaho koryo* and *Gazu rikai*, in Sakazaki Tan [Shizuka], *Nihon garon taikan*, vol. 1 (Arusu, 1929), pp. 97–103 (illustrations not included).

5 Translations of the *Groote Schilderboek* into numerous Western languages were made: German (1729), English (1738), and French (1787).

6 Kokan was himself responsible for sowing the seeds of confusion, for he claimed that the *Groote Schilderboek* had been a gift to him personally from the Dutchman Isaac Titsingh when the two had met in Nagasaki in 1789; see *Seiyo gadan*, p. 492. However, Titsingh was not in Japan at that time. Kokan (an inveterate self-mythologiser) had probably gained access to the book earlier.

7 Julian Lee, "The Origin and Development of Japanese Landscape Prints," unpublished PhD thesis (Washington, 1977), pp. 65–67.

8 Satake, *Gaho koryo*, p. 101.

9 Kishi Fumikazu, "Enpo ni-nen no pasupekuteibu," in *Bijutsushi* 132 (1992), 228ff. discusses the dating for these other early images, and mentions another Masanobu theatre print of 1743.

10 As Pozzo's original put it, the scene showed "a theatre representing the Marriage in Cana of Galilee, erected in the Jesuits Church in Rome in the year 1685, for the solemn exposition of the Holy Sacrament." Pozzo notes that Italian and German theatres differ in construction.

11 Two Western oil paintings by the Dutch artist Willem van Royen were to be seen in the Gohyaku Rakan-ji in Edo; see Timon Screech, "The Strangest Place in Edo: The

Temple of the Five Hundred Arhats," in *Monumentia Nipponica* 48 (1993); one supposed Rembrandt was also in Japan (authenticated by Kokan and certainly a late seventeenth-century piece, but since rejected as by Rembrandt himself); see Michigami Toshii, "Watashi no Renburanto: *Mangetsu no zu,*" in *Geijutsu shincho* 181 (1965), 102–109. For details of the de-attribution see Calvin French, *Shiba Kokan,* p. 185, n. 59. Reverse-glass painting (garasu-e) was quite abundantly imported from the West; see below note 14.

12 Shibo Kokan, *Seiyo gadan*; see above note 2.

13 *Buncho gadan,* in *Nihon shogaen,* vol. 2 (Kokusho Kaigyo-kai, 1916), p. 189.

14 The teacher specifies oils and glass painting. The latter, a rococo infatuation (biidoro-e in the text) was extensively emulated in Asia, including in Japan by (among others) Kokan.

15 The reversing of prints was common practice.

16 *Nagasaki Oranda shokan nikki,* vol. 22 (Iwanami, 1956), p. 133; modern Japanese critics refer to this instrument as a toshi-bako.

17 Male prostitutes (kagema) dressed as girls, sometimes (though not necessarily) with the addition of tassels on their sleeves. This picture is filled with covert references to the ninth-century prelate Kobo Daish, founder of Mt Koya and patron saint of man–boy love (nanshoku).

18 One of several optiques preserved in the Kobe City Museum was made in Paris.

19 For Gyokucho see his *Misemono zasshi,* in *Zoku zuihitsu bungaku senshu* (Hakubun-kan, 1928), pp. 355–356; for Kokan see his *Saiyu nikki,* which mentions many demonstrations. The fee is recorded under 29th of 4th month 1788; see *Kokan Saiyu nikki* (Toyo Bunko, 1986), p. 35.

20 The scene of the Serpentine Lake at Stowe has recently been traced to the series *A New Display of the Beauties of England,* vol. 1, published in 1776. This scene had previously been assumed to represent the Serpentine Pond in Hyde Park in London.

21 The exact connexion between uki-e and megane-e is problematic. The terms seem essentially impossible to disentangle, and this essay uses the former throughout. Recently, Oka Yasumasu has argued emphatically for the division of the terms, *Megene-e shinko* (Chikuma, 1992), p. 65 and passim, and while Oka is right technically speaking (by strict definition megane-e ought to be printed in mirror image to compensate for the reflection) in practice unreversed uki-e would no doubt often have been put in optiques too and the terms conflated as much then as now. Interestingly, Kokan produced a copperplate of Ryogoku Bridge both reversed and right way around. In English, *vue d'optique* was sometimes translated as "perspective view" and *optique* as "diagonal viewing machine," but I retain the French.

22 A painting in the collection of the Kobe City Museum by the otherwise unknown Nagasaki artist Nishi Kuraku depicts a Dutch raree-show in action, attesting to the fact that the nozoki-karakuri was known to come from the West.

23 *Yanagi daru* (Kyoiku Bunko, 1988), vol. 10, no. 152.

24 Santo Kyoden, *Kamon gawa,* in Tani Minezo (ed.), *Asobi no dezainu* (Iwasaki Bijutsu Shuppan-sha, 1984), p. 16.

25 Quoted in Furukawa Miki, *Shomin geino* (Yuzan-kaku, 1983), p. 247.

26 An example is in Kyoden's *Ko wa mezurashiki misemono-gatari* (1801), illustrated by Kitao Shigemasa.

27 Kiagawa Morisada, *Kinsei fuzoku shi,* quoted in Ono Tadashige, *Garasu-e to doro-e,* 2nd edn (Kawade Shobo Shinsha, 1990), p. 66.

28 Suzhou prints are mostly in the large hanging-scroll format. More likely, Chinese scenes are to be accounted for by the import to Japan of Western *vues d'optique* representing China (of which there were many). Peep-shows were known in China, however, and were called la yangpian, "Western-piece stretchers."

29 Shikitei Sanba, *Ukiyo-doko*, in *Share-bon, kokei-bon, ninjo-bon, Nihon koten bungaku zenshu*, vol. 47 (Shogakkan, 1971), p. 289. I differ from the editors of that volume, who believe that the last part of this passage does not refer to the showman's cry but to that of a rental telescope salesman. The racist term "Chinaman" is used to capture the flavour of the original tojin.

30 Hasegawa Mitsunobu, *Ehon otogishina kaganu*; this is quoted in most sources related to uki-e; see inter alia, Oka, *Megane-e*, p. 96. I follow Julian Lee in understanding this to imply pornographic pictures were in the box ("Origin and Development," p. 54). Erotica, though, was probably not shown in perspective.

31 Takezawa Bakin, *Kiryo manroku*, quoted in Fukamoto Kazuo, *Karakuri geijutsu shiwa*, 2nd edn (Fuji Shuppan, 1982), p. 136.

32 Jippensha Ikku, *Kane moke hana no sakariba*, p. 5.

33 Uki-e are not extant for all these places and events, but for the fireworks at least, see the version of Masyoshi in Timothy Clark, "The Rise and Fall of the Island of Nakazu," *Archives of Asian Art* XLV (1992), Fig. 6.

34 Kyoden, *Hitogokoro kagami no utsushi-e* (1796), p. 12 recto.

35 Kokan, *Ko wa mezukashiki misemonogatari*, ed. Fujisawa Yoshihiko (Kokin Kisho Kangyo-kai, 1935), pp. 26–27.

36 For more on this theme, see Tanemura Hidehiro, "Nozoki-karakuri no toposu," in his *Hako-nuke karakuri kidan* (Kawade Shobo Shinsha, 1991).

37 Satake, *Gazu rikai*, p. 103.

38 Shibo Kokan, *Seiyo gadan*, p. 492.

39 See above, note 26.

40 This switch from traditional to Western is often seen in the context of illustrated popular stories, for example, Koikawa Harumachi, *Kinken sensei eiga no yume* (1775), illustrated by the author, pp. 3 verso–4 recto.

41 Several examples of the scene of the Mitsui shop are preserved in the Eisei Bunko, Tokyo.

42 James Brandon, "Sugeroku: the Flower of Edo," in his *Kabuki: Five Classic Plays* (Harvard, 1975), p. 61; I have amended the translation in line with Kishi Fumikazu, "A View through the Peep-hole: a Semiotic Consideration of Uki-e," in *Kyoto daigaku kenkyu seika hokokusho* (March 1993), 15.

43 Hiraga Gennai, *Nenashi-gusa* (1763), in *Furai Sanjin shu, Nihon koten bungaku taikei*, vol. 55 (Iwanami, 1961), p. 77.

39

The Kizaemon Tea-bowl

Soetsu Yanagi

Introduction

Soetsu Yanagi (1889–1961), also known as Muneyoshi Yanagi, coined the term
mingei (folk-craft, or art of the people) in the 1920s and is often considered the
father of the Japanese folk art movement. In concert with similar arts and crafts
movements in Britain, Yanagi sought to preserve handmade art forms in the face of
industrialization, increasing uniformity, and artist-centered markets. The following
text comes from *The Unknown Craftsman*, a collection of his essays translated by
longtime friend of Yanagi's, Bernard Leach (1887–1979), a British potter heavily
influenced by Yanagi's aesthetics. In it, Yanagi uses a particular tea-bowl to illustrate
his approach to aesthetics, examining how and why this object should be valorized as
embodying the "essence of Tea."

Beginning in the 1920s, Yanagi joined forces with Leach and potters Shoji Hamada
(1894–1978) and Kanjiro Kawai (1890–1966). Founding the Mingei movement, the
four helped to preserve the work of anonymous artists, supporting the production of
pottery, papermaking, weaving, and other folk media. Many traditional Japanese
potters had begun closing kilns; Yanagi and his colleagues helped them to stay open
and continue their family craft traditions. In 1936 Yanagi again founded a museum,
Nippon Mingeikan, to showcase the traditional crafts of Japan, many of which he and
his collaborators had collected in their travels around the country.

Yanagi's interests were not limited to Japan. In 1916 Yanagi had traveled to Korea
and was captivated by the Yi (or Choson) Dynasty (1392–1910) pottery he found
there. For Yanagi, while the objects he saw were made for particular functions, this

Soetsu Yanagi, "The Kizaemon Tea-bowl," pp. 190–6 from *The Unknown Craftsman*. New York:
Kodansha, 1974 [1931]. The Unknown Craftsman: A Japanese Insight into Beauty by Soetsu
Yanagi, adapted by Bernard Leach. English language © 1972 and 1989 by Kodansha International
Ltd. Reprinted by permission. All rights reserved.

pottery rose above its utilitarian beginnings to find value in the way it captured the local materials, hands, and traditions of the artists. Yanagi founded the Korean People's Folk Crafts Museum in Seoul in 1924 to celebrate this tradition. Yanagi's efforts in Korea came at the same time as the Japanese occupation of the peninsula, in which Koreans were forced to adopt the Japanese language, Korean art and archaeological sites were destroyed, and many Koreans were killed and imprisoned. Yanagi decried the colonial damage to Korean culture. The occupation ended in 1945, with the defeat of the Japanese at the end of the Second World War; relations between Japan and Korea have been fraught with difficulty since.

This text addresses themes seen throughout Yanagi's career: the relationship between Korea and Japan, the value of handmade objects, and the preservation of past tradition. Yanagi's writings have influenced many potters and students of Japanese culture. While his message of returning to tradition and his exegesis of a particular kind of Japanese aesthetic are seductive, his writings also perpetuate an idea of Japan-as-traditional that essentializes our understanding of Japanese (and Korean) culture. Japanese aesthetics, pottery, and culture cannot be encapsulated by *mingei*; the movement must be seen in its historical context, as a response to industrialization, Westernization, and a perceived loss of culture.

This single Tea-bowl is considered to be the finest in the world. There are three main kinds of Tea-bowls, those originating in China, Korea, and Japan, respectively. The most lovely are from Korea, and men of Tea always give them first place. Of these, there are many varieties, such as *Ido, Unkaku, Komogai, Goki, Totoya*, etc. The one considered most aesthetically satisfying is the *O Ido* ("Great" *Ido*). Again, there are varieties of *O Ido: Ko Ido, Ao Ido, Ido Waki*. The finest are called *meibutsu O Ido*, *meibutsu* signifying the particularly fine pieces. There are twenty-six bowls registered as *meibutsu*, but the finest of them all, and the one of which I shall write here, is that known as Kizaemon *Ido*. This bowl is said to contain the essence of Tea.

It is not known whence the word *Ido* derives; it was the name of the place where these pots came from in all probability. Kizaemon is a man's name – Takeda Kizaemon, a merchant of Osaka, who owned the bowl. A *meibutsu* has to have a pedigree [like an English racehorse]. Honda Tadayoshi, lord of Noto, possessed this bowl at the beginning of the seventeenth century. In 1634 it passed into the hands of Nakamura Sosetsu, a Tea master of Sakai. In 1751 it went to Toshi Ieshige, then in 1775, approximately, it became the property of Lord Matsudaira Fumai of Matsue, who was a great collector of Tea-bowls, at a price of 550 *ryo* (an immense sum). Fumai was exceedingly fond of it and kept it by him constantly. In 1818 he gave it to his son Gettan with the injunction, "This is one of the finest pieces in the land; you must treasure it always".

But this Tea-bowl got the reputation of bringing sickness and death to its owner. There was once a dilettante who owned this particular bowl. He came down in the world and finally ended up as a groom for visitors to the Shimabara gay quarters in Kyoto, but he clung to the bowl without selling it. And the

unhappy man was stricken with boils and died. From this time legend had it that a curse was associated with the bowl. It had this repute before Lord Matsudaira bought it, and he himself twice fell ill with a plague of boils. His wife begged him to get rid of it, but he refused, and his son Gettan inherited it in due course. Thereupon Gettan got a plague of boils, and the family gave it into the keeping of their priests in the Kohoan, a subsidiary establishment of the Daitokuji temple in Kyoto, the site of the family graves. One can still see, hung up at the entrance to the temple, the palanquin that is said to have been used to bring the bowl in 1804. Before the Meiji era nobody could see it without the permission of the Matsudaira family. It is one hundred years since Matsudaira died; men die, but the bowl is as it always was.

In 1931 I was shown this bowl in company with my friend, the potter Kanjiro Kawai. For a long time I had wished to see this Kizaemon bowl. I had expected to see that "essence of Tea", the seeing eye of Tea masters, and to test my own perception; for it is the embodiment in miniature of beauty, of the love of beauty, of the philosophy of beauty, and of the relationship of beauty and life. It was within box after box, five deep, buried in wool and wrapped in purple silk.

When I saw it, my heart fell. A good Tea-bowl, yes, but how ordinary! So simple, no more ordinary thing could be imagined. There is not a trace of ornament, not a trace of calculation. It is just a Korean food bowl, a bowl, moreover, that a poor man would use every day – commonest crockery.

A typical thing for his use; costing next to nothing; made by a poor man; an article without the flavour of personality; used carelessly by its owner; bought without pride; something anyone could have bought anywhere and everywhere. That is the nature of this bowl. The clay had been dug from the hill at the back of the house; the glaze was made with the ash from the hearth; the potter's wheel had been irregular. The shape revealed no particular thought: it was one of many. The work had been fast; the turning was rough, done with dirty hands; the throwing slipshod; the glaze had run over the foot. The throwing room had been dark. The thrower could not read. The kiln was a wretched affair; the firing careless. Sand had stuck to the pot, but nobody minded; no one invested the thing with any dreams. It is enough to make one give up working as a potter.

In Korea such work was left to the lowest. What they made was broken in kitchens, almost an expendable item. The people who did this were clumsy yokels, the rice they ate was not white, their dishes were not washed. If you travel you can find these conditions anywhere in the Korean countryside. This, and no more, was the truth about this, the most celebrated Tea-bowl in the land.

But that was as it should be. The plain and unagitated, the uncalculated, the harmless, the straightforward, the natural, the innocent, the humble, the modest: where does beauty lie if not in these qualities? The meek, the austere, the unornate – they are the natural characteristics that gain man's affection and respect.

great attention to the cutting of a foot-ring, and delighted in natural runs and drips of congealed glaze. Then again they developed a high appreciation for the internal volume and curves of bowls; they looked to see how green tea settles into them. They were particular how the rims of bowls feel to the lips and how the endless ring is varied. They embraced the shape and kissed the thickness. And they knew what heart's ease there was in a gentle deformity. Finally, they worked out the conditions that made a bowl beautiful; for all beauty is inseparable from laws.

If Ido bowls had not been recognized in Japan, their beauty might not have been perceived in Korea or elsewhere. Japan became the native land of the Ido Tea-bowl. In the Gospel of Matthew, it says Jesus was born rather in Bethlehem than in Nazareth. In this statement there is truth.

So far I have looked at the character of the Ido Tea-bowls from the point of view of the users, the Tea masters. Now I would like to consider them from the potter's angle. By whose hands was that remarkable beauty produced, to be later discovered by the sharp eyes of men of Tea? Whence came that power?

It is impossible to believe that those Korean workmen possessed intellectual consciousness. It was precisely because they were not intellectuals that they were able to produce this natural beauty. The bowls were not products of conscious effort by the individual. The beauty in them springs from grace. Ido bowls were born, not made. Their beauty is a gift, an act of grace. The seven rules evolved by the masters of Tea were born by nature rather than made by man. They did not own the laws of beauty. Laws exist in a realm that transcends the self and ownership. Laws are the work of nature, not the product of human ingenuity.

It is nature that makes laws work. To observe them is appreciation. Neither is a matter of the maker's intellectual ingenuity. The artistic qualities inherent in a Tea-bowl belong to nature in their origins and to intuition in their perception. There is no objection to seeing seven "things to notice" (the points that constitute the aesthetic appeal) in the Ido bowls. But this would lead one to believe that they were made for the sake of these seven points. Nor should one assume that so long as these seven points are all present the result will be a beautiful bowl; for the points are a gift of nature, and not the product of conscious artifice. Yet how often in Japanese Tea-bowls have people laboured under the obvious delusion that you could create beauty by artificially lining up these seven qualities.

The Tea masters assert that Korean bowls are the best. It is an honest admittance. Why, one asks, do they surpass Japanese bowls? And the answer is that Japanese potters strove to make good pots according to accepted canons, or rules. To confuse the two approaches to pots, that of the maker and that of the user, is quite wrong. Production was poisoned by appreciation. Japanese bowls bear the scars of awareness. Raku Chojiro, Honami Koetsu, and other individual potters all to a greater or lesser degree suffer from the same sickness. It is all very well to find irregularities of form in Ido bowls charming, but to make pots with deliberate distortions is to immediately lose that charm. If glazes skip during the firing of a pot, it is natural, it may be a blessing in disguise, but deliberately to cause it

More than anything else, this pot is healthy. Made for a purpose, made to do work. Sold to be used in everyday life. If it were fragile, it would not serve its purpose. By its very nature, it must be robust. Its healthiness is implicit in its function. Only a commonplace practicality can guarantee health in something made.

One should correctly say, perhaps, that there is no chance for it to fall sick; for it is a perfectly ordinary rice bowl used every day by the poor. It is not made with thought to display effects of detail, so there is not time for the disease of technical elaboration to creep in. It is not inspired by theories of beauty, so there is no occasion for it to be poisoned by overawareness. There is nothing in it to justify inscribing it with the maker's name. No optimistic ideals gave it birth, so it cannot become the plaything of sentimentality. It is not the product of nervous excitement, so it does not harbour the seeds of perversion. It was created with a very simple purpose, so it shuns the world of brilliance and colour. Why should such a perfectly ordinary bowl be so beautiful? The beauty is an inevitable outcome of that very ordinariness.

Those who like the unusual are immune to the ordinary, and if they are aware of it at all, they regard it as a negative virtue. They conceive active beauty as our duty. Yet the truth is odd. No Tea-bowl exceeds an Ido bowl in beauty.

All beautiful Tea-bowls are those obedient to nature. Natural things are healthy things. There are many kinds of art, but none better than this. Nature produces still more startling results than artifice. The most detailed human knowledge is puerile before the wisdom of nature. Why should beauty emerge from the world of the ordinary? The answer is, ultimately, because that world is natural. In Zen there is a saying that at the far end of the road lies effortless peace. What more can be desired? So, too, peaceful beauty. The beauty of the Kizaemon Ido bowl is that of strifeless peace, and it is fitting that it should rest in that chapel, the Kohoan, for in that quiet place it offers its silent answer to the seeker.

From my heart I am thankful for those discriminating eyes of the men of Tea who chose their Tea-bowls. It was by an extraordinary honesty and depth of perception that they formed their standards. In the whole world I know of no parallel. In their appreciation lay an astonishing creativity. Emerging from a squalid kitchen, the Ido bowl took its seat on the highest throne of beauty. The Koreans laughed. That was to be expected, but both laughter and praise are right, for had they not laughed they would not have been the people who could have made such bowls, and if they had not continued to laugh they could not have gone on making them; and on the other hand if they had not been made as commonplace crocks the Tea masters would not have selected them. The Koreans made rice bowls; the Japanese masters made them into Tea-bowls.

The Tea masters liked the fine netting of crackle on Ido bowls for the warm, fresh friendliness it gives. They found a charm when the glaze skipped in firing, and when a "landscape" formed in the pattern of mended cracks. They enjoyed free, rough turning and felt that many pots are incomplete without it. They gave

427

to do so with the misguided idea of following some Tea master's rules is quite another matter.

The foot-ring of an Ido bowl is exceptionally beautiful, but to set out to copy its spontaneous irregularities is fatal; the beauty vanishes. All these wilful sorts of deformation are to be found in Japanese pots above all others. It is our specialized kind of ugliness, all in the pursuit of misconceived beauty. There are few parallels anywhere in the world. It is ironical that the Japanese Tea masters, whose appreciation of beauty was more profound than anybody else's, should have perpetuated, and still be perpetuating, this evil. There is hardly one bowl stamped with the Raku seal that escapes ugliness. By contrast, every single Ido Tea-bowl escapes. The Kizaemon O Ido bowl is the antithesis of and challenge to Raku.

As I have said, the eyes that first recognized this content in the Ido bowls were astounding in their perceptivity. Whence came this insight? Was their sense of appreciation different from others? The answer is simple: they saw things directly, and things appeared directly to them. To "see directly" here refers to unclouded intuitive perception. These men did not rely on certificates of authenticity. They did not rely on inscribed names. They did not ask whose work it was. They did not follow the judgements of others. They did not love a piece because it was old. They just looked at it directly. There was nothing between the thing and their eyes; their eyes were unclouded. That was why they could make a judgement unswayed by irrelevancies. The thing went into them, and they went into the thing. There was a healthy give-and-take between the two sides. There was an exchange of love.

Indeed, the only reason why Tea can constitute a religion of beauty is that the intuitive perception of beauty forms its basis. Intuition is its bedrock, just as intuition is the bedrock of religion. If a thing cannot be seen directly there can be no Way of Tea, nor any Tea-bowl. What can we learn from this?

With direct vision the real things of Tea can be found even today. Many great *meibutsu* can appear before our eyes tomorrow because there are still many products of craft in the world today that come out of like circumstance and have the same heartbeat, the same workmanship as those Ido bowls. So many worship those bowls because of the name, O Ido, and are thereby blinded to unseen O Ido around them. In actuality we today have more opportunities of seeing, of finding crafts of this order than the old Tea masters had. Were they to be amongst us once more, their tears would fall with delight, and they would be collecting newly seen things of Tea and adapting them for a new Way of Tea for all people. Direct vision makes hearts and eyes busy.

As I held the Kizaemon Ido bowl in my hands, many thoughts passed through my mind. I thought of all the things I had collected over the years for the folkcraft museum, and then of this one bowl. It seemed to be telling me to go on with the work I had undertaken. I was reconvinced that the road behind me and the road ahead were right roads. I shall go on pointing to the brethren of the Ido as I travel so that things of beauty and truth, even if but a few, shall adorn the world of

tomorrow. I shall tell of true beauty, and I shall strive to find the way for such things to be made again. The Kizaemon Ido was returned, repacked in its many boxes. I recognized a number of *koans* that demanded my solution. As I left the temple gate the wind blowing through the Zen forest appeared to be charging me to, "Speak, speak!"

<div align="right">1931</div>

40

Excerpts from *Quotations from Chairman Mao Zedong*

Mao Zedong

Introduction

Taken from various talks Mao Zedong gave in the 1940s and 1950s, this selection of quotes comprises one chapter in Mao's "Little Red Book," a heavily laden symbol in China during the Cultural Revolution (1966–9). After Japanese forces were expelled from China at the end of the Second World War, an internal civil war raged between the Communists and the Nationalists, a war won by the former in 1949. Mao Zedong, chairman of the Chinese Communist Party (CCP), proclaimed the People's Republic of China on October 1 of that year. The Communists had been gathering support among the peasants and workers since the late 1930s, and had begun instituting social reforms even as they fought against the Japanese and later against the Nationalists. In May 1942 at the Communist Party headquarters in Yan'an, Mao delivered two talks specifically intended to elucidate the relationship between the CCP's vision and the role of fine arts and literature within it. These became known as the "Yan'an Talks," and this chapter of the Little Red Book highlights excerpts from these speeches, along with several others. Mao's goal was to articulate a path for creative artists that focused on the tripartite audience of the workers, the peasants, and the soldiers. Thus, while Mao himself is the authority figure delivering these remarks, he places the final authority for art production with those three societal groups so central to communist ideology and political practice.

The combination of Mao's Yan'an Talks with an excerpt from his 1957 "On the Correct Handling of Contradictions among the People" is noteworthy, as the period

Mao Zedong, "Art and Culture," pp. 299–303 from *Quotations from Chairman Mao Tse-tung [Zedong]*. Peking [Beijing]: Foreign Languages Press, 1966.

of 1956–7 is an important one for the development of the CCP's shaping of a communist aesthetic. In May 1956, Mao invited intellectuals (a group largely disenfranchised by the new social emphasis on workers, peasants, and soldiers) to "let a hundred flowers bloom, let a hundred schools contend," implying that discussion and criticism was the proper path toward a space for artistic and intellectual practice that served the communist mission. After intellectuals refrained from discussion for fear of repercussions, Mao reiterated this message in 1957, and the criticisms of the communist government began. Seeing too much dissent and worried about the cohesion of the party and its mission, the CCP put an end to this position in July 1957, "sending down" many intellectuals to the countryside to be educated in the ways of the peasant, worker, and soldier. In the context of art development, Mao's statement in 1957 encouraged artists to work in different stylistic modes and paint a variety of subject matters, which through discussion were to be honed into works that the three elements of communist society could both understand and learn from. Thus, in the later 1966 context, this passage can be re-read not as a call for dissent but as a call to work with workers, peasants, and/or soldiers when creating art, thereby resituating authority not with the artist but with the particular audience of communist China.

With the republication of these select excerpts in 1966, this authority took on new form in the shape of an iconic book, carried by the Cultural Revolution's most aggressive group, the Red Guards. Thus, later communist ideology appropriated Mao's 1942 words, codifying and applying them very directly to art making. Art that did not carry an overt political message was seen as counter to the communist cause.

Culture and Art

In the world today all culture, all literature and art belong to definite classes and are geared to definite political lines. There is in fact no such thing as art for art's sake, art that stands above classes, art that is detached from or independent of politics. Proletarian literature and art are part of the whole proletarian revolutionary cause; they are, as Lenin said, cogs and wheels in the whole revolutionary machine.

"Talks at the Yan'an Forum on Literature and Art" (May 1942), *Selected Works of Mao Tse-tung*, 4 vols (Peking [Beijing]: Foreign Languages Press, Vols I–III, 1965; Vol. IV, 1961), Vol. III, p. 86.

Revolutionary culture is a powerful revolutionary weapon for the broad masses of the people. It prepares the ground ideologically before the revolution comes and is an important, indeed essential, fighting front in the general revolutionary front during the revolution.

"On New Democracy" (January 1940), *Selected Works*, Vol. II, p. 382.

All our literature and art are for the masses of the people, and in the first place for the workers, peasants and soldiers; they are created for the workers, peasants and soldiers and are for their use.

> "Talks at the Yan'an Forum on Literature and Art"
> (May 1942), *Selected Works*, Vol. III, p. 84.

Our literary and art workers must accomplish this task and shift their stand; they must gradually move their feet over to the side of the workers, peasants and soldiers, to the side of the proletariat, through the process of going into their very midst and into the thick of practical struggles and through the process of studying Marxism and society. Only in this way can we have a literature and art that are truly for the workers, peasants and soldiers, a truly proletarian literature and art.

> Ibid., p. 78.

[Our purpose is] to ensure that literature and art fit well into the whole revolutionary machine as a component part, that they operate as powerful weapons for uniting and educating the people and for attacking and destroying the enemy, and that they help the people fight the enemy with one heart and one mind.

> Ibid., p. 70.

In literary and art criticism there are two criteria, the political and the artistic....

There is the political criterion and there is the artistic criterion; what is the relationship between the two? Politics cannot be equated with art, nor can a general world outlook be equated with a method of artistic creation and criticism. We deny not only that there is an abstract and absolutely unchangeable political criterion, but also that there is an abstract and absolutely unchangeable artistic criterion; each class in every class society has its own political and artistic criteria. But all classes in all class societies invariably put the political criterion first and the artistic criterion second. ... What we demand is the unity of politics and art, the unity of content and form, the unity of revolutionary political content and the highest possible perfection of artistic form. Works of art which lack artistic quality have no force, however progressive they are politically. Therefore, we oppose both works of art with a wrong political viewpoint and the tendency towards the "poster and slogan style" which is correct in political viewpoint but lacking in artistic power. On questions of literature and art we must carry on a struggle on two fronts.

> Ibid., pp. 88–90.

Letting a hundred flowers blossom and a hundred schools of thought contend is the policy for promoting the progress of the arts and the sciences and a flourishing socialist culture in our land. Different forms and styles in art should develop freely and different schools in science should contend freely. We think that it is harmful to the growth of art and science if administrative measures are used to impose one particular style of art or school of thought and to ban another. Questions of right and wrong in the arts and sciences should be settled through

433

free discussion in artistic and scientific circles and through practical work in these fields. They should not be settled in summary fashion.

> *On the Correct Handling of Contradictions Among the People* (February 27, 1957), Ist pocket edn, (Peking [Beijing]: Foreign Languages Press, 1957), pp. 49–50.

An army without culture is a dull-witted army, and a dull-witted army cannot defeat the enemy.

> "The United Front in Cultural Work" (October 30, 1944), *Selected Works*, Vol. III, p. 235.

41

Icons of Power: Mao Zedong and the Cultural Revolution

Robert Benewick

Introduction

A representation, an enduring symbol, an object of attention and devotion, an idol – the revolutionary Chinese communist leader Mao Zedong (1893–1976) embodies all of these definitions of "icon." Indeed, many scholars claim that Mao's image has circulated more widely than that of any other historical figure. In the following reading, Robert Benewick, a scholar of international politics, explores the "cult of Mao" in Chinese visual culture from the 1960s through the 1990s. By primarily focusing on the life of one image, *Chairman Mao Goes to Anyuan*, Benewick examines Maoist "icons of power" and analyzes their use and reuse during this period.

During the Cultural Revolution (1966–9), artists and photographers created many portraits of Mao Zedong, either alone or in carefully staged group scenes. These images were widely disseminated through posters, badges, and other mass-producible items. The omnipresence of Mao's images continued through the 1970s, but tapered off after his death in 1976. During the 1980s, the government initiated a campaign to recall portraits and badges of the Chairman, collecting a large percentage of them. Nonetheless, an unexpected "revival" of Mao images began to occur in the late 1980s and early 1990s, at about the same time the country began to open up economically. In their new lives, these objects no longer served as

Robert Benewick, "Icons of Power: Mao Zedong and the Cultural Revolution," pp. 123–37 from Harriet Evans and Stephanie Donald (eds), *Picturing Power in the People's Republic of China*. New York: Rowman and Littlefield Publishers, Inc., 1999. Reprinted by permission of Rowman & Littlefield Publishing Group.

official government propaganda, but had become kitschy commodities, good luck totems, marketing gimmicks, inspiration for avant-garde artists, and, in some cases, "cultural relics."

In this reading, by probing the afterlife of an artwork or icon, Benewick demonstrates that even the most authoritarian image can take on new uses and meanings, ones unintended by the original producers of the work. Benewick also examines why certain visual images hold power, differentiating between those that create "totalizing" power and those that act as "individualizing" icons of power. Finally, he poses the provocative question of whether or not political movements, of whatever form, be they dictatorships or democracies, require an icon on which to focus.

This chapter describes the centrality of the representation of Mao Zedong in the revolutionary iconography of the Cultural Revolution. Written and visual representations and venerations of Mao appeared in many forms. These included imposing larger-than-life statues dominating the entrance to public buildings and occupying prominent public spaces. Porcelain figures of Mao in different poses were manufactured to adorn homes, offices, and meeting rooms. A staged photograph shows a naval hero studying Chairman Mao's works, with a portrait, a porcelain bust, and two plaster of paris figures of Mao on the table.[1] Three hundred and fifty million copies of *Quotations of Chairman Mao Zedong* (the "little red book"), which was originally published in 1964 for the People's Liberation Army (PLA), were distributed. Quotations were extracted and, along with Mao's poetry and calligraphy, were reproduced for display in poster form. The PLA also created behavioral models for emulations and encapsulations of Mao Zedong thought.[2] Mao's portrait first appeared on postage stamps in 1944. By the time of the Cultural Revolution, stamps were replicating the posters and featuring Mao. Not content with visual and written representations, Mao's supporters also composed hymns and anthems.

While there is nothing unique in the promotion of a personality cult, the sheer volume, scale, and pervasiveness of this iconography, along with that promoting agriculture, industry, commerce, the Communist Party, the PLA, sports, health, education, the *new* culture, Chinese revolutionary history, and patriotism and that portraying workers, peasants, soldiers, heroes and emulation models, women, children, national minorities, foreign friends and enemies, are revolutionary.[3] No doubt visual representation was also expedient given the limited means of alternative communication, the people's limited literacy, and Mao's limitations as a public speaker. Consequently, there was no physical, let alone politically permissible, space to challenge Chairman Mao, thereby imparting meaning to the slogan "The whole country is red." This is totalizing power.[4]

The promotion of the cult of Mao's personality was characterized by the extraordinarily high, perhaps unique, degree of politicalization featuring mass mobilization, violence, and indoctrination; a symbiotic relationship between authority and rebellion serving the leader – a distortion of the Yan'an talks; the creation of mass insecurity aligned with the promotion of Mao as the symbol of

stability and order; as well as the development and widespread use of revolution-
ary iconography. The strategy was one of upheaval, as reflected in the *People's
Daily* headline: "There Is Chaos under Heaven – The Situation Is Excellent."
Millions of Chinese were victims of the Cultural Revolution, particularly intellec-
tuals – universally a symptom of a tyrannical regime. The chosen instruments were
the peasants, workers, and in particular the eleven-million-strong Red Guards,
who were instructed to smash the Four Olds: old ideas, old culture, old customs,
and old habits of the exploiting class, while not only new ideas, new culture, new
habits, new customs but also new icons would be created. To give just one
example of the fanaticism engendered, the Red Flag Combat Regimental team
of the Beijing Institute of Aeronautics and its counterparts in other cities
attempted to turn China into a "Red Sea." Wearing Mao badges and carrying
copies of *Quotations of Chairman Mao*, members painted everything in sight red.
According to one account, "the stores, government offices, tea shops, noodle
restaurants and various eateries were so completely covered that it was impossible
to tell which was which." The Central Committee and State Council were forced
to issue a proclamation at the end of 1966 entitled "Notice about Restraining the
Indiscriminate Action of the So-Called Red Sea."[5]

This chapter will focus on portraits and posters as icons of the totalizing of Mao
Zedong's power and on badges as individualizing icons of his power.[6] The choice
of icons is commensurate with the levels of identity. Portraits of Chairman Mao
identify him with the Chinese nation and as the party-state. Crowd posters
identify Mao with the viewer; these and the portraits will be examined in the
next section, "Poster Power." Badges identify the viewer-wearer with Chairman
Mao and are the subject of the section "The Red Badge of Power." The com-
modification of Mao's identity and of icons of power is discussed in the conclud-
ing section.

Poster Power

The revolutionary iconography of the Cultural Revolution was multifunctional,
with thin lines of demarcation and considerable overlap between functions. The
list is imposing and includes education, propaganda, persuasion, communication,
inspiration, contemplation, ideology, exhortation, promotion (personality cult),
catalyst, interpretation, visual presentation, design, decoration, art production,
technology, and representations of socialist realism and revolutionary romanti-
cism. Above all they were expressions of power, and no more so than in the
representations of Mao Zedong. He was officially characterized as "Great Leader,
Great Teacher, Supreme Commander, and Great Helmsman." And as Chairman
Mao he was all four at one and the same time, reinforcing his identity with the
nation and as the party-state. What was intended, of course, could give way to the

unintended, so the viewer might perceive him as revolutionary hero or tyrannical dictator.

The portraits and posters can be classified into those that feature Mao directly and those that represent him indirectly. In the first set, Mao either fully occupies or shares poster space and may be depicted in different poses and settings and at different ages. In the second set this domination is indirectly and symbolically represented, by what Stephanie Donald describes as icons of political activism. The figures may be wearing Mao badges depicting Mao or carrying *Quotations of Chairman Mao* or copies of the *Selected Works,* or they may be Red Guards, presumably acting on Mao's behalf, wearing armbands and mouthing slogans, while the captions may repeat his quotations. They may appear in combination and in nonpolitical settings to promote production, education, or health, for example. In every poster, however, these figures are expressions of power.

Chinese Communist revolutionary art had been given a new twist. The original formulation and legitimization of this art dates from Mao's talks at the Yan'an Forum on Art and Literature in 1942. Yan'an was the revolutionary base in west-central China, established at the end of the Long March, which served as the headquarters for the communists during the anti-Japanese and civil wars. Mao ordered artists and writers to "go among the masses and serve the people." They were to discover and promote the revolutionary consciousness of the Chinese peasantry through all art and literary forms – the *old* was to serve the *new.* The campaign was also to broaden people's involvement in whatever was seen to serve as art.

The outcome was a series of symbiotic relationships: artistically between (revolutionary) realism and (revolutionary) romanticism; ideologically between the party and the state; culturally between Mao as leader, the nation, and the Chinese people. The Cultural Revolution and the promotion of the cult of Mao's personality, however, came to signify both Mao's authority and people's rebellion in the service of the leader against what appeared to be the party-state. Portrait and poster art expressed totalizing power, while badge art, which combined an optimistic aesthetic with political functionalism, expressed individualizing power. Traditional art forms (the old), rather than being made to serve the people and promote the new, were branded "poisonous weeds."

Domination and power are most explicit in the 2.2 billion poster portraits of Chairman Mao.[7] They signified deification, distance, and omnipresence. He may appear as a young scholar, as in *Chairman Mao goes to Anyuan* (*Mao zhuxi qu Anyuan*), or asking "Who is in charge of the universe?" (*Asking who is in charge of the universe [Wen cangmang dadi shei zhu chenfu],* 1978); as a young revolutionary in an army uniform (see below); as one of the immortals with Marx, Engels, Lenin, and Stalin;[8] as well as the omnipresent Chairman Mao.

Great care could be taken in presentation. Posters were reproduced from oils, watercolors, and photographs. The principal standards for painting Mao after 1971 were "*hong, guang, liang*" – red, bright, and shining – a fact that was precisely confirmed by the leading Sichuan landscape artist Li Huasheng. For the

red flag and for the star on Mao's cap, only the purest red pigment could be used. And one couldn't use any gray for shading.[9] In 1997 Men Songzhen revealed how the photographic department of the New China News Agency touched up photos. Her most famous work was a makeover of Edgar Snow's 1936 photograph of the young Mao in an army uniform, to give him a kinder look.[10] The transformed photograph appeared as posters, badges, and ceramics and in the 1990s as a laminated print in vehicles as a talisman.

The siting, hanging, and carrying of Mao's portraits served to reinforce distance and omnipresence. Face-on portraits occupied positions of honor in all workplaces and homes and featured in Cultural Revolution processions and demonstrations. His portrait dominates Tiananmen today; when it was defaced during the protests of 1989, it was quickly repaired. It should be remembered with respect to this particular form of representation that, for different reasons, democracies – both people's democracies and liberal democracies – need icons of personality, while affecting to disdain them. The icons will differ, however, according to inspiration and intensity, range and resonance, source and scale.[11]

The Red Badge of Power

The badge identified the wearer with Chairman Mao and, through him, with China and the party-state, workplace, and residence. It signified individualized power and demonstrated a peculiar mix of authority and rebellion. Not to wear a badge could be taken as a sign of disgrace, disloyalty, or bourgeois individualism, especially since those said to have a bad family background were forbidden to wear them.

Badges also served other purposes. They were issued to commemorate anniversaries such as the founding of the Party or the PLA; they had ceremonial functions commemorating visits or inspections by party-state leaders; and they were presented as rewards for achievements or attendance at meetings. What was special, however, was that in an environment that discouraged gifts and favors, badges acquired an exchange value and preserved the notion of reciprocity. For example, a badge *Chairman Mao goes to Anyuan* (discussed below) is inscribed on the reverse "Long Live Chairman Mao" but in addition has a personal inscription for presentation or exchange, "Keep in step with Chairman Mao and forge ahead courageously."[12] The more elaborate the badge and valuable the material, the greater the esteem. The badges' distinguishing feature was the omnipresent image of Mao Zedong.

Mao is shown facing left on over 85 percent of the badges, signifying the desired direction of change. As in the posters, he appears in different guises and poses: student, revolutionary, soldier, peasant, and, above all, Chairman Mao. Better use was made of less space than in the posters. The name and place of the issuing organization – factory, commune, PLA unit, revolutionary

committee – was normally inscribed on the reverse side of the badge, and slogans and quotations may appear on both sides. One favorite reads, "Follow the Leadership of the Proletariat. Long Live Chairman Mao/Commission of People's Liberation Army in the Ministry of Construction/Power in the fields of education, literature and the arts and the influence of the government has been controlled by the army during the Cultural Revolution."[13]

Many of the badges were loaded with symbolism. One of the most common replicated the slogan on a poster; red rays surround Mao's image, portraying him as the red sun in the hearts of the Chinese people. Symbols of national unity include cogs of industry, sheaves of grain, and red flags. Sets of badges were issued adorned with the sacred sites and monuments of the revolution or with the important landmarks along the route of the Long March. Unlike posters, badges used traditional symbols: the pine tree connotes toughness; the palace lantern was an expression of love and respect for Mao; and sunflowers, since they always turn towards the sun, were likened to the people's devotion to Mao. Even so, the badge contributed, and was intended to contribute, to replacing the old ideas, beliefs, and traditions with the new ones identified with the chairman.

It comes as no surprise that the number of posters and "little red books" printed and distributed is paltry compared with the production of the ubiquitous badge, of which an estimated 2.5 *billion* to 5 *billion* were produced. More than twenty thousand different badges have been produced. Plated aluminum badges, red in color, were the most common, but twenty-seven different materials have been noted, ranging from expensively produced ceramic to the fragile bamboo. As the number manufactured and worn increased, so did the size of the badges, suggesting not only competition for favor but also a change of use, that is, the badge could serve as a plaque, a wall decoration, or a talisman.

This adds up to individualizing power and personalizing ideology and culture, sanctifying the badge through the wearer's identification with Chairman Mao. The badge is serving the leader not the people. Moreover, there was conflict and competition to determine the true wearer or believer as distinct from the ritual wearer. In this sense, the badge had become an icon of a process of indoctrination and an instrument to settle old scores.

By the autumn of 1968 the Cultural Revolution was out of control, and Mao directed the PLA to restore order. In June 1969, orders were issued seeking to limit the manufacturing of the badges. It was during this period that the promotion of the cult of Mao's personality reached its peak. An examination of two badges illustrates the institutionalization of the cult and its relation to power.

The first badge is one of more than seventy different images of Mao in 1921 on his way to organize a miners' strike. They differ from the portrayal of Chairman Mao facing left, which adorned most badges, by showing the young Mao striding out in a scholar's gown. The images are based on an oil painting, credited mainly to Liu Chunhua, entitled *Chairman Mao goes to Anyuan*. Both Clunas and Gittings refer to the painting as a Cultural Revolution icon in its own right,

while Laing argues that the "work politically is perhaps the single most important painting of the Cultural Revolution period."[14]

The painting was important in a number of ways. First, it fed into the power struggle between Mao and Liu Shaoqi, who by then was being referred to as China's Khrushchev and who died in disgrace in prison in 1969. The Anyuan miners' union was the first important union led exclusively by the Chinese Communist Party and was one of the strongest sources of support for the Party prior to 1949. A 1961 painting by Hou Yimin entitled *Liu Shaoqi and the Anyuan coal miners,* of which 172,077 copies were printed, shows the young Liu leading the strike.[15] Six years later, in 1967, the painting was denounced as an attempt to rewrite history and was labeled a "poisonous weed."[16] Instead, an exhibition was organized in the Museum of Revolutionary History in Tiananmen Square to promote Chairman Mao's visits, in which the new painting of Chairman Mao on his way to organize the miners prominently featured.[17] Second, this painting signaled the shift away from the students/Red Guards to the workers/peasants/soldiers as the instruments of the Cultural Revolution, as signified by the mango in the second badge discussed below. Third, the painting represents the high point of the politicization of culture and the iconographic representation of Mao Zedong.

The artist claimed that nine hundred million copies of the painting were printed and distributed throughout China. Copies were also painted by established artists like Li Huasheng and Yu Jiwu.[18] The prints usually had a version of the following caption: "In autumn 1921 our great leader Chairman Mao went to Anyuan and personally kindled the flame of revolution there." It was ever present at meetings and demonstrations, along with other icons of the Great Helmsman. Red Guards even walked to Inner Mongolia holding aloft a reproduction of the painting. Jiang Qing, Mao's wife and arbiter of culture, declared it a model painting equal in stature to the eight model operas and ballets that she promoted. According to one Chinese analysis:

> Mao's eyes are gazing ahead over the road of revolutionary advance. His clenched fist shows his determination to smash the old world to smithereens. The old umbrella symbolizes his working style of shirking no hardships for the revolution.[19]

The artist's own description begins, "We placed the Chairman in the forefront of the painting, tranquil, farsighted and advancing towards us like a rising sun bringing hope to the people," thereby establishing an identification with the viewer. So while the painting identified Mao with the revolution and the Chinese people, the badge in its numerous versions identified the wearer with Mao and the revolution. A symbiotic relationship was established.

We are, however, still left with the romantic image of an effete young man in a scholar's gown who somehow is supposed to organize and lead those tough, exploited miners, as portrayed in the earlier painting of Liu Shaoqi, leading the strike. A later painting shows Mao in more convincing dress with the miners.[20]

Where the badges and posters of *Chairman Mao goes to Anyuan* illustrate how extensive and total the cult of Mao's personality and power was, the second badge signifies how intensive it had become. The different versions of the event that also led to more than seventy badges being produced can be reconstructed as follows. In August 1968 the foreign minister of Pakistan called upon Mao Zedong and presented him with a basket of mangoes. This was an appropriate gift since it represented agricultural produce of Pakistan. Even more, the red and golden colors of the mango traditionally symbolize happiness and prosperity for the Chinese; here they represent the red flag and yellow stars of the People's Republic, as well as the so-called red sun, that is, Mao, in the hearts of the Chinese people. There was one problem: Mao did not like mangoes.

After graciously accepting the basket of mangoes, he sent them to the worker–peasant–Mao Zedong–thought propaganda team that had been dispatched to Qinghua University to take over from the Red Guards and restore order after two months of campus warfare in which ten were reported dead and hundreds were injured. As with the portrait *Chairman Mao goes to Anyuan*, this was also a signal: Mangoes were in, the Red Guards were out. The *People's Daily* reported the receipt of the mangoes as follows:

> When this joyous news spread on the Qinghua campus, every one of us was overjoyed. We sang one song after another. We held in our hands the precious gift from Chairman Mao and looked at his portrait. Our hearts swelled and tears ran down our cheeks. We waved our red-covered book *Quotations from Chairman Mao Zedong*, and all our feelings were concentrated in our cheers "Long live our great leader Chairman Mao! A long, long life to Chairman Mao!"[21]

The mangoes were placed on a red table in the middle of the campus, and people came and pledged themselves to Mao and the proletarian revolution. In order to preserve the mangoes for future generations, some of them were placed in glass containers filled with formaldehyde. As the happy news spread, celebrations were held throughout China and pilgrimages were organized to view the mangoes. Some of the mangoes, or replicas, were sent to other cities, placed in glass cases, and given an honor guard.

What is interesting about this episode is the coincidence of the present of mangoes and the leashing in of the Red Guards. On 27 July 1968 the worker-peasant work team was sent into Qinghua University with a directive that they should cooperate with the PLA in taking over the revolution in education. On 5 August, the very day that Mao received the mangoes, he forwarded them to the work team. Was this a ruler's inspiration, and, if so, how was the response orchestrated? It also raises the more general question of what constitutes people's art and how it is determined.[22] The painting of *Chairman Mao goes to Anyuan* had a clear purpose, and it was promoted by Mao's wife, Jiang Qing. But we are left to speculate how the mangoes became an icon of power and devotion, decorating badges portraying the benevolent, mature Mao and identifying the

wearer with the shift in policy. An attempt to paint the celebration of the mangoes ranks as an inferior work of propaganda art.[23]

Although the Cultural Revolution decade lasted until Mao's death in 1976, the production of badges began to wind down in 1969. The generally accepted explanation stems from an incident in which, in response to a presentation of badges, Mao is alleged to have said, "Take them away and bring me airplanes." This is a reference to the use of aluminum as the material for the vast majority of badges. A more likely explanation is that the decline was part of the repudiation of Lin Biao, following his alleged attempted coup and flight from China in 1971.

Mao Meets the Market

The policies of the post-Mao reformers are rooted in the determination to prevent a recurrence of the upheavals of the Cultural Revolution and to legitimate and secure their own power. Mao's mandate on earth had proved as unstable as the Emperor's mandate of heaven was remote. The main instrument of reform has been the market-orientated economy. The 1950s Maoist slogan, "Anything can be achieved through will" has been superseded by the entrepreneurial motto, "Everything possible, nothing too weird."[24] One expression of this is the commodification of Cultural Revolution relics in general and the Mao image in particular. This can be seen as signifying a further stage in the evolution of China's ideology and cultural values. Yet it does not explain the revival of the cult of Mao's personality, which may suggest the opposite, that is, a cultural and ideological vacuum – what Gordon White has described as the decline of ideocracy.[25]

The revival that began in the late 1980s manifested itself in a number of ways. Photographs of Mao appeared in taxis, minibuses, and official cars, and along with them came apocryphal tales of accidents avoided and lives saved. A transformation of Mao from revolutionary icon to pop icon was achieved in 1991 when the Cultural Revolution ode to Mao Zedong, "The Red Sun," topped the charts for a single videotape with a sale of 5.8 million, rising to 14 million in 1993.[26] The centenary of Mao's birth in 1993 produced a heady mix of commemoration, commodification, and caricature. The market was flooded with brand-new lines of Mao kitsch, including watches, alarm clocks with Red Guards waving copies of the "little red book," medallions, commemorative plates and plaques, and cigarette lighters that, when they worked, played the Cultural Revolution anthem, "The East Is Red." The advent of the karaoke bar opened opportunities for more Maoist golden oldies to make a comeback; the Central Propaganda Department got into the act by issuing an anthology of Maoist songs. But most of all, the revival has centered on recycled and reproduced Mao badges and the commercialization of Cultural Revolution art.

Throughout the 1980s the party-state issued directives calling in Mao badges, and by 1988 an estimated 90 percent had been recovered.[27] This would still have left 50 million badges unaccounted for, so it is not surprising that the official *Beijing Review* headlined an article in 1993, "Mao Badge Craze Returns to China." Collectors and collections appeared or reappeared. Moreover, in Shaoshan, Hunan Province, Mao's birthplace, and at the Mao Zedong Memorial Hall, the sale of badges had never been stopped. Research societies were formed, exhibitions held, and catalogues published assigning commercial value to the badges.

These badges are for sale, trade, or display rather than for identifying a wearer with Chairman Mao. When a badge is worn, it is as a fashion accessory to adorn denim or, more spectacularly, as an outfit displayed at the International China Young Fashion Designers' Contest in Beijing in April 1998. The number of badges that decorated the model's clothes exceeded the number worn by even the most fanatical PLA soldier in the 1960s.

Cultural Revolution posters can be bought, at a price, in flea markets or viewed, in the Mao Zedong theme restaurants, of which more than forty exist in Beijing alone, serving what are purported to be Mao's favorite dishes, with Cultural Revolution Muzak in the background. A shrine with offerings to the chairman may dominate the entrance and reproductions of Mao badges are distributed as souvenirs by table attendants dressed in regional costume. Paintings featuring Chairman Mao, some of which were reproduced as posters, command high prices at auction.[28] To the best of my knowledge, no badges with new images have been created. The deconstruction of the sacred Mao image has been left to Chinese artists at home and abroad.[29] The juxtaposition of Mao and other Cultural Revolution images with advertisements can be interpreted as satirizing the Yan'an talks on serving the people.

It is apparent that this commodification and revival of the cult of Mao's personality is tolerated by the party-state. The Mao image, whether viewed for profit or for nostalgia, is no longer an icon of power but remains useful in contributing to the legitimation of the party-state and for promoting the market economy. It is my contention, however, that Mao, born again, is symptomatic of the exigencies of the transfer to a market-oriented economy and of the transformation of the totalizing-individualizing power relationships of the Cultural Revolution and the terror it inspired to the faceless power of the post-Maoist regimes. These are related phenomena but will be taken in turn in order to distinguish, at least analytically, between commodification and the personality cult.

First of all there are the opportunities that the market has opened up and the improvement in living standards for a significant proportion of the population. Against this are rising expectations, massive unemployment, and the risks, insecurities, and inequalities that are market induced. Faceless power can also exercise terror, as in the Tiananmen crackdown of 1989 and the subsequent attempts to stifle dissent. Moreover, widespread corruption and the limited means for

expressions of discontent stretch the credibility of the party-state. The commodi-fication of the Mao badge and related political icons signifies in the context of the market an independence from the party-state, while the Mao cult is representative of a failure to institutionalize political power. This disjuncture between economic and political change has also contributed to an ideological and cultural vacuum. The reformers, aware of the dilemma, have revised the official ideology from Marxism–Leninism–Mao Zedong thought to Marxism–Leninism–Mao Zedong thought and Deng Xiaoping's theory of Building Socialism with Chinese Char-acteristics. Many will argue that all power is faceless and that democratic politics also require icons, however much that need is denied. The differences between people's democracies and liberal democracies are more than matters of degree, however, and there is a responsibility to clarify the differences.[30]

Postscript

In March 1998 Liu Chunhua's painting *Chairman Mao goes to Anyuan* was declared a cultural relic. Moreover, a spokesperson for the Cultural Relics Bureau declared that posters, badges, and so on have been recognized as part of China's past and "are of educational significance and should not be lost to history." The painting, which had been purchased at a record price by the Construction Bank of China for US$660,000, was reported as the first painting since 1949 to be officially recognized as a cultural relic.[31]

Just as the rehabilitation of Liu Chunhua's painting may serve as a reminder of the totalizing-individualizing power relationships of the Cultural Revolution, a 1995 painting suggests faceless power. Here is the artist Wang Xingwei in his painting *Road to Anyuan*. Like Mao he carries the old umbrella and his other fist is clenched. Immediately, his Armani suit and Gucci shoes seem as unconvincing as Mao's scholar's gown and cloth shoes. But there is a bigger difference. His back is to the viewer as he sets off in the other direction. This may have been prescient, for as the Anyuan coal mine prepared for its hundredth anniversary in 1998, it was reported that because of the mine's poor performance, most of the fifty thousand workers receive a low wage and some retired workers receive no living expenses.[32]

Notes

1 *China Pictorial,* February 1968, 10.
2 Stefan R. Landsberger, "Mao as Kitchen God: Religious Aspects of the Mao Cult during the Cultural Revolution," *China Information* 11, nos. 2/3 (Autumn/Winter 1996): 202–4.
3 These categories are drawn from the University of Westminster collection.

4 While I was traveling by train in China in 1975, the "whole country" was full of graffiti, "Learn from Dazhai," a reference to the model production brigade. For a critique of explanations of the Cultural Revolution, see Lynn T. White III, *Policies of Chaos* (Princeton, N.J.: Princeton University Press, 1989), 3–49.

5 Yan Jiaqi and Gao Gao, *Turbulent Decade,* ed. and trans. D. W. Y. Kwok (Honolulu: University of Hawaii Press, 1996), 89–90.

6 Michel Foucault, "The Subject and Power," in *Michel Foucault: Beyond Structuralism and Hermeneutics,* ed. H. Dreyfus and P. Rabinow, 2d ed. (Chicago: University of Chicago Press, 1983), quoted in Mayfair Mei-hui Yang, *Gifts, Favors, and Banquets* (Ithaca, NY: Cornell University Press, 1994), 245.

7 Geremie R. Barmé, *Shades of Mao* (Armonk, NY: M. E. Sharpe, 1996), 8.

8 There were also separate posters of the "immortals," and their portraits were displayed on billboards in Tiananmen Square for national celebrations.

9 Jerome Silbergeld with Gong Jisiu, *Contradictions: Artistic Life, the Socialist State, and the Chinese Painter Li Huasheng* (Seattle: University of Washington Press, 1993), 43.

10 Rone Tempest, "The Woman Who Touched Up Mao's Great Revolution," *Guardian,* 4 February 1997, 8.

11 Robert Benewick and Stephanie Donald, "Badgering the People: Mao Badges, a Retrospective, 1949–1995," in *Belief in China,* ed. Robert Benewick and Stephanie Donald (Brighton, England: Royal Pavilion/Green Foundation, 1996), 31.

12 Circa 1967, author's collection.

13 Benewick and Donald, "Badgering the People," 36.

14 Ellen Johnston Laing, *The Winking Owl: Art in the People's Republic of China* (Berkeley and Los Angeles: University of California Press, 1988), 67. For other detailed analysis, see Julia F. Andrews, *Painters and Politics in the People's Republic of China, 1949–1979* (Berkeley and Los Angeles: University of California Press, 1994); Landsberger, "Mao as Kitchen God."

15 Andrews, *Painters and Politics,* 328.

16 The painting is reported to be destroyed. Andrews, *Painters and Politics,* 245.

17 According to the Party's official biography of Mao, although Mao visited Anyuan seven times, Li Lisan was "overall strike commander" and Liu Shaoqi "workers' representative" of the strike that took place in 1922. Unpublished English manuscript of the Department of Research of Party Literature, Central Committee of the Communist Party of China, "Mao Zedong: A Biography (1893–1949)," 62. Originally published in Chinese in Bejing by the Central Party Literature Press, 1996.

18 Silbergeld and Gong, *Contradictions,* 44.

19 *China Pictorial,* September 1968, 13.

20 *China Reconstructs,* August 1969, 9.

21 Quoted in Edward E. Rice, *Mao's Way* (Berkeley and Los Angeles: University of California Press, 1972), 455–56.

22 Michael Schoenhals, ed., *China's Cultural Revolution, 1966–1969* (Armonk, NY: M. E. Sharpe, 1996), 185.

23 See *Chinese Literature,* November 1968, 12 ff.

24 Matt Forney, "Record Maker," *Far Eastern Economic Review,* 3 October 1996.

25 Gordon White, "The Decline of Ideocracy," in *China in the 1990s,* ed. Robert Benewick and Paul Wingrove (London: Macmillan, 1995), 21–33.

26 Jing Wang, *High Culture Fever* (Berkeley and Los Angeles: University of California Press, 1996), 266.

27 Bill Bishop, "Badges of Chairman Mao Zedong," <http://www.cind.org/CR/Maobadge/index.html>, 11 [accessed in 1995 but no longer available].

28 China Guardian Auctions, *Important Art of New China, 1949–1979*, catalogue of auction, 19 October 1996 (Beijing: China Guardian Auction, 1996), items 405, 431, 443, 446, 450, 451, 457, 458, 460, 495, 497, 502, 511.

29 See, e.g., Erró, "Young Mao at San Marco, 1974," in *Von Mao bis Madonna* (Palais Lichtenstein, Vienna: Museum Moderner Kunst Stiftung Ludwig, 1996), 117. Exhibition catalogue.

30 See Michael Walzer, *The Company of Critics* (London: Peter Halban, 1989).

31 Wang Xingwei, "Road to Anyuan," in *Reckoning with the Past* (Edinburgh: Fruitmarket Gallery, 1996), 45. Exhibition catalogue.

32 Summary of World Broadcasts, FE/3244/G6, 4 June 1998.

42

Morphology of Revenge: The Yomiuri Indépendant Artists and Social Protest Tendencies in the 1960s

Alexandra Munroe

Introduction

Munroe, a leading scholar and curator of twentieth-century Japanese art, wrote the following essay as part of a catalog accompanying the influential exhibition *Japanese Art after 1945: Scream Against the Sky*. The exhibit, which traveled to several museums in the USA and Japan in 1994 and 1995, was one of the first to garner international attention for avant-garde Japanese art. The reading included here focuses on young artists associated with the Yomiuri Indépendent Exhibitions held between 1949 and 1963 to showcase the work of independent art-makers.

The 1870s to 1920s was a period of fast-paced modernization in Japan. In terms of art, this included setting up Western-style art schools and increasing knowledge of and interaction with European-based modern art movements. During this time Japan also became an imperial power, acquiring territory through victories in the Sino-Japanese (1894–6) and Russo-Japanese (1904–5) wars and the expansionist policies of the 1910s and 1920s. In many ways, Japan seemed to have embraced and mastered modernity. At the end of the Second World War (1939–45), however, the picture appeared different. After the atomic bombing of Hiroshima and Nagasaki that

Alexandra Munroe, "Morphology of Revenge: The Yomiuri Indépendant Artists and Social Protest Tendencies in the 1960s," pp. 150–63 from Alexandra Munroe, *Japanese Art after 1945: Scream Against the Sky*. New York: H. N. Abrams, 1994. Reprinted by permission of Harry N. Abrams Inc.

killed over 100,000 Japanese civilians, Japan unconditionally surrendered to the USA. Postwar artists reacted to this crisis, turning for inspiration to twentieth-century European movements such as Art Informel, Dadaism and Surrealism, all of which responded to the horrors of war by rejecting the dominant values of society through spontaneously executed works. Thus, many young Japanese artists set out to protest and subvert the existing codes of art, politics, and society.

Like other readings in this volume, this essay addresses the relationship between politics and art; in this case, the art is meant to shock. It is artist as iconoclast, pushing the boundaries of art to its limits. Ultimately, the reading – and the art examined within it – questions not only how far art can go, but also whether or not art and society can ever completely reject structures of power.

The 1960 *Anpo* Crisis

The US–Japan Security Treaty (*Nichi-Bei anzen hosho joyaku*, known as *Anpo*) was signed in 1951 as part of the conclusion of the peace settlement between Japan and the US. The so-called "*Anpo* crisis" surrounding the first renewal of the treaty in 1960 brought into sharp focus Japan's complex relationship to America – its dominant foreign "other" that represented conflicting extremes of democracy and imperialism, international culture and gross materialism. The upheaval was also remarkable because of the significant role played by artists and intellectuals. Not since World War II had the intelligentsia been so involved in a national political event. In 1960 they avenged their former silence and compliance with a unified pledge to speak out – their slogan was "Never Again!"

By 1951, the goals of the Occupation had been achieved: Japan's military machine had been dismantled, her wartorn economy revived, and a democratic form of government established. At the same time, the United States faced the threat of growing militant Communism in the Far East with the victory of Mao Zedong in 1949 and the Communist offensive in Korea in 1950. In this volatile political atmosphere, the US–Japan Security Treaty claimed for the US the right to station 100,000 troops on Japanese soil for the alleged purpose of defending Japan; in fact, it was conceived largely as a defensive Cold War military strategy. Ratified without deliberation in the last months of the Occupation, the treaty sparked controversy and opposition from its beginning.

As George R. Packard has written in a comprehensive history of the Security Treaty crisis, at the time of the treaty's signing in 1951 the Japanese were experiencing "a period of shock, tragedy, and of struggle for survival."[1] This deep sense of uncertainty helped stimulate the revival of prewar leftist sentiments and led to the formation of a broad-based, Marxist-oriented opposition comprising the pro-Soviet Japan Communist Party (JCP); the Socialists,

449

with powerful union support; and a newly-emerged group known as the "progressive intellectuals" (*kashushin interi*) – anti-conservative artists, writers, theater people, and underground agitators who regarded themselves as guardians of the "new democracy." Another important political force that appeared was a nationwide student organization united under the umbrella of the JCP as the All-Federation of Student Self-Governing Councils (*Zen Nihon Gakusei Jichikai Sorengo*, abbreviated to *Zengakuren*). All four groups were united by their loathing of militarism and imperialism, and opposed any compromise to Article IX of the postwar Constitution, which prohibited Japan from rearmament.

To the leftist art critics associated with the new opposition, the decorative sentimentality of most modern Japanese painting was irrelevant to the urgent realities of postwar Japan; they advocated instead the growing trend toward Surrealist-style Social Realism. Responding to the grotesque horrors of war and the political problems of contemporary Japanese society, this genre of leftist "*Reportage* Painting" (*Ruporutaju kaiga*) developed in the early 1950s.[2] Dedicated to recording the terrors of imperialism, nuclear holocaust, and social injustice, *Reportage* Painting was partly instigated by the JCP, which sent artists to rural villages, industrial zones, and the areas surrounding American military bases to depict instances of "class struggle" and "imperialism."

Among the most important *Reportage* painters was Yamashita Kikuji (b. 1919), whose loyalty to the Communist Party and obsession with ghoulish and perverse allegories of postwar Japan inspired a series of mural-like narratives depicting such subjects as the keloidal scars of atomic-bomb victims, the crass behavior of American GI's, and incidents of feudal injustice. In *The Tale of Akebono Village*, Yamashita illustrated a real story of a village revolt in rural Japan against the abusive treatment of a landowner. Interweaving several events that occurred over time, the painting depicts an old woman dangling from a suicide noose, with a fox, representing her granddaughter, eating the mucous that falls from her nostrils. Lying in a river of blood beyond her is the body of the Communist agitator who was sent to the village to support the revolt. Painting with house paint on unstitched jute pea bags, Yamashita strove for a style of illustration that recalled billboards and Socialist Realist propaganda paintings. Yamashita has attributed the political insistence of his fifties work to a sense of guilt over his passive failure to protest against Japanese atrocities he observed during his military service in southern China and Taiwan from 1939 to 1942. He was determined to be an active and outspoken participant in the politics and art of new Japan.[3]

The leftist artistic and intellectual trends of the 1950s may have represented a "reactive nationalism" as well as a form of "anti-Americanism."[4] Tired of postwar defeatism and anxious to apply their newly discovered socialist concepts, the Japanese advocated a political "neutrality" tied to neither the Soviet nor the Western bloc, thus asserting Japan's independence as a power. During the fifties, this "new postwar nationalism" was increasingly bolstered by the nation's

rapid economic growth and rising political prestige. Fears of US motives in East Asia and a desire to escape the overwhelming political and cultural influence of the US further contributed to a growing opposition against the ten-year renewal of the treaty, slated for 1960.

Considerable pressure from the left to change or cancel the treaty mounted steadily in the late 1950s. Anti-militarist sentiments and fear of involvement with American military activities intensified. In the spring of 1960, the announcement of the pro-American government of Prime Minister Kishi Shinsuke that it would renew the treaty with minimum revision ignited nation-wide resentment leading to mass popular protests, strikes, and demonstrations. The most violent clash occurred on June 15, when riot police wielding wooden clubs counterattacked a mob of students who had invaded the Diet building. Hundreds of students and police were injured, 196 arrests were made, and a twenty-year-old female student, Kamba Michiko, was crushed to death – becoming the opposition's martyr. Despite the severe public outcry, the treaty's renewal was automatically ratified on June 19. Kishi immediately resigned and the opposition movement, which came to be known as the "Old Left," was defeated.

The failure of the radicals affected Japanese artists, many of whom participated in the protests, in either of two ways. The collapse of faith in liberal humanism and Communism to penetrate the authoritarian and conservative structures of Japanese society led many to a state of introspective pessimism. In 1960, the Yomiuri Indépendant artist Kudo Tetsumi (1935–1990) embarked on a morbid series, *The Philosophy of Impotence*, in which he filled entire galleries with arrangements of black, castrated penis-like objects, symbolizing "the loss of wholistic communication" and the pathetic despair of human efforts.[5] Several New Wave directors made films about *Anpo* and the complex politics that characterized the postwar era. Oshima Nagisa's *Night and Fog in Japan* (1960), for instance, dealt explicitly with the Security Treaty crisis as illustrative of the collapse of revolutionary ideals and Japan's ineffectual attempts to prevent the return of feudalistic values and imperialistic aims. The film's content was so politically charged that it was pulled from distribution on its fourth day of release. Central to Oshima's interpretation of *Anpo* events was the alienation of the self, which was seen as the characters' alienation from each other and from their culture at large. This self-critical pessimism, intended to encourage reflection upon the meaning of *Anpo* and the identity of Japanese youth, pervaded much of sixties counterculture.

The second expression of the so-called "*Anpo* spirit" dismissed political ideology altogether and celebrated anarchistic revel. Several members of Neo-Dada Organizers, founded in April of 1960, participated actively in the *Anpo* demonstrations, mixing up slogans of "Down with *Anpo*!" with "Down with *Anfo*!" (*Informel* painting). According to Tono Yoshiaki, the group's leading critic, it is believed that Neo-Dada Organizer artist Shusaku Arakawa threw the brick at a police trooper that triggered the bloodiest of the riots.[6] To announce the opening of their third exhibition the members paraded through the streets, one

masked and bandaged like a mummy in paper Neo-Dada posters and another wrapped in a string of light bulbs. As Ushio Shinohara has recorded in his memoir of Neo-Dada Organizers, *The Avant Garde Road* (*Zen'ei no michi*, 1968), once inside the gallery Kazekura Sho stuck his face into a bucket of water, made bubbling sounds, and then started shouting, "The War! The War! The Third World War!"[7] As beer bottles were smashed and chairs split by *karate* chops, Akasegawa Genpei calmly read aloud the group's manifesto. On June 18, the eve of the treaty's ratification, they organized the "*Anpo* Episode Event" at member Yoshimura Masunobu's studio, the site for many of the group's rebellious shows and Happenings. The members stripped naked, some with bags tied over their heads, and danced wildly. Yoshimura attached a giant erect penis made of crushed paper bound with string to his loins, and painted his stomach with a gaping red diamond-shape of intestines – as if he had just committed *harakiri* – and marked the rest of his body with white arrows. These and other events staged by Neo-Dada Organizers, while teeming with the spirit of revolt, were intentionally empty of any specific ideology. Anarchism prevailed.

At the center of the *Anpo* crisis was the conflicting response of the Japanese people to the cultural and political Americanization of Japan. They recoiled from the horrors inflicted by the detonation of atomic bombs in Hiroshima and Nagasaki, and yet were drawn in their state of starvation and impoverishment to the world of plenty that Occupation culture represented, including jazz and Hollywood films. Tomatsu Shomei, who emerged as one of the leading figures in what became known as the "postwar school" (*Sengo-ha*) of Japanese photography, chronicled the images of Americanization in the series *11:02 Nagasaki*, which recorded the freakish keloidal burns and physical deformities caused by A-bomb radiation, and *Chewing Gum and Chocolate,* a portrait of the American bases in Japan. Writing on his theme, "Japan Under Occupation," Tomatsu stated, "If I were to characterize postwar Japanese history in one word I would answer without hesitation: 'Americanization.' "[8] In these and other series Tomatsu captured the ruins and refuse of post-atomic civilization, focusing on what critic Otto Breicha describes as "all sorts of war relics, boots stuck into mire, walls soiled by many hands, dead rats. . . . the neurosis of an overwhelmed presence, Occupation forces with their fences and fighter planes."[9] Other photographers who explored similar socio-political themes were Moriyama Daido and Kawada Kikuji. With its emphasis on fringe and perverse elements of contemporary Japan, the postwar school of Japanese photography captured the nation in a decade of doomed revolt.

The Yomiuri Indépendant Groups

The various groups that emerged from the Yomiuri Indépendant exhibitions from 1957 through 1963 represented both a reaction against and a transformation of the

dominant avant-garde practices of postwar Japanese art. As the third generation of postwar artists, the Yomiuri Indépendant groups inherited the lessons of Surrealism, practiced in the late forties by the first generation including Abe Nobuya, Fukuzawa Ichiro, and Okamoto Taro – whose paintings depicted such fantastic horrors of war as skeletal corpses lying in the sand or piled in a heap before a demonic landscape – which taught the necessity for art to function as a violent assault on the complacency of mundane consciousness. They also inherited the Social Realism of the second postwar generation, transforming its essential "realism" from one that served a Marxist dogma to one that embraced the detritus produced by mass capitalism. The *Reportage* painters' belief in art as a non-elite activity that is an integral part of social reality provided a foundation for the Yomiuri Indépendant groups. Further, the *Reportage* painters' preference for large-scale works made of non-art materials and heroic disregard for permanence, expressed by the artists' frequent destruction of their works influenced the Yomiuri Indépendant artists' approach to art as part "found object" and part "event."

By the mid-1950s, the didactic nature of leftist Social Realism was already being challenged in contemporary criticism. Concern over the danger of artists' dependence on subject matter prompted Haryu Ichiro (b. 1925), a leading left-wing critic and member of the JCP, to criticize the Nihon Indépendant exhibition of 1953 that concentrated on Social Realism for lacking originality and formal innovation, despite his well-known ideological sympathies with the movement. To the Yomiuri Indépendant artists who had witnessed the failure of Japanese Communism, *Reportage* painting was a form of "art as propaganda" no different in its authoritarian righteousness from the war paintings that many Japanese artists had produced under coercion a decade earlier. Further, the weakening of the "Old Left" exposed the futility of subjecting oneself to any organized political cause, leading the Yomiuri Indépendant artists to embrace unfettered individualism instead.

The catalyst for a new approach to the problems of self-expression and identity was provided by Okamoto Taro (b. 1911) who, in a series of influential books and essays, advocated the progressive regeneration of Japanese culture. In his best-selling *Art of Today* (*Konnichi no geijutsu*, 1954), Okamoto stated that "Postwar Japan must peel off the heavy shell of the past and forge a new young culture as if being reborn, and venture out into the world," and called upon young artists to overthrow the "authority blackened with age [that] still presses down stiflingly over our lives."[10] Believing that modern art was a universal property belonging neither to the East nor West, he advocated using its language to communicate the particular realities of contemporary Japan – but realities that went beyond the "isolation, helplessness, and bitter struggle" documented by the Social Realists. Okamoto called for young artists to make strident efforts to "destroy everything with monstrous energy … in order to reconstruct the Japanese art world."[11] Significantly, the purpose of such activism was to communicate the raw power of contemporary Japan to a Western audience – which was still, Okamoto lamented, mired in a romantic and misconstrued projection of *Japonisme*. "That which is

453

muddied in the struggle of Japanese soil must be thrust before them [the West] as is," Okamoto wrote. "The strike must be made."[12] Okamoto's revolutionary call for a new art that implied a physical engagement bordering on violence, his desire to forge a challenging Japanese art that would be contemporaneous with Western modernism, and his belief that art should communicate the *realities* indigenous to contemporary Japan became the guiding principles of the Yomiuri Indépendant groups.

Okamoto encouraged art that was not aesthetically pleasing, not technically skillful, and not complacent in any way. Art, Okamoto declared, must be "disagreeable." In *The Law of the Jungle* (1950), Okamoto depicted a monstrous creature in the form of a zippered change-purse devouring a human being and terrifying a host of surrealistic creatures. The confrontationalism of Okamoto's absurdist image would become the hallmark of the Yomiuri Indépendant artists, many of whom regarded Okamoto as their mentor. Shinohara, who considered himself among those who had "rejected the pursuit of eternal beauty," also advocated the urgent necessity for Japanese artists to "produce an original Tokyo style" that could be presented to the international art world "with pride." He identified as sources for the new art the noisy and brightly-lit *pachinko* pinball machine parlors that had become ubiquitous sights in Japanese cities since the war; Akasaka, Tokyo's burgeoning entertainment center; and the "spirit of Tokyo" itself, "packed with people and all their confused energy."[13]

One of the earliest groups that became identified with the tendencies that were to dominate the Yomiuri Indépendant exhibitions was Kyushu-ha (literally, "Kyushu School"), a group of avant-garde artists based in Fukuoka on the southernmost island of the Japanese archipelago.[14] Founded in 1957, when the group published the first issue of its journal, Kyushu-ha included in its fluctuating membership artists, poets, and Socialists gathered around Sakurai Takami (b. 1928), Ochi Osamu (b. 1936), Matano Mamoru (b. 1914), and Ishibashi Yasuyuki (b. 1930). Advocating at first gestural abstract painting in the manner of *Art Informel*, the members of Kyushu-ha always believed in the importance of instilling their art with social causes. But unlike their Tokyo counterparts, they were concerned with issues that related specifically to Kyushu and its rural realities – leading them to incorporate into their work allusions to the contemporary struggles of coalmining and agriculture.

Members of Kyushu-ha began showing at the Yomiuri Indépendant exhibition in 1957, and participated every year thereafter. Increasingly, their works displayed a tendency towards totemic structures made of debris such as discarded tires, broken bits of metal machinery, old bicycles, weathered wooden scraps of farmers' tools, and piles of cigarette butts. Kyushu-ha's subversive critique of technological modernization and high modernism as a system took the form of ritualistic agrarian primitivism in the work of Kikuhata Mokuma (b. 1935). In *Genealogy of Slaves*, two telephone poles, one symbolizing the male and the other the female, recline on a platform made of common red bricks. The surface of the male timber was hammered with hundreds of five-yen coins and displayed a phallus rising from

its center; the female timber was encased with twisted ropes made from shreds of old cloth, evoking the tools and labor of rural women. Tono Yoshiaki commented on the Shintoist symbolism of this work when he wrote of Kikuhata's "posts like wayside *kami* (gods) over which were spread offering coins."[15]

By the late 1950s, the term *objet* had come to designate an art form similar to the American proto-Pop combine and assemblage. To make *objets* was to confound the art system that the young Yomiuri Indépendant rebels aimed to destroy by their obstinate refusal to accommodate traditional definitions of art, and by their brazen transgression of the accepted division between art and life. Referring to Nakanishi Natsuyuki's *Clothespins Assert Churning Action* – a multiple-panel relief composed of underwear and hundreds of tin clothespins attached to burned canvases – Akasegawa reflected: "In the knowledge that this was not paint but simple, everyday objects, had we not discovered the minimum separation between painting and real life?"[16]

In 1960, the trend toward appropriating junk into high-relief or free-standing forms at the Yomiuri Indépendant exhibitions was termed "Anti-Art" (*Hangeijutsu*) by Tono, who had recently returned from a trip abroad where he had been in contact with the neo-Dada movement and the corresponding revival of the term "anti-art" in art critical discourse.[17] Responding in part to the publication of Robert Motherwell's *The Dada Painters and Poets: An Anthology* (1951), the American neo-Dada movement opposed the institutionalization of modern art and rejected the sublimity of Abstract Expressionism in favor of everyday imagery. Coined in 1958, "neo-Dada" referred to Jasper Johns's paintings of targets, numbers, and maps, and to Robert Rauschenberg's "combine paintings." Fluxus founder George Maciunas, in one of his early programmatic statements, "Neo-Dada in Music, Theater, Poetry and Art," also attempted to cast his intermedia movement in the iconoclastic tradition of "concrete ... non-art, anti-art, nature, reality."[18] Tono's application of the term "anti-art" to Kudo's *Proliferating Chain Reaction* – an ameoba-like work composed of scrub brushes enmeshed in a string web and attached to an iron frame – reflected the vanguard's growing sense of contemporaneity with and participation in the international art scene, a markedly different attitude from the former Social Realists' isolationist and regionalist identity. As part of this trend, a few galleries became active in promoting contemporary art from abroad in the early sixties. Foremost among them was Minami Gallery, which became the international center of the Tokyo avant-garde under its founding director Shimizu Kusuo.[19]

Tono's interest in the Anti-Art trend at the 12th Yomiuri Indépendant show in 1960 focused on the works of Kudo, Arakawa, and Shinohara – all of whom were affiliated with the newly-founded group, Neo-Dada Organizers, gathered under the charismatic leadership of Yoshimura Masunobu (b. 1932) and Ushio Shinohara (b. 1933). (Kudo and Miki Tomio were never officially members of the group, but participated in several of its events.) For that year's Yomiuri Indépendant, Shinohara made a version of Mathieu's "action painting" by dipping his boxing mitts wrapped in cloth rags into buckets of Japanese rice glue mixed with

sumi ink and then punching his way with large black splats across the surface of a makeshift canvas of discarded packaging; a similar work was exhibited in 1962.[20] Other group members included Akasegawa Genpei and Kazekura Sho, who were later active in Hi Red Center, and Shusaku Arakawa (b. 1936), who had made his debut at the Yomiuri Indépendant in 1958 with a series of coffin-like wooden boxes. Inside each of these boxes, which the viewer was invited to open, was entombed a congealed mass of cement whose surface was corrupted with odd bits of organic fur or hair. Each concrete form lay embedded in a cloth-lined case, conjuring a feeling of melted flesh deformed by atomic radiation and left to petrify in a casket (Fig. 42–1). Tono later reflected on his encounter with the Neo-Dada Organizers:

Fig. 42-1 Shusaku Arakawa, *Untitled Endurance I*, 1958. Cement, cloth, cotton, and wooden box (213.3 × 91.5 × 15 cm). Reproduced courtesy of Takamatsu City Museum of Art.

Their exhibits reflected the immense junkyard of the teeming city of Tokyo. The junk which they first saw, which influenced their way of feeling objects, was the junk of the burned ruins of the city during the war. The blasted city had been their playground: their first toys had been bottles melted into distortion from fire bombs, pieces of roof-beams found in the ashes. Now, their shows were full of these junk-flowers, with their queer blossoms.[21]

Despite certain affinities, Tono's term Anti-Art did not sit well with the artists. Shinohara especially was displeased, for it was not "anti-art" but an *expansion* of the very definition of art that they sought. For Tokyo's Neo-Dada Organizers, art was an extension of life and a discovery of the shocking grit of everyday, found materials spawned by the devastation of postwar Japan and contemporary urban reality. "One by one," Akasegawa recalls, "unobtrusive articles of daily life became redolent with new secrets.... as I clambered up these mountains of rubbish I began to find in them objects which had an unmistakable quality of their own."[22] Exactly contemporaneous with the French *Nouveaux Réalistes*, whose manifesto by critic Pierre Restany is dated to April 16, 1960, Tokyo's Neo-Dada Organizers embraced the mass waste emitted by the rampantly ma-terialistic and overly-Americanized cities of the postwar industrialized world.[23] Both groups legitimized their radical departure from abstract painting toward assemblages made of junk by associating their activities with the Dada heritage (the title of the first *Nouveaux Réalistes'* Paris show in 1961 was "40° au-dessus du Dada"), and both owed to Surrealism their practice of assembling found objects by fragmentation, juxtaposition, or accumulation. Unlike American Pop Art, it was not the directness, deadpan banality, and commercial anonymity of urban reality that appealed to the Paris and Tokyo groups, but rather the "hith-erto unrecognized strangeness latent in every object, old or new."[24] Yet where Arman, for instance, selected junk such as smashed violins to make permanent objects that still functioned as "art" in the traditional sense, the Neo-Dada Organizers used junk to create impermanent manifestations of their chaotic environment within the context of Happening-like performances – which is how they saw each opportunity to exhibit. As in Gutai art, physical interaction of body and material, and reliance on viewer or media participation to complete each "event" was fundamental to their strategy. Because the artists approached art-making as a theatrical act, their junk objects were destined to become them-selves temporary and discarded: Almost no original Neo-Dada Organizer objects are extant today.

Although the Neo-Dada Organizers disbanded within a year, members continued to be active in the Tokyo avant-garde until the mid-1960s. Anticipat-ing postmodernist "appropriation art" by several years and offering an ironic critique on the meaning of Pop Art, Shinohara embarked in 1963–64 on a series which he promoted as "Imitation Art."[25] These were copies of masterworks by leading American Pop artists, such as Johns' *Three Flags* and Rauschenberg's *Coca-Cola Plan*. Prompted in part by Rauschenberg's visit to Tokyo in

November, 1964 – when he demonstrated the construction of a work, *Gold Standard*, at an open forum held in Sogetsu Hall – Shinohara was inverting the common foreign view that modern Japanese art lacks originality. What was prescient in Shinohara's idea was that contemporary culture had reached such a level of simultaneity, commodification, and mass reproduction that works of art no longer held any authentic or unique value: They were reduced, in Baudrillard's terms, to "simulacra." Eschewing the modernist conceit that avant-garde art must always create something new and original, Shinohara proclaimed, "I think imitation is something ultimate in our age."[26]

The Tokyo Metropolitan Art Museum attempted to exclude the increasing number of works it decreed "markedly offensive to viewers" by issuing a set of regulations for the 1962 Yomiuri Indépendant show. Nonetheless, artists continued to provoke profound consternation. When museum guards found Kazekura Sho standing naked in a gallery, they threatened to call the police and asked, "Where is your work and what is its title?" Kazekura replied, "It's me right here. It's called *The Real Thing (Jitsu-butsu).*"[27] Not surprisingly, in early 1964 the Yomiuri Newspapers announced that their annual exhibition would be discontinued, citing that its initial goal of fostering new talent had been achieved. The move to control riotous tendencies reflected the government and media's exploitation of the 1964 Tokyo Summer Olympics as an occasion to usher in a positive "beyond postwar era" defined by the exemplary twin miracles of high economic growth and a vast, prosperous middle class. Unruliness had no place in this official image of Japan.

Yet despite the loss of the Yomiuri Indépendant as a venue, the Tokyo avant-garde continued to stage activities and stimulate critical debate on the nature of Anti-Art. At the forefront of the post-Yomiuri Indépendant avant-garde were the artists Takamatsu Jiro (b. 1936), Akasegawa Genpei (b. 1937), and Nakanishi Natsuyuki (b. 1935), who in May 1963 formed the group Hi Red Center – an acronym composed of the English for the first character of each of its members' names.[28] What connected these artists (who had been collaborating together for several months) was their conception of *objet* as the focus of "events" that would go beyond the walls of the museum or gallery, as well as their informed leftist concern for the social inequities of modern Japan. In the *Yamanote Line Event* of October 1962, Nakanishi rode Tokyo's busiest trainline carrying an egg-shaped "compact object" composed of junk set in polyester, while Takamatsu dragged around a long black string attached to various everyday objects. With his face painted white, Nakanishi crouched on a station platform and licked his egg, then calmly boarded a train where he hung it from the hand straps and observed people's reactions with a flashlight.[29] According to Akasegawa, Nakanishi and Takamatsu's purpose for using the train as a site for their event was to destroy the hierarchical status of art by bringing it into the "space of daily activities." Taking their cue from Okamoto, who stated in 1955 that "Utter nonsense may have more power to change social reality than seriousness,"[30] Hi Red Center used satirical performances staged in public spaces to critique the mechanical banality

and covert authoritarianism underlying Japan's mass capitalist society. The group's cooperative exploration of the inherent relationship of art to daily life attracted the attention of visiting Fluxus artists Nam June Paik and Yoko Ono – both of whom participated in the *Shelter Plan* event of January 1964 – which led to the reenactment of two Hi Red Center events in New York by Fluxus artists.

"Utter nonsense" collided with "social reality" in January 1964, when police authorities accused Akasegawa of counterfeiting currency, for which he was indicted in November 1965. Their evidence was Akasegawa's series of works (impounded by the police) in which the artist had used monochrome, one-sided prints of a thousand-yen note to wrap common objects such as a fan and an attaché case. Akesegawa had used the same "bill" as an invitation to his solo show at Shinjuku Dai-Ichi Gallery in February 1963.

Brought to court in August 1966, the spectacular series of public trials that followed are legendary in the annals of Japanese art. To demonstrate the definition of "event" and "Happening," Hi Red Center re-staged some of their most notorious works in the courtroom, insisting all the while that their accompanying *objets d'art* (which to the prosecutors looked like strange junk) be treated with museum-quality care. Critics Takiguchi, Haryu, and Nakahara; artists Nakanishi, Takamatsu and Ikeda Tatsuo; and Kyoto Museum of Modern Art director Imaizumi Yoshihiko all joined in Akasegawa's defense, which centered on the question, "What is, or is not, art?" Akesegawa claimed that a "copy" is not a "fake" of the real object, but rather a "model" which denies the hierarchical relationship between the real and the fake. Akasegawa lost the case and appealed twice; it was finally closed in 1970 when the Supreme Court pronounced the artist guilty of contravening the law. Akasegawa responded to his first sentence by making an oversize replica of a thousand-yen note, *Morphology of Revenge* (Fig. 42-2); at the end, he produced a zero-yen note printed with the words, "Legal Art – Genuine Article" which he sold for 300 yen.

Fig. 42-2 Akasegawa Genpei, *Morphology of Revenge* (*Fukushu no keitaigaku*), 1968. Gouache on paper, mounted on panel (90 × 180 cm). Collection of the artist.

Culminating the passionate anarchism that had animated the Yomiuri Indépendant phenomenon, the defeat of the radical artist by the conservative forces of bureaucracy in Akasegawa's famous case symbolized a death similar to that of the "Old Left" in 1960, when demonstrations failed to affect the renewal of the US–Japan Security Treaty. Like the figures in contemporary writer Oe Kenzaburo's (b. 1935) novels who like "a fuck rife with ignomy," the Yomiuri Indépendant artists practiced bacchanalian revel, public satire, and terrorist fantasies – like blowing-up the Tokyo Metroplitan Art Museum[31] – as a means to subvert and escape from the faceless socio-political system of the postwar world. Ultimately, however, they are left powerless. All they can do is cultivate what authority deems "perversions," which will hopefully liberate them from "the territory" of society.[32] What is true of Oe's protagonists applies as well to the Yomiuri Indépendant artists: Raised amid the rubble of Japan's catastrophic defeat and witness to the collapse of national myths, they reflected the gestalt of the postwar Japanese psyche – absolute loss and absolute freedom.

Notes

1 George R. Packard III, *Protest in Tokyo: The Security Treaty Crisis of 1960* (Westport, Conn.: Greenwood Press, 1966), p. 11.

2 Among the most prominent *Reportage* painters are Nakatani Tai, Nakamura Hiroshi, and Toneyama Kojin. See *Reconstructions: Avant-Garde Art in Japan 1945–1965*, exh. cat. (Oxford: Museum of Modern Art, 1985).

3 Kazu Kaido, "Reconstruction: The Role of the Avant-Garde in Postwar Japan," in ibid., p. 18.

4 Packard, pp. 338–43.

5 Kudo Tetsumi quoted in Nakahara Yusuke, "Erosu no geijutsuka-tachi 4: Kudo Tetsumi. Denki jidai no sei" (Artists of Eros 4: Kudo Tetsumi. Sex in the Age of Electricity), *Bijutsu techo*, no. 297 (May 1968), pp. 143–44.

6 Tono Yoshiaki, "Japan," in *Artforum* 5, no. 5 (January 1967), p. 53.

7 Ushio Shinohara, *Zen'ei no michi* (The Avant-Garde Road) (Tokyo: Bijutsu Shuppan-sha, 1968), p. 58.

8 Tomatsu, p. 62.

9 Otto Breicha, "Not to Be Passed Over," in *Shomei Tomatsu*, p. 6.

10 Okamoto Taro, 1954; quoted and trans. in Bert Winther, "Isamu Noguchi: Conflicts of Japanese Culture in the Early Postwar Years" (PhD diss., New York University, 1992), p. 113.

11 Okamoto, *c.*1948; quoted and trans. in Kaido, *Reconstructions*, p. 14.

12 Okamoto Taro, 1954; quoted and trans. in Winther, pp. 116–17.

13 Shinohara, pp. 108–9.

14 See *Kyushu-ha-ten/Group Kyushu-ha*, exh. cat. (Fukuoka: Fukuoka Art Museum, 1988).

15 Tono, "Exhibition Review," *Bijutsu techo* (August 1962), p. 173.

16 Akasegawa, quoted and trans. in John Clark, "The 1960s: The Art which Destroyed Itself: An Intimate Account," in *Reconstructions*, p. 86.

17 See Tono, "Neo-Dada et anti-art," in *Japon des avant-gardes 1910–1970*, exh. cat. (Paris: Centre Georges Pompidou, 1986), p. 329.

18 For George Maciunas, "Neo-Dada in Music, Theater, Poetry, and Music," see *In the Spirit of Fluxus*, pp. 156–57.

19 The leading galleries for contemporary art in Tokyo were Nantenshi Gallery (founded 1960) and Minami Gallery (founded 1956, closed 1979).

20 See William Klein, intro. by Maurice Pinguit, *Tokyo* (New York: Crown Publishers, 1964).

21 Tono, "Japan," p. 53.

22 Akesagawa, in *Reconstructions*, p. 87.

23 See *1960 Les Nouveaux Réalistes*, exh. cat. (Paris: MAM/Musée d'Art Moderne de la Ville de Paris, 1986).

24 Lucy R. Lippard, *Pop Art* (New York and Toronto: Oxford University Press, 1966), p. 176.

25 See *Shinohara Ushio-ten/Ushio Shinohara*, exh. cat. (Hiroshima: Hiroshima City Museum of Contemporary Art et al., 1992).

26 Shinohara, p. 141.

27 This anecdote is recorded in Akasegawa Genpei, *Tokyo mikisa keikaku: Hai redilo sentu chokusetsu kodo no kiroku* (Tokyo Mixer Plans: Documents of Hi Red Center's Direct Actions), Tokyo: PARCO Co., 1984), pp. 48–49.

28 Takamatsu (*high* pine), Akasegawa (*red* rapids river), and Nakanishi (*center* west).

29 Akasegawa, *Tokyo mikisa keikaku*, pp. 12–18.

30 Okamoto, 1955; quoted and trans. in Kaido, p. 20.

31 See Yoshimura Masunobu, "Neo-Dada Organizers," in "Hyakka seiho 60-nendai shoki" (Let One Hundred Flowers Bloom: The Early 1960s), *Bijutsu techo* (October 1971), p. 56.

32 See John Nathan, "Introduction," in Oe Kenzaburo, trans. by John Nathan, *Teach Us to Outgrow Our Madness* (New York: Grove Press, 1977).

43

Pseudo-languages: A Conversation with Wenda Gu, Xu Bing, and Jonathan Hay

Simon Leung

Introduction

In this reading, Wenda Gu (b. 1955) and Xu Bing (b. 1955), two giants of contemporary Chinese art, discuss their own works. In the form of a roundtable discussion, this article provides direct and personal insights into the artists' processes and frameworks, even as their works are in progress. Guided by the questions of art historians Jonathan Hay and Simon Leung, Xu and Gu touch on many of the primary aspects of their work, including medium, language, translation, the international art scene, intellectualism, Maoist attitudes, censorship, power, and the exotic.

Contemporary Chinese art exists at the cutting edge of the international art scene. Since the end of the Cultural Revolution and the death of Mao in 1976, China has seen a gradual opening of options for artists, broken only by the crackdown on dissidents that followed the 1989 Tiananmen Square incidents. By the end of the 1990s, however, options for artists had opened up, and indeed the governmental controls were pushing artists into new types of art making, including temporary, one-time, invitation-only shows in warehouse spaces and outdoor performance art. Works and artists traveled abroad, and as curators and gallery directors in the USA and Europe saw the work coming out of China, enthusiasm fed a series of internationally touring shows, the most prominent of which was *New Chinese Art: Inside/Out*, curated by Gao Minglu in association with the Asia Society and the San Francisco Museum of Modern Art in 1998 and 1999.

Simon Leung, "Pseudo-Languages: A Conversation with Wenda Gu, Xu Bing, and Jonathan Hay," pp. 149–63 from *Art Journal* 58:3 (Fall 1999). Reprinted by permission of Simon Leung.

The show was striking in the number of works that used or addressed the issue of writing, as the works of Gu and Xu do. Writing in Chinese characters, as the reading notes, must be separated from speaking Mandarin Chinese, as many different dialects and distinct languages also use Chinese characters, including Japanese and Cantonese. Furthermore, writing Chinese has changed over the millennia of Chinese history, from the earliest writing on oracle bones in the Shang Dynasty (c.1500–1050 BCE) to the revisions under Mao in the twentieth century that Xu discusses in this reading. Indeed, both artists discuss the ways in which they have tried to make their art speak "to the people" in the vein of Mao's speeches on art reproduced in his Little Red Book, whether that means using human hair as the medium or human participation in calligraphy lessons. Writing is always politically and historically charged, and these artists purposively choose the form and readability of their script.

Although the use of language is prevalent in much contemporary art, the appearance of the Chinese language at this historic moment is worthy of particular focus and attention. In the West, where the Chinese language is so often taken only as a sign of the exotic, the ways in which Chinese artists are tactically using language can sometimes get lost. This conversation, the second in a series devoted to aspects of contemporary Chinese art, features the participation of Wenda Gu and Xu Bing, two of the most prominent artists working through these issues, as well as Jonathan Hay, associate professor of Chinese art at the Institute of Fine Arts in New York. Born in Shanghai in 1955, Gu moved to the United States in 1987; he has exhibited his work in numerous exhibitions throughout the world. Born in Chongqing, Sichuan Province, in 1955, Xu has lived in the United States since 1990; he has also exhibited his work widely and was recently awarded a MacArthur Fellowship.

Numerous other Chinese artists are engaging with the issue of language. Zhang Peili's single-channel video, *Water – The Standard Version Read from the "Ci Hai" Dictionary* (1992), consists of a twenty-five-minute static camera recording of Xin Zhibin, the Chinese government's most prominent television broadcast personality, addressing the camera with all the definitions of "water" from a Chinese dictionary. While the premise of the work seems utterly simple, the power of it lies in how the simplicity of the reading implicitly challenges conventions and assumptions on all fronts. The newscaster, as the official media representative of the Chinese government, reads definitions of a single word with the same affect and conviction as she would a news story. To a viewer unaware of the subtleties of the Chinese language, *Water* might function similarly to other conceptual video artworks where state power is taken up as an object of critique. But Xin's "standard" pronunciation is actually in a dialect foreign to and imposed on most native Chinese speakers, incomprehensible to those who do not know Po-tun-hua, or Mandarin. In other words, while all Chinese speakers share the

Chinese written language – a fundamental basis of Chinese identity – Xin's "standard" Chinese is for most Chinese people spoken in a language at once their own and not their own. What *Water* highlights is how in contemporary Chinese art, the citation or use of words, whether written or spoken, is a performance of language both within and against a tradition in which language has always been of utmost importance. The Chinese language is a performance of culture, state, and self.

This performance of language (its functions, codes, oppression) has been the focus of much work by contemporary Chinese artists in the last fifteen years. Some, such as Qiu Zhijie and Song Dong, practice a calligraphy where Chinese characters are written against the goal of communication. Qiu's *Writing the Orchid Pavilion Preface One Thousand Times* (1986/97) is a work where the practice of the ancient art of calligraphy is overwritten to the point where it becomes a black block of ink on paper. In *Water Writing Diary* (1995), Song Dong takes almost the reverse strategy by practicing calligraphy on the surface of a stone tablet or table, using water instead of ink. The water evaporates, but the enactment remains in the hand and mind of the artist.

Ching-Ying Man, an artist from Hong Kong, also confronts the weight of Chinese history and identity in an installation made on the occasion of the turnover of Hong Kong's sovereignty from Britain to China. *97 Reunification, I Am Very Happy…* (1997) is an installation of red Chinese characters that filled the entire ceiling and wall space of a room with the sentence from the title. The repetition of words echoes the ubiquity of exactly such sentiments displayed in the celebratory signs throughout Hong Kong before the handover. Here, the imposition of a "glorious" national identity is met with extreme ambivalence and derided as farce.

Leung: Although both of you use Chinese script in your installations at P.S. I for the exhibition *Inside Out: New Chinese Art*, the forms of the scripts are very different. Xu Bing, in *A Book from the Sky* (1987–91), you use typeface that you carve yourself – a moveable type from the Song Dynasty (960–1279), like that which is used in books or newspapers, a typeface that connotes the public. And Wenda, in *Temple of Heaven* (1998), a site-specific installation that you created for the exhibition, you use ancient Chinese seal script, the oldest recorded form of the Chinese written language, which most contemporary Chinese speakers can't read. That seems related to other elements in your installation, like the use of old-style furniture.

Xu: I made *A Book from the Sky* in 1987. When I first showed it at the National Gallery in Beijing in 1988, I wanted to cover the entire space – the floor, the ceiling, the walls – with fake words. The installation consists of a series of beautifully bound boxed books arranged in a grid on the floor, giant scrolls arching from the ceiling, and smaller scrolls hung from the walls. I had invented the approximately four thousand unreadable characters printed on the books and

464

the scrolls, but when visitors first entered the space, they thought that the words they saw were words they could read. However, when they actually tried to read the words, they couldn't. They thought that some of the words were simply wrong. Then they realized that all of the words were wrong. Their expected response was disrupted.

Strictly speaking, *A Book from the Sky* doesn't have any connection with text, since there is no "real" text, even though it takes the form of books and the appearance of "words." But it does have a connection with writing and printing. In Beijing I worked with a small printhouse known for making beautifully bound books and facsimiles of classic books. I spent a lot of time studying book printing, so that eventually I was able to distinguish different styles of binding – the Song Dynasty style, the Ming Dynasty style, and so on.

I used a typeface invented during the Song Dynasty by professional engravers, because over time it has become like the newsprint style of today, which I liked. I didn't want to express my own personality. I wanted there to be a tension between the seriousness of the execution and the presentation and the underlying absurdity that animates the project.

Hay: There has been an historical evolution of this kind of woodblock typography, which basically begins in the Tang Dynasty.

Xu: When I began *A Book from the Sky*, I was trying to carve standard script characters. But as soon as I started to work with the carving process itself, I found myself developing images that were closer to this preexisting typographical model. I'm not particularly attracted to calligraphy because it is too self-expressive, too individualistic, too emotional for my purposes.

Leung: The typeface you use, because it's associated with books and newspapers, connotes the public, in contrast to calligraphy, which is, as you say, more expressive.

Xu: If I use this public mode of, I don't want to say writing, because it's already changed, but if I use this public mode of communication, it already belongs to everybody, not just to me.

Kaplan: It's not personal.

Hay: You want to get away from saying anything specific. You want to withhold that kind of statement.

Xu: I even want the artist not to be in the work.

Gu: *Temple of Heaven* is the most recent monument in my ongoing ten-year project, *United Nations*, which I began in 1993. This project consists of the creation of a series of national monuments made of the hair of people from the place in which the monument is sited and a final United Nations monument. The final project will be a giant wall built solely from the hair from the national

monuments. The hair will maintain its ethnic identity but will be woven together into pseudo-languages co-existing on the wall.

The four walls and the ceiling of *Temple of Heaven* are made of hair that I have collected from 325 barber shops around the world over the past five years, including Poland, the United States, Israel, Russia, Hong Kong, South Africa, and China. The hair is formed into curtain walls inscribed with invented, unreadable scripts based on the Chinese, English, Hindi, and Arabic languages. On the ceiling are large letters whose forms synthesize Chinese characters and English letters. On the floor is a Ming-style furniture setting for the tea ceremony. The seat of each chair is a TV monitor showing passing clouds. Visitors may sit on the clouds and meditate. The unreadableness of the languages is intended to evoke the limitations of human knowledge.

Hay: Could you talk about your use of seal script and also your use of old-style furniture?

Gu: It's related to my work from the early 1980s. At that time, I was intensively reading Ludwig Wittgenstein's and Bertrand Russell's philosophies of language, and I was just beginning to learn seal script, the first unified language in China, introduced by China's first emperor, Qin Shi Huang. Because I couldn't read the script, I felt liberated from the meaning of the words. I started to produce a series of ink paintings with different kinds of fake seal script. More recently I have become interested in how to integrate knowledge into the body, not through traditional calligraphy or printing.

My intellectual formation has been the result of four factors: the Marxist ideology I grew up with and the capitalist reality in which I exist today; my extreme Chineseness and my existence as a citizen of the world. I have benefited from experiencing both systems, both cultures. I am interested in fusing global cultures. I thought if I used a conventional printing style, both English and Chinese readers would realize immediately whether it was fake or not. When I used seal script, neither Chinese nor non-Chinese readers would be able to make that determination. So I am playing a double game. Chinese readers could interpret the concept of an unreadable language as the mythos of a lost history, while non-Chinese readers could interpret it as a misunderstanding of an "exotic" culture. In general, the miswritten language symbolizes misunderstanding as the essence of our knowledge of the material world, yet the pseudo-languages help us to imagine a universe beyond language.

Leung: How is that related to the furniture?

Gu: The furniture is a counterpart to the words. I want people to sit on the chairs, surrounded by the four invented languages in a transcultural setting, to meditate about issues like existence beyond knowledge, beyond nationality, beyond the boundaries of culture and race.

Kaplan: Are your works designed specifically for a non-Chinese audience or for any audience?

Gu: My more recent works, which I have executed all over the world, are for international audiences. But my early ink paintings were for Chinese ones. At that time, I was more interested in the philosophy rather than the politics of language. But the government suspected that unreadable characters might have hidden meanings or that I was destroying the code of tradition; they consequently closed my exhibitions several times.

Xu: I produced *A Book from the Sky* before I came to the United States. Although it was produced and first shown in China, it was not concerned with an audience of a certain nationality as much as with a larger public.

Hay: It was initially created for a Chinese context, even if you weren't specifically thinking in those terms. But since then it has had a very long international afterlife. What's involved for you in its transfer from China to other countries?

Xu: When I first showed it overseas, I wondered whether people would understand it. But in the countries in which I have shown it, they seem to like it. Maybe they like the idea, maybe the form.

Hay: I'm more interested in whether you think it can be effective here, or whether it's effective in a different way. You must have thought about this quite a lot.

Xu: All the responses are different. Chinese audiences lose part of the meaning, and Western audiences lose another part, but each side gets the part that the other doesn't.

Hay: Some of us who think about Chinese art have been critical of certain mainland Chinese artists who use obvious signs of Chineseness to exoticize themselves. Is this a criticism that can be made of either of you?

Xu: I don't feel that the desire to draw in a Western audience by exoticizing my Chineseness applies to me. Since I grew up in China and am involved in Chinese culture in a very deep way, what I do comes very naturally. I have no other choice but to draw from my own cultural tradition, which has been filtered through Mao's Cultural Revolution. I feel that to use Chinese cultural elements to address global issues, to participate in global cultural debates, is a positive development. The alternative pursued by some others is to avoid using Chinese cultural elements to address larger issues. The problem with this is that you're giving up your own culture; you're abandoning something of yourself. Part of the international success of *A Book from the Sky* has come precisely from the fact that it embodies a particularly Chinese approach to culture. The real problem is not what materials or cultural elements one uses, but the level of one's reflection.

467

Gu: Regarding the question of whether using Chinese cultural elements may be criticized as opportunistic exoticizing, I think this criticism not only applies to Chinese artists, but it should also be applied to non-Chinese ones, too. There has been a long tradition of Westerners exoticizing Chinese culture, and there would be no reason for Chinese artists to exoticize themselves were it not for this historical condition.

Hay: I agree.

Gu: This criticism must therefore apply to both sides.

Leung: I feel that the strength of Jonathan's question, however, lies in the fact that if you are Chinese in an international frame, you're given a type of *authority* that non-mainland Chinese artists are not given.

Gu: There is another issue I'd like to address. Artists like Xu Bing and I use Chinese elements, but not in a traditional way. This is difficult for non-Chinese audiences unfamiliar with Chinese culture to understand. They think that we are using traditional Chinese elements, when we are not. At the same time conservative Chinese intellectuals criticize us for revisionism. This is a dilemma we face because of the isolation and the ensuing level of incomprehension between different cultures.

Leung: I want to depart from that last comment and ask you specifically about the languages you use. On the one hand, there is a destruction of authenticity in making pseudo-languages; but, on the other, I'm struck by the underlying ideology of internationalism in your work and by the fact that the languages that you do fake from are not just any languages. They are hegemonic languages. Historically, they have been languages of domination, languages that empires have used as a form of unification.

Gu: Since I installed *Temple of Heaven* at P.S. I, I have sat in the gallery and talked to visitors. One Russian man who works for the United Nations, who knows of my private *United Nations* project, asked why I used four languages and didn't include Russian. Jewish visitors have asked why I didn't include Hebrew. Language is a sign of nationalism. When the project is finished in 2004, I will have produced works in twenty-five countries, probably using almost as many languages.

Leung: Can you address the internationalism of the project? I'm particularly interested in the problematic notion of the "united nations."

Gu: I began to think about *United Nations* in 1992. As more institutions around the world became interested in participating in the project, I began to think more about its political, philosophical, and ideological dimensions. The target is the United Nations, an organization whose utopian purpose is to create a better world by unifying its different races and cultures – a vision that probably won't

exist in our lifetime. But it can be realized in art, whose function is to serve as a projection of our imaginary.

Hay: That leads to a comment that I'd like to address to Xu Bing. You seem to make reference in your work to a different set of utopian ideals that basically comes from the Chinese Communist Party, from Yan'an, where Mao gave his famous "Talks on Art and Literature" in May 1942, in which he expounded his philosophy of art. In your work, these ideals, which as propaganda no one can believe in, take on a new form. There's kind of distortion. Are you trying in this aspect of your art to recover something positive from the Communist experiment? Do you want to find something in it that is still positive, that can still be believed in, and develop that? I'm especially struck by your identification with carvers, artisans, and designers, rather than with the model of the literati artist and the concept of authenticity that goes along with that.

Xu: A very interesting question. I develop these works from a certain doubt about cultural authority. For this reason, my work troubles intellectuals. Many of those who saw *A Book from the Sky* in China wanted to find real words, but they couldn't, and that bothered them.

Hay: It's threatening. It makes certain people uncomfortable, particularly those who are steeped in traditional Chinese culture. And those who are modernizing?

Gu: Both. It's disturbing to Chinese audiences and also to Western ones.

Hay: To conservatives on both sides who have an orthodox idea of culture.

Xu: This is the point of *A Case Study of Transference* (1993–95) (Fig. 43–1), an installation in which I put two pigs that were to be mated into a pen filled with books in different languages. The body of the male pig was printed with fake English words and that of the female with fake Chinese characters. The laborers who worked in the place from which I bought the pigs didn't care, but the intellectuals were horrified by my actions.

Leung: Regarding your use of animals, it seems that you're dealing with the issue of communication.

Xu: I work with animals as a way of rethinking human culture, because they offer a vantage point from which to look at culture, as embodied by the dense expression of writing. As I was preparing *A Case Study of Transference*, people were worried that the pigs wouldn't work. But the pigs really enjoyed it. They didn't care that they were in an art gallery, the arena of culture.

I contributed a piece with sheep to the exhibition *Animal. Anima. Animus.* at the Pori Art Museum in Finland in 1998, which included fifteen artists from all over the world whose work deals with animals. In my piece, *Net and Leash* I fabricated a steel cage in the form of a text that the curator wrote about the exhibition and a leash made of wire bent into the form of a verse from John Berger's poem "They Are the Last," which reads: "Now that they have gone/it is

469

Fig. 43-1 Xu Bing, *A Case Study of Transference*, 1993–95. Two live breeding pigs with text. Reproduced courtesy of the artist.

their endurance we miss./Unlike the tree/the river or the cloud/the animals had eyes/and in their glance/was performance." Working with animals makes it possible to highlight the difference between civilization and nature. The pigs really enjoyed themselves, but the people felt embarrassed as they watched them. That point is really important.

Leung: That's exactly how I thought about it. Animals are the object of language, but, in *A Case Study of Transference*, it's language that doesn't make any sense, so the self-consciousness returns to the person who provides the gaze. In a sense, the gaze of language turns back onto the person, and the person becomes the object.

470

Xu: My interest in books and words comes from my family and my generational background. My father used to work in the history department at Beijing University, and my mother worked in the library studies department. When I was very young, I grew up in an environment filled with books. I became familiar with all different kinds of typeface and binding, but only visually; I couldn't read them. When I started to learn to read, the Cultural Revolution was in full swing. I was sent to the countryside and could only read Mao's books. When the Cultural Revolution ended and I returned home, I had the opportunity to read many more books because of my parents. Yet, I felt uncomfortable. I was like a hungry person who, when he has the chance to eat, eats too much and gets nauseated.

In the past, people were very respectful toward books. I was very respectful. But after reading so many, my attitude changed in a strange way. I started to feel that there were too many books, and I also came up with the idea that I wanted to make a book of my own that would explain the world. This is why I made *A Book from the Sky*. When I came to the United States in 1990 as a visiting artist at the University of Wisconsin in Madison, I went to the university library. I would go into the stacks and touch the books, which I couldn't do in libraries in China. I looked at them closely, but I couldn't read them. It was like when I was child.

Hay: A throwback to that time.

Xu: Yes. I've always had a strange relationship to words. Familiar, but also kind of alienating. When Chinese children learn to write, we spend a lot of time memorizing and tracing characters in calligraphy lessons. My father would ask me to do a page every day. The purpose was not really to learn specific characters, but rather to teach me discipline within a particular cultural framework.

Hay: I don't want to lose the question of ideology here, the political issue, because it's sometimes very difficult to get artists from mainland China to speak directly about politics.

Xu: My generation of artists has a very strange relationship with words. During the Cultural Revolution, Mao was promoting simplified characters. We spent a lot of time memorizing the new words. Then they would change the words the next year. And then they would change them again.

Hay: They would go back to the earlier mode?

Xu: It was really confusing. Not only with respect to language but culturally.

Leung: I remember growing up in Hong Kong and learning the old style of Chinese script, but I would not be able to read books or newspapers from Mainland China. This simplification of the language that you are talking about, to the point that nobody could read it and certain aspects would therefore have to

be restored to make it more comprehensible, echoes what you say about the control of language, especially during the Cultural Revolution.

Gu: Language is the power of mind and manipulation. Think only of propaganda. Groups use language to impose their ideas on you. You learn to be controlled through their propaganda. It's very political. That's why the dictator is not as comfortable with the language inherited from the old emperor. He wants to establish his own language, currency, and so on to affirm his authority. Cultural texts encode political power.

Hay: So there's an issue of control, of power.

Gu: That also goes back to my training. When I was a student in the China National Academy in the 1980s, I was trained as a calligrapher and a landscape painter. For three years, from morning to late afternoon, I just copied from the masters. I learned the art of self-discipline, self-control, and meditation in the process. I learned the way to be patient.

Kaplan: It's very interesting that both of you have chosen the issue of translation in your approaches to language, and that you've chosen to make it impossible to translate, because you're not writing a real language. But are referencing a language that you've invented that doesn't say anything. Is the impossibility of translation one of the issues you are thinking about?

Gu: Translation is a metaphor of the global situation today, a transnational situation. We carry on the Chinese tradition in this global context. That's why I use hair from different races. I want people to feel that they are part of the work, not just passive viewers looking at it. The work is not shaped by stone or wood; its power comes from living people.

Leung: I want to ask you about your use of hair in relationship to translation. Although your idea is that hair is natural, and in some ways essential, hair is one of the most synthetic signifiers, in that there are different styles and cuts that go in and out of fashion. In other words, hair doesn't signal biology or nature, as much as it signals artifice, in that artifice is inherent in language, in that there may be elements in a language that can be choreographed to mean radically different things.

Gu: In today's technologically advanced world nothing is really natural. We live in a world in which engineering has invaded the human body, laying the foundation for a new stage of artificial evolution propelled forward by market forces and commercial objectives. My use of hair is coded biologically, as well as historically, socially, ethnically, culturally. Scientists can discover information about a person by analyzing the DNA in their hair.

Leung: Exactly. Hair is a type of text.

Xu: Regarding the issue of translation, some people have pointed out that even before *A Book from the Sky* left China, it was exploring questions of comprehension and incomprehension. I myself have doubts about the degree to which it's possible for there to be translation between cultures, since even people within the same culture have difficulty communicating. I feel that I'm working in a space between cultures.

In 1994 I produced *Introduction to New English Calligraphy*, which I first showed in Finland in 1996. It is a simulated classroom in which visitors may practice what seems to be traditional Chinese calligraphy. When visitors first read the characters they are to copy, they think that the characters are Chinese. However, when they become involved in the actual act of copying, they realize that the words are really characters composed of reconfigured Roman letters that spell out words in English, which they can read. The only way that they can achieve this experience is by finding a place between two languages, between two cultures. Moreover, in *Your Surname, Please* (1998), when a visitor types his or her name into a computer keyboard, the computer translates the name into a character composed of reconfigured Roman letters, which the visitor may then print out and take home. In this way, a close relationship occurs between such a language and the audience.

Leung: You translate Roman letters and English syntax into Chinese script, and it actually works.

Xu: I wanted to distance myself from the contemporary art system. A gap has opened up between contemporary art and its audience. Many people don't understand contemporary art, and they think they are the problem. But actually the problem is with contemporary art. I want to make work that engages the audience in a friendly way.

Hay: So we're back to the utopian ideal.

Xu: I want the audience to become involved in the work.

Gu: The issue of the relationship between the work of art and the audience is important. My use of the human body as my medium is my way of closing the gap between the work of art and the audience. I develop the monuments that comprise the *United Nations* project in close dialogue with issues central to the local contexts in which the works are sited. For example, I created *United Nations – Hong Kong Monument: The Historical Clash* (1997) on the occasion of the handover of Hong Kong to China. It included British hair formed into the shape of the Union Jack and Chinese hair formed into the shape of a flag inscribed with pseudo-Chinese seal script. Between these flags was a nineteenth-century British quotation, also rendered in hair, that was presented in Chinese format – that is, you had to read it from top to bottom, right to left. It said: "Once upon a time there was an English merchant who said, 'Imagine, if every Chinese wears one more inch of clothing.' " It's about the origins of the Opium War (1839–42) and

the extension of the British market into Asia. But ironically it also referred to modern China, an enormous market that has opened up and has attracted corporations from all over the world. The British merchant's words have become a reality today.

Kaplan: Could you talk more about this issue of audience?

Gu: I try to close the gap between the artwork and the audience by ensuring direct physical contact, interaction, and dialogue with the local population through the collection of the hair and reference to the cultural histories from which the monument will be created (Fig. 43–2). Each monument requires huge amounts of hair and usually involves the participation of twenty to forty barber-shops over a three- to four-month period. When the hair is transformed into bricks, curtain walls, carpets, and so on, it is reincarnated in a sense, and this process often has a tremendous psychological impact on the local population. I

Fig. 43-2 Wenda Gu, *United Nations-Africa Monument: The World Praying Wall*, 1997. Sitespecific installation. 40 × 44 feet (12.2 × 13.4 m). Second Johannesburg Biennale. Reproduced courtesy of the artist.

474

brought my proposal for *United Nations – Israel Monument: The Holy Land* (1995) before Parliament, which debated whether the use of hair in this manner was inappropriate because it evoked memories of the Holocaust. I argued that it was not, since it was about ensuring the Jewish people's presence in the project, which would otherwise be incomplete.

Kaplan: You create different situations in which different dialogues and debates can be framed and discussed.

Gu: Yes, that's the real function of the *United Nations* project. I don't just invent work privately in my studio. I go into the culture. I get material from local populations so that when I conclude the project, it will be as if millions of people helped shape it. In 1999 I will produce *United Nations: The Babel of the Millennium*, a site-specific installation for the San Francisco Museum of Modern Art. It will be an enormous tower referencing the biblical Tower of Babel constructed from rectangular panels depicting nonsensical languages, including pseudo-English, Hindi, Arabic, and a synthesis of Chinese and English; the panels will be made of human hair collected from over three hundred barbershops around the world. Designed for a space intended for public gathering, the tower's structure will combine two important symbols: a cross and a refined form of a funeral robe from the Han Dynasty (202 BCE – 220 CE) created for the Princess Liu from jade tablets sewn together with gold thread. The cross's arms will curve with the circular architectural space surrounding it, forming the image of the jade robe with folded arms. I will also present a performance in conjunction with the installation – a wedding ceremony presided over by a mixed-race child. I believe that we are on the verge of a historical transition in which we must choose whether or not to realize the vision of a powerful humanity by uniting different races and cultures.

Xu: *Introduction to New English Calligraphy* has been shown in different countries, too, and a lot of teachers have brought their students to the gallery to learn. Some have even asked where they may buy the instructional book for their students. They are trying to find new ways to teach the young generation about other cultures. During the Kwangju Biennial, the program was made available on a local television channel. Interestingly, some visitors later wrote to me in my invented characters, which they had learned.

I believe that art should serve the people. This is Mao's idea. Contemporary artists can learn something from Mao. I once made a work in which, if the text is read from left to right in the way it appears it ought to be read, it doesn't make any sense. If, on the other hand, you read it top to bottom, right to left, then the characters link together and make sense. This text is from Mao's "Talks on Art and Literature." If you read it horizontally, you can't get the exact meaning, but you still have the sense that it's Mao talking.

Gu: Yes, art as a service to the people. That's Mao's idea.

December 18, 1998

44

Believing Is Seeing: Transforming Orientalism and the Occidental Gaze

John Kuo Wei Tchen

Introduction

Tchen's essay, one of several introducing the catalog for the 1994 Asia Society show *Asia/America*, provides historical and theoretical background for readings of Asian American art. Beginning from Orientalism – the Western creation of "the Orient" as an object of study – in order to set up an opposition between the Western Self and the Eastern or Oriental Other, Tchen traces the history of Orientalist images, immigrant policies, and attitudes in nineteenth- and twentieth-century America. He describes a world of yellowface humiliation in which immigrants must conform to a created image of "Chinee" in order to survive in the USA. While in some ways his initial historical discussion may seem distant from contemporary concerns, he connects this older discourse on "the Oriental" to film, advertising, and other popular media of the 1990s, a list of examples that, unfortunately, continues to grow. Tchen thus paints a picture of the historical and social space from which Asian American artists must work. Similar historical research can be done for Asian immigrants in the UK and elsewhere in the West; while the details and history certainly differ, Tchen's message – of the difficulty of carving a space for oneself as an Asian American given these Orientalist preconceptions – still applies.

John Kuo Wei Tchen, "Believing Is Seeing: Transforming Orientalism and the Occidental Gaze," pp. 13–25 from Margo Machida (ed.), *Asia/America: Identities in Contemporary Asian American Art*. New York: The Asia Society Galleries and the New Press, 1994. Reprinted by permission of The Asia Society.

The term Orientalism as Tchen uses it relies on Edward Said's book *Orientalism* (1978). Said's work focused on the Middle East and northern Africa as the "Orient" for the French and British in the nineteenth century. He argues that through literature, art, scientific study, travel guide books, legislation, and a variety of other means, the Western societies who colonized places like Algeria (France) and Egypt (France and Britain) created an image of the Orient that justified colonial rule and produced a dualistic relationship of Western superiority and Eastern inferiority. Tchen uses Said's concepts to read similar asymmetries of power in Asian American history, asymmetries that continue even after legislation has in some cases ostensibly eliminated such constructions of otherness.

Part of Orientalism is the acknowledgment that the Western vision of the East seems internally contradictory: stereotypes of the Asian dragon lady rub shoulders with images of the shy, soft-spoken Asian woman. Some of this has to do with class, as a distinction between the elite Asian immigrant and the worker existed in both stereotype and reality. Tchen closes with an articulation of the difficulties of being an artist in this environment, hedged in on one side by his discussion of America's Orientalism and on the other by the art world's preoccupation with the modernist genius. In the end he raises more questions than he answers and offers one way of approaching Asian American art that stays true to the struggles these artists encounter as they pursue their chosen paths.

To find a place for oneself in this culture is a political act.

May Sun

I first thought of the intricacies of cross-cultural representation when I received my high school graduation "portrait." It was a black-and-white photograph expertly retouched and hand-tinted by the enterprising photo company, presumably to highlight attractive features and to minimize the undesirable skin eruptions common during those awkward years. Upon receiving the photograph, I didn't recognize myself. Surely the image was of someone else. The skin tones were rather odd and yellowed and my eyelids had been made puffy – a bit like those of white actors made up as the ace Hollywood sleuth Charlie Chan. I interpreted the photographer's intervention as a well-intentioned effort to make me look "better." In the representer's mind's eye I became more properly "Oriental." This was my first explicit understanding of being cast in yellowface, and of how deeply this phenomenon is inscribed into American ways of seeing.[1]

Zones of Dominance

This process of yellowface enculturation has broad yet largely unacknowledged relevance for both Asians and Americans. Virtually any person of Asian

descent – American or non-American – has been perceived by "Occidentals" of European descent as an "Oriental" other in some zone of contact. Given the legacy of different European colonialisms and the globalization of MTV culture and capitalism, these zones of encounter have also become zones of symbolic and actual dominance. That process has not only defined the identities of peoples and cultures being represented but also the identities of peoples and cultures doing the representing. The types of Orientalism and contexts in which they appear are actually quite varied and complex. For the purposes of this brief essay, I first describe Protestant, Anglo-American Orientalism, the primary United States form, and then discuss the problems that diverse émigré Asian artists encounter working within this environment.[2]

Orientalism, that eclectic, centuries-old master discourse, still filters virtually all that Westerners perceive of and act upon Asians, and affects even the most recent Asian immigrants.[3] *Rambo–Karate Kid–Kickboxer I, II, III* type films, China-loving/Japan-bashing (or vice versa), Ivory and Merchant's colonialist epics, cartoonist Matt Groening's parodies of South Asian British speech, Americans' penchant for certain Chinese/Japanese/Thai/Indian foods, jokes about bad Asian drivers ad nauseum all greet these immigrants with their first breath of American air. Not only do these individuals come to realize that they are now "ethnics" but they also learn of their ascribed racial identity. They are Korean (not a person from such-and-such a neighborhood in Seoul) and they are "Yellow" or "Oriental" (as opposed to "Black" or "White"). If they are female, certain indiscriminate associations come into play: *Suzie Wong, Miss Saigon/Madame Butterfly*, silk, bound feet, belly dancing, kimonos, chopsticks stuck in elaborately piled black hair, and so on. If they are of an elite class or appear to be bourgeois, they are expected to be experts of traditional court cultures and certain inscrutable philosophies. If they are poor, "heathen" laborers, they are particularly vulnerable to hostility and violence. Chinese men, of whatever class, quickly learn that they are nonthreatening as long as they do not challenge white male authority or take jobs when white men are unemployed. And as in the case of a lost Japanese student in Baton Rouge looking for a Halloween party, they can be shot and killed legally because they are perceived by a property owner as "threatening." Asian gays and lesbians may discover the added dominance and submission obsessions projected upon them by non-Asians. Filipino nurses discover that speaking to each other in Tagalog constitutes a severe threat to their fellow workers. Native Hawaiians are greeted and treated by newcomers as quaint, happy-go-lucky dancing primitives.[4] You can add your own variation to this list.

Such ideas of otherness share a certain common power dynamic. The Anglo-American tradition of rigid, polarized distinctions between heaven and hell, rational and irrational, male and female, active and passive, modern and traditional has created a peculiar cognitive strategy in which those included in "We The People" project onto cultural others whatever they believe they themselves are not. Two projection strategies have been deployed: (1) we are, therefore they are not, which further proves that we are; and (2) we are not, therefore they

are, which further proves that we are not. Benjamin Franklin, Thomas Jefferson, among other founding fathers, envied the wealth and civic authority of elite Chinese culture. They used this image of the Oriental other to instruct and inspire what this young nation was not. In fact, in the midst of the Revolutionary War for independence, George Washington regularly took time out from battle to correspond with his favorite merchants to purchase teas and porcelainware. For them and others who romanticized China and Japan, mimicking these idealized Orientalist constructs produced the popular rage for Chinoiserie and Japonisme. In contrast, the dark side of our much-prized Western Enlightenment heritage produced the far better-known "negative" projections of Asians as evil incarnate and villains, or Mr and Ms Hydes in yellowface, the antithesis of the virtuous West.[5]

These fetishes have been refined and elaborated in actual zones of contact with peoples of Asian heritage in Asia and elsewhere: Thai restaurant in the suburbs, touristy gift shops in Little Tokyo, at museum gallery talks, in telephone-sex ads, at gay bars, at Bruce Lee films, in Michael Crichton's *Rising Sun* novel turned into a blockbuster movie, at the red light fringes of US military bases, or some other Occidental/Oriental site. Although other types of relationships may certainly be possible, the typical, naturalized relationship has been one of dominance and submission. This history of Orientalism (along with Primitivism, directed at "darker" peoples) has been entwined into the development of European Enlightenment culture. Deep cultural structures of possessive individualism have penetrated every aspect of everyday life, including the most intimate ways of thinking about the body. And inversely, these everyday notions of the individual, bodily self and "otherness" have been projected out – onto the household, cityscape, and finally writ large onto global boundaries and zones.[6]

The Anglo-American body, in particular, has been segmented and ranked in relation to Western Enlightenment hierarchies. Like industrializing, urbanizing societies, every part of the body is to perform a specialized, rationalized function. At the top, of course, is the brain, which purportedly commands and retains all. It is understood as the "pure" superior organ of "enlightenment." The five senses are the organs of refinement and "taste," with sight and hearing considered the most prized possessions. The hands and musculature do manual, "sweaty" labor. Erogenous zones and sexual organs are strictly "private" and "X-Rated." And, finally, natural bodily excretions, like sweat, menstrual blood, urine, feces, and any type of mucus or emissions are generally thought to be "dirty" and best removed from the body in the most expedient, private ways possible. The spatial relations of the Victorian house, which still deeply influence Anglo-American modernist cultures today, manifested and reinforced such sociocultural attitudes. The library and parlor rooms represented the most important public displays of family character, whereas the privy or "out"-house and the kitchen, the sites in which bodily needs were met, were private and out of the way.[7] Etiquette manuals, discussions of household decoration and management, and guides to the "sunlight" and "shadows" of the urban landscape became required readings for the "civilized."[8]

479

The late-nineteenth-century association of Chinatown as a downtown, unclean zone of opium dens, gambling parlors, rats, underground tunnels, filth, and disease made it fascinating to those who sought some release from the dominating culture. In this sense, Victorians needed to both feel they could control Orientals and simultaneously not have any control. These attitudes and practices have operated sub rosa in the United States, just beneath a veneer of social rationality yet always filtering feelings of love, attraction, repulsion, and hatred. Rigidly bound norms of behavior necessarily created obsessive sites of uncontrollability. For example, while good bourgeois city dwellers fussed over their parlor displays of Oriental objets d'art as symbols of their elevated tastes, they also became obsessed with reforming (and enjoying) Orientalist evil.[9]

Furthermore, with the eclipse of romantic Enlightenment attitudes, Asian bodies, among others, were considered biologically different and inferior. In the American Orientalist context, the racialized Chinese body was the most observed and obsessed over. In part because of the nineteenth-century prevalence of Chinese immigrants but also because of a continuing fascination with the China market. (Besides, the great variety of Asian peoples, languages, religions, and cultures has consistently caused great confusion to the American general public. Consequently, Chinese have regularly stood for and been confused with many other Asian peoples in the United States.) In view of this historical position in the nineteenth-century United States, I will limit the remarks of the following paragraphs mainly to the Chinese American relation to Orientalist culture.

How did Chinese, or to use the terminology of the times, "Mongoloid," brains and bodies compare with those of Occidentals? Western European and European American folk mythology became scientized in the nineteenth century. Differences in body shapes and shades were measured, classified, and ranked hierarchically. Phrenologists, physiognomists, and craniologists ruled that forehead slopes, skull shapes, and brain capacities determined degrees of intelligence and civilization. Their data showed that "Mongolians" and "Malays" were considered halfway up the scale of human development, below "Caucasians" and above "Negroids."[10] American medical doctors testified that Chinese brought leprosy, yellow fever, and other diseases to the United States, and that their nerve endings were farther from the surface of the skin, which enabled them to work harder than European Americans, and that they were therefore unfair labor competition. And in the red light districts near neighboring U.S. Army bases, it was said that Asian women's vaginas were shaped differently than other women's.[11]

This "scientific" evidence added proof to what most Americans already felt they knew from the popular commercial culture. Advertising, stage performances, Tin Pan Alley sheet music, publishing, records, and both silent and "talking" films regularly mimicked what Chinese and other Asians looked like, sounded like, acted like, and thought like. No matter that most Americans never saw actual living and breathing Asians; they came to see staged and later filmed representations of European Americans playing Asian caricature types and yellowface

makeup kits became a standard part of American and Anglo-American theater. The costuming notes for George Baker's "New Brooms Sweep Clean" were typical of how a Chinese male became imagined: "Jing (as a Chinaman), blue blouse, loose yellow pants fastened at the ankles, white stockings, heavy brogans, flesh colored skull-cap . . . a long black cue [*sic*], very red face, black about the chin and over the lip to have the appearance of being unshaved."[12] The "Ah Sin" or "Heathen Chinee" caricature became the standard representation of a Chinese man – unmanly, asexual, waiflike, comic, yet slightly sinister and threatening.[13]

These expressions of Protestant Orientalism in the commercial and popular culture have been acts of ritual performance, reinforcing notions of "we"ness and cultural difference. The American stage helped to create controllable, commercial stereotypes that could then be imposed on living and breathing Chinese as standards of acceptable behavior. The mock opium-den tours organized in New York and led by the "mayor" of Chinatown, Chuck Connors, or Arnold Genthe's retouched photographs of San Francisco's Chinatown can be best understood in this way.[14] Waiters in Chinese restaurants and those who have had to work laundry counters have long known that Americans expect certain deferential and pidgin-English-speaking behavior. Good tips and repeat business have depended on it. Proper speech, the proper look, the proper smell, the proper behavior have been defined by the superior, rational, Protestant male self.[15]

As if the cultural and commercial expressions were not sufficiently persuasive, the attitudes embodied in American Orientalism came to be incorporated into this nation's immigration and civil laws, court cases, foreign policies, and ultimately the creation of segregated work and residential landscapes. The 1882 Chinese Exclusion Law, for example, was the first United States law to exclude immigrants on the basis of race or nationality. It was the forerunner of the better-known 1924 Immigration Act, which was applied more broadly to "undesirable" Eastern and Southern Europeans. The Chinese Exclusion Law and its subsequently amended versions, however, was not simply racially defined; it was qualified by class and gender. Those defined as laborers could no longer freely emigrate to the United States, nor could the wives and other family members of those who were already here. And given the 1790 Naturalization Act, nonwhites could not become naturalized citizens. Anti-"miscegenation" laws, furthermore, prohibited Chinese men from marrying non-Chinese women.

It should be clear that Anglo-American Orientalism was not all hostile. If one were a merchant, scholar, student, or diplomat one could, technically, immigrate freely and bring one's family. Indeed, many of the American cultural elite have harbored fond and "positive" feelings toward Asian court and elite cultures, especially their scholars and artists. Asian elites have been perceived to embody the revered Orientalist traits of hyper-aestheticism, refinement, simplicity, and arcane knowledge of ages past. Artists in particular have been cast as mystic masters whose work should deal with eternal beauty, timelessness, naturalism, harmony, and antimaterialism.[16] The contemporary representation of Asian Americans as a "model minority" is connected to these class and relational

perspectives. For example, I have argued elsewhere that neoconservatives and liberals alike have often explained the frequency of high school students of Asian heritage in the Westinghouse Science Award finalists by ascribing to them proto-Protestant Confucian and family values. Although Asian American student finalists have themselves criticized such unresearched generalizations, it is clear that the representation of Asians as a model American minority is used in relation to "less" successful African, Latino/a, and working-class Americans.[17]

Orientalism has also reinforced the idea of national boundaries and of national interests beyond the Pacific Coast. The 1784 voyage of the *Empress of China*, the first ship of the new nation to trade with China, sought to build the wealth of this country via the sumptuous, highly desired luxury goods manufactured by Chinese artisans. Trade with China marked the U.S. claim to international standing. However, by 1882, Chinese were thought to be infecting the American body politic with "slave," "heathen" labor with which Christian, family-oriented, white men could not compete.[18] By the 1890s, the "end" of the North American continental western frontier signaled an era of Pacific Rim expansionism and a century of virtually unabated economic interests and wars in Asia. Our national "fathers" believed it was this nation's divine and "manifest destiny" to expand westward past the Pacific Coast into Asia.[19] Yet while "free trade" was promoted abroad, intolerance was the policy at home. From 1882 to the present, protecting the borders from "alien" hordes of invaders has been a primary quick-fix obsession of domestic policymakers and the public. Indeed, early germ theory was intermixed with racial, anti-immigrant, and xenophobic rhetoric. The call to protect the national body politic from the attack of the impending "yellow peril" proved potent. Patrol of the Mexican-US border and Canadian immigration stations were first established to keep Chinese out of the country. And regular raids for such "illegals" in Chinatown reminded Americans of the dangers of letting down our vigilance.[20]

Such laws and attitudes clearly illustrate what the cultural scholar James Moy has called a "containment field," which in effect served as a territorial and spiritual internment camp. After 1882, this field limited and defined which Chinese could appear where. They were sorted and checked at the Angel Island Detention Center (among other federal detention facilities), and only the "acceptable" Chinese, those who could prove their elite pedigree, were allowed to enter. Once within the boundaries of the American continental "body," they were ghettoized. Chinese and whites in yellowface were allowed to appear on various stages, in dime museums, in circuses, and touristic venues in which non-Chinese could gaze at Chinese and mock-Chinese without being threatened. But the movements and opportunities of Chinese people in society at large was severely restricted.[21]

So how much has changed? The racially determined immigration laws were finally effectively repealed in 1965. Yet despite the repeal of de jure Jim Crow laws, the actual practice of Oriental containment has remained strongly embedded in the American national identity, imagination, and practice. Judging

from an advertisement for Canton Delicate Ginger Liqueur that appeared in the April 10, 1993, *New Yorker*, not much has truly progressed. The common advertising theme of desirable white female in a sexualized, submissive position with relation to a dominant, erect white male is typical. The stark use of colors, black in the clothing and a dark red in the background, contrasts with the blond woman's whiteness and adds dramatic intensity. But the key to the ad is the use of the words "Chinese Torture" in selling this "Chinese" product. "They call it torture. When your reason is threatened by your desire. Go for it!" The transgressive "Oriental" in this case – the locus of repressed fear and desire – is not a person but a thing, an intoxicating drink. And like advertising strategies for Opium perfume, the erotic, exotic, dangerous, sadistic Oriental is marketed as an object projected out of the omniscient self's "inner turmoil." Getting in touch with one's sexual desire, still repressed, is the promised result of association with things Asian. In effect, if one buys and consumes this mysterious, magical elixir (with implications of its being an "Oriental secret"), one can gain sexual potency and satisfaction.

Being Fetishized and Acts of Independence

Imagine, if you will, what it might be like to be an immigrant artist from somewhere out of Asia within the context of fin-de-siècle America. To create a "truthful" art, especially if it appears to be non-"traditional," is not considered "practical," especially not for a newcomer – definitely not for a person of the working classes and, if of the middle to upper-middle classes, a certain way to lose one's family's hard-earned security! Making art is particularly impractical for a person from a dramatically different cultural system – language, folkways, aesthetic codings are so different – how can one be understood across such a chasm?

These émigrés leave different localities, each of which has experienced some recombinant hybrid encounter with the West. Certainly the syncretic realities of post-Spanish Catholic colonialist and post-US Protestant colonialist culture in Manila is strikingly different from the experience of growing up in Buddhist Bangkok, and both of these are quite different from the diasporic, diplomatic world of being born Korean in Bonn. Nevertheless, even if one were to speak the Queen's English perfectly, or some American derivative, and have been schooled in colonial educational systems and neocolonial ways of being, to be anything more than a restaurant worker, a greengrocer, a seamstress, or a recruited professional working in that niche is very, very difficult. Even if one had watched all the American television programs, MTV twenty-four hours every day of the week, and even PBS, one would still not be prepared to realize how difficult it is to make a living at being a full-time or any-time artist. In this land of incredible material wealth, individualism reigns – and it promises both untold freedom and unimagined isolation. Recognition? Success? Self-realization? For a few, yes! yes!

483



But for the great majority, lots of non-art-related work to meet the bills. For them it must often be like being the proverbial salmon, swimming upstream against all odds to spawn, and then to die an unheralded death.

So why take such risks? Even if one were an artist in Asia, to continue that practice here must manifest some deep, driving force, some private proto-political, obsessive compulsion, to choose such an unpractical, nonimmigrant, individually driven, nonmainstream Asian, and (let us be frank) un-American way of life. Romanticism? Perhaps initially, but that quickly withers. And then, once this life is chosen, all too often the work is neither appreciated nor understood by the American public, nor by most community folks.

The convenient and dominant American answer, which has only recently been challenged in the postmodern fashion of the art world, is that of individual calling and genius. Artists are "bohemians" who "follow the beat of a different drummer" and, with some perseverance, "the cream rises to the top." For seemingly primordial reasons, creative people have to create. They are driven by some divine and idiosyncratic itch. The lone individual rises above the society in a universally superior display of extraordinary virtuosity, genius, and personal vision. Certainly, during the Cold War era, highly celebrated Western artists became symbols of the "freedom of expression" enjoyed by non-Communist moderns. Art and politics took on a particularly close identity. As Serge Guilbaut has argued, Abstract Expressionism was quickly appropriated by the powers that be to be the exemplar of capitalist ideological superiority. In a sense, the values attributed to these rebel male artists were also the values of a Malcolm Forbesian venture capitalist.[22]

Unfortunately, but not surprisingly, this still-dominant view of art and artists causes insensitivity to the riches of those working with other aesthetic trajectories. The recent rhetorical romance with postmodernist theories and multiculturalism has opened some space for critical discussion and practice, but in the art world this infatuation has yet to move beyond pluralist platitudes in support of understanding these basic cultural differences. The rhetoric of an inclusive "diversity" tends not to deal with underlying power relations and the sociocultural structures such as Orientalism. Therefore, such critics, museum directors, curators, and institutions tend to ignore the hard and unglamorous work at hand – the more fundamental critiques and practices necessary to alter the hierarchic process of visual arts production and criticism. In this sense, I agree with Barbara Christian's distrust of the recent academic and art world "race for theory" that is not grounded in addressing everyday lives.[23]

The artists whom curator Margo Machida has chosen for "Asia/America: Identities in Contemporary Asian American Art" can barely be understood within either the narrow auteur theory of artistic production or the I'm Okay, You're Okay – We're All Diverse school of liberal cant. They are not necessarily operating within the known, master narratives. Nor do they have the Clement Greenbergs to expound their universal virtues in the artist-critic-gallery-museum circuit that drives so much of the modern art market. Nor are they operating within the naif/folk craft scene assembled by colonial and neocolonial collectors making

forays into non-Western European cultures. Nor are they necessarily scrutable within the pluralist smorgasbord politics of multiculturalism.

But instead of trying to understand these artists from a Western art perspective, Machida has spent hours probing and learning how these artists understand their own works. Like a dedicated taxonomist, she has spent many more hours charting patterns among artists, and directs her critical eye and contextual understanding to the assembled works to help bring some analytic order to otherwise dispersed expressive fragments. Contrary to the established systems of art production and promotion, this curator/critic does not have one eye on the marketplace, but has fixed her gaze on the creative, cultural, and historical milieu in which these artists have been living. In her interpretive world, these are not the lone, idiosyncratic bohemians of dominant lore but expressive individuals performing within complex social landscapes. Artists and their creations, then, are brought back into the fold of living people and formative events – a simple, obvious, but nonetheless radically democratic attitude.[24]

For the Asian/Pacific American artists assembled for this exhibition, the year 1965 is a key date. That was the year the civil rights movement had the unintended effect of challenging racially defined quotas limiting immigrants from Asian countries. Beginning in 1968, when the new law went into effect, and continuing to this day, Asian immigrants have dramatically changed the makeup of this country. Virtually all the artists in "Asia/America" are part of the post-1965 generation. In many ways their experiences are dramatically different from those of earlier Asians and Pacific Islanders: they are free to establish families; they can become citizens; they are often educated and professional (the preference categories of immigration laws have made this so); and they are leaving postcolonial Asian nations.

Yet once they live in the United States for any length of time, the new immigrants begin to feel the sticky cobwebs of historical forces that still have a powerful impact on the Asian experience of the United States. Protestant Orientalism now, and as it has been transformed over the life of this nation, is deeply inscribed into the wishes, desires, fascinations – the obsessions – of this nation. On multiple levels these charged emotional associations can be understood as fetishes. What happens when Asian peoples and their cultures are ensnared by these powerful Orientalist scripts? From the point of view of the Western fetishizer, the Asian fetishee has a set of perverse norms of behavior within which to act.[25] The more distanced Americans are from actual Asian people and cultures, the easier it has been for the imaginary Orientalist reality to flourish and impact upon daily life and public policy.[26]

This is not a hermetic, totally controlled system of containment, however. There are opportunities for articulating alternative and transformative sensibilities, and I believe the artistic visual statements of these immigrant artists can best be understood in this light. Obsessions are generally thought to be entrapping and confining compulsions – the opposite of acts of liberation. Yet if a dominating culture has made a people into fetishized projections of them-

485

selves, with no independent voice or action, when the fetishized parties seek to finally speak for themselves, they need to decode and deconstruct what has happened to them. This seemingly self-conscious behavior is in effect an act of spiritual recovery.

The artworks gathered here are, in part, efforts to express and reformulate Asian identity in the West. If what I have argued about the nature of Orientalism in American culture is accurate, then these artists necessarily have to reckon with profoundly disempowering structures in their lives: and they have done so in a variety of ways that explicitly and implicitly chart territories beyond the (all-too-well-) known worlds of Orientalism and Occidentalism. Or to restate artist May Sun's point that serves as the epigraph to this essay, for Asian/Pacific peoples to find a place in a culture in which they are disempowered, it is necessarily a – small "p" – political act of rejection simultaneous with a searching for transformative alternative expressions resonant with one's "true" lived experience. These artists are visualizing and making tangible the often invisible and inchoate forces that have affected their identities and identifications. They are feeling the edges and contours of their various zones of contact and conflict. In their own ways, each artist is asking him- or her-self and the would-be audiences a series of existential and political questions. In this sense, these works are antifetishistic and anti-Orientalist.

A number of these artists' works are explicitly anti-Orientalist and evocative of the famous "double-consciousness" described by W. E. B. Du Bois. They are searching for the distinctive place of Asia/America; they are the defiant voices rejecting subjugation and asserting cultural autonomy. What does it mean to suddenly be cast as a racial "other"? Can one find historical roots? Can one find pre-Western "authentic" roots? In an Orientalist world, is it sufficient to be non-Orientalist?

Yet other artists in "Asia/America" implicitly question the very binary nature of Du Bois's "twoness." Aren't all expressions and all boundaries necessarily confounded mixtures of these two souls? Isn't it increasingly impossible to untangle the two? As we enter into the "Pacific Century," it will probably be more difficult to make easy distinctions between cultures. Are Korean Christians necessarily less Korean? Or are Amerasian children not Americans? Surely seeking fundamentalist purity in an ever-mixing world has its own pitfalls. Does it really do much good to make proprietary claims that the potatoes in *oorla-kayanga kari*, a south Indian curried dish, were originally cultivated by the native peoples of the Americas? Or that the television set was invented in the United States but is now "copied" and made almost exclusively in Asia? Should we bother to sort out twonesses in a globalizing, market-driven world? The very act of questioning the legitimacy of tightly drawn boundaries is itself an important rejection of imposed binary categories and the beginning of visualizing a post-Orientalist future in that nurturing, anticipatory space that Trinh T. Minh-Ha calls "the interval" and Homi Bhabha calls "the third space."[27]

Furthermore, other artists explore the complications beyond "twoness," including gender, class, sexuality, generation, and religion. In an era in which capitalism is no longer synonymous with Protestantism, how is possessive individualism being modified in non-Christian Asian cultures? Shouldn't we be speaking of multipled, layered, and even contradictory identities? Do identities have to be fixed in a geographical place? One culture? What does it mean to be in exile? Rootless? Alienated from one's home? From one's body? Can one be both traditional and modern? And what of the problems of multiple oppressions? What should be done when one has been anti-Orientalist but also misogynist? Or Orientalist but antihomophobic?[28]

Each artist may be searching to find his or her own "truth" in an obsessive journey, but as an ensemble it is clear there is no one "correct" answer to their non- and anti-Orientalisms. Their creative answers are provisional and particular to themselves. Their art may, therefore, appear rather opaque to those not equipped with the cross-cultural tools to decipher their images. Clearly, the more we understand each individual's concerns and life stories – in other words, the more we understand the larger contexts of their creativity – the better chance we have of more fully feeling and understanding the power of their work.

Although these are émigré Asian artists, who are often viewed and may still view themselves as "foreign," they are creating in a long, largely unacknowledged American tradition of anti-Orientalism. The personal letters of Chang and Eng Bunker, the famous "Siamese Twins" who performed in the United States and Europe from the 1820s until their deaths in the 1870s, clearly reveal their artistic and personal struggles with exotification and commercial exploitation. Chinese immigrants who were detained on Angel Island in San Francisco Bay, from 1910 to 1920, carved poems of frustration, longing, and anger on the wooden barrack walls. Filipino migrant workers like Carlos Bolusan left eloquent oral and written testimonies claiming their rights as Americans. Japanese Americans interned in many desert "camps" during World War II reworked the arid landscapes into bonsai gardens and baseball diamonds. Theresa Cha, the Punjabi Mexicans of the Imperial Valley, Yun Gee, and so many others that Americans don't know about are also part of this Asian/Pacific American lineage.[29] Why don't Americans know about them?

It is worth noting, too, that viewing these artists simply as immigrants, or minorities, or new Americans does them and ourselves a grave injustice. We Americans risk self-delusion when we continue to view the world as West versus East. Our material goods, fashions, foods, and music videos speak of a commodified global culture. Perhaps only the elite may speak of being international citizens, but anyone who has become part of the global electronic village has become translocal in one way or another. Through the media, we vicariously experience a mind-numbing montage of images and emotions: the napalming of innocents in Vietnam; the mass murder of school children, many of whom were Southeast Asian refugees, in Stockton, California; the Tiananmen massacre; Muslim-Hindu strife in Bombay; Chinese "slaves" off Rockaway Beach. Who

can help sort out this visual chaos for independent-minded, concerned Americans? Dan Rather and Connie Chung? We'd have a far better chance with the artists included here.

In the end, the artwork in "Asia/America" represents layers of cultural mixtures, hybrids that defy any dogmatic notion of purity. Yet to truly appreciate this art requires us to rid ourselves and our culture of the fetishes of Protestant Orientalism. The Jekyll and Hyde performance of pure good and pure evil, good self and evil self, normative self and nonnormative others does not allow for complexity, ambiguity, and variation. But where can otherwise isolated Asian/Pacific American artists express such subtle and nuanced perspectives? The practices of community-based organizations, museums, the art market, and associated media apparatus, therefore, play critical roles in furthering, or in challenging, these Orientalist constructs. Are they capable of being sufficiently reflexive? This show, organized by The Asia Society Galleries, is a breakthrough. It provides a temporary, nurturing space in which nuanced voices can be articulated without Orientalist wrappings. It is curious that simply trying to present and understand these Asian/Pacific artists from their own cultural perspectives is necessarily such a radical democratic project. But that is the tragedy, and that is the hope.

Notes

I'd like to thank Vishnakha Desai for initiating the *Asia/America* exhibition and the collaborative spirit and intellectual integrity she has brought to the project. I've been fortunate to work with and learn from Margo Machida at the Asian/American Center of Queens College (CUNY) these past few years and greatly value her constructive critical comments. And editor David Dternbach has made quick, incisive suggestions on how to improve this essay. The epigraph is from Sonora Hale's 1993 article [ed. note: this article is not cited in the original].

1 This essay focuses on the yellowface enculturation of seeing. In a forthcoming book I will be dealing with the Orientalist socialization of the five senses in the nineteenth-century commercial culture in relation to Chinese. For a discussion of blackface and yellowface in regard to the process of assimilation into the mainstream, see Michael Rogin, "Making America Home: Racial Masquerade and Ethnic Assimilation in the Transition to Talking Pictures," *Journal of American History* 79, no. 3 (December 1992), 1050–77.

2 I have found it terribly difficult to generalize about the vast diversity of the Asian/Pacific American experience. My own research and writing has focused on the Chinese experience in the United States with relation to the dominant political culture. I believe parallel relational studies need to be conducted with other Asian American ethnic and diaspora histories before we can understand the differences and nuances of each particular Orientalist experience.

3 Edward Said, *Orientalism* (New York: Pantheon, 1978): Lisa Lowe, *Critical Terrains: French and British Orientalisms* (Ithaca: Cornell University Press, 1991); Rey Chow, *Writing Diaspora: Tactics of Intervention in Contemporary Cultural Studies* (Bloomington: Indiana University Press, 1993). I agree with Professor Lowe's analysis that

not one but many Orientalisms varied from one European-derived culture to the next and from one local circumstance to the next. Also see Vassilis Lambropoulos, *The Rise of Eurocentrism: Anatomy of Interpretation* (Princeton: Princeton University Press, 1993); K. N. Chaudhuri, *Asia Before Europe: Economy and Civilization of the Indian Ocean from the Rise of Islam to 1750* (Cambridge: Cambridge University Press, 1990).

4 "Defense Depicts Japanese Boy as 'Scary'," *The New York Times*, May 21, 1993; David E. Sanger, "After Gunman's Acquittal, Japan Struggles to Understand America," *The New York Times*, May 25, 1993; Peter Applebome, "Verdict in Death of Student Reverberates Across Nation," *The New York Times*, May 26, 1993; "US Civil Rights Inquiry is Sought in Louisiana Slaying," *The New York Times*, May 28, 1993; Renee Tajima, "Lotus Blossoms Don't Bleed: Images of Asian Women," in *Anthologies of Asian American Film and Video* (New York: Third World Newsreel, 1984); Marjorie Garber, "The Occidental Tourist: M. Butterfly and the Scandal of Transvestism," in *Nationalisms and Sexualities*, eds. Andrew Parker, Mary Russo, Doris Sommer, and Patricia Yaeger (New York: Routledge, 1992), 121–46; Richard Fung, "Looking for My Penis: The Eroticized Asian in Gay Video Porn," in *How Do I Look? Queer Film and Video*, ed. Bad Object-Choices (Seattle: Bay Press, 1991), 145–68; Elizabeth Buck, *Paradise Remade: The Politics of Culture and History in Hawaii* (Philadelphia: Temple University Press, 1993).

5 For a more extended discussion of these issues, see John Kuo Wei Tchen, "New York Before Chinatown: Orientalism, Identity Formation, and Political Culture in the American Metropolis, 1784–1882" (PhD Dissertation, New York University, 1992).

6 C. B. MacPherson, *The Political Theory of Possessive Individualism: Hobbes to Locke* (Oxford: Oxford University Press, 1962); Albert O. Hirschman, *The Passions and the Interests: Political Arguments for Capitalism Before Its Triumph* (Princeton: Princeton University Press, 1977); Asa Briggs, *Victorian Cities* (Berkeley: University of California Press, 1993); Paul Boyer, *Urban Masses and Moral Order in America, 1820–1920* (Cambridge, Mass.: Harvard University Press, 1978); George W. Stocking, Jr., *Victorian Anthropology* (New York: Free Press, 1987); Marianna Torgovnick, *Gone Primitive: Savage Intellects, Modern Lives* (Chicago: University of Chicago Press, 1990); Sally Price, *Primitive Art in Civilized Places* (Chicago: University of Chicago Press, 1989); Lois Whitney, *Primitivism and the Idea of Progress in English Popular Literature of the Eighteenth Century* (New York: Octagon Books, 1973); Edward Soja, *The Postmodern Geographies* (New York: Verso, 1989); Henri Lefebvre, *The Production of Space* (Oxford: Blackwell, 1992).

7 Michel Foucault, *Discipline and Punish: The Birth of the Prison* (New York: Vintage, 1977); Peter Gay, *Education of the Senses* (New York: Oxford University Press, 1984); Don Richard Cox, *Sexuality and Victorian Literature* (Knoxville: University of Tennessee Press, 1974); John F. Kasson, *Rudeness and Civility: Manners in Nineteenth-Century Urban America* (New York: Hill & Wang, 1990); Carroll Smith-Rosenberg, *Disorderly Conduct: Visions of Gender in Victorian America* (Oxford: Oxford University Press, 1985).

8 Kasson, *Rudeness and Civility*; Barbara Welter, "The Cult of True Womanhood: 1800–1860," *American Quarterly* 18 (Summer 1966), 151–74; Mary Cowling, *The Artist as Anthropologist: The Representation of Type and Character in Victorian Art* (Cambridge: Cambridge University Press, 1989); Stephen Jay Gould, *The Mismeasure of Man* (New York: Norton, 1981).

9 Peter Stallybrass and Allon White, *The Politics and Poetics of Transgression* (London: Methuen, 1986).

10 Tchen, "New York Before Chinatown," 163–208; Partha Mitter, *Much Maligned Monsters: A History of European Reactions to Indian Art* (Chicago: University of Chicago Press, 1992); David Gordon White, *Myths of the Dog-Man* (Chicago: University of Chicago Press, 1991); John Block Friedman, *The Monstrous Races in Medieval Art and Thought* (Cambridge, Mass.: Harvard University Press, 1981). Such research is still being conducted, for example, see Fung's discussion of the work of Canadian psychologist Philippe Rushton in "Looking for My Penis" and Martin Baker, "Biology and the New Racism," in *Anatomy of Racism*, ed. David Theo Goldberg (Minneapolis: University of Minnesota Press, 1990), 18–37.

11 The Committee, *Chinatown Declared a Nuisance* (San Francisco: The Committee, 1880); Curt Abel-Musgrave, *The Cholera in San Francisco* (San Francisco: San Francisco News Company, 1885); Arthur B. Stout, *Chinese Immigration and the Physiological Causes of the Decay of a Nation* (San Francisco: Agnew & Deffebach, 1862). For a provocative discussion of the pornography of Asian women's and Asian gay men's bodies, see Moy's last chapter, "Imperial Pornographies of Virtuosity: Problematizing Asian American Life," in James S. Moy, *Marginal Sights: Staging the Chinese in America* (Iowa City: University of Iowa Press, forthcoming); and Fung, "Looking for My Penis."

12 Tchen, "New York Before Chinatown," 365–431; Robert Bogdan, *Freak Show: Presenting Human Oddities for Amusement and Profit* (Chicago: University of Chicago Press, 1988); George M. Baker, "New Brooms Sweep Clean," 1870 (Readex Microfilm), 263; *Denison's Make-Up Guide for Amateur and Professional* (Chicago: T. S. Denison & Company, 1932), 68.

13 For a discussion of the "Ah Sin" trope, see Tchen, "New York Before Chinatown," 367–82; Bret Harte, *The Heathen Chinee*, illustrated by S. Eytinge, Jr. (Boston: Osgood, 1871); "Heathen Chinee," stereopticon card, Wong Ching Foo Collection, NY.

14 John Kuo Wei Tchen, "Quimbo Appo's Fear of Fenians: Chinese-Irish-Anglo Relations in New York City," in *The New York Irish, 1625–1990*, eds. Ronald H. Bayor and Timothy Meagher (Baltimore: Johns Hopkins University Press, 1994); John Kuo Wei Tchen, *Genthe's Photographs of San Francisco's Old Chinatown* (New York: Dover Publications, 1984).

15 Moy, *Marginal Sights;* Jean H. Baker, *Affairs of Party: The Political Culture of Northern Democrats in the Mid-Nineteenth Century* (Ithaca: Cornell University Press, 1983), 220; Mark C. Carnes, *Secret Ritual and Manhood in Victorian America* (New Haven: Yale University Press, 1989), 120–27, 156–58.

16 This point should be credited to Margo Machida's comments on an earlier draft of this essay.

17 John Kuo Wei Tchen, " 'Whiz Kids' and American Race Relations: Some Thoughts on the 'Model Minority' Phenomenon," in *Race, Gender, and Eyeglasses*, ed. Roger Sanjek (Flushing, NY: Asian/American Center, 1988); and John Kuo Wei Tchen, "Modernizing White Patriarchy: Re-Viewing D. W. Griffith's Film *Broken Blossoms*," in *Moving the Image: Asian Pacific Americans in the Media Arts*, ed. Russell Leong (Los Angeles: UCLA Asian American Studies Center & Visual Communications, 1991), 133–43.

18 Tchen, "New York Before Chinatown."

19 Michael H. Hunt, *Ideology and US Foreign Policy* (New Haven: Yale University Press, 1987); Gil Loescher and John A. Scanlan, *Calculated Kindness: Refugees and America's Held-Open Door, 1945–Present* (New York: Free Press, 1986).

20 Sucheng Chan, ed., *Entry Denied: Exclusion and the Chinese Community in America, 1882–1943* (Philadelphia: Temple University Press, 1992); Sandra Pollock Sturdevant and Brenda Stoltzfus, *Let the Good Times Roll: Prostitution and the US Military in Asia* (New York: The New Press, 1992).

21 Tchen, *Genthe's Photographs*, 19–32; Tchen, "New York Before Chinatown," 48–113, 163–208; Moy, *Marginal Sights*. Cary-Hiroyuki Tagawa, a Japanese American actor who has a lead role in Philip Kaufman's *Rising Sun* (1993), has described his performance career as one of working "within the limits of a limited character" (Michael Shapiro, "Is 'Rising Sun' a Detective Story or Jeremiad?," *The New York Times*, July 25, 1993).

22 The Paul Mazursky film *An Unmarried Woman* (1978), with Alan Bates portraying a Soho artist, embodied many archetypal notions of the character and personality of a modern artist in American society. On Abstract Expressionism, see Serge Guilbaut, *How New York Stole the Idea of Modern Art: Abstract Expressionism, Freedom, and the Cold War* (Chicago: University of Chicago Press, 1983).

23 For an interesting effort to educate and change the art museum world, see *Different Voices: A Social, Cultural, and Historical Framework for Change in the American Art Museum*, ed. Marcia Tucker (New York: Association of Art Museum Directors, 1992). For a general critique of recent intellectual fads, see E. San Juan, Jr., "Beyond Identity Politics: The Predicament of the Asian American Writer in Late Capitalism," *American Literary History* 3, no.3 (Fall 1991):542–65; Barbara Christian, "The Race for Theory," *Cultural Critique* 6 (Spring 1987):51–63. In this essay I am trying to maintain the distinctions between a politics of "diversity" and a more radical politics of "difference" that Bhabha articulates. Jonathan Rutherford interview with Homi Bhabha, "The Third Space," in *Identity: Community, Culture, Difference*, ed. Jonathan Rutherford (London: Lawrence & Wishart, 1990), 207–21.

24 Vera Zolberg, *Constructing a Sociology of the Arts* (Cambridge: Cambridge University Press, 1990). This approach can be described as "dialogic" or "dialogue-driven"; for some discussion of the concept, see John Kuo Wei Tchen, "Towards a Dialogic Museum: The Chinatown History Museum Experiment," in *Museums and Communities*, eds. Ivan Karp and Steven Lavine (Washington, DC: Smithsonian Institution Press, 1990), 285–326.

25 In colonial anthropology, fetishes have been described as the superstitious beliefs of primitive peoples. They are often thought of as talismans or magical objects imbued with powers believed to have efficacy independent of the human possessor. Arjun Appadurai, "Introduction: Commodities and the Politics of Value," in *The Social Life of Things: Commodities in Cultural Perspective*, ed. Arjun Appadurai (Cambridge: Cambridge University Press, 1986), 3–63; Hal Foster, "The Art of Fetishism," in *Fetish, The Princeton Journal*, special issue (Princeton: Princeton Architectural Press, 1992), 6–19; Emily Apter and William Pietz, eds., *Fetishism as Cultural Discourse* (Ithaca: Cornell University Press, 1993).

491

26 Frank Chin, "Racist Love," in *Seeing Through Shuck*, ed. Richard Kostelanetz (New York: Ballantine, 1972); Yi-Fu Tuan, *Dominance and Affection: The Making of Pets* (New Haven: Yale University Press, 1984).

27 W. E. B. Du Bois, *The Souls of Black Folk* (Chicago: A. C. McClurg, 1903). Trinh T. Minh-Ha comments, "Towards a New American Sensibility" roundtable, San Francisco, 1990, organized by Peter Pennekamp and Marie Acosta Colon, cited from 6/ 90 transcript, 39–40; Rutherford interview with Bhabha in *Identity*, 220–21; John Kuo Wei Tchen, "Rethinking Who We Are: A Basic Discussion of Basic Terms," in *Achieving Cultural Equity: Voices from the Battlefront*, ed. Molefi Asante (Trenton, NJ: Africa World Press, 1993). For a discussion of how to move past dualistic thinking, see John L. Hodge, "Equality: Beyond Dualism and Oppression," in *Anatomy of Racism*, 89–107.

28 Such are the questions explored by Trinn T. Minh-Ha in *Woman Native Other* (Bloomington: University of Indiana Press, 1989) and *When the Moon Waxes Red* (New York: Routledge, 1991).

29 Tchen, "New York Before Chinatown," 163–279; Him Mark Lai, Genny Lim, and Judy Yung, *Island: Poetry and History of Chinese Immigrants on Angel Island, 1910– 1940* (San Francisco: Hoc Doi Project, 1980); Patricia Nelson Limerick, "Disorientation and Reorientation: The American Landscape Discovered from the West," *Journal of American History*, 79, no. 3 (December 1992): 1021–49; Theresa Hak Kyung Cha, *Dictée* (New York: Tanam Press, 1982); Karen Isaksen Leonard, *Making Ethnic Choices: California's Punjabi Mexican Americans* (Philadelphia: Temple University Press, 1992); Joyce Brodsky, *The Paintings of Yun Gee* (Storrs, Conn.: William Benton Museum of Art, 1979).

Index

Abe Nobuya 453
abhishekha (initiation ceremony) 142
Abstract Expressionism 455, 484
Abul Fazl 93, 94
academic painting 383
Acker, William 242
acrylic paint 159
action painting 455
actor prints (*yakusha-e*) 411
Aditya (god of solar month) 86
advertising 483
aesthetics 2, 77, 141
Afghan people 102, 105
Afghanistan 13, 31, 101
Africa 7
 northern 477
African American 482
afterlife 5
Agni 39
Agra 95, 99, 102, 104–5, 107,
 110–12, 114
Agra fort 95, 106, 110
Ahmadnagar 111
Ain-i Akbari (*Laws of Akbar*) 93
Ajita, disciple of the Buddha 239
Akasaka 454
Akasegawa Genpei 452, 455–6, 458–60
Akazome Emon 306
Akbar 93–4, 97, 102–3, 105, 107, 110,
 112–14, 118–19, 124
 tomb of 108, 109, 111–12, 115

Akbarnama 5, 93–4, 98, 118
Akikonomu 316
Alamgir 110
album (*muraqqa*) 98
album painting 354, 388
alcohol 98–9
al-Daurani, Rabia 111
Alexander 15, 20
Algeria 477
Ali (son-in-law of the Prophet
 Muhammad) 131
Ali Raza 126
alienation 451, 471
Allah 131
Altick, Richard 134
Amar Singh II, Rana of Mewar 121, 122,
 123
Amaterasu 261–3, 265–6, 268–9, 271
amateur painting 289, 328, 352, 381
Ambala 180
Amber 110
Ambika 41
Americanization 452
Americans 157
Amida Buddha 295–7, 300, 301, 304,
 310
Amitabha 142, 296, 298, 308
Amman 131
Amritsar 180
An Lushan rebellion 279
Anand, Mulk Raj 77

Ananda 22, 24, 29
anarchism 452, 460
ancestor worship 208, 212, 214–15,
 250, 370, 373
Anderson, Aeneas 5, 7, 376, 379
Andhra Period 11
Andhra State 20
Andong 401
Angel Island Detention Center 482, 487
Angkarn Kalayanapongse 157, 164
Angkor 84
Angkor Dynasty 11
Angkor Thom 87, 90
Angkor Wat 5, 58, 83–4, 86, 87, 89–90
 plan of 85
Anglo-Mysore War 129, 132, 137
animism 263
anjali mudra 49
Anpo crisis 449, 451
Anpo Episode Event 452
anti-Americanism 450
Anti-Art 455, 457–8
Antigonus 15, 20
Antiochus II 15, 17, 20
Anyang 373
Anyuan 441, 445–6
Apanggong 228
ape 21, 237
apotropaic 76–7, 81
appropriation 150, 190
appropriation art 457
apsara 49, 304
Arabic 466, 475
Aram Bagh 105
Arc de Triomphe 202
archaeology 170, 219, 221–2, 267, 425
archaism 383
Archer, Mildred 135
architecture: vernacular 267, 274
Aries 88
Arjuna 44, 46–7, 50–2, 54, 171
Arjuna's Penance 46, 53–4, 56
Arman (Armand Fernandez) 457
Art for Life 157
Art Informel 449, 454
art school 168, 409, 448, 472
 in Chandigarh 183

in India 172, 176
artha 76
Articles of War 133
arts and crafts movements 424
arupa loka 153
arupadhatu (realm of formlessness) 61,
 64
Arya Shura 3, 237
Asaf Khan 108–9
ascetic 14–15, 20, 47–50, 52, 152,
 314–15, 330
ashes 143
Ashikaga Yoshimasa 325–6
Ashmolean Museum, Oxford 176
Ashoka 5, 13–15, 17–20, 31, 33, 52, 226
Asia Society 463, 488
Asian American 476, 482
Asiloma 40
Assam 20
assemblage 455
Assembly, Chandigarh 183
astronomy 86, 88, 155, 372
Asuka period 3, 199
asura (demon) 35, 39–42, 86–9
atomic bomb 450, 452
audience 467, 473–4
 hall of 369
Aurangabad 111
authenticity 388, 429, 469, 486
Avalokiteshvara 142
avant-garde 448, 458
Awrangzeb 103, 110–12
 tomb of 111, 115
Ayutthaya 151, 153–4, 163
Ayutthaya Era 12, 147, 149–51, 163

Babur 98, 103–5, 112–14
 tomb of 111–12
Bacon, John 135
Badakshan 104
badge 435, 439
Baker, George 481
Bala 38
Bali 69, 86
ballet 441
bamboo 284, 289, 291, 347, 386, 390
Ban Chiang 161

Ban Gu 212
Bangkok 152, 157, 159–61, 163, 483
Bangkok Bank 158
Bangkok Era *see* Rattanakosin Era
Bangladesh 182, 192
Bank of China 196
banyan tree 19, 22
barakat 131
baray (reservoir) 84
Baroda *see* Vadodara
Baroque period, Italian 168
Barthes, Roland 353
basara tea *see* tea, *basara*
Bashkala 40
Bataille, Georges 211
Batman 157
Baudrillard, Jean 458
Bayon 89, 90
Bayram Khan 105
bazaar 96, 110, 132
beauty 427–30, 454, 481
Begley, Wayne 4
Beijing 194–5, 363, 366–8, 370, 372,
 376, 378, 399, 444, 464–5
 historical plan of 364
 University 471
Benares *see* Varanasi
Benewick, Robert 5, 7
Bengal 169, 179
 partition of 173
Bengal, Bay of 45
Berger, John 469
Berlin 413
Berry, Mary E. 339
Bhabha, Homi 486
Bhagavata Purana 44, 117
Bhagiratha 44–5, 49–52
Bhaishajyaguru 297
Bharavi 47
Bharhut 21–2
Bhirasri Institute of Modern Art 158
bhoga (enjoyment) 79
Bhumi 35
bhumis (grounds) 60
Bi Yong 372
Bian He 245–6
Bianjing 285

Bibi ka Maqbara 111
Bidala 40
Bikaner 116, 119–20, 125
billboard 450
binding 465, 471
biography 21, 382
biology 472, 480
Bo Juyi 324, 351
boar 34, 47–8, 131
bodhi 66, 69
bodhi tree 20–1, 151
bodhisattva 3, 22, 24, 27, 32–3, 66, 238,
 240–1, 297, 303–4, 310, 383
body 473, 479–80
bohemian 484
Bois, Yve-Alain 252
Boisselier, Jean 150
Bolusan, Carlos 487
Bombay *see* Mumbai
bonsai 487
book 465, 470
boon 28, 48
booty 133
 see also looting
Borobudur 3, 5, 57–60, 61, 62–6, 69,
 237
Boston 197
Bourdieu, Pierre 353
Brahma 34–7, 39
Brahmadatta 22, 24
brahman 14–15, 18, 20, 25, 38, 170,
 238
Brahmanas 68
Brahmi script 13
Brahmos 176
Brand, Michael 5
Brasilia 182
Brazil 182
Breicha, Otto 452
Brion, Marcel 66
Britain 424, 477
Britannia 135–6
British colonialism 11, 127, 129, 178
British Empire 167
British public 171
British Raj 128, 136, 168, 173
Brittlebank, Kate 130

bronze 204–5, 207, 214, 222, 263, 265, 267, 269, 273, 275–6, 298, 355
Bronze Age 270, 359
Brown, Kendall 2, 5, 7
Brunelleschi, Filippo 410
brush 243, 245, 247, 253, 282, 356, 385, 388–9, 396, 402, 404, 412
Bua Luang 158
Buddha 21, 32, 33, 59, 64, 69, 141–6, 149, 151–2, 154, 237–8, 240–1, 275–7, 283, 295, 303, 304, 307, 309, 413
 biography of 59, 76
 first sermon of 14
 footprint of 151
 historical 156, 300
 teachings of 155
Buddhism 5–6, 8, 14–16, 30–1, 33, 57–8, 60, 62–3, 65, 69, 76, 88, 107, 140, 144, 147–8, 153–4, 158–9, 164, 170, 261, 267, 269, 272, 276, 280–1, 299, 305, 325, 328–30, 333, 335, 337, 357–8, 371, 373, 483
 Chan 332, 336
 Tendai 296, 299
 Tibetan 141
 Zen 325–7, 336, 339, 427, 430
Buddle, Anne 137
buffalo 42
buffalo demon (Mahisha) 34–5, 40–1
Bukhara 106
Buncho Tani *see* Tani Buncho
Bundi 116, 119–20
Bunker, Chang and Eng 487
Burhanpur 110
Burma 163
Byodoin 295–6, 300–3, 307
Byron, Lord 171

Cahill, James 242
Cai Yan (Lady Wenji) 383
Calcutta *see* Kolkata
calendar 86, 88–90, 372
calligraphy 2, 98, 246–9, 252–9, 278, 289, 299, 307, 327, 335, 344, 347–8, 352, 354, 356, 389, 463–5, 471–3
Cambodia 8, 11, 58, 83–5, 87, 89–90

Canaletto 413
Cantonese 463
cantonment 180
Cao Buxing 244
capitalism 195, 453, 466, 478, 484, 487
cardinal directions 367
caricature 480–1
caste 116
cat 49
Cate, Sandra 7
Catholicism 399, 483
Caucasian 480
censorship 462
census 367
Central Asia 93, 101, 103, 358
ceramics 2, 228, 347, 352, 354, 439
ceremony 19, 32–3, 142, 265, 267, 316, 322, 370, 372
Ceylon *see* Sri Lanka
Cha, Theresa 487
chajin 339, 341
chakra (centers of spiritual energy) 79
chakra (wheel) 14, 142
Chakri Dynasty 12, 148–9, 152, 163
Chalermchai Kositpipat 147, 157–9, 164
Cham people 163, 399
Chamara 40
Chan Buddhism 332, 336
Chan, Charlie 477
Chandella Dynasty 11, 72, 74–5
Chandi 181
chandi see temple
Chandi Kalasan 58
Chandi Mendut 58–9
Chandi Pawon 58
Chandigarh 177, 179, 181–2, 184–5, 187
 capitol complex in 183
Chandika 40, 42
Chandra 88
Chang Keng 384
Chang'an *see* Xi'an
Ch'ang-hup 401
Ch'ang-hyop 401
Ch'ang-jip 401
chanoyu 342
Chanyue 332

characters 464
 simplified 471
chariot 40
chashitsu 341–2, 344, 351
Chassériau, Théodore 176
chatri 106, 108–9
Chausa, battle of 114
chedi 150–1, 163
Chen Chunyou 330
Chen Shu 380–1, 383–4, 386, 387, 388–9, 391
Chen Shun 385–6, 389–90
Chen Yuan 390
Cheng Jingfeng 390
Cheng, king of the Zhou 205
Chengdu 337
Chengzhou 215
Chennai (Madras) 45, 129, 169, 173, 175–6
Chicago 190, 195
chigi 263
Chikshus 40
children 323, 359, 380
Chin dynasty 390
China 3, 6, 31, 149, 150, 189, 190, 191, 194–5, 199, 202–4, 207, 218, 225–6, 242, 247, 261, 269, 276, 286, 300, 325, 333–4, 338, 348–9, 352, 362–3, 365, 377, 395, 398, 416–17, 423, 437, 462, 464, 466–7, 469, 471–3, 479, 481
 influence of 155–6, 162, 272
 People's Republic of 199, 219, 363, 431
 Republic of 199
 western 8
China National Academy 472
Chinatown 480–1
Chinese 62, 312, 466, 469, 475
Chinese Communist Party (CCP) 431–2, 439, 469
Chinese Exclusion Law 481
Chineseness 466
chin'gyong (true-view) 395–6, 400–2
Chin-Ying Man 464
Chishti order 106
Cho Yong-sok 401

Choen 303
Chola Dynasty 11, 17, 73, 130, 135
Chong Sang-gi 400
Chong Son 396–7, 401–5
Chongjo 396
Chongqing 463
Choson dynasty 200, 395–6, 399, 401, 425
Chowdhury, U. E. 184
Christianity 271
Chu kingdom 205, 209–10, 224, 227, 246
Chu Suiliang 250
Chulalongkorn, King of Thailand 163
Chung, Connie 488
Chunyu Kun 359
Churning of the Sea of Milk 87, 89
Churyo, Morishima *see* Morishima Churyo
circumambulation *see pradakshina*
city 182, 191, 197, 362, 370, 376, 409, 413, 457
 imperial 370–1
 mega 2
 palace 370
cityscape 479
civil law 481
Civil War, United States 154, 202
Clark, John 159
Clark, Kenneth 279
class 339, 353, 359, 368, 381, 401, 408–9, 433, 481, 487
classicism 170, 175
Clive, Robert 135
Clunas, Craig 5, 44
Coaldrake, William 5
Cold War 484
collecting 127, 354, 356, 381, 384, 429, 444
colonialism 11, 127, 168–71, 173–4, 178–9, 181–2, 186, 190, 425, 477, 483, 491
colophon 385, 388, 397, 403
color 243, 367
combine art 455
comic allusions 45
commodification 444, 458
communalism 178

communication 469
Communism 431–2, 438, 441, 449, 453, 484
communitas 345–6, 348
Conan 157
conch shell 41
concubine 388, 390
Confucianism 8, 247–8, 252, 254–7, 261–2, 275, 277–80, 283, 325, 327–9, 332, 335, 338, 340, 363, 371, 380–2, 482
Congress Party, India 173
connoisseurship 258, 356, 358, 381, 391
Connors, Chuck 481
Constantinople 364, 368
Coote, General Eyre 130
cosmology 91, 147, 156, 237, 367
Buddhist 153
cosmos 83–4, 86, 140, 185, 282, 357, 373
court 47, 97, 117, 121, 124, 130, 173, 255, 268, 285, 296–7, 299–300, 307, 311–12, 336, 338–9, 369, 379, 386, 399, 401, 478, 481
courtyard 369, 377–8
craft 272–3, 424–5, 429
craniology 480
cremation 143
Crichton, Michael 479
cubit 85–6, 91
cult of personality 436–7, 439, 442, 445
Cultural Revolution 431–2, 435, 437, 439–40, 443–4, 462, 467, 471
curiosities, cabinets of 136
Curzon, Lord 169, 173

Dadaism 449
Daibutsu (Great Buddha) 275–6
daimyo tea *see* tea, *daimyo*
Dainichi Buddha 299
Daitokuji 426
Daitya 40
dakshina (right-handed) tantra 80
Dalai 140
Damrong Wong Uparaj 164
dance 33, 123
Daoan 329

Daoism 8, 279–80, 325, 327–30, 332–3, 335, 337, 357, 359, 371, 383
darbar 117, 120–3
dargah (saint's tomb) 106
Daulatabad 111
David, Jacques-Louis 175
Davis, Richard 5, 7
Dayton, Ohio 194
death 5, 240, 367, 426
Deccan 72–3, 108, 111
deer 25, 27–9, 149, 237
golden 21–2, 26
Dehejia, Vidya 5
Delhi 102–6, 110–11, 115, 118, 126
democracy 436, 439, 445, 449–50
demon 360, 400, 453
asura 35, 39–42, 47, 86–9
Deng Xiaoping 445
Desai, Vishakha 116
Descent of the Ganges 49–50, 53, 56
desire 62
realm of *see kamadhatu*
Desmond, Ray 134
despotism, Oriental 137
Dethe, J. S. 184
Deutsch, Ludwig 173
deva 32, 33, 83, 86–9
see also god
Devadatta 22–4, 29
devaraja (god-king) 83–4
Dhalukya 130
dhammaraja 154
Dhanga 74–5
dharma 14–16, 19–21, 22, 65, 67, 69, 76, 241
Dharmapada 60
dhvani see pun
Diamond Mountain 401
Diamond Vehicle Buddhism 140
diamond, Koh-i Nur 108
diaspora 2, 488
dictatorship 436, 438, 472
Dieng 58
Diet building, Tokyo 451
digambara (sky-clad) 75, 79
Din-Panah 106
directions, cardinal 367

discrimination *see viveka*
discus 131
diwani (minister of revenue) 127, 135
DNA 472
dome, double 110, 112
domestic life 62
Donald, Stephanie 438
Dong Gao 385
Dong Yu 285
doomsday 100
dragon 253, 285, 367
dragon lady 477
dress 170, 173, 176, 219, 317, 320
Drew, Jane 184
drum 41, 372
Du Bois, W. E. B. 486
du hua 359
Dublin 413
Dunhuang 3, 237
Durga 35, 131
Dushyanta 168, 171, 175–6
Dutch East India Company 127, 410,
 414, 417
Dutchman 413
Dvarasamudra 130
dwarf 47

eagle, double-headed 131
Early Feudal period 199
East India Company 127–9, 133–5, 167
East India House 134–6, 138
Eastwood, Clint 157
Edo (Tokyo) 408–10, 412, 414–15,
 417–18, 420
Edo period 200, 329, 342, 408
Egypt 477
elephant 38, 40, 42, 47, 49, 51, 93–6,
 99, 122, 148
elixir 86
emblem 52, 56
Embree, Ainslie 13
Empire State Building 191
En school 303, 310
Engels, Friedrich 438
Engi era 271
England 136, 147, 413, 376, 466, 469,
 473, 475

engraving 465
enlightenment 18, 21, 22, 65–6, 140–2,
 146, 152, 239–40, 279, 300
Enlightenment, European 182, 479, 480
Enryaku period 258
Ensei 303
Enshu 350
Enshu Kobori 342, 346
epics 171–2
equestrian image 119
equinox 86, 89–90
eremitism 341, 345
erotic imagery 71–5, 77, 81, 423, 483
etching 412, 414–15, 422
ethnicity 466, 472, 478, 488
eunuch 359, 377
exhibition 455
exoticism 98, 125, 135–6, 192, 372,
 376, 417, 462–3, 466–8, 483

fables 44
factory 225, 229
fair 20, 414–15
Fan Kuan 285–6
farang (foreigners) 153, 158
fashion 176
Fatehpur Sikri 93–4, 96, 115, 368
Faxian 5–6, 30–1
feng shui 195, 368, 373
Fergusson, James 107, 112
fertility 76, 78
festival 16, 20, 62, 123, 151–2, 268,
 312, 324, 354
fetishization 483, 485–6, 491
feudalism 74, 123, 205, 212, 227
filial piety 131, 214, 216–17,
 380, 391
film
 Indian 169
 New Wave 451
Finland 469, 473
Five Dynasties 244, 246, 279–80, 332
Fletcher, A. L. 183
Floating Market school 157, 163
floating pictures *see uki-e*
floating world *see ukiyo-e*
Florence 410

flower arranging 326
flower painting 385, 388–9
flowers 291, 382, 386
Fluxus 455, 459
fly whisk 122
folk art 2, 424
Fong, Wen 5
foot binding 478
Forbes, Malcolm 484
Forbidden City 362, 376
Ford, Larry R. 2, 7
foreigners *see farang*
form, realm of *see rupadhatu*
formlessness, realm of *see arupadhatu*
fortifications 366
Four Graybeards of Mt Shang 294,
 344, 348
Four Old Men of Mt Shang 291, 294
Foyin Chanshi 335
France 84, 127, 129, 132, 477
Franklin, Benjamin 479
Fry, Maxwell 184
Fu Xi 382
fudo 304
Fuji 418–21
Fujitsubo 311–12
Fujiwara 296, 303, 306
 regency of 295, 302, 308
Fujiwara no Kunitsune 302
Fujiwara no Michinaga 295, 298–300,
 302, 306–7
Fujiwara no Sukefusa 302
Fujiwara no Toshitsuna 310
Fujiwara no Yorimichi 296, 298–99, 302,
 306–7
Fujiwara no Yukinari 300, 307
Fukuoka 197
Fukuyama Toshio 274, 303
Fukuzawa Ichiro 453
Funan (Cambodia) 58
funerary decoration 286
funerary monument 103
funerary paraphernalia 204
funerary tablets 257
furniture 352, 376
Furuta Oribe 342, 350
Fushimi 341, 349

ga (pictures) 412
gaku (framed picture) 412
gallery 173, 455, 458, 469
gambling parlor 480
Gandhara 31
gandharva 49, 241
Gandhi, Mahatma Mohandas 179
Ganga 44, 45, 49–51
Gangaikondacholapuram 135
Ganges 22–3, 25, 44–6, 49, 53
 descent of 49–50, 53, 56
Ganjin (Jianzhen) 258
Gao Lian 358
Gao Minglu 463
garden 2, 96, 105, 107, 110–12, 121,
 263, 327, 339, 341, 343, 346, 369,
 372, 376, 378, 487
 roji 343–7, 350–1
Garden City Movement 183
Garuda 39
garuda 131
gates 366, 377, 379
Gaya 20
gaze 142, 356, 419, 470, 476, 482
Geertz Clifford, 347
gender 5, 269, 481, 487
genius 477, 484
Genji 311–13, 315–19, 322–3
Gennai, Hiraga *see* Hiraga Gennai
Genpei Civil War 296
Genshin 296, 300
Genthe, Arnold 481
gentleman 252, 255–6, 282, 284, 290,
 339, 355–6, 358
geomancy 368, 373
George III 135, 377
Gérôme, Jean-Léon 176
geta 345
Gettysburg 202
Ghazna 135
Ghiyas al-Din Tughluk 104
Giedeon, S. 211
gilt-bronze 275
Ginza 195
Ginzburg, Carlo 354
Gittings, John 440
globalization 190, 192, 478, 486

Gnostics 68
Goa 98, 169
Gobi desert 31
God 96, 100, 103
 ninety-nine names of 108, 110
god (*deva*) 34–5, 39, 41, 44, 49, 52, 64,
 83, 86–9, 148, 153, 167, 240–1, 243,
 265–6, 270, 313
goddess 34, 39–41, 44, 72, 167
god-king *see devaraja*
Gokula 38
Golden Temple 180
Gomati Monastery 31–2
gong (palace) 369, 373
Goris, R. 69
Goswamy, B. N. 123, 175
Gottman, Jean 191
Govardhana, Mt 34–5, 37–8
Governor's Residence, Chandigarh 183
gozan bunka 325–8, 333, 335–6
Great Wall of China 228, 366
Greeks 14–15, 17
Griffith, D. W. 169
grisaille 121, 125
Gu Junzhi 245
Gu Mei 388
Gu Wenda 462–3, 465–9, 472–3, 474, 475
guan 357–9
Guan Daosheng 388–9, 391
Guan Tong 285
Guan Yu 383
Guandi 371
Guanxiu 357
Guanyin 383
Guercino 168, 171, 176
Guilbaut, Serge 484
Gulbadan Begam 105
Guo Xi 1–2, 5, 9, 279, 284, 286,
 289–90, 397
Gupta Era 11
Gur-i Amir 104, 107, 113
Gutai 457
Gyalpo, Tangtong 144
Gyatso, Janet 5–6

habitus 353
hair 466, 472, 474

Ha-jin 399
Haldar, Rakhaldas 138
halo 122–3
Hamada, Shoji 424
Han dynasty 199, 208, 212, 223, 229,
 246, 254, 279, 291, 294, 382–3,
 398, 475
Han Paek-kyom 400
Han Yutao 250
handscroll 352, 354
Hangzhou 358, 368
haniwa 269
happening 457, 459
Hara 37
harakiri 452
Hari 38
harmika 68
Harunobu Suzuki 414
Haryu Ichiro 453, 459
Hasegawa Mitsunobu 417
Havai 93
Hawaii 478
Hay, Jonathan 462
Haydar Ali Khan 127, 129–31
He Liangjun 354
heaven 16–17, 35, 41, 50, 67, 205, 207,
 221, 240, 245, 253, 265, 276, 315,
 365, 367, 369–70, 373, 397, 418,
 421, 443, 478
Heian period 5, 199, 261–2, 274,
 295–302, 305–7, 311–12
Heike monogatari see Tales of the Heike
hell 153–4, 299, 418, 478
Herat 104, 106
heritage 161–2
hermit 239, 281, 289–90, 293, 330,
 338–9, 341, 343–8
hero 52, 73, 135, 438
Heshen 385
Hi Red Center 456, 458–9
Hideyoshi, Toyotomi 273, 340–2,
 346, 349
hierarchy 267
hieratic style 14
Higashiyama era 327–8
High Court, Chandigarh 183
highway 194, 196, 239–40

hill-station 179
Himalaya 240
Himavant 22
Himavat 40
Hinayana Buddhism 241
Hindi 466, 475
Hindu temple 46, 50, 73–4
Hinduism 8, 34–5, 44, 46, 57–8, 62,
 68–9, 71, 76, 83, 88, 101–2, 104,
 107, 116, 118, 130–1, 134, 138,
 167–70, 173, 181, 185
Hindu–Muslim relations 179, 487
Hiraga Gennai 412, 421
Hirazawa Tsuneyoshi 413
Hiroshima 301, 418, 449, 452
history painting 169–71, 175
Hofland, Barbara 136
Hojoji 299, 302, 308
Hokongoin 301, 305
Hokusai, Katsushika 420
Holi (Phag) 121, 122, 123
Holland 409, 414, 422
Hollywood 169, 452, 477
Holocaust 474
holy men (*rishi*s) 49–50
Honda Tadayoshi 425
Hong Kong 189–91, 194, 196–7, 464,
 466, 471
honyo (true style) 296, 305, 307
hookah see huqqa
hospital 33
Hotan *see* Khotan
Hou Yimin 441
housing 184
Hoysalas 130
Huain River 228
Huang Dingjian 332, 335
Huang Yuanjie 388
Huiyao 337
Huiyuan 329–30, 332, 335, 337
Huizong 386
human hair 465–6, 472, 474
Humayun 103–7, 109, 112, 114
 tomb of 106, 111, 115
hunting 18, 47–50, 62, 95, 117, 121,
 123, 131, 372
Huntington, Susan 45

huqqa 117, 122, 138
hybridity 488
Hyderabad 172

Ian Geijoshin 334
icon 435–7, 439, 445
 religious 141
iconography 43, 47, 50, 80, 124,
 129–31, 135, 141, 171, 205, 269,
 279, 295–6, 357, 383, 436–7, 441
idealization 124
Ijzerman, J. W. 63
ikat 160
Ike no Taiga 329
Ikeda Tatsuo 459
Imaizumi Yoshihiko 459
Imitation Art 457
Immigration Act of 1924 481
immigration law 481
immortality 86–7, 218
immortals 72, 243, 279, 290, 383
In school 303
Inayat Khan 98–9, 100
Incho 305
India 3, 8, 58, 68, 73–4, 76, 83, 85, 88,
 94, 97, 103, 105–7, 112, 124–5, 136,
 149, 156, 177–8, 182, 226, 237, 276
 southern 72
India Museum 134–6, 138
Indochina War 157
Indonesia 3, 11, 57–8, 90, 160, 192, 195
Indra 35, 37–9, 87, 91, 241
Indrajit 172, 176
Indrani 173
Industrial Exhibition of the
 Congress 173
industrialization 181
industry 440
initiation 142–3
Injo 303
ink 253, 282, 325
Inkaku 305
Inner Mongolia 228, 441
inscription 72, 110, 115, 129, 214–15,
 225–6, 228–30, 234, 327, 330, 331,
 334–5, 337, 359, 384, 386, 411
installation 464, 475

interior design 159
international art scene 454–5, 462
international style 157
internationalism 468
Inwang, Mt 397, 404
Iran 101, 110
Iron Age 270
Ise Bay 264
Ise Jingu 5, 261–2, 264–5, 267–73, 351
Isfahan 364, 368
Ishibashi Yasuyuki 454
Islam 8, 76, 93, 103–4, 111–12, 127,
 131, 178, 192–3
 Shiite 131
 Sunni 130
Islamabad 182
Islamic saints 102
Israel 466, 474
Isuzu River 262
Itimad al-Dawla, tomb of 112
Ivory, James 478
iwan 107, 112

Jackson, John Brinckerhoff 202–3
Jahangir 97–8, 102–4, 107–10, 112–13,
 121, 123–4
 tomb of 111–12, 115
Jahangirnama (*Tuzuk-i Jahangiri*) 5,
 97–9, 118, 120
Jai Singh, Raja of Amber 110
Jain 51, 72, 75, 79, 101
Jaisalmer 119
Jakarta 196, 413, 417
Jambudvipa 33
Jamuna river 95, 105, 110
Janaloka 36
Japan 2, 3, 5, 7–8, 191–2, 199, 237,
 250, 258, 261, 263, 265–6, 268, 273,
 275, 295, 297–8, 301, 306–7, 311,
 325, 335, 338, 348–9, 362, 395,
 408–9, 413, 422, 424–5, 431, 448,
 450, 452, 460, 479
Japan Communist Party (JCP) 449–50,
 453
Japanese 312, 463
Japanese American 487
japonisme 453

jataka 3, 5–6, 21–4, 27–9, 59, 152, 162,
 237, 238
jatakamala 237
Java 5, 57, 60–2, 69, 83,
 136, 237
 Nail of 58
jaya (victory) 67
jazz 452
Jeanneret, Charles Edouard *see*
 Le Corbusier
Jeanneret, Pierre 184
Jefferson, Thomas 479
Jerde, Jon 196
Jerusalem 203
Jesuit Order 342, 349–50, 376–7, 399,
 409, 421
Jiang Pu 390
Jiang Qing 441–2
Jiang Tingxi 390
Jianzhen *see* Ganjin
Jie (last king of the Xia) 205–7
Jim Crow laws 482
Jin dynasty 246, 248, 279, 333, 337
Jin Mao Tower 195
Jin region 215
Jin Tingbao 390
*jina*s 64–5, 67–8
Jing Hao 281–2, 285, 397
Jingshan 336
Jippensha Ikku 418
jnanasattva (actual Buddha) 142
Jocho 295, 297–8, 300, 302–7
Jodo 296
Jodoin 301
Johns, Jasper 455, 457
Jokhang Temple 144–5
Josetsu 326
Juran 285
justice 18

kabuki theater 408, 411–12, 420
Kabul 102, 105, 111–12
Kai Tak 194, 197
Kaifeng 368
Kailasanath temple 48, 50
Kaimal, Padma 5
Kaiser-i-Hind 173

Kakushu Sanri 334
Kala 40, 70
Kalanaur 105
Kali 131
Kalidasa 168–71
Kalimantan 57
Kalinga 14–15, 20
Kama 241
kama (love) 76, 81
kamadhatu (realm of desire) 61, 63–4
Kamakura period 200, 326, 336
Kamba Michiko 451
kami 263–5, 271, 455
Kammu, Emperor 272
Kamo festival 324
kampung 196
kan (to see) 356
Kanchipuram 48, 50, 73
Kandariya Mahadeo Temple 71, 74–5, 77–8, 80
Kang Sehwang 397
Kang'won Province 398, 402
Kangxi 377
Kanjiro Kawai 424, 426
Kanto Plain 268
kanyu 368
Kaoru 312
Kapila 50
karakuri 416–18, 420
Karan Singh, Raja of Bikaner 119
karate 452
Karate Kid 478
Karle 76, 170
karma 62, 69, 156, 312
Karmavibhanga 62–3
Karnataka 127–8, 130
Kashiwagi 311–14, 319–20, 322–4
Kashmir 108
Kathakali dance 172
Katsura villa 339
Katsuragi, Mt 314
Katsushika Hokusai *see* Hokusai
Kaula sect 79
Kawada Kikuji 452
Kazekura Sho 452, 456, 458
Keats, John 137
Kegon philosophy 277

keloidal scars 450
kemon 172
Ken'en 303–5
Kenninji 337
Kerala 167–8, 171–2
Keralaputras 17
Khajuraho 71–4, 77, 79
Khan, Amanat 115
Khema 25
Khmer culture 5, 58, 83–7, 91, 163
Khotan (Hotan) 5, 30–2
Khrua In Khong 155–6, 163
Khubilai Khan 362–3
Khuldabad 111
Khusraw 102, 107
Kickboxer 478
Kikuhata Mokuma 454–5
Kikuji Yamashita 450
Killimanoor 168
kiln 224, 228, 424, 426
Kim Ch'ang-hup 401
kingship 21, 45, 51–2, 54, 73, 83–4, 93, 116, 118, 120, 151
kinnara (*kinaree*) 49, 156
Kiratarjuniyam 47
Kishi Shinsuke 451
Kiso River 264
Kitano, Grand Tea Gathering at 340
Kitao Masayoshi *see* Masayoshi Kitao
Kitchanukit 155
kitsch 436, 443
Kizaemon tea-bowl 424, 427, 430
Kleenex 160
koan 430
Kobori Enshu *see* Enshu Kobori
Kodaiji 342, 349
Kodera Gyokucho 414
kodo (lecture hall) 261
Kofukuji 300
kogi 344
Koh-i Nur diamond 108
Kohoan 426–7
Koikawa Harumachi 413
Kojiju 311–15
Kojo 300, 304
Kokan, Shiba *see* Shiba Kokan
Kolkata (Calcutta) 173, 176, 179

kondo (golden hall) 261
Koran 103, 105, 110–11
Korea 7, 192, 200, 275, 395, 398, 402, 417, 425–8, 478, 483, 486
Korean People's Folk Crafts Museum 425
Kowloon 194
Koya, Mt 414
Krishna 35, 37–8, 44
Krishna III of the Rashtrakuta Dynasty 73
Krishnaraja II 129
Kuala Lumpur 189–90, 192–4, 196
Kuala Lumpur City Center (KLCC) 192, 197
Kubera 39–40
kubomi-e (sunken pictures) 409
Kuchean 62
Kudo Tetsumi 451, 455
kudra 141
Kumgang, Mt 397, 402–4, 406–7
kundalini 69
Kunitsunedo 303, 305, 307
Kurma 87
Kushan Empire 11
Kwangju Biennial 475
Kyoto 273–4, 295–7, 301, 310, 325–37, 339, 351, 362, 417, 426
Kyushu 340
Kyushu School (Kyushu-ha) 454

labyrinth 66
lacquer 224–5, 228–9, 298, 304, 354
Lahore 102, 108, 111–12, 179–80
Lahori, Abd al-Hamid 109–11
Laing, Ellen 441
Lairesse, Gérard de 410, 412
Lakshmana Temple 71, 74, 78–80
lama 140, 143–4, 146
Lamba, N. S. 184
landscape 1–2, 144, 150, 156, 171, 175, 192, 202, 278–80, 282, 284, 286, 289–91, 382–4, 386, 390, 397, 400, 428, 453, 472, 487
 monumental 285, 384
 true-view 395–6
Langsak 89

language 9, 22, 462–4, 466, 468–9, 472–3
Lanna-style 160
Lao 163
Late Heian 199
Latin 203
Latino American 482
law *see dharma*
Lawrence, Stringer 135
Le Corbusier 177, 183–7
Leach, Bernard 424
League of Nations 185
Lecomte, Louis 5, 7, 376–8
Ledderose, Lothar 5
Lee, Bruce 479
Lenin, Vladimir 432, 438
Leninism 445
leprosy 480
Leung, Simon 5, 7
Lhasa 145
Li Ao 280
Li Cheng 282–4, 285
Li Gonglin 335
Li Huasheng 438, 441
Li Ji (*Book of Rites*) 255
Li Ping'er 357
Li Si 220
Li Yin 388
Li Yu 285
Li Yufen 390
Li Zuoxian 383
Li, Mt 220–1
Liang dynasty 209, 253, 258
Liang Guozhi 385
Liang Tongshu 388–9
Liao mausoleum 285
library 369, 372
liminality 343–6
Lin Biao 443
Lincoln Memorial 202
Ling Tai 372
linga 34–7, 74, 79–80
Linnean Society 134
lion 14, 33, 40–2, 47, 52–3, 56, 95, 129, 131, 138, 156
liqi 205, 211, 215
literacy 436

literati 289–90, 328, 330, 333, 336, 352, 389, 469
lithography 167
Little Tokyo 479
Liu Chunhua 440, 445
Liu Shaoqi 441
Liu Yin (Liu Shi) 388
Liu Yiqing 253
Lochana Buddha 276–7
Lockwood, Michael 45
lohan 357
London 127–8, 136, 168, 172
 Tower of 134
London Missionary Society 134
Lone Wolf 157
Long March 438, 440
Longmen 276
looting 132–3, 135, 221
lotus 40, 65, 68, 337, 386, 404
lotus leaf texture 385
Lotus Sutra 351
Louis XIV of France 377
Lü Buwei 220
Lü Dongbin 383
Lu Jianzeng 389
Lu Sui 245
Lu Tanwei 243–5
Lu Xiujing 330, 332
Lu, Mt 329–30, 337, 351
Ludwig, Theodore 340, 343
Luo Zhichuan 284
Luoyang 205, 368

Ms, the five 79
Ma Quan 388–9
Ma Shouzhen 388
Ma Yuan 336
MacArthur Fellowship 463
McDonald's 160, 197
Machida, Margo 484
Maciunas, George 455
mada (wine) 79
Madame Butterfly 478
Madhusudana 39
Madras *see* Chennai
Magas 15, 20
Mahabharata 44, 46–7, 49

Maha-dhanaka 25
Mahahanu 40
Mahavairochana Buddha 299
Mahavairochana sutra 69
Mahayana Buddhism 31–2, 66, 141, 241, 305, 327–8, 330
Mahdi Khwaja 104
Mahisha (buffalo demon) 34–5, 40–1, 131
Mahmud of Ghazna 135
maithuna 79–80
Maitreya 37–8, 144
makara 69–70
Malay people 163, 480
Malaysia 189–90, 192–3, 195
Maldeo of Marwar 119
Malhotra, Jeet Lal 184
Mamallapuram 43, 44, 45–8, 50
mamsa (meat) 79
Manchu rule 380, 398
mandala 57, 65–6, 328
Mandara, Mt 86, 88–9, 91
Mandarin 463
mandorla 297, 304
mango 19, 22–3, 25–6, 442
Manhattan 194, 197
manifest destiny 482
manifesto 452
Manjushri 141
Mannikka, Eleanor 5, 83
mantra 47, 66, 68–9, 88, 142–3
manuscript 116, 120–1
Mao Zedong 195, 363, 431–2, 435–45, 449, 462–3, 467, 469, 471, 475
Mao Zedong Memorial Hall 444
Maoism 194, 462
map 366, 400
mappo 300, 306, 308
Mara 152–4, 163, 240–1
Maravijaya Buddha 152
marble 108–11, 377
Mariamman 131
maritime warfare 46
market 372
 see also bazaar
marriage 19, 119, 168, 266, 390
martyr 131, 451

Maruyama Okyo 418
Marwar 116, 119–20
Marx, Karl 438
Marxism 433, 445, 449, 453, 466
Masanobu Okumura *see* Okumura
 Masanobu
Masaru Sekino *see* Sekino Masaru
Masayoshi Kitao 418
masonic regalia 169
mass production 225
Matano Mamoru 454
Mathur, B. P. 184
Matsudaira Fumai 425
matsya (fish) 79
Matsyagandha 172
Mauryan Empire 11, 13, 14, 31, 226
mausoleum 107, 110–11, 369
 see also tomb
Mayer, Albert 183
measurement 85, 91, 141, 231, 400
meditation 60, 64–5, 79–80, 94,
 140–3, 145, 239, 317, 337,
 357–8, 466, 472
Mediterranean Sea 226
megane-e 415, 422
meibutsu 429
Meiji era 426
memoir 97
Men Songzhen 439
Meng Haorjan 284
Merchant, Ismail 478
Meru, Mt 58, 65, 68, 86, 88, 91
Metropolitan Art Museum, Tokyo
 458, 460
Mewar 116–17, 119–23
Mi Fu 283–4, 335,
 402, 405
mice 49
Middle East 7, 477
Middle Way 164
midtown 190, 194
Miki Tomio 455
milana-sthala (meeting place) 75
militarism 450
Minami Gallery 455
minaret 109
miner 440–1

Ming dynasty 199, 337, 352–3, 356–9,
 362, 373, 377, 383, 386, 390–1, 398,
 406, 465–6
Ming Tang 372
mingei 424
Mirak Mirza Ghiyas 106–7
miscegenation 481
Miss Saigon 478
missionaries, Christian 153, 377
Mitakiji 301
mithuna 71, 76, 81
Mitsudera I 268
Mitter, Partha 5, 7
Miwa, Mt 268
model minority 482
modern architecture 187, 195
modern city 177, 181
modern look 156
modern, as a category 161, 243, 478
modernism 454
modernity 147, 157–9, 161, 163, 174,
 178, 180–2, 184–6, 190, 448,
 453–4, 458, 477, 479, 484
modernization 182, 448, 454
modules 233
moksha (spiritual liberation) 76
Moku'un Ryutaku 333, 337
molds 230–2
Momoyama period 7, 200, 338–42,
 344, 348
Mon culture 163
monastery 32, 76, 142, 144–5, 275,
 299–300, 332, 336–7, 371
Mongkut, King of Thailand 148, 151–2,
 155, 159, 163
Mongol rule
 of China 336, 362, 372
 of Persia 101
Mongolia 285
Mongolian people 480
Monier Williams, M. 171, 176
monism 77
monk 6, 22, 30–2, 60, 76, 79, 140, 142,
 148, 150, 152, 157, 162, 258, 300–1,
 306, 316, 326–7, 329, 332, 334–6,
 358
monkey 21–2

Index

monument 201, 203, 465
Monument to the People's Heroes 202
monumentality 201, 203–6, 210, 261–2, 275, 377
Moody, Piloo 184
moon lineage *see* Somavamsha
Moor, Edward 170
morality 16–17, 62, 148, 154, 157, 170, 238, 246, 279–80, 282, 284
Morishima Churyo 412
Moriyama Daido 452
Morotoki 304–5
Morse, Samuel 5
mosaic 109
mosque 111, 115
Mount Hiei 300, 306
Mount Lu *see* Lu, Mt
Mount Rushmore National Memorial 202
mountain 1, 36, 38, 42, 58, 73, 95, 156, 239–40, 264–5, 279–82, 286, 289–94, 313–14, 317, 319, 325, 330, 334, 338–9, 345, 347, 368, 384–5, 404
Moy, James 482
Mozi 208
Mu Qi 336
mudra (gesture) 47, 49, 54
mudra (grain) 79
Mughal Empire 4–6, 11, 93–4, 97, 101–4, 106, 110–11, 116–28, 135, 171, 179
Muhammad 131
Muhammad Azam 111
Mukherjee, Tinkari 170
multiculturalism 484–5
Mumbai (Bombay) 169, 173, 176
Mumtaz Mahal 110
Munroe, Alexandra 5, 7
mural painting 148–9, 160–1
muraqqa (album) 98
Murasaki (character in *Tale of Genji*) 312
Murasaki Shikibu 5, 298, 307, 311
Muromachi period 200, 325–6, 328, 333, 336
Mus, Paul 59–60
museum 127, 129, 134–6, 162, 183, 458, 488

Museum of Modern Art, Kyoto 459
music 33, 123, 138, 254, 255, 316, 335, 480
Mustard Seed Garden Manual of Painting 402
Mutiny Act 133
Mysore 129–32, 138, 171–3, 176
Mysore Kingdom 11, 127

Nafilyan, Guy 84, 91
naga 47, 49, 51, 83, 156, 241
Nagarjunakonda 76
Nagasaki 409–10, 414, 421–2, 449, 452
Nagoya 414, 418
Nail of Java 58
Nair women 172
Nakamura Sosetsu 425
Nakanishi Natsuyuki 455, 458–9
Nakhon Khiri 155
Nakhon Pathom 163
Nam June Paik 459
Nambokucho 267
Nandara 413
Nara 3, 267, 273–4, 276, 300, 362
Nara period 199, 258, 275
Narasimha 43, 36–7
narcissus flower 386
Naresuan, Ayutthayan king 163
narrative 5, 21, 34, 43, 45–6, 49–50, 52, 54, 59, 62–3, 149, 152, 155, 162, 169–70, 215, 238, 279–80, 311–12
National Gallery, Beijing 464
nationalism 76, 167–70, 173, 175, 182, 190, 431, 450, 468
nationality 160, 466
nativism 157
Naturalization Act of 1790 481
nature 5, 290, 327, 341, 343, 345, 428, 472
 cycles of 270
necropolis 220, 222, 224, 226, 228, 372
needlework 381
Negroids 480
Nehru, Jawaharlal 177–81, 183, 185–7
nembutsu 298
neoclassicism 135
neocolonialism 483

neo-Confucianism 278–81, 284, 398
neo-Dada 455
Neo-Dada Organizers 451–2, 455, 457
neo-traditional 147–8, 157–9, 161
New Chinese Art: Inside/Out 463–4
New Traditional Art 164
New Wave film 451
New Year's celebrations 388
New York 190–1, 195, 459
New York City Municipal Building 190
newsprint 465
Ni Zan 284, 390
Niccolo, Giovanni 409
Nihon Shoki 265, 275
Nijo palace 312
Nippon Mingeikan 424
Niraya 33
nirvana 22, 65, 140–1, 143
Nizam al-Din Awliya 106
no theater 326–7, 341
nostalgia 181, 306, 312, 343, 444
Nouveaux Réalistes 457
Nowicki, Matthew 183
nozoki-e 413–15
numerology 67–9, 84, 87, 195, 365
nun 316–17, 322–3
nunnery 275
Nur Jahan 108–9, 112

objet 455, 458–9
Occident 478
Occidentalism 486
Occupation, American, of Japan 452
ocean 37, 40, 42–3
Ochi Osamu 454
Oda Nobunaga 340
Oe Kenzaburo 460
offerings 145, 151, 216–17, 271
Ogen 303–4, 309
Ogimachi 340
Oguri school 333
Oguri Sotan 326
Okamoto Taro 453–4, 458
Okumura Masanobu 411
Oldenburg, Claes 202
oleography 169, 176
om 37, 69, 142

Ono, Yoko 459
opera 441
opium 97–9, 480, 483
opium den 481
Opium War 473
oracle bones 208, 463
oral narrative 34
Orchid Pavilion 248–50, 252, 254,
 257–9, 464
Orient 478–80, 483
Oriental despotism 137
Orientalism 6–8, 161, 173, 182, 476–7,
 479, 481, 484–8
Orientalist painting 176
Orientalists 172
Orissa 20
orthodox 101–2, 104–5, 109, 111–12,
 115, 335, 384
Osaka 273, 301, 341, 416–17, 425
Oshima Nagisa 451
Otomo Yakamochi 348
Ouyang Xiu 256, 330

Pacceka Buddha 151
pachinko parlors 454
Pacific Rim 482
Packard, George R. 449
Padshahnama 115, 120
Paegak, Mt 402
pagoda 261, 303, 305
Pahari painting 171
Painter, Baburao 169
painting bureau, Korean royal 401, 406
Pak T'ae-yu 403
Pakistan 2, 177–9, 182, 442
palace 149, 368–9, 378
palace city 370
palanquin 99, 426
Pali 22, 62, 237
Pallava Dynasty 11, 43, 45–7, 50, 52,
 55–6, 73
Pamini 172
Pancharatra system 80–1
Panchatantra 44
Panchkula 184
Pandya culture 17
Panya Vijinthanasarn 147, 157–61, 164

Pao Xi 245
paradise 421
 Islamic 102, 109
parasol 151
Paris 172, 414, 457
Parsi
 adherents 176
 theater 173
partition
 of Bengal 173, 179
 of Punjab 177, 179
Parvati 75
pashupatastra 47
Pataliputra 6, 13, 20, 31–2
Patiala 180
Patna 13, 31
patriotism 436
patron 5, 22, 57, 215, 299
patronage 35, 83, 103, 117, 120, 123,
 130, 132, 149–51, 190, 214, 237,
 261–2, 267, 269–70, 272, 276, 296,
 300, 302–3, 306, 326, 339–42, 344,
 354, 363, 381, 408
patterns 149
 geometric 225
Pawlin, Alfred 158
peacock 99
peasant 431–3, 436, 439, 441
pedagogy 3
peeping-pictures *see nozoki-e*
Pelli, Cesar 192, 197
penance 47–8, 50–1
Peng Yuncan 390
People's Liberation Army (PLA) 436,
 439–40, 442, 444
performance 52, 117, 123, 358, 464,
 470, 475, 481
performance art 2, 457
Period of Division 199
Persia 94, 101–2, 129, 150
personality cult 436–7, 439, 442, 445
perspective 46, 123, 408–10, 412–17,
 419–21, 423
 aerial 123
 isometric 123
 linear 150
 multiple 149

single-point 148, 155–6
vanishing point 409
pessimism 451
Petronas Towers 192, 193, 195
Phag (Holi) 121, 122, 123
Phalke, Dadasaheb 169
Phetracha 154
Philippines 189, 478, 487
phoenix 373
photography 438, 452
Phra Weandorn Jataka 152
phrenology 480
phyeam (four cubits) 85
physiognomy 480
Picasso 210
Pichai Nirand 157–8, 164
pietra dura 109–10
pigment 149, 219, 224, 228, 413
pigs 469, 470
pilgrim 57–60, 63, 66, 69, 144
pilgrimage 20, 31, 62, 66, 151, 344, 351
Pillow Book of Sei Shonagon 299
pine tree 282, 284, 292, 313, 324, 385,
 389, 405, 440
Pinyin 9
pir 131
Piro-bong Peak 403
Plassey, Battle of 127
Pocock, George 135
poetry 47, 54, 137, 279–80, 284, 307,
 312, 323–4, 326–30, 332–6, 381–3,
 390–2, 396–7, 401–4, 406, 469, 487
Poh Chang 161
Poland 466
Pollilur 129
Pompeii 76
pop art 455, 457
popular culture 2, 169, 40
population 368
porcelain 229, 436, 479
pornography 417, 423, 490
Porter, Robert Ker 137
Porto Novo 130
portraiture 116–20, 123–5, 131, 170–1,
 219, 232–4, 382, 400, 413, 437–8,
 477
Portuguese colonialism 169

Portuguese Jesuits 342
Portuguese people, in Japan 408
possession, by spirits 314
postcoloniality 180, 182, 485
poster 2, 435, 437–9
postmodern architecture 195
postmodernism 457, 484
Potalaka, Mt 383
potter 228, 424–6, 428
poverty 344
Prabhawalkar, A. R. 184
pradakshina (circumambulation) 62,
 65–7
Prajapati 39
Prakash, Aditya 184
Prakash, Vikramaditya 7
Prakrit 13
Pramanik, Ramjee 134
Prambanan 58
prasada 65
Pratihara Dynasty 74
Pratuang Emcharoen 157–8, 164
Preecha Thaothong 157
primitive culture 478, 491
primitivism 454, 479
Prince of Wales 169
Princely States 11
printing 465
printmaking 159
procession 30, 32–3, 146, 154
profile 124
program 80, 110
 sculptural 43
proletariat 433, 440, 442
propaganda 437, 442–3, 450, 453, 472
prostitution 422
prostration 145
protest 448
pseudo-languages 462, 466, 475
Ptolemy 15, 20
Pudong 197
pun 51, 53, 75, 312, 327
Punjab 11, 105, 108–9, 116–17, 125–6,
 138, 177, 179–80, 187
purana 5, 34, 44, 170–1, 241
Pure Land Buddhism 142, 296,
 298–300, 308, 358

purification 265, 271, 345
purity 270, 273
Pythagoras 68

Qazvini 105
qi 242, 404
Qi kingdom 209–10, 227, 243
Qian An 384
Qian Changling 390
Qian Chenqun 381–2, 384, 389–90
Qian Juying 390
Qian Ruizheng 386
Qian Yuling 390
Qian Yunsu 390
Qian Zai 390
Qian Zhie 390
Qianlong emperor 366, 377, 381–2, 385
Qin dynasty 199, 209, 212, 218–21,
 223, 225–7
Qin Shi Huang (First Emperor of
 Qin) 218–19, 221, 224–5, 226, 466
 plan and cross-section of tomb of 223
 plan of necropolis of 222
Qing dynasty 199, 229, 359, 362, 377,
 380–1, 383–4, 386, 388, 390–1,
 398–9, 402, 406
Qinghua University 442
Qingling 285
Qingzhou 282
Qiu Ying 355
Qiu Zhijie 464

race 466, 478, 481, 485–6
Radcliffe, Sir Cyril 178
Ragamala 117
Rai Singh, Raja of Bikaner 119
raigo (welcoming descent) 298
Raj *see* British Raj
Raj Singh, Rana of Bundi 120
raja (king) 83, 116
Rajasimha (Nandivarman II Pallava) 53,
 56, 73
Rajasthan 11, 116–18, 120, 124–6
Rajendra 135
Rajput culture 116–21, 124–6, 171
raku ware 347, 429
Rama 35, 44

Rama I, Chakri king 148–9, 153
Rama III, Chakri king 162–3
Rama IV, Chakri king 163
Ramayana 44, 49, 117
Rambo 157, 478
Ramkhamhaeng, King of Thailand 163
Ran Bagha 95
Ranthambhor fort 119
rasas 77
rasashringara 77
Rashtrakuta Dynasty 73
Rather, Dan 488
Rattanakosin Era 12, 147, 149
Rauschenberg, Robert 455, 457
Ravi River 108
realism 400
 see also socialist realism
rebirth 59, 63, 65, 270, 299–300, 306,
 346
reception 5
recession, spatial 293
recluse 280, 282, 284, 290, 329, 335,
 338, 341, 343, 344–5, 347–8
Recognition of Shakuntala 168
Red Guards 432, 438, 441–2
red light districts 480
relic 30, 143, 146, 436, 445, 452
relief sculpture 43–4, 53, 58, 62–3, 87
religion 5, 140, 148
Rembrandt van Rijn 171, 410, 412, 422
renga poetry 339
repatriation 128
Reportage Painting 450, 453
reservoir (*baray*) 84
Restany, Pierre 457
revolution 432–3, 436–9, 442
revolutionary romanticism 437–8
Reynolds, Sir Joshua 168, 170, 175
rhinoceros 99
Ricci, Matteo (Ri Madu) 400
Riegl, Alois 202–3, 206
Rig Veda 68
Rig Yajur 37
Rikyu *see* Sen Rikyu to Daitokuji
Rinpoche, Jowo 144
*rishi*s (holy men) 49–50
Rising Sun 479

Rites, Book of 255
ritual 5, 19, 51–2, 66, 68, 130, 140, 143,
 204–7, 211, 256, 261–3, 266–7,
 270–2, 285, 338, 343–4, 347–8,
 362, 481
ritual vessels 214–15
Robinet, Isabelle 358
Rockaway Beach 487
Rodrigues, João 342, 347–8, 350
roji garden *see* garden, *roji*
Rokujo Mansion 311, 316, 321
Roman Empire 226
romanization 9
Rome 364, 368, 421
rosary 68–9, 88, 143
Rose, Barbara 210
Rosenfield, John 5
Rousseau, Jean-Jacques 185
Royal Academy, London 168, 170–1
Royal Asiatic Society 134
Royal United Services Institution 134
rupadhatu (realm of form) 61, 63–4
Ruqayya Sultan Begam 105, 114
Ruskin, John 181
Russell, Bertrand 466
Russell, Edmund 173
Russia 466, 468
Russo-Japanese War 448
Rysbrack, Michael 135

SAS Nagar 184
Sabrat Vilas 121
sacrifice 240, 370, 372
Sadashiva 80
sadhana (meditation) 141–2
sage 76
Said, Edward 7, 477
Saigyo 348
saint 131
 Islamic 102–3
Sakai 425
Sakurai Takami 454
sal tree 25–6
Salim, Prince (later known as
 Jahangir) 107
salon 170, 172
salon painting 168

Sama Vedas 37
Samantabhadra 66–7
Samarqand 103–4, 107, 113
samgha 241
samsara 62
samurai 7–8, 338–40, 408, 411–13
San Diego 197
San Francisco 481, 487
San Francisco Museum of Modern
 Art 463, 475
Sanchi 21–2
sanctum 72, 74–6, 80, 263, 266
sandhara temple 75, 77
sandhi (union, juncture, combination) 75
sandhikshetra (place of juncture) 75
sang hyang widi 69
sangha 151, 152, 157
Sangram Singh 122
Sang-ui 399
Sanjonishi Sanetaka 339
Sanskrit 34, 43, 62, 168, 170–2, 237,
 298
Santo Kyoden 416–17
Saraburi 151
Sarnath 13–14
Sassoon, Victor 194
Satake Yoshiatsu 410–12, 419
Satyaputras 17
scholar 280–1, 283–4, 289, 328, 341,
 343, 352, 359, 381–2, 385, 389, 399,
 401–2, 438, 441, 481
Schwarzenegger, Arnold 157
Scott, Walter 137
Screech, Timon 5, 7
script
 cursive 248
 regular 248
 running 248
scroll 245, 283, 357, 386–8, 423, 464
 hanging 352, 354
scroll painting 343–4
Sea of Milk, Churning of *see* Churning of
 the Sea of Milk
seal script 220, 466
seasons 354, 367, 388
Secretariat, Chandigarh 183
secularism 328

Sehi 30
Sei Shonagon 307
Sekino Masaru 274
Sen Rikyu to Daitokuji 339, 342, 344,
 246–8, 350
Sendai 267
Sengo-ha 452
Seoul 401–2, 425, 478
Serai 110
Seringapatam 129, 136
Sesshu Toyo 326
Seven Sages of the Bamboo Grove 344,
 348
sexual practices 71
sexual terminology 77
sexuality 5, 74, 78, 487
Shah Jahan 4, 103–5, 108–10, 112–14
 tomb of 111, 115
Shahdara 108, 114
shahriyar 108
Shailendra Dynasty 11, 57–8
Shaiva Siddhanta system 80
Shaivism 79, 130
shakti 35, 131, 181
Shakuntala 168–9, 171, 175–6
Shakya clan 22
Shakyamuni 69, 296, 300
 see also Buddha
Shakyasimha 14
Shambhu 39
Shandong 209
Shang dynasty 199, 201, 205–9, 212,
 214–15, 463
Shanghai 189, 194, 463
Shangqing Supreme Purity School 357–8
Shankara 39
shanshuihua 279
Shao Yong 280
sharia 111
Sharma, M. N. 184
Shaykh Salim 96
Shaykh Zaynuddin 111
Shen Nong 382
Shen Zhou 328, 385
Sher Shah Sur 105
Sher-e-Bangla Nagar 182
Shesha 40

Shi Zhou 245
Shiba Kokan 410, 412, 414–15, 419, 421–2
Shigaraki 276
Shigehisa Kuriyama 359
Shiism 131
Shikitei Sanba 417
shilpa (art) 75
Shimabara 426
Shimizu Kusuo 455
Shimla 179
Shinjuku Dai-Ichi Gallery 459
Shinohara Ushio *see* Ushio Shinohara
Shinto 5, 8, 261, 263, 268–70, 272–3, 455
Shirakawa (Retired Emperor) 302–3, 309–10
Shiva 9, 34–7, 44, 47–51, 55, 69, 72, 74–5, 79–80, 130, 134
Shiva Bhikshatana 51
Shoden 266–9, 272
shogun 325–6, 338, 419, 421
shoin 339, 346
Shoji Hamada *see* Hamada Shoji
Shokomyoin 304–5
Shoku Nihongi 275
Shomu, emperor of Nara period Japan 5, 258, 275–6
Shubun Tensho 326, 333
Shunga Period 11
shunyata 66, 68
Shusaku Arakawa 451, 456
Siam Commercial Bank 160
Siamese twins 487
Sichuan 224, 438
Siddhanta system 80–1
Siddhartha 284
Siddhas 36
Sikandra 102, 107–9, 111–12
Sikh 138, 180
Sikri 96
silk 371, 478
Silk Road 31
silkworms 371
Silla dynasty 399
Silpa Bhirasri (formerly Corrado Feroci) 155, 162

Silpakorn University 158–9, 161–2, 164
Sima Qian 212, 220–1
simha (lion) 53
Simhavishnu 53
simulacra 458
sin 317
Sin Kyong-jun 400
Singapore 8, 189–92, 194, 196
Singer Building 190
Sinhala Buddha 297, 305–6
Sino-Japanese War 448
sirhak thought 399, 401
Sirhind 105
Sita 176
Six Dynasties 279
sky-clad *see digambara*
skyline 191, 195
skyscraper 2, 189, 191, 194
Smith, Al 191
Snow, Edgar 439
So 399
soan 341–2, 345–8
socialism 445, 454
socialist realism 437–8, 450, 453, 455
sog shing (soul pole) 143
soldier 153, 431–3, 436, 439, 441
solstice 86, 88–90
Somavamsha (moon lineage) 83
Somdet Phra Buddhakhosachan 154
Somporn Rodboon 159
Song Dong 464
Song dynasty 4, 199, 245, 256–7, 278–9, 285, 289, 326, 333, 336, 368, 382–4, 386, 395–7, 464–5
Song Si-yol 398
Soper, Alexander 242
South Africa 466
Southeast Asia 3
Spiridion Roma 135
spirituality 5, 13, 57–8, 64, 78–9, 279
Sri Lanka 17, 31, 60, 151, 154
Sri Rangapattana 128–9, 132–3, 137–8
St Petersburg 364, 368
Stalin, Joseph 438
Statue of Liberty 202
stereotype 477
student 439, 441, 451

stupa 21, 31–3, 57–60, 64–5, 67–8, 76, 144, 150
stupika 67
Su Dongpo 330, 332, 335
Su Shi 396
subalterns 133
Subhadra 171
suburbs 191, 370, 372, 479
subway 194
succession 103, 112
Sudhana 65
Suesada 304
suffering 17
Sufism 131
suiboku painting 326, 328
suicide 313
Sukchong 403
Sukeroku 420
Sukhothai 163
Sulawesi 57
Sultanate period 104
Sumatra 31, 57
sumi 455
sumo 411–12
sun goddess *see* Amaterasu
Sun Guoting 255
Sun Ruozhi 212
Sun, May 486
Sunni Islam 130
Superman 157
Surasit Saokhong 157
Suri clan 105
Surjan Singh, Rao of Bundi 119
Surrealism 449–50, 453–4, 457
Surya 35, 39, 72, 88
Suryavarman II 83–5
sutra 30–1, 358
Suzaku emperor 312, 317, 319
Suzhou 352, 354, 385, 416, 423
Suzie Wong 478
symbolism 53, 67, 69, 89–90, 103, 106, 113, 116, 196, 204, 206–8, 210, 269–70, 327, 402, 406, 440, 455

Tagajo 267
Tagalog 478
Tagore, Rabindranath 168–9, 174

Taian at Myokian 342, 347
Taihang, Mt 282
Taiji 367
Taizong 248, 253–5, 259
Taizu 382
Taj Mahal 4, 101, 110–13
Takamatsu Jiro 458–9
Takasaki 268
Takeda Kizaemon 425
Takiguchi Shuzo 459
Takizawa Bakin 417
Tale of Genji 298, 307, 311–12
Tales of the Heike 418
Tamamushi shrine 3, 237
Tambiah, Stanley J. 305
Tamil 20
Tamil Nadu 44
Tan Kudt 159, 161, 164
Tang dynasty 199, 246, 248–9, 253–9, 278, 280–2, 285, 332, 382, 386, 398, 465
Tang Hou 356
Tan'gun, Silla king 399
Tani Buncho 412
Tanjavur (Tanjore) 73, 173
Tanjore *see* Tanjavur
tantra 71, 79–81, 144, 146
Tantric Buddhism 69, 140, 146
Tao Hongjing 358
Tao Qian 279, 396
Tao Yuanming 329–30, 332, 335, 348
taotie 215
Tara 141–2
tatami 347, 411
Tathagata 22, 24
Taxila 17
Taylor, Meadows 137
Tchen, John Kuo Wei 7
tea 7, 338–9, 341, 344–5, 424–5, 479
 basara 342, 350
 bowl 7, 426
 ceremony 326, 466
 daimyo 342, 350
 house 339, 408
 master 429
 vessels 340
 wabi 340, 342–4, 346

technology 185, 219, 227, 278, 399,
 437, 454, 472
tejas 39
Teleport Town 195
Temmu 271
temple 46, 50, 57, 71–4, 76, 81, 83,
 134–5, 144–5, 147, 149, 151–2, 160,
 162, 204, 208–9, 211, 261, 281, 290,
 295, 299, 303, 306, 326, 345, 371, 426
Tempyo reign 276
Tendai sect 296, 299
Tensho Shubun *see* Shubun Tensho
terracotta 218–20, 222, 224, 225–30,
 232–3
textiles 225, 352, 354, 376
"Thai Art" 80, 158–9
Thai culture 153, 157
Thai food 479
Thai military 163
Thailand 12, 90, 147–8, 150, 155,
 158–62, 189, 297, 305, 377
Thainess 158
Thammayut sect 152
Thapar, P. N. 184
Thawan Duchanee 157–8, 164
Theravada Buddhism 151
Third Reign 160
Thoreau, Henry David 181
Three Dynasties 211
Three Laughers of the Tiger Ravine 331
Thucydides 341
thunderbolt (*vajra*) 143–4
Tiananmen Square 195, 202, 439, 441,
 444, 446, 462, 487
Tiantai Buddhism 336
Tibet 2, 5–6, 62, 141–5
Tidar, Mt 58
tiger 95, 128, 130–1, 137–8, 237, 253,
 329–30, 332, 334–5, 367
tigress 3, 239–40
Tilottama 172
Timur 101, 103, 106, 110, 113
Timurid culture 104, 112, 115
Timurid rule, in India 105
Tin Pan Alley 480
Tipu Sultan 127, 129–34, 136–8
Tipu's Tiger 127, 128, 129, 132, 134–8

tirtham 51
To no Chujo 311–16, 319–20
Toba 301
Toba Detached Palace 303, 309
Toba, Retired Emperor 303, 309–10
Tod, James 117
Todaiji 258, 276
tokonoma 347
Tokugawa period *see* Edo period
Tokugawa shogunate 273–4
Tokyo 195, 408–10, 412, 451, 454, 457
Tokyo Summer Olympics 458
Tolstoy, Leo 181
Tomatsu Shomei 452
tomb 5, 101–3, 106, 109, 219–20, 226,
 233, 250, 367, 369, 399
 Islamic 104–5
 of saint (*dargah*) 103, 106
Tono Yoshiaki 455, 457
torii 262–4, 266
Torii Kiyotada 411
Toronto 192
Toshi Ieshige 425
Toshihito 339
tourism 72, 148, 154, 157, 160, 162–3,
 192, 202, 362, 482
Toyouke 262
trade 13, 46, 127, 154
tradition 148, 201, 425, 468, 478
Traiphum (Three Worlds) 153
translation 472
transliteration 9
Travancore 168
 Maharaja of 169
travel 401, 404, 406
treasury 369
Trichy 50
trident 37, 41, 47
Trinh T. Minh-Ha 486
tripod 201
Trivandrum 171, 173, 176
true-view landscape painting 395–6,
 400–2
Tsuda Sokyu 339
Tu Fu 279
Tughluk Sultanate 11, 102, 104,
 107, 114

tumulus 221
Tumulus period 269
turkey 97
Turkey 160
Turner, Victor 343–6, 348
Tuzuk-i Jahangiri see Jahangirnama
typeface 465, 471

ubosot 150
Udagra 40
Udai Singh of Marwar 119
Udaipur 122, 171, 173
Udayagiri 35
ugliness 429
Ugradarshana 40
Uji 295, 304
Uji River 301
Ujjain 17
uki-e 409, 411–15, 417, 419–23
ukiyo 408
ukiyo-e 408–9
Umed Singh 122
union (*sandhi*) 75
union, of workers 441, 450
United Nations 465, 468, 475
United Nations Building 185
United States 177, 190–1, 414, 449,
 451, 460, 462–3, 466–7, 471, 477–8,
 480, 485–6
universalism 171, 453
Upanishads 77
Uragami Gyokudo 329
urban planning 183, 365
Ushio Shinohara 452, 454–5, 457–8

Vadodara (Baroda) 170–3, 176
Vairochana Buddha 65, 69
Vaishnava Pancharatra system 80
Vaishnavism 131
vajra (thunderbolt) 143–4
Vajrayana Buddhism 140
Vajrayogini 141
vama (left-handed) tantra 80
vanishing point 411
varada mudra 47, 49, 54
Varaha 34–5
Varanasi (Benares) 22, 24–6, 28, 49

Varma, Raja Ravi 167–74, 176
Varuna 39
Vasari, Georgio 409
Vasuki 87, 89
Vayu 39
Vedas 79–80, 238, 241
veduta 413–14
vegetarianism 16
veil 94
Venice 413
Verma, P. L. 180, 184
vernacular architecture 267, 274
Victoria 194
 death of 173
Victoria and Albert Museum 127–9
Victoria Memorial 173
Victorian culture 76, 167, 169–72, 176,
 479, 480
victory (*jaya*) 67
Vidyadhara 74–5
Vienna 172
Vietnam 163, 487
viewer 46, 138
viewing practices 352, 355, 409, 419
viharn 150
Vijayalaya 73
village 181, 185–6, 268, 450
Vishnu 34–7, 39, 44, 50–1, 72, 75, 80,
 83–4, 86–7, 90–1
Vishvakarman 36, 40
Vishvanatha Temple 71, 74–5, 77–80
Visual Dhamma Gallery 158–9
visuality 357, 359
visualization 142, 298, 357–8
viveka (discrimination) 65
Vraja 38
vue d'optique 414–15, 418–19, 423

wabi tea *see* tea, *wabi*
wabi-sabi 339
Wade Giles 9
Wagner, Peter 353, 359
walls 53, 66, 69, 72–3, 75–81, 104, 149,
 151–3, 159–61, 169, 221, 223, 225,
 227, 230, 263, 267, 269, 285, 297–8,
 304, 330, 341, 347, 378, 400, 404,
 464, 466, 474, 487

walls (*contd*)
of city 362, 366–7, 369, 372–3
Wanchai District 194, 196
wandering 291
wang (initiation ceremony) 142
Wang Fu 384
Wang Gui 254
Wang Hui 383–4
Wang Keyu 356–7
Wang Meng 384–5, 390
Wang Shen 335
Wang Shiren 372
Wang Wei 294
Wang Xianzhi 248
Wang Xingwei 445
Wang Xizhi 247–8, 249, 252, 255–6, 258
Wang Yuan 386
Wang Zheng 388
Wangsun Man 205–7, 209–10
warfare, maritime 46
Warring States period 209, 227, 367
warrior 35, 43–4, 48, 51, 73, 116, 131,
218–19, 222, 224–5, 229–30, 232–3,
252–3, 338–9
Washington Monument 202
Washington, George 479
wat see temple
Wat Benchamabophit 155
Wat Buddhaisawan 154
Wat Buddhapadipa 147–8, 150, 157–9,
161, 163–4
Wat Kanmatuyaram 152
Wat Maha Phruttharam 152
Wat Phumin 160
Wat Ratchaburana 151
Wat Suthat 160
Wat Suwannaram 160
water 51, 84, 95, 253, 291,
333, 367
watercolor 438
wayo (native style) 296
weapon 40–1, 44, 47, 51, 123, 225–7,
229, 231, 346, 433
Wei dynasty 279
Wei furen *see* Wei Shuo
Wei Shuo (Madam Wei) 253, 390
Wei Xie 243–4

Wei Zheng 254
Weidner, Marsha 5
Wellesley, Colonel Arthur 132–4
Wellesley, Governor-General Richard 132
Wellington, Duke of (Arthur
Wellesley) 132
Wen Shimin 383
Wen Shu 388–9
Wen Zhengming 328, 354, 385, 389
Wen Zhenheng, 356–7
Wenda Gu *see* Gu Wenda
Wengnan Yi 208
Wenji, Lady *see* Cai Yan
Wenk, Klaus 149
wenren 328, 336
West, Benjamin 135, 175
Western Paradise 296, 298, 301
westernization 148
Westinghouse Science Award 482
wheel *see chakra*
White Cockatoo 386, *387*
White, Gordon 443
Wilkins, Charles 136
Wimbledon 147
wine 99
Wisconsin, University of, at Madison 471
Wittgenstein, Ludwig 466
Wodeyar kingdom 127, 129, 131
women 359–60, 380–2, 455
words 464–5, 471
worker 431–3, 436, 441, 481
workshop 73, 116–17, 298, 369
World Trade Center, Bangkok 160
World War II 274, 425, 449, 487
writing 463, 465
Wu Hung 5
Wu kingdom 227
Wu Liang Shrine 212
Wu School 385
Wudi, Liang emperor 253
Wuyi, Mt 400
Wuzhun Shifan 336
Wuzong 333
Wyatt, David 151

xenophobia 482
Xia dynasty 205–6, 208–9

Xi'an (Chang'an) 31, 279, 364, 366–8, 372
Xiang Yu 221–2, 224
Xiang Yuanbian 354
Xianyang 221, 224, 228–9
Xiao and Xiang Rivers, Eight Views of 396
Xibeigang 373
Xie He 242–3, 245, 357
Xin Zhibin 463
Xu Bing 462–9, 470, 471–3, 476
Xu Can 388
Xu Wei 386
Xu You 290, 294
Xue Susu (Xue Wu) 388
Xun Xu 244
Xunzhi 245

yaksha 241
Yakushi 297
Yama 39
Yamanoue Soji 342
Yamato 268
Yamazato 341
Yan 227
Yan Shuai 209–10
Yan Su 285
Yanagi, Soetsu 7, 425
Yan'an 431, 438
Yan'an talks 436, 444, 469
Yang Guefei 386
Yang Shoujing 250
Yangzi River 221, 227, 329, 381
yantra 57, 59, 65–6
Yao, mythical emperor 294
Yashovarman Chandella 74–5
Yellow Emperor 227
Yellow River 221, 228
yellowface 476–7, 488
yi 246
Yi Chung-hwan 400
Yi Ha-gon 401
Yi Ik 399–400
Yi Man-bu 404
Yi Pyong-yon 401, 403
Yi Song-Mi 5
Yi Su-gwang 399
yin–yang 269, 403

yoga 37, 69, 77, 79
yogic power 74
yogic sleep 36
yogin 37, 146
Yomiuri Indépendant Artists 448, 451–5, 458, 460
Yongjo 396, 401, 403
Yongle 363
Yosa Buson 329
Yoshimochi 326
Yoshimura Masunobu 452, 455
Yoshiwara 417
Yu Guanghui 390
Yu Jiwu 441
Yu Zhaosheng 390
Yuan dynasty 199, 377, 384, 386
Yuan Qian 245
Yuan Zhongyi 229
Yubai Hoshin 333
Yue kingdom 227
Yugiri 313, 320–1, 323
Yun Bing 388–9
Yun Gee 487
Yun Shouping 388–9
Yun Tu-so 400
Yunqi Zhuhong 358

Zen Buddhism 325–7, 336, 339, 427, 430
Zhang Cao 281
Zhang Dafu 353, 357
Zhang Geng 382–3, 390
Zhang Mo 244
Zhang Peili 463
Zhang Tingji 390
Zhang Yi 209
Zhang Zai 281
Zhao Mengfu 284, 389
Zhongkui 360
zhongqi 201, 207, 211
Zhou dynasty 199, 201, 205, 207–10, 212, 214–17, 227, 246, 382
Zhou sisters 388
Zhou, king of the Shang dynasty 206–7
Zhu Xin 388
Zijin Cheng 367
zograscope 414–15
Zong Bing 404